Audio in Media

From the Wadsworth Series in Mass Communication

General Mass Communication

Biagi, *Media/Impact*, Updated 2nd
Biagi, *Media/Reader*, 2nd
Day, *Ethics in Media Communications*
Fortner, *International Communication*
Frederick, *Global Communication and International Relations*
Jamieson/Campbell, *The Interplay of Influence*, 3rd
Rosen/DeVries, *Introduction to Photography*, 4th
Whetmore, *Mediamerica, Mediaworld*, 5th
Wimmer/Dominick, *Mass Media Research*, 4th
Zelezny, *Cases in Communications Law*
Zelezny, *Communications Law*

Radio/Television/Cable/Film

Armer, *Directing TV and Film*, 2nd
Armer, *Writing the Screenplay*, 2nd
Austin, *Immediate Seating: A Look at Movie Audiences*
Butler, *Analyzing Television*
Eastman, *Broadcast/Cable Programming*, 4th
Gomery, *Movie History: A Survey*

Gross/Ward, *Electronic Moviemaking*
Hausman, *Crafting News for the Electronic Media*
Hausman, *Institutional Video*
Hilliard, *Writing for Television and Radio*, 5th
Madsen, *Working Cinema: Learning from the Masters*
Meeske/Norris, *Copywriting for the Electronic Media*, 2nd
Morley, *Scriptwriting for High-Impact Video*
O'Donnell/Benoit/Hausman, *Announcing*, 2nd
O'Donnell/Benoit/Hausman, *Modern Radio Production*, 3rd
O'Donnell/Benoit/Hausman, *Radio Station Operations*
Smith, *Video Communication*
Sterling/Kittross, *Stay Tuned: A Concise History of American Broadcasting*, 2nd
Viera, *Lighting for Film and Electronic Cinematography*
Warner/Buchman, *Broadcast and Cable Selling*, Updated 2nd
Zettl, *Sight-Sound-Motion*, 2nd
Zettl, *Television Production Handbook*, 5th
Zettl, *Television Production Workbook*, 5th

Audio in Media

Fourth Edition

Stanley R. Alten
Syracuse University

Wadsworth Publishing Company
Belmont, California
A Division of Wadsworth, Inc.

Editor: Kristine Clerkin
Advertising Project Manager: Sarah
 Hubbard
Editorial Assistant: Joshua King
Production Editor: Vicki Friedberg
Managing Designer: Kaelin Chappell
Art Editor: Nancy Spellman
Print Buyer: Barbara Britton
Permissions Editor: Robert M. Kauser
Production Assistance: Roberta Broyer
Illustrators: Hans & Cassady, Inc.
Copy Editor: Cheryl Ferguson
Cover Design: Craig Hanson
Cover Photo: Courtesy of Otari
 Corporation
Signing Representative: Tom Orsi
Compositor: Thompson Type
Printer: Arcata Graphics/Fairfield

International Thomson Publishing
The trademark ITP is used under license.

Printed in the United States of America
1 2 3 4 5 6 7 8 9 10 — 98 97 96 95 94

Library of Congress Cataloging-in-Publication Data

Alten, Stanley R.
 Audio in media / Stanley R. Alten. — 4th ed.
 p. cm.
 Includes bibliographical references and index.
 ISBN 0-534-19602-0
 1. Sound — Recording and reproducing.
 I. Title.
TK7881.4.A46 1994
621.389'3 — dc20 93-41203

For Claudette — the loveliest sound —
Ariane and Renee

And in memory of Laura

Brief Contents

Detailed Contents

Preface

In the little more than ten years since the first edition of *Audio in Media*, advances in audio technology and techniques have had a wider impact on sound production and reproduction than during any other decade in audio history. The more obvious examples are the development of digital recording, MIDI, and the workstation.

The good news is that these revolutionary advances have significantly improved sound quality in the electronic-mechanical media, greatly increased the flexibility and quickness in producing and postproducing audio, and put sophisticated equipment at the fingertips of the professional and nonprofessional sound designer. The not-so-good news is that the proliferation of so much new technology in such a short time combined with the technology that has been around for a few years (which, though no longer state-of-the-art, is not obsolete either) present the formidable challenge of creating a comprehensive new edition of *Audio in Media* that is teachable to the beginner and useful to the experienced practitioner, without appreciably expanding the book or altering its approach.

Therefore, the fourth edition is roughly the same length as the third and maintains the same structure and emphasis. It is still designed to reflect "process" in the planning and producing of sound and is organized into five major sections: Principles, Equipment, Preproduction, Production, and Postproduction. The emphasis remains mostly on principles and practices: ten chapters are devoted to theory, aesthetics, and techniques; seven chapters cover the technology. As with previous editions, this edition may be used selectively, based on need, level of instruction, and medium. New to this edition is a more generic approach to production. For example, instead of chapters that deal specifically with radio production, multi- and single-camera audio production, and music recording, this material has been integrated into chapters that focus on the three building blocks of

sound design: speech, sound effects, and music. Also new to this edition are a separate chapter on digital recording, a fuller discussion of MIDI, a section covering nonlinear hard-disk editing, expanded treatments of 3-D and surround sound, plus many new illustrations.

Structure of the Text

In Part 1, *Principles*, Chapter 1, "Sound Design," sets a context for the rest of the book by describing the nature of sound design, the role of the sound designer, and the basic structure of sonic communication. Chapter 2, "Sound and Hearing," introduces the physical behavior of sound and its relationship to human hearing. Chapter 3, "Acoustics and Psychoacoustics," develops the material in Chapter 2 as it applies to the objective behavior of received sound and its subjective effect on those who hear it.

Part 2, *Equipment*, begins with "Sound Studios," Chapter 4 (which in the third edition concluded Part 1). Also, more in keeping with the concept of signal flow, the principles, types, characteristics, and accessories of microphones are covered in Chapter 5, before we present consoles. Chapter 6, "Consoles," is essentially divided into two sections: the first, using less complex designs, introduces the theory behind and operation of most consoles; the second describes the more complex consoles used mainly for production. Most of the first six chapters are basic to the study of audio. Chapter 7 is devoted entirely to analog recording, containing three major sections: general characteristics of audiotape and tape recorders, analog recording on videotape, and audio recording on film. Except for the first section, which is fundamental, the other sections can be read based upon need. Chapter 8 presents

digital recording and can be used based on need. It contains sections on the basic principles of digital recording, digital audiotape and digital audiotape recorders, digital recording on videotape, and disk-based audio systems. Chapter 9, "Signal Processing," covers the general principles of signal processing and discusses the most commonly used signal processors and their effect on sound. This chapter may be read in whole or in part, as needed. Chapter 10, "Loudspeakers and Monitoring," is fundamental to audio because most recorded and broadcast sound is monitored and evaluated through a loudspeaker.

Part 3, *Preproduction*, consists of one chapter, "Creating the Sound Design." Although it applies mainly to radio, TV, and film preproduction, it should be useful to anyone interested in the aesthetics of audio and its interaction with picture.

Part 4, *Production*, as mentioned earlier, takes a generic approach to audio production. The first three chapters focus on the three basic components sound designers have at their disposal—speech, sound effects, and music. Chapter 12, "Producing Speech," treats the various approaches that are used in radio and multi- and single-camera audio production. The subject of Chapter 13 is producing sound effects, using prerecorded libraries, Foleyed effects, sounds recorded in the field, and electronically generated sound effects. Chapter 14, "Producing Music," covers music production in radio and commercials, the use of prerecorded music libraries, and live music studio sessions. Chapter 15, "On-Location Recording and Production," covers field producing news, press conferences, sports, music, and drama for radio, multi- and single-camera TV and film.

Part 5, *Postproduction*, begins with Chapter 16, "Editing," which describes techniques of editing audio on analog and digital audio-

tape, videotape, film, and hard-disk–based systems. It also addresses the aesthetic considerations that apply to editing, including speech, dialogue, sound effects, music, and the uses of transitions. Chapter 17, "Mixing and Rerecording," is basic to the four media because it covers the final stage in production when sounds are combined and processed. To facilitate specific reference, the chapter is divided into sections directed to radio, music, and sound-picture postproduction.

Audio Production — Content and Technology

The revolutionary changes in audio production over the past decade should not redirect attention from sound's importance in mediated communication or from the relationship between the creative and technical personnel.

In a study conducted to ascertain what effect sound had on television viewers, three tests were administered. In one test, the sound quality of the audio and the picture quality of the video were without flaws. The viewers' general response was, "What a fine, good-looking show." In the second test, the sound quality of the audio was without flaws but the picture quality of the video was tarnished—it went from color to black-and-white and from clear to "snowy," it developed horizontal lines, and it "tore" at the top of the screen. The audience stayed through the viewing but generally had a lukewarm response: "The show was nothing great, just okay." In the third test, the picture quality of the video was without flaws but the sound quality of the audio was tarnished—it cut out from time to time so there was intermittent silence, static was introduced here and there, and volume was sometimes made too loud or too soft. Most of the audience had

left by the end of the viewing. Those who stayed said the show was "quite poor." The study obviously demonstrated the importance of sound, but it can also be taken as a warning to those producers and directors who underestimate that importance.

Producing audio is a creative process that requires the use of technology to bring it to fruition. Students sometimes conclude that mastery of those tools is the end in itself rather than simply the means to an end. Actually, audio production depends on the symbiotic relationship between two dissimilar "organisms"—the sound designer's aesthetic sensibility and the engineer's technical expertise—in a mutually beneficial association. The role of each partner should be kept in perspective: The engineer has the responsibility to make material sound *good*; the sound designer has the responsibility to make material sound *interesting*.

Acknowledgments

No book of this scope and complexity can be produced without the advice and guidance of the teachers and practitioners in the field. Whatever success the fourth edition of *Audio in Media* enjoys is due in no small measure to their good counsel.

To the following reviewers for the fourth edition, I offer my sincere gratitude for their insightful contributions: Allan Barber, Temple University; Tom Basmajian, Art Institute of Philadelphia; Doug Carroll, Menlo College; James P. Gallagher, Art Institute of Philadelphia; and Joe Krauss, Art Institute of Philadelphia.

To the academic and industry professionals who provided their assistance, my continued deep appreciation: John Adelman, General Manager, Superdupe, New York; Scott Austin, Producer, Power Station, New York;

Bruce Bartlett, author; Jerry Bruck, Posthorn Recordings; Deborah Bryce, Otari Corporation; John Butler, News Director, WSYR, Syracuse; Jessica Casavant, ADR and Foley recordist, McClear Pathé, Toronto; Bill Cooper, Director of Audio Services, Syracuse University; Chris Corrazzo, Esto Photographics, Mammaroneck, N.Y.; Bob Costas, Sportscaster, NBC-TV; Lee Dichter, rerecording mixer, Sound One, New York; Ron Estes, sound mixer, NBC-TV, Burbank; Ed Greene, Greene, Crowe Productions, Hollywood; Joe Grimaldi, rerecording mixer, McClear Pathé, Toronto; Tom Holden, Radio Systems Design Engineer, CBC, Toronto; Tomlinson Holman, University of Southern California and LucasFilm; Chris Irwin, Dolby Laboratories; Ron McKee, Ryerson Institute, Toronto; William Murphy, Director of Broadcast Promotion, WTIC-TV, Hartford; Chris Palmer, Production Manager, Professional Sound Corporation, Hollywood; Jim Perry, Chief Engineer, WTIC-TV, Hartford; Tom Ray, Chief Engineer, WTIC-AM & FM, Hartford; special thanks to Ron Remschel, Marketing Manager for Audio, Sony Corporation of America; Gary Rydstrom, rerecording mixer, Hollywood; Rick Sanchez, Mark IV Audio: Vega, Electro-Voice; Tim Self, Opcode Systems; Mike Shane, Wheatstone Corporation; Bill Shelton, Sound Department Administrator, Universal City Studios; Tom Shipton, Studio Manager, Glenn Gould Theater, CBC, Toronto; Dick Stumpf, Senior Vice President for Audio Development, Universal City Studios; John Sullivan, Senior Audio Engineer, NBC-TV, New York; John Terrelle, Producer, Clack Studios, New York; Clive Vanderburgh, Ryerson Institute, Toronto; Bill Varney, Vice President in Charge of Sound, Universal City Studios; Jeff Wilson, Digital Audio Labs; Herbert Zettl, San Francisco State University.

Sincere thanks to David Rubin, Dean, Newhouse School of Public Communications, Syracuse University, for his help and support.

To the all-star team at Wadsworth Publishing Company, who, with each new edition, manage to outdo themselves, goes my deep thanks and appreciation. In particular, production editor, Vicki Friedberg, with whom it was a pleasure to work; copy editor, Cheryl Ferguson; and production designer, Kaelin Chappell. And to Becky Hayden, now retired, who will always be a part of *Audio in Media*.

Sound is a very special modality. We cannot handle it. We cannot push it away. We cannot turn our backs to it. We can close our eyes, hold our noses, withdraw from touch, refuse to taste. We cannot close our ears though we can partly muffle them. Sound is the least controllable of all sense modalities. . . . We are therefore looking at a problem of considerable depth and complexity.

Julian Jaynes, *The Origin of Consciousness in the Breakdown of the Bicameral Mind* (Boston: Houghton Mifflin, 1976), pp. 96–97.

Principles

Sound Design

Handwritten note (overlay):
with sound the emotion communicates the idea.
Sound is a force
sound is omnidirectional its everywhere.
Listening is a dynamic activity
Taken for granted

"With the sense [...] re shifts, the orig-
communicat [...] und can be lay-
Whereas wit[...] dded to another
tion communicates the idea [...] nd is attention-
direct and therefore more po[...] mmunicate, they
the noted philosopher and [...] o comprehend
Alfred North Whitehead. Rei[...] necessarily the
rector Akira Kurosawa put i[...] Listening is a
"The most exciting moment [...]
when I add the sound. . . . [Th[...] ning" television or
[...]g a movie. Radio and recordings are
Sound is a force: emotiona[...] often used as background to other engross-
physical. It can excite feeling, convey mean- ments. Sound is taken for granted or often
ing, and, if it is loud enough, resonate the ignored. The history of sound in film and
body. Sound is omnidirectional; it is every- electronic media is replete with examples
where. The human eye can focus on only one

of audio, and those who produce it, being thought of as secondary to other creative functions.

It wasn't too long ago, for example, that the only screen credit for sound in most films went to the head of the studio's sound department, regardless of who served on a film's audio crew. In fact, for the first 40 years of sound films, the Academy of Motion Picture Arts and Sciences awarded the Oscar for best sound to the head of the producing studio's sound department, no matter what his creative contribution to the winning film's sound track actually was. Similarly, although television traditionally gave individual program credit for sound, the networks were also parsimonious in acknowledging the extent to which audio people contributed to a production. And on record albums, if a production credit was listed at all, it was the producer's. Even radio, which during its heyday was the one medium completely dependent on all types of sound, seldom identified those responsible for the audio production.

To the artistic and financial benefit of media and audio personnel alike, times have changed. Since 1971, when Oscars were first awarded to individual sound mixers, film credits for sound production have expanded to include, among others, boom operators; recordists; sound effects, music, Foley, and dialogue editors; scoring producers; and re-recording mixers. And in 1979 the Academy acknowledged audio's broader importance by awarding an Oscar to a specified sound designer. Since then, the term *sound designer* has become a craft designation for those who are assigned creative license.

Television audio credits also have become more generous. Furthermore, most compact discs now credit producer, mixer, and mastering engineer. Sometimes, recording assistants are listed as well. Micro-CDs now credit at least the producer. Frequently, the recording engineer is also noted. In public radio, many programs identify contributors to the audio production.

For media professionals and the general audience, all this has affirmed in principle what those in audio production have long known in fact: that planning and producing an effective sound design is as deserving of recognition as the more familiar craft designations of writer, editor, production designer, cinematographer, and scene and costume designer. Like these other functions, the design and production of sound requires talent, artistry, imagination, meticulousness, and time. Sound's impact on communication in media, as in life, is vital, potent, and fundamental.

The Sound Designer

Sound design represents the overall artistic styling of the sonic fabric in an audio production. Similar to the cinematographer, who is responsible for the overall look of a video or film, the sound designer is responsible for the overall sound of a video or film (after the producer and director). That responsibility may be directed by a designated sound designer who coordinates the artistic and operational activities of the various sound personnel, or it may be carried out without a designated sound director by the various members of the sound crew. These people have various titles and perform such tasks as selecting and operating the microphones, operating the production console, production recording, producing and recording sound effects, producing music, recording and re-recording dialogue, editing, and mixing.

Smaller facilities usually require a person to perform more than one function. In larger operations each individual often performs a

single function, generally due to contractual agreement with one or more unions.

Throughout this book the term **sound designer** is used inclusively. This is not to diminish the importance of the various functions noted previously, especially in light of the fact that the term is not yet routinely applied, but rather to underscore the notion that if someone is involved in audio production, whatever the function, that person is involved in sound design.

For example, suppose that in shooting a romantic scene, the film director wants to convey a sense of the relationship's inevitable collapse without being visually heavy-handed—that is, without obviously showing, say, the couple's incompatibility. The sound designer can handle this in a number of ways, such as through microphone selection, microphone placement, or use of room acoustics.

Microphones (*mics*, for short) can affect the tonal quality of a sound source. One mic may enhance mellow sound, another may bring out crispness, still another may make sound more full-bodied. In this scene a mic that made the couple's voices sound sharper or harsher would convey an emotional edge to their dialogue, regardless of its content.

Where a microphone is situated in relation to a sound source also affects sonic quality. A mic placed close to the couple would help to create an intimate, warm sound; a mic placed farther away would help to create a sense of distance and, perhaps, coolness.

Adjusting room acoustics is another way to affect aural perception. A room filled with cushiony furniture and hung with thick drapes would absorb sound, thereby creating an intimate, comfortable aural texture. By contrast, to help foreshadow the couple's breakup, the space in which they are playing the romantic scene could contain hard surfaces such as wood and glass, which reflect sound, thus creating a harder, more uncomfortable aural texture. In addition, the sound designer could employ sound effects, music, and signal processing to heighten the desired effect in this scene.

A condemned prisoner walks through a steel gate that squeaks when it slams shut. Instead of just any squeak, the sound could be mixed with an agonized human groan.

In another scene, a football player has been dropped from the team after years of stardom. Leaving the locker room, he walks onto the playing field. To heighten the sense of emptiness, a lonely sounding wind is added. To intensify the effect, the wind sound could be mixed, subtly, with a crowd roar.

Suppose a director wanted to convey, with sound, a sense of alienation and dehumanization in a high-tech office. One approach would be to orchestrate the scene using sounds of ringing telephones with futuristic tonalities, whisper-jet spurts of laser printers, machines humming in monotonous tempos, and synthesized Muzak in the background.

Or in a hotel room appropriate for a mental breakdown a mosquito whines and wallpaper peels off in Velcro rasps. Overhead comes the thud of an axe hitting something disgustingly soft. In the corridor outside, wind screams down the hall like devils in a high-speed chase.*

A sound design can be developed on a larger scale—for an entire film, TV program, radio commercial, or music recording. Suppose a film's overall visual quality is diaphanous and the director wants the sound design

*"When Sound Is a Character," Judith Shulevitz, *New York Times*, August 18, 1991.

to complement the visual effect. This can be achieved with a sound track that has, for example, an airy, impressionistic quality. In a TV police drama, sonic intensity conveyed through background chatter and clatter, ringing telephones, blaring horns, and screeching tires would underscore the urgency of police business. Sound design in a radio commercial comparing electric shavers might use a smooth, quiet motor sound when operating the sponsor's brand and a louder, harsher motor sound when operating the competitor's brand. Moreover, the writer could be instructed to use pleasant-sounding words for the sponsor's brand and unpleasant-sounding words for the competitor's brand. In a music recording, the producer might design the overall sound to convey any of a number of feelings: epic, romantic, spare, dense, rich, saturated, contrastive, abrasive, bluesy, heavy-metal, funky, wall-of-sound, lilting, and so on. And all the audio personnel along the way, from the person selecting the microphones (usually the first stage in audio production after preproduction planning) to the people mixing the sound (usually the final stage), affect the sound design in some way.

Of all the talents necessary in audio production, none is more important than having the perceptual acuity to shape the sound you want to hear. Or, to put it in audio vernacular, nothing is more important than having good "ears." This requires at least two basic skills: the ability to listen discriminately and an understanding of sound's fundamental effects on human communication.

Listening

The aural stimuli we hear day to day are unexceptional phenomena. We may pay attention to a particular song, to a siren, or to an explosion, but generally, sound functions as little more than background to our comings and goings. To a sound designer, however, such unawareness is professionally ruinous.

A sound designer must be sensitive to all sound, pleasant or unpleasant, exciting or unexciting, significant or insignificant, well performed or poorly performed. The more aware you are of sound, the better you will be able to articulate the literal and aesthetic sonic requirements of a production.

Innate sensitivity to sound varies, and not everyone has the same perceptual acuity. However, you can acquire certain skills through training, and guidelines for listening can be helpful.

What Listening Is and Is Not

Listening is perceiving sound with careful and responsive discrimination. It is thinking about sound — analyzing its quality, style, interpretation, and nuance. It is trying to understand what motivates a sound. It is engaging in new sonic experiences regardless of their strangeness. It is examining your reaction to sound in relation to your mood and feeling.

Listening is not reading while playing music. It is not talking or shouting during a concert. It is not paying attention only to the picture in a film or TV program. It is not riding a bicycle while listening to a Walkman. It is not strolling in the country and just looking. If you are not listening, sound remains part of the environment; it does not become part of your consciousness.

It can be argued that most sounds are part of the environment and many offer so little aesthetic satisfaction that they are not worth listening to. Some sounds even annoy. Listening to undesired music from an adjacent

apartment, in an elevator, or at the supermarket, or listening to the sound of babble, shouting, traffic, a jet plane, or a jackhammer could desensitize aural acuity and make it difficult to enjoy worthwhile sound.

Therefore, it seems reasonable to conclude that listening should be selective. Such a conclusion might be appropriate for most people, but it does not apply to the sound designer.

How to Listen and What to Listen For

Telling you how to listen and what to listen for is an easy task. The difficult part—listening—is yours; training the ear demands effort and years of practice.

You learn how to listen by paying attention to sound wherever and whenever it occurs: in different rooms, in traffic, or at sports events, when showering, getting dressed, dining, or walking, during conversation, at a concert, or lying in bed. You learn what to listen for by analyzing both the components that make up a sound and the relationship of a sound to its environment.

Take the sound of a dog barking. A bark is generally harsh and abrupt. But barks vary widely in pitch, loudness, rhythm, and context. For example, low-pitched barks last longer than high-pitched barks, and some barks begin with a gurgling-type sound rather than with a sharp attack. Within a bark may be a whine, yelp, growl, howl, or boom. Also, some barks have regular rhythms, while others shift beats and produce irregular rhythms. Each of these sounds tells you something about the dog and the situation.

The sound a chick makes while hatching may seem obvious: gradual cracking of the egg shell and then peeping. But listening to a hatching reveals more. The chick peeps inside the egg before cracking it; the peeping is muffled. The shell begins cracking slowly with short, tentative splitting sounds that increase in force. With the increase in force and slightly longer cracking sounds, peeping increases in clarity, loudness, and rapidity. The final cracks of the shell sound more like crunches as the chick stumbles into the world. Once out of the shell, the peeping is unmuffled, steady, and strong, but not quite so loud as it was just before emergence.

Television sound varies from program to program. By noting the credits, you can begin to identify certain sound designs with certain sound designers. In sports, for example, you can recognize different approaches to audio by how sound sources are covered, how sounds are balanced, and which sounds are emphasized. Some sound designers like to keep levels of crowd sounds and the announcer's voice nearly the same to maintain excitement. Others prefer to keep the level of crowd noise relatively low so that, when the action justifies it, the level can be increased to accent the excitement.

Most sound designers have identifiable styles. Some sound people can identify who produced a particular sound, the film or program in which it was first used, or the prerecorded collection from which it came.

Listen to sound in speech. Words may denote meaning, but sound often defines it. On paper, the meaning of the phrase "Have a nice day" is clear. The meaning changes, however, when the stress on certain words changes, or when the words are spoken with a lilt; in a monotone, whine, or drawl; or by an old man, young woman, or child.

Sound in speech conveys such qualities as confidence, fear, anxiety, arrogance, humor, and concern. A person may *appear* confident at an interview, but if the pitch of sentences goes up at the end, if there are unnatural pauses between words or phrases, or if there

is a parched quality to the speech, the person's speech will belie the appearance.

Music perhaps presents the greatest challenge in listening. Its sonic combinations are infinite, and its aesthetic value fulfills basic human needs. Musical taste is intensely personal; two people listening to the same music may respond in two different ways, both valid.

A single note on a single acoustic guitar string can generate a variety of sounds and responses, depending on whether the string is gut or steel, whether it is plucked with a finger or a pick, whether the pick is plastic or metal, the force with which the string is plucked, the type of wood and finish used to make the guitar, the acoustics of the room, and so on. Violins played in warm air have a richer but less crisp sound than do violins played in cool air. Two concert grand pianos may be of the highest quality, but one has a sharper attack more suitable for Baroque or jazz music, while the other has a more "singing" tonality better suited to Romantic music.

When you listen to music, notice how slight changes in attacks and sustains affect accents, how holding or releasing notes for a fraction of a second more or less alters rhythm, how slightly different tonal balances change sonority, how the bass line, drum fills, lyrics, arrangement, production, and musicianship add interest and meaning.

Listen to several recordings of, say, Beethoven's *Fifth Symphony*. Keep constant as many factors as possible, such as the quality of the compact discs, the recording format (stereo, digital, analog), the audio system, and the room. You may be surprised at all the differences in sound and interpretation. You may prefer the sound in one recording and the interpretation in another. That does not mean that one recording is necessarily better; it means that, based on your perception, one is preferable to another for certain reasons. Someone else may disagree.

Because response to sound is personal, standards and guidelines are difficult to establish, and so listening is the key to improving aural discrimination. The ear is capable of constant improvement in its ability to analyze complex sounds. As your aural sensitivity improves, so will your level of auditory achievement. One way to speed realization of that goal is by understanding the elements of sound structure and their effects on response.

Sonic Structure and Human Response

For most of us, sound is elemental. It provides all sorts of *cognitive information* — information related to mental processes of knowledge, reasoning, memory, judgment, and perception — and *affective information* — information related to emotion, feeling, and mood.

Categories of Sound

Everything aural can be grouped into three categories: *music, sounds,* and *speech*. Philosopher Susanne Langer said that music is a tonal analogue to forms of human response, bearing "a close logical similarity to conflict and resolution, speed, arrest, terrific excitement, calm, dreamy lapses."* Music can also suggest a locale, a people, a period in history. Similar characterizations can be made for sounds and speech as well.

A fire engine or police car speeding down a street creates little sense of emergency without the siren blaring. The bright, rapid peal

*Susanne Langer, *Feeling and Form* (New York: Charles Scribner's, 1953), p. 27.

5. Sound provides cognitive information (information related to mental processes of knowledge, reasoning, memory, judgment, and perception) and affective information (information related to emotion, feeling, and mood).

6. Sound can be grouped into three categories: music, sounds, and speech.

7. The basic components of sound structure include pitch, loudness, timbre, tempo, rhythm, attack, duration, and decay.

Sound and Hearing

In Chapter 1 we discussed the relationship between sound in our daily lives and basic principles of sound design; in this chapter we examine in detail the nature of sound and the process of hearing. To better understand the nature of sound, think of it as a natural event in a system of periodic changes between sets of opposite conditions. Examples of such periodicity include changes between day and night, summer and winter, high and low tide, inhalation and exhalation, and systolic and diastolic pressure. Although the type of motion in each of these systems differs, they are all vibrating systems in which the motion repeats in regular time intervals and a force restores the system toward its point of equilib-

rium. Such is the case with the basic component of sound—the sound wave.

The Sound Wave

Sound waves are vibrational disturbances that involve the motion of molecules transmitting energy from one place to another. When an object is struck, plucked, blown, scraped, or bowed, or when the vocal cords are vibrated, air molecules closest to the source of the vibration are set into motion. A sound wave propagates as these molecules begin moving outward from the vibrating body. These molecules pass on their energy

to adjacent molecules starting a reaction, much like the waves that result when a stone is dropped into a body of water. The transfer of momentum from one displaced molecule to the next propagates the original vibrations longitudinally from the vibrating object to the hearer. What makes this reaction possible is air or, more precisely, a molecular medium with the property of elasticity. **Elasticity** is the phenomenon in which a displaced molecule tends to pull back to its original position after its initial momentum has caused it to displace nearby molecules.

As a vibrating object moves outward, it compresses molecules closer together, increasing pressure. **Compression** continues away from the object as the momentum of the disturbed molecules displaces adjacent molecules and so produces a crest in the sound wave. When a vibrating object moves inward, it pulls the molecules farther apart and thins them, creating a **rarefaction**. This rarefaction also travels away from the object in a manner similar to compression, except that it decreases pressure, thereby producing a trough in the sound wave (see 2-1). As the sound wave moves away from the vibrating object, the individual molecules do not advance with the wave; they vibrate at what is termed their *average resting place* until their motion stills or until they are set in motion by another vibration. Inherent in each wave motion are the components that make up a sound wave: frequency, amplitude, velocity, wavelength, and phase (see 2-1).

Frequency and Pitch

When a vibration passes through one complete up-and-down motion, from compression through rarefaction, it has completed one cycle. The number of cycles that a vibration completes in one second is expressed as its **frequency**. If a vibration completes 50

cycles per second (cps), its frequency is 50 hertz (Hz); if it completes 10,000 cps, its frequency is 10,000 Hz, or 10 kilohertz (kHz).*

Every vibration has a frequency, and generally humans are capable of hearing frequencies from 20 Hz to 16,000 Hz. Although frequencies at the **high** and **low ends** of this range are felt more than heard, if perceived at all, some sound designers are uncomfortable with the lack of "air" if they do not sense the frequencies above 16,000 Hz. To enable audiences to feel the rumble of an earthquake or the roar of planes at takeoff, film sound tracks have generated frequencies around 20 Hz at loud levels through large loudspeakers. These ultrasonic and infrasonic experiences, however, are uncommon.

Psychologically, we perceive frequency as pitch—the relative tonal highness or lowness of a sound. The more times per second a sound source vibrates, the higher its pitch. A whistle vibrates more times per second than a foghorn; therefore, its pitch is higher. The G string of a guitar vibrates 196 times per second, so its fundamental frequency is 196 Hz. The A string has a frequency of 110 Hz, so the pitch of the G string is higher.

Pitch influences our perception of a sound's tonal characteristic—whether we hear it as bright, mellow, raspy, hissy, and so on. The range of audible frequencies, or the **sound frequency spectrum**, can be divided into sections, each having a unique and vital quality. The usual divisions in Western music are called **octaves**. An octave is the interval between any two frequencies that have a tonal ratio of 2 to 1. The range of human hearing covers about 10 octaves. Starting with 20 Hz, the first octave is 20 Hz to 40

*The term *cycles per second* was used to designate frequency until a few decades ago when the term *hertz* was adopted to honor Heinrich Hertz, who defined radio waves in 1886. The term *hertz* or the abbreviation *Hz* is used throughout this book.

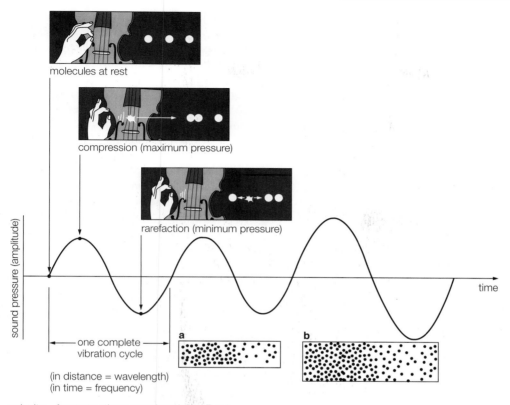

molecules at rest

compression (maximum pressure)

rarefaction (minimum pressure)

sound pressure (amplitude)

time

one complete vibration cycle

(in distance = wavelength)
(in time = frequency)

velocity = frequency times wavelength $V = F \times \lambda$

2-1 Components of a sound wave: (*1*) Compression and rarefaction in sound waves. The vibrating object causes compression when it moves outward (causing molecules to bump into each other). The vibrating object causes rarefaction when it moves inward (pulling the molecules away from each other). (*2*) Amplitude of sound. The number of molecules displaced by a vibration creates the amplitude or loudness of a sound. Because the number of molecules in the sound wave in part *b* is greater than the number in the sound wave in part *a*, the amplitude of the sound wave in *b* is greater.

Hz; the second, 40 Hz to 80 Hz; the third, 80 Hz to 160 Hz; and so on (see back endpaper). The octaves grouped into bass, midrange, and treble, are subdivided as follows:

- **Low bass** — first and second octaves (20 Hz–80 Hz). These are the frequencies associated with power, boom, and fullness. The lowest notes of the piano, organ, tuba, and bass are in this range, as are the low frequencies of traffic, thunder, and explosions. Sounds in these octaves need not occur often to maintain a sense of fullness. If they occur too often, the sound can become thick or muddy.

- **Upper bass** — third and fourth octaves (80 Hz–320 Hz). Most of the lower tones generated by rhythm and other support instruments such as drums, piano, bass, cello, trombone, and French horn are in this range. They establish a balance in musical structure. Too many frequencies from this range make sound boomy; too

few make it thin. When properly proportioned, pitches in the second, third, and fourth octaves are very satisfying to the ear because we perceive them as giving sound an anchor — that is, fullness or bottom. Frequencies in the upper bass range serve aural structure the way the horizontal line serves visual structure, by providing a foundation.

The bass control on home stereo systems usually acts in this range.

- **Midrange** — fifth, sixth, and seventh octaves (320 Hz–2,560 Hz). The midrange gives sound its intensity. It contains the fundamental and the rich lower harmonics and overtones of most sound sources.* The midrange does not necessarily generate pleasant sounds, however. Too much emphasis of sixth octave frequencies is heard as a hornlike quality; too much emphasis of seventh octave frequencies is heard as a tinny quality; extended listening to midrange sounds can be annoying and fatiguing.

- **Upper midrange** — eighth octave (2,560 Hz–5,120 Hz). We are most sensitive to frequencies in the eighth octave, a rather curious range. The lower part of the eighth octave (2,560 Hz–3,500 Hz) contains frequencies that, if properly emphasized, improve the intelligibility of speech. These frequencies are roughly 3,000 Hz to 3,500 Hz. If these frequencies are unduly

emphasized, however, sound becomes abrasive and unpleasant; and speech, in particular, becomes harsh and lispy, making some consonants difficult to understand.

The upper part of the eighth octave (above 3,500 Hz), on the other hand, contains rich and satisfying pitches that give sound definition, clarity, and realism. Listeners perceive a sound source frequency in this range (and also in the lower part of the ninth octave, up to about 6,000 Hz) as being nearby, and for this reason it is also known as the **presence range**.

- **Treble** — ninth and tenth octaves (5,120 Hz–20,000 Hz). Although the ninth and tenth octaves generate only 2 percent of the total power output of the sound frequency spectrum, and human hearing does not extend much beyond 16,000 Hz, they give sound the vital, lifelike qualities of brilliance and sparkle, particularly in the upper ninth and lower tenth octaves. Increasing loudness at 5,000 Hz, the heart of the presence range, gives the impression that there has been an overall increase in loudness throughout the midrange. Reducing loudness at 5,000 Hz makes a sound seem farther away and transparent. Too much emphasis above 6,000 Hz makes sound hissy and brings out electronic noise. Too little emphasis above 6,000 Hz dulls sound.

The treble control on most home stereo systems is used to emphasize or de-emphasize ninth and tenth octave frequencies.

Amplitude and Loudness

We have noted that vibrations in objects stimulate molecules to move in pressure waves at certain rates of alternation (compression–rarefaction) and that rate determines frequency. Vibrations not only affect the mole-

*A **fundamental**, also called the first harmonic, is the lowest or basic pitch of a sound source, its **harmonics** are exact multiples of the fundamental, and its **overtones** are pitches that are not exact multiples of the fundamental but also color sound. If a trumpet sounds a low G, the fundamental is 392 Hz, its harmonics are 784 Hz, 1,568 Hz, 3,136 Hz, and so on, and its overtones are the frequencies in between (see the section on timbre). Another term for harmonics and overtones is *partials*. The term *overtones* is also sometimes used to include harmonics.

cules' rate of up-and-down movement but also determine the number of displaced molecules that are set in motion from equilibrium to a wave's maximum height (*crest*) and depth (*trough*) (see 2-1). This number depends on the intensity of a vibration; the more intense it is, the more molecules are displaced. The greater the number of molecules displaced, the greater the height and depth of the sound wave. The number of molecules in motion, and therefore the size of a sound wave, is called **amplitude** (see 2-1a,b). Our subjective impression of amplitude is a sound's loudness or softness.

The ear's ability to hear wide variations in loudness is so extraordinary that we measure loudness using a relative and dimensionless value—the decibel (dB)—that expresses the ratio of two quantities (such as sound pressure, power, or intensity), or that expresses the ratio of one such quantity to an appropriate reference. Acoustic pressure is measured in terms of **sound pressure level** (dB-SPL) because there are periodic variations in atmospheric pressure in a sound wave.* Humans have the potential to hear an extremely wide range of these periodic variations, from 0 dB–SPL, the threshold of hearing, to 120 dB–SPL, the threshold of pain, and beyond (see 2-2). The range of the difference in decibels between the loudest and quietest sound a vibrating object makes is called **dynamic range**. Because this range is so wide, a logarithmic scale is used to compress loudness measurement into more manageable figures.

Humans have the capability to hear loudness at a ratio of 1 to 10,000,000 and greater.

*dB is also measured in several other ways. A few of them are: dBm—an electrical measurement of power; dBV—an electrical measurement of voltage; dBA, dBB, dBC—filtered *frequency responses* that measure the ear's sensitivity to different sound levels (40 dB-SPL, 70 dB-SPL, and 100 dB-SPL, respectively).

Sound at 60 dB-SPL is 1,000 times louder than sound at 0 dB-SPL; at 80 dB-SPL it is 10 times louder than at 60 dB-SPL. If the amplitude of two similar sounds is 100 dB-SPL each, their amplitude, when added, would be 103 dB-SPL. Nevertheless, most people do not perceive a sound level as doubled until it has increased at least 6 to 10 dB-SPL.

The Ear, Hearing Loss, and Behavior

A sound wave is a physical force; hearing loss and adverse nonaural effects result if the ear is exposed to loud levels for too long. Unfortunately, hearing loss from exposure to loud sound is not regenerative (self-corrective). The ear is durable and capable of hearing sounds over a wide dynamic range, but it is also a delicately integrated mechanism. It is divided into three parts: (1) the **outer ear**, (2) the **middle ear**, and (3) the **inner ear** (see 2-3).

Sound waves first reach the outer ear, where they are collected and directed to the **auditory canal**. The auditory canal channels the sound waves to the eardrum, which then starts to vibrate. These vibrations are transmitted by three small bones in the middle ear to the inner ear. The inner ear contains a spiral filled with fluid. Within the spiral is a membrane that contains the **auditory nerve** endings. Vibrations in the fluid excite these nerve endings, which transmit impulses along the auditory nerve to the brain.

For our purpose the tiny snail-shaped structure in the inner ear called the **cochlea** is most important because damage from loud sound levels takes place here. The cochlea is a coiled tube filled with fluid. At its base and extending the length of the coil is a membrane known as the **basilar membrane**. While

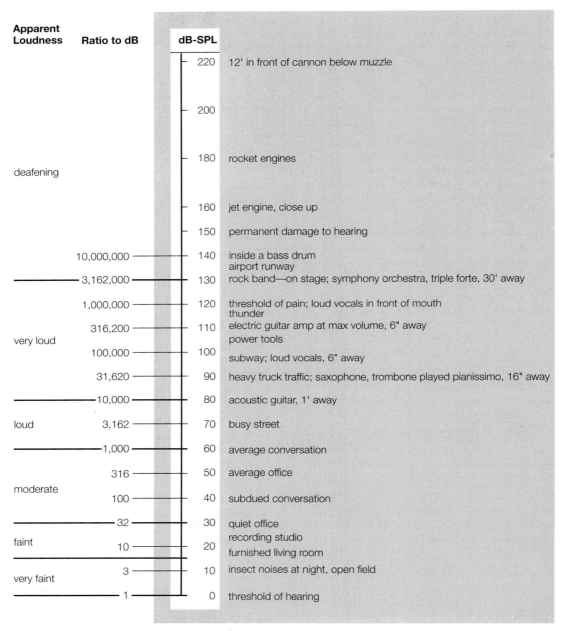

2-2 Sound pressure levels of various sound sources

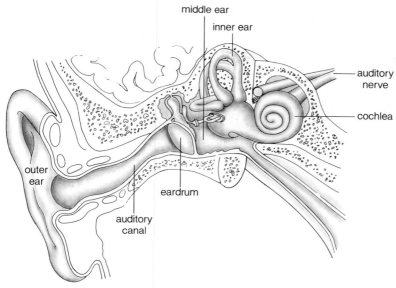

2-3 **Cross section of the human ear**

all other structures in the ear transmit vibrations, the basilar membrane transduces them from mechanical vibrations to electrical impulses. The basilar membrane supports hair cells that are the sensory receptors for hearing and are part of the auditory sense organ called the **organ of Corti**. The hair cells have different stiffnesses and each, therefore, responds to a different frequency. This difference helps to explain the wide variety of tonal impressions we can experience. The sensitive hair cells carry impulses to the nerve cells, which in turn carry them to the brain.

The greater the vibratory motion of the basilar membrane, the more hair cells are stimulated. The more hair cells that are stimulated, the louder will be the perceived sound. When these hair cells become damaged, fewer impulses reach the auditory center of the brain, and hearing is impaired (see 2-4).

The middle ear does contain a small muscle that contracts under the impact of a loud sound and so limits the movement of the bones in the middle ear. This helps to reduce the sound level before it reaches the inner ear. The muscle, however, takes about one-tenth of a second to tighten and therefore provides little protection from sudden loud sounds.

Hearing damage caused by exposure to loud sound varies with the exposure time and the individual. Prolonged exposure to loud sound decreases the ear's sensitivity. Decreased sensitivity (1) creates the false perception that sound is not as loud as it actually is and (2) necessitates increasing levels to compensate for the hearing loss, thus making a bad situation worse.

After exposure to loud sound for a few hours, you may have experienced the sensation that your ears are stuffed with cotton. This is known as *temporary threshold shift* (TTS) — a reversible desensitization in hearing that disappears in anywhere from a few hours to several days. TTS is also called *auditory fatigue*. With TTS, the ears have,

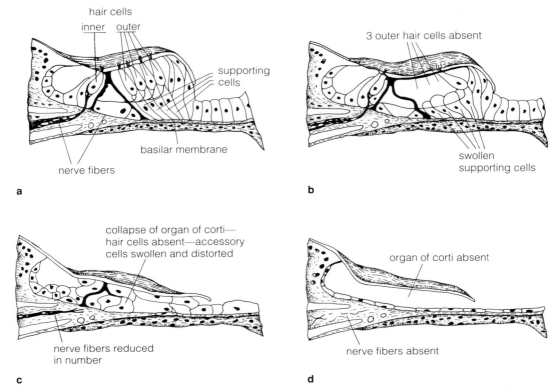

2-4 **Increasing degrees of noise-induced permanent damage to the organ of Corti:** (*a*) normal organ of Corti, (*b*) partial injury, (*c*) severe injury, (*d*) total degeneration.

in effect, shut down to protect themselves against very loud sounds.

Prolonged exposure to loud sounds can bring on *tinnitus*, a ringing, whistling, or buzzing in the ears, even though no loud sounds are present. Tinnitus is a danger signal that the ears may already have or soon will suffer *permanent threshold shift* with continued exposure to loud sound.

Deterioration of the auditory nerve endings occurs through the natural aging process and usually results in a gradual loss of hearing first in the higher frequencies and then in the lower frequencies (see 2-5). Prolonged listening to loud sounds adversely affects the auditory nerve endings and hastens their deterioration. It is not uncommon for young people who are constantly exposed to loud sound levels to have the hearing acuity of a 70-year-old person. To avoid premature deterioration of your auditory nerves, do not expose them to excessively loud sound levels for extended times (see 2-6 and Table 2-1). If you are in the presence of loud sound, particularly music, wear special earplugs designed to reduce loudness without seriously degrading frequency response.

Some options among available earplugs are custom-fit earmolds, disposable foam plugs, reusable silicon insert plugs, and industrial headsets. The custom-fit earmold is best to use when listening to loud music. It

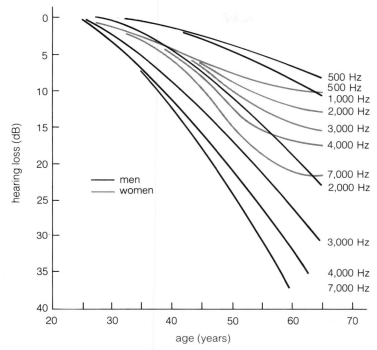

2-5 **Typical hearing loss for various age groups of men and women**

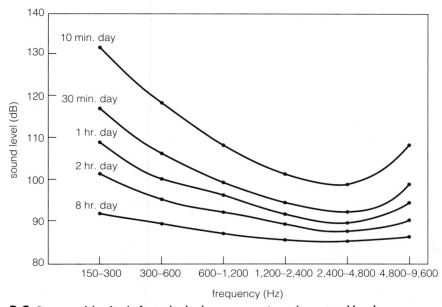

2-6 **Damage risk criteria for a single-day exposure to various sound levels**

Table 2-1 Hours of exposure to high sound levels permitted by the U.S. government and the British Occupational Hygiene Society

U.S. Government — Occupational Safety and Health Act		British Occupational Hygiene Society	
Sound Level (dB-SPL)	Daily Permissible Hours of Exposure	Sound Level (dB-SPL)	Daily Permissible Hours of Exposure
90	8	90	8
92	6	91	6
95	4	93	4
97	3	94	3
100	2	96	2
105	1	99	1
110	½	102	½
115	¼	105	¼

provides 15 dB to 20 dB of balanced sound-level reduction and attenuates all frequencies evenly. The disposable foam plug is intended for one-time use. It provides noise reduction from 12 dB to 20 dB, mainly in the high frequencies. The reusable silicon insert plug is a rubberized insert cushion that covers a tiny metal filtering diaphragm. It reduces sound levels by approximately 17 dB. The silicon insert plug is often used at construction sites and firing ranges. The industrial headset has a cushioned headpad and tight-fitting earseals. It provides maximum sound level attenuation, often up to 30 dB, and is particularly effective at low frequencies. This is the headset commonly used by personnel around airport runways and in the cabs of heavy construction equipment.

Loud sound levels also produce adverse physiological effects. Sounds transmitted to the brain follow two paths. One path carries sound to the auditory center, where it is perceived and interpreted. The other goes to the brain centers that affect the nervous system. Loud sound taking the latter path can increase heart rate and blood pressure; con-strict small blood vessels in the hands and feet; contract muscles; release stress-related hormones from adrenal glands; disrupt certain stomach and intestinal functions; and create dry mouth, dilated pupils, tension, anxiety, fatigue, and crankiness. These stress reactions are believed to be an evolutionary holdover from the days when loud sound could mean trouble or danger for our prehistoric ancestors.

The implications of all this should be obvious, especially to someone working in audio. Not only are one's hearing in particular and one's overall physiological well-being in general at risk, but so is one's livelihood.

Frequency and Loudness

Based on our discussion of frequency and amplitude, you might assume that just as pitch gets higher when frequency increases, so does loudness become greater as amplitude increases. Frequency and amplitude, however, are interdependent, and the assumption is not valid. Varying a sound's fre-

2-7 Responses to various frequencies by the human ear. This curve shows that the response is not flat and that we hear midrange frequencies better than low and high frequencies.

quency also affects perception of its loudness, and varying a sound's amplitude affects perception of its pitch.

Equal Loudness Principle

The response of the human ear is not equally sensitive to all audible frequencies (see 2-7). Depending on loudness, we do not hear low and high frequencies as well as we hear middle frequencies. In fact, the ear is relatively insensitive to low frequencies at low levels. Oddly enough, this is called the **equal loudness principle** rather than that of unequal loudness (see 2-8).

The equal loudness principle has important implications for the sound designer. You have to be aware of the levels at which you record and play back sound. If you have the loudness of a sound at a high level during recording and at a low level during playback, both bass and treble frequencies will be reduced considerably in volume and may seem to disappear. The converse is also true: If

sound level is low when recording and high when playing back, the bass and treble frequencies will be too loud relative to the other frequencies and may even overwhelm them.

If a guitarist plucks all six strings equally hard, you do not hear each string at the same loudness level. The high E string (328 Hz) sounds louder than the low E string (82 Hz). To make the low string sound as loud, the guitarist would have to pluck it harder. This suggests that the high E string may sound louder because of its higher frequency. If you sound three tones—50 Hz, 1,000 Hz, and 15,000 Hz—at a fixed loudness level, however, the 1,000-Hz tone sounds louder than either the 50-Hz or the 15,000-Hz tone.

In a live concert, sound levels are usually louder than they are on a home stereo system. Live music often reaches levels of 100 dB-SPL and higher. At home, levels may go as high as 70–75 dB-SPL. Sound at 70 dB-SPL requires more bass and treble boost than does sound at 100 dB-SPL to obtain equal loudness. Therefore, the frequency balances

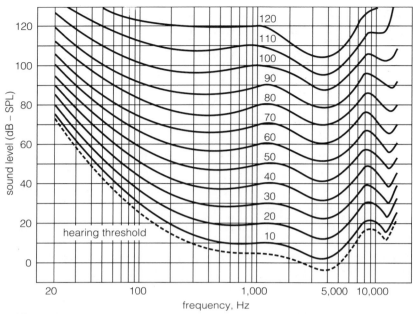

2-8 Equal loudness curves. These curves illustrate the relationships in 2-7 and our relative lack of sensitivity to low and high frequencies as compared with middle frequencies. A 50-Hz sound would have to be 50 dB louder to seem as loud as a 1,000-Hz sound at 0 dB. To put it another way, at an intensity, for instance, of 40 dB, the level of a 100-Hz sound would have to be 10 times the SPL of a 1,000-Hz sound for the two sounds to be perceived as equal in loudness. (Based on Robinson-Dadson.)

you hear at 100 dB-SPL will be different when you hear the same sound at 70 dB-SPL. The equal loudness principle is one reason that bass and treble controls allowing you to adjust the volume of high and low frequencies are put on home stereo systems.

Masking

Another perceptual response dependent on the relationship between loudness and frequency is **masking**—covering a weaker sound with a stronger sound when each is a different frequency and both vibrate simultaneously. High-frequency sounds are easier to mask than low-frequency sounds, and loudness is relative to other sounds present at the same time. The effect of masking is

greatest when frequencies are close to each other, diminishing as frequencies become farther apart.

If a 100-Hz tone and 1,000-Hz tone are sounded together at the same level, both tones will be audible, but the 1,000-Hz tone will be perceived as louder. Gradually increasing the level of the 100-Hz tone and keeping the amplitude of the 1,000-Hz tone constant will make the 1,000-Hz tone more and more difficult to hear. If a 900-Hz tone is somewhat softer than a 1,000-Hz tone, the 900-Hz will be masked. If an LP record has scratches (high-frequency information), they will probably be masked during loud passages and audible during quiet ones. A symphony orchestra playing full blast may have all its instruments involved at once; however,

Table 2-2 Selected frequencies and their wavelengths

Frequency (Hz)	Wavelength	Frequency (Hz)	Wavelength
20	56.5 feet	1,000	1.1 feet
31.5	35.8	2,000	6.7 inches
63	17.9	4,000	3.3
125	9.0	6,000	2.2
250	4.5	8,000	1.6
440	2.5	10,000	1.3
500	2.2	12,000	1.1
880	1.2	16,000	0.07

flutes and clarinets will probably not be heard over trumpets and trombones, because woodwinds are generally higher in frequency and weaker in sound level than are the brass.

Awareness of masking is important in recording and mixing sound. A sound source that is audible and defined by itself may be altered in tonal quality or masked when combined with other sound sources. Hence, compensating for altered tone quality through **equalization** and placement in the aural imaging are necessary to overcome masking.

Velocity

Although frequency and amplitude are the most important physical components of a sound wave, another component—**velocity**, or the speed of a sound wave—should be mentioned. Velocity usually has little impact on pitch or loudness and is relatively constant in a controlled environment; sound travels 1,130 feet per second at sea level when the temperature is 70 degrees Fahrenheit. (In water it travels 4,800 feet per second and in solid materials such as wood and steel it travels 11,700 and 18,000 feet, respectively, due to the greater conductivity of the relatively denser molecular structures.) Velocity

changes significantly, however, in very high or low temperatures, increasing as air warms and decreasing as air cools. For every change of 1 degree Fahrenheit, the speed of sound changes 1.1 feet per second.

It is worth noting, although it is too complex to discuss in detail here, that humidity also affects velocity. Sound is absorbed more and therefore travels faster in wetter air than in drier air. For example, if you live or work near railroad tracks, you might be able to tell whether rain is on the way by how much closer a passing train sounds on a humid day compared to on a dry day.

Wavelength

As noted previously, each frequency has a **wavelength**, determined by the distance a sound wave travels to complete one cycle of compression and rarefaction. That is, the physical measurement of the length of one cycle is equal to the velocity of sound divided by the frequency of sound ($\lambda = v/f$) (see 2-1). Therefore, frequency and wavelength change inversely with respect to each other. The lower a sound's frequency, the longer its wavelength; the higher a sound's frequency, the shorter its wavelength (see Table 2-2).

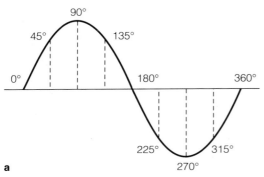

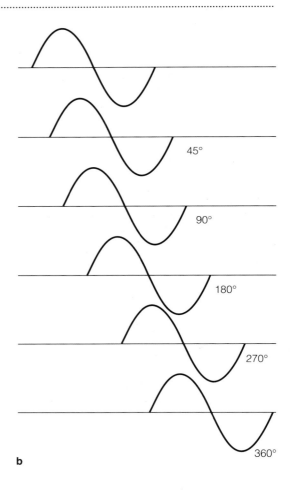

2-9 Sound waves. (*a*) One full wavelength is equivalent to 360 degrees of travel. Half a wavelength corresponds to 180 degrees. (*b*) Selected phase relationships of sound waves.

Understanding the concept of wavelength will be important later when considering binaural hearing, acoustics, and studio design.

Acoustical Phase

Acoustical phase refers to the time relationship between two or more sound waves at a given point in their cycles. Because sound waves are repetitive, they can be divided into regularly occurring intervals. These intervals are measured in degrees (see 2-9).

If two waves begin their excursions at the same time, their degree intervals will coincide and the waves will be *in phase*. If two waves begin their excursions at different times, their degree intervals will not coincide and the waves will be *out of phase*.

Waves that are in phase reinforce each other, increasing amplitude. Conversely, waves that are out of phase weaken each other, decreasing amplitude (see 2-10a). Two sound waves that are exactly in phase (0-degree phase difference) and have the same frequency, shape and amplitude will double in loudness. Two waves that are ex-actly out of phase (180-degree phase difference) and have the same frequency, shape, and amplitude cancel each other (see 2-10b). These two conditions rarely occur in the studio, however.

It is more likely that sound waves will begin their excursions at different times. If the waves are partially out of phase, however, there would be **constructive interference**, increasing amplitude, where compression and rarefaction occur at the same time, and **destructive interference**, decreasing amplitude,

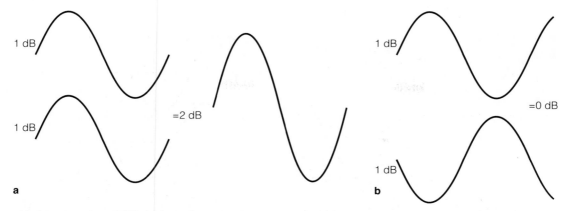

2-10 **Sound waves in and out of phase.** (*a*) In phase: Their amplitude is additive. Here the sound waves are exactly in phase — a condition that rarely occurs. It should be noted that dB does not add linearly. These values have been assigned only to make a point. The actual additive amplitude here would be 6 dB. (*b*) Out of phase: Their amplitude is subtractive. Sound waves of equal amplitude 180 degrees out of phase cancel each other. This situation also rarely occurs.

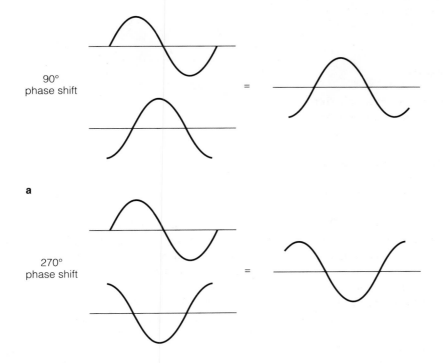

2-11 **Waves partially out of phase (*a*) increase amplitude at some points and (*b*) decrease it at others**

2-12 A complex waveform displayed on an oscilloscope

where compression and rarefaction occur at different times (see 2-11). The implications of acoustical phase are critical to an understanding of acoustics, microphone placement, and creation of time-related effects.

Timbre

For the purpose of illustration, sound is often depicted as a single, wavy line (see 2-1). Actually, a wave that generates such a sound (known as a **sine wave**) is a **pure tone**—a single frequency devoid of harmonics and overtones.

Most sound, however, consists of several different frequencies that produce a complex

waveform—a graphic representation of a sound's characteristic shape, usually displayed on test equipment (see 2-12). Each sound has a unique harmonic structure that distinguishes it from all other sound (see 2-13). This difference between sounds is what defines their timbre—tone quality or tone color. Timbre has been defined as that attribute of auditory sensation whereby a listener can judge that two sounds are dissimilar regardless of similar pitch, loudness, or duration.*

*Definition based on R. L. Pratt and P. E. Doak, "A Subjective Rating Scale for Timbre," *Journal of Sound and Vibration* 45 (1976): 317.

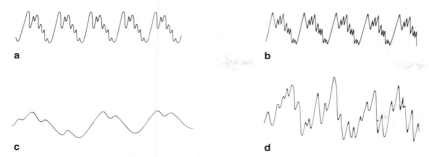

2-13 **Waveforms showing differences between musical sounds and noise.** (*a*) The pitch C from a piano. (*b*) The pitch C from a clarinet. (*c*) The waveform of an oboe. (*d*) The waveform of a noise. Notice its irregular pattern compared to the regular pattern of musical sounds.

Unlike pitch and loudness, which may be considered as unidimensional, timbre is multidimensional. The sound frequency spectrum is an objective scale of relative pitches; the table of sound pressure levels is an objective scale of relative loudnesses. But there is no objective scale that orders or compares the relative timbres of different sounds. The best we can do is try to articulate our subjective response to a particular distribution of sonic energy or to know how harmonics affect timbre. For example, sound consisting mainly of lower harmonics and played by cellos may be perceived as mellow, mournful, or quieting; these same lower frequencies played by a bassoon may be perceived as raspy, comical, or hornlike.

Each harmonic or set of harmonics adds a characteristic tonal color to sound. In general, even-numbered harmonics—second, fourth, and sixth—create an open, warm, filled-out sound. Odd-numbered harmonics—third and fifth—produce a closed, harsh, stopped-down sound. The second harmonic, an octave above the fundamental, can be barely audible, yet it adds fullness to sound. The third harmonic (called *musical twelfth* or *quint*) softens sound. Harmonics above the seventh harmonic give sound edge, bite, and definition.

Sound Envelope

Another factor that influences the timbre of a sound is its shape, or *envelope*, which refers to changes in loudness over time. A **sound envelope** has three stages: (1) attack—how a sound starts up after a sound source has been vibrated, (2) **internal dynamics**—variations in loudness and sustains after the attack, and (3) decay—the time and manner in which a sound diminishes to inaudibility. The sound envelope may also be divided into four stages: (1) attack, (2) initial decay, (3) sustain, and (4) release (ADSR) (see 2-14).

Two notes with the same frequency and loudness can produce different sounds within different envelopes. A bowed violin string, for example, has a more dynamic sound overall than does a plucked violin string. If you take a piano recording and edit out the attacks of the notes, the piano will start to sound like an organ. Do the same with a French horn and it sounds similar to a saxophone. Edit out the attacks of a trumpet and it creates an oboelike sound. In a similar vein, the word *schedule* has a different sound when spoken with the harder, shorter attack and sustain in the United States (skĕj′ool) than it does when spoken with the softer,

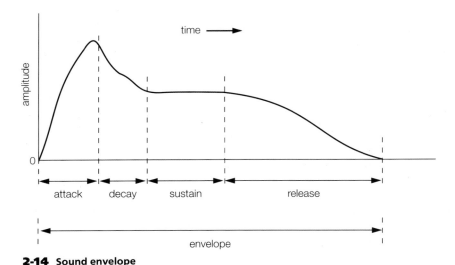

2-14 **Sound envelope**

longer attack and internal dynamics in Great Britain (shěd′yōol).

To this point we have examined the components of a sound wave and how they are heard without taking into consideration that we hear most sound in built-up or enclosed spaces. Behavior of sound waves in such spaces, and our perception of them, is the province of acoustics and psychoacoustics, which we will discuss in the next chapter.

Main Points

1. A sound wave is a vibrational disturbance that involves mechanical motion of molecules transmitting energy from one place to another.

2. A sound wave is caused when a body vibrates and sets into motion the molecules nearest to it; the initial motion starts a chain reaction. This chain reaction creates pressure waves through the air, which are perceived as sound when they reach the ear and brain.

3. The pressure wave compresses molecules as it moves outward, increasing pressure, and pulls the molecules farther apart as it moves inward, creating a rarefaction by decreasing pressure.

4. The components that make up a sound wave are frequency, amplitude, velocity, wavelength, and phase.

5. Sound acts according to physical principles, but it also has a psychological effect on humans.

6. The number of times a sound wave vibrates determines its frequency or pitch. Humans can hear frequencies between, roughly, 20 Hz and 16,000 Hz—a range of almost 10 octaves. Each octave has a unique sound in the frequency spectrum.

7. The size of a sound wave determines its amplitude or loudness. Loudness is measured in decibels.

8. Humans can hear from 0 dB-SPL, the threshold of hearing, to 120 dB-SPL, the threshold of pain, and beyond. The scale is logarithmic, which means that adding

two sounds each with a loudness of 100 dB-SPL would bring it to 103 dB-SPL. The range of difference in decibels between the loudest and quietest sound a vibrating object makes is called dynamic range.

9. If the ear is exposed to loud sounds for extended periods of time, the auditory nerve endings in the inner ear can deteriorate. In the presence of loud sound, use an ear filter designed to reduce loudness.

10. The ear does not perceive all frequencies at the same loudness even if their amplitudes are the same. This is the principle of equal loudness. Humans do not hear lower- and higher-pitched sounds as well as they hear midrange sounds.

11. Masking—covering a weaker sound with a stronger sound when each is a different frequency and both vibrate simultaneously—is another perceptual response dependent on the relationship between frequency and loudness.

12. Velocity, the speed of a sound wave, is 1,130 feet per second at sea level and 70 degrees Fahrenheit. Sound increases or decreases in velocity by 1.1 feet per second for each change of 1 degree Fahrenheit.

13. Each frequency has a wavelength, determined by the distance a sound wave travels to complete one cycle of compression and rarefaction. The length of one cycle is equal to the velocity of sound divided by the frequency of sound. The lower a sound's frequency, the longer its wavelength; the higher a sound's frequency, the shorter its wavelength.

14. Acoustical phase refers to the time relationship between two or more sound waves at a given point in their cycles. If two waves begin their excursions at the same time, their degree intervals will coincide and the waves will be in phase, reinforcing each other and increasing amplitude. If two waves begin their excursions at different times, their degree intervals will not coincide and the waves will be out of phase, weakening each other and decreasing amplitude.

15. Timbre is the tone quality or color of a sound.

16. A sound's envelope has three stages: (1) attack, (2) internal dynamics, (3) decay. It also may be divided into four stages: (1) attack, (2) initial decay, (3) sustain, (4) release (ADSR).

CHAPTER 3

Acoustics and Psychoacoustics

At concerts in St. Mark's Square in Venice, Italy, musicians are situated in certain parts of the plaza, depending on the music they are playing. For example, if it is Wagner, they sit in one place; if it is Mozart, they sit in another. They do this to take advantage of the sound quality peculiar to different locations in the square. One location generates more sound reflections, enriching sound and thereby enhancing Wagner's robust, full-bodied music. Another location generates fewer reflections, thinning sound and thereby enhancing Mozart's more subtle, delicate music.

The principles at work here are based on **acoustics** — the objective study of the physical behavior of received sound — and **psychoacoustics** — the psychological response to physical sound stimuli. Although both subjects are quite complex, at least a rudimentary knowledge of each is important to understanding their critical influences on binaural hearing, sound dispersion, sound shaping, and room design.

Controlling the behavior of sound in a sound-reflectant space for perceptual and artistic ends is a never-ending challenge in the performance and recording of acoustically

generated audio. An insight into the difficulty begins with an understanding of how we discern sound waves reaching our ears.

Binaural Hearing

Both human ears are anatomically and functionally similar. By itself, each provides sufficient information for perception of pitch, loudness, and timbre. The use of only one ear, however, impairs perception of two elements essential to the fullest enjoyment of sound: location and dimension.

Sound Localization

If you are at a party where people are talking, music is playing, and plates are clattering, hearing with both ears—**binaural hearing**—makes it possible for you to focus your attention on a particular conversation or sound and push all other sounds into the background. This is difficult to do with one ear. Two factors produce this focusing ability, the so-called cocktail party effect: (1) the difference in a sound's intensity and (2) the difference in its arrival time as it reaches your two ears.

Intensity of Sound

A sound from a single source usually reaches one ear before it reaches the other. A sound emitted toward the left side of the head reaches the left ear first; a sound emitted toward the right side of the head reaches the right ear first.

When sound waves encounter an obstacle, frequencies with wavelengths shorter than the obstacle bounce off of it, while frequencies with wavelengths longer than the obsta-cle bend or diffract around it. The average adult head is roughly 7 inches wide. Therefore, once the higher frequencies—with wavelengths about 7 inches or less—reach, say, the left ear, they reflect off the head, casting a "sound shadow" on the opposite side of the head. The result is a more intense sound in the left ear than in the right ear. Lower frequencies—with wavelengths about 7 inches or more—diffract around the head, causing the sound to reach the right ear slightly later than it reaches the left ear. In this case the result is that the sound waves reaching the left and right ears are slightly out of phase.

From this we may conclude that higher frequencies (that is, shorter wavelengths) are more directional and easier to localize than are lower frequencies (longer wavelengths). Somewhere between 1,000 Hz and 5,000 Hz, however, wavelengths may partially bounce off and partially diffract around the head; at these frequencies it is difficult to tell from where a sound is coming.

Time of Arrival

There is an important addition to this principle known as the **precedence effect** or **Haas effect** (after one of its originators). When a sound is emitted in a sound-reflectant space, **direct sound** reaches our ears first, before it interacts with any other surface. **Indirect** or **reflected sound**, on the other hand, reaches our ears only after bouncing off of one or a few surfaces. If similar sounds reach the ear within about 20 milliseconds of one another, the reflected sounds and the direct sound are usually perceived as coming from the same direction. As the time between the direct and indirect sound reaching the ears increases beyond 20 milliseconds, localization becomes increasingly difficult.

Another aspect of the precedence effect is that direct and reflected sounds reaching the ear approximately 10 to 20 milliseconds after the original waves are perceived as a single sound; the ear does not distinguish them. This is called **temporal fusion**. This effect gradually disappears as the time interval between direct and reflected sound increases from roughly 30 to 50 milliseconds. Once the time interval becomes greater than 50 milliseconds, however, repetitions of the sound are heard as echo.

Dimension

The relationship between the arrival time and intensity of a sound reaching your ears also affects the depth and breadth of a sound. Listen to a compact disc on a good audio system. Switch the system back and forth from stereophonic (two-channel) to monophonic (one-channel). Notice that the sound is fuller, richer, and more spacious in the stereo mode. What creates this perceived sonic depth and breadth is the combined effect of intensity and time differences between the direct and reflected waves.

Direct Sound, Early Reflections, Reverberation, and Echo

The acoustic "life cycle" of a sound wave can be divided into three components: direct waves, early reflections, and reverberation (see 3-1).

Direct waves reach the listener without bouncing off of any surface (see 3-2). They provide information about a sound's origin, its size, and its tonal quality.

Early reflections hit at least one surface before reaching the listener in roughly 10 to 30 milliseconds after the direct sound (see

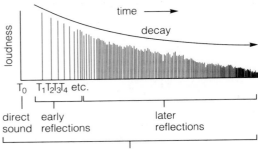

3-1 Anatomy of reverberation in an enclosed space. At time$_0$ (T$_0$) the direct sound is heard. Between T$_0$ and T$_1$ is the initial time delay gap — the time between the arrival of the direct sound and the first reflection. At T$_2$ and T$_3$ more early reflections of the direct sound arrive as they reflect from nearby surfaces. These early reflections are sensed rather than distinctly heard. At T$_4$ repetitions of the direct sound spread through the room, reflecting from several surfaces and arriving at the listener so close together that their repetitions are indistinguishable.

3-2). Although they are perceived as part of the direct sound, the time between their arrival and arrival of the direct sound adds loudness and fullness to the initial sound and helps to create our subjective impression of the room's size.

Reverberation (reverb for short) usually results when sound reflects from many surfaces, reaching the listener more than 10 milliseconds after the direct sound (see 3-2). **Reverberation** (also known as **later reflections**) is densely spaced reflections created by random, multiple, blended repetitions of a sound. Reverb fills out the loudness and body of a sound and contains most of a sound's total energy. And depending on the **decay**, or **reverberation, time** (the time it takes a sound to decrease 60 dB-SPL after its steady-state sound level has stopped), reverb also provides information about the absorption and reflectance of a room's surfaces, as well as about a listener's distance from the sound source. The longer it takes a sound to decay, the larger

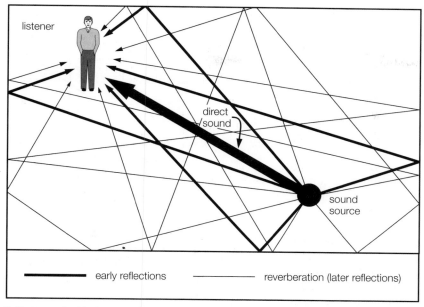

listener

direct sound

sound source

——— early reflections – – – reverberation (later reflections)

3-2 **Acoustical behavior of sound in an enclosed room**

and more hard-surfaced the room is perceived to be, and the farther from the sound source the listener is or feels him- or herself to be.

Five basic acoustic conditions demonstrate the relationship between reverberation and decay time:

1. *Considerable reverberation and long decay time.* This combination creates the acoustics of a concert hall, castle, gymnasium, or large church. Most speech studios do not have the capability to produce such acoustics.

2. *Considerable reverberation and short decay time.* This combination produces the type of reverberation you hear in a tiled bathroom, a barroom (as opposed to a cocktail lounge), or an open office area.

3. *Little reverberation and medium decay time.* Sounds created under these conditions mimic the effect of a living room with rugs and drapes, a cocktail lounge, or a conference room.

4. *Little reverberation and short decay time.* These factors produce quiet rooms such as a radio performance studio, a closet, or the inside of a car.

5. *No reverberation.* This is what it sounds like in an open field or in any wide open space or in an anechoic (that is, echo- and reverberation-free) chamber.

If the path of the reflections is long — 50 milliseconds or greater — the reflections are perceived more and more as a distinct repetition of the direct sound, often inhibiting sonic clarity. This perceptible sound repetition is called **echo**. In large rooms discrete single echoes are sometimes perceived. In small rooms these repetitions, called **flutter echoes**, are short, come in rapid succession,

and are often quite noticeable. Because echoes usually inhibit sonic clarity, studios and concert halls are designed to eliminate them.

Matching Acoustics to Program Material

Although the science of acoustics is highly developed, there is no such thing as a sound room with perfect acoustics. The sonic requirements, for example, of speech in radio, dialogue rerecording in TV and film, and rock, jazz, and classical music recording all differ markedly.

A radio announcer in a reverberant studio gives the impression of being in a large room or hall and so creates a "picture" that adds unnecessary and perhaps confusing information to the overall sound. Moreover, because one of radio's strengths is the perceived sonic closeness between announcer and listener, a reverberant studio would also create distance between the two. Yet, such a reverberant studio might be suitable for a symphony orchestra because the reflections add needed richness to the music, as they do in a concert hall. The extremely loud music a rock-and-roll group generates, however, would swim amid too many sound reflections, becoming virtually unintelligible. At the same time, a studio with relatively few reflections, and therefore suitable for rock-and-roll, still may be too reflectant for dialogue rerecording, which requires a room almost as nonreverberant as a closet because ambience is added later.

Rooms with reverberation times of one second or more are considered to be "live"; rooms with reverberation times of one-half second or less are considered to be "dead" (see 3-3).

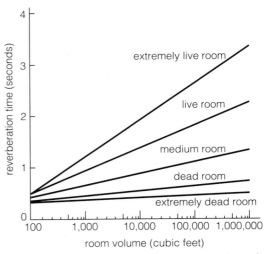

3-3 **Room liveness in relation to reverberation time and room size**

Live rooms reinforce sound, making it relatively louder and more powerful, especially, although not always, in the lower frequencies. They also tend to diffuse detail, smoothing inconsistencies in pitch, tonal quality, and performance. In dead rooms sound is reinforced little or not at all, causing it to be concentrated, weak, and lifeless. Inconsistencies in pitch, tonal quality, and other aspects of undesirable performance are readily apparent. In instances where dead rooms are required for recording, as they are with rock-and-roll and most speech recording, artificial electronic and acoustic means are used to provide appropriate reverberation effects (see 3-4 and Chapter 9).

In the final analysis, preference for the amount of reverberation and reverb time is a matter of individual taste, as all judgments in sound should be. Generally, however, acousticians have calculated optimum reverb times for various types of sonic material that have proved suitable for emulation in the production room (see 3-5).

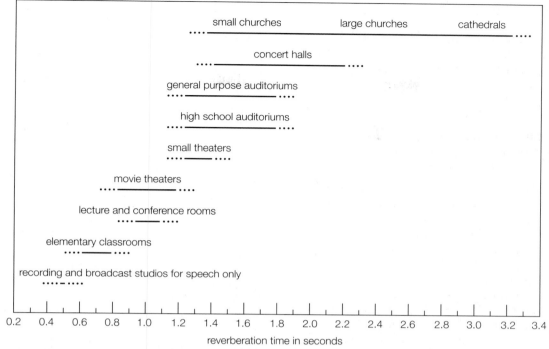

3-4 Typical reverberation times for various performance spaces

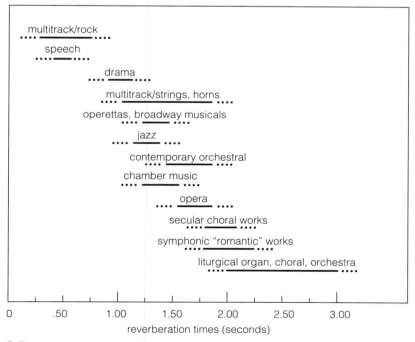

3-5 Optimum reverberation times for various types of music and speech produced indoors

Studio Design

Now that you have some idea of how sound waves behave in an acoustic environment and how that behavior affects aural perception, it is logical to consider the factors that influence this behavior: (1) the isolating of sound outside and inside a room, (2) the dimensions of the room, (3) the shape of the room, (4) the construction materials in the room, and (5) acoustical features. These five factors are directly related to one overriding concern: noise.

Noise

Noise — unwanted sound — is enemy number one in audio production. Noise is everywhere. Outside a room noise comes from traffic, airplanes, jackhammers, thunder, rain, trees rustling, people shouting, stereos playing, and so on. Inside a room noise can be generated by fluorescent lights, ventilating and heating systems, air conditioning, and appliances. And these are only the more obvious examples. A few not so obvious examples include the "noise" made by the random motion of molecules, by our nervous and circulatory systems, and by our ears. In short, noise is part of our existence and can never be completely eliminated. (Audio equipment also generates **system noise** and recording tape generates tape noise.)

Even though unwanted sound is always present, in producing audio it must be brought within tolerable levels so that it does not interfere with the desired sound. Among other things, noise can mask sounds, make speech unintelligible, create distraction, and cause annoyance.

To this end, acousticians have developed **Noise Criteria** (**NC**) that identify, by means of a rating system, background noise — also called *ambient noise* — levels (see 3-6). From

Table 3-1 Recommended Noise Criteria (NC) levels for selected rooms

Type of Room	Recommended NC Curve	dB
Broadcast and recording studios	NC 15–25	25–35
Concert halls	NC 20	30
Drama theaters	NC 20–25	30–35
Motion picture theaters	NC 30	40
Sports coliseums	NC 50	60

this rating system, NC levels for various types of rooms can be derived (see Table 3-1). This raises the question: Once NC levels for a particular sound room are known, how is noise control accomplished?

Isolation

Sound studios must be isolated to prevent outside noise from leaking into the room and to keep loud sound levels generated inside the room from disturbing neighbors. This is accomplished in two ways: (1) by determining the loudest outside sound level against the minimum acceptable NC level inside the studio, which is usually between NC 15 and 25 (approximately 25–35 dBA), depending on what type of sound the studio is used for, and (2) by determining the loudest sound level inside the studio against a maximum acceptable noise floor outside the studio.

For example, assume the maximum measured noise outside a studio is 90 dB-SPL and the maximum acceptable noise level inside a studio is 30 dB-SPL, at, say, 500 Hz. (These values are always frequency-dependent but are usually based on 500 Hz.) That means the construction of the studio must reduce the loudness of the outside sound level by 60 dB. If the loudest sound inside a studio is 110

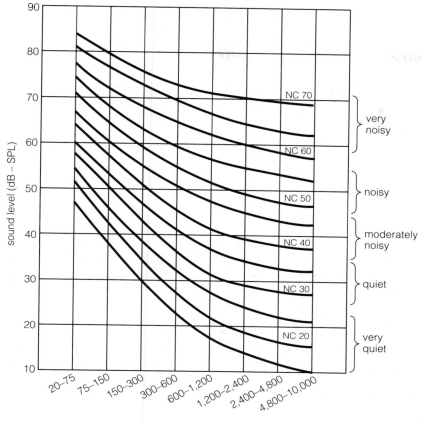

3-6 Noise Criteria (NC) curves

dB-SPL and the maximum acceptable noise outside the studio is 45 dB-SPL, then the studio's construction must reduce the loudness level by 65 dB.

The amount of sound reduction provided by a barrier — wall, floor, or ceiling — is referred to as **transmission loss** (**TL**). Because TL works both ways, determining barrier requirements is equally applicable to sound traveling from inside to outside the studio, and vice versa. Therefore, the barriers constructed to isolate the studio in our example

would have to reduce the loudness level by at least 65 dB (500 Hz).

Just as it is convenient to define a noise spectrum by a single NC number, so it is useful to measure a barrier on the basis of its transmission loss. Such a measurement is called **sound transmission class** (**STC**). Sound transmission classes vary with the type and mass of materials in a barrier. A 4-inch concrete block has an STC of 48, indicating that sound passing through it will be attenuated by 48 dB. An 8-inch concrete block has an

STC of 52, which makes it attenuate 4 dB more sound than the 4-inch block.

In addition to using relatively solid materials in barriers for noise reduction, one part of the construction may be isolated from another by "floating" a middle wall between two air spaces. The floor may be "floated" on springs or cork pads, or both. For example, a wall may be 20 or more inches thick and consist of 6 inches of concrete, a 1-inch air space, a 6-inch strut, 2 layers of ⅝-inch gypsum board, another air space, a 2½-inch strut, and 1 inch of dense spun-fiberglass board.

Dimensions

Sometimes, a room's dimensions accentuate noise by reinforcing certain frequencies, thereby altering, or "coloring," the natural sound. This may also increase reverb time. Such coloration also affects perception of tonal balance, clarity, and imaging. Recordings mixed in a control room with these problems will sound markedly different when played in another room. Other factors, related to the shape of and construction materials used in a studio (discussed in the following two sections), may also affect coloration.

Rooms have particular resonances at which sound will be naturally sustained. These are related to the room's dimensions. **Resonance** results when a vibrating body with the same natural frequencies as another body causes it to vibrate sympathetically and increases the amplitude of both of them at those frequencies if the vibrations are in acoustic phase.

The story is told of soldiers on horseback galloping across a wooden bridge. The sound created by the hoofbeats on the wood generated the resonant frequency of the bridge, causing it to collapse. In another incident wind excited the resonant frequency of a modern steel-and-concrete bridge, increasing amplitude until it was torn apart.* By generating resonant frequencies, you can break glass—whether the sound you use is live or on tape. These are interesting examples, but they are extreme for our purpose.

In a room, resonances occur at frequencies whose wavelengths are the same as or a multiple of one of the room's dimensions. These resonances are called **room modes**—increases in loudness at resonant frequencies that are a function of a room's dimensions. When these dimensions are the same or multiples of a common value, such as $10 \times 20 \times 30$ or $15 \times 30 \times 45$, the resonance amplitude is increased. This creates unequal representation of the frequencies generated by a sound source. In other words, certain frequencies will be reinforced while others will not be.

To avoid additive resonances, room dimensions should not be the same, nor be integer multiples of one another. For example, a room 9 feet high might be 10.1 feet wide and 12.5 feet long, or 11.5 feet wide and 13.8 long, or 16.2 feet wide and 18.9 feet long.

Resonance is not always bad, however. The tubing in wind and brass instruments, the pipes in an organ, and the human mouth, nose, chest, and throat are resonators. Air columns passing through them excite resonant frequencies, creating sound. Without resonators such as the "box" of a guitar or violin, weak sound sources would generate little sound. Some studios use this principle to construct resonators that help amplify certain frequencies to enhance the type of sound

*Tacoma Narrows Suspension Bridge at Puget Sound, Washington, in 1940.

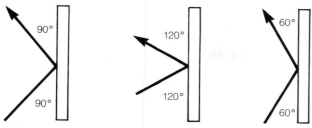

3-7 **Angle of incidence and angle of reflectance.** In sound, as in light, these angles are equal.

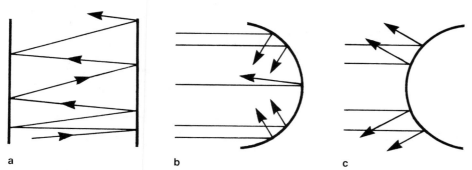

a b c

3-8 **Shape of a room's surface affecting direction of sound reflections.** (a) Two parallel surfaces opposite each other generate standing waves by reinforcing sound. (b) Concave surfaces concentrate sound waves by converging them. (c) A convex surface is more suitable because it disperses sound waves.

being produced. As we shall see in the section on construction materials, resonators are also used to absorb sound.

Shape

Acoustics is a science of interacting relationships. Although a studio may have preferred dimensions, its shape is also important to good noise reduction.

Except for bass frequencies, sound behaves like light; its angle of incidence is equal to its angle of reflectance (see 3-7). If a studio has parallel walls, sound waves reflect into one another, creating standing waves (see 3-8a). If there are concave surfaces, they serve as collecting points, generating unwanted

concentrations of sound (see 3-8b). A studio should be designed to break up the paths of sound waves. This is called **diffusion** — the uniform distribution of sound energy in a room so that its intensity throughout the room is approximately equal (see 3-8c). To break up the paths of sound waves, various types of *diffusers*, which scatter sound waves, are used.

Typical studio designs have adjacent walls at angles other than 90 degrees (see 3-9) and different-shaped wall surfaces (see 3-10 and 3-11) to help disperse the sound waves. In acoustics everything interacts with everything else, however, and a studio's shape has to be considered along with the materials used in its construction.

3-9 **Examples of studio shapes with nonparallel plane surfaces**

a b c d

3-10 **Examples of studio walls with different surface shapes:** (*a*) spherical, (*b*) cylindrical, (*c*) serrated, and (*d*) a combination of square and diamond

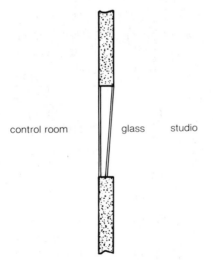

control room glass studio

3-11 **Glass between the control room and the studio.** Note that glass is angled down toward the floor for sound dispersal and to avoid studio light reflections.

Construction Materials

When sound hits a surface, one of three things happens, depending on the surface's material and mass. Sound is reflected, absorbed, or partially absorbed and partially reflected (see 3-12). Absorption, unlike diffusion, does not scatter a sound wave but entraps some of it. All materials absorb and reflect sound to some degree.

The amount of indirect sound energy absorbed is given an acoustical rating called a **sound absorption coefficient**. Theoretically, on a scale from 1.0 to 0.0, material with a sound absorption coefficient of 1.0 completely absorbs sound, while material with a sound absorption coefficient of 0.0 is completely sound reflectant. Soft, porous materials absorb more sound than do hard, nonporous materials. Drapes, for example, have a higher absorption coefficient than does glass. However, sound absorption ratings for

3-12 Sound paths hitting a flat surface

reflect

absorb

partially
absorbed/
reflected

a

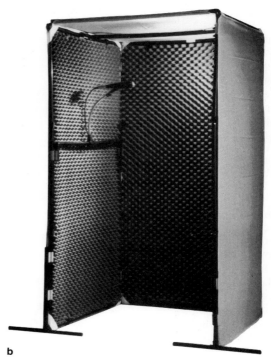

b

3-13 (*a*) Polyurethane-foam sound absorber and
(*b*) polyurethane-foam sound absorber lining a
portable sound booth

the same material vary with frequency (see
Table 3-2).

Three classifications of acoustic absorbers
are porous absorbers, diaphragmatic absorb-
ers, and Helmholtz resonators. Examples
of **porous absorbers** are acoustical tiles, car-
pets, fiberglass, and urethane foams (see
3-13a,b). Porous absorbers are most effective
with high frequencies. Because the wave-
lengths of high frequencies are short, they
tend to get trapped in the tiny air spaces
of the porous materials. The range and de-
gree of high-frequency absorption depends
on the density and thickness of the porous
materials.

Diaphragmatic absorbers are generally
flexible panels of wood or pressed wood
mounted over an air space (see 3-14). When

a sound wave hits the panel, it resonates at
a frequency (or frequencies) determined by
the stiffness of the panel and the size of the
air space. Other sound waves of the same
frequency (or frequencies) approaching the
panel, therefore, are dampened. Diaphrag-
matic absorbers are used mainly to absorb
low frequencies. For this reason they are also

Table 3-2 Sound absorption coefficients of commonly used materials (figures for people — adult, youth, and child — are determined by adding their absorption units to other absorbers in a room)

Materials	125 Hz	250 Hz	500 Hz	1,000 Hz	2,000 Hz	4,000 Hz
¾-in. mineral fiber acoustical tile						
hard backing	0.03	0.27	0.83	0.99	0.82	0.71
suspended	0.68	0.67	0.65	0.84	0.87	0.74
1-in. fiberglass tile						
hard backing	0.06	0.25	0.68	0.97	0.99	0.91
suspended	0.69	0.95	0.74	0.98	0.99	0.99
Brick						
unglazed	0.03	0.03	0.03	0.04	0.05	0.07
painted	0.01	0.01	0.02	0.02	0.02	0.03
Carpet, heavy						
on concrete	0.02	0.06	0.14	0.37	0.60	0.65
on foam pad	0.08	0.24	0.57	0.69	0.71	0.73
Concrete block						
coarse, unpainted	0.36	0.44	0.31	0.29	0.39	0.25
painted, sealed	0.10	0.05	0.06	0.07	0.09	0.08
Fabric						
10 oz. medium velour hung flat to wall	0.03	0.04	0.11	0.17	0.24	0.35
14 oz. medium velour draped to half area	0.07	0.31	0.49	0.75	0.70	0.60
18 oz. heavy velour draped to half area	0.14	0.35	0.55	0.72	0.70	0.65
Floor materials						
concrete or terrazzo	0.01	0.01	0.01	0.02	0.02	0.02
tile on concrete	0.02	0.03	0.03	0.03	0.03	0.02
wood parquet on concrete	0.04	0.04	0.07	0.06	0.06	0.07
wood on wood joists	0.15	0.11	0.10	0.07	0.06	0.07
Glass						
std. window glass	0.35	0.25	0.18	0.12	0.07	0.04
heavy plate glass	0.18	0.06	0.04	0.03	0.02	0.02
Gypsum wall board						
nailed to 2 × 4 studs	0.29	0.10	0.05	0.04	0.07	0.09
Plaster						
smooth, on brick	0.01	0.02	0.02	0.03	0.04	0.05
rough, on lath	0.14	0.10	0.06	0.05	0.04	0.03
¾-in. plywood paneling	0.28	0.22	0.17	0.09	0.10	0.11
Water surface, as in a swimming pool	0.008	0.008	0.013	0.015	0.020	0.025
Audience, seated in upholstered seats	0.60	0.74	0.88	0.96	0.93	0.85
unoccupied cloth-covered seats	0.49	0.66	0.80	0.88	0.82	0.70
unoccupied leather-covered seats	0.44	0.54	0.60	0.62	0.58	0.50
Chairs, metal or wood, occupied	0.15	0.19	0.22	0.39	0.38	0.30
People						
adult				4.2		
youth				3.8		
child				2.8		

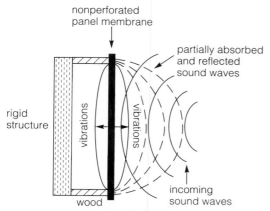

3-14 Diaphragmatic absorber. The approaching sound wave strikes the cover panel or diaphragm, setting it into motion and canceling resonant frequencies and reflecting nonresonant frequencies.

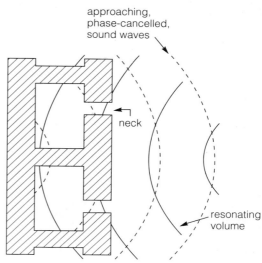

3-15 Helmholtz resonator. As a sound wave at or close to the natural frequency of the absorber strikes the opening, the air in the neck vibrates. These vibrations are sent out toward the approaching sound wave. Phase cancellation occurs and the approaching wave is absorbed.

called **bass traps**. This principle can also be applied to absorbing high frequencies. Because it is difficult to completely dissipate standing waves, especially in small rooms, even with optimal acoustics, bass traps are usually designed to introduce significant absorption for frequencies between 30 and 100 Hz.

A **Helmholtz resonator** functions, in principle, not unlike the action created when blowing into the mouth of a soda bottle. The tone created at the frequency of the bottle's resonance is related to the air mass in the bottle. By filling the bottle with water, the air mass is reduced, so the pitch of the tone gets higher. Helmholtz resonators are often designed to absorb sound at specific frequencies or within specific frequency ranges, usually the lower-middle frequencies (see 3-15).

Acoustic Features

Basic principles of acoustics apply to any room in which sound is generated. As noted earlier, however, a room's purpose has a great deal to do with how those principles are applied. If a studio is used for popular music and speech, the acoustics must absorb more individual sound than they diffuse so there is minimal interference from other sounds or from reverberation, or from both. On the other hand, studios used for classical music and some types of jazz and drama should diffuse more sound than they absorb to maintain a balanced, blended, open sound imaging.

Theoretically, this means that a studio designed to fulfill one sonic purpose is inappropriate for another. In fact, to be more functional, many studios are designed with variable acoustics. They have movable panels, louvers, walls, or gobos to alter diffusion, absorption, and reverb time (see 3-16, 3-17).

Purpose also affects design differences between studios and control rooms. Studios are designed for sound that is appropriate for microphone pickup, whereas control rooms

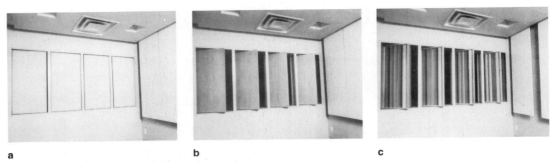

a b c

3-16 **Variable acoustics built into a wall.** Each unit has (*a*) a reflecting face, (*b*) an absorbing face, and (*c*) a diffusing face.

3-17 **Movable baffles or gobos showing absorbent and reflective surfaces**

are designed for listening to loudspeakers. Therefore, it is important that the diffusion–absorption proportions in a control room facilitate accurate assessment of the loud-speaker sound at particular locations in the room.

There are several different approaches to control room design. One solution is the *Live-End–Dead-End (LEDE)* concept (LEDE is the trademark of Synergetic Audio Concepts), in which the front of the control room

is sound absorbent, while the rear of the control room reflects sound, directing it toward the operator's position. This design helps maintain a diffuse sound field. As the reflected sound continues past the operator toward the front of the room, it is absorbed by the dead end of the room. This absorption helps to minimize unwanted build-up of room reflections that would otherwise color the sound (see 3-18). Another concept is displayed in 3-19.

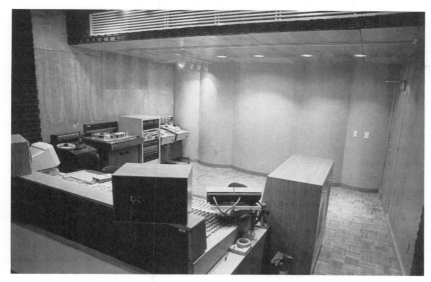

a

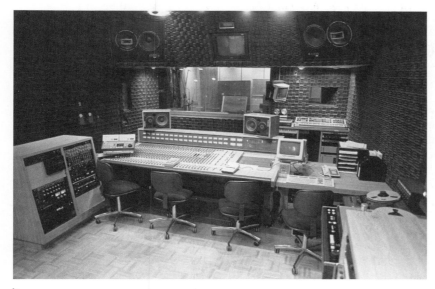

b

3-18 **Live-End–Dead-End control room.** (*a*) Live-End part of the control
room. (*b*) Dead-End part of the control room.

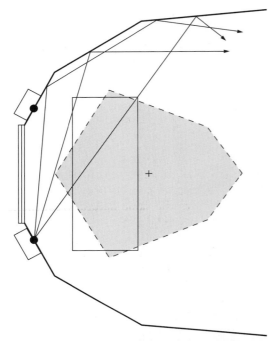

3-19 The shaded area in this control room design is a reflection-free zone

Now that the behavior and perception of sound in an enclosed space have been discussed, let's turn to the types of facilities in which audio is produced.

Main Points

1. Acoustics is the objective study of the physical behavior of received sound. Psychoacoustics is the study of the psychological response to physical sound stimuli.

2. Humans hear sound binaurally — with two ears. Lower frequencies diffract around the head, which means the sound reaches the ears at different times. Higher frequencies are reflected by the head, creating intensity differences in the sound reaching both ears.

3. Sound waves in a room reach the listener in two stages: directly — before they interact with any other surface — and indirectly — after bouncing off one or more surfaces.

4. Reflected sounds reaching the listener within about 20 milliseconds of the original sound are usually perceived as coming from the same direction. This is known as the precedence, or Haas, effect. Sound localization becomes increasingly difficult from 20 milliseconds and beyond.

5. Direct sound and its early reflections reaching the listener approximately 10 to 20 milliseconds after the original waves are perceived as a single sound. This is known as temporal fusion. Later reflections — sound reflecting from many surfaces reaching the listener more than 10 milliseconds after the direct sound — is called reverberation.

6. Direct sound provides information about a sound's origin, its size, and its tonal quality. Early reflections add loudness and fullness to the initial sound and help to create our subjective impression of room size. Reverberation fills out the loudness and body of a sound and contains most of its tonal energy.

7. Reverb or decay time is the time it takes a sound to drop 60 dB-SPL, usually from average loudness — 85 dB-SPL — to, generally, inaudible — 25 dB-SPL.

8. If reflection delays are greater than 50 milliseconds, repetitions of the sound are distinctive. This is known as echo.

9. There are five basic acoustic conditions: (1) considerable reverberation and long decay time, (2) considerable reverbera-

tion and short decay time, (3) little reverberation and medium decay time, (4) little reverberation and short decay time, (5) no reverberation.

10. No one sound room is acoustically suitable for all types of sound. Therefore, it is important to match studio acoustics to sonic material.

11. Five factors influence how sound behaves in an acoustic environment: (1) isolation of sound outside and inside the room, (2) dimensions of the room, (3) shape of the room, (4) construction materials in the room, (5) acoustical features.

12. Noise is any unwanted sound (except distortion) in the audio system, the studio, the environment, and so on.

13. The Noise Criteria (NC) system rates the level of ambient, or background, noise.

14. Sound isolation in a room is measured in two ways: by determining the loudest outside sound level against the minimum acceptable NC level inside the room, and by determining the loudest sound level inside the studio against a maximum acceptable noise floor outside the room.

15. Transmission loss (TL) is the amount of sound reduction provided by a barrier—wall, floor, or ceiling. This value is given a measurement called sound transmission class (STC).

16. The dimensions of a sound room—height, width, and length—should not equal or be exact multiples of one another or else certain frequencies will be reinforced, thereby coloring the sound.

17. The shape of a studio and the shapes within it should be irregular to help break up sound, thereby preventing unwanted echoes, standing waves, and poor sound diffusion.

18. Resonance, another factor important in studio design, results when a vibrating body with the same natural frequencies as another body causes that body to vibrate sympathetically, thereby increasing the amplitude of both of them at those frequencies if the variables are in acoustic phase.

19. When sound hits a surface, it is reflected, absorbed, or partially absorbed and partially reflected.

20. The amount of indirect sound energy absorbed is given an acoustical rating called a sound absorption coefficient.

21. Three classifications of acoustic absorbers are porous absorbers, diaphragmatic absorbers, and Helmholtz resonators.

22. To be more acoustically functional, many studios are designed with movable panels, louvers, walls, and gobos to alter diffusion, absorption, reflection, and reverb time.

PART 2

Equipment

Sound Studios

A sound studio is a room or group of rooms used for the performance, production, and processing of sonic materials for broadcast, film, or music recording. Generally, sound studios fall into three categories: *performance*, *production*, and *postproduction*. Some studios are portable, such as TV news vans. A *workstation* is not even a studio in the conventional sense: It is a self-contained unit that can be used for most production and postproduction operations. It takes up comparatively little space, and it does not require audiotape, videotape, or film as the recording medium.

Performance Studios

A **performance studio** is where the talent performs. Studios vary in size from a small announce booth used by a single announcer to a large sound stage where productions are photographed and recorded. Performance studios may also contain microphones, lights, cameras, loudspeakers, acoustic and electric musical instruments, furniture, scenery, and an audience. The size of equipment and sets in TV and film performance studios makes acoustics more difficult to control than in radio and music recording studios.

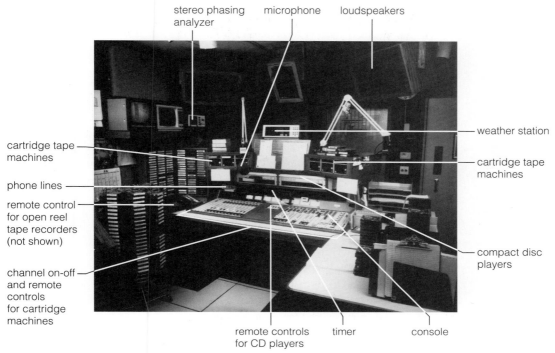

stereo phasing analyzer microphone loudspeakers

weather station

cartridge tape machines

cartridge tape machines

phone lines

remote control for open reel tape recorders (not shown)

compact disc players

channel on-off and remote controls for cartridge machines

remote controls for CD players timer console

4-1 Combination ("combo") control room and performance studio

Radio

In radio a performance studio usually doubles as a production studio/control room; when it does not, talent works from a studio next to the control room (see 4-1). A glass window often separates the rooms so that performer and operator can communicate various cues by hand or through a **talkback** system.

Some performance studios are no more than small announce booths containing a microphone and a switch to turn it on and off. Other performance studios may contain disc players, tape recorders, several microphones, and a small control panel to activate them (see 4-2).

Television

In television the studio and the control room may be separated, sometimes on different floors or even in different buildings. Visual communication is maintained through studio cameras and control room TV monitors. Oral communication is facilitated by headsets worn by appropriate control room and studio personnel or by direct talkback through a control room microphone—studio loudspeaker system.

The control area is separated from the studio for sound isolation and sometimes for logistics, perhaps to have one control room serve two or more studios or to locate a control area central to other video sources,

4-2 Radio talk/interview studio that is also used for music performance

such as videotape recorders and film projectors.

Some television studios also have a section for an audience. These studios must be large, and may have TV screens so the audience can follow on-stage action if it is blocked by TV cameras, microphone booms, and production personnel.

Film

Film performance studios include sound stages, scoring stages, and dialogue recording rooms. In a **sound stage** productions are filmed (or taped) and recorded. They are usually huge and barnlike inside to accommodate elaborate sets and several shooting areas.

The **scoring stage** (see 4-3) is similar to a large music recording studio, but it also has film projectors isolated in booths and a large screen like those in movie theaters. Music sound tracks are recorded and synchronized with the picture here.

In the **dialogue recording**, or **automated (or automatic) dialogue replacement (ADR), room** dialogue that is not taped during production or that needs to be redone is recorded and synchronized to the picture (see 4-4). The room contains a studio with a screen, TV monitors, and microphones and a separate control area with a console and loudspeakers.

Music Recording

In music recording, as in radio and film, performance studios and control rooms are contiguous, with a glass window between them. Performance studios are likely to contain isolation booths for drummers and vocalists to

4-3 Scoring stage. Screen is at left and control room is at right.

4-4 Automated dialogue recording studio and control room

4-5 **Performance studio for recording music.** Note booth to isolate drum sound on left.

prevent their sound from leaking into the microphones of other instruments, or to prevent the sound of other instruments from leaking into the vocalists' microphones. Decor and lighting are apt to be specially designed to provide a more comfortable atmosphere for the musicians (see 4-5).

Electronic Music Studios

At one time synthesizers and the musicians who used them belonged to the difficult and esoteric domain of electronic music. Most synthesizers were cumbersome and required considerable technical and sonic instruction to master. Moreover, these synthesizers could produce only one sound at a time.

Only by connecting and synchronizing two or more synthesizers could complex timbres be reproduced.

Today, synthesizers are available in ever-increasing variety, from basic to complex. They have been simplified to the point where virtually anyone with an ear can use them — musical training is not a requirement. They have also been developed to such a sophisticated level that any number of them can be connected and synchronized to mimic any existing sound and create just about any other sound the mind can imagine. In conjunction with computers, the sonic possibilities of synthesized sound are limitless. This development is called **Musical Instrument Digital Interface** (**MIDI**).

As a result, the use of synthesizers has moved beyond the world of electronic music into most facets of audio in media. Entire studios now consist of electronic, computer-assisted instruments that meet virtually any sonic need in performing and producing music and sound effects for commercials, jingles, and sound tracks for TV and film. MIDI has become an inseparable part of popular music recording (see 4-6). Instruments and musicians generating sound acoustically and electrically are being replaced, more and more, by synthesizers.

Production Studios

Audio **production studios** house most of the equipment needed to prepare sound materials. They may be used exclusively for production or also serve as performance studios for radio disc jockeys, newscasters, and talk-show hosts. The array and complexity of equipment in production studios vary with their purpose, but certain basic equipment is found in most of them (see 4-7, p. 60), including the following:

■ Microphone — a familiar, almost ubiquitous piece of sound equipment.

■ **Compact disc player** — a disc player that uses a laser beam to read information recorded on a **compact disc (CD)**.

■ **Turntable** — a sturdy record player specially designed for professional audio facilities. It has been supplanted by the compact disc player.

■ **Tape recorder** — an analog or digital device that records and plays information stored in the form of magnetic energy. Most production studios have at least two types of recorders: the familiar open-reel machine, often including multitrack for-

mats, and the analog cartridge tape recorder that uses a continuous tape loop enclosed in a plastic cartridge or digital carts that use CDs or computer disks. Analog cassette tape recorders are also available, although they are seldom used for production.

■ **Console** — a device that takes all incoming audio signals from microphones, disc players, audiotape and videotape recorders, and other sound sources and amplifies, balances, mixes, and routes them for recording or broadcasting.

■ **Signal processors** — devices that change some characteristic of a sound, such as the equalizer and limiter–compressor.

■ **Loudspeaker** — a device that makes electric signals audible by converting them into sound.

■ **Headphones** — "miniature loudspeakers" that fit over the ears to provide private listening and to isolate outside sound.

■ **Remote control** — a device to automatically start, stop, and cue equipment.

■ **Patch panel** — an assembly of wired connections linking the inputs and outputs of the audio components in a studio, which facilitates the routing and rerouting of signals.

In television and film production, the videotape recorder and magnetic film recorder/reproducer are also commonly used in the preparation of sound materials.

Radio

Radio control rooms are usually designed so that the equipment, with or without remote control, is within arm's reach of the operator. In control rooms used for on-air broadcasting, the operator is generally the performer as well.

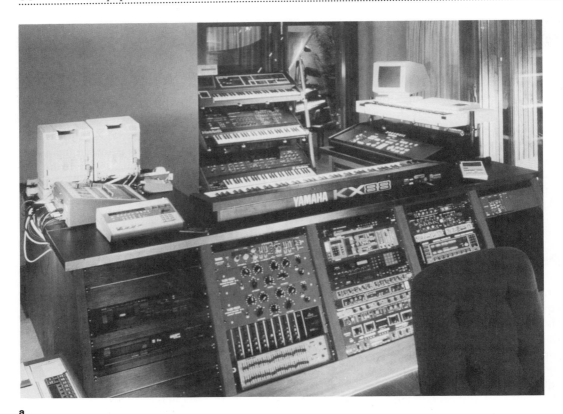

a

4-6 (*a*) Studio with MIDI and (*b*) control room layout of studio in (*a*)

Radio stations also have off-air control rooms for recording and editing commercials, jingles, announcements, news stories, and other program materials. These production studios, or **production control rooms**, house basically the same type of equipment as an on-air control room only more of it, including additional signal processors such as the Harmonizer, time compressor, and digital delay (see 4-7).

Television

Two types of television production studios are production control, used for broadcasting and recording, and postproduction control, used for editing and recording after a production has been taped.

Production control is divided in two sections, one for video equipment and the other for audio equipment (see 4-8). The two areas are usually in separate rooms, either next to or near each other, so that the audio operator can monitor the program sound without being disturbed by or disturbing the director and other control room personnel. The audio operator and director communicate through headsets that have a mouthpiece and an earpiece.

The audio section's console is usually more elaborate than that used in radio because TV deals with more sound sources

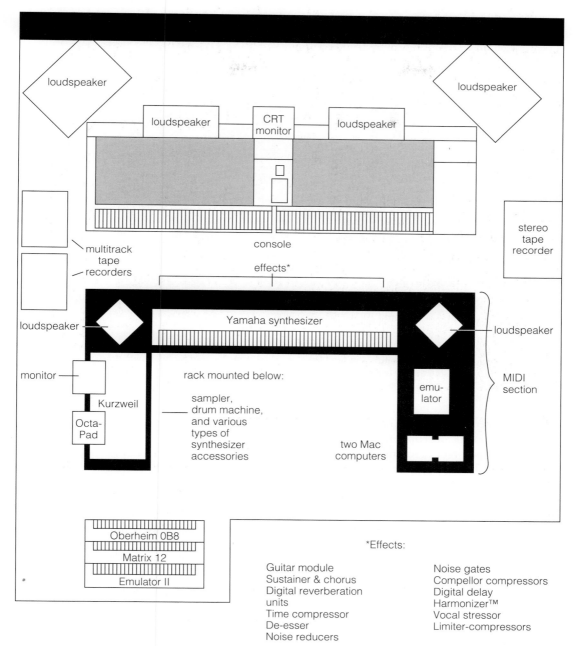

loudspeaker

loudspeaker

loudspeaker

CRT monitor

loudspeaker

loudspeaker

stereo tape recorder

multitrack tape recorders

console

effects*

loudspeaker

Yamaha synthesizer

loudspeaker

monitor

Kurzweil

Octa-Pad

rack mounted below:

sampler, drum machine, and various types of synthesizer accessories

emu-lator

MIDI section

two Mac computers

Oberheim 0B8

Matrix 12

Emulator II

*Effects:

Guitar module
Sustainer & chorus
Digital reverberation units
Time compressor
De-esser
Noise reducers

Noise gates
Compellor compressors
Digital delay
Harmonizer™
Vocal stressor
Limiter-compressors

b

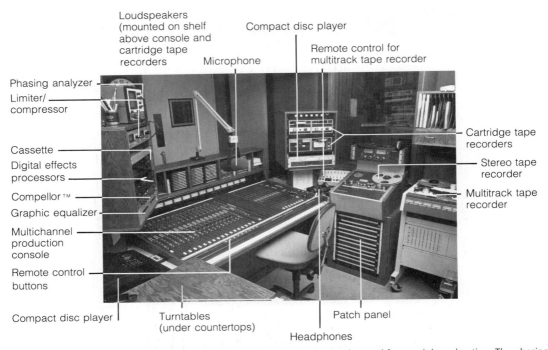

Loudspeakers (mounted on shelf above console and cartridge tape recorders)

Compact disc player

Microphone

Remote control for multitrack tape recorder

Phasing analyzer

Limiter/ compressor

Cassette

Digital effects processors

Compellor™

Graphic equalizer

Multichannel production console

Remote control buttons

Compact disc player

Turntables (under countertops)

Headphones

Patch panel

Cartridge tape recorders

Stereo tape recorder

Multitrack tape recorder

4-7 **Radio production control room.** This production studio also can be used for on-air broadcasting. The phasing analyzer is used to make sure that stereo disc recordings are compatible — in phase — for monaural reception. The compellor⑩ is a limiter/compressor/level corrector.

(including videotape recorders) and sometimes several additional microphones. TV audio control has open-reel tape and cartridge recorders, disc players (sometimes), and signal-processing equipment.

Postproduction control (discussed later in the chapter) houses the audio and video recorders and editing equipment used to edit a production that has already been videotaped. Audio may also be enhanced or "sweetened" during postproduction.

Film

In film two types of production studios are the Foley stage and the rerecording room. The **Foley stage** (named after its developer, Hollywood sound man Jack Foley) is the stu-

dio where sound effects that are not recorded during shooting or that require rerecording are produced (4-9). The stage consists of two rooms, one of which is the actual Foley studio. It includes various materials in the floor such as cement, wood, cardboard, water, sand, and gravel. This room also contains all manner of objects used to create sound effects, such as bells, buzzers, doors, latches, tools, cans, tables, glass, plates, silverware, switches, and so on. The other room is the control room, containing console, loudspeakers, and, sometimes, audiotape recorders. (Recording machines, magnetic film recorders/reproducers, and audiotape recorders are usually housed in a separate **machine room,** due to the noise they generate, and are operated by either remote control or

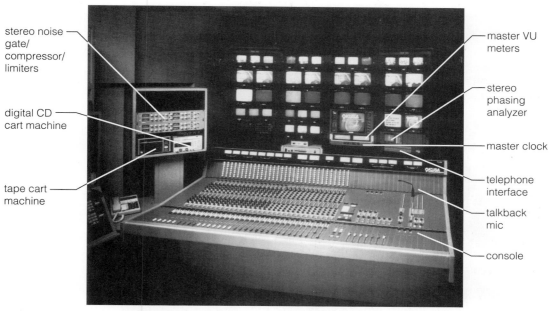

stereo noise gate/ compressor/ limiters

digital CD cart machine

tape cart machine

master VU meters

stereo phasing analyzer

master clock

telephone interface

talkback mic

console

4-8 **Audio control room used in television**

4-9 **A Foley room setup.** The two Foley walkers are using the various pits and equipment to perform, in sync, the sounds that should be heard from the picture on the screen.

4-10 Rerecording room or theater. The console seats at least three operators to mix dialogue, music, and sound effects. This particular theater contains sound diffusion panels along the side wall interleaved with surround-sound loudspeakers along each wall. Loudspeakers are situated across the front behind the screen. Each operating position at the console incorporates workstation capability (discussed later in this chapter) with touchscreen control.

machine-room personnel. This not only reduces noise in the production studio but is also logistically more convenient because it locates this equipment in one place for use in dialogue recording and rerecording.)

The **rerecording room**, used for the rerecording mix, is similar to a motion picture theater; it contains a large screen, projection booth, and sometimes audience seating. However, it is also acoustically controlled; it has an extremely high-quality sound system. In the middle of the room, a huge mixing console is often operated by three or more mixers (4-10). Here the edited dialogue, music, and sound effect tracks are combined and rerecorded, for the last time, in sync with the picture. These tracks are fed from the magnetic film reproducers in the machine room. After being appropriately combined at the mixing console, the final, composite sound track is routed to magnetic film recorders in the machine room.

Music Recording

Control rooms used for music recording contain very large consoles, with many inputs and outputs, capable of handling several sound sources at once (see 4-11). Open-reel tape recorders (analog or digital, or both), are in two-track and various multitrack formats; several different types of signal proces-

4-11 Control room used for music recording

sors are available; and two, three, or four sets of loudspeakers are used to compare how a tape sounds on different reproducing systems.

Special lighting is often part of the design of a recording control room and studio. Its function is not only to illuminate but also to create a mood conducive to musical performance.

Postproduction Studios

Postproduction is when the raw materials recorded during production are assembled, through editing and mixing, into a finished tape or film. The practice is not new; postproduction has almost always been a part of the process of producing film because film sound can only be edited and mixed after production is completed. Advances in digital technology, tape coding, tape recorder synchronization, synthesizers, computer interfacing, and information storage have helped to develop postproduction into a major stage in the production process and have led to the establishment of the postproduction editing suite and the workstation, also known as the tapeless studio.

Editing Suite

The **postproduction editing suite** is a room or group of rooms in which previously taped sound or picture, or both, are edited and assembled (see 4-12). The quantity and capability of the equipment in an editing suite usually depends on how the suite is used; editing feature materials requires more technical support, for example, than does news.

Generally, however, even in modest editing suites it is possible, by touching a few buttons, to arrange and rearrange sound and pictures from tape or hard disk, or both, at

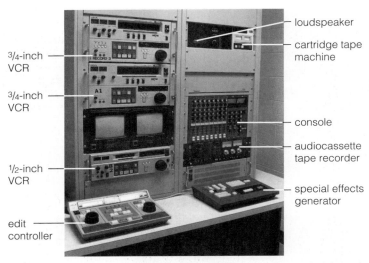

3/4-inch VCR

3/4-inch VCR

1/2-inch VCR

edit controller

loudspeaker

cartridge tape machine

console

audiocassette tape recorder

special effects generator

4-12 Upscale postproduction television facility. Audio area is right center.

once; add and mix sound effects and music from audiotape or disk recorders (often multi-track); preview, for comparison, various editing approaches to a particular sequence in any order; assemble all the elements in proper order; and store, in a computer memory, every cue for the record and for recall at any time.

Workstations

Several types of equipment in different locations are often needed when a postproduction editing suite is used to create a finished product. The digital audio **workstation,** by comparison, can do most everything at a central location. A digital audio workstation is a computer-controlled system or networked collection of devices that allows digital audio recording, processing, editing, mixing, and replay functions to be controlled from a central location. Most audio workstations have a central computer with integrated, multi-functional hardware and software that allow general-purpose computing, signal process-

ing, real-time synthesis and interaction, and random access retrieval. They also contain various input and output devices and sizable information storage capacity. What all this high-tech equipment means is that the audio it once took many people in various studios to create, produce, edit, and mix can now be turned out, to the specific requirements of TV, film, music recording, or radio, by one or a few individuals at a single workstation.

Basic workstations are hard-disk recorders and editors that usually handle mono or stereo audio. The next level facilitates multitrack recording and mixing, usually controlled through a "virtual" console representation on the monitor screen (see 6-21). With increased capability, a digital audio workstation can perform more complex mixing with additional tracks and *digital signal processing* (DSP) — such as equalization, limiting—compression, and reverberation. A "hard" mixing console, putting traditional console controls in the user's hands, is often a component of an upscale audio workstation (see 4-13 and 4-14).

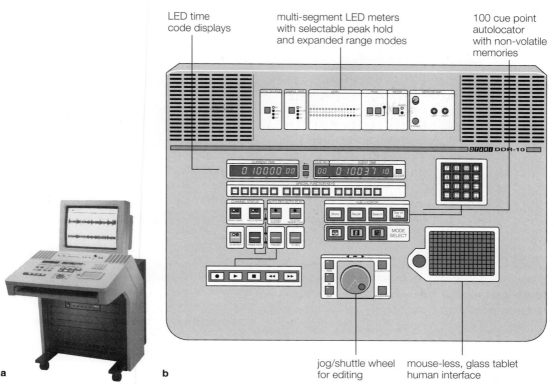

LED time
code displays

multi-segment LED meters
with selectable peak hold
and expanded range modes

100 cue point
autolocator
with non-volatile
memories

jog/shuttle wheel
for editing

mouse-less, glass tablet
human interface

a b

4-13 (*a*) Transportable, self-contained, hard-disk audio workstation that can record, edit, and signal process. (*b*) Enlarged view of control panel.

4-14 **An upscale workstation.** This one incorporates a 38-channel digital mixer, 24-track random access recorder, multitrack audio editor, multiple machine controller, automated routing system, and random access video system.

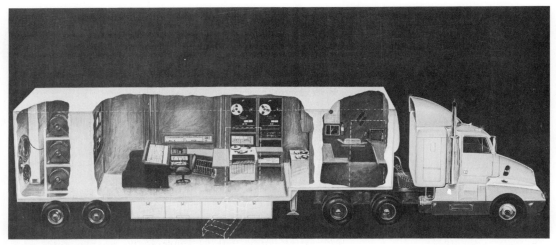

4-15 Audio mobile unit

Mobile Studios

Much production occurs on location, away from permanent studios. To facilitate production at a location site, specially designed vehicles have been outfitted with the same type of equipment used in studios. These compact studios on wheels range in size from small vans, used to produce spot news reports, disc jockey programs, and commercials, to tractor trailer trucks, used for sports events, music concerts, and specials (see 4-15).

Master Control

Broadcast stations have another control area—**master control**. Signals from the control room(s) are fed to master control for final adjusting and processing before they are sent on to broadcast or, sometimes, recording. Master control is usually a separate room with highly technical equipment operated by specially trained engineers and tech-

nicians. In some smaller stations part of the main on-air production studio may be used to house the master control equipment.

Ergonomics

Sound is obviously the most important factor in studio design, but human needs should not be ignored. Designing an engineering system with the human element in mind is called **ergonomics**.

Earlier we mentioned the special lighting often used in music recording studios. This is an ergonomic consideration. Other such considerations in studio design include:

- *Size.* Ample room for personnel and equipment should prevent a cramped, claustrophobic feeling.

- *Position of equipment.* Equipment and remote controls should be situated within arm's reach, and easy access should be provided to equipment that cannot be so positioned. The operator should be lo-

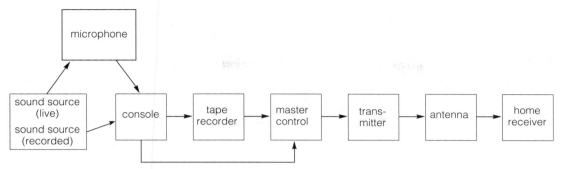

4-16 Broadcast signal chain

cated at the point where hearing and seeing are optimal.

- *Furniture.* Chairs should be comfortable and should move around easily on wheels, without squeaking. Other furniture should be functional, rather than just decorative, and reflect as little sound as possible.

- *Floor covering.* Rugs should be static-free and permit anything on wheels to move about easily.

In production, make it as easy on yourself as possible.

The Sound Chain

In audio production the route sonic materials take from their source to their destination, and their processing along the way, is known as the **sound chain**. Regardless of the medium, the equipment being used, or the audio being produced, awareness of the sound chain is important to the organization, and hence the smooth and economical operation, of the production process, especially because, given the technology involved, that process can be labyrinthine.

Sound chains, of course, vary with the medium, the production, and the audio facility. To provide some idea of their structures and, thereby, their usefulness, see 4-16 through 4-18.

With modern technology, sound chains have become regional and even global. Media coverage of the Gulf War is a prime example of global communications. Inter-regional sound links can have a considerable impact on the way audio professionals work (see 4-19). Voice talent can connect directly to clients without the delay of overnight mail and without having to schedule a satellite link in advance. The progress of a recording mix in a distant studio can be monitored remotely from the disc label's headquarters. The producer of a network television show can have daily screenings with synchronized audio directly from the production facility across town or across the state. If a feature film in Hollywood requires some last-minute ADR with a star already working in New York on another project, the actor can go into a New York studio and complete the ADR directed from the facility in Hollywood.*

*"Global Audio," Chris Reilly, *MIX* magazine, April 1992, p. 96.

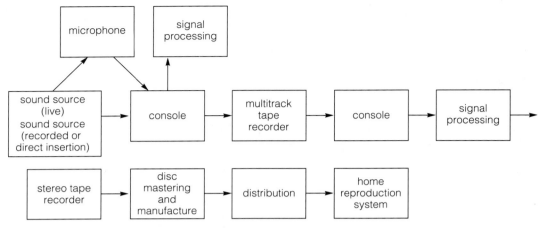

4-17 Disc recording and reproduction chain

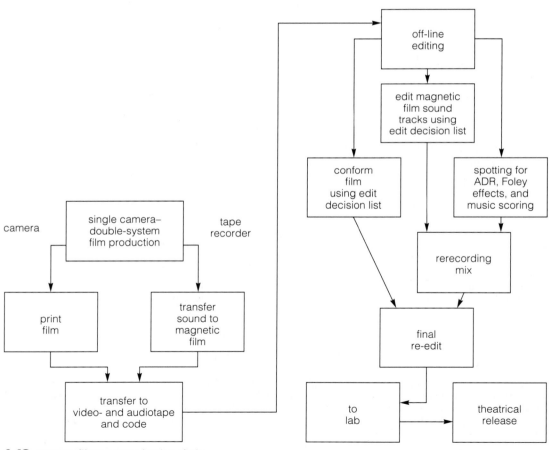

4-18 Feature film postproduction chain

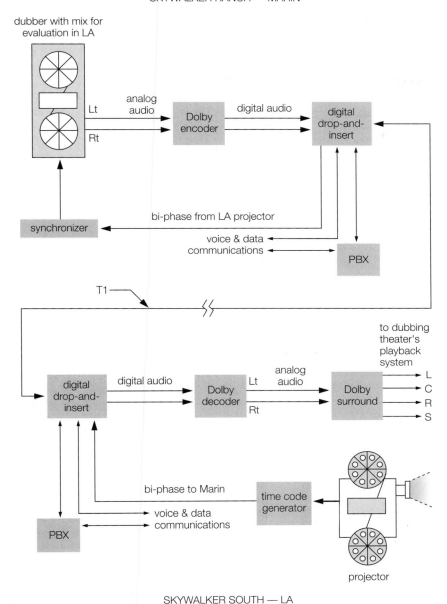

SKYWALKER RANCH — MARIN

dubber with mix for
evaluation in LA

Lt
Rt

analog
audio

Dolby
encoder

digital audio

digital
drop-and-
insert

synchronizer

bi-phase from LA projector

voice & data
communications

PBX

T1

to dubbing
theater's
playback
system

digital
drop-and-
insert

digital audio

Dolby
decoder

Lt

Rt

analog
audio

Dolby
surround

L
C
R
S

bi-phase to Marin

time code
generator

voice & data
communications

PBX

projector

SKYWALKER SOUTH — LA

4-19 Inter-regional sound link between Lucasfilm's Skywalker production facility north of San Francisco and its Los Angeles production facility. (T1 is a format developed to move voice traffic more efficiently through a telephone network. PBX — Private Branch Switching — is a private switching system to serve a business or government agency, usually located on the customer's premises.)

On a more day-to-day basis, within a sound studio, and within the various pieces of equipment a sound studio contains, audio signals follow a prescribed path, called the **signal flow**. This concept is central to the discussion of equipment in the rest of Part 2.

Main Points

1. Two types of rooms are usually found in a sound facility: a control room and a performance studio.

2. Performance studios, where talent performs, vary in size from one-person announce booths to large studios where major productions are videotaped or filmed.

3. A control room houses the equipment that combines, processes, and routes sound from its source to its destination. It generally contains a microphone, disc players, open-reel and cartridge recorders, a console, signal processors, and loudspeakers.

4. Depending on the medium, control rooms may be used for broadcasting, producing, postproduction, editing, recording, rerecording, and mixing.

5. A performance studio or control area may consist, for the most part or entirely, of electronic instruments for production using Musical Instrument Digital Interface (MIDI).

6. Another type of control area is the audio workstation at which it is possible to produce, edit, and mix sound computer-assisted, without tape, and single-handed.

7. Mobile units — control rooms on wheels — are designed to handle production away from the studio, on location.

8. The master control is a highly technical facility where signals from the control room(s) are fed for final processing before being sent to the transmitter and then to broadcast.

9. Ergonomics addresses the design of an engineering system with human convenience in mind.

10. The route sonic materials take from their source to their destination, and their processing along the way, is known as the sound chain.

Microphones

Most of what is recorded or broadcast begins with a microphone.* The analogy can be made that microphones are to the sound designer what colors are to a painter. The more colors and hues available to a painter, the greater the possibilities for coloration in a visual canvas. For the sound designer, the more models of microphones there are, the greater variety of tones in the sonic "palette," and hence, the greater the possibilities for coloration in designing an aural canvas.

When choosing a microphone, you should consider four things about its particular "color" and "hue":

- Type
- Directional characteristics
- Sound
- Appearance (for television)

Types of Microphones

The microphone is a transducer that converts acoustic energy into electric energy. The device that actually does the transducing is

*In the interest of accuracy, it should be noted that the earliest recordings were made through a horn. Sounds were emitted into the horn and recorded directly onto a cylinder or disc. This type of acoustical recording was supplanted by electrical recording around 1925, and then the microphone took over.

mounted in the mic head and is called the *element*. Each type of microphone gets its name from the element it uses. There are six types, four normally used by professionals — (1) moving-coil,* (2) ribbon, (3) printed-ribbon, (4) capacitor (or condenser) — which we will discuss in detail, and two used by nonprofessionals — (5) **ceramic** and (6) **crystal**. The difference between a professional and a nonprofessional microphone is in the sound quality produced.

After a microphone changes acoustic energy into electric energy, the electric energy flows through a circuit as voltage. Whatever resistance that voltage encounters in the circuit is called **impedance**. Less resistance means lower impedance.

Low-impedance microphones have two advantages over high-impedance mics: (1) They are much less susceptible to hum and electric noise, such as static from motors and fluorescent lights; and (2) they can be connected to long cables without increasing the noise. For these reasons professionals use low-impedance mics (and equipment).

Types of Low-Impedance Microphones

Moving-Coil Microphones

Of the four types of low-impedance microphones — moving-coil, ribbon, printed-ribbon, and capacitor — the **moving-coil** is the most widely used. The transducing ele-

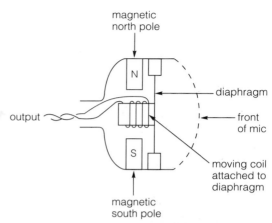

5-1 **The element of a moving-coil microphone**

ment consists of a coil of wire attached to a mylar diaphragm suspended in a magnetic field (see 5-1). When sound waves move the diaphragm, they move the coil, which gives the element its name. As the coil moves in the magnetic field, voltage is induced within the coil; the voltage is the electric-energy analog of the acoustic energy that first caused the diaphragm to vibrate.

Ribbon Microphones

In **ribbon microphones** the diaphragm and moving coil are replaced with a thin, corrugated metal ribbon suspended in a strong magnetic field (see 5-2). As the ribbon vibrates from the pressure of the sound waves, voltage is induced in the ribbon.

*The term *dynamic* is often used to describe moving-coil microphones. Actually, **dynamic microphones** constitute a class of mics that transduce energy electromagnetically by means of a conductor moving in a magnetic field. This classification also includes ribbon types, sometimes called *velocity* microphones. To avoid confusion, we will designate a microphone's type by its element, not its classification, although in actual use it probably would

be more convenient to use the term *dynamic* synonymously with *moving coil*. Capacitor mics, classified as electrostatic, used to be called condenser mics because of their element, and the name has remained in popular usage. However, enough time has passed since their element has been a capacitor to make continued use of *condenser* misleading.

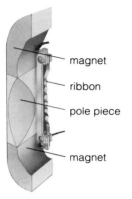

magnet

ribbon

pole piece

magnet

5-2 The element of a ribbon microphone

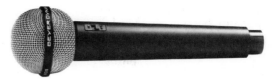

5-4 **Newer model of ribbon microphone with smaller, longitudinal ribbon**

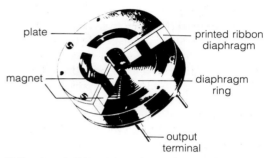

plate

printed ribbon diaphragm

magnet

diaphragm ring

output terminal

5-5 Printed-ribbon microphone element

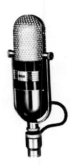

5-3 Older model of ribbon microphone

The long, vertical ribbon design found in older ribbon mics makes the element quite fragile (see 5-3). Strongly blown sounds or sudden, loud changes in sound pressure can damage the ribbon.

A newer design places a smaller ribbon longitudinally between the pole pieces. This, and other design features (such as a less fragile element and stronger casing), makes this type of ribbon mic more durable and able to take louder sound-pressure levels than its predecessors (see 5-4).

Ribbon microphones are sometimes called *velocity* or *pressure-gradient* microphones. Both sides of the ribbon are exposed to the velocity of the air molecules and are activated by the difference in pressure between the front and back of the ribbon.

Printed-Ribbon Microphones

The most recent advance in ribbon design is the **printed-ribbon microphone,** sometimes also called the *regulated-phase* microphone (see 5-5). In principle, it operates like the conventional ribbon pickup, but in a considerably more rugged design. In other words, it has the durability of a moving-coil mic with the compliance of a ribbon microphone.

A spiral aluminum ribbon is printed on a diaphragm made of polyester film. Two ring magnets in front of the diaphragm and two in the back produce the magnetic structure. Sound waves arrive at the diaphragm

through the inner and outer ring openings and also through the center hole of the inner magnet.

Capacitor Microphones

Capacitor microphones operate on a principle different from that of the moving-coil and ribbon types. They transduce energy using voltage (electrostatic) variations instead of magnetic (electromagnetic) variations. The capacitor design consists of two parallel plates separated by a small space (see 5-6). The front plate is a thin, metalized plastic diaphragm, the only moving part in the mic head, and the back plate is fixed. Together these plates or electrodes form a **capacitor** — a device that is capable of holding an electric charge. As acoustic energy moves the diaphragm back and forth in relation to the fixed back plate, the capacitance change causes a voltage change, varying the signal. The signal output, however, has a very high impedance and requires a preamplifier (mounted near the mic capsule) to make it usable.

Because the capacitor requires polarizing voltage and the preamplifier requires power voltage to operate, capacitor microphones must have a separate power supply. The older, tube-type condensers came with a bulky, external power supply for condensers and preamp (see 5-7). Today, capacitor mics are powered by batteries contained inside the microphone (see 5-8) or by a phantom power supply that eliminates the need for batteries altogether. Phantom power supplies may be at the console, installed in the studio microphone input circuits, or portable, thereby providing voltage the instant a mic is plugged in.

Some capacitor microphones have an *electret* diaphragm. An electret is a material (high-polymer plastic film) that can hold a

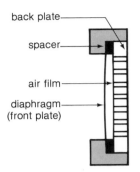

5-6 **Cross-section of the element in a capacitor microphone**

5-7 **External power supply for an older, tube-type condenser microphone.** (See also Groove Tubes MD-2, p. 106).

charge permanently, thus eliminating the need for external polarizing voltage. Because a small battery is all that is required to power the preamp, **electret microphones** can be made more compact (see 5-8b and the discussion of lavalier microphones later in this chapter).

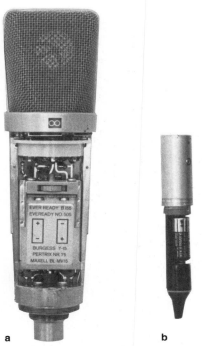

5-8 **Power supplies in capacitor microphones.**
(a) Battery location in one model and (b) smaller-size battery in electret model.

General Transducer Performance Characteristics

Microphone performance depends substantially on the type of transducer. It is not that one type of microphone is better than another, but that one type of microphone is more suitable for a particular application than another.

Moving-coil microphones are well-suited for high sound-pressure-level applications. They are quite rugged and generate low self-noise. They tend to be less susceptible to humidity and wide temperature variations.

They are usually less expensive than the other professional types and come in a wide variety of makes and models.

Generally (there are a number of exceptions), the frequency response of moving-coil mics is transparent; they tend not to color sound. They are slower to respond to **transients**—sounds that begin with a quick attack, such as a drum hit or breaking glass, and then quickly decay. This makes them ideal for applications that do not require considerable detail.

Ribbon microphones are not widely used today, except in music recording and live concerts and for the speaking voice. They are more expensive than many moving-coil mics and even the newer, more rugged models have to be handled with care, particularly when it comes to loud sound levels.

Older-type ribbon mics have mediocre high-frequency response, which can be turned into an advantage because it gives sound a warm, mellow quality. The longitudinal ribbon mics have a more extended high-frequency response. The *printed-ribbon microphone* also has good high-frequency response, but it is somewhat limited at low frequencies. Generally, ribbon mics have low self-noise and excellent transient response but have the lowest output level of the three major types. This means a poorer signal-to-noise ratio if the mic is too far from the sound source or if the cable run is too long.

Capacitor microphones are considered high-performance instruments. They reproduce clear, detailed sound and are the choice among professional-quality microphones when it is necessary to record sounds rich in harmonics and overtones. Capacitor mics have excellent transient response and high sensitivity, which makes them the preferred microphone for distant miking. They also have the highest output level, which gives them a wide signal-to-noise ratio.

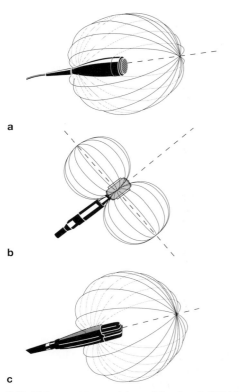

5-9 **Pickup patterns:** (*a*) omnidirectional, (*b*) bidirectional, and (*c*) unidirectional or cardioid

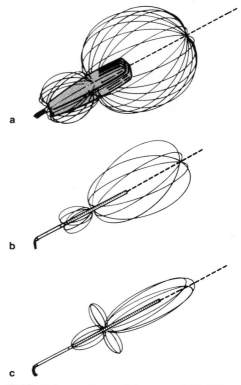

5-10 **Pickup patterns:** (*a*) supercardioid, (*b*) hypercardioid, and (*c*) ultracardioid

These advantages come at a cost, for capacitors are generally the most expensive type of microphone and, in most cases, are too sensitive for use outdoors. Some models are specially designed for use in live, indoor concerts, however.

Directional Characteristics

A fundamental rule of good microphone technique is that a sound source should be on-mic—at an optimal distance from the microphone and directly in its pickup pattern.

Pickup pattern refers to the direction(s) from which a mic hears sound. Depending on the design, a microphone is sensitive to sound from (1) all around—**omnidirectional,** (2) its front and rear—**bidirectional,** or (3) its front only—**unidirectional** (see 5-9). Omnidirectional mics are also called **nondirectional** and unidirectional mics are also called **directional. Cardioid** is still another commonly used name for a unidirectional microphone because its pickup pattern is heart-shaped. Five unidirectional patterns are in common use: **wide-angle cardioid,** cardioid, **supercardioid, hypercardioid,** and **ultracardioid** (see 5-10).

ports

5-11 Microphone with single-entry ports. (Note: This figure and Figures 5-12 and 5-13 indicate the position of the ports on these microphones. The actual ports are concealed by the mic grille.)

ports ——— ports

5-12 Microphone with dual-entry ports

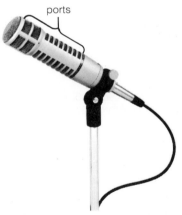

ports

5-13 Microphone with multiple-entry ports

Figures 5-9 and 5-10 show basic microphone directionalities. The precise pattern varies from mic to mic. To get a better idea of a microphone's pickup pattern, its polar response diagram should be studied (see next section).

A microphone's unidirectionality is facilitated by ports at the side and/or rear of the mic that cancel sound coming from unwanted directions. (For this reason you should not cover the ports with a hand or with tape.) In relation to ports, directional microphones are referred to as **single-entry,** or **single-D**™ — having one port; **dual-entry** — having two ports; or **multiple-entry,** also called **variable-D**™ — having several ports. A single-entry directional mic has one rear-entrance port to handle all frequencies (see 5-11). A dual-entry directional mic has two ports, one to handle high frequencies, the other to handle low frequencies (see 5-12). A multiple-entry directional mic has several ports, each tuned to a different band of frequencies (see 5-13). The ports closer to the diaphragm process the higher frequencies; the ports farther from the diaphragm process the lower frequencies.

Polar Response Diagrams

As an aid to microphone selection, manufacturers provide specification sheets ("spec" sheets, for short) that display, among other things, a microphone's **polar response pattern** — a graph of the microphone's directional sensitivity (see 5-14). The graph consists of concentric circles, usually divided

5-14 Polar response diagram

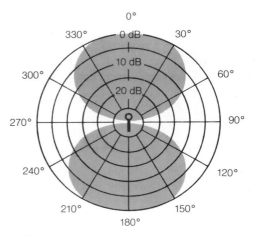

5-16 Bidirectional polar diagram

5-15 Omnidirectional polar diagram

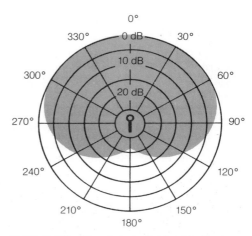

5-17 Unidirectional or cardioid polar diagram

into segments of 30 degrees, to depict directionality. Reading inward or outward, the circles represent sound levels; the interval between each circle is usually 5 dB.

The omnidirectional polar pattern shows that sound is picked up almost uniformly from all directions (see 5-15). The bidirectional polar pattern indicates maximum sensitivity to sound coming from the front and rear, from 0 and 180 degrees (see 5-16). Sen-

sitivity decreases when moving toward the sides. Sound that reaches the mic at roughly 50, 130, 230, and 310 degrees is reduced by 5 dB; sound at 60, 120, 240, and 300 degrees is reduced by 10 dB; and for sound at 90 and 270 degrees, there is minimal response.

The cardioid polar pattern illustrates response from, in effect, one direction with maximum sound rejection at 180 degrees (see 5-17). The wide-angle cardioid has a less di-

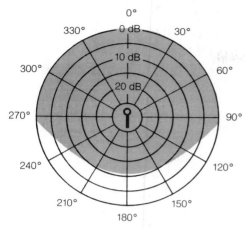

5-18 Wide-angle cardioid polar pattern

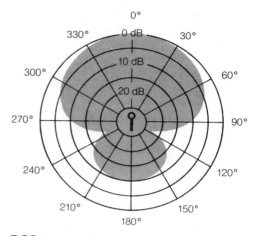

5-20 Hypercardioid polar diagram

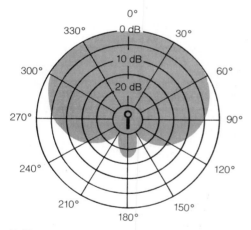

5-19 Supercardioid polar diagram

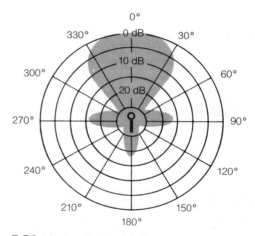

5-21 Ultracardioid polar diagram

rectional pickup pattern than does the cardioid (see 5-18). Supercardioid and hypercardioid polar patterns are acutely directional with areas of acceptance at the front and maximum rejection at the sides (see 5-19 and 5-20). There is often confusion about the differences between supercardioid and hypercardioid mics — it may appear from the diagrams that they pick up and reject sound at almost the same points. In fact, the supercar-

dioid mic has good sound rejection at the sides and fair sound rejection at the rear. The hypercardioid is more highly directional, having better side rejection but poorer rear rejection.

An even more directional response has been designed into the ultracardioid microphone (see 5-21). Its angle of acceptance is narrower than the hypercardioid's and its off-axis rejection at the sides is more acute.

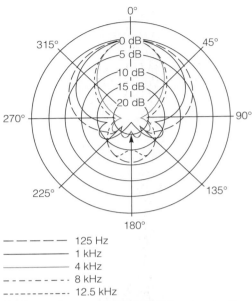

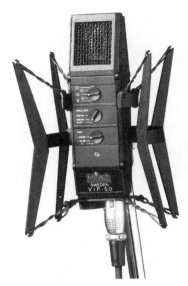

------ 125 Hz
—————— 1 kHz
—————— 4 kHz
- - - - - - - 8 kHz
- - - - - - - 12.5 kHz

5-22 Polar pattern indicating differences in directionality at certain frequencies. Notice that the lower the frequency, the less directional the pickup.

5-23 Multidirectional microphone with five pickup patterns: omnidirectional, wide-angle cardioid, cardioid, hypercardioid, and bidirectional. This microphone also has a 3-position bass roll-off (flat, 200 Hz, and 500 Hz) and a 3-position pad (0, −10 dB, and −20 dB). See "Proximity Effect" and "Overload" later in this chapter.

The polar diagrams shown here are ideals. In actual use a microphone's directional sensitivity varies with frequency — the higher the frequency, the more directional a mic becomes. Even some omnidirectional microphones positioned at an angle to the sound source tend not to pick up higher frequencies coming from the sides and rear, thus making the nondirectional pattern somewhat directional at these frequencies. Figure 5-22 shows an example of a polar pattern indicating frequency response.

Multidirectional Microphones

Microphones with a single directional response have one fixed diaphragm (or ribbon). By using two diaphragms and a switch to select or proportion between them, a microphone can be made **multidirectional** (or **polydirectional**), providing two or more pickup patterns (see 5-23).

System Microphones

Another multidirectional mic of sorts is the **system microphone,** which uses interchangeable heads or capsules, each with a particular pickup pattern, that can be mounted onto a common base (see 5-24). Because these systems are capacitors, the power supply and preamplifier are in the base, and the mic capsule simply screws into the base. Any number of directional capsules — omnidirectional and bidirectional, cardioid, supercardioid, and hypercardioid — can be interchanged on a single base.

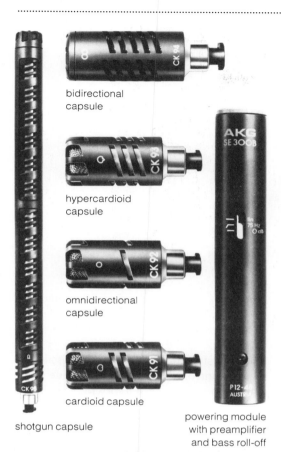

bidirectional
capsule

hypercardioid
capsule

omnidirectional
capsule

cardioid capsule

shotgun capsule

powering module
with preamplifier
and bass roll-off

5-24 Example of a system microphone

5-25 **Stereo microphone with two separate capsules.** The upper capsule in this model can be turned 360 degrees, in 10-degree increments. The pattern selectors on the microphone body can be set to R for remote control of the capsule configurations.

Stereophonic Microphones

Stereophonic (*stereo*) **microphones** are actually microphone capsules with electronically separate systems housed in a single case (see 5-25).

The stereo mic has two distinct elements. The lower element is stationary, and the upper one rotates 180 to 360 degrees, depending on the mic, to facilitate several different stereo pickup patterns. Some stereo mics can be remote controlled.

Middle-Side (M-S) Microphones

The **middle-side** (*M-S*) **microphone** consists of two mic capsules housed in a single casing. One capsule is designated as the mid-position microphone aimed at the sound source to pick up mostly direct sound; it is usually cardioid. The other capsule is designated as the side-position microphone. It is usually bidirectional with each lobe oriented 90 degrees laterally to the sides of the sound source to pick up mostly ambient sound. The

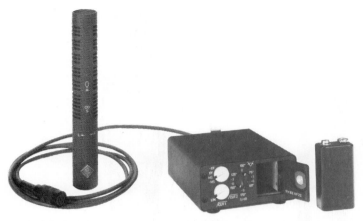

5-26 Middle-side microphone and battery-powered matrix controller

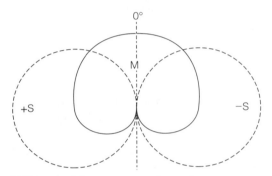

5-27 M-S pickup pattern and capsule configuration

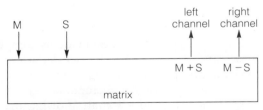

5-28 Generalized diagram of how the M-S signals are matrixed

outputs of the cardioid and bidirectional capsules are combined into a sum-and-difference matrix through a controller (see 5-26, 5-27, and 5-28).

The system in 5-26 makes it possible to remote control the ratio of mid-to-side information to adjust the stereo width of the direct-to-ambient sound. It is also possible to produce left–right (also called XY) information. In addition to its advantage in recording stereo sound, the M-S microphone's matrixed stereo signal is completely mono-compatible.

Soundfield Microphone System

Another concept in multidirectional sound pickup is the **soundfield microphone system**—four capacitor microphone capsules shaped like a tetrahedron and mounted on a single casing. The outputs of the various capsules can be combined into different matrices by using a specially designed control unit (see 5-29 to 5-31). This approach has been given the name **ambisonic** sound, which means the sound can be picked up from all

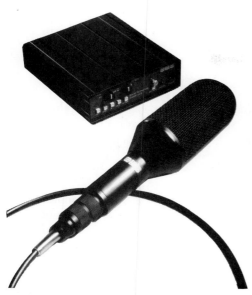

5-29 Soundfield microphone and its control unit

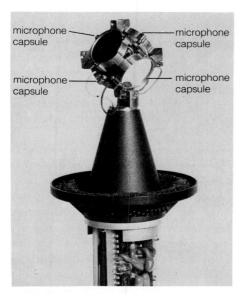

microphone capsule

microphone capsule

microphone capsule

microphone capsule

5-30 Four rotating capsules of the soundfield microphone

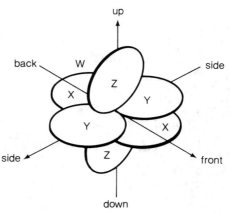

up

back

W

Z

side

X

Y

side

Y

X

Z

front

down

5-31 Pickup arrays of the soundfield microphone system
W = omnidirectional pattern — Left Front + Right Rear + Right Front + Left Rear
X = bidirectional pattern — (front-to-back)
LF + RF — (LR + RR)
Y = bidirectional pattern — (side-to-side)
LF + LR — (RF + RR)
Z = bidirectional pattern — (up-and-down)
LF + RR — (RF + LR)

three dimensions. The addition of vertical or height information to the sonic depth and breadth from a single microphone assembly makes sound quite spacious and localization very realistic.

The Sound of a Microphone

It cannot be stressed too often that final decisions about sound must be made by using your ears. But shortcuts to final decision making are possible using specification sheets. The first clue to a microphone's sound is its *response curve* — a chart showing the microphone's frequency response. The chart is part of the information included in a mic's spec sheet (see 5-32). A response curve displays the microphone's sensitivity to the

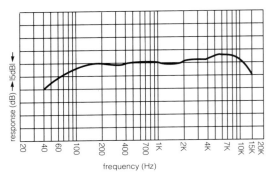

response (dB) →↓

frequency (Hz)

20 40 60 100 200 400 700 1K 2K 4K 7K 10K 15K 20K

5-32 **Response curve of the Electro-Voice 635A mic**

audible frequency range. The vertical line indicates amplitude (dB); the horizontal line, frequency. When the curve is straight or **flat**, response is without coloration; all frequencies are reproduced at the same level. But flat is not necessarily desirable. In looking at a response curve it is important to know for what purpose the microphone was developed.

In 5-32, for example, the bass begins "rolling off" at 150 Hz, there is a boost in the high frequencies between 4,000 and 10,000 Hz, and the high end rolls off beyond 10,000 Hz (see next section). Clearly, this particular microphone would be unsuitable for instruments such as the bass drum, organ, and cello because it is not sensitive to the lower frequencies from these instruments. It is also unsuitable for high-frequency sound sources such as the female singing voice, cymbals, and the piccolo because it is not sensitive to their higher frequencies or harmonics. The microphone, however, was not designed for these purposes — it was designed for the speaking voice. And for this purpose it is excellent. Reproduction of frequencies through the critical upper bass and midrange is flat, the slight boost in the upper midrange

adds presence, and the roll-offs in the bass and treble are beyond the ranges of most speaking voices.

Proximity Effect

When most bidirectional and unidirectional microphones are placed close to a sound source, bass frequencies increase in level relative to midrange and treble frequencies. This response is known as **proximity effect** or bass tip-up (see 5-33).

Proximity effect is most pronounced in pressure-gradient (ribbon) microphones — mics in which both sides of the diaphragm are exposed to incident sound. Response is generated by the pressure differential, or gradient, between the sound that reaches the front of the diaphragm relative to the sound that reaches the rear of the diaphragm. As mic-to-source distance decreases, acoustic pressure on the diaphragm increases. Because pressure is greater at lower frequencies and the path between the front and rear of the diaphragm is short, bass response rises.

Response of directional microphones is, in part, pressure-gradient and, therefore, also susceptible to proximity effect, but not to the extent of ribbon mics. Omnidirectional microphones are not subject to proximity effect.

Proximity effect can be a blessing or a curse, depending on the situation. For example, in close-miking a bass drum, cello, or thin-sounding voice, proximity effect can add power or solidity to the sound source. Where a singer with a deep bass voice works close to the mic, proximity effect can increase boominess, masking middle and high frequencies.

To neutralize unwanted proximity effect (rumble, or 60-cycle hum), most microphones susceptible to the proximity effect

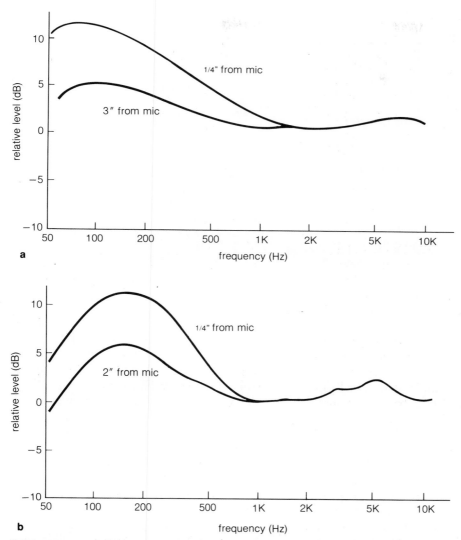

5-33 Proximity effect: (a) a typical cardioid moving-coil mic and (b) a cardioid capacitor mic

include the feature, called **bass roll-off,** of a limited in-mic equalizer (see 5-23). When turned on (switch is in one of these positions: ⌐ or /), the roll-off attenuates bass frequencies several decibels from a certain point and below, depending on the microphone, thereby canceling or reducing any proximity effect (see 5-34).

Because bass roll-off has so many advantages, it has become a common feature even on microphones that have little or no proximity effect. In some models bass roll-off has

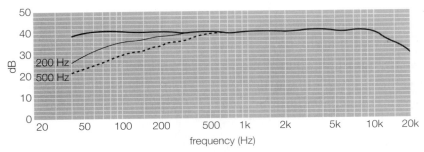

5-34 **Bass roll-off curves of the microphone in 5-23**

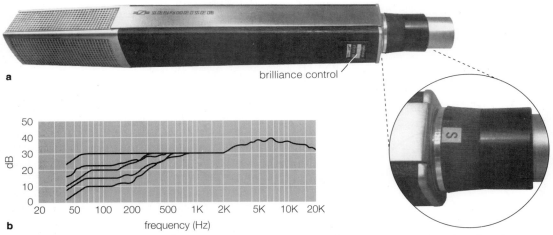

5-35 **(a) Five-position roll-off control and (b) its effect on bass response.** S = Speech, M (not shown) = Music. This particular microphone also has a brilliance control. The response curve in (b) shows the curve when the high-frequency boost is switched into the pickup.

been extended to include several different frequency settings at which attenuation can occur or different levels of attenuation at the same roll-off frequency (see 5-35, 5-36).

Another way to reduce proximity effect is to use a multiple-entry directional microphone, because these mics have some distance between the rear-entry low-frequency ports and the sound source. At close mic-to-source distances, however, most multiple entry microphones have some proximity effect.

To avoid proximity effect at close working distances down to a few inches, directional microphones have been designed that are frequency independent. Such mics use two transducers, one to process high frequencies, the other to process low frequencies. This *two-way system* design also produces a more linear response at the sides of the microphone.

Sometimes, a greater-than-normal proximity effect is desirable. For this reason, sin-

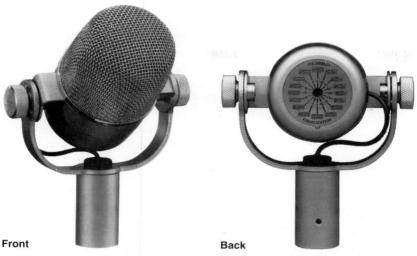

Front **Back**

5-36 Microphone with 16 different low-frequency response adjustments

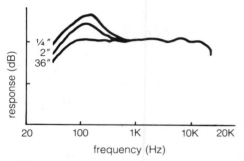

5-37 Proximity effect of the single-entry microphone shown in 5-11

gle-entry directional microphones with extended increase in the bass are often used to enhance bass frequencies further (see 5-37).

Overload

All microphones will distort if sound levels are too high—a condition we have identified as **overload**—but some mics handle it better than others. Moving-coil and capacitor microphones are not as vulnerable to distortion caused by excessive loudness as are ribbon

mics. Moving-coil mics can take high levels of loudness without internal damage. Do not use ribbon mics when there may be overload, however, for you risk damaging the element.

In the capacitor system, although loud sound pressure levels may not create distortion at the diaphragm, the output signal may be great enough to overload the electronics in the mic. To prevent this, many capacitors contain a built-in pad. Switching the pad into the mic system eliminates overload distortion of the mic's preamp, thereby reducing the output signal several decibels (see 5-23).

A pad and a bass roll-off are not the same. A bass roll-off attenuates only the low frequencies and is found on all three types of professional microphones. A pad, which is found on many capacitor mics, reduces the overall microphone level (see 5-38).

Pop Filters and Windscreens

Loudness is only one cause of microphone distortion. Others include blowing sounds caused by wind and breathing, and tran-

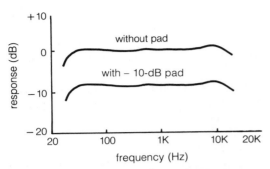

5-38 Effect of a −10 dB pad on response

sients. These sounds are often unaffected by attenuation and require either a built-in **pop** (**blast**) **filter** or an externally mounted **windscreen** to neutralize them (see 5-39). (Another way to minimize distortion from blowing sounds or popping is through microphone placement, discussed in Chapters 12, 14, and 15.)

A pop filter is most effective against blowing sounds and popping. It allows you to place a mic so that it almost touches the sound source with little fear of this type of distortion. External windscreens reduce the

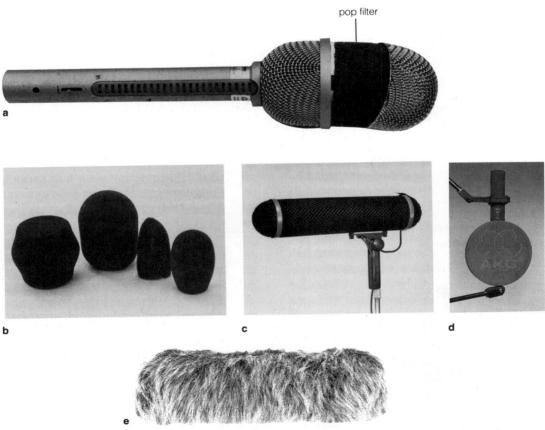

5-39 Pop filters and windscreens. (*a*) Built-in pop filter. (*b*) Various windscreens for conventional microphones. (*c*) So-called zeppelin windscreen enclosure for shotgun microphones. (*d*) Stocking (fabric) windscreen designed for use between the sound source and the microphone. This particular model has two layers of mesh material attached to a lightweight wooden ring. (*e*) Windscreen cover or windjammer to cover zeppelin-type windscreens.

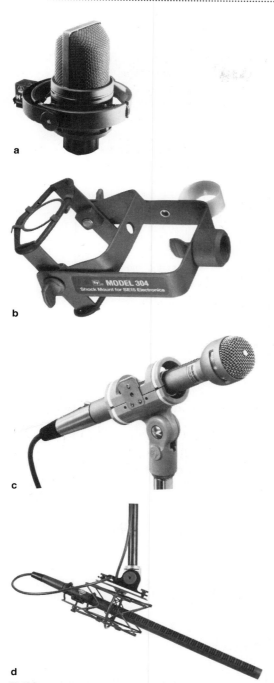

a

b

c

d

5-40 Various types of shock mounts. See also 5-23.

distortion from blowing and popping but rarely eliminate it from particularly strong sounds. Pop filters and windscreens also slightly affect response, somewhat reducing the crispness of the high frequencies. Some directional mics with pop filters are designed with a high-frequency boost to compensate for reduced treble response.

Pop filters are mainly found in moving-coil, printed-ribbon, and some capacitor microphones, particularly unidirectional models, because they are more susceptible to wind noise, due to their partial pressure-gradient response, than are omnidirectional mics. (They are also more likely to be used closer to a sound source than are other mic types.) An omnidirectional mic is about 15 dB less sensitive to wind noise and popping than a unidirectional microphone of similar size.

The elements in older-type ribbon and many capacitor microphones make it difficult to place a pop filter inside the mic head without seriously affecting response. Another reason not all microphones have pop filters is that they increase cost.

Shock Mounts

Because solid objects are excellent sound conductors, the danger always exists that unwanted vibrations will travel through the mic stand to the microphone. To reduce noises induced by vibration, you should place the mic in a **shock mount** — a device that suspends and mechanically isolates the microphone from the stand (see 5-40). Some microphones are designed with a shock absorber built in.

Humbuck Coil

Hum is an ever-present concern in microphone pickup, particularly with electric musical instruments. To minimize this problem,

there are microphones designed with a **hum-buck coil**—a circuit that reduces hum by several dBs. It is built into the microphone system and requires no special operation to activate it.

The amount of hum reduction varies with the microphone. The information is included in the spec sheet. As with all printed information about audio equipment, however, use it only as a guideline; use your ears to determine how much hum is getting through.

Environment and Handling

Poor care of audio equipment adversely affects sound quality—this cannot be stressed enough. Moisture from high humidity or breath can greatly shorten a microphone's life. When moisture is a problem, a windscreen will help protect the microphone element.

Dirt, oil from hands, and jarring also reduce microphone efficiency. Working environments should be kept clean and vacuumed. Microphones should be cleaned and serviced regularly and kept in carrying cases when not in use. Microphones left on stands between sessions should be covered with a cloth or plastic bag but not so tightly as to create a condensation problem.

Special-Purpose Microphones

A microphone's looks were seldom a problem until television was invented. Then it became clear that a microphone that is seen on camera must not only have the appropriate directional characteristics and sound response but be good-looking as well. It would not be good show business to use a microphone because of its exquisite sound if it also blocked a performer's face, or to ask a singer to hold a shotgun mic because it had the

5-41 Lavalier microphone

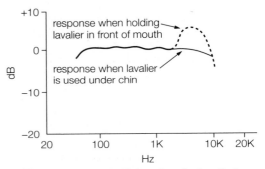

5-42 Response curve illustrating the lavalier's built-in high-frequency boost

appropriate directional pattern. Television mics must satisfy both aural and visual requirements.

Lavalier Microphones

The first TV microphone created primarily for looks was the small and unobtrusive **lavalier microphone** (see 5-41). The microphone was hung around the neck, hence the name lavalier. Today these mics are attached to a tie or the front of a dress in the sternum area, or to a lapel. Although the term *lavalier* is still used, it has come to mean any small microphone designed to be attached to clothing (or mounted on a musical instrument).

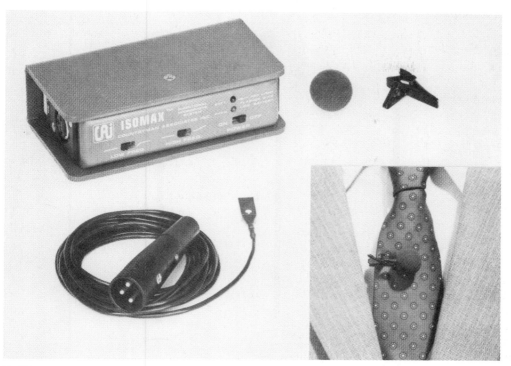

5-43 **Directional lavalier.** The system (Countryman Isomax) comes in three pickup patterns: cardioid, hypercardioid, and bidirectional. The electronics module houses the batteries and switches for low-frequency cut and high-frequency boost.

Most lavaliers designed for use in controlled acoustic situations have two things in common: (1) they are omnidirectional and (2) they have a built-in high-frequency boost. The omnidirectional pickup is necessary because, with the mic being mounted under the chin, a speaker does not talk directly into the mic but across it. A unidirectional response would not pick up much room presence and would sound too dead. In addition, as a speaker talks, high frequencies, which are directional, travel straight ahead. The chin cuts off many of the less directional high frequencies with longer wavelengths that, otherwise, would reach the mic. The built-in high-frequency boost compensates for this loss (see 5-42). If you hold a lavalier in front of your mouth, its response will be overly bright and hissy. Their sensitivity to breathing and popping sounds makes lavaliers unsuitable for use in front of the mouth; they have no pop filter, although windscreens come with many models.

Because lavaliers are unobtrusive and do not have to be hand-held, they are used outdoors. To isolate the speaker and reduce extraneous noise, directional lavaliers are also available (see 5-43).

Lavaliers are available in two types: moving-coil and electret capacitor. Generally, the capacitors have better frequency response.

Until recently lavaliers were proximity-oriented — they added presence to close speech while reducing background sound.

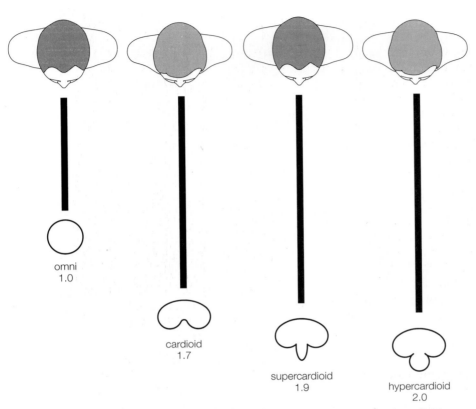

omni
1.0

cardioid
1.7

supercardioid
1.9

hypercardioid
2.0

5-44 Differences in relative working distances between omnidirectional, cardioid, supercardioid, and hypercardioid microphones

Some newer miniature lavaliers have a more transparent sound so they blend more naturally with the overall sound, which means their drawback is that they pick up more ambience (see page 105).

Shotgun Microphones

Television created the need for a good-looking on-camera microphone, but the need for an off-camera mic first became apparent in sound motion pictures. The problem was to record actors' and actresses' voices without a microphone being visible. Of course, directors had many ingenious ways to hide a mic on the set; they tried flower pots, vases, lamps, clothing, and virtually anything else that could conceal a microphone. These attempts only made more obvious the need for a microphone capable of picking up sound from a distance.

The solution was the **shotgun microphone** (see 5-40d). The basic principle of all shotgun mics is that they attenuate sound from all

directions except a narrow angle at the front. This creates the perception that they have greater reach. Actually, most microphones have extended reach. Omnidirectional, bidirectional, and cardioid mics, however, pick up a diffused sound that includes the target sound plus the **ambience**—the acoustics of an environment that interact with the sound source. Because the shotgun mic is supercardioid, hypercardioid, or ultracardioid, it can discriminate against unwanted ambience and lock in on the main sound source.

Compared to an omnidirectional microphone, mic-to-source distances can be 1.7 times greater with a cardioid, 1.9 times greater with a supercardioid, and 2.0 times greater with a hypercardioid and not affect on-mic presence (see 5-44). Some shotguns, however, are better than others, so be careful when you choose a shotgun mic, especially for use in mediocre acoustic environments. Your main consideration should be how well it discriminates sound, front-to-back, in a given situation.

Also consider that many models of shotgun mics sacrifice quality for apparently greater reach. The shotgun becomes less directional at lower frequencies because of its inability to deal well with wavelengths that are longer than the length of its tube, called the *interference tube*. Interference tubes come in various lengths from 6 inches to 3 feet and longer.

If the tube of a shotgun mic is 3 feet long, it will maintain directionality for frequencies of 300 Hz and higher—that is, wavelengths of approximately 3 feet and less. For 300 Hz and lower the mic becomes less and less directional, canceling less and less of the unwanted sound. This factor limits its use in situations where considerable low-frequency sound is present. As lower frequencies increase in level, response becomes "muddy."

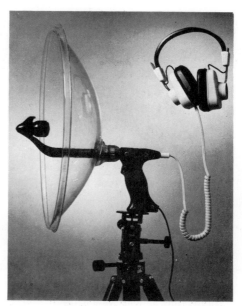

5-45 Parabolic microphone system with headphones for monitoring the sound.

Many shotgun mics do have bass roll-off, however.

Parabolic Microphones

Another microphone that is used for long-distance pickup, mainly outdoors at sporting events, film and video shoots, and in gathering naturalistic recordings of animals in the wild, is the **parabolic microphone**. It consists of either an omni- or a unidirectional microphone facing inward and attached to a parabolic reflector (see 5-45). More than canceling unwanted sound, the parabolic dish, which is concave, concentrates the sound waves from the sound source and directs them to the microphone. As with the shotgun mic, the parabolic mic is less directional at low frequencies and is most effective within the middle- and high-frequency ranges.

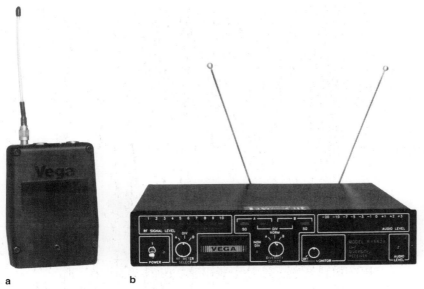

a b

5-46 Wireless microphone system: (*a*) transmitter, (*b*) diversity receiver

Wireless Microphones

The **wireless microphone** increases mobility and flexibility in plotting sound pickup, regardless of camera-to-source distance (see 5-46). The wireless microphone, also called a **radio, FM, transmitter,** or *cordless microphone,* consists of three components (four, if you count the mic): transmitter, antenna, and receiver. A standard mic is used with the system in one of three modes, depending on the transmitter. Lavalier and hand-held mics are used with a body transmitter, or a hand-held microphone and transmitter can be integrated (see 5-47). The microphone's signal is sent to the battery-powered transmitter, which relays the signal to a receiver anywhere from several feet to many yards away, depending on the system's power. Wireless microphone systems operate in the VHF and UHF bands. Each system has its own FCC-approved frequency because its transmissions may be subject to interference from other transmitting devices in a given vicinity. Wireless microphone systems can also be mounted on cameras and booms (see Chapters 12 and 15).

Headset Microphones

Sports broadcasting has led to the development of the **headset microphone**—a moving-coil mic with a built-in pop filter mounted to headphones. The microphone may be unidirectional to keep background sound to a minimum or omnidirectional for added event ambience (see 5-48).

The headphones can carry two separate signals; the program feeds through one head-

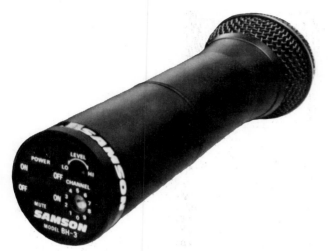

5-47 Handheld microphone mounted inside a transmitter

phone and the director's cues through the other. The headset system frees the announcer's hands and frontal working space. Another benefit is that the announcer's distance from the mic does not change once the headset is in place.

Contact Microphones

The **contact microphone** picks up vibrations pulsing through solid objects (see 5-49). Attached to a vibrating surface on an object such as an acoustic bass, acoustic guitar, or sounding board of a piano, it produces a close, direct sound almost devoid of reflections. Because contact microphones come with various impedances, make sure to select ones with low impedance — they are compatible with professional recording equipment.

Boundary Microphones

When a microphone is placed near a reflective surface, such as a wall, floor, or ceiling, time differences between the early-arriving

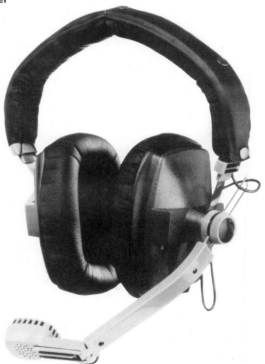

5-48 **Headset microphone system with directional mic.** Headset microphone systems can be wired or wireless.

a
b

5-49 Contact microphones, also called acoustic pickup mics. (*a*) Bidirectional contact mic used for low- to mid-frequency pickup. (*b*) Cardioid mic used for mid- to high-frequency pickup. These particular contact mics are designed for acoustic string instruments.

5-50 Comb-filter effect. Delayed reflected sound combined with direct sound can create this effect.

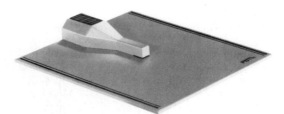

5-51 Boundary microphone

5-52 Triangular-shaped boundary microphone with mic inset into the plate. This particular configuration is designed to avoid the linear distortion common to some other types of boundary microphones.

direct waves reaching the mic and the later-arriving indirect waves create a *comb-filter effect*—additive and subtractive phase shifts that give sound an unnatural, hollow coloration (see 5-50). The **boundary microphone** solves this problem by shortening the delay of the reflected sound so that it arrives at the mic at the same time as the direct sound (see 5-51). The boundary, or pressure zone, is defined as the .04- to .08-inch area within which the microphone diaphragm must be

placed to move any comb-filter effect out of the audible frequency band.

Most boundary microphones are mounted on rectangular, square, or circular plates. These shapes, and in some cases the microphone mounting itself, tend to create linear distortion in the frequency response. To avoid this problem, some boundary microphones come in a triangular shape with the microphone inset in the plate and off center (see 5-52).

a

b

5-53 **Boundary mics with (*a*) cardioid pickup and (*b*) stereo pickup.** The stereo boundary mic is a PZM™ (Pressure Zone Microphone) called SASS™, for Stereo Ambient Sampling System. It uses two boundary-mounted mics, with a foam barrier between them, to make each mic directional.

5-54 **Microphone cable.** To keep cable intact and avoid damage to internal wires and connections, wind and secure it when not in use.

Boundary microphones have an electret transducer. Their pickup pattern is hemispheric, directional, or stereophonic (see 5-53). Their response is open and spacious.

Microphone Accessories

Microphone accessories are necessary for connection to the sound system and for mounting microphones.

Cable

Microphone cable is either **balanced** — consisting of two conductors and a shield — or **unbalanced** — consisting of one conductor with the shield serving as the second conductor. As with all professional equipment, the balanced line is preferred because it is less susceptible to electric noise.

When winding mic cable, do not wind it around your arm, and be careful not to make the angle of the wrap too severe or it can damage the internal wires. It is also a good idea to secure the cable with a clasp especially made for this purpose to prevent it from getting tangled (see 5-54).

Connectors

Most professional mics and mic cable use a three-pin plug that terminates the two conductors and shield of the balanced line. These

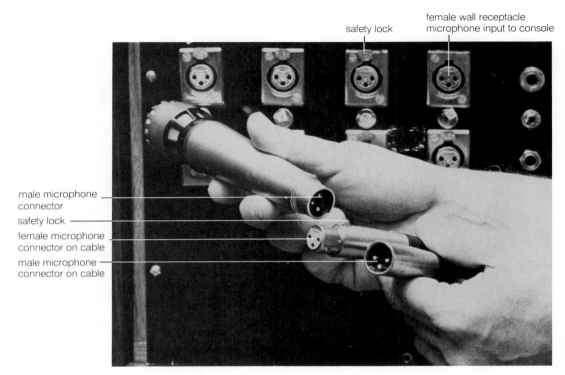

safety lock

female wall receptacle
microphone input to console

male microphone
connector

safety lock

female microphone
connector on cable

male microphone
connector on cable

5-55 Microphone connectors. The female cable connector plugs into the male microphone connector; the male cable connector plugs into the female wall receptacle, which is connected to the microphone input on the console.

plugs are generally called **XLR connectors** (X is the ground or shield, L is the lead wire, and R is the return wire). Usually, the female plug on the microphone cable connects to the mic and the three-prong male plug connects to the console (see 5-55).

Microphone Mounts

Just as there are many types of microphones to meet a variety of needs, many types of microphone mounts are available for just about every possible application. From the standpoint of miking performers, productions are either *static* — requiring little or no movement — or *dynamic* — requiring broad movement. Using these two classifications as guidelines, we can divide microphone use into two categories: *fixed* and *mobile*.

Fixed Microphone Mounts

For static productions there are a number of ways to mount a microphone: (1) on a flexible "gooseneck" stand (see 5-56); (2) on a desk stand (see 5-57); (3) on a floor stand

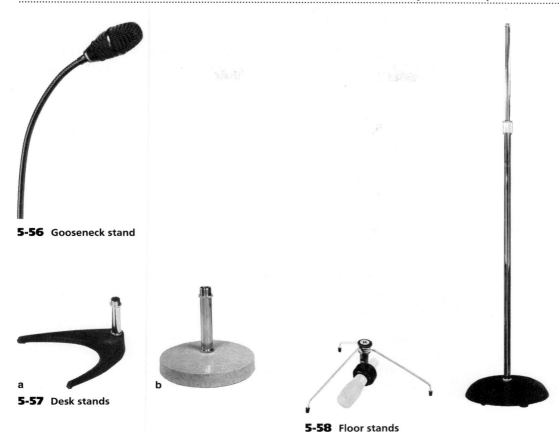

5-56 Gooseneck stand

a b
5-57 Desk stands

5-58 Floor stands

(see 5-58); (4) attached to clothing (this mic mount can also be used in dynamic productions) (see 5-59, also see 5-43); (5) suspended from overhead (see 5-60); and (6) hidden (see 5-61). Microphone mounts for special purposes are also available (see 5-62).

Mobile Microphone Mounts

In dynamic productions microphones are (1) mounted on a movable **boom** (see 5-63, 5-64, 5-65), (2) hand-held (see 5-66), or (3) wireless (see 5-46, 5-47).

5-59 Clip-on boundary mic molded to a tie bar

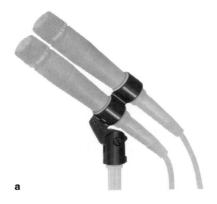

a

5-60 Hanging microphone

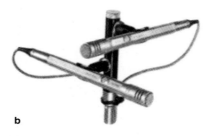

b

c

5-61 Hidden microphone

5-62 Special microphone mounts. (*a*) Redundant mono microphone mount, (*b*) stereo microphone mount, (*c*) remote panner boom mount and control module.

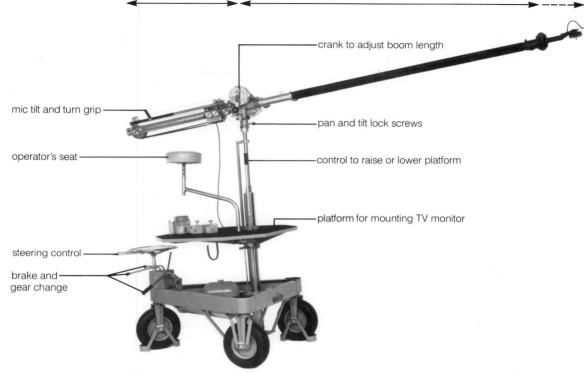

4' 10' 20'

crank to adjust boom length

mic tilt and turn grip

pan and tilt lock screws

operator's seat

control to raise or lower platform

platform for mounting TV monitor

steering control

brake and
gear change

5-63 Parambulator (mobile) boom. On most booms used in TV and film, the boom arm extends and retracts, moves up and down and side to side. Some booms rotate 180 degrees, others rotate 300 degrees. This particular boom rotates 360 degrees.

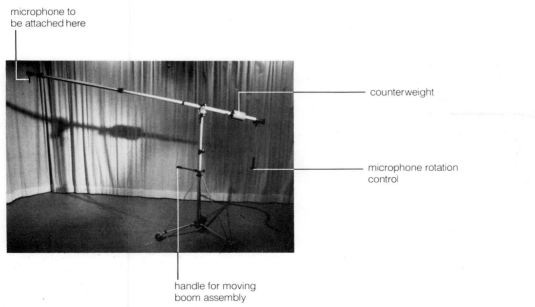

microphone to
be attached here

counterweight

microphone rotation
control

handle for moving
boom assembly

5-64 Tripod or "giraffe" mobile boom

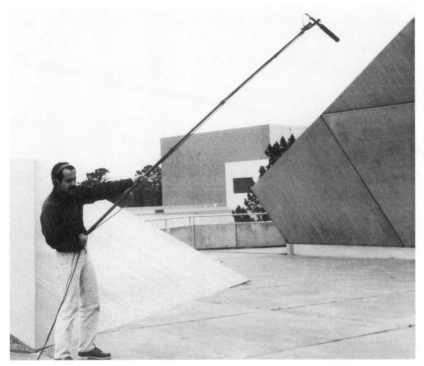

5-65 Hand-held "fishpole" boom

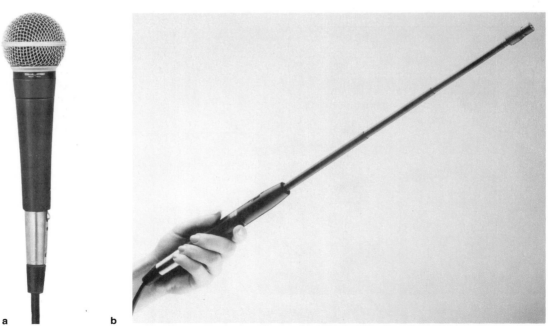

a b

5-66 Hand-held microphones. (*a*) Microphone with thin tube. It is easily hand-held and is also shock-resistant and has a pop filter, which is essential in a hand-held microphone. (*b*) Microphone mounted on a telescoping wand.

Selected Microphones: Their Characteristics and Uses

The purpose of the microphone section is to display, for convenient reference, some commonly used microphones that are in production or readily available. There is no implication that these mics are the "best" or that professional microphones not included are inferior. This section is intended as only a guide. Always *listen* to equipment before you make a decision involving sound.

Capacitor/Condenser

Microphone	Directional Pattern(s)	Characteristics	Uses
AKG The Tube	Variable	Extremely wide, flat response; vacuum tube preamplifier; six intermediate directional response steps in addition to omni, bi, and cardioid pickup patterns. Two-position roll-off; high overload and low distortion capabilities.	Wonderfully clean and mellow sounding on most instruments and voice.
AKG C—414EB ULS	Omni Bi Cardioid Hypercardioid	New version of the excellent C—414EB designed to meet the demands of digital recording. FET, large diaphragm, extremely wide, flat response; greatly improved dynamic range; increased sensitivity; −10- and −20-dB pad; two-position bass roll-off. Also available in transformerless model.	Almost anything. Very good on orchestral sections; excellent for blending; excellent for brass, woodwinds, and voice.

Microphone	Directional Pattern(s)	Characteristics	Uses
AKG C535	Cardioid	Clear and open sounding with a slightly rising high frequency response. Unique four-position control to select (1) full sensitivity, full frequency response, (2) full sensitivity, 12-dB roll-off below 100 Hz, (3) −14-dB sensitivity, full frequency response, (4) −14-dB sensitivity, 6-dB roll-off below 500 Hz. FET preamp.	Excellent live-performance vocal and instrumental mic and in-studio mic for announcing and choir pickup.
Bruel & Kjaer 4003	Omni	Excellent wide, flat response; extra protection grid for flat response in a reverberant field; low noise; warm-sounding mic.	For low noise recordings; excellent for vocals and ensembles, particularly in reverberant conditions.
Bruel & Kjaer 4004	Omni	Extraordinary wide, flat response; extended high-frequency amplitude and phase responses; superior transient reproduction.	Everything, so long as isolation is not a critical factor; excellent for close-miking.

Microphone	Directional Pattern(s)	Characteristics	Uses
Bruel & Kjaer 4011	Cardioid	A directional model of the B&K omnis above. Smooth on- and off-axis frequency and phase responses; wide dynamic range; very low distortion.	Everything, including digital recording.
Crown GLM-100 (shown) & GLM-200	Omni and Hypercardioid	Miniature in size, these sister mics are designed for clip-on and hidden mic applications. Wide, smooth response; excellent transient response; minimal off-axis coloration; takes very loud SPL (150 dB); low feedback.	Attached to drums, horns, acoustic guitars, saxophones; as a hidden mic on a film or TV set; as a lavalier.
Electro-Voice CS 15P	Cardioid	Wide, flat response over fundamental portion of audio spectrum with slow roll-off below 100 Hz and slight boost above 4 kHz. Can take very loud SPL (141 dB). Extended proximity effect at 3 inches and closer.	Good for up-close pickup, especially where extended low-frequency response is desired. From 2 feet and farther response is flat.

Microphone	Directional Pattern(s)	Characteristics	Uses
Gefell UM70s fet	Omni Bi Cardioid	Nicknamed the "Perestroika," this former Soviet bloc mic is now available in the U.S. It contains the M-7 condenser capsule similar to that used in the classic Neumann U-47. It has wide, smooth frequency response with rising midrange response in the cardioid and bidirectional patterns. It has high sensitivity and maximum SPL of 128 dB without preattenuation and of 135 with preattenuation.	Like the classic U-47 it is excellent on vocals, strings, brass, and saxophones.
Groove Tubes MD-2 (& power supply)	Cardioid	Vacuum tube condenser with extremely wide frequency response and very low noise; maximum SPL is 150 dB; -30 dB to -50 dB pad; extremely good front-to-back rejection.	Designed to offset the sterile, brittle character of digital sound, it provides warmth and sweetness to sound; can be used for anything from drums and heavy metal guitar to strings and vocals.
Milab VIP-50	Variable	Extremely wide, smooth frequency response on- and off-axis; low noise; high output level; five-position switch selects the pickup patterns anywhere between omni- and bidirectional; bass roll-off; -12-dB pad; mic or line level output switch.	Almost everything. Extremely versatile mic intended for the most critical types of music recording, including digital.

Microphone	Directional Pattern(s)	Characteristics	Uses
Milab DC 96B	Cardioid	Natural sounding capacitor with exceptionally flat response to 5,000 Hz, then slightly rising in the upper midrange. Very wide dynamic range, maximum SPL is 128 dB; low noise; high sensitivity. Gives full-bodied, bright, clean sound.	First-rate mic for horns, woodwinds, strings, acoustic bass, acoustic guitar, and choir.
Neumann KM 100	System mic	Miniature microphone system with various directional capsules designed to be inconspicuous on camera or in miking live concerts. It has low self noise and wide dynamic range.	Speech, acoustic guitar, woodwinds, brass, hi-hat cymbal, and snare drum.
Neumann TLM 50	Omni	Updated version of the vintage Neumann M50. Extremely wide frequency response and dynamic range; rising response and increasing directionality above 1000 Hz.	Virtually any situation in which an omnidirectional microphone is suitable for music recording.
Neumann TLM 170i	Omni Bi Cardioid Wide-angle cardioid Hypercardioid	Transformerless; wide, flat response; extremely low noise; handles loud SPL (140 dB); − 10 dB pad; bass roll-off; equipped with mounting to isolate mic from mechanical noise.	Everything, particularly digital recording.

Microphone	Directional Pattern(s)	Characteristics	Uses
Neumann U 87 Ai	Omni Bi Cardioid	Classic mic; extremely wide, flat, rich response; bass roll-off; −10-dB pad; sensitive to breathing and popping noises.	Everything, except close-miking instruments that emit loud SPLs.
Neumann U 89i	Omni Bi Cardioid Wide-angle cardioid Hypercardioid	Smaller version of the U 87Ai with several different features: Capsule has greater isolation against dirt, humidity, and breathing sounds; high overload level; two-position bass roll-off; −6-dB pad.	Everything; size also makes it suitable for on-camera use in TV.
Schoeps Colette System Microphone	Omni Omni (speech) Cardioid Cardioid (speech) Hypercardioid Omni and cardioid Omni, bi, and cardioid	A first-rate line of microphones; excellent wide, flat response with added high-frequency boost in capsules recommended for speech; high output level; extremely clean, smooth, natural, uncolored sound.	Excellent for most musical instruments, ensemble sections, and blending. Shotgun capsule excellent for field recording.

Microphone	Directional Pattern(s)	Characteristics	Uses
Sennheiser MKH 20 & 40 P48 (shown)	Omni (20) Cardioid (40)	Omni and cardioid sister mics developed for digital recording. Extremely low noise; wide, glasslike response. Responds to high and low levels accurately, without coloration.	Everything, particularly instruments with subtle sonic nuances.
Shure SM81	Cardioid	Wide, flat response; excellent rear rejection; three-position bass roll-off; -10-dB pad; slim, sleek, lightweight; rugged.	Good for drums (except bass drum), guitar, brass, and speech; good-looking for TV; can be used as boom in close mic-to-source situations.
Sony C-37P	Omni Cardioid	Classic mic, wide, flat, smooth response; four-position bass roll-off; -8-dB pad.	Excellent on strings, horns, guitar, banjo sections, and vocals.
Sony C-48	Omni Bi Cardioid	Wide, flat, smooth response; takes edge off overly bright, harsh sound; transparent sound quality; two-position bass roll-off; -10-dB pad; vibration-resistant.	Excellent on vocals and orchestra sections, especially strings.

Microphone	Directional Pattern(s)	Characteristics	Uses
Sony C-800G	Omni Cardioid	Condenser-quality warm, strong, smooth sound with extremely accurate transient response. High sensitivity; low noise; low distortion; wide dynamic range (more than 114 dB); built-in cooling system to dissipate tube heat. Microphone body is divided into two parts to eliminate acoustic vibration.	Virtually anything requiring critical vocal and instrumental recording.
Beyer MCE 10	Hypercardioid	Designed for situations where background noise from camera movements or production communications must be controlled. Internal mounting is designed to reduce cable and handling noise.	Lavalier.
Shure SM83	Omni	Frequency response dip at 730 Hz that minimizes the "chest resonance" phenomenon common in lavalier pick up. Side-exit cable reduces handling noise and is easier to conceal than the conventional rear-exit lavalier cable.	Television and film.
Sony ECM 66 (shown) & 77	Omni (77) Uni (66)	Two of four new models replacing the venerable ECM-50. Smooth response.	Lavalier; also good as contact mic (wrapped in foam plastic) on acoustic bass, guitar, and piano.

Microphone	Directional Pattern(s)	Characteristics	Uses
AKG CK68/ULS	Double Barrel Shotgun — Supercardioid/ Hypercardioid	Incorporates a divisible interference tube that allows a single mic to be conformed to either short-reach or long-reach sound pickup by removing or adding the front tube. The mic works in conjunction with a preamp that has a −10dB pad; switchable 70 or 150 Hz bass roll-off.	Boom or fishpole for short-reach or long-reach pickup.
Neumann KMR82i	Hypercardioid	Unusually wide, flat response for a boom mic; rising characteristic between 5 and 10 kHz; high overload level; insensitive to wind and handling noises but should have windscreen outdoors; good rejection of incident sound; bass roll-off.	Boom and fishpole; good enough to use in critical long-distance music recording, either indoors or out.
Sennheiser 416	Supercardioid	New edition of the classic boom mic, the 415; unusually wide, flat response for this type of mic; rising response between 2 and 15 kHz; excellent rejection of incident sound.	Boom and fishpole; used almost everywhere for remote recording; excellent pickup at closer mic-to-source distances; also good enough for boom pickup of music.
Sennheiser 816	Hypercardioid	New edition of the classic 815, the long-reach version of the 415; sharp boost from 5 to 15 kHz; as good a rejection of incident sound as any mic available.	Boom and fishpole; virtually universal long-reach mic used for remotes.

Microphone	Directional Pattern(s)	Characteristics	Uses
Crown SASS™	Stereo boundary mic	Near-coincident array with sharp stereo imaging beyond 3 feet; wide, flat response; mono-compatible; reduced off-axis coloration; bass roll-off. (Upgraded version provides a warmer sound.)	Music ensembles; stereo ENG and EFP; sports crowd and ambience; sampling.
Neumann USM69	Stereo-variable	Identical to the Neumann SM69, but with directional switching built into the microphone body eliminating the need for a remote control. Excellent sound quality.	Stereo recording.
Schoeps KFM 6 U Sphere	Stereo	Designed to handle the disparities in commonly used stereo miking techniques. Two mic capsules are surface-mounted on opposite sides of the almost 8-inch sphere producing a stereo image of natural and spatial integrity. Frequency response is linear for sound reaching the sphere from both the front and for the integrated resultant of sounds reaching the sphere from any angle in the reverberant field. Stereo recording is mono-compatible.	Stereo recording.

Microphone	Directional Pattern(s)	Characteristics	Uses
Shure VP88	Middle-Side	Forward-facing cardioid middle capsule and a perpendicular bidirectional side facing capsule. Three switch-selectable levels of stereo width control the degree of stereo spread and ambience pickup. A fourth switch position provides Mid and Side outputs directly. Also switchable are phantom or 6-volt internal battery power and bass roll-off. Extremely wide frequency response and completely mono-compatible.	TV and film drama, ENG, crowd in sports events, stereo sampling, overhead drums, and ambient recording applications.

Moving Coil

Microphone	Directional Pattern(s)	Characteristics	Uses
AKG 222	Cardioid	Smaller version of the AKG 202 (see 14-38); good clean response; excellent rear rejection; no proximity effect; pop filter, two-position bass roll-off; rugged.	Excellent on drums, cymbals, Leslies (cabinets with two loudspeakers, usually used to amplify organs), and other amplifiers; good on strings and wind instruments.
AKG 224E	Cardioid	One of the best moving-coil mics around; wide, clean, bright response—"capacitor" quality; virtually does not "hear" at 180 degrees off-axis; little proximity effect; two-position bass roll-off.	Everything, except vocals and bass instruments.

Microphone	Directional Pattern(s)	Characteristics	Uses
AKG D112	Cardioid	Successor to the D12. Large diaphragm mic can take extremely loud SPL (168 dB); pronounced proximity effect; presence lift at 4 kHz; pop filter; shock mount; low feedback.	First-rate bass drum mic and excellent for any low-register instrument requiring punchy, powerful bass.
Beyer M380	Bi	Mic designed for extremely large overload margin for high-SPL pickup. Low feedback. Effective against wind noise, hum, and mechanical vibration.	Bass drum, bass guitar, amps, trombone, tuba.
Beyer M600	Hypercardioid	A moving-coil mic with an extremely light diaphragm that enables it to respond to transients like a ribbon mic. Three-position bass roll-off and lockable on-off switches; pop filter; humbuck coil; capable of handling loud SPLs.	Originally designed as a vocal mic, it has considerable versatility and is capable of handling many recording situations.
Electro-Voice RE15	Supercardioid	Enhanced coloration in midrange; little proximity effect; excellent side-to-rear rejection; sensitive to popping; bass roll-off.	Excellent on snare and other drums, cymbals, piano, viola, and cello.

Microphone	Directional Pattern(s)	Characteristics	Uses
Electro-Voice RE16	Supercardioid	Flat, smooth, transparent response; bright, even high end; bass roll-off; pop filter; hum rejection; can take high sound levels; little proximity effect; rugged.	Excellent on amplifiers, Leslies, drums, cymbals, brass, guitar, and vocals; good-looking for TV.
Electro-Voice RE18	Supercardioid	Similar to the RE16 but with an integral shock mount; no bass roll-off.	See RE16.
Electro-Voice RE27N/D	Cardioid	New version of the classic, "capacitor" quality, RE-20 moving coil mic (see 5-13) with higher output and wider frequency response. Three recessed slide switches: in the "flat" position, the mic is flat from 80–2,000 Hz with a 6 dB rise from 2–16 kHz; in the first roll-off position, bass is rolled off 6 dB from 250–100 Hz; in the second roll-off position, bass is cut 12 dB from 1,000–100 Hz; the third roll-off position decreases high frequency rise by 3 dB. The mic has a shelving emphasis above 4,000 Hz; little proximity effect; humbuck circuit; shock mount; and integral pop filter.	Everything, except on camera. Even in this smaller version of the RE-20, it is not a good-looking mic.

Microphone	Directional Pattern(s)	Characteristics	Uses
Electro-Voice 635A and RE50	Omni	Similar mics with good, clean responses; lack edge and brilliance; main difference: RE50 has pop filter; both very rugged.	Very good for practically anything where isolation and bass and treble response are not critical; RE50 has been the standard mic for on-location reporting.
Electro-Voice RE55	Omni	One of the best moving-coil omnidirectional mics around; very smooth, wide, flat, clean, bright response.	Everything; particularly superb on piano and at reducing sibilance; good-looking for TV.
Sennheiser 421	Cardioid	Very clean, uncolored sound with rising response from 3 kHz; five-position bass roll-off; excellent rear rejection; high overload capacity.	Excellent on drums, cymbals, piano, brass, woodwinds, strings, and speech.
Sennheiser 441	Supercardioid	Similar to 421 with added equalization for midrange boost; internal shock mount; excellent side-to-rear rejection; very high overload capacity.	Same as 421 plus advantage of tight miking.
Shure Beta 57	Supercardioid	Supercardioid version of the workhorse SM57 with extended low bass response, a smoother, more gradual presence rise, and an extended high-frequency response.	Snare drum, conga, guitar amp, Leslie speaker (top).

Microphone	Directional Pattern(s)	Characteristics	Uses
Shure Beta 58	Supercardioid	Supercardioid version of the venerable SM58 with extraordinary gain-before-feedback for live venues. Excellent transient response; smooth presence rise; low-frequency warmth; pop filter; shock mount; humbuck coil; rugged.	Live-performance vocals.
AKG 900E	Hypercardioid	Wide response; excellent long-range pickup and side-to-rear rejection; problem with reverberant sound, which is the case with most shotguns; bass roll-off.	Boom and fishpole.
Electro-Voice RE45 N/D	Cardioid	Excellent wide, flat response, particularly close up; smooth off-axis response; has many of the advantages of a capacitor mic including low noise and wide S/N ratio.	In addition to boom and fishpole, it is small and light enough to be handheld.
Shure SM 5	Cardioid	Smooth response up to 10 kHz; excellent rear rejection; proximity effect; best when used at close-to-average mic-to-source distances.	Boom and fishpole; particularly good for speech.

Ribbon

Microphone	Directional Pattern(s)	Characteristics	Uses
Beyer M 160	Hypercardioid	Smooth, wide response; can take higher SPL than most ribbons.	Good on brass, strings, and especially piano.
Beyer M 500	Hypercardioid	Wide, smooth, rising response; very low feedback; built-in pop filter.	Good for voice reproduction and vocal presence in on-location venues.
Coles 4038	Bi	Extremely wide response for a ribbon mic—30 Hz–15 kHz. Yet, with extended high-end response, it is smooth and mellow sounding. Good transient response; hum-bucking system; sturdy for a ribbon mic.	Long respected in Europe as a first-rate ribbon mic. Its bidirectional pickup pattern does limit its use in multiple microphone music recording.
RCA 77 DX	Omni Bi Uni	Classic ribbon mic; warm, resonant response; extremely delicate and sensitive to overload; three-position bass roll-off.	Excellent on strings, tympani, saxophones, horns, sections, and speech; not recommended for tight miking.

Main Points

1. Microphones are transducers that convert acoustic energy into electric energy.

2. The three types of professionally used microphones are moving-coil, ribbon, printed-ribbon, and capacitor.

3. Microphones pick up sound from essentially three directions: all around — omnidirectional; front and rear — bidirectional; and front — unidirectional.

4. The unidirectional, or cardioid, design has even narrower pickup patterns: supercardioid, hypercardioid, and ultracardioid.

5. A microphone's unidirectionality is facilitated by ports at the side and/or rear of the mic that cancel sound coming from unwanted directions.

6. Standard accessories used for professional microphones include the following: twin conductor cables called balanced lines, XLR connectors, and various types of stands and clips for microphone mounting on a desk, floor, person, or musical instrument.

7. There are also multidirectional microphones — mics with more than one pickup pattern.

8. Other microphones with variable pickup patterns are the system, stereo, middle-side, and soundfield.

9. Bidirectional and most unidirectional microphones are susceptible to proximity effect — an increase in the level of bass frequencies relative to midrange and treble frequencies — when they are placed close to a sound source. To neutralize proximity effect, most of these microphones are equipped with bass roll-off.

10. To help protect against loudness distortion, many capacitor microphones are equipped with a pad to reduce overloading the mic's electronics.

11. Pop filters and windscreens are used to reduce distortion caused by wind and transients. An external shock mount, or a built-in shock absorber, is used to prevent unwanted vibrations from reaching the microphone element.

12. Some microphones are equipped with a humbuck coil to reduce hum from a musician's amplifier loudspeaker.

13. Microphones have been developed for special purposes: the lavalier to be unobtrusive; the shotgun and parabolic mics for long-distance pickup; the wireless mic for greater mobility and flexibility in plotting sound pickup, regardless of camera-to-source distance; the headset mic to keep background sound to a minimum by maintaining a close mic-to-source distance; and stereo, middle-side, soundfield, and boundary mics for different spatial pickups.

Consoles

I f the control room can be considered the heart of a sound studio, then the mixing console or **board** is the nerve center. At the console, signals flowing from microphones, disc players, electric and electronic musical instruments, and tape recorders are amplified, balanced, combined, monitored, and routed for broadcasting or recording. All consoles perform these basic functions.

They may also perform additional functions, such as equalization—altering a sound's frequency; stereo *panning*—positioning sound in a left-to-right spatial perspective between two loudspeakers; reverb send and return—feeding sound to and retrieving it from an external reverberation source; *limiting* and compressing—control-

ling a sound's dynamic range; in-board **patching**—rerouting assigned signal paths within the console; computer-assisted operation; and all-digital signal processing. As this list suggests, consoles vary in complexity, from the very simple to the extremely elaborate; and in dimension, from the portable, suitcase-sized to the king-sized rerecording units that require two or more operators.

Basics of Console Design

At first glance the larger, more complex consoles, with their hundreds of pushbuttons, switches, knobs, and variously colored lights,

may seem intimidating. Most consoles, however, share two design characteristics. First, they take, or input, signals from a sound source; send, or output, signals to broadcast or recording; and enable the signals to be monitored, electronically and acoustically. Second, these systems function according to a prescribed signal flow. Although complexity of design and pattern of signal flow vary between consoles, most operate in the same way. Thus, once you understand the basic system theory behind the design, learning how to operate a console is relatively straightforward. Of course, the more complex the console design, the more time it takes to learn.

Input/Output Specifications

Two indications of a console's layout and capabilities are provided by the number of input sources it can accommodate at the same time and the number of discrete signals it can output. Consoles are often specified by their number of inputs and outputs. For example, a 6 × 1 (or 6-in, 1-out) console has 6 inputs and 1 output; a 6 × 2 (or 6-in, 2-out), 6 inputs and 2 outputs; a 32 × 32 (or 32-in, 32-out), 32 inputs and 32 outputs. Clearly, a 6 × 1 console is limited to situations requiring few sound sources to input and one-channel, or **monophonic** (*mono*), output. A 6 × 2 console is still limited to a few sound sources, but it is capable of a two-channel, or **stereophonic** (*stereo*), output. By contrast, a 32 × 32 console could be used for most large-scale recording assignments requiring any number of input/output configurations. Some consoles may even have a three-number specification, such as 24 × 8 × 2, which indicates 24 inputs, 8 **submasters** (for submixes, in which selected inputs are combined before they reach the master outputs, where all inputs are combined), and 2 master outputs.

To get a handle on console theory, let's construct a simple 6 × 2 console. (Later, we'll examine the more complex multichannel production consoles.) For the sake of illustration, let's assume the console must meet the needs of a small stereo radio station using two microphones, one for the disc jockey in the control room and one for the newscaster in the studio; two CD players; and two tape recorders. The design problem is threefold: (1) to get the signals from each sound source to inputs on the console, (2) to combine these inputs at some point into an output that can be conveniently routed to broadcast, and (3) to provide a way to hear the resulting signals. In other words, we need to create an input, output, and monitor system.

Input System

The **input** section takes an incoming signal from a microphone, disc player, or tape recorder, processes it, and routes it to the output and monitor sections. A simple input module may consist of an input connector, an amplifier to boost the level of the input signal, and a volume control. A more elaborate input module might be capable of additional functions, such as phantom power for microphones that require voltage to operate, equalization, cue and reverb sends, panning, and channel selection, among others.

Microphone Inputs

Let's begin with the microphones. Recall that the microphone (mic, for short) changes sound energy into electric energy. That energy, however, is too weak to go very far. Because it needs a power boost to get anywhere, the first component on the console input system should be a **preamplifier** (*preamp*, for short) — a device that boosts the

signal from the microphone to usable proportions. Although we are constructing a stereo console, mic channels are always mono. (See 6-1* and 6-2.)

Loudness Control

Solving one problem often creates another. A preamplifier boosts the signal a fixed amount and has no way of varying the mic's level of output (loudness). The device that regulates the level coming from a preamp is called a **potentiometer**, or **pot** (rhymes with hot). A pot is also known as an *attenuator*, a *gain* or *volume control*, or, most commonly, a **fader**. On the console the fader controls the amount of signal that comes from the preamp by being either rotated or moved up or down (see 6-5 and 6-6).

On-Off Key (Switch)

An on-off key at each fader can switch signal flow on or off (or, we shall see later, switch a signal to program, audition, or off). With the devices described so far, the microphone's output signal can be amplified, controlled, and turned on or off.

Other Inputs

Compact disc (CD) players, like microphones, also require preamplification. But unlike microphones, broadcast-quality CD players are medium-level signal sources and do not require as much preamplification.

Tape recorders — open-reel and cartridge — are high-level sound sources. They still require preamps at the console, but these do not have as much gain as the preamps used for microphones and CD players. Be-

cause various pieces of equipment have different output levels, each input on the console is electrically matched to take a particular component: mic to mic preamp, CD player to CD player preamp, tape recorder to tape recorder preamp, and so on. Input channels carrying the left and right stereo signals are designed to feed them in tandem.

Output System

With the equipment described so far it is possible to feed sound from microphones, CD players, and tape recorders to their own separate inputs at the console, control their amplitude, and turn their signals on and off. But there is no way to (1) combine their signals, (2) send their signals out of the console, (3) measure the amount of signal passing through each channel that has its level regulated by a fader, and (4) hear the sound.

The **output** section routes signals from the console to a recorder or master control. It includes a network that combines signals from the input section, and volume controls for the submasters (if any) and *master(s)*, which regulate overall output level.

To solve the first two problems, each signal can be combined and then fed through a single, tandem output from the console. For these signals to be fed into one output line, there must be a mixing network, known as a **combining amplifier, summing network, active combining network (ACN)**, or **bus**, the most common term, to combine them. The level of the combined signal is regulated by a *master fader*. Regardless of how many input signals are fed to the output section, usually they are all eventually combined into one (mono), two (stereo), or more (for four-channel and six-channel Dolby Stereo) master outputs. Many consoles with two master outputs combine them into a single, tandem,

*Refer to Figure 6-1 throughout the discussion of the 6 × 2 console.

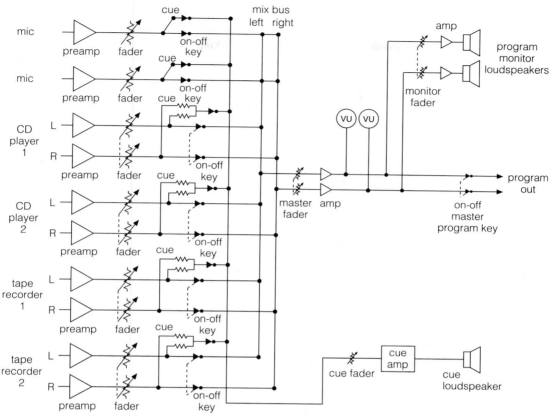

6-1 Block diagram of a 6 × 2 stereo console. Each channel (except the mic channels) carries the left and right signals in tandem. (To avoid clutter, all keys are shown as "on." See 6-2.)

6-2 Selected symbol conventions

volume control. Also, a relatively recent console design combines some of the functions of the input and output sections (see "The In-Line Console" later in this chapter).

Metering

Although signals feed in and out of the console, there is still no way to determine their level. If they are too high, they will **overload** the output channel and generate **overload distortion**; if they are too low, they will decrease the signal-to-noise ratio.* Listening to the signals does not solve the problem because they are not in the form of acoustic energy; besides, determining what is loud, soft, or just right is too subjective a judgment to be reliable. An instrument is needed that objectively measures the signal level. The instrument most commonly used in this country is the **volume unit (VU) meter** (see 6-3). When the VU meter is wired to the output of the console, it measures the level of the signal leaving the console. With our 6×2 stereo console, two VU meters are wired to the console's output, one for the left channel and one for the right channel.

The VU meter is uniquely suited to the sound medium. Unlike most devices that measure voltage, the VU meter responds to changes in electric energy similarly to the way that the human ear responds to changes in acoustic energy. It "perceives" average sound level rather than momentary peaks. Its

unit of measurement is the *volume unit*, which is closely related to the ear's subjective impression of loudness.

Two calibrated scales are on the face of the VU meter: a percentage of modulation scale and a volume unit scale. A needle, the volume indicator, moves back and forth across the scales, pointing out the levels. Some consoles use light-emitting diodes, or so-called plasma or bar graph displays, instead (see 6-20).† Both the needle and the light-emitting diodes respond to the electric energy passing through the VU meter. If the energy level is excessively high, the volume indicator will **pin** — slam against the meter's extreme right-hand side. Pinning can damage the VU meter's mechanism, rendering the volume indicator's reading unreliable.

Percentage of modulation is the percentage of an applied signal in relation to the maximum signal a sound system can handle. It is a linear scale defined such that 100 percent of modulation is equal to 0 VU on the volume unit scale. Therefore, 30 percent of modulation is equal to slightly less than -10 VU, 80 percent of modulation is equal to -2 VU, and so on.

Any sound below 20 percent of modulation is too quiet or **in the mud**, and levels above 100 percent of modulation are too loud or **in the red**. (The scale to the right of 100 percent is red.) As a guideline, the loudness should "kick" between 60 and 100 percent of modulation, although the dynamics of sound make such evenness difficult to accomplish. Usually, the best that can be done is to **ride the gain** — adjust the faders from time to time so that, on average, the level

*The difference between the sound a sound system records or reproduces and the inherent system noise generated must be as great as possible. This difference is known as **signal-to-noise** (*S/N*) **ratio** and is measured in decibels. Most professional audio systems have S/N ratios of at least 55 to 1. (Some are as wide as 96 to 1.) This means that it is possible to produce 55 dB of signal when the system generates 1 dB of noise. S/N ratios actually are expressed in negative numbers; hence, an S/N ratio of -55 to 1 is better than an S/N ratio of -50 to 1.

†In multitrack recording, several meters operate at the same time, making it difficult to keep track of them all at once. Some operators use a TV monitor that displays levels in vertical two-color bars. When a signal overmodulates, the bar shows red.

6-3 Volume unit (VU) meter

stays between 60 and 100. It is normal for the peaks and dips to move momentarily above or below these points, however.

The operator should ride the gain with a light, fluid hand and not jerk the faders up and down or make adjustments at the slightest fall or rise in loudness. Changes in level should be smooth and imperceptible because abrupt changes are disconcerting to the listener.

When the VU meter is in the red, it is a warning to be cautious of loudness distortion. All modern consoles are designed with headroom so that a signal peaking a few dB above 0 VU will not distort. **Headroom** is the amount of level equipment can take, above working level, before overload occurs. The problem, however, is that although the console may have sufficient headroom, other equipment in the sound chain, such as the tape recorder, may not be able to handle the additional level. In digital recording there is no such thing as headroom. When you have run out of room, there is nothing left.

Another instrument used for measuring loudness is the **peak program meter (ppm)** — a device with faster ballistics than a VU meter that indicates peaks in level rather than averages (see 6-4). It is used in Europe, and many think it gives a more accurate indication of a signal's actual level of loudness than does the VU meter. The argument is that although humans may not hear momentary peaks in loudness, the electronics do. Therefore, the peak program meter is better insurance against signal distortion. The ppm is calibrated in decibels, not volume units. Some newer consoles have both VU and ppm meters.

Monitor System

The **monitor** section controls what is heard from the monitor loudspeakers and headphones. It typically includes a monitor mixer, a cue mixer for **foldback** — a system that feeds the signals from the console to the headphones — volume controls, and monitor

6-4 Peak program meter. A reading of 6 on a ppm is equivalent to 100 percent of modulation on a VU meter. Each scale increment represents a level difference of 4 dB, so that the scale range is −20 dB to +4 dB, if 6 is 0 level. Dual movement ppms with two indicators are for two-channel stereo applications.

assigned VU (or ppm) meters for each, as well as other features.

In the console system we have discussed so far, the level of a signal passing through the console can be measured and read, but there is still no way we can hear the sound. Perhaps the easiest approach is to take another output line from the master fader and wire it to a loudspeaker. To control the signal level and its amplitude, another amplifier and fader are added to the console. Because the loudspeaker in a sound studio is often called the monitor, this new fader is called the monitor fader.

There is one problem to avoid. If the monitor is close to the microphone when the mic is turned on, its signal will feed through the speaker and back into the mic. This can continue round and round, causing a high-pitched squeal or lower-pitched howl known as **feedback**. To prevent this, a monitor **mute** is put on each mic's on-off switch so that when it is turned on, the signal to the loudspeaker is automatically cut. To hear the sound when the mic is on, it is necessary to use headphones.

How the 6 × 2 Stereo Console Works

It is now possible to take output signals from any sound source, feed them into separate console inputs, and amplify, balance, mix, measure, hear, and route them. For example, you may start a disc in CD player 1 feeding fader 3, and then want to announce its title, over the music, from mic 1 feeding fader 1. Turn on fader 3, start the disc, and raise the fader so the loudness level of the music peaks between 60 and 100 percent of modulation. At an appropriate point in the music, lower fader 3 so the music does not drown out your announcement. At about the same time, turn on fader 1 and raise its loudness level higher than the sound on fader 3. In the balance of these two sounds, the announcement is in the aural foreground and the music is in the background. You have to balance these sounds by listening to them in the headphones; the VU meters, remember, read the combined levels passing through the output channel. After the announcement, continue to feed the music by raising fader 3 to its original level and turning off fader 1. All sound routed out of the console is controlled at the master fader.

Now, with the music on the air, you want to prepare the next disc for broadcast. There is no way to preview the music without putting it on the air, however, because there is only one routing system and it feeds to the master fader. Another routing system, one that is off-air, is needed. Because this system performs a monitor function, it can be part of the monitor system. It is called **audition**, or **cue**, because of the purpose it serves.

One way to add this capability to a channel is to change the two-position on-off key over each fader to three positions: (1) on or **program**, routing signals to the master fader; (2) off; and (3) audition (or cue), routing

signals to the separate audition system. This audition system would require separate feeds from each fader to another output line with an amplifier, master audition fader, and loudspeaker. No VU meters are necessary because sound from the audition system is not recorded or broadcast. However, VU meters are useful to preset levels. In order not to confuse the program sound with the audition sound, the program loudspeaker and the audition (cue) loudspeaker should be placed in different locations. Some consoles have two independent audition (cue) systems: one activated from the channel on-off key and one activated from the fader when it is clicked just beyond its off position (see 6-5).

Now, to audition the disc in CD player 2 through fader 4 while the disc in CD player 2 is on the air, switch fader 4 to audition (some consoles label this "cue") and turn it up. You can hear the disc from CD player 2 through the audition speaker at the same time the on-air signal is feeding through the program speaker.

The stereo console just designed has six inputs and one master stereo output and will serve a small sound facility. Larger sound facilities may require more inputs and outputs for additional microphones, telephone talk shows, live music recording, network programs, video and film sound, broadcasts done away from the studio, and so on. Mixing consoles used in music recording and film sound sometimes require more than one operator. These consoles are impractical for most broadcasting stations.

By applying the theory of our console design to accommodate larger audio operations, the appropriate number of preamps, faders, and keys can be added to build a bigger console. However, that could result in a console that is either too large for many stations or too unwieldy for one person to operate. Another modification is needed.

6-5 Channel fader with cue control

Assume that our console has to handle two additional microphones, two cartridge tape recorders, four videotape recorders (VTRs), a network, and a remote input. Because we want to add inputs without significantly increasing the size of the console, and because it is unlikely that all sound sources will be used at once, even in the busiest studio, certain functions can be doubled up. Instead of one mic for channels 1 and 2, use two for each channel; put the two cartridge recorders on channels 6 and 7; put two VTRs on channel 8 and two VTRs on channel 9; and so on. Now two signal sources are assigned to each channel. To make sure they do not feed at the same time, connect them first to an input **selector switch**. As the term suggests, this switch selects which of the two sound sources assigned to a given channel will be routed to program or audition (see 6-6). The selector control gives consoles greater capability without adding unnecessarily to their size.

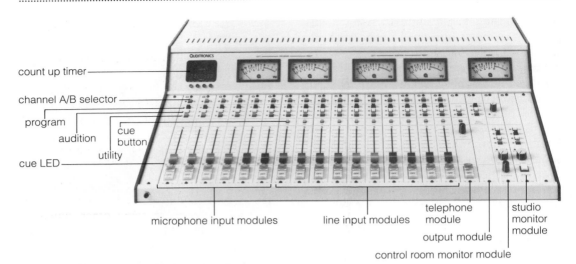

count up timer

channel A/B selector

program

audition

cue
button

utility

cue LED

microphone input modules

line input modules

telephone
module

output module

control room monitor module

studio
monitor
module

6-6 **16-input stereo console with A/B selector controls.** (Note: There is no master output fader because the master output level is set internally. This is to keep the operator from changing it.)

Production Consoles

In broadcasting, most sound sources, such as discs, as well as taped announcements and programs, are produced beforehand; they are already premixed. There is no need for the console operator to adjust stereo balances or to do much of anything except maintain levels and coordinate the routing of audio materials to broadcast; sound shaping in these materials has been done already. Therefore, the requirements for an on-air console are not as diverse as are the requirements for a console used to record and mix sound. Such production, or recording, consoles require not only much more flexibility to shape and route signals but also the multichannel capacity to send those signals to and retrieve them from a multitrack tape recorder.

Production consoles, like broadcast consoles, have an input, output, and monitor system. In first-generation multichannel pro-

duction consoles, the input and output systems are separate. Such consoles are referred to as *split-section consoles*.

For reasons that will be explained later, second-generation production consoles — **in-line consoles** — combine several input/output functions into one input/output (I/O) system. Regardless of generation, however, production consoles include functions not typically found in consoles required solely for broadcast. These functions allow greater flexibility in handling input and output signals, greater convenience in monitoring, and greater control over sound shaping.

Although production consoles have three main systems, the layout of each system may include functions belonging to another system. For example, input modules contain *cue* (foldback) *send*, a monitor function that feeds an input signal to the headphones. The master cue send, however, is usually found in the monitor section. An I/O module contains

both input and output functions but includes selected monitor functions as well. Therefore, instead of input, output, and monitor controls being grouped in discrete sections, they are scattered around most production consoles.

Input System Functions

In most modern multichannel split-section production consoles, typical functions of the input system include the following:

■ *Microphone-line input selector.* Generally, two types of signal sources are fed to input modules: low-level, such as microphones, and high-level, such as tape recorders. The microphone-line input selector controls which signal source enters the input section.

■ *Trim.* Although mic and line inputs are broadly grouped into low- and high-level sound sources, within these categories the sensitivity of various types of mics and line sources varies. Among microphones dynamic mics tend to be lower level, while capacitor mics are higher level (see Chapter 5). Among line sources (all higher level than mics) preamplified electric instruments, CD players, and tape recorders vary from low line level to high line level.

　The **trim** is a gain control that changes the input sensitivities to accommodate the nominal input levels of various input sources. Trim boosts the lower-level sources to usable proportions or prevents overload distortion in higher-level sources.

■ *Overload indicator.* The **overload indicator** is a light-emitting diode (LED) that flashes when the input signal is approaching or has reached overload and is distorting. In some consoles the LED flashes green when the input signal is peaking in the safe range and red to warn of impending distortion.

■ *Pad.* A **pad** reduces the power of a signal. On a console it is placed ahead of the mic input transformer to prevent overload distortion of the transformer and mic preamplifier. It is used when the trim, by itself, cannot prevent overload in the mic signal. The pad should not be used otherwise because it reduces signal-to-noise ratio.

■ *Phantom power.* One type of microphone, the capacitor, requires a power supply from batteries or some other source to operate (see Chapter 5). Some multichannel consoles are equipped with a **phantom power** supply that provides voltage to the capacitor mic, thus eliminating the need to bother with batteries.

■ *Equalizer and filter.* An **equalizer** is an electronic device that alters a signal's frequency response by boosting or attenuating selected portions of the audio spectrum. A **filter** alters frequency response by attenuating frequencies above, below, or at a preset point. Most production consoles have separate equalizer controls for selected frequencies grouped in the low, middle, and high ranges. Filters are usually high-pass and low-pass. (Equalizers and filters are discussed in Chapter 9.)

■ *Phase (polarity) reversal.* **Phase**, or **polarity, reversal** is a control that inverts the polarity of an input signal 180 degrees. It is used to reverse the polarity of miswired equipment, usually microphones, whose signal is out of phase with the signal from a piece of similar equipment correctly wired. Sometimes, intentional polarity reversal is helpful in canceling leakage from adjacent microphones or in creating electroacoustic special effects by mixing together out-of-phase signals from mics picking up the same sound source.

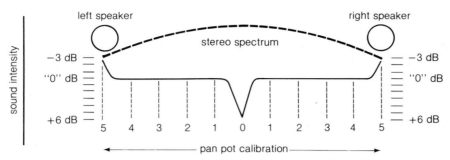

6-7 Pan pot's effect on sound placement. Values for sound intensity and calibration will vary with the console.

- *Bus assignment.* Recall that this is a group of switches on each input channel used to assign the input signal to one or more output buses. For example, if there are eight output buses, then each input channel contains eight switches to allow its signal to be assigned to any one or more of the eight output buses. To save space in consoles with many outputs, bus assignment switches may be paired. Each switch assigns a signal to more than one output bus at a time—either alternate buses 1 and 3, 2 and 4, and so on, or adjacent buses 1 and 2, 3 and 4, and so on. Usually, odd numbers are left channels and even numbers are right channels.

- *Pan pot.* A pan pot (short for *panoramic potentiometer*) is a control that can shift the proportion of sound to any point from left to right between two output buses and, hence, between the two loudspeakers necessary for reproducing a stereo image (see 6-7). If you want the signal louder in one bus than in the other, the pan pot varies the relative levels being fed to each of the two output buses. This facilitates the positioning of a sound source at a particular place in the stereo field between two loudspeakers.

- *Cue send (pre- or postfader).* Cue send is a monitor function that routes a signal from an input channel to the headphone,

or foldback, system. The cue send volume control adjusts the level of the headphone signal before it is sent to the master cue sends in the monitor module.

At the input channel the cue send can be assigned before or after the channel fader. Before, or prefader cue, means that the volume control at cue send is the only one affecting the channel's cue send level. After, or postfader cue, means that the main channel fader also affects the cue send level. In the postfader mode the volume control at cue send is still operational but the main channel fader overrides it.

Pre- and postfader controls add flexibility in providing a suitable headphone mix to performing musicians. For example, if the musicians were satisfied with their headphone mix and did not want to hear channel fader adjustments being made during recording, cue send would be switched to the prefader mode. On the other hand, if the musicians did want to hear changes in level at the channel fader, cue send would be switched to the postfader mode.

- *Reverb (or echo) send (effects send, aux send) (pre- or postfader).* The reverb send control feeds the input signal to an external reverberation system (see Chapter 9). Some consoles call this feature echo send. But echo is a misnomer because reverber-

ation, not echo, is the effect usually being achieved.

After the "dry" reverb send signal reaches the reverb system, reverb is added and it returns "wet" to the reverb return in the output system for mixing with the main output. The wet signal may also feed to a monitor return system. This return is independent of the reverb in the main output.

Reverb send may be called effects send or aux (for auxiliary) send. Regardless of what this function is called, it can be used to send an input signal to a reverb system, or to another external signal processor. Moreover, it can be used to create a submix if the console lacks a submaster section.

The send function also has pre- and postfader controls, so any signal can be sent from before or after the channel fader.

- *Solo and prefader listen (PFL).* Feeding different sounds through several channels at once can create an inconvenience if you want to hear one of them to check something. It is not necessary to shut off or turn down all the channels except the one you want to hear, however, because each input module has a **solo** control. Activating it automatically cuts off all other channels feeding the monitor system; it has no effect on the output system. More than one solo can be pushed to audition several channels at once and still cut off the unwanted channels.

 The solo function is usually prefader. On some consoles, therefore, it is called **prefader listen** *(PFL)*. In consoles with both solo and prefader listen functions, PFL is prefader and solo is postfader.

- *Mute (channel on/off).* The mute function, also called *channel on/off*, turns off the signals from the input channel. Dur-

ing mixdown when no sound is feeding through an input channel for the moment, it shuts it down or mutes it. This prevents unwanted channel noise from reaching the outputs.

- *Channel fader.* In today's consoles this is a pot, usually controlled by a sliding fader, that adjusts the level of the input signal just before it is sent to its assigned output bus(es).

- *Meters.* Most production consoles have a volume indicator (VU or peak program meter, or both) for each input channel to indicate the level (voltage) of the postfader signal.

Output System Functions

The output system may be called master, bus, bus master, group, group master, submaster, or submix. In most modern multichannel production consoles, typical functions of the output system include the following:

- *Buses.* After a signal leaves an input channel on its way to the output, it travels to its assigned bus(es). In many consoles these signals may be grouped, for premixing, at submaster buses before being finally combined at the master bus(es).

 For example, a submaster may be used to group the various input channels used for backup vocals, drums, or keyboards before they are all combined at the master bus(es). There may be any number of submaster buses, but usually there are only a few master buses because most final output signals are mixed down to mono, two- or three-channel stereo, or four-channel surround-sound.

- *Bus fader.* Bus faders control the output level from the submaster and master combining networks as their signals leave the console on the way to recording.

- *Reverb (or echo) return (effects return, aux return).* The signals sent to the reverb system or other effects devices from the reverb send(s) at the input channel(s) return to the console at the reverb returns. Here the reverb or effects signal is assigned to the master bus(es) and mixed with the main program signal. A volume control at each reverb return controls the reverb or effects levels being mixed with the output buses.

- *Return assign control.* Some production consoles have a control that allows the return signal to be assigned to the buses for **mixdown** — combining several individual channels of recorded sound into one or a few channels — or to the monitor or cue mix.

- *Pan pot.* Most production consoles have pan pots at the returns to facilitate panning the reverb or effects signals.

- *Cue return.* This returns the playback from the multitrack tape recorder to the cue (foldback) system.

- *Meters.* There is a VU or peak program meter to indicate the output level of each master fader. There also may be metering to display send and/or return levels.

Monitor System Functions

In most modern multichannel production consoles typical functions of the monitor system include the following:

- *Bus/tape switch.* In the bus mode this control lets you monitor the program buses; in the tape mode you can monitor the record or playback signal directly from the tape recorder.

- *Monitor mixer.* During recording each sound source is usually recorded on a separate track at optimal level, with little or no signal processing. The monitor mixer

makes it possible to mix these sound sources to get some idea of what they will sound like in a mixdown. The adjustments and balances of the monitor mix are heard over the monitor loudspeakers and have no effect on the signals being recorded.

- *Monitor source select.* These controls permit monitoring of signals from the bus, reverb, cue, and monitor matrixes.

- *Cue send masters.* At the cue send masters, signals from the input channels' cue sends are combined and adjusted before being sent to the cue system and foldback.

- *Reverb (echo) send masters.* Signals and levels from the input channels' reverb (echo) sends are combined and adjusted here. Most production consoles can then route reverb to the studio headphone mix or to the monitor mix without affecting the signals being recorded. This allows studio and control room personnel to get some idea of how a recording will sound with reverb. Also, if a studio is too "dry," musicians may want to hear reverb added through their headphones during recording so the sound is more realistic.

Other Features of Multichannel Consoles

Multichannel consoles usually have other features, including slate/talkback, oscillator, patch panel, and additional signal processing such as limiting-compressing and noise gating (see Chapter 9).

- *Slate/talkback.* Most consoles have a talkback to communicate with persons in the studio. Multichannel consoles also have a **slate** feature that automatically feeds to the recording tape anything said through the talkback. It is a convenient way to transcribe information about the name of the recording, the artist, the number of the cut (*take*), and so on.

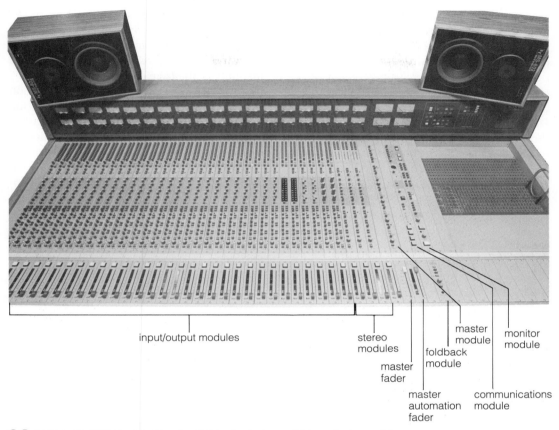

input/output modules stereo
 modules
 master
 fader
 master
 module
 foldback
 module
 master
 module
 monitor
 module

 master communications
 automation module
 fader

6-8 **In-line production console.** See 6-9 for the features of this particular model.

■ *Oscillator.* An **oscillator** is a signal genera-
tor that produces pure tones or sine waves
(sound waves with no harmonics or over-
tones) at selected frequencies. On a con-
sole it is used to (1) calibrate the console
with the tape recorder so their meters in-
dicate the same levels and (2) put reference
tone levels on tape recordings (see Chap-
ters 14 and 17).

■ *Patch panel.* The inputs and outputs of
console components are wired to jacks in
the **patch panel**—a central routing termi-
nal—to facilitate the routing of sound

through pathways not provided in the nor-
mal console design (see 6-8 and "Patch-
ing," later in this chapter).

The In-Line Console

As mentioned earlier, the multichannel con-
sole was developed to permit greater sonic
control over individual sound sources. Its ev-
olution also goes hand in hand with the de-
velopment of the multitrack audiotape re-
corder (see Chapter 7). As the multitrack

tape recorder became capable of handling more and more tracks, the multichannel console had to be expanded to process additional channels of information.

In a multichannel recording session it is customary to record a separate sound source on each track of a multitrack tape recorder. During recording a sound source is fed through the input module, then to the output module, and finally to a designated track of the tape recorder. The signal is also fed to the monitor module for in-studio reference.

Often during recording, little, if anything, is done to the sound by way of equalization, panning, reverberation, and other signal processing. Signal processing more often occurs during mixdown when all tracks are combined into one (mono), two (stereo), or more tracks. During recording, therefore, some of the console may go unused.

Moreover, if a producer wishes to get an idea of how something will sound panned or with equalization, for example, without being recorded, the appropriate module must be patched to the monitor system—a procedure that can be time-consuming and cumbersome. Unless the module is patched, the signal and the processing will be routed to the output bus and recorded because the effects can only be routed into the signal flow of the input module or bypassed.

Furthermore, if a console is, say, a 16 × 16, or 24 × 16, or 24 × 24 design, in most recording sessions it would be rare that all output mixing buses would be used at the same time even if all inputs were used simultaneously. For example, if 24 inputs were mixed—assigning 2 to each output, which would be unlikely because usually an output bus is used to mix more than 2 inputs—it would require just 12 output mixing buses. This leaves 4 unused mixing buses in a 16-output console and 12 unused mixing buses in a 24-output console. Should the 24 inputs be fed directly to 24 separate tracks of the tape recorder, then there is little need for the output mixing buses during recording. Thus, during recording, the buses are just taking up space.

To make the multichannel production console more efficient, various delegation functions of the input and output sections have been combined into a single module called the **input/output** (*I/O*) **module.** Input and output sections have been brought vertically "in a line," hence the term **in-line console.** Each I/O module contains one input and one output channel. The I/O design makes it possible to route a signal from, say, the input of I/O channel 4 either directly to track 4 of the tape recorder or to the mixing buses. The signal is then routed back into channel 4's input section, passing through the module's equalizer, fader, and pan pot for delegation (if desired) to the mixing buses that are used to feed the signal to the monitor system during recording and to the master(s) during mixdown.

This routing allows EQ (equalization) and panning to be delegated to the monitor system for auditioning without affecting the signal being sent to the tape recorder for recording. At the mix the output from the channel bus can be delegated to feed a signal from the tape recorder to the mono, stereo, or more master mixing output buses. The in-line console, therefore, requires only a few master output buses rather than 16 or 24.

Although some features of the in-line console differ from model to model, the basic design includes four main modules—input/output, master, monitor, and communications—which perform the following functions (see 6-8 and 6-9).

■ *Input/output module. (1) Input Section:* As in the earlier multichannel console designs, this section is where the microphone

or line level source is selected, amplified, and sent on its way to the output. In the I/O module the signal can be either assigned to a channel output and bus or sent directly to the tape recorder, bypassing them. *(2) Output Section:* Here the signal is actually routed to the tape recorder and also routed back to the I/O channel input where it feeds through the module's equalizer, fader, pan pot, and monitor controls. It is then routed to the mixing buses. The mixing buses may be assigned monitor or master functions.

■ *Master module.* The **master module** contains the master controls for the mixing bus outputs, reverb send and reverb return, master fader, and other functions.

■ *Monitor module.* Some monitor functions are performed by the I/O module — such as setting monitor level and panning for each channel. The monitor module selects inputs to the studio and control room monitors and controls their overall levels and also permits monitoring line output or tape input.

■ *Communications module.* The communications module houses such systems as talkback and slating.

Patching

Regardless of how elaborate the console, or the studio, *signal flow* — the paths a signal takes from its source to its destination — is restricted by how active components are wired. When components are wired directly to one another (for example, a microphone to a tape recorder, or the output of a microphone, CD player, and tape recorder to the input of another tape recorder), they are considered **hard wired**. The signal can travel only one route (see 6-10, p. 141). In an on-air

console or a small production control room with little equipment, hard wiring usually presents no problem.

Large production consoles, however, require flexibility in routing signals to various components within the console. Also, most sound facilities contain not only more pieces of the basic equipment with more complex designs, but also additional components such as equalizers, limiter–compressors, noise reducers, and special setups for talk programs and broadcasts done away from the studio. In these circumstances the multiple routes a signal may have to take make hard wiring impractical.

In large production consoles and most sound studios, therefore, active components are not wired directly to one another but to the console patch bay or studio patch panel, or both. Each hole in the bay or panel, called a **jack**, becomes the connecting point to the input or output of each electronic component in the sound studio (see 6-11). Patching is the interconnecting of these inputs and outputs using a **patch cord** (see 6-12; also see 6-17). In this context a patch panel is more like an old-fashioned telephone switchboard.

But such flexibility is not without its problems. In a well-equipped and active facility the patch panel could become a confusing jungle of patch cords. In all studios, regardless of size and activity, a signal travels some paths more often than others. For example, it is more likely that a signal in a console will travel from mic (or line) input to pan pot to equalizer to delegation control to fader than directly from mic (or line) input to output bus. It is also more likely that a signal will travel from mic to console to tape recorder than directly from one tape recorder to another.

As a way of both reducing the clutter of patch cords at the patch panel and simplifying production, terminals wired to certain

(text continues on p. 142)

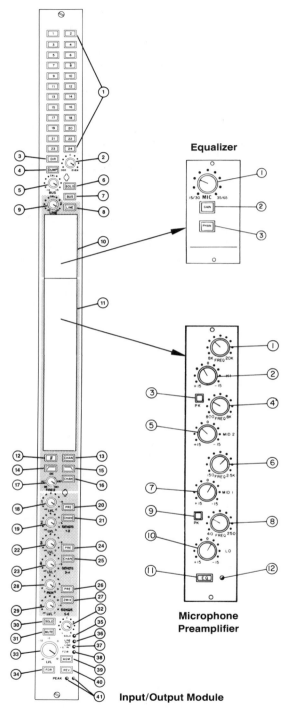

Equalizer

Microphone Preamplifier

Input/Output Module

6-9 Basic modules and functions of the in-line console in 6-8

Input/Output Module Controls

(1) Assignment Switches 1 to 24: These switches are used to select the track(s) to which the I/O Channel signal is to be directed. These signals may be subject to left/right panning (see PAN Control).

(2) PAN control (bus pan): Shifts the apparent physical position of the input source. This control is used only when both odd and even tracks are selected by the assignment switches.

(3) DIR switch (direct): Directly connects the Channel path signal to the Channel line output, bypassing the Channel ACN (Active Combining Network) and thus reducing noise. DIR is used when the I/O signal is to be directed to its own channel on the multitrack recorder.

(4) DUMP switch: Assigns the post-PAN, post-Fader Monitor path signal to the selected channel ACN buses. This function can be used to "dump" Multitrack signals over to other tracks on the recorder.

(5) BUS control (bus trim): Sets the channel output level. Has a detent position (CAL) that sets unity gain. (Unity gain occurs when the output level equals the input level.)

(6) SOLO switch (channel solo): Places the Channel signal on the Solo Bus and mutes signals from all other I/Os so that the only I/O heard is that with SOLO selected.

(7) BUS switch (monitor to bus): Directs the Monitor post-Fader signal to the Channel Fader, enabling the use of the Channel buses as additional Sends in the mix-down mode.

(8) LINE switch (microphone/line): Selects either microphone or line as the Channel input.

(9) LINE control (line level): Sets the line input gain. Has a detent position (CAL) which sets unity gain.

(10) Microphone Preamplifier:
 (1) MIC control (preamplifier gain): Is used to compensate for different microphone output levels. The control has two ranges, 15 dB to 35 dB and 30 dB to 65 dB (see GAIN switch).
 (2) GAIN switch: Sets the range for the MIC control.
 (3) PHAN switch: Supplies + 48 Volt phantom power for microphones requiring external power.

(11) Equalizer:
 (1) FREQ control: Selects the high frequency to be boosted or cut.
 (2) Level control: Sets the degree of boost or cut between the limits − 15 dB to + 15 dB.
 (3) PK switch (peak): Selects the response for the high frequency section. With the switch

in, the response curve is peaking. With the switch out, the response curve is shelving.

(4–10) FREQ level and PEAK controls for midrange and low-frequency sections.

(11) EQ switch: Switches the Equalizer on.

(12) Equalizer LED: Illuminates to show when the Equalizer is effective.

(12) ø switch (phase): Reverses the phase of the signal to the Equalizer. This may be either Channel or Monitor signal.

(13) CHAN switch (equalizer monitor/channel): Places the Equalizer in either the Monitor path or the Channel path.

(14) ⌐ switch (high pass filter): Switches the High Pass Filter in or out.

(15) ⌐ switch (low pass filter): Switches the Low Pass Filter in or out.

(16) CHAN switch (filter monitor/channel): Places the High Pass and Low Pass Filters in either the Monitor path or the Channel path.

(17) FREQ control (frequency): Sets the cutoff frequency for the High Pass Filter.

(18–19) LVL controls 1 and 2: Sets the level of the Sends 1 and 2 signals.

(20, 24) PRE switch (pre-fader): Selects between pre-Fader or post-Fader signals for Sends 1 and 2 and 3 and 4.

(21, 25) CHAN switch (channel/monitor): Selects between Channel and Monitor signals for Sends 1 and 2 and 3 and 4.

(22–23) LVL controls 3 and 4: Sets the level of the Sends 3 and 4 signals.

(26) PRE switch (prefader): Selects between prefader and postfader signals for Sends 5 and 6.

(27) 2 MIX switch: Routes the 2-Mix signal (post-PAN and postfader) to Sends 5 and 6.

(28) PAN control: Sets the left/right balance for Sends 5 and 6. Has a detent position (C) which provides evenly balanced left and right Sends.

(29) LVL control: Sets the levels for Sends 5 and 6.

(30) SOLO switch (monitor solo): Same as Channel SOLO (6), but for Monitor path signals.

(31) MUTE switch: Mutes the 2-Mix output.

(32) Pan control (monitor pan): Pans between 2-Mix left and right outputs.

(33) LVL (rotary fader): Is usually used to control the Channel level, but can be switched to control the Monitor level (see FDR switch.)

(34) FDR switch (fader interchange switch): Reverses the functions of the rotary (Channel) Fader and the linear (Monitor) Fader so that the rotary Fader controls the Monitor path and the linear Fader controls the Channel path.

(35) SOLO LED (yellow): Becomes illuminated to indicate that the I/O is in either Channel Solo or Monitor Solo mode.

(36) LINE OUT LED (red): Is illuminated to indicate that the Monitor path is being fed from line output.

(37) LINE IN LED (green): Is illuminated to indicate that the Monitor path is being fed from line input.

(38) VCA LED (red): Illuminates when the FDR switch (34) is in, showing that the Fader functions are interchanged.

(39) AGM switch (Audio Grouping Master): Selects Audio Grouping Master Mode. If a requirement arises to use a single control for adjusting the signals from several tracks during mixdown, the Audio Grouping Master (AGM) mode can be implemented. In this mode, any number of I/O modules (group I/Os) can be assigned for control by a master I/O.

(40) REV switch (reverse): Switches the Monitor path feed between line input and line output.

(41) PEAK LEDs (overload): Indicate proper levels of Microphone Pre-amplifier output. The green LED indicates that a −20 dB signal is present. If the red LED becomes illuminated, it indicates that the signal is overloading to the point of becoming clipped.

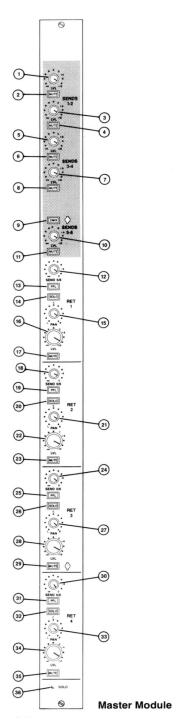

Master Module

Master Module Controls

(1, 3, 5, 7, 10) LVL control: Sets Sends 1, 2, 3, 4, 5, and 6 output levels.

(2, 4, 6, 8, 11) MUTE switch: Mutes Sends 1, 2, 3, 4, 5, and 6 output when switch is in.

(9) 2-MIX switch: Directs 2-Mix signal to Sends 5 and 6. Is effective when switch is in.

(12, 18, 24, 30) SEND 5/6 control: Sets level of Returns 1, 2, 3, and 4 outputs to Sends 5/6.

(13, 19, 25, 31) PFL switch: Selects Returns 1, 2, 3, and 4 for PFL when switch is in.

(14, 20, 26, 32) SOLO switch: Selects Returns 1, 2, 3, and 4 for Solo listening when switch is in.

(15, 21, 27, 33) PAN control: Sets balance between left and right signals from Returns 1, 2, 3, and 4. Has detent (C) at point where left and right signals are balanced.

(16, 22, 28, 34) LVL control: Sets Returns 1, 2, 3, and 4 signal input levels.

(17, 23, 29, 35) MUTE switch: Mutes Returns 1, 2, 3, and 4 signals when switch is in.

(36) SOLO LED: Illuminates when solo is selected for any return.

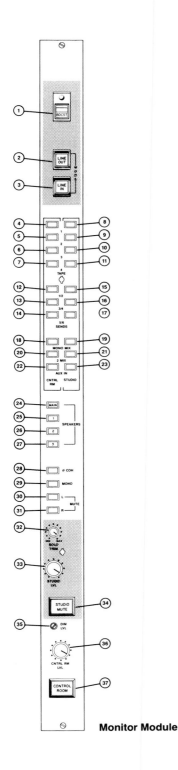

Monitor Module

Monitor Module Controls

(1) BDCST switch: Sets all the I/Os into broadcast mode, allowing the input signals to be fed to the Channel and Monitor paths simultaneously.

(2) LINE OUT switch: Sets all I/Os for line output monitoring.

(3) LINE IN switch: Sets all I/Os for line input monitoring.

(4, 5, 6, 7) TAPE 1, 2, 3, and 4 switches (left): Selects Tapes 1, 2, 3, and 4 for input to the control room monitor.

(8, 9, 10, 11) TAPE 1, 2, 3, and 4 switches (right): Selects Tapes 1, 2, 3, and 4 for input to the studio monitor.

(12, 13, 14) SENDS 1/2, 3/4, 5/6 switches (left): Selects Sends 1 and 2, 3 and 4, 5 and 6 for input to the control room monitor.

(15, 16, 17) SENDS 1/2, 3/4, 5/6 switches (right): Selects Sends 1 and 2, 3 and 4, 5 and 6 for input to the studio monitor when the switch is in.

(18) MONO MIX switch (left): Selects Mono mix input for the control room monitor.

(19) MONO MIX switch (right): Selects Mono mix input for the studio monitor.

(20) 2-MIX switch (left): Selects 2-Mix signal for input to the control room monitor.

(21) 2-MIX switch (right): Selects 2-Mix signal for input to the studio monitor.

(22) AUX IN switch (left): Selects the Auxiliary input for the control room monitor.

(23) AUX IN switch (right): Selects the Auxiliary input for the studio monitor.

(24) MAIN SPEAKER switch: Selects main left and right speakers in the control room.

Alternate speaker switches 25, 26, and 27 perform the same function as the main speaker switch, but select alternate speakers 1, 2 or 3.

(28) ø COH switch (phase coherence): Inverts the left channel signal, then adds the left and right signals to provide a single out-of-phase component to the control room right channel speaker.

(29) MONO switch: Directs a summed Mono signal to the control room monitor.

(30, 31) L MUTE and R MUTE switches: Mutes the left and right channel signals to the control room monitor.

(32) SOLO TRIM control: Sets the level of the Solo signals fed to the control room monitor.

(33) STUDIO LVL control: Sets the level of the signals supplied to the studio monitors.

(34) STUDIO MUTE switch/indicator: Mutes the signals to the studio monitor.

(35) DIM LVL control (screwdriver adjust): presets the audio dim level for the control room speakers.

(36) CNTRL RM LVL control: Sets the level of the signals fed to the control room.

(37) CONTROL ROOM switch/indicator: Reduces the control room audio to the dimmed level.

Communication Module

Communication Module Controls

(1) FREQ control: Sets the test oscillator base frequency, the frequency range being 20 to 200 Hz.
The OSC ×1, ×10 and ×100 switches (2), (3) and (4) are frequency multipliers for the test oscillator.

(5) OSC LED (red): Illuminates to show that the test oscillator is selected.

(6) WHT switch: Turns on the white noise generator when the switch is in.

(7) PINK switch: Turns on the pink noise generator.

(8) NOISE LED (red): Illuminates to show when either noise generator has been selected.

(9) OFF switch: Switches off the test oscillator and/or noise generators.

(10) LVL control: Sets test oscillator and noise generator output levels.

(11) Talkback Microphone: Used in conversations between the console operator and the studio.

(12) MIC LVL control: Sets Talkback microphone pre-amplifier gain.

(13) TKS switch (tracks): Assigns Slate tone, oscillator or noise signals to the recorder tracks.

(14) MIX switch: Assigns Slate tone, oscillator or noise signals to the 2-Mix Bus.

(15) PFL LVL: Sets the level of the signal to the PFL speaker.

(16) PFL switch/indicator: Mutes the PFL signal and redirects it to the Solo Bus.

(17, 18, 19) COMM TO SEND 1-2, 3-4, 5-6 switcher: Switches the communication microphone signal to the Send 1 and Send 2, Send 3 and Send 4, Send 5 and Send 6 buses.

(20) COND preset (screwdriver adjust): Presets the Talkback level to the music conductor.

(21) TALK BACK preset (screwdriver adjust): Presets the Talkback output level.

(22) SLATE preset (screwdriver adjust): Presets the Slate tone output level.

(23) COM preset (screwdriver adjust): Presets the COM output level.

(24) ⊲ switch/indicator: Directs the Talkback audio to the conductor output.

(25) ⊲ switch/indicator: Directs the Talkback audio to the studio monitor.

(26) ଠୄଠ switch/indicator: Directs the Talkback audio to the Slate system.

(27) ⌒⌒ switch/indicator: Directs the Talkback audio to the cue system.

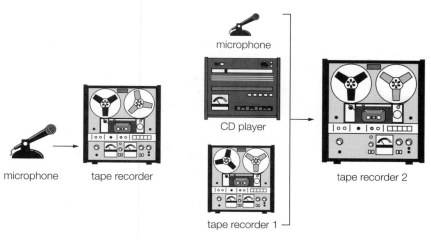

microphone

CD player

microphone tape recorder

tape recorder 1

tape recorder 2

a

b

6-10 **Hard wiring can limit signal flow.** In *a*, signal flow can go only one way, so hard wiring makes no difference. In *b*, however, the microphone could feed to tape recorder 1, tape recorder 2 could feed to tape recorder 1, and so on. If these sound sources are hard wired as shown, such flexibility is not possible.

terminal

jack

6-11 Patch panel with a row of jacks

output

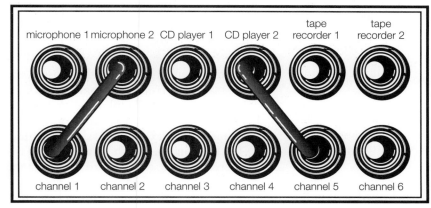

microphone 1 microphone 2 CD player 1 CD player 2 tape recorder 1 tape recorder 2

channel 1 channel 2 channel 3 channel 4 channel 5 channel 6

input

6-12 **Use of patch panel.** Any sound source wired to the patch panel can be connected to any other one with a patch cord plugged into the appropriate jacks.

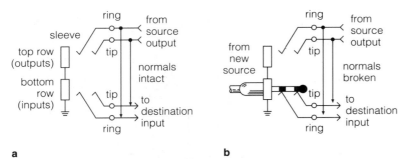

6-13 **Normaling.** (a) With no patch cords inserted, output of source equipment is automatically normaled to the input of another piece of equipment (tip = high, ring = low, sleeve = shield [ground; ⏚ symbol for ground]). (b) When a patch cord is inserted in the bottom-row (input) jack, the normals are interrupted, breaking the original signal routing. The new source signal will now feed the destination.

equipment can also be wired or *normaled* to one another. A *normal* connection is one that permits a signal to flow freely between components without any patching. To route a signal through components that have terminals not normaled or wired to one another, patch cords are put in the appropriate jacks to *break normal* — that is, interrupt the normal signal flow — thus rerouting the signal (see 6-13).

The ability to reroute a signal is also advantageous when equipment fails. Suppose a CD player is normaled to input A on the console and the module becomes defective. If all inputs and outputs are connected to the patch panel, the defective module can be bypassed by patching the CD player's output to another input module, say, input B.

Some other features of patch panels include:

- *Input/output.* Most patch panels are wired so that a row of input jacks is directly below a row of output jacks (see 6-16).

- *Full-normal and half-normal.* Input jacks are wired so that a patch cord always interrupts the normal connection. These

connections are called *full-normal.* Output jacks may be wired as either full-normal or *half-normal* — connections that continue rather than interrupt signal flow. Half-normal connections are useful when a signal must be fed to its normal destination and, via patching, elsewhere as well. Half-normal outputs also permit patching to another input in addition to the normaled one (see 6-14).

- *Multiple.* Most patch panels have special jacks called **multiples** (or "mults") that are wired to one another instead of to any electronic component. Multiples provide the flexibility to feed the same signal to several different sources at once (see 6-15).

- *Tie Line.* When the only patch bay in a control room is located in the console, the other control room equipment, such as tape recorders, CD players, and signal processors have to be wired to it in order to maintain flexibility in signal routing. **Tie lines** in the patch bay facilitate the interconnecting of outboard devices in the control room. When a control room has two patch panels, one in the console and one for the other control room equipment,

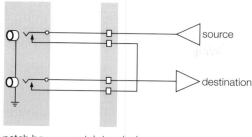

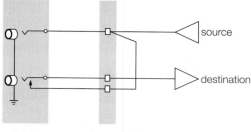

patch bay patch terminals

b

6-14 (*a*) **Full-normal and** (*b*) **half-normal patch configurations**

6-15 Multiples in a patch panel. The output of one sound source is patched into a multiple. Three patch cords feed that sound from the multiple to three separate inputs.

tie lines can interconnect each patch panel. The tie line is also used to interconnect separate studios, control rooms, or any devices in different locations. 6-16 displays and details the patch bay of the console shown in 6-8.

General Guidelines for Patching

1. Do not patch microphone-level signals into line-level jacks and vice versa. The signal will be barely audible in the first instance and will distort in the latter one.

2. Do not patch input to input or output to output.

3. Unless jacks are half-normaled, do not patch the output of a component back into its input, or feedback will occur.

4. When patching microphones make sure the fader controls are turned down. Otherwise, the loud popping sound that occurs when patch cords are inserted into jacks with the faders turned up could damage the microphone or loudspeaker element.

Plugs

While we are on the subject of patching, something more should be said about the plugs on the end of the patch cords. The plugs most commonly used in professional facilities are the *¼-inch phone plug* and the *bantam* (or mini) *phone plug* (see 6-17). Both plugs route sound from one terminal to another. The bantam plug is a smaller version of the ¼-inch phone plug and was designed

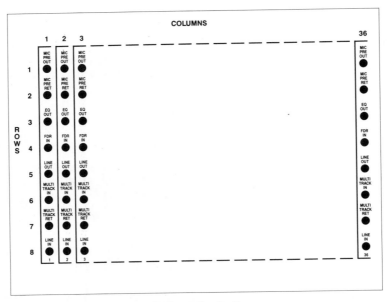

Upper Patch Bay Section

Row 1 MIC PRE OUT: Microphone Pre-amplifier output patch. Normalized to the MIC PRE RET.

Row 2 MIC PRE RET: Microphone Pre-amplifier return. This is the input point for the Channel path on the I/O module. Normalized from MIC PRE OUT.

Row 3 EQ OUT: Post-Equalizer output patch. Normalized to FDR IN.

Row 4 FDR IN: Fader input patch. Normalized from EQ OUT (the Equalizer is pre-Fader).

Row 5 LINE OUT: Provides access to the Channel line output. Normalized to MULTITRACK IN.

Row 6 MULTITRACK IN: Allows connection to be made to the Multitrack input. Normalized from LINE OUT.

Row 7 MULTITRACK RET: Patch point from the Multitrack output. It is normalized to LINE IN.

Row 8 LINE IN: Provides access to the line input. Is normalized from MULTITRACK RET.

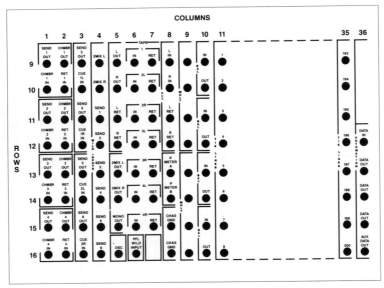

Lower Patch Bay Section

6-16 Patch bay of the console in 6-8 and its jack assignments

Lower Patch Bay Section

Columns 1 and 2

Columns 1 and 2 are arranged in four sets of four jacks each, these being used to provide outputs from Sends 1, 2, 3, and 4 to echo chambers or other effects units.

Each set of four jacks is assigned as follows:

SEND OUT: Provides access to signals from the Send Bus. Is normalized to CHMBR IN.
CHMBR IN: Is for connection to the effects unit input. Is normalized from SEND OUT.
CHMBR OUT: Is for connection from the effects unit output.
RET IN: Is the input jack for the echo return.

Column 3

The patch jacks in Column 3 are used to make interconnections from Send Buses 3, 4, 5, and 6 to cue inputs 1 and 2. The SEND OUT jacks provide access to the bus signals, and the CUE IN jacks are the cue signal input points. The patches are normalized as detailed below:

Row 1 SEND 3 OUT is normalized to Row 2 CUE 1L

Row 3 SEND 4 OUT is normalized to Row 4 CUE 1R

Row 5 SEND 5 OUT is normalized to Row 6 CUE 2L

Row 7 SEND 6 OUT is normalized to Row 8 CUE 2R

Column 4

The eight jacks in Column 4 are used to accommodate external "wild" inputs to 2-Mix or Sends. Each individual jack is labeled with its specific destination.

Column 5

Rows 1 through 7 of Column 5 are assigned to 2-Mix and stereo functions, and Row 8 is assigned to the Test Oscillator. The patch function for each row is listed below:

The assignments for Rows 1 through 4 (2MIX PATCH) are:

Row 1 L OUT: Provides a pre-Fader, left stereo channel patch point. Normalized to L RET.
Row 2 R OUT: Same as L OUT, but for right stereo channel. Normalized to R RET.
Row 3 L RET: Reinsertion point for left stereo signal. Normalized from L OUT.
Row 4 R RET: Same as L RET, but for right stereo signal. Normalized from R OUT.

Rows 5, 6, and 7 are assigned as follows:

Row 5 2MIX L OUT: Post-Fader patch point for left stereo channel. Picks up the 2-Mix left channel signal at a point immediately preceding the tape recorder input. Normalized to TAPE 2L IN, TAPE 3L IN and TAPE 4L IN.
Row 6 2MIX R OUT: Same as 2MIX L OUT, but for right stereo channel. Normalized to TAPE 2R IN, TAPE 3R IN and TAPE 4R IN.
Row 7 MONO OUT: Post-Fader patch point for Mono signal. Picks up the signal at point immediately preceding the tape recorder input. Normalized to TAPE 1 IN.
Row 8 (OSC) is assigned to the Test Oscillator, and provides an output from the Oscillator for external use.

Column 6

Rows 1 through 7 of Column 6 are assigned to tape recorder input patches, and Row 8 is assigned to PFL wild input.

The TAPE IN jacks provide patches for tape recorder inputs, and are normalized in the following manner:

1 IN is normalized from MONO OUT.

2L IN, 3L IN, and 4L IN are normalized from 2MIX L OUT.

2R IN, 3R IN, and 4R IN are normalized from 2MIX R OUT.

ROW 8 (PFL WILD INPUT) provides a direct input to the PFL amplifier.

Column 7

Rows 1 through 7 of Column 7 provide return patches for the tape recorder output. The TAPE RET jack functions are listed below:

1 RET — Return from Mono tape recorder.

2L RET, 3L RET, and 4L RET — Returns from left stereo channels.

2 R RET, 3R RET, and 4R RET — Returns from right stereo channels.

Row 8 (S.V. INPUT) is reserved for a future option.

Column 8

The first four rows of Column 8 (AUX jacks) provide a means of inserting auxiliary inputs into the Monitor system. The AUX RET jacks are wired to the AUX selection switches on the Monitor module.

Rows 5 and 6 (PHASE METER A and PHASE METER B) allow external signals to be patched to the console phase meter.

Rows 7 and 8 (CHAS GND) provide chassis ground points which can be used for grounding any desired point on the Patch Bay.

Column 9

Two sets of MULT (multiple) jacks are provided in Column 9. These afford a means of supplying up to three outputs from a single input. When a signal is patched into any one of the jacks in Rows 1, 2, 3, or 4, it becomes available at the other three jacks in the group. The second group (Rows 5, 6, 7, and 8) are used for the same purpose.

Column 10

Four pairs of BAL IN/BAL OUT JACKS are available in Column 10. These provide access to four balancing transformers which are normally used to isolate console circuits from external devices.

Columns 11 through 35

The tieline jacks in Columns 11 through 35 are used to connect to external devices

Column 36

This column is used for patching tape-based Automation data functions.

a

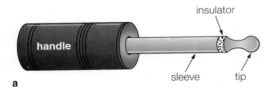

b

6-17 Patch cords with (a) ¼-inch phone plugs and (b) bantam (mini-phone) plugs

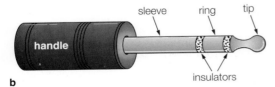

a

b

6-18 (a) Unbalanced and (b) balanced phone plugs

for the smaller-size jack panels. These plugs are either *unbalanced*—tip and sleeve—or *balanced*—tip, ring, and sleeve (see 6-18). An unbalanced audio cable has two conductors: a center wire and a braided shield surrounding it. A balanced audio cable has three conductors: two center wires and a braided shield. The balanced line is preferred for professional use because it is not as subject to electrical interference.

Console Automation

The mixdown can be exacting and tedious. It requires dozens of tape replays and hundreds of adjustments to get the right equalization, reverberation, blend, spatial balance, timing of inserts, and so on. Comparing one mix with another is difficult unless settings are written down (which is time-consuming) so that controls can be returned to previous positions if necessary. It is not uncommon to discard a mix because someone forgot to adjust one control or decided after a few days to change a few settings without recording the original positions. Then the controls have to be set up all over again. Mixing down one song can take many hours or even days.

Much of this tedium has been eliminated from the mixdown by automated consoles that provide the means to store and retrieve data to recreate any level setting made during a mix. The **voltage-controlled amplifier (VCA)**, **voltage-controlled equalizer (VCE)**, data encoder–decoders, and storage memory make this possible. The VCA controls the level of an audio signal. Its gain is regulated by an external direct current (DC) voltage. The VCE changes the frequency response of an amplifier as a function of the DC voltages applied to its control inputs. The automation system's storage medium, which may be one track on a multitrack tape but is more likely

a computer disk, encodes the information from the VCAs and VCEs.

Console automation also allows the free grouping of signals. Several channels can be assigned to and controlled by one fader without concern for the number of channels available to a given multichannel fader. In a fully automated console, the console controls are used simply to apply varying DC control voltages to their respective voltage controllers; the VCAs, VCEs, and routing system actually perform the fader, equalizer, and switching functions.

Console automation systems have three basic operating modes: write, read, and update (see 6-19).

- *Write Mode.* The **write mode** is used to create an automated mix. In the write mode, the automation system monitors and stores data from the faders. Only current fader movements are stored in the write mode.

- *Read Mode.* The **read mode** plays back or recalls the stored automation data. In the read mode, the console's faders are inoperative. They take their control voltage information only from the stored data on the disk or tape to reproduce the "recorded" fader movements in real time.

- *Update Mode.* The **update mode** allows the operator to read the stored information at any time and make changes by simply moving the appropriate fader. A new data track is generated from the original data track that is being read with the changes that have been made.

Console automation has greatly facilitated the record-keeping and accuracy of mixing, but it has its disadvantages. Automation systems tend to be confusing, even to experienced operators. Some systems are so complex that it is easy to lose track of the many operations necessary to perform a mix, which defeats the purpose of console automation. Some systems may not play back exactly what the operator wrote. If the mix is complex, a difference of a few dBs, overall, may not be perceptible. That would not be the case, however, in more subtle mixes. Automation systems, like all computer systems, are vulnerable to crashing. Getting the system operational again, even assuming that you had forethought to make a backup copy of the mix before completion, often involves a frustrating loss of production time and continuity, to say nothing of the financial cost. If recording tape is being used as the storage medium, the automation data requires two tracks—one for the data and a blank adjacent track to prevent the data from interfering with program information on an adjacent track. Moreover, if the data is recorded on the tape at too low a level, the automated playback may not be properly controlled.

MIDI-Based Console Automation

Although it is beyond the purview of this book, it should be noted here that console automation can also be MIDI-based. Among the several advantages of MIDI-based automation are greater flexibility in automating a mix, increased data storage capacity, the capability to include MIDI effects devices during the mix, and greater affordability. It makes affordable automation available both to nonprofessional producers and to facilities with nonautomated consoles. (See Chapter 14 for more about MIDI.)

Assignable Consoles

The ever-increasing demands that modern audio production is placing on console design have begun to create an ergonomic

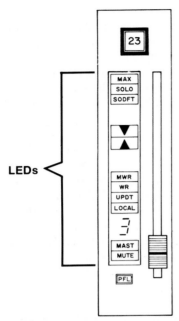

LEDs

6-19 Channel fader, with automation features, from the console in 6-8. (LED = Light Emitting Diode.)

MAX indicates that no more gain is available in the channel

SOLO indicates that the fader is in SOLO via the automation SOLO function

SODFT indicates that the fader is in Solo Defeat and will not be affected by an automation SOLO of another fader

Down Arrow indicates that the fader must be moved down to reach the null point. (The null point is the position at which the fader is set, intentionally or not, at the beginning of an update pass through the mix.)

Up Arrow indicates that the fader must be moved up to reach the null point. When both arrows are lit, the fader is at the null point

MWR indicates that the channel is in the Mute Write mode

In MWR, the mute switch controls the mute circuitry

WR puts the automation system in the Write mode for that channel. The MWR and WR modes are independent of each other. This allows the operator to rewrite the Mute switch assignments without affecting the VCA data already written

UPDT puts the automation system in the Update mode for that channel. When the WR and UPDT LEDs are not lit, the channel is in the READ mode. Similarly, the channel is in MUTE READ when the MWR LED is not lit. In READ, the faders and mute switches on the console are inoperative

LOCAL indicates that the channel is no longer under the control of the automation system master fader

The lighted number ("3" in this illustration) indicates the VCA grouping to which the channel (23) has been assigned

MAST indicates that the Group Master fader is controlling all other channels with that VCA grouping number

MUTE indicates that the mute circuitry is active

PFL (Prefader Listening) is a momentary switch that places the prefader audio signal on the PFL bus.

nightmare. Even as sound designers call for more in-board functions and greater operational flexibility, the growing use of outboard equipment necessitates ill more auxiliary console controls. Cons are becoming too complex and unwiel for one-person operation. Additionally, re rdless of how large or small the console, a. operator can only deal with a few controls at any one time. Therefore, most of the console, most of the time, simply represents wasted space.

A new concept in console desig seems to have successfully addressed these problems. Instead of the traditional individual controls for channel-to-track routing found on each channel strip, these functions have been centralized into single sets, with no input and output modules in the conventional sense.

The assignable concept can be provided in two approaches. In one configuration, instead of each input module carrying its own set of functions, only one control module is used. This system works in combination with a group of push-button controls, each one corresponding to an input channel. This means that instead of routing a signal through an existing input channel and making individual adjustments, such as EQ, cue and reverb send, and bus assignment at that channel, the various controls of an input channel are grouped into separate, centralized panels. From these panels a signal is assigned to a channel, processed, and routed. Routing assignments are entered into a central control panel and stored on disk.

A second configuration uses as many modules as there are input channels. But each module has only one control fader that works in conjunction with a group of function buttons. All required effects are distributed among the function buttons. In this system, you choose a module and assign one or more functions to the control fader of that particular module. In both assignable approaches, a given control set may be used to perform either the same set of functions for a variety of channels or different functions for a single channel.

The assignable console design has several advantages over large, conventional production consoles: (1) It makes many more operations possible in a more compact chassis; (2) an operator can remain in the central listening location without having to move back and forth to adjust controls; (3) signals can be handled more quickly and easily because functions are grouped and, with fewer controls, there are fewer operations to perform; and (4) the reduced number of controls lessens the chance of error and makes console layout easier on the eye.

Digital Consoles

The digital mixing console has been designed using the assignable concept and is available in three configurations. One configuration is actually an analog console that is digitally controlled. The signal path is distributed and processed in analog form, but the console's control parameters are maintained digitally.

The all-digital console uses two approaches. The analog input signal is first encoded into a digital signal or it is directly accepted as digital information. In either case, the data are distributed and processed digitally. The output might be either decoded back into analog or remain in digital form, depending on its destination. A third type of digital mixer uses computer software that configures the computer hardware into a "virtual" console.

The digital console has several advantages over its all-analog counterpart: (1) A greater number of operations are possible in a streamlined chassis; (2) there is greater flexibility in signal processing and routing; (3) more data can be stored; (4) in-board

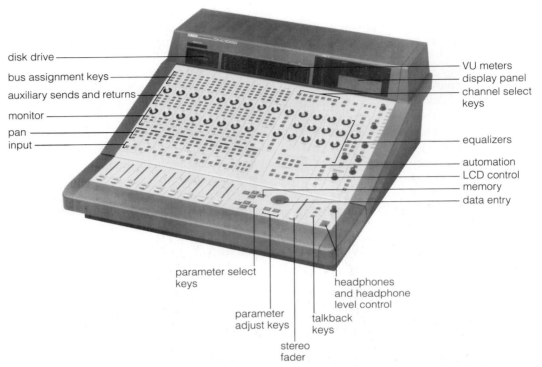

disk drive
bus assignment keys
auxiliary sends and returns
monitor
pan
input

VU meters
display panel
channel select keys
equalizers
automation
LCD control
memory
data entry

parameter select keys

parameter adjust keys

stereo fader

talkback keys

headphones and headphone level control

6-20 **All-digital console.** In this model, signals are digitized before entering the console. Although there are 9 fader controls, it can be regarded as a 22-input console, with 10 buses, 4 auxiliary buses configured in the following way: 8 mono input channels; 3 stereo input channels; 8 monitor channels; 8 program buses; one stereo bus; 4 auxiliary buses (2 mono and 2 stereo). All sends are available on all 22 inputs. The console is fully automated and the data can be stored in the console's in-board disk drive. Relevant numerical and graphic information is shown on the console's display panel. Display information includes Word Clock, which provides information about the console's digital setup; EQ graphic representation of a channel's equalization response; Effect Parameter displays the settings of an effect, such as reverberation; Automation Track Edit displays automation status.

patch panels are unnecessary; and (5) distortion and noise are reduced significantly, especially in the all-digital system (see 6-20).

"Virtual" Consoles

As the term suggests, a "virtual" console is not a console per se, but an integrated system that combines a hard-disk computer and specialized software to record stereo or multitrack audio direct to disk. Instead of feeding a sound source to a conventional console, it

is fed directly to the computer. On the computer monitor are displayed the console controls — faders, EQ, panning — (see 6-21). The controls are usually maneuvered by a mouse.

The number of channels a "virtual" console can handle depends on the capacity of the hard disk. For example, a system may provide 4 channels per hard disk. Therefore, if you require 16 channels for recording, a total of four hard drives are necessary. Although each channel has a dedicated input and output on the computer, or computer interface, once a track has been recorded, any number of tracks can be processed.

a mixer modules

b EQ and effects modules

6-21 **Example of "virtual" console's display screen.** (a) Each Mixer Module controls the panning, level, EQ/ Effect, etc. for every virtual track. External Sends route signals for additional processing. Each track has its own pre-fader VU meter. The Edit button takes you to the playlist to arrange regions, spot effects, and create crossfades. (b) Every track has two real-time EQ and Effects Modules including Low Shelf EQ, High Shelf EQ, Peak/Notch EQ, Chorus, Delay, Stereoization, and Distortion options. All Parameter Control knobs can be automated.

Main Points

1. The mixing console or board amplifies, balances, combines, processes, and routes signals to broadcast or recording.

2. Most consoles operate with three basic systems: input, output, and monitor.

3. The input section takes an incoming signal, processes it, and routes it to the output and monitor sections.

4. The output section routes signals to a recorder or broadcast.

5. The monitor section controls what is heard from the monitor loudspeakers and headphones.

6. In mono and stereo consoles used for broadcast and for uncomplicated recordings, input signals feed to (1) the input selector switch, (2) the preamplifier, (3) the fader, (4) the channel selector switch, (5) the program (or audition) master fader, (6) the VU meter, (7) the program monitor loudspeaker, and (8) broadcast or recording.

7. The volume unit (VU) meter measures the amount of electric energy flowing

through the console. The meter has two scales: percentage of modulation and volume units.

8. The VU meter responds to average sound intensity, unlike another popular meter, the peak program meter (ppm), which responds to peaks in loudness.

9. Loudness levels on a VU meter should average between 60 and 100 percent of modulation (about -4 to 0 VUs). If the loudness remains at levels too much higher or lower, the sound may distort or be too quiet.

10. In first-generation—split-section—production consoles the input, output, and monitor systems are separate.

11. Input system functions may include the following: microphone-line input selector, trim, overload indicator, pad, phantom power, equalizer and filter, phase reversal, bus assignment, pan pot, cue send, reverb (or echo) send, solo and prefader listen (PFL), mute, and meters.

12. Output system functions may include the following: buses, bus fader, reverb (or echo) return, return assign control, pan pot, cue return, and meters.

13. Monitor system functions may include the following: bus/tape switch, monitor mixer, monitor source select, cue send masters, and reverb (echo) send masters.

14. Other production console features may include slate/talkback, oscillator, and patch panel.

15. In newer, second-generation production consoles, called in-line or I/O consoles, the input and output functions are vertically in line and combined in each channel.

16. In-line consoles usually consist of the input/output (I/O), master, monitor, and communications modules.

17. A patch panel is a central routing terminal to which are wired the inputs and outputs of a console or the equipment in a studio, or both, thus making multiple signal paths possible. Patch cords plugged into jacks connect the routing circuits.

18. The signal paths that are used most often are wired together at the terminals of the patch panel. This normals these routes and makes it unnecessary to use patch cords to connect them. It is possible to break normal and create other signal paths by patching.

19. Plugs at the end of patch cords are either unbalanced, comprising a tip and sleeve, or balanced, comprising a tip, ring, and sleeve.

20. The voltage-controlled amplifier (VCA) makes it possible to automate fader functions. This facilitates encoding and decoding positional information as adjustments in level are made.

21. The newest production consoles are called assignable consoles. Instead of individual controls for channel-to-track routing on each channel strip, these functions have been centralized into single sets so they can be assigned to any channel. Once assigned, the commands are stored in the console's computer so different functions can be assigned to other channels. There are no input and output modules in the conventional sense.

22. Digital consoles use the assignable concept in three configurations; in an analog console that is digitally controlled; in an all-digital console; and in a console that uses computer software to configure its hardware into a "virtual" console.

Analog Recording

I t is difficult to overestimate the role of magnetic recording in broadcasting and production. Most of what you hear and see in media today is prepared, stored, and transmitted by magnetic recording systems. Radio stations record much, if not all, of their program material: music, commercials, and information. Television stations record almost all their sound and picture for broadcast. In film, sound is recorded before laboratory processing. By definition, discs are recordings.

Magnetic recording has become indispensable to media production and broadcasting for several reasons. A recorder is convenient to use almost anywhere. A magnetic recording can be played back immediately after encoding. The process is extremely flexible, for a recording may be arranged and rearranged by editing. Several discrete tracks of information may be recorded at once or at different times, in synchronization, and can be erased and reused. Sound quality in magnetic recording can be extremely good.

Until relatively recently, all audio magnetic recording was done on audiotape or magnetic film — for many years in the analog format and, beginning in the early 1980s, in the digital format, as well. Also in the 1980s, videotape was incorporated into all-audio recording. Today, the newest formats accomplish audio recording using disk-based systems. No audiotape is involved at all. In fact, so much already has been made of tapeless

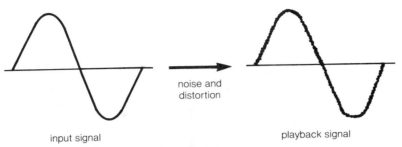

noise and distortion

input signal

playback signal

7-1 Representation of the analog recording process

recording that tape has been pronounced an endangered species.

Actually, what the proliferation of recording formats has demonstrated is that none, yet, is the panacea; each one has its advantages and disadvantages. Overall, the benefit of so many recording formats is the wide range of systems made available to professional and nonprofessional alike. The drawbacks, however, especially to the professional, are the incompatibility among the various systems and the cost of either changing from one format to another or having to accommodate several formats at once.

It will be some time before the marketplace decides which audio recording systems go and which stay. In the meantime, tape-based and disk-based recording will be with us for the foreseeable future.

Tape-Based Audio Recording

In audiotape recording, electrical signals are converted into magnetic signals at the recording stage and encoded onto tape. At the playback stage these taped magnetic signals are reconverted into electrical signals. This process is accomplished in two different ways: using the analog method or the digital method.

Analog Audiotape Recording

In **analog recording,** the signals encoded on the tape are analogous to the waveform of the original signal and the signal is continuous; that is, it is always "on" (see 7-1). Although the digital tape recording process is entirely different (see "Digital Recording" in Chapter 8), the tape and tape recorders used in analog and digital recording have a number of features in common.

Physical Characteristics of Audiotape

We tend to take tape (and film) for granted, perhaps because they are so familiar and easy to obtain. This attitude is a mistake, however, because tape and film store the record of your creative output. Therefore, to avoid using inferior, defective, or inappropriate tape or film, you must be aware of the properties and composition of your storage medium.

Composition

Audiotape is a thin plastic ribbon consisting of (1) hard, needlelike magnetic particles composed of iron (ferric) oxide, chromium dioxide, cobalt, or pure metal particles; (2) a plastic base material that supports the oxide; (3) a binder of synthetic varnish that holds

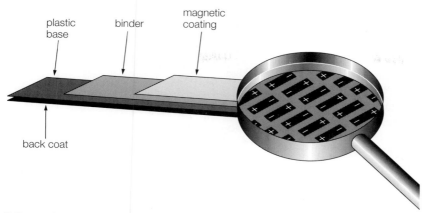

7-2 The four layers that make up audiotape and the random distribution of magnetic domains on the microscopic magnetic particles

the magnetic particles and adheres them to the base; and (4) a back coating to reduce slippage and buildup of magnetic charges (see 7-2).

Magnetic Particles and Magnetism

Tape recording is made possible by the ability of the magnetic particles to store electromagnetic impulses. Certain metallic compounds are magnetized when exposed to a field of force such as magnetic or electric current. In tape recording, the electric current flows through the record head of the tape recorder creating the magnetic field that *polarizes* the magnetic particles on the tape — arranges them into patterns — as they pass across the head. The arrangement of these polarized particles is the magnetic analogue of the original sound.

Plastic Base

The plastic material most commonly used for a tape's backing is **polyester**, also called **mylar**™. Polyester is strong, supple, and resistant to temperature extremes as well as humidity. Its one significant drawback is that it

stretches when placed under too much tension or when used too often. Once a tape is stretched, so is the recording.

To reduce the possibility of stretching, (1) use only the highest-quality tape, (2) make sure that tape recorders have the proper tension when spooling, and (3) use new tape for each project.

Dimensions

Two physical dimensions of magnetic audiotape are thickness and width. Knowing a tape's thickness helps to determine (1) how much tape can be spooled onto a reel, (2) how long it will play, and (3) how vulnerable a magnetic signal on one layer of tape will be to a magnetic signal on an adjacent layer.

Thickness

Most audiotape comes in four thicknesses, measured in **mils** (thousandths of an inch): 1½, 1, ½, and ¼ mil. (These measurements are taken from the plastic base. Actually the plastic base plus the magnetic coating is slightly thicker.) A tape's thickness determines how much can be spooled onto a given

size of reel. For example, the most common open-reel sizes are 5, 7, 10½, and 14 inches.

A 7-inch reel holds 1,200 feet of 1½-mil tape, 1,800 feet of 1-mil tape, or 3,600 feet of ¼-mil tape. The more tape on a reel, the longer the playing time (see Table 7-1).

One-quarter-mil tape may look like the best buy, but not for professionals. Broadcasters and recordists prefer 1½-mil tape for two reasons: (1) it is the thickest and most durable tape and is therefore least likely to crease, snap, stretch, or shrink; and (2) the print-through is considerably lessened. **Print-through** usually occurs in storage, when a signal from one layer of tape "prints" a low-level replica of itself on an adjacent layer. When the tape is played back, you can hear both signals, one strongly and one faintly. The thicker the tape, the less chance of sound "spilling" from layer to layer. Other factors that affect print-through are discussed later in this chapter.

Width

Open-reel audiotape is available in four widths: ¼, ½, 1, and 2 inches (see 7-3). Cassette tape (discussed later in this chapter) is roughly .15 inches wide.

7-3 Open-reel audiotape, on 10½-inch reels; available in ¼-, ½-, 1-, and 2-inch widths

Magnetic Properties of Audiotape

Much of the tape used in electronic media has been designed to provide particular response characteristics. For example, the type normally used to record popular music is **high-output tape** capable of handling higher levels than is standard tape. The louder recording levels make print-through more noticeable, however. **Low-output tape** is used to preserve program material for long periods of time with reduced print-through. But low-output tape must be used on a tape recorder set up to handle it. If it is used on a machine set up for high-output tape, distortion can occur (see the section on bias).

Several measures are used to determine how suitable a tape is for a particular recording. Three ways to determine a tape's ability

Table 7-1 Recording times for open-reel analog tape. Times are not exact because extra tape is provided to spool around the take-up and feed reels.

Reel Size (inches)	Tape Thickness (mils)	Tape Length (feet)	Playing Time (minutes)			
			30 ips	*15 ips*	*7½ ips*	*3¾ ips*
5	1½	600		7½	15	30
5	1	900		11¼	22½	45
7	1½	1,200	7½	15	30	60
7	1	1,800	11¼	22½	45	90
7	½	2,400		30	60	120
10½	1½	2,500	16.6	33.3	66.6	133.2
14	1½	5,000	33.3	66.6	133.3	266.4

to retain magnetic information are to check (1) how strong a force field must be to change the magnetic charge of a given particle, (2) how well the tape retains magnetization once the force field is removed, and (3) how great an output level the tape can reproduce. The terms used to describe these measures are *coercivity*, *retentivity*, and *sensitivity*.

Coercivity

Coercivity indicates the magnetic force (current) necessary to erase a tape fully. It is measured in oersteds—units of magnetic intensity. Analog open-reel tapes that are used professionally usually have oersted measurements between 360 and 380. The oersted measurements of digital open-reel tapes are in the 700s. Standard analog cassette is 360; metal-particle analog cassettes have oersted measurements between 1,200 and 1,500. Digital audio cassette tape is 1,500 oersteds. (See "Cassette Recording System" later in this chapter and "Digital Audiotape" in Chapter 8.)

The higher the coercivity, the more difficult it is to erase the tape. A tape recorder should be able to completely erase the tape being used. If it does not, some part of a previously recorded signal may be heard with a newly recorded signal.

Retentivity

Retentivity is a measure of the tape's magnetic field strength remaining after an external magnetic force has been removed. Retentivity is measured in **gauss**—a unit of magnetic density. A higher gauss rating means greater retentivity, which, in turn, indicates that a tape has a greater potential output level. Greater is not necessarily better; what is better depends on what you are recording and why. Gauss ratings between

1,200 and 1,700 are typical in professionally used open-reel tapes, analog and digital, and in standard analog audio cassette tape. Digital audio cassette tape has gauss ratings between 2,300 and 2,500.

Sensitivity

Sensitivity is similar to retentivity in that it indicates the highest output level a tape can deliver; however, sensitivity is measured in decibels and the test must be made against a reference tape. If the maximum output level of a reference tape is 0 dB and the output of the tape you are testing is + 3dB, that means your tape is capable of handling 3 dB more loudness before it *saturates*—becomes fully magnetized.

Special-Purpose Tape

We have said that many recordings require a special tape made to satisfy a particular response requirement. The two most common types of special-purpose tapes are low-print-through and high-output. There is low-noise tape, but it is not a special type so much as it is a response characteristic of any high-quality tape with a finely grained oxide coating. Low-noise tape reduces hiss and modulation noise, thereby improving signal-to-noise ratio.

Low-Print-Through Tape

As the name suggests, **low-print-through tape** reduces the chance of magnetic information on one tape layer transferring to another tape layer. If you intend to store recordings for any length of time, this is the tape to use. Low-print-through tape has low retentivity and lower sensitivity; it cannot handle high energy levels without becoming saturated. Tape that is both low-print-through

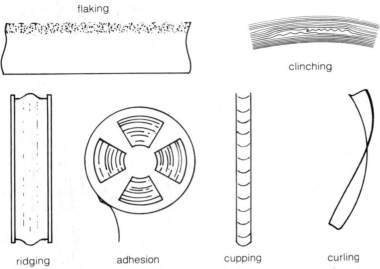

7-4 **Common problems caused by poorly made tape**

and low-noise is particularly vulnerable to loud sound levels. Two other factors also increase the possibility of print-through: heat and thin tape. Tapes with a print-through rating of at least −50 dB are considered good.

High-Output Tape

Since very high levels of loudness became an inherent part of popular music, there has been a need for recording tape that could help combat noise buildup on multitrack machines. In addition to noise reduction (see Chapter 9), **high-output tape** was developed. Its increased retentivity and sensitivity can take higher sound levels than most standard tape before saturation occurs.

Tape Defects

Most tape defects are the product of inferior manufacturing, and it is false economy to try to save money by purchasing such tape. To make the point emphatically: *Do not use cheap tape*!

Following are several results of using cheap tape (see 7-4):

- **Dropout** — sudden, irregular drops in sound level caused by poor distribution or flaking of the magnetic coating
- *Clinching* — slippage between the tape layers due to loose packing (also known as windowing)
- *Ridging* — a bulge or depression, seen after winding, caused by deformed layer(s) of tape
- *Adhesion* — one tape layer sticking to another
- *Cupping* — deformation of the backing due to expansion of the magnetic coating and base (usually occurs only with cheap tape)
- *Curling* — twisting of tape when it hangs due to a problem in the binding between plastic and magnetic coating.

Each of these defects adversely affects the sound quality, to say nothing of accelerated tape head and machine wear.

Care of Tape

Because the entire tape-recording process ultimately depends on the tape, it is important to exercise proper care when handling and storing magnetic tape.

Handling

1. Never handle the tape surface, front or back. The oil from a fingerprint can catch dust and grime that can damage the tape surfaces. If touching the tape cannot be avoided, use lint-free gloves. This is especially important when using digital tape.

2. Do not smoke or eat in the tape area. Smoke and food particles can contaminate the tape and also cause damage.

3. Carry the tape reel by the hub.

4. Trim damaged tape ends to avoid depositing debris on the tape transport and recording heads.

5. Always store tape in a dust-proof container when it is not in use.

6. Do not stack tapes on top of one another. Store tapes vertically so they will be supported by the hub.

7. Keep tape away from heat-generating equipment and magnetic fields when not in use.

Storage

If you intend to keep a recording for any length of time, take the following precautions against alteration of the magnetically encoded signal:

1. Use low-print-through tape 1½ mil thick.

scattered wind

7-5 Scattered wind. Individual tape strands are exposed and vulnerable to damage.

2. Store the tape in a controlled environment, between 60 and 75 degrees Fahrenheit and 40 and 60 percent humidity.

3. Wind the tape **tails out**—with the end of the recording on the outside of the reel. Then if print-through does occur, the weaker signal or decay will be post-echo (transferred into the stronger signal), thus masking the print-through, instead of pre-echo (before the signal), thus being audible.

4. Beware of exposed edges that result from *scattered wind* or *stepping* of tape due to uneven winding (see 7-5).

5. If the tape is in long-term storage, try to wind and rewind it at least once a year as an added precaution. Even if print-through has occurred, rewinding can reduce it somewhat.

Open-Reel Audiotape Recorders

With an **open-reel audiotape recorder** the operator manually mounts and threads the tape so that it can spool from a feed or supply reel, across magnetic heads, to a take-up reel. Open-reel audiotape recorders, and audiotape recorders (ATRs) in general, have three essential elements: (1) the tape transport system, (2) magnetic heads, and (3) record and playback electronics. You may consider the recording tape as a fourth element. By far, the most common type of open-reel transport

system used today is the open-loop transport system.

Open-Loop Tape Transport System

Tape transports have different features, but they are all designed to pull the tape across the magnetic heads at a constant speed and tension without causing fluctuations in the tape movement. In a typical **open-loop tape transport system**, a tape is prepared for record or play by placing it on the feed reel, threading it past the tape guide, across the head assembly, and between the capstan and pinch roller, through another tape guide to the take-up reel (see 7-6).

Capstan and Pinch Roller

The heart of the transport system is the **capstan**—a precision drive shaft that regulates the tape speed. When you put the machine in "Play," the tape is forced against the motor-driven shaft by the **pinch roller**. The pinch roller is usually rubber, and as the spinning capstan comes into contact with it, the capstan drives the roller and the two together pull the tape.

Feed (Supply) and Take-up Reels

The feed and take-up reels are also driven by motors. Electric current feeding these motors controls the tension on each reel so that (1) tape will not spill as it is pulled by the capstan and pinch roller, and (2) tape maintains optimal contact with the heads without stretching.

Tension (Reel-Size) Control

Although electric current to the feed and take-up motors keeps the torque on the reels constant, it does not control differences in tension created when tape winds from one size reel to a different size reel. Therefore, many professional recorders that are designed to take different size reels have a **tension** or **reel-size switch** so the tape wind from reel to reel is constant regardless of tape distribution and reel sizes. Other professional ATRs use a microprocessor for reel tension control.

Safety Control

Professional ATR transports incorporate a safety control that stops the transport when it senses the absence of tape along the guide path because the tape ran out or broke. The control may be a light beam interrupted by the presence of tape in its path or the control may be incorporated in the tape-tension sensor. Because the safety control stops the transport without turning off the entire recorder, it cuts down on machine wear and tear.

Tape Guides

Tape guides are used to position the tape correctly on the heads and as it winds from the feed to the take-up reel.

Wow and Flutter

Constant tape movement and tension are critical to acceptable recording. If a problem develops with some part of the tape transport system, the sound may take on wow or flutter. **Wow** is instantaneous variations in speed at moderately slow rates caused by variations in the tape transport, and perceived as frequency changes; **flutter** is generally the result of friction between the tape and heads or guides resulting in amplitude changes.

Some recorders come with **scrape flutter filters** to reduce flutter. Scrape flutter filters

are installed between the heads to reduce the amount of unsupported tape, thereby restricting the degree of tape movement as it passes across the heads (see 7-7).

Tape Speeds

Five speeds generally are used in analog audiotape recording: 1⅞, 3¾, 7½, 15, and 30 inches per second (ips). (A sixth speed, ¹⁵⁄₃₂ ips, is used with logging tape — tape used for transcribing the oral record of a broadcast station's program day, communications recording in emergency agencies and security institutions.) In analog recording the faster the speed, the better the frequency response and signal-to-noise ratio. Many ATRs operate at two, three, or four speeds.

Professionals usually use 7½ ips as a common speed when distributing or airing tape recordings, but they often work at 15 or 30 ips for improved sound quality and ease of editing. In any case, do not use speeds lower than 7½ ips. To give you an insight into the relationship between speed and sound quality, a top-quality professional tape recorder may have a frequency response to 20,000 Hz at 15 ips; at 7½ ips response may reach 15,000 Hz, and at 3¾ ips it may only go as high as 10,000 Hz. Also, faster speeds make it easier to edit tape (see Chapter 16). The more tape that passes across the heads per second, the more spread out the sound is on the tape. (A speed of 1⅞ ips is standard for analog audio cassette recorders. Digital ACRs run at ¼ ips.)

Tape Transport Controls

Several different controls operate the tape transport system (see 7-6).

- *On-off switch.* This control turns the electric power to the tape recorder on or off.

- *Selectable speed control.* Most professional recorders operate at more than one speed. This control selects the speed.

- *Variable speed control.* Some two- and three-speed recorders have a control that adjusts the tape speed to a rate that is ±5 to 50 percent of the machine's set speeds. This **variable speed control** comes in handy when you want to change the pitch of a sound for special effect or to correct slight anomalies in pitch resulting from AC voltage changes or batteries that gradually lose power during recording. The variable speed control also permits a shortening or lengthening of material that may be desirable and acceptable if the change in frequency and rate is unimportant.

- *Play.* This control activates the tape transport in the play mode.

- *Record.* This control activates the erase and record electronics. To avoid accidental erasure, it usually will not work unless you also press the "Play" button.

- *Fast Forward and Rewind.* These controls disengage the capstan/pinch roller and wind or rewind the tape at high speed. In either mode tape lifters hold the tape away from the heads to avoid the increased friction that would rapidly wear both tape and heads and to mute the annoying high-pitched squeal that comes when running the tape at high speed. If that high-pitched squeal is loud enough, by the way, it can damage the tweeter(s) in a loudspeaker (see Chapter 10).

- *Stop.* This control stops the feed and take-up reels and disengages the pinch roller from the capstan.

- *Edit control.* This control allows you to spool off unwanted tape without the take-up reel turning. For **edit control** press

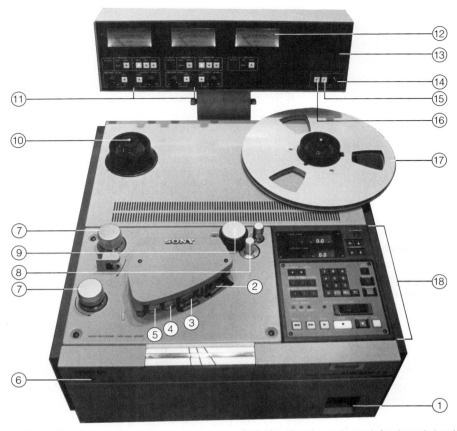

(1) Tape recorder on/off control
(2) Playback head
(3) Record head
(4) Erase head
(5) Time code head
(6) Headphone jack
(7) Tape guides
(8) Capstan
(9) Pinch roller
(10) Feed reel

(11) Meter housing and controls for channels 1 and 2
(12) Time code VU meter
(13) Monitor speaker
(14) Volume control for monitor speaker
(15) Track 2 Select assigns audio channel 2 to the monitor speaker
(16) Track 1 Select assigns audio channel 1 to the monitor speaker
(17) Take-up reel
(18) Transport control panel

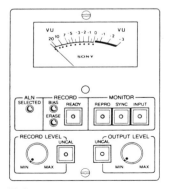

Meter Housing and Controls

ALN Selected: LED indicates whether the channel is selected during alignment operation.

RECORD: Bias and Erase LEDs indicate whether the Bias and Erase signals are active, which they are during recording. RECORD READY is pressed to put the channel into the record mode.

MONITOR: Repro, Sync, and Input buttons select from where the output of the audio channel will come — playback head, time code head, or record head.

RECORD LEVEL: Volume control adjusts record level when UNCAL(ibration) is off. In the CAL mode, the record level is internally preset.

OUTPUT LEVEL: is similar to the RECORD LEVEL but adjusts for output level.

7-6 Tape recorder with an open-loop transport system and its functions

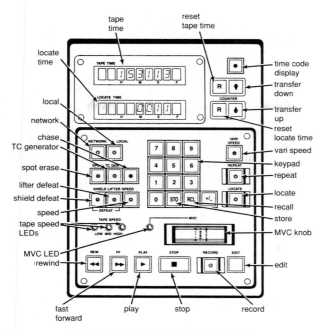

Transport Control Panel and Its Functions

REWIND puts the transport into fast rewind

FAST FORWARD puts the transport into fast forward

PLAY starts the tape at the selected speed

STOP stops the tape

RECORD pressed together with PLAY (and with the RECORD READY LED on the meter housing controls lit) puts the tape recorder into the record mode

EDIT puts the transport into the Dump Edit mode by turning off the take-up reel

MVC (Manual Velocity Control) Knob shuttles the transport from fast to slow wind in either rewind or forward

KEYPAD permits entering of specific values into the LOCATE TIME DISPLAY and is used in conjunction with STO (Store) and RCL (Recall) for search-to-cue operation

STORE stores in a memory the numbers punched into the KEYPAD

RECALL recalls the stored numbers from the memory

LOCATE causes the transport to fast wind from the location shown in the TAPE TIME display to the location shown in LOCATE TIME display

REPEAT causes the tape recorder to play a segment of tape repeatedly

VARI SPEED varies the selected tape speed by ±50 percent

RESET LOCATE TIME resets locate time display

RESET TAPE TIME resets tape time display

TRANSFER UP causes the value shown in the LOCATE TIME display to be loaded into the TAPE TIME display

TRANSFER DOWN causes the value shown in the TAPE TIME display to be loaded into the LOCATE TIME DISPLAY

TIME CODE DISPLAY displays TAPE TIME in time code — hours, minutes, seconds, and frames

TAPE TIME displays the tape time either in hours, minutes, and seconds or in time code

LOCATE TIME displays the locate time

LOCAL mode keeps tape recorder control at the transport control panel (or at a parallel remote control)

NETWORK mode transfers tape recorder control to a network (serial remote control) and disables the transport control (or parallel remote control)

CHASE model slaves the tape recorder to an external time code source

TC GENERATOR selects the internal time code generator

SPOT ERASE disables the record head with the erase head on so that tape can be erased with no bias frequency from the record circuitry

LIFTER DEFEAT disables the tape lifters so the tape passes over the heads in any fast wind mode

SHIELD DEFEAT deactivates the head shields during Play or Record

SPEED selects high (30 ips), medium (15 ips), or slow (7½ ips) tape speed

TAPE SPEED LEDs indicate which tape speed has been selected

MVC LED indicates that the MVC has been selected

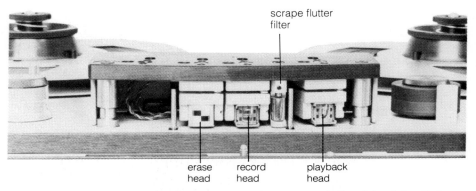

7-7 **Audiotape recorder with three magnetic heads.** These are half-track heads (see 7-12 and 7-13).

"Edit" to disengage the take-up reel while allowing the rest of the tape transport to continue functioning.

Magnetic Heads

The heads of a tape recorder are small electromagnets. These magnetic heads are transducers; they convert electric energy into magnetic energy during recording or magnetic energy back into electric energy during playback.

Most professional tape recorders have at least three heads: erase, record, and playback (see 7-7). A good way to identify them is to remember that the erase head is always closest to the feed reel, the record head is in the middle, and the playback head is closest to the take-up reel.

Machines with four heads use the fourth head as either a four-track playback head (the standard playback head on professional open-reel ATRs is two-track), or as a sync head for either time code (see 7-6) or pilot tone (see "Double-System Recording" later in this chapter and "High Quality Portable Open-Reel Tape Recorders" in Chapter 15).

Bias

Before we examine the function of each magnetic head, we need to discuss **bias**. The response of magnetic particles on recording tape (and magnetic film) is nonlinear — their magnetic energy is not a perfect analog of the signal from the record head. A method is needed to force the magnetic properties of the particles as the audio current directs.

The force is a high-frequency current several times that of the highest recorded frequency and, therefore, far above the frequency limits of human hearing (100,000 Hz and higher). This high-frequency current, referred to as **bias current**, is added to the audio signal during recording. It affects the magnetic tape particles so that they respond and conform to the audio signal. During playback the bias frequency is not reproduced because the playback head is unable to read such high frequencies.

In addition to making magnetic recording linear, the strength of the bias current also affects frequency response, distortion, and signal-to-noise ratio. A particular amount of bias current will work best with a particular type of recording tape. It is critical, there-

fore, that the tape recorder you use has been *biased* for the specific tape that you are using. Otherwise, a bias current set too high results in loss of high frequencies, and one set too low results in increased distortion and background noise. Always check with a technician to be sure.

Types of Heads

Erase Head The **erase head** is activated during recording. Its function is to neutralize the polarities of the magnetic particles — to remove sound from the tape with a high-frequency current before the tape passes across the record head.

Bulk Erasers Another way to erase tape is with a **bulk eraser** (also known as a **degausser**) — a large magnet that can erase an entire reel at once (see 7-8). It is fast and easy to use but generally gives a poorer signal-to-noise ratio than does the erase head. When using a bulk eraser with no conveyor belt, take the following precautions:

1. Keep the tape (and your watch) away from the demagnetizer when it is turned on or off, because the tape could get a surge of magnetism that may be difficult to neutralize.

2. Before (and after) degaussing, slowly move the tape into (and away from) the bulk eraser's field.

3. Rotate the tape over the degausser slowly at a rate not more than 2 inches per second. Faster rates will leave residual magnetism on the tape. Do not scrape the tape too hard or jerk it across the surface of the bulk eraser or it will reduce signal-to-noise ratio and increase background noise in the form of a swishing sound. Make

a

b

7-8 High-quality bulk erasers. (*a*) This model erases open-reel tapes from 150-mil to 2-inch widths, as well as cartridges, cassettes, and magnetic film. The erase field electronically diminishes at the end of each 20-second cycle. A fan blower protects the eraser from overheating damage. (*b*) High-energy bulk eraser for high-coercivity tapes.

sure the passes include both sides of the entire reel.

4. Make sure you know the use time of the demagnetizer; some of them tend to heat up quickly and will burn out if left on too long.

Record Head The **record head** transduces electric energy into the magnetic force that

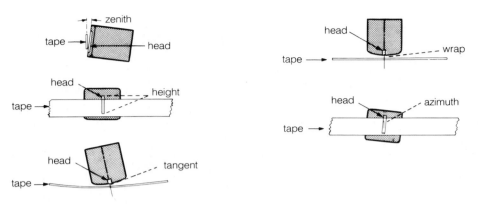

7-9 Five alignment adjustments made to a magnetic head

magnetizes the tape. It carries two signals: the record bias current and the audio current — the signal fed to the recorder from the original sound.

Playback Head The **playback head** transduces the magnetic field from the tape back into electric energy.

Head Care

Magnetic heads require very careful treatment. The slightest change in their alignment, any accumulation of dust, dirt, or magnetic particles, scratches, wear, or overmagnetizing will adversely affect sound quality.

Aligning the Heads Although a technician usually aligns the heads, you should be aware of what adjustments are made and some problems that can result when the heads are out of alignment. There are five adjustments (see 7-9):

■ **Zenith.** The vertical angle of the heads is important to maintain uniform tape tension across the entire width of the tape-

to-head contact. If a head is tilted and the top or bottom portion applies greater pressure to the tape than the other, it causes the tape to *skew* — ride up or down on the head. In less severe cases the lack of pressure can cause degraded performance.

■ **Height.** The heads must present themselves to the tape at exactly the right height. Otherwise, the result could be signals that are only partially recorded or reproduced, crosstalk between tracks, more noise, or poor erasure.

■ **Tangency.** The head-to-tape contact at the head gap must be at the right pressure. The head gap is the space between the poles of a magnetic head (see 7-10). The farther forward the head, the greater is the pressure. Too little or too much pressure noticeably degrades a signal by reducing high-frequency response and causing dropout.

■ **Wrap.** The angle at which the tape curves around the head must ensure proper contact at the gap. Without firm tape-to-head contact, as with poor tangency, there is sound dropout and high-frequency loss.

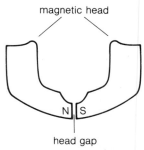

7-10 **The poles and head gap of a magnetic head**

7-11 **Head demagnetizer**

■ **Azimuth.** Adjustment of the gap must be exactly perpendicular to the length of the tape. Heads that are not in azimuth alignment record and reproduce out-of-phase stereo signals.

It is difficult to visually spot heads that are out of alignment, but you can hear many of the problems caused by misaligned heads. Most studios have a routine schedule of preventive maintenance that includes head alignment. If you are getting poor sound from a tape recorder, have a technician check the heads. As for the other aspects of head care, you can handle them yourself.

Demagnetizing the Heads Before you use a tape recorder (and once or twice during long sessions), make sure the heads are free from any magnetization that may have been left from previous use. When heads build up enough permanent magnetism, they can partially erase a recording; higher frequencies are particularly susceptible. Recordings so affected sound "muddy"; they often lack presence and brilliance.

You can demagnetize heads with any of several demagnetizers available (see 7-11). Select one that does not produce too strong a magnetic field, however, or it can permanently magnetize a head instead of demagnetizing it. Turn off the tape recorder before demagnetizing. Also, turn the demagnetizer

on and off away from the heads; otherwise, the surge or cut in power could leave remnant magnetization on the heads. Make sure, too, that the demagnetizer does not touch or scrape the heads, or they could be scratched and permanently damaged. An etched head acts like sandpaper in scraping magnetic particles off tape.

Cleaning the Heads Dust, dirt, and magnetic particles collect on the heads and tape guides even in the cleanest studios. Some of these particles are abrasive; when the tape picks them up and drags them across the heads, they can scratch both the magnetic coating and the heads. If these particles build up sufficiently, sound quality suffers noticeably.

The best preventive maintenance is to clean the heads and tape guides each time you use a tape recorder. Cotton swabs and an approved head cleaner or easy-to-obtain and inexpensive isopropyl alcohol will do. Use one cotton swab for each head and guide (two if the cotton turns brown) and swab the head gently. Special head cleaner is available, but it may be too potent for some heads and dissolve part of the plastic. Check with a technician if you are in doubt. A rubber cleaner may be better for the pinch rollers because alcohol could swell and crack the rubber.

Electronics

The *record electronics* receive the audio input to the tape recorder and convert it to the current that flows through the record head.

The *playback electronics* take the signal from the playback head and amplify it into the voltage, which is then sent to the output of the tape recorder.

Total Transport Logic

Modern tape recorder transport designs incorporate *Total Transport Logic* (TTL) using microprocessor monitoring and control over transport functions. In older ATRs, for example, to stop a tape in fast forward or rewind by pressing the "Stop" button meant risking stretching the tape. To prevent tape damage it was necessary to "rock" the tape to a stop by engaging the fast forward mode when the tape was in rewind and vice versa. When the tape slowed, it was safe to press the "Stop" button. With TTL, the recorder "rocks" the transport until stopping is safe. Also, a shuttle control makes it possible to shuttle tape at various speeds in either direction (see 7-6).

Features of Audiotape Recorders

Audiotape recorders have various features that increase flexibility in their use.

Tracks and Track Widths

Professional analog open-reel audiotape recorders come in 1-, 2-, 4-, 8-, 16- and 24-channel/track formats. The amount of surface area on each head (or **headstack**, as it is called on multitrack heads) used for recording or playback varies with the size of the head (see 7-12). Between each head is a **guard band** that reduces considerably the chance of magnetic information from one head affecting the magnetic information on an adjacent track.

Do not confuse *channel* with *track*; these terms are not synonyms. A **channel** is a con-

a

b

7-12 (*a*) 8-track headstack for ½-inch tape and (*b*) 24-track headstack for 2-inch tape

duit through which signal flows. The path the signal makes on the tape is the **track**. See 7-13 for a graphic explanation of the relationship between channel and track in analog recording.

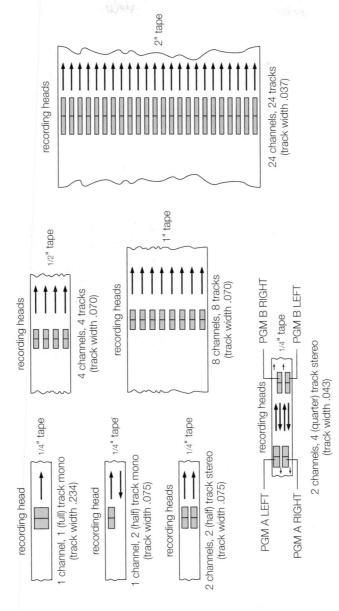

7-13 Channel and track formats of standard-gauge open-reel analog recorders

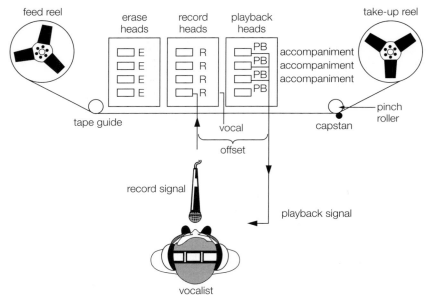

incorrect

7-14 Overdubbing without Sel Sync. This method creates an offset between the sound being played back and the sound being recorded.

Narrow-Gauge Formats

A relatively new development in analog tape recorders is the narrow-gauge headstack. Narrow-gauge headstacks make it possible to record more tracks on ¼-, ½-, and 1-inch tape — as many as 8 tracks on ¼-inch tape, 8 or 16 tracks on ½-inch tape, and 16 tracks on 1-inch tape.

Narrow-gauge formats were developed for industrial-grade and nonprofessional audio production. Their main advantage is greater multitrack capability at a lower cost because narrow-gauge ATRs are considerably less expensive than conventional analog multitrack machines. Their main disadvantages are generally poorer sound quality and greater risk of crosstalk.

Selective Synchronization (Sel Sync)

Multitrack recorders were developed to permit greater control of the sound sources during recording and playback by making it possible to assign each one to its own track. Multitrack recorders also make it possible to record various sound sources at different times by **overdubbing** — recording new material on open tracks and synchronizing it with material on tracks already recorded. The technology that facilitates this production technique is called by the copyrighted term **Sel Sync** (short for *selective synchronization*). It was developed by Ampex (the innovator was guitarist Les Paul).

Under normal conditions, if you first recorded, say, only the instrumental accom-

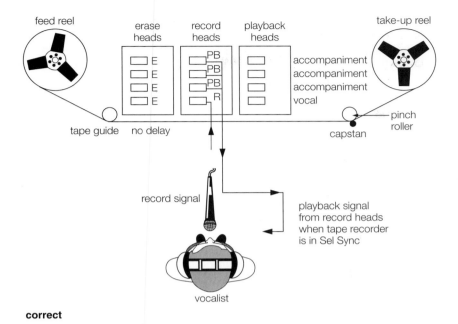

feed reel

erase
heads

record
heads

playback
heads

take-up reel

E
E
E
E

PB
PB
PB
R

accompaniment
accompaniment
accompaniment
vocal

pinch
roller

tape guide no delay

capstan

record signal

playback signal
from record heads
when tape recorder
is in Sel Sync

vocalist

correct

7-15 Overdubbing with Sel Sync. Playback and record are synchronized.

7-16 So-called footage counter

paniment to a vocal, the vocalist would have
to listen to the recording (through head-
phones) to synchronize the words to the mu-
sic. A distance of a few inches separates the
record and playback heads, however. This
will create a delay between the music and

the lyrics as they are played back together
(see 7-14). To eliminate this delay, Sel Sync
uses the record head as a playback head for
the previously recorded tracks and plays
them in sync with the new material being
recorded (see 7-15; also see the section on
overdubbing in Chapter 14).

Time Counter

Most tape recorders manufactured today are
equipped with either a **footage counter** (see
7-16) or a **tape timer** (see 7-6). They provide
an easy way to locate recorded material.

Footage counter is actually a misnomer
because it does not indicate how many feet
of tape pass across the heads. What turns the
counter is either the feed reel or one of the
tape guide rollers. The footage reading is

really a count of the number of revolutions of the feed reel or tape guide roller. Nevertheless, it is a convenient, if imprecise, reference and better than nothing.

An actual tape timer is wound by a tape guide roller with revolutions that are converted to inches per second. Tape timers read out in hours, minutes, seconds, and, in many ATRs, in frames.

Automated Cue Location

Even with timing devices, locating specific cue points on a tape can be time-consuming. An accessory that is part of many ATRs makes it possible to program cues so that the recorder will automatically stop and start at the preset points and store the information in a memory. This function is commonly known as *auto-locator* (see 7-6). Most auto-locators have remote control.

Cartridge Tape System

The first major departure from open-reel recording was the **cartridge tape recorder**. The system was developed in 1958 to speed up and simplify the threading, recording, cueing, and playing of short program materials such as spots, news actualities, and jingles, and enable tighter production. Although the tape cartridge system has been an integral part of broadcast production for many years and is still widely prevalent, disk-based cartridge systems have made significant inroads (see "Disk-Based Audio Systems" in Chapter 8).

Cartridge Tape

Cartridge tape (*cart*, for short) is actually a continuous loop of 1½-mil, ¼-inch polyester tape housed in a plastic cartridge. The tape is highly lubricated to ensure smooth, non-abrasive winding, because the same relatively short length of tape is used over and over again.

Carts come in various sizes standardized by the National Association of Broadcasters (NAB). These sizes, designated A, AA, B, and C, vary in dimension and tape length. A- and AA-size cartridges contain prepackaged tape in lengths from 20 seconds to 10½ minutes. The slightly larger and wider B-size carts can hold up to 20 minutes of tape. C-size carts have a maximum of 40 minutes playing time. Tape times assume a playing speed of 7½ ips.

Cartridge tape comes in normal-output and high-output formulations. The high-output tape helps to reduce tape noise and intermodulation distortion.

Cartridge Tape Recorders

The operation of the cartridge system is ingenious. The tape is wound loosely around a hub so it can be easily pulled from the center of the reel. The tape feeds in a continuous loop around the tape guides that are in the cartridge casing. When the cart is pushed into the recorder and locked in place, the hole in the bottom upper-right-hand side of the cart sits over the pinch roller. When the machine is put into "Play (or "Start"), the pinch roller engages the capstan, pulling the tape across the heads and rotating the roll as it does so (see 7-17 and 7-18).

Because the tape is continuous, there is no need for separate feed and take-up reels or for a "Rewind." For several years there was no "Fast Forward" either. Sometimes, however, several different bits of material are recorded on a single cart and "Fast Forward" speeds cueing. On most machines "Fast Forward" is now standard, and other features have been added (see 7-19).

capstan pinch roller

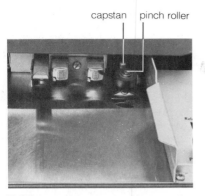

7-17 **Cartridge tape in "Play" mode.** When the cartridge tape recorder is in "Play," the pinch roller and the capstan are engaged.

capstan and pinch roller engage tape here

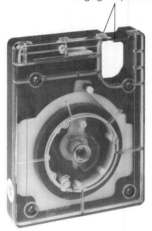

7-18 **Cartridge tape.** The capstan and pinch roller engage the cartridge tape to keep the tape winding at a constant speed.

What makes the cartridge system invaluable is the **cue tone**—a pulse that tells the continuous **tape loop** when to stop. The record head puts the pulse on the tape, and the playback head senses it. (The heads are designed so that the cue tone track is in-

7-19 **Cartridge tape recorder playback and record units.** The 1 kHz defeat function allows the cartridge tape to play continuously, turning it into a tape loop. In another model, the cart scan system allows cartridges recorded at elevated levels in mono and matrix stereo to be intermixed with carts recorded in standard level and discrete stereo formats. (See Chapter 12 for a discussion of discrete stereo.)

cluded—see 7-19.) As you can see in 7-20, carts recorded in mono should not be played on stereo cart machines, and vice versa. To improve sound quality, some cart machines use a wide-track stereo format (see 7-21).

To give you an idea of how the cue tone works, assume you are recording a 30-second spot on a 40-second cart. (Always use a cartridge that runs slightly longer than the material.) After loading the cart, push "Record" to put the machine into the record mode. This automatically puts the cue tone on the tape. Push "Play" (or "Start") to start the tape spinning and recording. On some cart machines the cue tone is put on the tape when "Record" is pushed; on other cart machines it is put on the tape when "Play" is pushed. Make sure to begin the material you are recording just after you start the cart machine; otherwise, when you play back the cart, the material will not start when the tape does and there will be some dead air.

Once the tape starts, it will wind 30 seconds for the spot, continue for another 10 seconds until it reaches the cue tone, and then

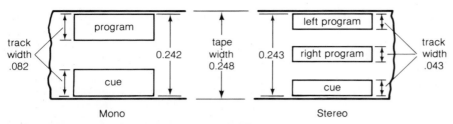

7-20 Head and track formats for mono and stereo cartridge tape recorders

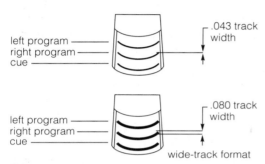

7-21 Wide-track format. Some cartridge tape recorders use a wide-track format to improve sound quality: (*top*) ¼-track standard format; (*bottom*) wide-track format.

7-22 Cartridge tape eraser and splice-finder

stop, recued. Either the machine will automatically switch off the record mode or you will have to do it manually. Once that is done, the tape is ready for playback.

Keep in mind that each time you hit the "Record" or "Play" button when the machine is in the record mode, it puts a pulse on the tape. Therefore, it is important to be careful during recording or you may have unwanted cue tones that will stop the cart at the wrong place(s). Many cartridge decks play back only, thereby reducing the chance of placing unwanted cue tones on carts that are already recorded.

The primary cue tone that is put on a cartridge tape to stop it is 1,000 Hz. Some machines are also capable of putting secondary and tertiary cue tones on a cart. These tones are 150 Hz and 8,000 Hz, respectively.

The secondary tone can be put on a cart at the end of the program material and used to start automatically another cartridge tape machine containing the program material to follow, or any other type of tape recorder — audio or video.

The tertiary tone can be used for a similar function or for functions such as cueing slide changes in slide–tape presentations or warning the operator that the material has run out.

Cartridge tape recorders have either record and playback heads, or just a record or just a playback head. Thus, carts cannot be erased by rerecording; they must be bulk-erased each time you reuse them. Bulk erasers specially designed for carts are available as are cartridge machines equipped with only an erase head (see 7-22).

Cassette Recording System

The cartridge tape system was developed mainly for broadcasting to speed and simplify tape handling and operation. However, it was obvious that a tape that is enclosed and ready for immediate use, that can be easily inserted in a tape recorder and removed regardless of how much tape is on the reels, that is small, and that can be handled without being sullied had potential beyond broadcasting. It took only five years from the development of the cartridge tape until the cassette was introduced in 1963.

The cassette improved upon the cartridge concept in three ways: (1) The tape is in the reel-to-reel format, which allows more tape on the reel, recording or playback in two directions, and hence, more playing time. (2) Cassettes have a narrower tape size (about ⅛ inch) and slower speed (1⅞ ips), which makes it possible to have a recorder that is small, lightweight, and highly portable. (3) Cassettes operate on both AC current and batteries.

Analog Audiocassette Tape

Analog **cassette tape** is a miniaturized reel-to-reel in a box. Because of its small size, light weight, and portability, it is extremely convenient and can be used virtually anywhere. Due to the size of both tape and recorder, however, only the highest-quality analog cassette systems are capable of producing broadcast-quality sound. A cassette tape is also difficult to splice. Professionals, particularly in news, use them for remote recording, but usually dub the cassette to an open-reel or cart tape for broadcast.

Two reasons for the cassette's mediocre sound quality are the analog format and the tape's dimensions. Most cassette tape is either ½ or ¼ mil thick and .15 inch wide. Regardless of the grade of magnetic coating, there is simply not enough surface, track width, or stability to encode a strong output signal with an acceptable signal-to-noise ratio and frequency response. The slow tape speed of 1⅞ ips is another problem. However, improvements in tape, heads, and circuitry design, plus the addition of noise reduction (see Chapter 9) have increased analog cassette sound quality significantly. Currently, there are four types of analog tape used in audiocassette recorders (ACRs), as designated by the IEC (International Electrotechnical Commission): Type I, gamma ferric oxide; Type II, chromium dioxide and cobalt-treated; Type III, ferrichrome (rarely used); Type IV, metal particle.

Type I tape is also referred to as "normal" tape because it can be used on all ACRs and requires normal bias. Type II tape is high-output tape (coercivity is 500 oersteds) requiring high bias. The most commonly used magnetic formulation for Type II is chromium dioxide, although cobalt-treated tape is also available. Type III, or ferrichrome, tape is also high-output tape although it requires only intermediate bias. Ferrichrome is double-layered with a thin top layer of chromium dioxide and an underlayer of ferric oxide. Type IV tape is metal-particle tape with a magnetic surface of pure metal instead of oxide compounds. It is very high-output tape (coercivity of 1,200–1,500 oersteds) requiring extra high bias.

Because the various types of cassette tapes require different biases (and equalization), better ACRs have a switch that selects the circuitry appropriate to the tape being used. Some units do this automatically using a sensor to set the appropriate electronics.

Analog cassette tape comes in prepackaged cartridges of 30-, 40-, 45-, 60-, 90-, 120-, and 180-minute lengths — that is, using both sides of the tape. You can determine the

length of time for one side by dividing the total time in half. The 30- to 60-minute tapes are ½ mil; the 90- to 180-minute tapes are usually ¼ mil. Try not to use any ¼-mil tape. In addition to its fragility and poor response, it tends to have slippage problems winding in "Fast Forward" and "Rewind."

Cassette Tape Recorders

Since its development, the **cassette tape recorder** has revolutionized tape recording. Now it is possible to take a recorder practically anywhere with little physical or logistical inconvenience; to record up to 180 minutes of material on tape that is smaller than a 3 × 5 card; and to store these tapes in a small amount of space. Cassettes are even built into consoles (as are open-reel ATRs).

For the professional, however, three problems limit the analog cassette's use: (1) lack of portability of high-quality units, (2) difficulty in editing, and (3) difficulty in cueing. When a cassette recording is to be edited or used for broadcast, it is usually dubbed onto an open-reel or cartridge recorder.

Besides the size and sound quality, another difference between the analog cassette and other recorders is the track format. In stereo cassette recorders, unlike standard quarter-track stereo recorders, the pairs of stereo tracks are adjacent rather than alternate.

Analog cassette recorders have been developed with added features to facilitate their use in broadcast conditions, but with the advent of the digital audiocassette the changeover from analog is well under way (see 7-23).

Analog Audio on Videotape

For years the quality of sound on videotape stayed the same. The various formats of videotape recording were not conducive to the reproduction of high-quality audio, and loudspeakers in most television receivers could not reproduce good sound even if high-quality audio were being transmitted. Now with videotape used increasingly for audio processing (particularly in digital recording); with improved video recorders; with videotape producing wider frequency response, in some cases up to 20 kHz; with the advent of stereo TV, with frequency response in video transmission up to 15 kHz; and with improving loudspeakers in TV receivers; analog audio on videotape has improved significantly.

Videotape Formats

Although a number of different analog videotape formats are used today, most encode the same types of information. A videotape recording consists of a video track, one or more audio tracks, and a control track to regulate the playback timing of the system. A control track is analogous to sprocket holes on film. Depending on the format, there may be a dedicated **address track** for encoding time code or one of the audio tracks is used for time code. A sync track controls the scanning of the video information.

Several analog videotape formats are used in professional and industrial production and the number is increasing each year. There is the 1-inch C-format; ¾-inch U-matic and U-matic SP (SP stands for Superior Performance); ½-inch Betacam, Betacam SP, MII, and S-VHS (Super-Video Home System); and 8mm and Hi8mm. (Digital videotape formats are discussed in Chapter 8.) The C-format is open-reel; all the other formats are cassette.

Type C-Format

The **Type C-format** is the television industry's high-end 1-inch format. It carries three high-quality audio tracks: Tracks 1 and 2 are used

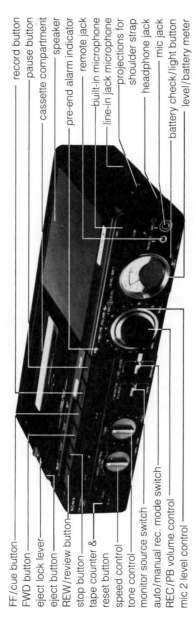

FF/cue button
FWD button
eject lock lever
eject button
REW/review button
stop button
tape counter & reset button
speed control
tone control
monitor source switch
auto/manual rec. mode switch
REC/PB volume control
mic 2 level control

record button
pause button
cassette compartment
speaker
pre-end alarm indicator
remote jack
built-in microphone
line-in jack microphone
projections for shoulder strap
headphone jack
mic jack
battery check/light button
level/battery meter

7-23 Analog portable cassette recorder/reproducer used in radio news. (Compare this tape recorder to the portable cassette tape recorder in 8-13.)

for program sound. Track 3 can also be used for program sound, but is usually dedicated to other functions such as time code, cues, and language translation (see 7-24). A 1-inch production VTR can record or playback up to two hours of program material.

¾-Inch Format

The ¾-inch format, *U-matic* and *U-matic SP*, is used mainly in television news and as worktape for making editing decisions during postproduction, thereby eliminating the need to tie up the more expensive 1-inch tape equipment during program assembly in final editing. Studio record time per U-matic SP cassette can be up to 60 minutes; field record time is 20 minutes.

The ¾-inch format dedicates two tracks for audio, both of mediocre sound quality. In the U-matic format, signal-to-noise ratio is about 48 dB (tape coercivity is 700 oersteds). The U-matic SP uses a higher coercivity tape (740 oersteds) and, therefore, has somewhat better sound quality.

Either one or both audio tracks are used for recording. If one track is used, it is usually the inside track 2 because it is less likely to suffer tape edge damage than the outside track 1. In fact, most video cameras with a built-in microphone (see Chapter 15) feed the audio signal directly to track 2.

With any videotape, if you use only one audio channel for recording, it is always a good idea to select the track farther from the tape edge. Be careful, however, that the inside audio track is not subject to interference from signals on an adjacent address or time code track. Time code, in particular, is recorded at a high level and could interfere with a recorded signal. Newer U-matic VCRs place the address and/or time code tracks farther from the audio tracks than older models do (see 7-25).

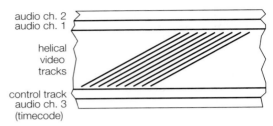

7-24 Type C videotape format

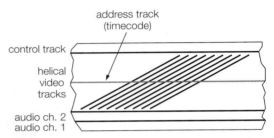

7-25 ¾-inch videotape format

½-Inch Format

The ½-inch videocassette format is gradually replacing the popular ¾-inch format because it is smaller in scale and easier to manage; some ½-inch formats even produce better sound and picture quality.

Betacam (developed by Sony) was the first ½-inch format intended for broadcast news and field production. It has two audio tracks and mediocre sound quality (coercivity is 740 oersteds). The Betacam SP is a significant improvement over Betacam both in sound and picture. It has two regular (longitudinal—fixed head) audio tracks and two additional AFM (audio frequency modulation) tracks in the video waveform that deliver high-fidelity sound. Betacam SP uses metal particle tape (1,500 oersteds) and employs noise reduction.

Betacam SP uses 30-minute cassettes and can accommodate special large cassettes that

provide up to 90 minutes of recording time. (A recent development in Betacam technology is the digital betacam, which is discussed in Chapter 8.)

Panasonic developed **MII** to compete with Betacam SP. It has four dedicated audio tracks, two regular and two AFM, uses metal particle tape (1,500 oersteds), and employs noise reduction. Studio and field record time can be up to 90 minutes per cassette.

S-VHS is the high-grade version of the well-known VHS consumer system and is making inroads not only in corporate production houses but in some television newsrooms. Although it boasts four audio tracks—two regular and two high-fidelity, AFM—and noise reduction, sound quality is not up to Betacam or MII standards. One reason is that it uses cobalt-based oxide tape with an oersted rating of 900. However, in a digital audio format, S-VHS serves quite well (see the discussion of digital audio recording on videotape in Chapter 8). Cassette record time can be up to 120 minutes.

Hi8 is still another entry into the industrial production market that is making inroads into broadcast production. For an analog tape that is only slightly more than ¼-inch wide, it produces sound and picture of impressive quality. It has two digital audio tracks for stereo and one mono AFM track (see 7-26). Hi8 uses either metal evaporated tape (950 oersteds) or metal particle tape (1,500 oersteds). With metal particle tape, signal-to-noise ratio, without noise reduction, can be a respectable 60 dB or better. A Hi8 cassette cartridge can record up to 120 minutes. Like S-VHS, Hi8 is also used in digital audio recording on videotape.

The problem with Hi8, in relation to sound and picture, is that with multiple dubs the audio lags behind the video. The digital audio tracks are recorded by the video heads in spurts. This "segmented" digital audio has

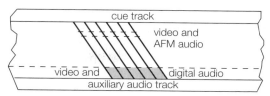

7-26 Hi8 format

to be reconstructed again into a continuous analog audio signal. The process, which takes up to ¹⁄₃₀ of a second, creates an increasingly more noticeable delay of audio behind picture with each dub.

Another problem with the Hi8 format is the same as with any new format, including the various ½-inch formats: once the television and film industries have made substantial investments in one technology it is expensive to reconvert to another technology every few years when a new format is developed. And in this discussion, we have not considered the digital videotape formats that have been developed in recent years. Moreover, as smaller formats make inroads into broadcasting and production, professionals and nonprofessionals alike have to be wary—these formats could be supplanted by solid-state systems that use even smaller tape formats.

Audio Recording on Film

Videotape has replaced film in broadcasting. Even films shown on TV are dubbed to videotape before airing. Many TV commercials are filmed, but they are transferred to videotape for broadcast purposes. In theatrical film production, between shooting and final processing, picture is dubbed to videotape to facilitate postproduction editing decisions. Yet, despite the premature reports of film's imminent demise because of videotape,

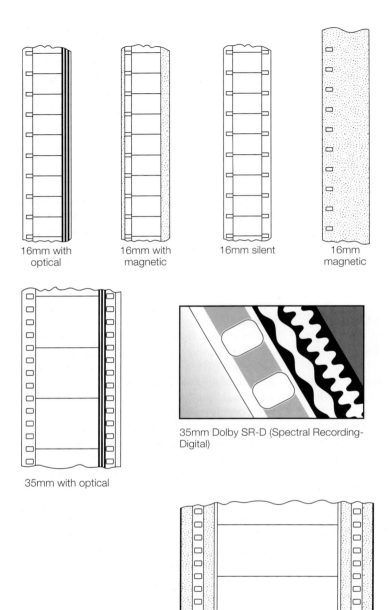

16mm with optical

16mm with magnetic

16mm silent

16mm magnetic

35mm with optical

35mm Dolby SR-D (Spectral Recording-Digital)

70mm with four magnetic tracks

7-27 Various film stock formats. Note for 35mm SR-D (see "Spectral Recording" in Chapter 9) the analog soundtrack is in its normal location. The digital soundtrack is optically recorded in blocks between the sprocket holes.

it is still integral to cinema and will be so for the foreseeable future.

Film

Picture **film** consists of a clear, plastic-base material coated with **emulsion**—tiny particles of light-sensitive silver halide that undergo a chemical reaction when struck by light.

Picture film commonly used today is 16mm, 35mm, and 70mm (see 7-27). The larger the width, the better the image and sound quality. Generally, 70mm is used in wide-screen feature films and plays only in theaters; 35mm is also used in feature films and to produce TV commercials; 16mm is used by amateur filmmakers for small-budget films.

There are three basic types of film: silent, sound, and magnetic. **Silent film**, which carries no sound information, consists of the picture area and two columns of sprocket holes, one on each edge of the film. Sixteen-mm **sound film**, which carries both picture and sound, replaces the sprocket holes on one edge of the film with an audio track that is either in the optical or magnetic stripe format. In the optical format the sound is put on the film photographically. The magnetic stripe format resembles audiotape. **Magnetic film** is similar to audiotape in that it contains all sound and no picture, and it has the same magnetic characteristics. However, magnetic film is the same size as regular film stock, and it contains sprocket holes. Magnetic film is opaque and comes either fully coated with iron oxide (also called *full coat*) or with several *magnetic stripes* of iron oxide, in which case it is transparent where there is no stripe (see 7-28).

Coercivity for analog 16mm and 35mm magnetic film recording runs between 320 and 365 oersteds. Dynamic range, signal-to-noise ratio, and frequency response are mediocre without Dolby processing. In 35mm, Dolby digital audio greatly improves film sound quality.

Double-System Recording

Film is shot using **double-system recording**. In the double-system method, sound and picture are recorded separately and in sync; the camera records the picture and a specially designed ¼-inch mono or stereo open-reel tape recorder (see Chapter 15) or an R-DAT records the sound.

After shooting, the audio is dubbed to either full-coat 16mm magnetic film or single-stripe 35mm magnetic film so the corresponding frames of picture and sound match. (Single-stripe film is used during editing and premixing 35mm because it is less expensive than multistripe and the sound quality is the same.) If sound is dubbed to videotape after shooting, time code is used to synchronize picture and sound (see Chapter 16).

The most common methods of synchronizing the sound and picture in double-system recording are using a crystal synchronizing oscillator in both camera and tape recorder or time code (time code is discussed in Chapter 16). **Crystal synchronization** regulates the camera and tape recorder motors to run at the same speed so they stay in sync. The oscillator in the tape recorder regulates tape speed to camera speed and also puts the synchronizing tone onto the tape.

Sync Tones

The tones that help to synchronize sound and picture are recorded in various ways, depending on the system used. Nagra, for example, with its *Pilot Tone* system, records

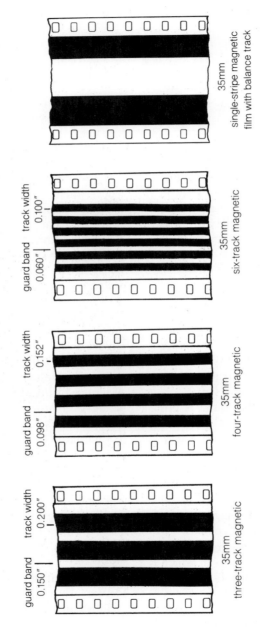

7-28 Types of 35mm multistripe magnetic film

System	Head Displacement	Track Positions ⬚⬚ audio ▬ ▬ pulse	
Pilot Tone	erase audio rec pulse rec audio PB		
Synchrotone (stereo)	erase audio rec pulse rec audio PB		

7-29 Head and track configuration for Nagra sync pulse systems

two tones down the center of the tape superimposed over the main audio signal (see Chapter 15). These two tones are 180 degrees out of phase so they cancel each other during playback and do not interfere with the sound on the main track. *Synchrotone* is used for stereo recording. It has a separate third track for pulse tone recorded down the center of the tape between the two stereo tracks (see 7-29).

Slating

One of the easiest but most important procedures in double-system sound recording is *slating*. Although the picture and sound are shot in sync, to match them properly the editor has to know the precise point at which recording began. For this purpose a **clapslate** (clapstick attached to a slate) is used (see 7-30). The clapslate is filmed just before each take, after the camera and the tape recorder have begun rolling. It serves two purposes. First, it displays the names of the production, director, and cameraperson; the number of the scene and take; the number of

7-30 Time code slate

the sound take; the date; and whether the shot is interior or exterior. Second, on top of the slate is a clapstick, which can be opened and then closed quickly to produce a loud snapping sound. This sound is the sync mark that tells the editor at exactly what point to begin synchronizing sound with picture.

a b

7-31 **Magnetic film recorder/reproducers.**
(*a*) Sound from audiotape is dubbed to the insert trans-
fer recorder, in or out of sequence. The reproducer plays
it back. Some units are reproducers only. (*b*) The re-
corder is to the left, and the reproducer is to the right.

Sound Transfer: Audiotape to Magnetic Film

Although the double-system method records the sound and picture in synchronization, there is no way to align ¼-inch audiotape and film for editing; one format has sprocket holes and the other does not. The sound must be transferred to magnetic film. Then, with sound and picture in the same format and the same length, they can be aligned and edited frame to frame.

Transferring sound from ¼-inch tape to magnetic film requires two recorders: one to play back the audiotape and a magnetic film transfer recorder to rerecord the signal on magnetic film (see 7-31). During transfer the **sync pulse** on the audiotape controls the speed of the ¼-inch machine or the transfer machine, depending on the type of transfer system used, so that it matches the speed of the camera motor.

Main Points

1. In audiotape recording, electrical signals are transduced into magnetic signals during recording. During playback the magnetic signals are transduced back into electrical signals.

2. In analog recording, signals are oriented on the tape in patterns analogous to the waveform of the original signal. In digital recording, analog signals are converted into digital information during recording and reconverted back to analog information during playback.

3. Most recording tape is composed of a thin, plastic ribbon of polyester, microscopic needlelike magnetic particles that can be magnetized, a binder of synthetic varnish so the particles adhere to the polyester, and a back coating to reduce slippage.

4. Analog audiotape comes in four thicknesses: 1½, 1, ½, and ¼ mil. Professionals prefer 1½-mil tape because it is least likely to crease, snap, or stretch, and it reduces the chance of print-through.

5. Audiotape comes in five widths — .15 inch (for cassette tape) and ¼, ½, 1, and 2 inches — to accommodate the various formats used in recording today.

6. There are several measures of a tape's ability to reproduce sound: coercivity, the magnetic force it takes to erase a tape fully; retentivity, a measure of the tape's magnetic field strength remaining after an external magnetic force has been removed; and sensitivity, the output level a tape can reproduce.

7. Some tape is made for special purposes. Low-print-through tape has lower retentivity and sensitivity so it can handle lower energy levels, thus reducing the chance of magnetic information transferring from one tape layer to another. High-output tape has higher coercivity and sensitivity and, therefore, is capable of reproducing higher output levels.

8. Cheap tape can have several defects, which may cause dropout, clinching, ridging, adhesion, cupping, and curling. All adversely affect sound quality.

9. Tape should be carefully handled. The tape surface can be sullied by fingerprints, smoke, and dust, and the tape reels can be damaged by being stacked one upon the other. Tape should be stored tails out in a controlled environment of 60 to 75 degrees Fahrenheit and 40 to 60 percent humidity.

10. The three essential sections of a tape recorder are the tape transport system, the magnetic heads, and the record and playback electronics.

11. A number of controls operate the transport: the power switch, selectable and variable speed control, play, record, stop, fast forward, rewind, and the tape edit release.

12. An important function of the transport system is to restrict tape movement as it passes across the heads. This is to prevent wow — instantaneous variations in tape speed at moderately slow rates — and flutter — friction between the tape and tape heads or guides resulting in volume changes.

13. Analog tape recorders run at various speeds: $1\frac{7}{8}$, $3\frac{3}{4}$, $7\frac{1}{2}$, 15, and 30 ips. The faster the speed, the better the sound quality.

14. Most professional analog tape recorders have three heads: erase, record, and playback. Many newer models also have a fourth head for time code.

15. Because the magnetic particles on tape respond to magnetization nonlinearly (they cannot make sense of the information carried by the input signal), the record head has a high-frequency bias current that linearizes the magnetic information so it can be encoded on the tape.

16. The position of the heads is critical, and any change in their alignment — zenith, height, tangency, wrap, or azimuth — adversely affects sound quality.

17. Heads should be demagnetized and cleaned before use.

18. A multitrack analog tape recorder has a headstack that contains 4, 8, 16, or 24 separate tracks, allowing individual control of each recorded element. Headstacks may be conventional- or narrow-gauge. For example, an 8-track conventional-gauge head is used with 1-inch tape; an 8-track narrow-gauge head may be used with $\frac{1}{4}$- or $\frac{1}{2}$-inch tape. A 16-track conventional-gauge head is used with 2-inch tape; a 16-track narrow-gauge head may be used with $\frac{1}{2}$- or 1-inch tape.

19. Multitrack tape recorders have Sel Sync, which temporarily changes selected

tracks on the record head into the playback mode. This permits various elements in a recording to be taped synchronously at different times.

20. Cartridge tape is a continuous loop of highly lubricated, standard, 1½-mil, ¼-inch tape. Carts come in lengths from 20 seconds to 40 minutes.

21. Cartridge tape recorders play a continuous tape loop that winds until it reaches a cue tone and then automatically stops, recued. Carts eliminate threading and cut down the time it takes to cue and play tape.

22. Because cart machines have no erase head, cartridge tapes must be erased before they are reused, either on a bulk eraser specially designed for carts or on a cartridge machine equipped with only an erase head.

23. A primary cue tone is put on a cartridge tape during recording to stop it after playback. Some machines also have secondary and tertiary cue tones to increase cueing capability.

24. Cassette tape is reel-to-reel tape in an enclosed cartridge. Analog cassettes are ½ or ¼ mil thick and .15 inch wide and come in several lengths, from 30 to 180 minutes.

25. Due to the dimensions and playing speed of the analog cassette, its sound quality generally has not been acceptable for broadcast. Successful efforts to change this have been made with chromium dioxide, cobalt-treated oxide, and metal-particle tape, with improved circuitry, and with noise reduction. These measures have widened the frequency response, increased output level and dynamic range, and improved the signal-to-noise ratio.

26. Videotape recording, basically, encodes a video track, two or three audio tracks, a control track, and an address or time code track.

27. The analog videotape formats in most common use today are 1-inch C-Format; ¾-inch U-matic and U-matic SP; ½-inch Betacam, Betacam SP, MII, and S-VHS; and 8mm and Hi8mm.

28. There are three types of film: silent, sound, and magnetic.

29. Sound film comes in an optical format, in which the sound is put on the film photographically, and in a magnetic stripe format, which resembles audiotape.

30. Magnetic film is the same size and shape as regular film but is used only for sound; it contains no picture.

31. Film is recorded using the double-system sound process—sound recorded by an audiotape recorder and film recorded by a camera separately but simultaneously and in synchronization.

32. In double-system recording, a clapslate is used to make a visible and audible sync mark on the film and tape, respectively. This helps in identifying and synchronizing scenes during their transfer from audiotape to magnetic film and in editing.

Digital Recording

Since its development at the end of the 19th century, magnetic recording has been done by the analog method—encoding and decoding a signal whose waveform is similar to the waveform of the original signal (see 7-1). Tape recording, in general, and the analog method, in particular, have several advantages: convenience, flexibility, portability, relatively cheap cost, and comparatively good fidelity. Yet, of all the links in the sound chain, except for loudspeakers, tape recording is the weakest; it is the main inhibitor in achieving better signal-to-noise ratio.

Analog recording is subject to any number of sonic anomalies such as crosstalk, wow and flutter, distortion, degeneration of sound quality in tape-to-tape dubbing, and print-through. Under the best conditions analog recording is never noise-free; if tape is over-polarized or underpolarized, noise becomes an even greater problem. The best analog recording produces a dynamic range of 80 dB to 90 dB. Much analog recording, however, is in the 65 dB to 70 dB range, roughly half the dynamic range that is possible with live sound.

Digital Recording

In the late 1960s a new method of recording sound for commercial purposes was developed. This method, known as digital recording,

converts analog signals into coded pulses that are recorded on the tape. This format is also known as **pulse code modulation** (**PCM**). The pulses do not resemble the waveform of the original signal. They are actually samples of the original information. Upon playback the pulses are reconverted into analog information. In **digital recording**, signals are noncontinuous—that is, they are either on or off and represented in a binary code of zeros and ones (see 8-1).

Digital processing results in greatly increased dynamic range and considerable reduction of the noise and distortion of analog recording. But digital recording is more costly than analog, and if top-notch equipment and techniques are used, sound quality in analog recording can be quite impressive.

The Digital Recording Process

The process of converting analog signals into a digital format involves four basic steps: anti-aliasing, sampling, quantizing, and coding (see 8-2).

Anti-Aliasing

In the conversion of analog to digital, the input signal may contain very high frequencies beyond the need and means of digital processing in audio recording. Although these frequencies are above the range of human hearing, if they are not filtered out before the sampling stage, they will be transferred or aliased into the audible frequency range during recording and playback.

To prevent aliasing, the input signal must first go through a **low-pass filter**—a device that cuts off all frequencies above a preset point and permits only those frequencies below that point to pass through (see Chapter 9). This **anti-aliasing** stage eliminates the unwanted high frequencies before sampling and, therefore, before any processing occurs.

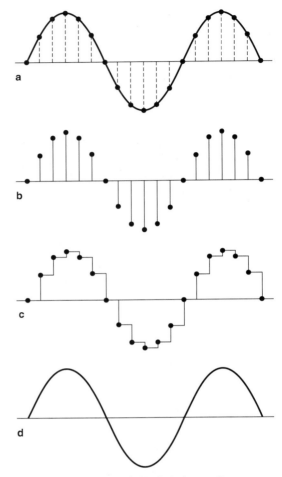

8-1 **Representation of the digital recording process.** (*a*) The analog signal is sampled at the input. (*b*) These samples are stored as numerical values (see 8-4). (*c*) These samples form a representation of the original analog signal. (*d*) The "representation" is smoothed at the output when the original waveform is recovered.

Sampling

As we said earlier, in analog recording the waveform of the signal on the tape is similar to the waveform of the original signal. In digital recording, the process of **sampling** involves samples (voltages) of the original signals taken at fixed intervals and coded into

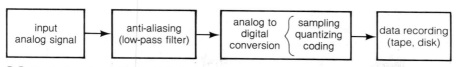

8-2 Basic steps in analog-to-digital conversion

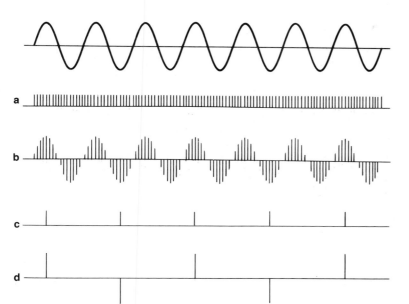

a

b

c

d

8-3 Sampling. A signal (*a*) sampled frequently enough (*b*) contains sufficient information for proper decoding. (*c*) Too low a sampling rate (*d*) loses too much information for proper decoding.

pulses that are a representation of the original waveform. The rate at which the fixed intervals sample the original signal is called the **sampling frequency**.

It was determined several years ago that if the highest frequency in a signal were to be successfully encoded, it had to be sampled at a rate at least twice its frequency.* In other words, if high-frequency response in digital

recording is to reach 20,000 Hz, the sampling frequency must be at least 40,000 Hz. Too low a sampling rate would cause loss of too much information and perhaps introduce distortion (see 8-3).

Think of a movie camera that takes 24 still pictures a second. A sampling rate of $1/24$ second seems adequate to record most visual activities. Although the camera shutter closes after each $1/24$ second and nothing is recorded, not enough information is lost to impair perception of the event. A person running, for example, does not run far enough in the split second the shutter is closed to alter the naturalness of movement. If the

*This concept was developed by a Bell Laboratories researcher named Harry Nyquist. To honor this discovery, the sampling frequency has been named the Nyquist frequency.

sampling rates were slowed to one frame a second, the running movement would be quick and abrupt; if it were slowed to one frame every minute, the running would be difficult to follow.

For practical and economic reasons (see section on formats), digital audio today uses essentially four sampling rates: 32, 44.056, 44.1, and 48 kHz. Thirty-two kHz is the international sampling rate used for broadcast digital audio. Because maximum bandwidth in broadcast transmission is 15 kHz, 32 kHz is sufficient. For laser disc, compact disc, and for digital tape recording, however, 44.056, 44.1, and 48 kHz, respectively, are used.

Many people believe that higher sampling frequencies are necessary to realize fully the potential of digital sound.

Quantizing

As samples of the analog waveform are taken, they are converted by a process known as **quantizing** into discrete quantities or values called *quantizing levels*. If two quantizing levels are encoded, two discrete values represent the infinite number of values of the original analog waveform; if eight quantizing levels are encoded, eight discrete values represent the original analog waveform. Therefore, the greater the number of quantizing levels, the more accurate the digital representation of the analog signal. This being so, then, how can a representation of the original signal be better than the original signal itself?

Assume that the original analog signal is an ounce of water with an infinite number of values (molecules). The amount and "character" of the water changes with the number of molecules; it has one "value" with 500 molecules, another with 501, still another with 2,975, and so forth. But all together the values are infinite. Moreover, changes in the

original quantity of water are inevitable: Some of it may evaporate, some may be lost if poured, and some may be contaminated or absorbed by dust or dirt.

But what if the water molecules are sampled and then converted to a stronger, more durable form? In so doing, a representation of the water would be obtained in a form from which nothing would be lost. Sufficient samples would have to be obtained, however, to make sure that the character of the original water is maintained.

For example, suppose the molecule samples were converted to ball bearings and a quantity of 1 million ball bearings was a sufficient sample. In this form the original water is not vulnerable to evaporation or contamination from dust and dirt. Even if a ball bearing is lost, they are all the same; therefore, losing one ball bearing does not affect the content or quality of the others.

Coding

As samples of the analog signal are quantized, these voltages are converted through the process of **coding** into a code of *binary digits* (*bits*) composed of a series of pulses. A binary digit is a numeral with only two symbols, 0 and 1. In analog-to-digital conversion the presence of voltage is signified by a 1, and the absence of voltage is signified by a 0.

A quantity expressed as a binary number is referred to as a digital word. If a quantity is expressed as 001, the digital word is three bits; 0101 is a four-bit word; 01010 is a five-bit word, and so on. Each bit permits two discrete levels of quantification. Therefore, a two-bit word can quantify four levels—00, 01, 10, 11; a three-bit word can quantify eight levels—000, 001, 010, 011, 100, 101, 110, 111; and so on. In other words a word of n bits yields 2^n discrete levels. So the more quantizing levels there are, the longer the digital word must be (see 8-4).

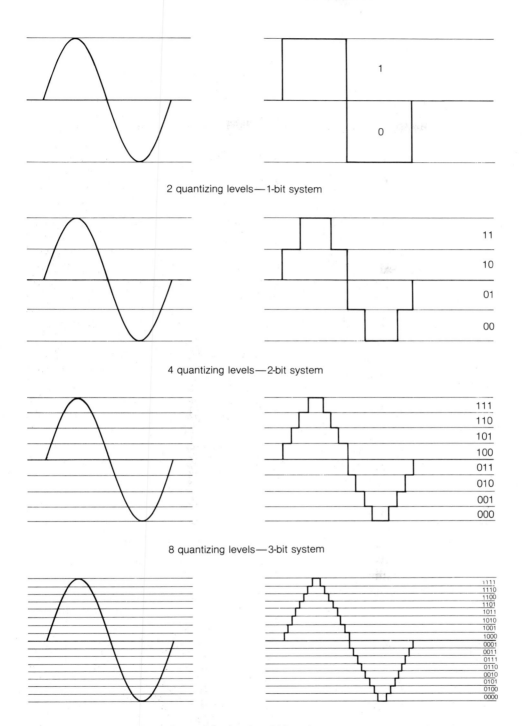

2 quantizing levels—1-bit system

4 quantizing levels—2-bit system

8 quantizing levels—3-bit system

16 quantizing levels—4-bit system

8-4 Coding. As the number of quantizing levels increases, the digital representation of the analog signal becomes more accurate.

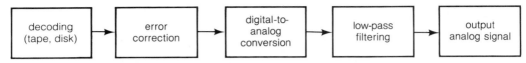

8-5 **Basic steps in reconverting digital to analog**

In quantizing the analog signal into discrete binary numbers (voltages), noise, known as quantizing noise, is generated. The signal-to-noise ratio in an analog-to-digital conversion system is 6 dB for each bit. It has been generally agreed, at least for now, that a 16-bit system is sufficient to deal with quantizing noise (although some digital formats may use a 20-bit system). This, therefore, gives digital sound a signal-to-noise ratio of 96 dB (6 dB × 16-bit system), which is significantly better than anything most analog recording can produce.

Reconverting Digital to Analog

Reconverting digital information back to analog information begins with correcting errors in the digital pulses. It continues with changing the pulses back into analog signals and, finally, filtering unwanted high frequencies from these signals (see 8-5).

Digital Audiotape

There are several essential differences between the types of audiotape used for analog and digital recording.

First, digital tape does not have to be as thick as tape used for analog recording; the magnetic coating, in particular, does not need to be as thick. In the analog system, varying signal strengths recorded on the tape correspond to the different levels from the input signal. To a great extent the thickness of the oxide coating determines the tape's signal-to-noise ratio. Moreover, saturating the tape with too much signal must be avoided.

In digital recording the sampling frequency is constant and at each sample the tape is saturated with a series of pulses. There is no resultant distortion because the digital system only has to deal with the presence (1) or absence (0) of a pulse. Therefore, tape thickness is not a factor in the tape's ability to reproduce dynamic range.

The total thickness of digital tape (base, back, and magnetic coating) is about ½ mil less than the analog tape used professionally (which is 1½ mil). This, plus the sampling rates, affects recording times on the various-size open reels (see Table 8-1).

Second, the coercivity of non-metal tape used for digital recording is about twice that of analog tape. Greater coercivity is needed to retain the very short wavelengths of the higher frequencies and the densely packed digital information, which is about 10 times that stored in analog recording.

Third, any tape requires care in handling, but digital tape requires more care than analog tape. It is essential that the working area be as free from dust and dirt as possible. Temperature and humidity should be kept within ranges of ±10 percent. Oils from the hands can cause degradation of the quality of both the magnetic and back coatings. If tape is soiled, it should be wiped gently with a soft cloth. Tape recorder heads must be completely dry from cleaning liquids before digital tape is used.

Table 8-1 Recording times for open-reel digital tape

Format	Sampling Rate (kHz)	Tape Speed (ips)	Tape Width (inches)	Playing Time (minutes) per Reel Size			
				7-inch	*10½-inch*	*12½-inch*	*14-inch*
DASH-S (slow)	44.1	6.89	¼	69	139	208	
	48	7.5	¼	63	127	191	
Twin-DASH	44.1	13.67	¼	34	69	104	
(slow and medium)	48	15	¼	31	63	95	
DASH-F (fast)	44.1	27.56	½				65
	48	30	½				60
PD (Pro Digi)	44.1						
	48	7.5	¼				240
	44.1						
	48	15	¼				120
	44.1						
	48	30	½				60
	44.1						
	48	30	1				60

Digital Audiotape Recorders

Digital audiotape recorders are divided into two categories: stationary head and rotary head.

Stationary Head Digital Audio Recording

In the early stages of the digital audio revolution, as manufacturers rushed to the marketplace with their "unique" digital ATR designs, the need to standardize became clear almost at once. About the only things the digital ATRs had in common were their operational functions, such as "Play," "Record," "Fast Forward," and so on, functions similar to those in analog ATRs.

Some digital ATRs operated at the familiar speeds of 7½, 15, and 30 ips, but others ran at such speeds as 22½, 25, 35, or 45 ips. Head configurations, tracks formats, sampling rates, and other technical specifications differed. In short, most designs were incompatible with one another. Fearing chaos, and at the urging of the Audio Engineering Society (AES), some companies agreed to attempt to standardize digital formats. Although the results, so far, are less than satisfactory, at least stationary head digital tape recording now has greater design and format compatibility.

Formats

Two formats are currently being used by most companies producing stationary head digital ATRs: the **DASH** (*Digital Audio Stationary Head*) **format** used by Sony, Studer, Matsushita, and TEAC; and the **PD** (*Professional Digital* or *Pro Digi*) **format** used by Mitsubishi and Otari.

DASH Format The DASH format is not so much one format as it is a family of formats.

Track Density and Channel Numbers				
Tape Width	1/4"		1/2"	
Track Density	Normal	Double	Normal	Double
Digital Tracks	8	16	24	48
Aux. Tracks	4	4	4	4
Fast	8	16	24	48
Medium	TWIN DASH 2	8	—	24
Slow	2	4	—	—

(left row label spanning Fast/Medium/Slow: Digital Audio Channels)

Tape Speed and Sampling Rate			
Sampling Rate	Tape Speed		
	Fast	Medium	Slow
48kHz	30 ips	15 ips	7.5 ips
44.1kHz	27.56 ips	13.78 ips	6.89 ips

8-6 DASH formats

It specifies sampling frequency, tape format, track geometry, packing density, and error correction for 2-channel to 48-channel digital tape recorders using ¼-inch or ½-inch tape, respectively (see 8-6).

A stereo DASH single-density recording on ¼-inch tape actually records 12 tracks on the tape (see 8-7). In the slow speed 8 digital audio tracks would be used for 2 audio channels. At medium speed the 8 digital tracks are used for either 4 audio channels or, in the Twin-DASH format, 2 audio channels (Twin-DASH was developed to increase error protection in heavy-duty usage). At fast speed the 8 digital audio tracks could be used for 8 audio channels. Four auxiliary tracks are used for stereo analog cue track recording and for a time code track and a control track. With DASH ½-inch tape using fast speed in the single-density mode, for example, 28 tracks are recorded: 24 digital audio tracks and 4 auxiliary tracks for cue, time code, and control track recording (see 8-8).

Double-density recording, known as DASH II, packs more digital audio channels

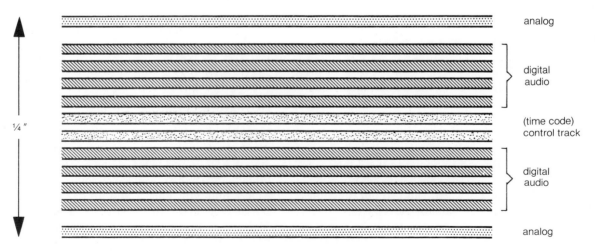

¼"

analog

digital audio

(time code) control track

digital audio

analog

8-7 Twelve tracks of a DASH single-density recording on ¼-inch tape

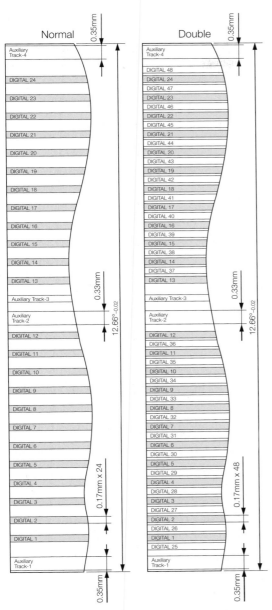

8-8 DASH ½-inch normal and double density formats

and tracks onto the ¼- and ½-inch tape. This is made possible by the thin-film heads that are used instead of the conventional ferrite heads.

PD Format There are several differences between the DASH and PD formats. Although most are too technical for discussion here, listing a few should provide at least a superficial understanding of their dissimilarities.

One difference is that the PD format supports three tape widths: ¼-inch for stereo recording; ½-inch for 16-channel recording; and 1-inch for 32-channel recording. One-quarter-inch machines operate at 7½ ips, encoding data in high-bit density, and at 15 ips, encoding data in high- or low-bit density. One-half-inch and 1-inch machines operate at 30 ips with medium-bit data density (see Table 8-2).

Another important difference between PD and DASH is the absence of a specific control track in PD. A **control track** is used to provide information for tracking control and tape speed. PD integrates this information on each main data track.

The ¼-inch format consists of 10 tracks: 8 digital audio tracks (6 for audio signal data and 2 parity tracks for error correction) and 2 auxiliary tracks (1 analog track for tape cueing and 1 analog track for time code (see 8-9). One-half-inch and 1-inch PD-formatted tape recorders encode 24 and 45 tracks, respectively.

Head Configuration

In digital audio, using the conventional analog head configuration—erase, record, playback—would make editing, particularly cut-and-splice editing (see Chapter 16), synchronous recording, and overdubbing (see

Table 8-2 Pro Digi formats

	PD 2-channel *high rate*	PD 2-channel *low speed*	PD 2-channel *high speed*	PD 16-channel	PD 32-channel
Tape Speed (ips)	15	7.5	15	30	30
Tape Width (inches)	¼	¼	¼	½	1
Sampling Frequency (kHz)	96	48 and 44.1	48 and 44.1	48 and 44.1	48 and 44.1
Quantization (linear PCM)	16- or 20-bit	16- or 20-bit	16- or 20-bit	16-bit	16-bit
Number of Tracks	12	12	12	24	45
Tracks per Channel	4	4	4	1.25	1.25
Bit Density (thousands of bits per inch)	40	40	20	29.9	29.9

8-9 Pro Digi ¼-inch track format

Chapter 14), as well as other operations, extremely difficult. Recording and reproducing digital information requires head functions and head configuration different from those in analog. There are several arrangements in digital audio, but two examples should illustrate the point.

In one ¼-inch stereo design there is an advanced or forward record head—the **write head**—and playback head—the **read head**. The **write-sync head** is a second record head next to the playback head. There is no erase head. An operation called *overwriting* is used instead. The first recording head is used during normal recording; the second one is used to synchronize new audio with prerecorded audio. The distance between the playback head and the sync head is adjusted to match the decoding and encoding delay of the two heads. Some digital ATRs may also have an analog head to facilitate cut-and-splice editing and performance of conventional erase, record, and playback functions (see 8-10).

In one digital multichannel design there are erase, record-1, playback, and record-2 (sync) heads (see 8-11). The record-1 and playback heads are used for playback after record, and the playback and record-2 heads are used for sync recording.

Stationary Head Digital Audiocassette Recorders

The **stationary head digital audio recorder** (**S-DAT**) uses a fixed, instead of a rotating, head. Until recently, it was not given much of a chance against R-DAT, discussed in the next sections. The main problems with S-DAT are the limited recording time per cassette and mechanical problems with the fixed head design in relation to the sonic requirements of digital audio. One viable use of S-DAT

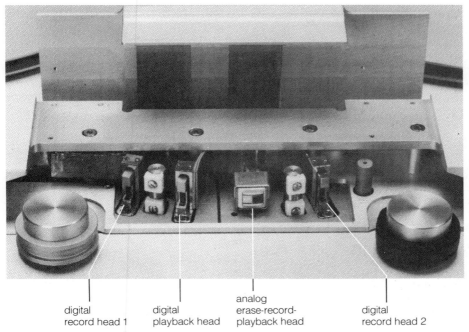

digital digital analog digital
record head 1 playback head erase-record- record head 2
 playback head

8-10 **Head block of one type of ¼-inch digital ATR**

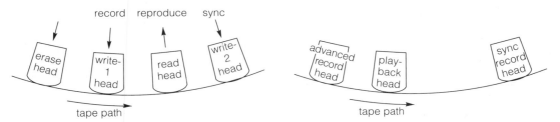

8-11 **Head blocks for two different multichannel digital ATRs**

was designing the concept into a multitrack digital recorder and integrating it into a console (see 8-12). But recording time per cassette is only about 20 minutes with the system shown in 8-12.

The Dutch conglomerate Philips, developer of the compact analog cassette, has also developed its digital successor: the **digital compact cassette** (DCC). It was introduced

for the consumer market, but it holds implications for the broadcast industry in a stationary head design. Although it has a fixed head, the DCC's coding, tape formulation, and mechanism differ significantly from the earlier S-DAT design. The DCC records and plays back 18-bit stereo digital audio, supports three sampling frequencies (48 kHz, 44.1 kHz, and 32 kHz), has a dynamic range

tape housing

8-12 S-DAT digital mixer/recorder

of 105 dB, and produces CD-quality audio. Signal-to-noise ratio can be as wide as 90 dB.

The DCC runs at 1⅞ ips, the same as analog cassette. It is similar to the chrome-type tape used in video, with a cobalt-treated magnetic coating that is slightly narrower and thinner than R-DAT tape. The digital compact cassette records bidirectionally (the tape cannot be turned over; the tape recorder heads invert at the end of a side). The casing sizes of the DCC and compact analog cassette are the same. The single head combines both digital and analog transducing, which makes it possible to play back analog cassettes. There is no erase head; you rerecord over the previous track. Tape time of up to 120 minutes per digital compact cassette is possible.

Rotary Head Digital Audio Recording

Storing video information on tape requires a different recording system than the one used to record sound in fixed-head formats. Due to the considerable bandwidth it takes to

store video, very high tape speeds are necessary. In a stationary head format the tape speed would have to be many times faster than the 30 ips of today's fastest ATRs and it would take thousands of feet of tape to make a video recording. Therefore, instead of increasing longitudinal tape speed in video recording, the videotape head rotates at very high speed (2,000 revolutions per minute in rotary head digital audiotape recording). This creates the tape-to-head velocity essential for the wide bandwidth to store video information without requiring faster longitudinal tape speeds. This technique is called **helical scanning,** due to the somewhat spiral shape of the tape when it is threaded around the head assembly (the Greek word for spiral is *helix*).

Helical videotape recording has not only made it possible to record picture on tape, but to produce digital sound on audiocassette and on videocassette. With videocassette, instead of using the narrower longitudinal audio tracks laid down by the fixed audio heads, the wider video portion of the tape is used to encode the digital audio signals. To-

day, digital audio on cassette can be produced in stereo and multitrack.

Rotary Head Digital Audio Recorders

The **rotary head digital audio recorder** (**R-DAT**, commonly known as DAT) has the wide dynamic range, low distortion, and immeasurable wow and flutter common to digital audio. Although the DAT uses cassette tape, it equals or exceeds many standard digital specifications.

DATs usually operate at two sampling frequencies: 44.1 kHz or 48 kHz. Many DATs include a third sampling frequency of 32 kHz. A few also use 44.056 kHz. Recording and playback can be done at all sampling rates. Originally, 44.1 kHz was a playback-only mode to discourage unlawful copying of prerecorded DAT tapes and compact discs. Consumer units still cannot duplicate this sampling rate in the record mode. Many professional DATs, however, do provide recording at 44.1.

Most DAT recorders have a longitudinal tape speed of about $\frac{1}{3}$ ips, $\frac{1}{6}$ the speed of analog cassette recorders. The very slow speed does not affect sound quality, however, due to the high speed of the head drum and digital processing of the audio signal. Most digital audiocassettes have a two-hour running time at the 44.1 kHz and 48 kHz sampling rates.

DAT specifications provide for four record/playback modes: standard record/play speed; record/play option 1; record/play option 2; record/play option 3. Standard record/play records two (stereo) channels using the 48 kHz sampling rate. This speed must be supported in all DAT equipment. Record/play options 1, 2, and 3 provide for the 32 kHz sampling rate. In option 1, two (stereo) channels are provided with 16-bit linear quantization. Option 2 also supports two (stereo) channels, but tape speed is half that of most DATs and has only 12 bits of resolution that is nonlinear—the amplitude steps are not all the same size. All this results in reduced sound quality but increased tape time, up to four hours. Option 3 is a combination of options 1 and 2. Speed and data rate are the same as in option 1 but fidelity is comparable to option 2 because this mode uses four channels instead of two. The chief advantage of option 3 is that it enables four-channel multitrack recording.

DAT has other advantages. For example, the encoding of nonaudio data permits automatic cueing to a particular selection, skipping over selections, and numbering selections. In addition, a high-speed search function facilitates quick search-to-cue spooling. DAT machines are available in portable, light-weight cassette-size units, as well as in nonportable studio models (see 8-13 and 8-14).

R-DAT Audiocassette Tape

Audiocassette tape for R-DATs is about $\frac{1}{7}$-inch wide, slightly wider than the standard analog audio cassette. Tape thickness is similar to that of a 90-minute analog cassette (30 microns). The cartridge itself is half the size of an analog cassette and the length of tape in a cartridge is one-fourth that of an analog cassette. Most digital audiocassette tape is metal particle, not lower than 1,500 oersteds.

Although the tape is enclosed in a plastic cartridge, its thinness and the density of encoded information (114 million bits per square inch) make the tape and data extremely susceptible to damage from dirt, dust, and mishandling, especially because the track width of the encoded data is about one-tenth the thickness of a human hair (see 8-15).

Front Panel Description

(1) REC key/LED: Starts recording. The LED illuminates during recording

(2) REC PAUSE key/LED: Pauses recording. The LED illuminates while in pause mode

(3) S-ID key: Records a START .D while recording

(4) ERROR MARK key: Records an ERROR MARK while recording

(5) SLATE switch: Records a 1kHz slate tone, or the sound picked up by the internal microphone on both audio channels

(6) SLATE MICROPHONE: A condenser type microphone

(7) LIMIT switch: Switches the internal limiter on/off

8-13 R-DAT recorder/reproducer and its functions

(8) MESSAGE RESET switch: Clears the error message currently shown on the LCD

(9) OVER LOAD LED: Illuminates when the microphone or line signal is clipped (CH1 and CH2)

(10) PCM ERROR LED: Lights green when the BER (block error rate) is greater than 1% and red when the BER is greater than 10% (1 block = 288 bits; 1 track = 196 blocks)

(11) LIGHT switch: Switches on the internal lights for viewing the cylinder drum and the LCD side light

(12) TC MONITOR switch: Monitors the TC using the internal speaker and headphones (TC = time code)

(13) JAM switch: Synchronizes the tape recorder's internal TC generator with the external TC source, allowing you to disconnect the external TC and let the tape recorder's internal TC generator continue striping the tape (free-run mode)

(14) MONITOR LEVEL: Adjusts the volume of the monitor speaker

(15) PHONES LEVEL: Adjusts the volume of the headphones

(16) METER switch: Selects the source for the LCD bargraphs: INPUT or follow the REC MON switch

(17) REC MON switch: Selects the monitor source: INPUT or REPRO. During recording REPRO allows off tape "confidence" monitoring

(18) PHONES MODE switch: Selects the headphones mode: MONO/STEREO, LEFT only/RIGHT only, MS mono/MS stereo

(19) PHONES ST/MONO: Used in conjunction with the PHONES MODE switch

(20) PHONES JACK: Headphone connection

(21) LCD: See detail on the following page.

(22) FUNCTION KEYS: See detail below.

(23) CH1 CH2 Record level controls: Adjusts the level of signal recorded on to tape

(24) GANG/NORMAL LEVER: Gangs the record level controls together, or normal allows independent channel record level setting

Function Keys

(A) A-TIME LOCATE key: Enters an A-TIME value that is to be used for locating

(B) TC LOCATE key: Enters a TC value that is to be used for locating

(C) PNO LOCATE key: Enters a PNO that is to be used for locating (PNO = program number)

(D) MARK 1 / >> key: Stores the current A-TIME value in memory as MARK 1. Also used as the right cursor key when entering or editing numeric values

(E) TAPE REMAIN key: Shows the remaining time on tape

(F) RCL key: Sets the real time clock. TC generator start time. PNO starting number and edit MARK 1 & 2

(G) DATE DISPLAY key: Displays the current date and time. When playing a tape, the date information recorded in the sub code will be displayed

(H) MARK 2 / << key: Stores the current A-TIME value in memory as MARK 2. Also used as the left cursor key when entering or editing numeric values

(I) COUNTER key: Uses a linear tape counter instead of A-TIME

(J) CUE key: Cue mode: monitor off tape during F.FWD and REWIND

(K) END-ID REC key: Records an END ID while recording

(L) LOC-M1 / QUIT key: Locates to the MARK 1 A-TIME value. Also used as the QUIT key when using the soft functions

(M) CLR key: Resets the linear tape counter. Sets numeric values to zero when in edit mode and resets the peak hold function when using manual reset mode

(N) BATTERY CHECK key: Checks the battery voltage under any load condition

(O) HEATER key: Pre-heats the cylinder drum to prevent dewing

(P) LOC-M2 / EXECUTE key: Locates to the MARK 2 A-TIME value. Also used as the EXECUTE key when using the soft functions

LCD

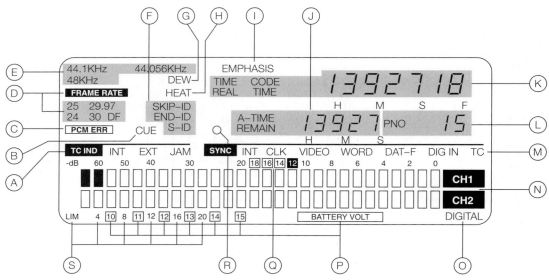

(A) TC mode indicator: Indicates the TC source: INT, EXT, or JAM operation

(B) CUE mode indicator: Indicates that CUE mode is on

(C) PCM ERROR indicator: Flashes when a PCM error occurs

(D) FRAME RATE indicator: Indicates the currently selected TC frame rate

(E) SAMPLING FREQ indicator: Indicates the currently set sampling frequency

(F) SKIP-, END-, S-ID indicator: Indicates the type of ID marker that is recorded, or being recorded on tape

(G) DEW indicator: Indicates that dew has been detected on the tape transport

(H) HEATER indicator: Indicates that the internal heater is on

(I) EMPHASIS indicator: Indicates that the EMPHASIS switch is on

(J) A-TIME field: Displays the A-TIME

(K) TIMECODE field: Displays the TC value

(L) PNO field: Shows the current PNO

(M) SYNC mode indicator: Indicates the current SYNC mode: INT CLK, VIDEO, WORD, DAT-F, DIG IN or TC

(N) Bargraph level meters: While recording these meters show the level of the signal being recorded to tape. During playback they show the signal level recorded on the tape

(O) DIGITAL INPUT indicator: Indicates that a digital input signal corresponding to the consumer (SP DIF) or professional (AES/EBU) is connected at the DIGITAL IN connector

(P) BATTERY VOLTAGE: Shows when the battery check function is being used

(Q) REFERENCE LEVEL marker: Shows the current setting of the reference level marker

(R) ERROR MARK indicator: Indicates that an ERROR MARK has been recorded onto tape

(S) LIMITER indicator: Indicates that the limiter is currently on

Top Panel

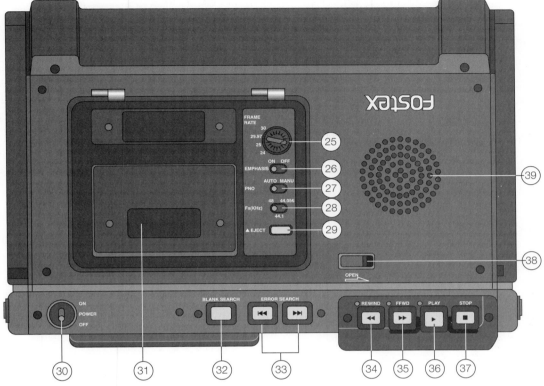

Top Panel Description

(25) FRAME RATE selector: Sets the TC frame rate of the INT TC generator

(26) EMPHASIS switch: Records an analog source with emphasis

(27) PNO switch: Records program numbers either MANUALLY by pressing the S-ID key, or AUTOMATICALLY when recording is started

(28) Fs SELECT switch: Sets the sampling frequency for analog recording

(29) EJECT key: Ejects the cassette

(30) POWER SWITCH: Switches on the power

(31) Tape transport and cover: Tape insertion slot and protective cover

(32) BLANK SEARCH key: Searches for an END ID, or if there is no END ID, the blank section of tape after the last recording

(33) ERROR SEARCH keys: Searches for ERROR MARKS

(34) REWIND key: Starts rewind mode. Press once for slow (× 5), or twice for fast (× 100). Repeated pressing will toggle between slow and fast rewind

(35) F.FWD key: Starts fast forward mode. Press once for slow (× 5), or twice for fast (× 100). Repeated pressing will toggle between slow and fast forward

(36) PLAY key: Starts play mode

(37) STOP key: Stops all tape transport modes. Press once for pause mode and twice for stop mode. Repeated pressing will toggle between pause and stop mode

(38) Protective cover open lever: Opens the protective cover

(39) MONITOR SPEAKER: Internal speaker used for monitoring

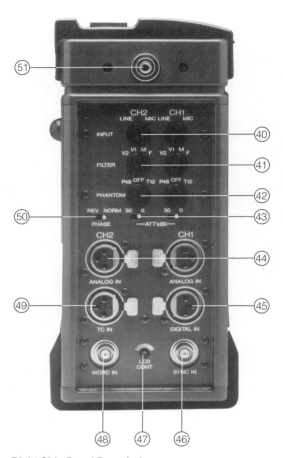

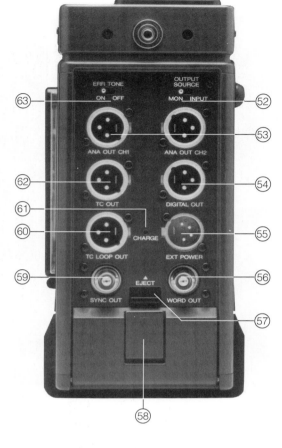

Right Side Panel Description

(40) INPUT switch: Selects microphone or line for analog recording

(41) FILTER switch: Selects a filter type for microphone recording

(42) PHANTOM switch: Phantom powering for condenser type microphones

(43) ATT switch: Input gain attenuator for microphone recording

(44) ANALOG IN: Balanced analog-input signal connection

(45) DIGITAL IN: Digital input connection for AES/EBU professional and consumer (SP DIF) formats

(46) SYNC IN: Synchronizing-video, or DAT frame input connection

(47) LCD CONTRAST: Adjusts the contrast of the LCD display

(48) WORD SYNC IN: Synchronizing-wordclock input connection

(49) TC INPUT: Balanced external TC input connection

(50) PHASE switch (CH 2): Reverses the phase of CH 2 microphone input

(51) Shoulder strap fixing stud: Shoulder strap fixing point

Left Side Panel Description

(52) ANALOG OUTPUT SOURCE: Sets the output source to INPUT or MON

(53) ANALOG OUT: Balanced analog-output signal connection

(54) DIGITAL OUT: Digital output connection for AES/EBU professional and consumer formats

(55) EXT POWER: External power supply connection

(56) WORD SYNC OUT: Wordclock output connection

(57) BATTERY EJECT lever: For removing the Ni-Cd battery

(58) BATTERY DOOR open button: Opens the door of the battery compartment

(59) SYNC OUT: Video-frame sync pulse output connection

(60) TC LOOP OUT: Balanced output of TC applied at the TC INPUT connection

(61) CHARGE INDICATOR: Lights red during normal charging, and green during trickle charging

(62) T.C. OUTPUT: Balanced TC output connection

(63) ALARM TONE switch: Sounds a 1kHz error tone in the following situations: PCM error, input amplifier clipping, and battery low charge condition

8-14 **Digital audio multitrack recorder with remote controller.** This model can record 108 minutes of digital audio on a standard Hi-8mm videotape.

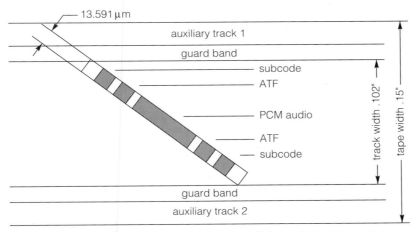

8-15 **Tape pattern of an R-DAT recorder.** Actual digital audio data is recorded on center portion of tape. The width of each data bit is 13.591 microns, about ¹⁄₁₀ the thickness of a human hair. ATF (automatic track finding) pilot signal is used for servo track alignment. Subcode data enables rapid program access.

Bulk erasing cannot totally eliminate the recorded signal on the high-density DAT tape surface. A recorded signal can only be completely removed by rerecording.

Many DAT recorders have a moisture prevention cut-off to help protect the tape. Any moisture entering the unit from the tape stops the recorder, which then heats up to evaporate the moisture. When the unit is dry, it begins to function again.

NT (Nontracking) Tape Format

Another helical-scan cassette tape recorder design is the **NT** (*nontracking*) **tape format**. It was developed by Sony for the consumer market to replace the analog microcassette, but it has significant professional implications.

The nontracking format has a specialized small rotary head drum that spins at 3,000 rpm. That and the capstan are the only external elements that are engaged into the cassette during operation. Tape guides and pressure rollers are built into the cassette shell. Tape speed is ¼ ips.

The NT format uses the 32-kHz sampling rate and 12-bit nonlinear coding. This provides 15-kHz stereo audio and 86-dB dynamic range, making it adequate for broadcast-quality voice and field recording. Battery life is seven hours on a single AA battery.

The cassette cartridge is slightly larger than a postage stamp. The tape is an ultrathin metal-evaporated tape formulation, two sided, allowing 60-, 90-, or 120-minutes per cartridge, depending on the amount of tape in a cartridge.

Multitrack R-DAT Recording on Videotape

So far, the size of digital cassette audiotape has not been conducive to more than two-channel stereo encoding. The option 3 mode, discussed previously, offers four-channel recording. At 32 kHz, however, fidelity is not up to professional standards. By employing the video track on videocassette tape (Hi8 and S-VHS are most commonly used) with its greater width, compared to DAT tape, it is possible to use R-DATs for multitrack recording (see 8-14). Recording times, for the present, are limited to roughly 15 to 40 minutes per cartridge, depending on the tape format and hardware used.

Digital Audio on Digital Videocassette Tape

It is somewhat ironic that it became possible to digitize an audio signal on videotape before it was possible digitize a video signal. In the late 1980s, the first digital videotape system was introduced. Today, there are five systems in use, undoubtedly, with more to come. The five systems are D-1, D-2, D-3, D-5, and Digital Betacam. Each one produces four high-fidelity digital audio tracks. Because the advantages and disadvantages among the five systems have more to do with their compatibility in relation to other systems and with their video quality than they do with audio quality, let's briefly review the differences among the five systems.

D-1 is a *component system* (see 8-16). In the component system, the red, green, and blue (RGB) channels are kept separate and treated separately during the recording process. The D-1 system is used with 1-inch VTRs and ¾-inch videocassettes. It produces high-quality sound and picture. It loses very little image quality after several dubs. However, it is also not compatible with most existing editing equipment. Therefore, it must be used with other component equipment, which can be costly. Playing times for D-1 cassette tape are 11–13 minutes with

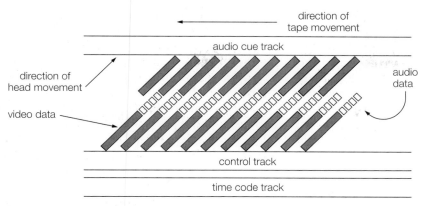

8-16 D-1 videotape format

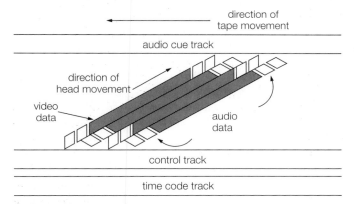

8-17 D-2 videotape format

small-sizes cartridges, 31–41 minutes with medium-size cartridges, and 76–94 minutes with large-size cartridges.

D-2 and D-3 are *composite systems* (see 8-17). In the composite system, the luminance information, including brightness and resolution, and the chrominance information, including the RGB colors, are combined into a single signal. This system conforms to the National Television Standards Committee (NTSC) format that has been adopted for standard television equipment. The disadvantage of a composite system is noticeable degeneration of information from dub to dub. On the other hand, the D-2 and D-3

systems do not require modification or replacement of existing video equipment. D-2 is used in the ¾-inch format, and D-3 is used in the ¾-inch and ½-inch formats.

Playing times for D-2 tapes are 31 minutes for small-size cartridges, 93 minutes for medium-size cartridges, and 207 minutes for large-size cartridges. For D-3 tapes, small-size, medium-size, and large-size cartridges have up to 50-, 125-, and 245-minute playing times, respectively.

D-5 and Digital Betacam are ½-inch component systems. Both have four digital audio tracks and one analog audio cue track and use high-coercivity metal tape. D-5 cassette

tapes have a two-hour recording capacity. Depending on the cartridge size, Digital Betacam tapes have recording times from 40 minutes up to 124 minutes. Although they are both component, ½-inch videotape recording systems, D-5, made by Panasonic, and Digital Betacam, made by Sony, are incompatible.

Disk-Based Audio Systems

In recent years, many new tape recording systems, particularly digital systems, have emerged. The entry of several different types of disk-based audio systems has made "progress" in magnetic encoding of audio bewildering. The good news is that these new systems have revolutionized the quality, random access, and editing of audio materials. The bad news is that many of these systems are complex, and with so many already on the market—most of them incompatible with one another—and more surely to come, audio producers face the dilemma of which systems(s) to choose, how long they will be around, and how cost-effective their choice(s) will be.

Disk-based audio production has already reached the point where entire books have been devoted to the subject (see Bibliography). In this section, only the systems that have come into professional use or that have a reasonable near-future chance of doing so are discussed.

Compact Disc System

One of the most revolutionary developments in the history of sound is digital recording and reproduction. Among other things, it has led to the replacement of records with compact discs (CDs) and phonographs with compact disc players. These devices are now being used in most broadcasting stations and production houses. They have supplanted the 45- and 33⅓-rpm records and their players just as those replaced the 78-rpm record and its playback system in the 1950s.

The main advantages of the CD system are its greatly improved sound quality (especially signal-to-noise ratio and dynamic range), convenience, and compactness.

Compact Discs

A standard compact disc is 4.7 inches in diameter, about 2 inches less than a 45-rpm record (the center hole is ⅝ inch across).

Unlike analog records the compact disc is quite resistant, although not impervious, to damage from dust and dirt. Audible scratches, mechanical wear, and surface noise are minimal. More music can be encoded on a CD—more than 1 hour—than on an LP, even though sound is impressed on only one side of a CD. Micro-CDs are also available. A micro-CD is 2½ inches across and has a playing time of 8 to 9 minutes.

Compact Disc Players

The CD player used by consumers generally weighs less than 10 pounds and is smaller than a stereo receiver/amplifier. Professional CD players are heavier and larger; they are also sturdier, more versatile, and more expensive than consumer units. With most units the compact disc is loaded into the player by pressing the "Open" button, which slides a tray forward to receive the disc. The disc is placed on the tray, and when the "Close" button is pressed, the tray slides back into the player. CD players read the information on the disc with a laser beam that moves from the inside to the outside of the record. The disc spins at 500 rpm for the inside tracks and gradually slows to 200 rpm as the laser moves to the outer edge of the disc. CD players can be manually controlled to play

selections from a disc in any order or programmed to do so automatically. Skipping forward or backward is done quickly and noiselessly. There is no wow at start-up, no modulation noise, no echo before or after loud passages, no mistracking in loud passages, and no end-of-side distortion as there can be with grooved records.

Despite the CD system's many advantages, it is not without problems. Chemical deterioration of the disc's inner core is possible, resulting in partial or total signal loss; the laser beam must be realigned periodically (how often depends on the amount of use) or signal loss will result from its inability to read the disc properly; and disrupted tracking can occur, resulting in interrupted or skipped sound.

In addition, as the number of CD factories increase, more and more faulty discs are finding their way to market. Moreover, in efforts to gain longer playing time on a CD, spiral traces of the data track are being pushed closer together. This practice makes it difficult for the laser guidance mechanism to track properly if there are mechanical or optical aberrations (or if the CD player is jarred).

Professional CD Systems

CD players used in broadcasting and professional audio production have an array of features to facilitate various operations not required by most nonprofessionals. Although the terms used to describe these features, and the number of features incorporated into a CD player, may vary, most units are capable of the following functions:

- *Autocue.* This positions the readout at the start of the first note of the selected track. Some CD players confirm the park position by a "standby" indicator. Playback occurs the instant "Play" is activated.

(Relatively tight cueing can be accomplished with nonprofessional CD players by pressing "Play/Pause" to park the cue point and then pressing "Play" to start the selection. It takes about a half second before the selection begins.)

- *Search dial cueing.* This enables manual cueing, forward or backward, to a precise track or *frame* (point within a track). Dial rotation may be set at slow speed—one second of program time (75 frames) per 360 degrees of rotation—or fast speed—anywhere from 20 to 60 seconds of program time per 360 degrees of rotation (depending on the CD unit).

- *Rocker control.* This is the CD equivalent of slip cueing. It can control the start of a CD, or advance it, to $1/10$ second.

- *Key cueing.* This cues a CD to the track, index number, and time of your choice after you enter the appropriate information on the CD player's key pad.

- *Start and end review.* This enables you to quickly check the start and end of a selection.

- *Random access programming.* This allows you to play a series of selections, in the order you choose, automatically.

- *Auto spacing.* This adds a few seconds of silence between tracks, making it easier to transfer a selected CD recording to tape (see the section on dubbing in Chapter 17).

- *Digital LED displays.* These provide various types of information such as track and index number, elapsed and remaining playing time for a disc or track, and, in some models, the disc selection(s) chosen for play.

CD systems used professionally can be remote controlled from the console (the same as tape recorders) or from a separate remote controller (see 8-18).

(1) Indication of selection and index number
(2) Indication of the elapsed and remaining time in minutes and seconds
(3) Control indication FADER ACTIVE
(4) Control indication for determining whether or not the corresponding CD player will be switched to pause at the end of the music selection
(5) Control indication for determining whether or not the CD player positions automatically at the modulation start
(6) Control indication FADER OPEN
(7) 10-Key pad for track selection
(8) Control indication changeover for remaining to elapsed time and vice versa
(9) Key for activating the editing field with special functions for the corresponding command module

(10) Index selection key
(11) Key for storing/selecting the cue point
(12) Play key
(13) Pause key
(14) Fader start mode On/off key
(15) Auto pause mode On/off key
(16) Autocue mode On/off key
(17) Changeover of the DIAL resolution
(18) END REVIEW for prelistening the end of a cue
(19) START REVIEW for prelistening the start of a cue
(20) If START and END REVIEW are pressed simultaneously, the middle of the cue can be prelistened.

8-18 Compact disc player remote control unit. This particular model can operate up to three compact disc players.

8-19 Digital cartridge machine that uses 3½-inch floppy disks. It can record in mono or stereo. Standard floppy disks are used for spot announcements and other short audio material. 13.3 MB disks, with recording time up to 5 minutes and 18 seconds per disk, can also be used. A PC keyboard can be added to the cart machine's operation to perform, among other things, editing cue tones, end checking, and looping.

Cartridge Disk Systems

A recent addition to digital disc players is the **digital cartridge system**. Although the storage medium is disc, both operationally and in its applications to broadcast production, the digital cart machine is much like its analog counterpart. That said, there are still a number of significant differences. For example, the sound is digital quality, and retrieval of encoded material is virtually instantaneous.

For the most part, digital cart machines use one of two media, enclosed in a plastic cartridge — either the compact disc or the 3½-inch floppy disk. CD cart machines are available in play-only and record/play configurations, as are the 3½-inch floppy cartridge units (see 8-19).

Recordable Compact Discs

Until recently, the CD, like its predecessor the phonograph record, was a play-only disc. But unlike the phonograph record, which was encoded mechanically, the CD is encoded optically. Optical technology has made it possible to develop the recordable compact disc, abbreviated either **CD-R**, short for *compact disc-record*, or **CD-WO**, short for *compact disc-write only*.

The CD-R makes the compact disc somewhat similar to recording tape. It has unlimited playback but it can only be recorded on once and cannot be erased. Even false starts are there for good. Hence, many users assemble their audio on DAT and then transfer it to CD-R.

The CD-R conforms to the standards document known as "Orange Book." According to this standard, data encoded on a CD-R does not have to be recorded all at once but can be added to whenever the user wishes, making it more convenient to produce sequential audio material. CD-Rs conforming to the Orange Book standard, however, are not compatible with standard CD players. To be playable on any standard CD player, CD-R must conform to the "Red Book" standard, which requires that a table of contents file (TOC) be encoded onto the disc. A TOC file is written at the start of the disc and includes information related to subcode and copy prohibition data, index numbering, and timing information. The TOC, which is written onto the disc after audio assembly, tells the CD player where each cut starts and ends. Once it is encoded, any audio added to the disc will not be playable on standard CD players due to the write-once limitation of CD-R.

One answer to this problem is to use preformatted TOC tracks of different lengths, depending on the amount of TOC data to be encoded. Preformatted CD-Rs are available with 10-, 30-, or 60-second tracks. Audio program data can be written on the first available track and continue to be written uninterrupted across track boundaries until

8-20 CD cartridge recorder with remote control

the recorder is stopped. The disadvantage to this approach, however, is that preformatting reduces disc time for program material.

There are two broad, basic categories of CD-R systems: stand-alone and computer-based. The stand-alone CD-R system incorporates the optical drive and the processing and control systems into a single unit (see 8-20). Computer-based systems, as the term suggests, use computer hardware and software to run the CD-R system.

CD-R units are expensive, although prices are coming down. Blank discs alone sell for several times what a DAT tape costs for about an hour of playing time.

Despite the write-once limitations and the cost of the CD-R, it has applications for customized CD-quality music mastering, spot announcements, announcer tracks for automation, sound effects, and program demos. Moreover, it has already had far-reaching

implications in the battle for supremacy in the ever-widening competition among digital audio storage systems.

Magneto-Optical Recording

Magneto-optical (MO) recording, like magnetic digital tape recording, uses tiny magnetic particles to encode digital information. But unlike magnetic tape recording, (1) the MO recording medium is disc-based, (2) instead of magnetic heads to orient the particles a laser beam is used, and (3) to orient the magnetic particles they must be heated to extremely high temperatures. This process has made it possible to produce erasable compact disc recording (abbreviated, **CD-E**, for *compact disc-erasable*, or **CD-MO**, for *compact disc-magneto-optical*. The magneto-optical disc is also called by the more colorful term, *floptical*).

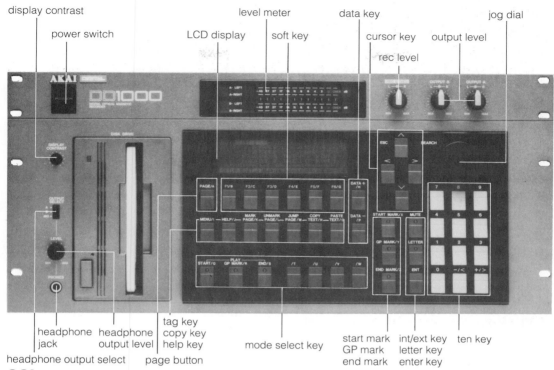

display contrast
power switch
level meter
LCD display soft key
data key
cursor key
rec level
output level
jog dial

headphone jack
headphone output level
tag key
copy key
help key
headphone output select page button
mode select key
start mark
GP mark
end mark
int/ext key
letter key
enter key
ten key

8-21 Magneto-optical disc recorder

The CD-E's main advantages are that it can be used like tape due to its write-many, read-many (WMRM) format and that it is two-sided to increase playing time. Its main disadvantages are that it is not interchangeable with ordinary CD players, that even with two-sided recording, playing time is limited, and it is expensive. Also, MO drives are slow, and it takes careful design and software optimization to record and playback CD quality sound. This problem has begun to improve, however (see 8-21).

Mini Disc (MD)

A potentially far-reaching development in magnetic-optical recording is **mini disc**™ (**MD**™), a compact disc that stores more than an hour of digital-quality audio, with a dynamic range of 105 dB, on a 2.5-inch-wide CD (see 8-22 and 8-23). The MD system uses two types of media: magneto-optical media for recordable blank discs and CD-type optical media for prerecorded software. The MD is Sony's answer to the Philips DCC. Intended for the consumer market, its potential in professional audio is already apparent because of its CD-quality audio, its fast random access of encoded information, and its easy portability.

Computer-Based Systems

Generally, computer-based systems, more commonly known as digital audio workstations, are more elaborate than record and

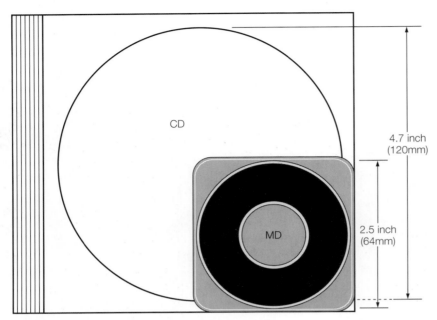

8-22 Comparison between mini disc and compact disc

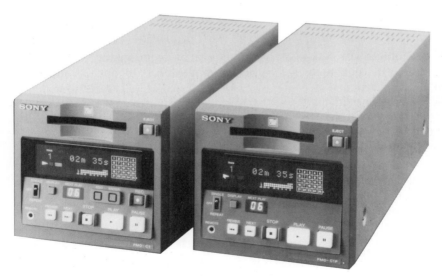

8-23 Mini disc cartridge recorder (left) and player (right)

playback devices. They perform many functions, among the most important of which is editing. Therefore, computer-based systems are discussed in relation to editing in Chapter 16.

Main Points

1. The format used since modern tape recording began has been analog, which can reproduce a dynamic range of about 80 dB, much less than the human ear is capable of hearing. At this point the digital format can deliver a dynamic range up to 110 dB, virtually noise-free.

2. The process of converting analog signals into a digital format involves four basic steps: (1) anti-aliasing, (2) sampling, (3) quantizing, (4) coding.

3. Reconverting digital to analog involves (1) decoding at the playback head, (2) error correction, (3) digital-to-analog conversion, (4) low-pass filtering.

4. Tape used for digital recording is different from tape used for analog recording. It is thinner, has about twice the coercivity, must be used in an environment whose temperature and humidity are more closely controlled, and must be handled with greater care.

5. Digital audio tape recorders fall into two categories: stationary head and rotary head.

6. Stationary head digital audiotape recorders are similar in operation to analog ATRs. They differ, however, in head configuration, the relationship of channel to track, and — in some machines — playing speed.

7. In an attempt to standardize stationary head digital audiotape recorders, most manufacturers conform their machines to one of two formats: DASH or PD (Professional Digital or Pro Digi).

8. The rotary head digital audio recorder (R-DAT) uses the principle of the videotape recorder's spinning heads to encode audio on tape.

9. Most R-DATs operate at three sampling speeds: 32 kHz, 44.1 kHz, and 48 kHz. A few also use 44.056 kHz. Longitudinal tape speed is $1/3$ ips.

10. Audiocassette tape for R-DAT is about $1/7$-inch wide and similar in thickness to a 90-minute analog cassette (30 microns). The cartridge is half the size of an analog cassette cartridge and the tape length is one-fourth that of an analog cassette.

11. Multitrack digital audiocassette tape recorders are available in the R-DAT and S-DAT formats.

12. Digital videocassette tape is available in five formats: the D-1, D-5, and Digital Betacam component systems, and the D-2 and D-3 composite systems. D-1 is 1- and $3/4$-inch, D-5 and Digital Betacam are $1/2$-inch, D-2 is $3/4$-inch, and D-3 is $3/4$- and $1/2$-inch.

13. Disk-based audio recording uses, for the most part, the compact disc, $3\frac{1}{2}$-inch floppy disk, magneto-optical disc, or a hard disk for encoding.

CHAPTER 9

Signal Processing

Signal processors are devices used to alter some characteristic of a sound. Most signal processors can be grouped into four categories: spectrum processors, time processors, amplitude processors, and noise processors. A **spectrum processor**, such as the equalizer, affects the spectral balances in a signal. A **time processor**, such as a reverberation or delay device, affects the time interval between a signal and its repetition(s). An **amplitude processor**, such as the compressor–limiter, affects a signal's loudness. A **noise processor**, such as the Dolby system, does not alter a signal as much as it makes the signal clearer by reducing the noise added in analog recording.

Some signal processors can be assigned to more than one category. For example, the equalizer also alters a signal's amplitude and, therefore, can be classified as an amplitude processor as well. The flanger, which affects the time of a signal, also affects its frequency response. A de-esser alters amplitude and frequency. Moreover, various signal processing functions may be combined in a single unit. The signal processors discussed in this chapter have been categorized according to their primary function.

Their specific applications are discussed in Chapter 14, "Producing Music," and Chapter 17, "Mixing and Rerecording."

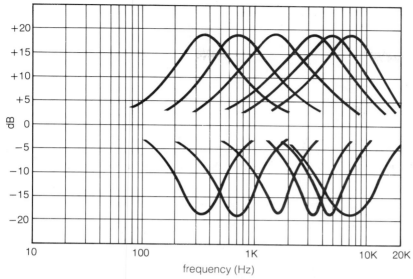

9-1 Bell or haystack curves showing 18-dB boost or cut at 350, 700, 1,600, 3,200, 4,800, and 7,200 Hz

Spectrum Signal Processors

Spectrum signal processors include equalizers, filters, and psychoacoustic processors.

Equalizers

The best-known and most often used signal processor is the **equalizer**—an electronic device that alters frequency response by increasing or decreasing the level of a signal at a specific portion of the spectrum. This alteration can be done in two ways: by boost or cut (also known as *peak* or *dip*) or by **shelving**.

Boost/cut increases or decreases the level of a band of frequencies around a **center frequency**, the frequency at which maximum boost or cut occurs. This type of equalization is often referred to as *bell curve* or *haystack* due to the shape of the response curve (see 9-1).

Shelving also increases or decreases amplitude but gradually flattens out or shelves at the maximum selected level when the chosen (turnover) frequency is reached. Level then remains constant at all frequencies beyond that point (see 9-2).

The number of frequencies on equalizers varies. Generally, the frequencies are in full-, half-, and third-octave intervals. If the lowest frequency on a full-octave equalizer is, say, 50 Hz, the other frequencies ascend in octaves: 100 Hz, 200 Hz, 400 Hz, 800 Hz, 1,600 Hz, and so on, usually to 12,800 Hz. A half-octave equalizer ascends in half-octaves. If the lowest frequency is 50 Hz, the intervals are at or near 75 Hz, 100 Hz, 150 Hz, 200 Hz, 300 Hz, 400 Hz, 600 Hz, and so on. A third-octave equalizer would have intervals at or near 50 Hz, 60 Hz, 80 Hz, 100 Hz, 120 Hz, 160 Hz, 200 Hz, 240 Hz, 320 Hz, 400 Hz, 480 Hz, 640 Hz, and so on. Obviously, the more settings, the better the sound control—but at some cost. The

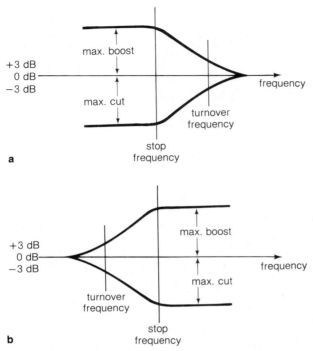

9-2 (*a*) **Low-frequency shelving equalization and (*b*) high-frequency shelving equalization.** The turnover frequency is that frequency where the gain is 3 dB above (or below) the shelving level; in other words, the frequency where the equalizer begins to flatten out. The stop frequency is the point where the gain stops increasing or decreasing.

more settings on an equalizer (or any device, for that matter), the more difficult it is to use correctly, because technical problems such as ringing, phasing, and so on may be introduced.

Two types of equalizers are in general use: fixed frequency and parametric.

Fixed-Frequency Equalizer

The **fixed-frequency equalizer** is so called because it operates at fixed frequencies usually selected from two (high and low) or three (high, middle, and low) ranges of the frequency spectrum. Each group of frequencies is located at a separate control, but only one

center frequency at a time per control may be selected. At or near each frequency selector is a level control that boosts or cuts the selected center and band frequencies (see 6-9). On consoles, if these controls are concentric to save space, the outer ring chooses the frequency, the inner ring increases or decreases level.

A fixed-frequency equalizer has a preset **bandwidth** — a range of frequencies on either side of the one selected for equalizing that is also affected. The degrees of amplitude to which these frequencies are modified forms the **bandwidth curve.** If you boost, say, 350 Hz a total of 18 dB, the bandwidth of frequencies also affected may go to as low as

9-3 Two-channel, third-octave graphic equalizer. This particular model provides a scale switch that allows a choice of either a 12 dB boost/cut or a high resolution 6 dB boost/cut for each channel; a filter control that switches a 30 Hz subsonic filter in or out of each channel; and an input level control that facilitates interfacing each equalizer channel with the output signals of other equipment.

9-4 Two-channel parametric equalizer. In this particular model, the outer concentric controls of the four larger dials in the top row of each channel adjust the level of the boost or cut and the inner concentric controls adjust the bandwidth of the affected frequencies. The four larger dials in the bottom row of each channel select frequencies for four overlapping frequency ranges: low frequency (LF), 20–500 Hz; middle-low frequency (MLF), 80–1600 Hz; middle-high frequency (MHF), 315–6,300 Hz; high frequency (HF), 1–20 kHz. Each channel also has a high-pass filter, variable from 20–315 Hz and a low-pass filter, variable from 2–20 kHz (see "Filters" in this chapter). The "cascade" function can change the two-channel four-band configuration into a one-channel eight-band configuration. The parametric equalizer shown here is also a notch filter (see "Notch Filter" later in this chapter).

80 Hz on one side and up to 2,000 Hz on the other. The peak of the curve is 350 Hz — the frequency that is boosted the full 18 dB (see 9-1). The adjacent frequencies are boosted also but to a lesser extent, depending on the bandwidth. Because each fixed-frequency equalizer can have a different fixed bandwidth and bandwidth curve, it is a good idea to study the manufacturer's specification sheets before you use one.

Graphic Equalizer

The **graphic equalizer** is a type of fixed-frequency equalizer. It consists of sliding, instead of rotating, controls that boost or attenuate selected frequencies. It is called graphic because the positioning of these con-

trols gives a graphic display of the frequency curve set. (The display does not include the bandwidth of each frequency, however.) Because each frequency on a graphic equalizer has a separate sliding control, it is possible to use as many as you wish at the same time (9-3).

Parametric Equalizer

The main difference between a **parametric equalizer** (see 9-4) and a fixed-frequency equalizer is that the parametric has continuously variable frequencies and bandwidths. Because the parametric equalizer's frequencies and bandwidths are continuously variable, it is possible to change a bandwidth curve by making it wider or narrower,

thereby altering the frequencies affected and their levels (see 9-5). This provides greater flexibility and more precision in controlling equalization (EQ).

The digital programmable parametric equalizer can store and recall several different EQ settings and bandwidths either separately or simultaneously (see 9-6).

For example, in a recorded announcement, if one word sounds too bassy, another too harsh, still another both too shrill and lacking in low end, the appropriate frequencies and bandwidths can be programmed to correct these problems and the corrections can be stored in a memory. During playback the equalizer will automatically make the appropriate EQ changes at the precise points in the announcement. For the word that is too shrill and lacking in low end, two different EQ settings can be programmed for the same instant. Also if, say, a song requires EQ changes, different EQ settings can be programmed and stored in the same equalizer without disturbing the settings for the announcement (up to the equalizer's storage limit).

Paragraphic Equalizer

A **paragraphic equalizer** combines the sliding controls of a graphic equalizer with the flexibility of parametric equalization (see 9-7).

Filters

A **filter** is a device that attenuates certain bands of frequencies. The difference between attenuating with an equalizer and attenuating with a filter is sometimes confusing, because both reduce loudness. There are generally two differences. First, with an equalizer attenuation affects only the selected frequency and the frequencies on either side of it, whereas with a filter all frequencies above

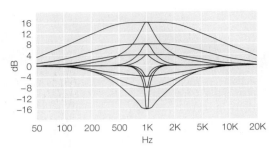

9-5 Selectable bandwidths of the parametric equalizer shown in 9-4. In this particular model, the boost curves are broad and the cut curves are tight. Many parametric equalizers use the same range of adjustment for the boost and cut curves.

or below the selected frequency are affected. Second, an equalizer allows you to vary the amount of the drop in loudness; with a filter, however, the drop is preset and precipitous.

The most commonly used filters are high-pass, low-pass, band-pass, and notch filters.

High- and Low-Pass Filters

A **high-pass (low-cut) filter** attenuates all frequencies below a preset point; a **low-pass (high-cut) filter** attenuates all frequencies above a preset point (see 9-8).

Suppose, in a recording, that there is a bothersome rumble between 35 and 50 Hz. By setting a high-pass filter at 50 Hz, all frequencies below that point are cut and the band of frequencies above it continues to pass—hence the name "high-pass" (low-cut) filter.

The low-pass (high-cut) filter works on the same principle but affects the higher frequencies. If there is tape hiss in a recording, you can get rid of it by setting a low-pass filter at, say, 10,000 Hz. This cuts the frequencies above that point and allows the band of frequencies below 10,000 Hz to pass through. You should keep in mind, however, that *all* sound above 10 kHz—the program material along with the tape hiss—will be filtered.

9-6 **Digital programmable parametric equalizer.** This particular model has 99 storage memories for individual curves, each nameable and recallable at the touch of a button. The frequency bands allow control from 30 Hz to 20 kHz, in increments of one hertz. Level in each band is adjustable up to +12 dB.

9-7 **Stereo paragraphic equalizer**

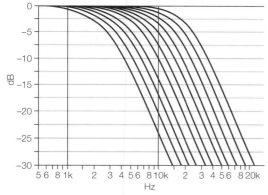

9-8 **Curves of the low-pass filter in 9-4**

Band-Pass Filter

A **band-pass filter** is a device that sets high- and low-frequency cutoff points and permits the band of frequencies between to pass (see 9-9). Band-pass filters are used more for corrective purposes than for creative purposes.

Notch Filter

A **notch filter** is a filter used mainly for corrective purposes (see 9-4 and 9-5). It can cut out an extremely narrow band, allowing the frequencies on each side of the notch to pass. For example, a constant problem in audio is AC (alternating current) hum, which has a frequency of 60 Hz. A notch filter can

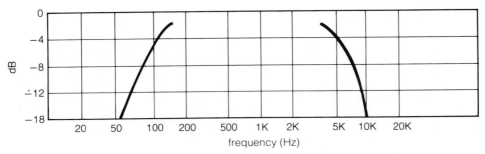

9-9 Band-pass filtering. The frequencies below 120 Hz and above 5,000 Hz are sharply attenuated, thereby allowing the frequencies in the band between to pass.

remove it without appreciably affecting adjacent frequencies.

Psychoacoustic Processors

A **psychoacoustic processor** is designed to add clarity, definition, overall presence, and life or "sizzle" to program material. Some units add odd and even harmonics to the audio, tone-generated from 700 Hz to 7 kHz; others are fixed or program-adaptive high-frequency equalizers. A psychoacoustic processor might also achieve its effect by adding comb filtering and by introducing narrow-band phase shifts between stereo channels. The best known psychoacoustic processor is the Aural Exciter® (see 9-10a).

Another type of psychoacoustic processor acts like a dynamic equalizer on low-level signals. It brings out quiet details without affecting louder sounds, disturbing the overall sense of dynamics, or increasing noise (see 9-10b).

Time Signal Processors

Time signal processors are devices that affect the time relationships of signals. These effects include reverberation, delay, and pitch shifting.

Reverberation

Reverberation, you will recall, is created by random, multiple, blended repetitions of a sound or signal. As these repetitions decrease in intensity, they increase in number. Reverberation increases average signal level and adds depth, spatial dimension, and additional excitement to the listening experience.

A common principle is basic to reverberation and, hence, reverb systems. Think of what it takes to produce an echo: A sound has to be sent, hit a reflective object, and then bounce back. In the parlance of audio, the sound sent is **dry**—without reverb—and the sound returned is **wet**—with reverb.

Actually, as defined, there is a difference between echo and reverb. Echo is one or, at most, a few discrete repetitions of a sound (or signal); reverb consists of many blended repetitions (see Chapter 3). To produce either, the dry sound must be sent, reflected, and returned wet.

The *reverberation (reverb) unit* is a device that artificially reproduces the sound of different acoustic environments such as a large hall, small room, auditorium, nightclub, and so on. Three types of reverberation systems are in popular use: (1) the so-called acoustic echo chamber, which is more accurately an acoustic reverb chamber, (2) plate and foil reverb, and (3) digital reverb. A fourth type

a

b

9-10 Psychoacoustic processors. (*a*) Aural exciter. The SPR (Spectral Phase Refractor) function corrects the bass delay inherent in the recording process to restore clarity and openness, and increases the apparent bass level without adding bass boost. Harmonics mixing is adjustable to whatever level is desired. Null Fill is a tuning adjustment. Used in conjunction with the Peaking and Tune controls, it adds the flexibility to enhance most types of audio sources. (*b*) This particular psychoacoustic processor acts on low-level signals while leaving the high-level signals untouched.

9-11 Sound in an acoustic chamber. The sound feeding from a loudspeaker bounces around the chamber off highly reflective walls and into a microphone. The dead sides of the microphone and loudspeaker are opposite each other to reduce direct sound and avoid feedback.

of reverberation device, the spring reverberation unit, used to be widely used because it was available in many models. It has been supplanted by digital reverb in popularity and availability. In spring reverb, the dry signal activates a driver that vibrates coiled springs, then a pickup senses the motion and feeds the wet signal from the springs to the console. Controls on the reverb unit vary the reverb time.

Acoustic Chamber

The *acoustic chamber* is the most natural and realistic of the four types of reverb because it works on acoustic sound in an acoustic environment. It is a room with hard, highly sound-reflective surfaces and nonparallel walls to avoid flutter echo — multiple echoes at a rapid, even rate — and standing waves — apparently stationary waveforms created by multiple reflections between opposite, usually parallel, room surfaces (see 9-11). It usually contains a directional microphone (two for stereo), placed off room center, and a loudspeaker, usually near a corner at angles to or back-to-back to the mic

to minimize the amount of direct sound picked up by the mic(s). The dry sound feeds from the console through the loudspeaker, reflects around the chamber, is picked up by the mic(s), and is fed back wet into the console for further routing.

Reverb times differ from chamber to chamber. Generally, however, reverb time should be about 3½ seconds at 500 Hz, and about 1¼ seconds at 10,000 Hz. Reverb times can be varied by using movable acoustic baffles (gobos) (see 9-12).

Although an acoustic chamber creates very realistic reverberation, it is the most expensive of the reverb systems. It must be at least 2,000 cubic feet in size (too small a room is poor for bass response) with specially treated surfaces; it must be isolated; and it must contain professional-quality microphones and loudspeaker. Arranging the baffles to produce appropriate reverb times can also be time-consuming and costly. Even with a chamber, studios use other reverb devices to provide additional sonic alternatives.

Plate and Foil Reverberation

The reverberation plate is a mechanical-electronic device consisting of a thin, steel plate suspended under tension in an enclosed frame (see 9-13). It is large and heavy and requires isolation in a separate room. A moving-coil driver, acting like a small speaker, vibrates the plate, thus transducing the electric signals from the console into mechanical energy. A contact microphone (two for stereo) picks up the plate's vibrations, transduces them back into electric energy, and returns them to the console. The multiple reflections from the vibrating plate create the reverb effect.

A characteristic of plates is long reverb times (more than two seconds) at high frequencies that produce a crisp, bright decay. Plates, however, are susceptible to overload.

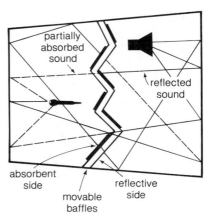

9-12 Movable baffles. Using these gobos with absorbent and reflective sides in various arrangements can alter the acoustics in an acoustic chamber.

With louder levels, low frequencies tend to increase disproportionately in reverb time compared to the other frequencies, thus muddying sound. Rolling off the unwanted frequencies will help, but be careful—too much roll-off reduces a sound's warmth.

Foil reverberation operates similarly to plate reverb. The main differences are that the foil reverb unit is smaller and it replaces the steel plate with gold foil (see 9-14).

Digital Reverberation

Digital reverberation, the most commonly used today, is accomplished electronically. The analog signal, when fed into the circuitry and digitized, is delayed for several milliseconds. The delayed signal is then recycled to produce the reverb effect. The process is repeated many times a second, with amplitude reduced to achieve decay. After processing, the signal is reconverted into analog.

High-quality digital reverb units are capable of an extremely wide range of effects, produce high-quality sound, and take up very little room.

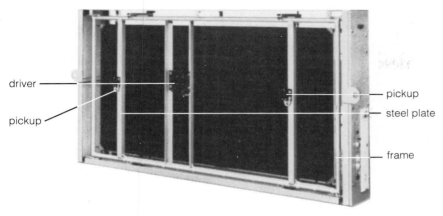

driver

pickup

pickup

steel plate

frame

9-13 Reverberation plate

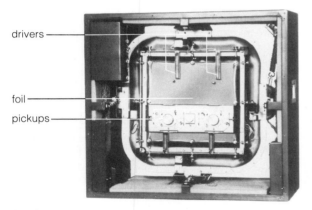

drivers

foil

pickups

9-14 Gold-foil reverberation unit

Some digital reverb systems can simulate a variety of acoustical and mechanical reverberant sounds such as small and large concert halls, bright- and dark-sounding halls, small and large rooms, and small and large reverb plates. With each effect it is also possible to control individually the attack; decay; diffusion (density); high-, middle-, and low-frequency decay times; and other sonic colorings.

Programmable digital reverb systems are also available. They come with prepro-grammed effects but also permit newly created effects, not previously in the memory, to be programmed and stored for reuse. This provides an almost limitless variety of reverberant effects (see 9-15 and 9-16).

Choosing a Reverberation System

When you choose a reverberation system, personal taste notwithstanding, the system should sound natural. The high end should be bright and lifelike, and the low end should

9-15 **Digital reverberation control unit and processor.** This device can call up the reverberant conditions reproduced in various-sized concert halls and rooms, as well as by reverb plates.

BANK	PROGRAMS									
	1	2	3	4	5	6	7	8	9	10
1. **HALLS**	Large Hall	Large + Stage	Medium Hall	Medium + Stage	Small Hall	Small + Stage	Large Church	Small Church	Jazz Hall	Auto Park
2. **ROOMS**	Music Club	Large Room	Medium Room	Small Room	Very Small	Lg. Wood Room	Sm. Wood Room	Large Chamber	Small Chamber	Small & Bright
3. **WILD SPACES**	Brick Wall	Buckram	Big Bottom	10W — 40	20W — 50	Metallica	Silica Beads	Inside Out	Ricochet	Varoom
4. **PLATES**	A Plate	Snare Plate	Small Plate	Thin Plate	Fat Plate					
5. **EFFECTS**	Illusion	Surfin'	Vocal Whispers	Doubler	Back Slap	Rebound	Elinar	Sudden Stop	In The Past	Tremolo L & R
6. **SAMPLING**	Forward/ Reverse	Rate Changer	Mono 3 s	Mono 6 s	Stereo 3 s	Dual Sampler				
7. **DRUM SAMPLER**	Mono 3 s	Mono 6 s	Stereo 3 s							
8. **DOPPLER**	Doppler	Band- wagon								
9. **SO WHAT ELSE?**	The In/Out	Twin Delays	Stereo Adjust							

9-16 Programs of the reverb system displayed in 9-15

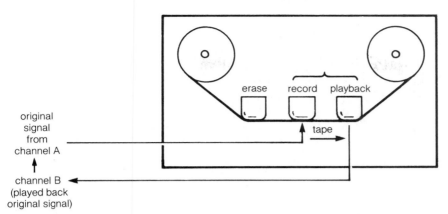

original
signal
from
channel A

channel B
(played back
original signal)

9-17 **Tape delay.** To produce tape delay manually, feed a signal through one channel to
a tape recorder that is in the record and playback modes at the same time. When the signal
reaches the playback head, feed it to another channel, then back again to the original channel,
the tape recorder, the second channel, and round and round.

not thicken or muddy the sound. Good dif-
fusion is essential; repeats should be many
and random. There should be an absence of
flutter, twang, "boing," and tinniness.

A good test to check for muddy sound is
to listen to a vocal. If the reverb system
makes the lyrics more difficult to understand,
then the unit is not clear or transparent
enough. To check for density and random-
ness of the early reflections, try a transient
sound like a sharp drumbeat or handclap.
Poorer reverb systems will produce a sound
like an acoustic flutter. To check for random-
ness of the later reflections, listen to a strong
male voice completely wet — with no dry feed
from the reverb send on the console. If the
lyrics are clear, then the combined wet and
dry signals will probably be muddy.

Delay

Delay, echo, and *reverberation* are terms
often wrongly used interchangeably; never-
theless, their psychoacoustical effects differ.
As we have said, reverb is formed by multi-
ple, random, blended repetitions that occur
after a sound is emitted. The time between
repetitions is imperceptible. Echo is a re-

flected sound of about 50 milliseconds ($\frac{1}{20}$
second) or longer of the original sound. The
time between echoes is perceptible. The time
between reflections is the delay.

By manipulating delay times it is possible
to create a number of sonic effects (see sec-
tion on uses of delay). Generally, delay can
be produced with a tape recorder or electron-
ically with an analog or digital delay unit.

Tape Delay

The oldest and perhaps least expensive way
to produce delay is by using a tape recorder
with separate record and playback heads.
With the machine in record and set to moni-
tor playback, the console (or sound source)
feeds the signal to the record head. As the
tape passes to the playback head a split
second later, the signal is reproduced and
returned to another channel, usually at
the console. The signal path then contin-
ues round and round; the tape speed and
the distance between the heads determine the
amount of delay (see 9-17). The slower the
delay, the more deliberate and discernible
the repeat. A slow-repeating echo — about
$\frac{1}{2}$ second between repeats — creates a

haunted house or outer-space effect. Faster delays generate more cascading sounds.

At 3¾ ips the delay is roughly half a second, assuming the record and playback heads are the typical 2 inches apart. At 7½ ips the delay is ¼ second; at 15 ips, it is ⅛ second; and at 30 ips it is ¹⁄₁₆ second. You can obtain an even greater range of effects by changing these fixed times using a variable-speed recorder.

You can also create a variety of sound intensities by coordinating the loudness controls on the console and tape recorder, because different levels of loudness also change the sonic character of delay. Make sure to coordinate these settings, however, because in most reverb and delay systems the "return" is noisier than the "send." Set "send" at a higher level and "return" to taste. It is common practice to set the level of the "returns" lower than the level of the "sends."

In addition to the electronic noise a signal generates as it passes through the channels, the tape produces noise. As the number of repeats in the delay increases, the signal-to-noise ratio decreases. For these reasons tape delay, although it produces a variety of effects for almost no extra cost, may not always create clean delay.

Electronic Delay

Electronic delay is produced using an analog or digital delay device.

Analog Delay An analog delay device performs the same function as tape delay, but it does so electronically. Basically, the input signal is fed to the circuitry, which samples it several thousand times a second. These samples are stored in a long series of capacitors and stepped along from one capacitor to the next until the signal reaches the output as a delayed copy of the original input signal. Delay times can be selected. The variety of

delay times available depends on the delay unit (see 9-18).

Digital Delay Digital delay converts the analog signal to digital information at the input and reconverts it back into analog at the output. After conversion at the input, the signal is fed to a memory that stores it. After the selected amount of delay time, it is read out. It is then converted back to analog and sent to the output. As with analog delay, the amount and number of delay times vary with the unit (see 9-21).

Analog Versus Digital Delay The attributes of analog and digital delay are different; each has its advantages and disadvantages. Analog units are less expensive and warmer sounding. They are especially good at creating sound effects, particularly flanging effects (see section on flanging). The stepped delays in the analog process are smaller than in digital delay and can be hastened or slowed more conveniently. A significant problem, though, is that with delays of about 80 milliseconds and longer, signal-to-noise ratio drops dramatically. Also, the longer the delay time, the worse the high-frequency response.

Digital delays are generally more expensive than analog, but they can offer better signal-to-noise ratio, less distortion, and improved high-frequency response with longer delay times. They are also excellent for pre-reverb delay (see section on delay with reverberation).

Uses of Delay

Delay has two basic applications: (1) to create a variety of effects in a studio, and (2) to improve the clarity and intelligibility of sound in concert reinforcement (see Chapter 15). Perhaps the studio effects most frequently used are to double, chorus, and slap

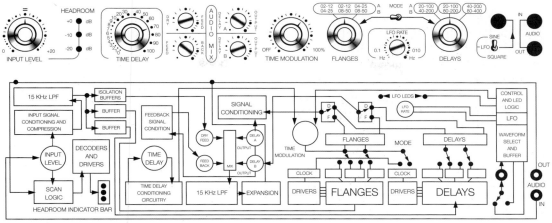

Simplified Block Diagram

9-18 Analog delay unit with flanging and pitch shifting (see "Flanging" and "Pitch Shifting" in this chapter)

back sound and to create more realistic reverberation.

- *Doubling.* One popular use of delay is to fatten sound. The effect gives an instrument or voice a fuller, stronger sound and is called **doubling** or **automatic double tracking** (*ADT*). It is created by setting the delay around 15 to 35 milliseconds. These short delays are like early sound reflections and lend a sense of openness or ambience to dead-sounding instruments or voices.

 Doubling can also be done live by recording one track and then repeating the same part on a separate track in synchronization with the first track. Because it is not possible to repeat a performance exactly, variations in pitch, timing, and room sounds add fullness or openness to sound. By continuing this process it is possible to create a chorusing effect.

- *Chorus.* The **chorus effect** is achieved by recirculating the doubling effect. The delay time is about the same as in doubling—15 to 35 milliseconds—but is re-

peated. This effect can make a single voicing sound like many and add spaciousness to a sound. Two voices singing in a relatively dead studio can be made to sound like a large choir singing in a cathedral by chorusing the original sound.

- *Slap back echo.* A **slap back echo** is a delayed sound that is perceived as a distinct echo, much like the discrete Ping-Pong sound emitted by sonar devices when a contact is made. Slap back echo can be created with delay times of around 35 milliseconds or more.

- *Delay with reverberation.* In an acoustic situation there is a definite time lag between the arrival of direct waves from a sound source and the arrival of reflected sound. In some reverb systems there is no delay between the dry and wet signals. Therefore, by delaying the input signal before it gets to the reverb unit, it is possible to improve the quality of reverberation, making it sound more natural. Some reverb systems have a delay line of their own.

2-millisecond delay

500-microsecond delay

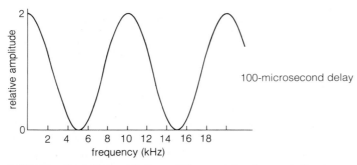

100-microsecond delay

9-19 Flanging effect with three different delay times. In flanging, the direct signal and the output of the delay line are combined. Varying the delay time produces the flanging effect.

Flanging

Flanging is a time-delay effect that gets its name from the way in which it was first produced. The same signal was fed to two different tape recorders and recorded simul-taneously. The playback from both was fed to a single output, but one playback was delayed, usually by applying some pressure to the flange of the supply reel to slow it down. The sonic result is a kind of swishing sound that has many uses in creating special

effects for music recording and sound effects for TV and film.

Today, these effects are produced electronically (see 9-18). The delay time is automatically varied from 0 to 20 milliseconds. Ordinarily, the ear cannot perceive time differences between direct and delayed sounds that are this short. But due to phase cancellations when the direct and delayed signals are combined, the result is a series of peaks and dips in the frequency response (called a *comb filter*), which creates a filtered tone quality that sounds swishy, hollow, and spacey (see 9-19).

Flanging can be "positive," meaning that the direct and delayed signals have the same polarity. Or it can be "negative," meaning that these two signals are opposite in polarity. Negative flanging can create strong, sucking effects like a sound being turned inside out. Flanging can also be "resonant." That is, by feeding some of the output back into the input, the peaks and dips will be reinforced creating a "science fiction"–type effect.

Phasing

Phasing and flanging are similar in the way they are created except that phasing uses a phase shifter instead of a time delay circuit. The peaks and dips are more irregular and farther apart than in flanging. Sonically, this results in something like pulsating, wavering vibrato or the undulating sound produced by talking or playing an instrument underwater. Phasing is produced electronically (see 9-20).

Pitch Shifting

A **pitch shifter** is a device that changes the pitch (frequency) of a signal. It is used to correct minor off-pitch problems, create spe-

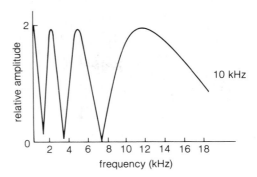

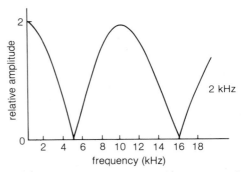

9-20 **Phasing effect at two resistances.** In phasing, the direct signal and the output of a phase shift network are combined. The phasing effect is produced as the cancellations move up and down the audio bandwidth.

cial effects, or change the length of a program without changing its pitch. The latter function is called **time compression**. Some pitch shifters can change frequencies over a couple of octaves without changing duration, allowing you to harmonize an input signal. For example, if a singer delivers a note slightly flat or sharp, it is possible to raise or lower the pitch so that it is in tune. To create harmony, the input signal can be mixed with the harmonized signal at selected pitch ratios (see 9-21).

As a time compressor a pitch shifter can shorten audio material on film, videotape,

a Harmonizer®

100–119	*Basic Effects Algorithms*	These are the basic "algorithms," the building blocks upon which the rest of the factory programs are based.
500–534	*Chorus/Flange/Thickeners*	This group of effects contains choruses, flanges, micro-pitch shifts and other "thickening" types of effects.
535–554	*Delay Effects*	Echoes, recirculating delay lines, multi-tap delays, and other delay-based effects are in this group.
555–574	*Small/Ambient Reverbs*	This group of reverbs contains the smaller rooms and ambient spaces.
575–589	*Large Reverbs*	Large halls and other immense spaces are found here.
590–604	*Alternative Reverbs*	This group contains reverb-like effects, including gated and reverse reverbs.
605–629	*Pitch Shift Effects*	The more extreme pitch shift effects are found here. This includes the "Diatonic" pitch shifters.
630–674	*Unique/Filter Effects*	This is the miscellaneous group. Dramatic filtering effects are found here.
675–689	*Tone Generators*	This group of effects generates sounds.
690–699	*MIDI Controlled Effects*	In this group, the programs are specifically designed to be used with MIDI.

b Preset programs of the Harmonizer® in *a*

9-21 (*a*) **Harmonizer® and (*b*) selected preset programs of this Harmonizer.** This particular unit, in addition to pitch shifting, is also capable of flanging, delay, reverberation, and tone generation. There are four ways to enter data: with the keypad, what Eventide calls the Knob, the Up/Down buttons, and MIDI. The keypad is used when you know the preset values or the parameter values (delay times, for example) you wish to use. Punch them in and hit enter. The Knob is used to dial up an existing program and fine-tune its parameters. The Up/Down keys are used to "nudge" a parameter value or to scroll through the presets. The MIDI function facilitates entering MIDI data into the Harmonizer. The Soft Keys affect the various programs in different ways; their functions are labeled on the character display.

and audiotape with no editing, no deletion of content, and no alteration in pitch. In broadcasting, many stations time-compress recordings to gain additional time for more music or commercials. Commercials are often time-compressed to include more information without going over the contracted time. Time compression also comes in handy when timing sound to picture. If the nonsynchronous audio is longer than the video by a few seconds, it is possible to shorten the audio to the appropriate length without having to physically or electronically edit (see 9-22 and 9-23).

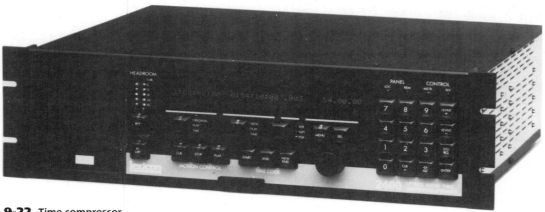

9-22 Time compressor

1:27:00	Leave titles at 1X to avoid VTR jitter		Compress boring dialog 20%		More boring dialog— Compress 20%		Compress 10% to increase excitement	
Original Play Time	5:00	15:00	20:00	10:00	15:00	5:00	15:00	2:00
Program Material	Titles	Action	Dialog	Fight Scene	Dialog	Action	Action	Credits
		Compress 10% to increase excitement		Compress 5% to pick up pace		Don't compress or expand		Leave credits at 1X to avoid VTR jitter
1:16:30 New Play Time	5:00	13:30	16:00	9:30	12:00	5:00	13:30	2:00
Program Material	Titles	Action	Dialog	Fight Scene	Dialog	Action	Action	Credits

9-23 Example of time compression of an event sequence

Amplitude Processors

Amplitude processors are devices that affect dynamic range. These effects include compressing, limiting, and expanding a signal.

Compressors and Limiters

Earlier, we discussed dynamic range, comparing a human's ability to perceive an extremely wide range of sound levels with the inability of typical analog recording to reproduce little more than half that range. There are two reasons for this limitation.

First, the analog tape medium can handle only a certain amount of information before reaching its "threshold of pain" and becoming saturated. Second, at its "threshold of hearing," the tape's noise level is often as loud as, or louder than, the information. Before the development of certain signal-processing devices, the only way to control the program level was to ride the gain— manually control loud sound surges to prevent them from going into the red and raising the level of quiet passages to lift them above the noise floor. Today, most sound designers use electronic devices called compressors and limiters to keep a signal automatically within

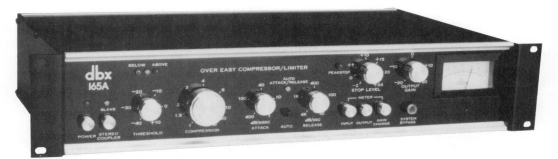

9-24 Compressor/Limiter

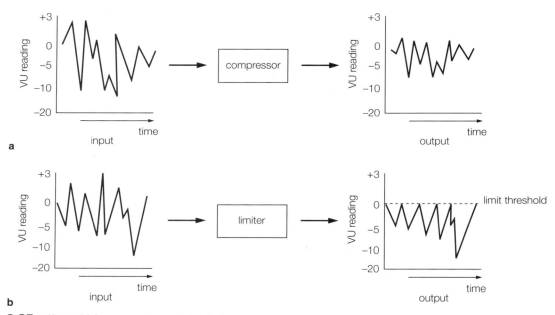

a

b

9-25 Effect of (*a*) compression and (*b*) limiting

the dynamic range that a medium can handle (and also for other sonic purposes that will be discussed later) (see 9-24 and 9-25).

Compressors

The **compressor** is a processor whose output level increases at a slower rate as its input level increases. Compressors usually have four controls—for compression ratio, compression threshold, attack time, and release time, each one of which can affect the others.

The **compression ratio** establishes the proportion of change between the input and output levels. The ratios are usually variable, and depending on the compressor, there are several selectable points between 1.1 to 1 and 20 to 1. If you set the compression ratio for,

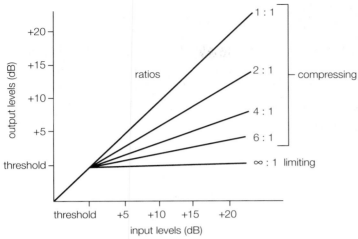

9-26 **A representation of the relationship of various compression ratios to a fixed threshold point.** The graph also displays the difference between the effects of limiting and compressing.

say, 2 to 1, it means that for every 2-dB increase of the input signal, the output will increase by 1 dB; at 5 to 1, a 5-dB increase of the input signal increases the output by 1 dB. This is how sound with a dynamic range greater than a tape can handle is brought to usable proportions.

The **compression threshold** is the level at which the compression ratio takes effect. You set it based on your judgment of where compression should begin. (For an idea of the relationship between compression ratio and threshold, see 9-26.) There is no way to predetermine what settings will work best for a given sound at a certain level; it is a matter of listening and experimenting.

Attack time is the length of time it takes the compressor to react to the signal being compressed. Attack times, which usually range from .25 to 10 milliseconds, can enhance or detract from a sound. If the attack time is long, it can help to bring out percussive attacks, but if it is too long, it can miss or overshoot the beginning of the compressed

sound. If the attack time is too short, it reduces punch by attenuating the attacks, sometimes producing popping or clicking sounds. When it is controlled, however, a short attack time can heighten transients and add a crisp accent to sound. Again, set attack time by using your ear.

Release time (or *recovery time*) is the length of time it takes a compressed signal to return to normal. Release times vary from 50 milliseconds to several seconds. It is perhaps the most critical variable in compression because it controls the moment-to-moment changes in the level and, therefore, the overall loudness. Generally, the purpose of the release-time function is to make the variations in loudness level caused by the compression imperceptible. Longer release times are usually used with music that is slower and more legato (that is, smoother and more tightly connected), and shorter release times for sound that is fast.

This is not to suggest a rule, however; it is only a guideline. In fact, various release

times produce various effects. Some enhance sound; others degrade it, as the following list of potential effects suggests. For example:

1. A fast release time combined with a close compression ratio makes a signal seem louder than it actually is.

2. Too short a release time with too wide a ratio causes the compressor to pump or breathe. You actually hear it working when a signal rapidly returns to normal after it has been compressed and quickly released.

3. A longer release time smooths a fluctuating signal.

4. A longer release time combined with a short attack time gives the signal some of the characteristics of a sound going backward. This effect is particularly noticeable with transients.

5. A release time longer than about half a second for bass instruments prevents harmonic distortion.

6. Too long a release time creates a muddy sound and can cause the gain reduction triggered by a loud signal to continue through a soft one that follows.

Limiters

The **limiter** is a compressor whose output level stays at or below a preset point regardless of its input level. It has a compression ratio between 10 to 1 and infinity; it puts a ceiling on the loudness of a sound at a preset level (see 9-26). Regardless of how loud the input signal is, the output will not go above this ceiling. This makes the limiter useful in situations where high sound levels are frequent or where a performer or console operator cannot prevent loud sounds from going into the red.

The limiter has a preset compression ratio but a variable threshold; the threshold sets the point where limiting begins. Attack and release times, if they are not preset, should be relatively short, especially the attack time. A short attack time is usually essential to a clean-sounding limit.

Unlike compression, which can have little effect on the frequency response, limiting can cut off high frequencies. Also, if you severely limit a very high sound level, the signal-to-noise ratio drops dramatically.

De-essers

Some compressors are equipped with a filter to help control the stronger, more annoying high-frequency sounds around 3,200 Hz such as "s," "z," "ch," and "sh." The filter, called a **de-esser**, is frequency-selective and handles the highly sibilant signals without affecting the rest of the sound.

A more sophisticated application of this principle is the **relief stressor** (or *enlarger*). Instead of compressing frequencies in a preset bandwidth, it tracks the sibilance and compresses it where it occurs.

Uses of Compressors and Limiters

Compressors and limiters have many applications, several of which are listed here.

1. Compression minimizes the wide changes in levels of loudness caused when a performer fails to maintain a consistent mic-to-source distance.

2. Compression smooths the variations in attack and loudness of instruments with wide ranges or wide sound pressure levels, such as the guitar, bass, trumpet, French horn, and drums. It can also smooth percussive sound effects such as jangling keys, breaking glass, and crashes.

3. Compression can improve speech intelligibility in an analog tape recording that has been rerecorded, or dubbed, several times.

4. Compression reduces apparent noise if the compression ratios are close. Wider ratios add more noise.

5. Compression creates the effect of moving a sound source back in relation to the noncompressed sound sources. This may or may not be desirable depending on the overall spatial balance.

6. Limiting prevents high sound levels, either constant or momentary, from saturating the tape.

7. The combination of compression and limiting is often used by AM radio stations to prevent distortion from loud music and to bring out the bass sounds. This adds more power to the sound, thus making the station more obvious to someone sweeping the dial.

8. Compression in commercials is used to raise average output level and thus sonically capture audience attention.

Expanders

An **expander**, like a compressor, affects dynamic range (see 9-27 and 9-28). But whereas a compressor reduces it, an expander increases it. Like a compressor, an expander has variable ratios and is triggered when sound reaches a set threshold level. However, the ratios on an expander are the inverse of those on a compressor: 1 to 2, 1 to 3, and so on. At 1 to 2 each 1 dB of input expands to 2 dB of output; at 1 to 3 each 1 dB of input expands to 3 dB of output. Because an expander is triggered when a signal falls below a set threshold, it can be used as a **noise gate** to reduce or eliminate unwanted low-level

9-27 Expander/noise gate

noise from amplifiers, ambience, rumble, tape hiss, and leakage from one microphone to another.

Assume, for example, that you have two microphones, one for a singer and one for an accompanying piano. When the singer and pianist are performing, the sound level will probably be loud enough to mask unwanted low-level noises. But if the pianist is playing quietly and the vocalist is not singing, or vice versa, the open, unused microphone may pick up these noises.

An obvious solution to this problem is to turn down the pot when a microphone is not being used, cutting it off acoustically and electronically. But this could become hectic for a console operator if there are several

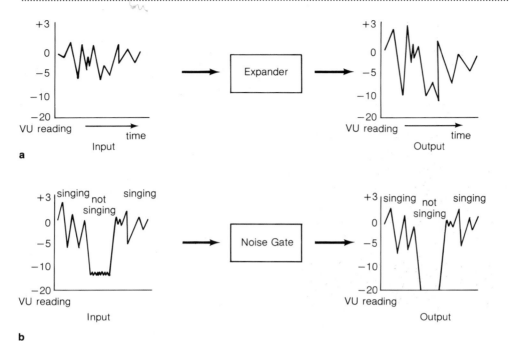

9-28 Effect of (a) expansion and (b) noise gating. Without noise gating, ambient noise is masked during singing and audible when singing is not present. Noise gating eliminates the ambient noise when there is no singing.

sound sources to coordinate. A better solution would be to set the expander's threshold level at a point just above the quietest sound level that the vocalist (or piano) emits. When the vocalist stops singing, the loudness of the sound entering the microphone falls below the threshold point and shuts down, or *gates*, the mic.

The key to successful noise gating is in the coordination of the threshold and ratio settings. Because there is little difference between the low level of a sound's decay and the low level of noise, you have to be wary that in cutting off noise, you do not cut off program material also. Always be careful when you use a noise gate. Unless it is set precisely, it can adversely affect response.

Noise gates are also used to create effects. Shortening decay time of the drums can produce a very tight drum sound. Taking a 60-Hz tone and feeding it so that it is keyed or triggered by a bass guitar can produce not only a simulated bass drum sound but also one that is synchronized with the bass guitar.

Noise Processors

Of the many links in the sound chain, analog tape is a major cause of noise. Noise processors are designed to reduce that noise.

As discussed in Chapter 2, the dynamic range of human hearing is 120 db-SPL and beyond. In Chapter 7, we pointed out that

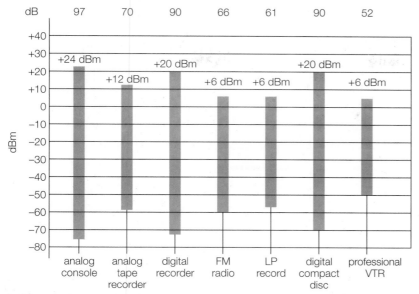

dB	97	70	90	66	61	90	52

9-29 **Dynamic ranges of various audio devices in dBm (an electrical measurement of power) and in dB**

the best analog recording produces a dynamic range of 80–90 dB. Much analog recording, however, is in the 65–70 dB range, half as much as humans are capable of hearing. Videotape and film are worse (see 9-29). Recording at high levels could improve dynamic range but it could also increase distortion. And there is the problem of tape noise.

The inherent unevenness of a tape's magnetic coating, even in the highest-quality tapes, always leaves a slight polarization of the magnetic particles in the coating after erasure, regardless of how complete erasure is. Each time a tape is used, some of the magnetic coating is worn away, thus decreasing the signal-to-noise ratio. Poor dispersion of the magnetic particles creates sound dropout and noise. Residual magnetization after erasure due either to an improper erase current or to poor bulk-erasing technique increases tape noise. A problem with the re-

cord current will result in a recording that is not uniformly magnetized. A tape recording made at a level that is too quiet will underpolarize the magnetic particles, thereby creating hiss. Multitrack tape brings an associated increase in tape noise.

To improve dynamic range and reduce noise, the signal must be processed before it is encoded on tape and after it is decoded from tape. Such a process is called *double-ended noise reduction*. Noise reduction that occurs either just before recording or just after playback is called *single-ended noise reduction*.

Double-Ended Noise Reduction

As mentioned in the previous section, a compressor can process noise "before the fact," during recording, and the expander can process noise "after the fact," during playback.

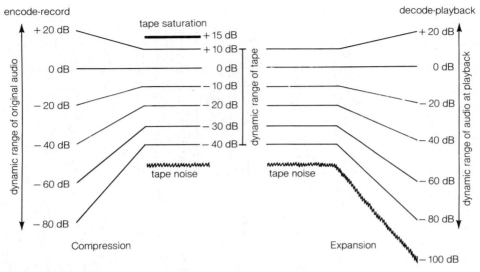

9-30 How a noise reducer decreases noise in a tape recording

During recording the input signal is compressed — that is, dynamic range is reduced. Where quiet passages occur in the sound, they are recorded at a higher-than-normal level. During playback the signal is expanded — returned to its original dynamic range — but with one difference. The level is reduced, and so is the noise, in all of the places where it was increased during recording (see 9-30).

Using the compression and expander for noise reduction is an exacting and time-consuming job. It is also expensive. It involves setting the appropriate thresholds and ratios on each unit for each tape track being produced; a 24-track recording would require 24 compressors and 24 expanders to reduce overall tape noise. Therefore, the double-ended process of noise reduction has been incorporated into a single unit called a **compander** (from its functions, compression and expansion). The compander is more popularly known as a *noise reducer*.

In double-ended noise reduction, a tape encoded with noise reduction must be decoded during playback. If it is not, the increased signal and noise level that was encoded during recording will be annoyingly perceptible. The most commonly used double-ended noise reduction systems are Dolby and dbx. The systems are not compatible, so tapes made with one are not interchangeable with the other.

The Dolby System

Dolby has several systems currently in use: SR (Spectral Recording), S, A, B, and C. (Dolby Stereo and Dolby Surround Sound are discussed in Chapter 17.)

SR (Spectral Recording) uses the principle of least treatment to the audio signal (see 9-31). At the lowest levels or when no signal is present, SR applies a fixed gain/frequency characteristic that reduces noise and other low-frequency disturbances by about 25 dB.

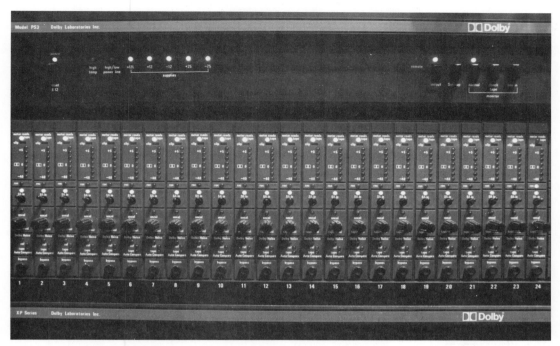

9-31 Dolby SR noise reduction system for a 24-track analog tape recorder

When any part of the signal spectrum increases in level significantly, SR changes the gain only by the amount required and only at frequencies where the change is needed, thereby achieving as nearly optimum a level as possible at all frequencies. SR increases headroom to the point where the risk of underrecording analog tape and overrecording digital tape is reduced considerably.

Dolby S noise reduction is based on the SR process. It is less complex and less costly than SR and was designed for the home audiocassette.

The Dolby A system, predecessor of SR, divides the frequency spectrum into four bands with separate compression and expansion for each: (1) 80 Hz and below, to deal with rumble and hum; (2) 80 to 3,000 Hz, to deal with midrange noise; (3) 3,000 to 9,000 Hz; and (4) 9,000 Hz and above, to deal with hiss and modulation noise. Dolby A provides 10 dB of noise reduction from 30 to 5,000 Hz, increasing gradually to 15 dB at 15,000 Hz. Dolby A operates on only quiet passages—below about 10VU. The theory is that high-level sound does not require noise reduction because it masks the noise.

Dolby SR and Dolby A differ in two significant ways. One is in the SR's greater amount of overall noise reduction. The other is that SR seeks to maintain full noise reduction across the entire frequency spectrum until the incoming signal rises above the threshold level, while Dolby A leaves the signal alone until it drops below a certain threshold.

The Dolby B system is used for less critical noise reduction in home tape recorders. It

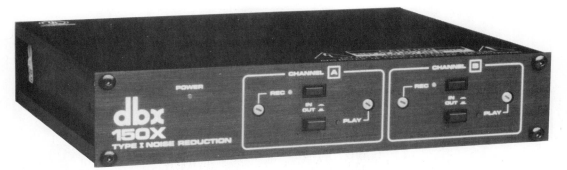

9-32 dbx Type 1 noise reduction unit

reduces high-frequency noise 10 dB above 8 kHz and has no operating effect on lower-frequency noises. Dolby C, also for non-professional systems, reduces noise 20 dB across a wider range than Dolby B, acting down to 100 Hz.

The dbx System

The dbx system reduces noise 30 dB across a single, full-frequency-range band from 20 to 20,000 Hz. There is no division of noise reduction among frequency bands. The compression ratio is 2 to 1, so sonic material with a dynamic range of, say, 90 dB is compressed to 45 dB during recording and expanded to 90 dB during playback. dbx is not level-dependent.

The original dbx noise reduction system, designated Type 1, was developed for use in professional recording studios (see 9-32). However, broadcast cartridges and telephone transmission lines do not offer the excellent frequency response available in professional tape recorders; the low end and high end fall off considerably. To meet the needs of broadcasters, the dbx Type 2 noise reduction system was developed. The Type 1 and Type 2 systems are incompatible; a tape encoded

with one system cannot be decoded by the other.

Dolby Versus dbx

A question often asked is, "Which system is better, Dolby or dbx?" That is, of course, a matter of taste; both systems are excellent. Generally, however, it seems that dbx is preferred for popular music recording in which there is less dynamic content and Dolby is preferred for music recording in which there is wide dynamic content and for film and TV sound production.

The dbx system provides impressive noise reduction with a very low noise floor and considerable headroom. Therefore, it "hears" quite critically. But it also exaggerates dropouts more than does Dolby and tends to produce audible modulation of background hiss and, sometimes, audible "pumping" noises. Dolby, on the other hand, is more "forgiving." It handles dynamic content better than does dbx. Also, because the frequency response of film and TV is not as wide as that of music recording, Dolby is more flexible to work with. It should be stressed, again, that these are generalizations. Personal preference should be your guide.

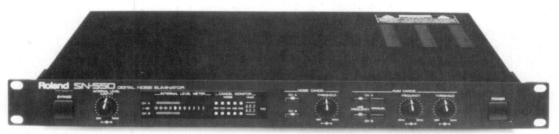

9-33 **Single-ended noise reducer.** Single-ended noise reducers can be connected just prior to the input of a master tape recorder and also enable individual channels from a mixer to be processed independently. They can be connected to process reproduced sounds during playback, as well.

Single-Ended Noise Reduction

Double-ended noise reduction systems do not remove noise from a signal, they prevent it from entering. Single-ended noise-reduction systems work to reduce existing noise from a signal or recording. Generally, single-ended noise reduction senses the level of the incoming signal. When the level falls below a certain threshold, high frequencies in the low-level signal are reduced progressively, thereby reducing the level of hiss. High-level signals are not processed.

The noise gate can be considered as a single-ended noise reducer. When a particular threshold is set and the signal level falls below that threshold, the noise gate shuts down, thereby preventing unwanted noise from passing through. Of course, if the threshold level is not set carefully, program information may also be prevented from coming through. Another type of single-ended noise reducer is shown in 9-33.

Noise Reduction with Digital Signal Processing

Digital signal processing (DSP) in hard disk recording and editing systems — EQing, limiting, compressing, pitch shifting, and so on — can also be used as a powerful antidote

to noise (see Chapter 16). DSP is accomplished through the use of algorithms, programs that perform complex calculations according to a set of controlled parameters.

One digital processing system for noise reduction (NoNoise by Sonic Solutions) uses three main tools: manual de-clicking for removal of clicks, pops, thumps, electrostatic ticks, and other impulse noises; production de-clicking and de-crackling for automatic click and scratch detection and removal; and broadband de-noising to eliminate hiss, surface noise, and unwanted background noise. For example, it is possible to take a sample of a hiss or hum, isolate it in a section as small as half a second, and then take a signature of it. Analysis is done on all frequency components of that noise, and the signature is digitally removed from the digital audio signal that contained it. If the problem is a 60-cycle hum, each one of the frequencies associated with the 60 cycles is attenuated by the exact multiple of the hum. The desirable part of the signal remains undisturbed. The frequency components contributing to the hum are brought down.

Clicks and pops can be removed manually, one at a time, or automatically. The area to the left and right of the click or pop is analyzed to determine what frequencies in the signal are present. The gap that results from

the removal of the click or pop is filled with appropriate synthesized material. De-crackling is a more intensive de-clicking operation that interpolates and removes thousands of clicks and pops per second.

The system is particularly effective at removing constant, steady noises. For example, in a dialogue track with high-level background noise from lights, ventilating fans, and studio acoustics, 85 percent of the noise can be removed without affecting voice quality.

Main Points

1. Signal processors are devices used to alter some characteristic of a sound. They fall into four categories: (1) spectrum, (2) time, (3) amplitude, and (4) noise.

2. The equalizer and filter are examples of spectrum processors because they alter the spectral balance of a signal. The equalizer increases or decreases the level of a signal at a selected frequency by boost or cut (also known as peak and dip), or by shelving. The filter attenuates certain frequencies above, below, between, or at a preset point(s).

3. Two types of equalizers in common use are the fixed-frequency and the parametric.

4. The most commonly used filters are high-pass (low-cut), low-pass (high-cut), band-pass, and notch.

5. Psychoacoustic processors add clarity, definition, and overall presence to sound.

6. Time signal processors affect the time relationships of signals. Reverberation and delay are two such effects.

7. Reverberation is random, multiple, blended repetitions of a sound or signal.

It adds spatial depth and dimension to the listening experience.

8. Three most common types of reverberation systems used today are (1) acoustic chamber, (2) plate (or foil), and (3) digital.

9. Delay is the time between sound reflections.

10. Delay can be produced mechanically using a tape recorder or electronically using an analog or digital delay device.

11. Flanging and phasing split a signal and slightly delay one part to create controlled phase cancellations that generate a pulsating sound. Flanging uses a time delay; phasing uses a phase shifter. A pitch shifter can change the pitch of a sound or running time of a program without altering pitch.

12. Amplitude processors affect a sound's dynamic range. These effects include compressing, limiting, and expanding a signal.

13. With compression, as the input level increases, the output level also increases but at a slower rate, reducing dynamic range. With limiting, the output level stays at or below a preset point regardless of its input level. With expansion, as the input level increases, the output level also increases but at a greater rate, increasing dynamic range.

14. Noise processors are designed to reduce tape noise in analog recording. They are either double-ended or single-ended. Two commonly used double-ended noise reduction systems are Dolby and dbx.

15. Digital signal processing (DSP) is extremely effective at noise reduction.

CHAPTER 10

Loudspeakers and Monitoring

Each component in the sound chain is important; but no matter how good the components are, when you listen to their product, you hear only what the loudspeaker can reproduce. To put it another way, the quality of every sound you evaluate is based on what you hear from the loudspeaker. The tendency is to underestimate the importance of the loudspeaker, perhaps because it is the last link in the sound chain. There may be a subconscious correlation between last and least. This attitude is aesthetically fatal.

The point seems straightforward: Always use the best loudspeaker. But which is best? Is it the most expensive, the largest, the loudest, the one with the widest, flattest frequency response, or the one suitable for symphonic music or AM radio? Although a loudspeaker is critical to any audio operation, choosing the best one for your needs is anything but a straightforward procedure. It involves several decisions; each influences later decisions and most are mainly subjective.

In deciding which loudspeaker is "best," you should look at several factors: frequency response, linearity, amplifier power, distortion, output-level capability, sensitivity, polar response, arrival time, and phasing. Where the monitors are to be placed will also affect the sound. These factors will be discussed later in the chapter.

Like the microphone, the loudspeaker is a transducer, but it works in the opposite direction. Instead of changing acoustic energy into electric energy, it changes electric energy back into acoustic energy. Also, like the microphone, the loudspeaker uses moving coils, ribbons, or capacitors as transducing elements. Although all three types of microphones are readily available and commonly used, the overwhelming majority of loudspeakers in use are moving-coil.

The **moving-coil loudspeaker** is so popular because it can deliver excellent sound quality, in a rugged design, at various price ranges. Ribbons and capacitors are virtually extinct. For these reasons, this chapter deals with the moving-coil loudspeaker.

Loudspeaker Systems

The function of a loudspeaker is to convert the electrical energy that drives it into mechanical energy and in turn to acoustic energy. Theoretically, a loudspeaker should be able to reproduce all frequencies linearly — that is, having an output that varies proportionately with the input. In reality, this does not happen. A loudspeaker that is large enough to generate low-frequency sound waves most likely will not be able to reproduce the high frequencies efficiently. Conversely, a speaker capable of reproducing the shorter waves may be incapable of reproducing the longer wavelengths.

To illustrate the problem, many radio and television receivers, as well as 16mm film projectors, contain a single speaker; even many stereo radios and tape recorders contain only one loudspeaker in each of the two loudspeaker enclosures. Because a single speaker has difficulty coping with the entire range of audible frequencies, a compromise is made: The long and short wavelengths are sacrificed for the medium wavelengths that a single midsized loudspeaker can reproduce more efficiently. Therefore, regardless of a recording's sound quality, a receiver with just one loudspeaker cannot reproduce it with full-frequency response. (As we note later, this imposes certain restrictions on selecting studio loudspeakers and monitoring.)

Crossover Network and Drivers

To widen the loudspeaker's frequency response and make reproduction of the bass and treble more efficient, the **crossover network** was created. Also, individual speaker elements, called drivers, were developed to handle the different physical requirements necessary to emit the long, powerful, bass frequencies and the short, more directional, treble frequencies.

The crossover network divides the frequency spectrum between the low and high frequencies. The actual point, or frequency, where the bass and treble divide is called the **crossover frequency**. A driver large enough to handle the low frequencies is dedicated to the bass and a driver small enough to handle the high frequencies is dedicated to the treble. Informally, these drivers, or loudspeakers, are called the **woofer** and the **tweeter**. Low- and high-frequency drivers are contained in a single cabinet. The size of the drivers is related to the power output of the loudspeaker system.

If a loudspeaker system divides the frequency spectrum once, it is called a **two-way system loudspeaker**. The crossover frequency in a two-way system is in the neighborhood of 1,500 to 2,000 Hz. The frequencies below the crossover point are assigned to the woofer and the frequencies above the crossover are assigned to the tweeter. A loudspeaker may have more than one driver for each frequency range (see 10-1).

10-1 Two-way system loudspeaker with two woofers and a dome tweeter

10-2 Three-way system loudspeaker with two woofers, midrange driver, and a horn-type tweeter to widen the dispersion of the high frequencies

A loudspeaker system that uses two cross-over frequencies is called a **three-way system loudspeaker** (see 10-2), and one that has three crossover frequencies is called a **four-way system loudspeaker** (see 10-3). Three-way systems divide the frequency spectrum at roughly 400 to 500 Hz and 3,500 to 5,000 Hz. Four-way systems divide it at anywhere between 400 to 500 Hz, 1,500 to 2,000 Hz, and 4,500 to 6,000 Hz.

10-3 Four-way system loudspeaker with two 15-inch woofers, 10-inch midbass, midrange, and high-frequency horn-loaded tweeters

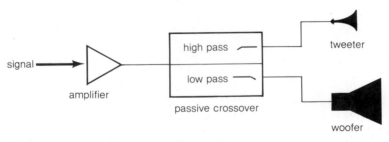

10-4 Monitor system with a passive crossover

Passive and Active Crossover Networks

Two types of crossover networks are used in loudspeakers, passive and active. In a **passive crossover network** the power amplifier precedes the crossover (see 10-4). This design can create certain problems: Output level at

the crossover frequency is usually down by a few dB; intermodulation distortion is more likely to occur, particularly at loud levels; harmonic distortion may be heard in the high frequencies.

In an **active crossover network** the crossover precedes two power amps and operates at low power levels. One amp receives the

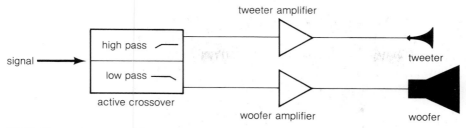

10-5 Biamped system with an active crossover

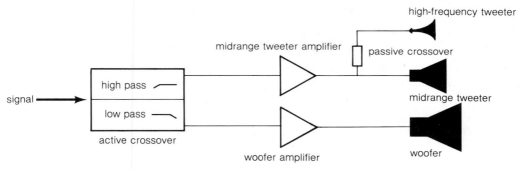

10-6 Biamped monitor system with both active and passive crossovers

low-frequency signals and drives the woofer; the other amp receives the high-frequency signals and drives the tweeter. This is known as a **biamplification**, or *biamped*, system (see 10-5). An active crossover network has several advantages over a passive one. It reduces distortion, and if distortion should occur in either the woofer or the tweeter, it will not be transferred to the other component. Power requirements are more efficiently used because a lower-power amp can drive the tweeter, which requires less power than the woofer. Both woofer and tweeter have their own power amp. Transient response is better, especially in the lower frequencies.

Three-way system loudspeakers can be *triamped*, meaning that each speaker is driven by its own amp. If a three-way system is biamped, a passive crossover is added before the tweeter to create the three-way design (see 10-6).

Selecting a Monitor Loudspeaker

Loudspeakers are like musical instruments in that they produce sound. They are not like purely electronic components such as consoles, which can be objectively tested and rationally evaluated. No two loudspeakers ever sound quite the same. Comparing the same make and model loudspeakers in one room only tells you what they sound like in that acoustic environment; in another room they may sound altogether different.

Furthermore, a loudspeaker that satisfies your taste might be unappealing to someone else's taste. Thus, it is extremely difficult to suggest guidelines for selecting a studio monitor. Nevertheless, all loudspeakers used for professional purposes should meet certain requirements.

Frequency Response

Evaluating **frequency response** in a loudspeaker involves two considerations: (1) how wide it is and (2) how flat, or linear, it is. Frequency response ideally should be as wide as possible, from at least 40 Hz to 16,000 Hz. But the relationship between the sound produced in the studio and the sound reproduced through the audience's receiver/loudspeaker becomes a factor when selecting a monitor loudspeaker (see section on near-field monitoring).

Each medium has a particular response capability (see 10-7). The same is true for the components that reproduce the sound from each medium (see 10-8). For example, TV audio can carry the entire range of audible frequencies. You may have noticed during a televised music program, however, that you see certain high- and low-pitched instruments being played but you hear them only faintly or not at all. Overhead cymbals are one example. Generally, their frequency range is between 300 and 15,000 Hz (including overtones), but they usually begin to gain good definition between 4,500 and 8,000 Hz, which is well within the frequency of television transmission. However, the highest response of many home TV receivers is about 6,000 Hz, which is below a good part of the cymbals' range.

Assume you wish to boost the cymbal frequencies that the home TV receiver can barely reproduce. Unless you listen to the sound over a monitor comparable in output level and response to the average TV speaker, you cannot get a sense of what effect the boost is having.

This situation is improving, however. Stereo TV and digital sound have helped to increase interest in bettering television audio both in the studio and at home. Many TV receivers are now equipped with loudspeakers capable of reproducing wider frequency response.

Unlike television sound, optical film sound is limited in frequency response not only by the projector's speaker system but also by the medium itself. Suppose a film calls for the sound of distant thunder. If you record and equalize that sound on a good studio monitor, you may be tempted to boost the very low frequencies to make the thunder sound louder and boomier. When that sound is transferred to a 16mm optical film track, however, the frequencies below about 100 Hz are lost. Furthermore, the speaker usually found in a 16mm projector has limited low-frequency response at roughly 300 Hz and below. Unless you take these two factors into consideration when recording and equalizing, the thunder effect may be considerably diminished or lost, or it can make the speaker and its enclosure rumble annoyingly if they are unable to handle such amplitudes in the unlikely event they are reproduced. High frequencies are also difficult to produce in 16mm optical sound because the frequency response does not extend much beyond 8,000 Hz.

With film, 35mm optical sound produces a wider frequency response than 16mm optical sound can and, with Dolby Stereo and Dolby Stereo Digital sound, that difference is significant. This is especially true in theaters, where large and powerful loudspeakers reproduce the sound. Of course, the quality among the sound systems in movie theaters varies.

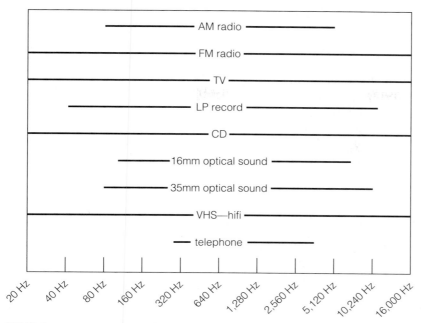

10-7 Frequency responses of various reproducing systems

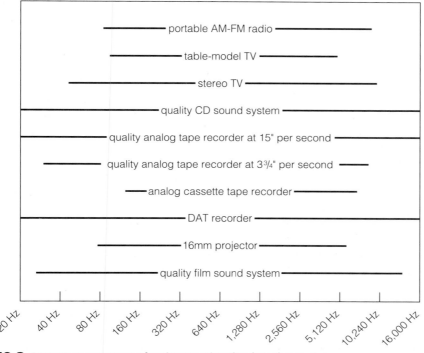

10-8 Frequency responses of various receiver/loudspeaker systems

Due to the differences between the potential sound response of a medium and its actual response after processing, transmission, and reception, it makes sense to choose at least two types of studio monitors. One should provide both wide response and enough power to reproduce a broad range of sound levels, and the other should have response and power that reflect what the average listener hears. Many recording studios use three sets of monitors to check sound: (1) low-quality loudspeakers with only mid-range response and limited power output, such as those in portable and car radios and cheap tape decks; (2) average-quality loudspeakers with added high and low response, such as moderately priced component systems; and (3) high-quality loudspeakers with a very wide response and high output capability. In film rerecording studios, usually only theater-size loudspeakers are used.

Linearity

The second consideration in evaluating frequency response in a loudspeaker is how linear it is—regardless of a loudspeaker's size, power requirements, or wideness of response. **Linearity** means that frequencies being fed to a loudspeaker at a particular loudness are reproduced at the same loudness. If they are not, it is very difficult to predetermine what listeners will hear. If the level of a 100-Hz sound is 80 dB going in and 55 dB coming out, some—if not most—of the information may be lost. If the level of an 8,000-Hz sound is 80 dB going in and 100 dB coming out, the information may be overbearing.

Loudspeaker specifications include a value that indicates how much a monitor deviates from a flat frequency response, either by increasing or decreasing level. This variance should be no greater than ±3 dB.

Amplifier Power

To generate adequately loud sound levels without generating distortion, the loudspeaker amplifier must provide sufficient power. At least 30 watts for tweeters and 100 watts for woofers is generally necessary. Regardless of how good the rest of your loudspeaker's components are, if the amplifier does not have enough power, it is as if you were trying to power a large boat with a small outboard motor—efficiency suffers considerably.

There is a commonly held, seemingly plausible, notion that increasing amplifier power means a proportional increase in loudness; for example, that a 100-watt amplifier can play twice as loud as a 50-watt amplifier. In fact, if a 100-watt and a 50-watt amp are playing at top volume, the 100-watt amp will sound only slightly louder. What the added wattage gives is clearer and less distorted reproduction in loud sonic peaks.

Distortion

Discussion of amplifier power leads naturally to consideration of **distortion**—appearance of a signal in the reproduced sound that was not in the original sound. Any component in the sound chain can generate distortion. Because distortion is heard at the reproduction (loudspeaker) phase of the sound chain, regardless of where in the system it was generated, and because loudspeakers are the most distortion-prone component in most audio systems, it is appropriate to discuss briefly the various forms of distortion—intermodulation, harmonic, transient, and loudness—here.

Intermodulation Distortion

The loudspeaker is perhaps most vulnerable to intermodulation distortion. **Intermodulation distortion** (*IM*) results when two or

more frequencies occur at the same time and interact to create combination tones and dissonances that are unrelated to the original sounds. Audio systems can be most vulnerable to intermodulation distortion when frequencies are far apart, as when a piccolo and a baritone saxophone are playing at the same time. Intermodulation distortion usually occurs in the high frequencies because they are weaker and more delicate than the low frequencies.

Wideness and flatness of frequency response are affected when IM is present. In addition to its obvious effect on perception, even subtle distortion can cause listening fatigue.

Unfortunately, not all specification sheets include percentage of IM, and those that do often list it only for selected frequencies. Nevertheless, knowing the percentage of IM for all frequencies is important to loudspeaker selection. A rating of .5 percent IM or less is considered good for a loudspeaker.

Harmonic Distortion

Harmonic distortion occurs when the audio system introduces harmonics into a recording that were not present originally. Harmonic and IM distortion usually happen when the input and output of a sound system are **nonlinear** — that is, when they do not change in direct proportion to each other. A loudspeaker's inability to handle amplitude is a common cause of harmonic distortion. This added harmonic content is expressed as a percentage of the total signal or as a component's *total harmonic distortion (THD)*.

Transient Distortion

Transient distortion relates to the inability of an audio component to respond quickly to a rapidly changing signal such as percussive

sounds. Sometimes, transient distortion produces a ringing sound.

Loudness Distortion

Loudness (or *overload*) **distortion** arises when a signal is recorded or played back at a level of loudness that is greater than the sound system can handle. The clipping that results from loudness distortion creates a fuzzy, gritty sound.

Output-Level Capability

Overly loud signals give a false impression of program quality and balance; nevertheless, a loudspeaker should be capable of reproducing loud sound levels without distorting, blowing fuses, or damaging its components. An output capability of 110 dB-SPL is desirable for studio work. In live concerts even louder levels may be used. Even if studio work does not often call for very loud levels, the monitor should be capable of reproducing them, because it is sometimes necessary to listen at a loud level to hear subtlety and quiet detail.

Sensitivity

Sensitivity is the on-axis sound pressure level a loudspeaker produces at a given distance when driven at a certain power (about 3.3 feet with 1 watt of power). A monitor's sensitivity rating gives you an idea of the system's overall efficiency. Typical ratings range from 84 dB to over 100 dB.

In real terms, however, a sensitivity rating of, say, 90 dB indicates that the loudspeaker could provide 100 dB from a 10-watt input and 110 dB from a 100-watt input, depending on the type of driver. The point is that it is the combination of sensitivity rating and power rating that tells you whether a monitor

loudspeaker will be loud enough to suit your production needs. Generally, a sensitivity rating of 93 dB or louder is required for professional applications.

Polar Response

Polar response indicates how a loudspeaker focuses sound at the monitoring position(s). Because it is important to hear only the sound coming from the studio or the tape without interacting reflections from the control room walls (vertical surfaces) and ceiling or floor (horizontal surfaces), dispersion must be controlled (see Chapter 3).

Bass waves are difficult to direct because of their long wavelengths. Therefore, bass traps and other low-frequency absorbers are included in control room design in order to handle those bass waves not focused at the listening position.

Frequencies from the tweeter(s), on the other hand, are shorter and easier to focus. The problem with high frequencies is that, as the wavelength shortens, the pattern can narrow. Therefore, the **coverage angle**, defined as the off-axis angle or point at which loudspeaker level is down 6 dB compared to the on-axis output, may not be wide enough to include the entire listening area.

To help in selecting a loudspeaker with adequate polar response, specifications usually list a monitor's horizontal and vertical coverage angles. These angles should be high and wide enough to cover the listening position and still allow the operator or audience some lateral movement without seriously affecting sonic balance (see 10-9).

Arrival Time

Even if coverage angles are optimal, unless all reproduced sounds reach the listening position(s) at relatively the same time they were

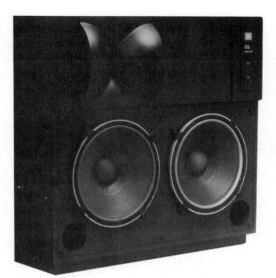

10-9 JBL Bi-Radial® horn monitor loudspeaker. This model is designed to provide constant vertical and horizontal polar coverage.

produced, aural perception will be impaired. When you consider the differences in size and power requirements among drivers and the wavelengths they emit, you can see this is easier said than done.

In two-, three-, and four-way system loudspeakers the physical separation of each of the speakers in the system causes the sounds to reach the listener's ears at different times. Loudspeaker systems exist that are time-accurate within 1 millisecond or less (see 10-10). Arrival times different by more than 1 millisecond are not acceptable in professional applications.

Phasing

Sometimes, although dispersal and arrival time are adequate, sound reaching a listener may not be as loud as it should be or the elements within it may be poorly placed. For example, a rock band may be generating loud

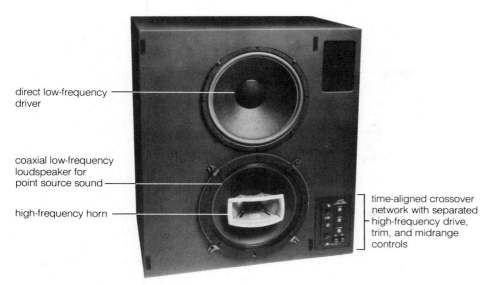

direct low-frequency driver

coaxial low-frequency loudspeaker for point source sound

high-frequency horn

time-aligned crossover network with separated high-frequency drive, trim, and midrange controls

10-10 **The UREI time-aligned™ loudspeaker.** This loudspeaker is designed to ensure precise arrival times. Instead of separate transducers to handle high, middle, and low frequencies, which could cause stereo imaging to "smear," the UREIs use a coaxial loudspeaker — literally two speakers in one — to cover the full audio range.

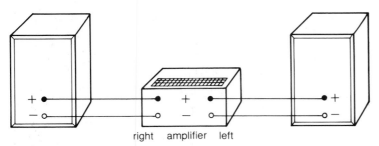

right amplifier left

10-11 **Properly wired loudspeakers.** These loudspeakers will reproduce in phase.

levels in the studio but the sounds in the control room are, in relative terms, not so loud, or a singer is supposed to be situated front and center in a recording but is heard from the left or right loudspeaker.

These problems may be the result of out-of-phase loudspeakers: One loudspeaker is pushing sound outward (compression) and the other loudspeaker is pulling sound inward (rarefaction). Phase problems can occur between woofer and tweeter in the same loudspeaker enclosure or between two separate loudspeakers. In the latter case it is usually because the connections are not wired properly (see 10-11 and 10-12). If you think sound is out of phase, check the VU meters.

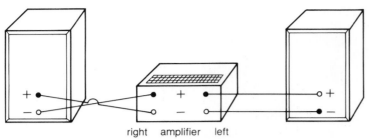

10-12 Improperly wired loudspeakers. These loudspeakers will reproduce out of phase.

If they show a similar level and the audio still sounds skewed, then the speakers are out of phase; if they show quite different levels, then the phase problem is probably elsewhere.

Monitor Placement

Where you place monitor loudspeakers also affects sound quality, dispersal, and arrival time. Loudspeakers are often designed for a particular room location and generally positioned in one of four places: (1) well toward the middle of a room, (2) against or flush with a wall, (3) at the intersection of two walls, or (4) in a corner at the ceiling or on the floor. Each position affects the sound's loudness and dispersion differently.

A loudspeaker hanging in the middle of a room radiates sound into what is called a *full sphere* (or *full space*), where — theoretically — the sound level at any point within a given distance is the same (see 10-13). If a loudspeaker is placed against a wall, the wall concentrates the radiations into a *half sphere*, thereby theoretically increasing the sound level by 3 dB. With loudspeakers mounted at the intersection of two walls, the radiation angle is concentrated still more into a *one-quarter sphere*, thus increasing the sound level another 3 dB. Loudspeakers

placed in corners at the ceiling or on the floor radiate in a *one-eighth sphere*, generating the most concentrated sound levels in a four-walled room. A significant part of each increase in the overall sound level is due to the loudness increase in the bass (see 10-14).

In nonprofessional situations one of these monitor positions is not necessarily better than another; proper placement depends on your needs and personal taste. In professional situations, however, it is preferable to flush mount loudspeakers in a wall. The most important thing in monitor placement is to avoid any appreciable space between the loudspeaker and the wall. Otherwise, the wall will reflect unwanted low frequencies, adversely affecting level, frequency response, and phase.

Near-Field Monitoring

Large monitor loudspeakers may serve as the sonic reference during recording and much of the mixdown, but they do not reproduce the sound that listeners hear over small sets and automobile stereo systems. A complex mix played over high-resolution monitors may sound excellent, but that same mix played over small loudspeakers may lose significant musical detail. This is particularly

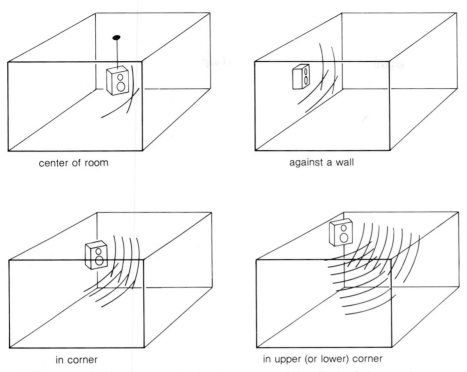

center of room

against a wall

in corner

in upper (or lower) corner

10-13 Four typical loudspeaker locations in a room and the effects of placement on overall loudness levels

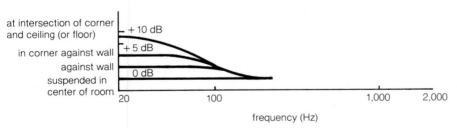

at intersection of corner and ceiling (or floor)

in corner against wall

against wall

suspended in center of room

+ 10 dB

+ 5 dB

0 dB

20 100 1,000 2,000

frequency (Hz)

10-14 An example of the effects of loudspeaker placement on bass response

true in relation to the bass, treble, and vocal balances. Remember, too, the equal loudness curves: A mix that is monitored at a loud listening level will sound quite different at a lower level.

In addition to the elaborate, matched, equalized built-in monitors that are found in most studio control rooms, mounted several feet from the mixing console, many control rooms therefore also have small near-field

10-15 Near-field monitors on console's meter bridge

monitors placed on or near the console's meter bridge close to the recording engineer (see 10-15). **Near-field monitoring** enables the sound engineer to reduce the audibility of control room acoustics by placing loudspeakers close to his or her position. Moreover, near-field monitoring improves source localization because most of the sound reaching the recording engineer is direct; the early reflections that hinder good source localization are reduced to the point where they are of little consequence. At least, that is the theory. In practice, problems with near-field monitoring still remain (see 10-16).

Near-field monitoring became a vital link in the sound chain in the last decade, but it is not new. What limited its use for so long was the absence of good-quality small loudspeakers. Now, small loudspeakers that meet the requirements of near-field monitoring are readily accessible. Among those requirements are a uniform frequency response from about 70 to 16,000 Hz, especially

smooth response through the midrange, a sensitivity range from 87 to 92 dB, sufficient amplifier power, and good vertical dispersion for more stable stereo imaging.

Adjusting Monitor Sound to Room Sound

No loudspeaker–room interface produces a perfectly wide, flat response. Even a studio designed for acoustic control colors sound in some way. In one studio acoustics may boost 500 Hz, 4 dB and attenuate 4,300 Hz, 5 dB; in another studio the frequency response may drop off 10 dB at 10,000 Hz. The sound of any loudspeaker, no matter where it is placed in a room, is colored by the acoustics of that room.

To neutralize these effects, monitors are equalized by feeding the signal through an equalizer before it reaches the amplifier and loudspeaker. The equalizer is adjusted to compensate for idiosyncrasies in the room re-

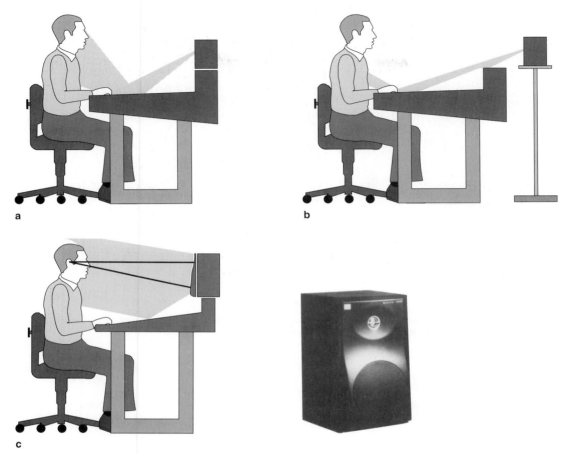

10-16 **Near-field monitoring.** (*a*) If a meter bridge is too low, early reflections will bounce off the console degrading the overall monitor sound reaching the operator's ears. (*b*) One way to minimize this problem is to place the near-field monitors a foot or so in back of the console and cover the meter bridge with absorptive material. (*c*) The curved design of this near-field monitor was intended, among other things, to direct the shorter wavelengths away from the listening position.

sponse. For example, in the studio that boosts 500 Hz, 4 dB and attenuates 4,300 Hz, 5 dB, the frequencies are equalized by attenuating 500 Hz, 4 dB and boosting 4,300 Hz, 5 dB to make the response flat. Typically, however, studios are EQed by attenuating only. Tests for analysis of loudspeaker–room response are done with a **real-time analyzer**—a device that displays response curves on an instantaneous basis (see 10-17). Real-time analyses should be taken at different amplitudes.

Equalizing monitor loudspeakers does not correct gross deficiencies in monitor design or studio acoustics, however. Before you do any equalizing, it is important to start with a compatible room–loudspeaker

10-17 Real-time spectrum analysis displaying (in a waterfall plot) the response curve of a room with a broad notch from 350–550 Hz, caused by destructive reflections

relationship. Proper acoustic design is the first priority; equalization is the subsequent fine-tuning for a monitor system.

Evaluating the Monitor Loudspeaker

The final test of any monitor loudspeaker is how it sounds. Although the basis for much of the evaluation is subjective, there are guidelines for determining loudspeaker performance.

■ Sit at the designated listening position—the optimal distance away from and between the loudspeakers (see 10-18). This position should allow some front-to-back and side-to-side movement without altering perception of loudness, frequency response, or spatial perspective. It is important to know the boundaries of the listening position(s) so that all sound can be monitored on-axis within this area.

■ Use familiar material for the evaluation. Otherwise, if some aspect of the sound is unsatisfactory, you will not know whether the problem is with the original material or with the loudspeaker.

■ In listening for spatial balance, make sure the various sounds are positioned in the same places relative to the original material. If the original material has the vocal in the center (in relation to the two loudspeakers, assuming a stereo recording), the first violins on the left, the bass drum and bass at the rear center, the snare drum slightly left or right, and so on, then these

10-18 To help create an optimal travel path for sound from the loudspeakers to the listening position, carefully measure the loudspeaker separation and the distance between the loudspeakers and the listening position. In (a), the distance between the acoustic center (between the loudspeakers) and the listening position are equal. In this arrangement, head movement is restricted somewhat, and the stereo image will be emphasized or spread out, heightening the sense of where elements in the recording are located. Shortening D2 and D3 will produce a large shift in the stereo image. In (b), the distance between the acoustic center and the listening position is about twice as long. With this configuration, the movement of the head is less restricted and the stereo image is reduced in width, although it is more homogeneous. The more D2 and D3 are lengthened, the more monaural the stereo image becomes (except for hard left and hard right panning).

should be in the same spatial positions when the material is played through the monitor system.

- In evaluating treble response, listen to the cymbal, triangle, flute, piccolo, and other high-frequency instruments. Are they too bright, crisp, shrill, or dull? Do you hear their upper harmonics?

- In testing bass response, include instruments such as the tuba and bass, as well as the low end of the organ, piano, bassoon, and cello. Sound should not be thin, boomy, muddy, or grainy.

- Assess the transient response, which is also important in a loudspeaker. For this, drums, bells, and triangle provide excellent tests, assuming they are properly recorded. Good transient response reproduces a crisp attack with no distortion or breakup.

Other important elements to evaluate were touched upon earlier in this chapter: intermodulation, harmonic, and loudness distortion. (See also "Monitoring 3-D and Surround Sound" in Chapter 17.)

Headphones

Headphones (also referred to as "cans") are a too-often-overlooked but important part of monitoring, especially in on-location recording (see Chapter 15). Three considerations are vital in using headphones for professional purposes: (1) frequency response should be wide, flat, and uncolored; (2) you must be thoroughly familiar with their sonic characteristics before you use them; (3) they should be *circumaural*—nearly airtight against the head for acoustical isolation.

Headphones are usually indispensable in on-location recording because monitor loudspeakers are often unavailable or impractical.

In studio control rooms, however, there are pros and cons to using headphones. The pros are that (1) sound quality will be consistent in different studios; (2) it is easier to hear subtle changes in the recording and the mix; and (3) there is no aural smearing due to room reflections. The cons are that (1) the sound quality will not be the same as provided by the monitor loudspeakers; (2) the aural image is inside the head rather than out in front; (3) there is no interaction between the program material and the acoustics, so the tendency may be to mix in more artificial reverberation than necessary; (4) if open-air, or *supra-aural*, headphones are used, bass response will not be as efficient as with circumaural headphones, and outside noise might interfere with listening; and (5) in panning signals for stereo, the distance between monitor loudspeakers is greater than the distance between your ears.

Main Points

1. Loudspeakers are transducers that convert electric energy into sound energy.

2. The moving-coil loudspeaker is the type most often used. Ribbon and capacitor loudspeakers are almost extinct.

3. Single, midsized loudspeakers cannot reproduce high and low frequencies very well; they are essentially midrange instruments.

4. For improved response, loudspeakers have drivers large enough to handle the bass frequencies and drivers small enough to handle the treble frequencies. These drivers are called, informally, woofers and tweeters, respectively.

5. A crossover network separates the bass and treble frequencies at the crossover point and directs them to their particular drivers. Two types of crossover networks are used: passive and active.

6. Two-way system loudspeakers have one crossover network, three-way system loudspeakers have two crossovers, and four-way system loudspeakers have three crossovers.

7. Each medium that records or transmits sound, such as AM radio, TV, or optical film, and each loudspeaker that reproduces sound, such as a studio monitor or home receiver, has certain spectral and amplitude capabilities. For optimal results sound should be produced with an idea of how the system through which it will be reproduced works.

8. In evaluating a monitor loudspeaker, frequency response linearity, amplifier power, distortion, output-level capability, sensitivity, polar response, arrival time and phasing should also be considered.

9. Linearity means that frequencies being fed to a loudspeaker at a particular loudness are reproduced at the same loudness.

10. Amplifier power must be sufficient to drive the loudspeaker system or distortion, among other things, will result.

11. Distortion is the appearance of a signal in the reproduced sound that was not in the original sound. Various forms of distortion include intermodulation, harmonic, transient, and loudness.

12. Intermodulation distortion (IM) results when two or more frequencies occur at the same time and interact to create combination tones and dissonances that are unrelated to the original sounds.

13. Harmonic distortion occurs when the audio system introduces harmonics into a recording that were not present originally.

14. Transient distortion relates to the inability of an audio component to respond quickly to a rapidly changing signal such as that produced by percussive sounds.

15. Loudness distortion results when a signal is recorded or played back at an amplitude greater than the sound system can handle.

16. The main studio monitors should have an output-level capability of 110 dB-SPL.

17. Sensitivity is the on-axis sound pressure level a loudspeaker produces at a given distance when driven at a certain power. A monitor's sensitivity rating provides a good overall indication of its efficiency.

18. Polar response indicates how a loudspeaker focuses sound at the monitoring position.

19. A sound's arrival time at the monitoring position(s) should be no more than 1 millisecond; otherwise, aural perception is impaired.

20. Where a loudspeaker is positioned affects sound dispersion and loudness. A loudspeaker in the middle of a room generates the least concentrated sound; a loudspeaker at the intersection of a ceiling or floor generates the most.

21. Near-field monitoring enables the sound engineer to reduce the audibility of control room acoustics by placing loudspeakers close to his or her position.

22. For monitoring sound the designated listening position should allow some front-to-back and side-to-side movement without altering perception of loudness, frequency response, or spatial perspective.

23. Headphones are an important part of monitoring, particularly on location. Three considerations are vital in using headphones: (1) Frequency response should be wide, flat, and uncolored; (2) you must be thoroughly familiar with the headphones' sonic characteristics before you use them; and (3) the headphones should be airtight against the head for acoustical isolation.

Preproduction

COMM'L NO.: FCOJ 2336

LENGTH: 30 SECONDS

(MUSIC UNDER THROUGHOUT)

ANNCR: (VO) Isn't that Florida Orange Juice?

SINGERS: (VO) Orange You Smart . . .

(SFX: MUSIC TO ACCENT FINGER TAPPING)
for drinking orange juice,

for that clean sunny taste.

Hey, Orange You Smart --

(SFX: MUSIC TO ACCENT FINGER TAPPING)
for drinking orange juice,

pure refreshment any place.

Hey, Orange You Smart for drinking

to your body's content -- the taste only

nature could invent.
ANNCR: (VO) 100% pure from Florida.

SINGERS: (VO) Hey Skipper,

Orange You Smart!

(SFX: MUSIC TO ACCENT FINGER TAPPING)

Creating the Sound Design

There are three stages in the production process: preproduction, production, and postproduction. In **preproduction**, material is evaluated; approaches to its conceptualization and realization are decided on; budgeting, hiring, and logistical planning are taken care of. In **production**, material is recorded on tape, film or disc or, often in radio and sometimes in TV, aired directly. In **postproduction**, recorded material is processed, edited, and mixed into its final form. Each stage is important to the successful outcome of a production. Perhaps the most critical stage, however, is preproduction.

Murphy's Law states that if something can go wrong, it will. The proposition may ap-

pear facetious, but during production Murphy seems to be everywhere. If a program is to demonstrate Newton's Law of Gravity and in preproduction it is planned that the apple will fall to earth, and if during rehearsal it falls to earth, do not underestimate Murphy's uncanny knack to somehow make the apple rise during taping. Although this might overstate the case, the basic caution stands: Each detail in a production must be worked out in advance to thwart Murphy. Murphy is costly and frustrating. His only benefit is in the comic relief sometimes provided by the unexpected. But the unexpected is to be avoided if possible, and that is why preproduction is so important. During preproduction creative

(and business) decisions that will affect the two later stages are carefully worked out. In most cases, as preproduction goes, so goes the rest of the production.

In TV and film, preproduction for audio may not occur at the same time as preproduction for shooting the picture. It may not be possible to make certain decisions about such things as sound effects, music, editing, and mixing until the visual production stage has been completed. Regardless, the essential point is that any audio should be planned before it is produced.

Depending on the elaborateness of the production (and the unions), a sound designer may be involved in one or a number of activities, from selecting the microphone and handling the boom to developing an entire sound track—dialogue, music, and sound effects. The larger the production, the greater the number of people involved in the sound design. In large-scale TV and film productions different people are usually responsible for various functions: recording dialogue, developing and recording sound effects, editing the effects, composing the music, editing the music, rerecording dialogue, recording Foley effects, and mixing all the sonic elements. In smaller-scale productions one or only a few persons may be responsible for most or all of these functions. In music recording, one person may serve as producer and engineer or several people may take the roles of producer, assistant producer, engineer, recordist, editor, and so on. Even in radio production, which can often be handled by one person, complex programs require at least a few people to produce effects, edit, and mix.

Because sound design can run from the simple to the complex and involve from one person to several, this discussion of preproduction applies to creative planning in general and not to the relating of a particular task to a designated (union) title or function.

Technical planning is also a vital part of preproduction, particularly in preparing for field production. For this reason, therefore, technical planning is discussed in Chapter 15.

Functions of Sound

In creating a sound design, you have three elements with which to work: speech, sound effects, and music. This may not seem to be an impressive arsenal, especially when compared to the number of elements available in pictorial design—light, color, picture composition, scenery, costumes, focal length of shots, camera angle, camera movement, and so on—and when coupled with the fact that visual memory is more retentive than is aural memory. In reality, sound is a formidable agent in communicating cognitive and affective information. Throughout history music has not only had an informational role but has been a transcending spiritual necessity. For years radio was extremely effective in creating a "theater of the mind" using just sound. In the so-called visual media sound often carries a substantial portion of the overall information. Sound has an undeniable power to direct our attention to, and shape our interpretation of, an image; to create expectations; and to underscore an idea or an emotion.

Spoken Sound

Speech interpretation is the responsibility of the director and performer, not the sound designer. Nevertheless, it is important for those involved in sound production to know the various ways in which speech—verbal and nonverbal—affects meaning. Speech has basically two functions, narration and dialogue, and conveys meaning primarily

through emphasis, inflection, and aural mood.

Narration

Narration is usually descriptive and voiced-over. That is, a narrator describes events from outside the action, not as a participant but as an observer. Three types of narration are direct, indirect, and contrapuntal.

Direct narration describes what is being seen or heard. If we see or hear an automobile coming to a stop, a car door opening and closing, footsteps on concrete and then on stairs, and a wooden door opening and closing, and are told as much, the narration is direct. If, on the other hand, the narrator tells us that the person emerging from the car and going into the building is on an urgent mission that is about to be resolved, and the action in the scene speaks for itself; this is **indirect narration. Contrapuntal narration,** as the term suggests, counterpoints narration and action to make a composite statement not explicitly carried in either element. For example, the action may contain people happily but wastefully consuming a more-than-ample meal, while the narration comments on the number of starving people in the world. The conflict between the two pieces of information makes a separate comment.

These examples may suggest that indirect and contrapuntal narration are better than direct narration because they supplement and broaden information and, therefore, provide more content. Indirect and contrapuntal narration are preferable if the action is somewhat obvious. But direct narration is useful in radio when sounds may not convey the necessary meaning. It is also helpful in educational or instructional programs when information requires reinforcement to be remembered and understood.

Narration provides nonverbal information as well. If the style of the delivery is formal and unemotional, content will come across as impersonal and objective. If the sound is heavily inflected and personalized, content takes on a more emotional and subjective quality.

Although the particular narrational approach depends on the script, understanding the influences of narration on content in general results in a better-conceived sound design.

Dialogue

Dialogue is a conversation between two or more people. Obviously, the verbal content of the conversation is essential to meaning, but nonverbal sound in dialogue also shapes meaning. Some examples follow.

An *accent* can tell you if a character is cultured or crude, an American from the Deep South or an immigrant from the Far East, England, France, and so on. It can also color an entire drama. Suppose a drama set in Russia and depicting events that led to the 1917 Revolution has an all-British cast. Although acting and dialogue may be superb, the refined, rounded, mellifluous British sound may not be so effective as the more guttural Slavic sound and may not give the necessary "edge" to people and events. A performer playing Adolf Hitler without the rawness of the German accent dilutes the force and impact of the characterization. Shakespeare played by actors who are not British seems to sound unnatural. Films rerecorded from one language to another rarely sound believable.

The *pace* of dialogue can convey meaning nonverbally to complement or supplement information. For example:

HE: Go away.

SHE: No.

HE: Please.

SHE: Can't.

HE: You must.

SHE: Uh-uh.

Certainly, there is not much verbal content here apart from the obvious. But by pacing the dialogue in different ways, meaning can be not only defined but also changed. Think of the scene played deliberately, with each line and the pauses between them measured, as opposed to a rapid-fire delivery and no pauses between lines. The deliberately paced sound design can convey more stress or, perhaps, inner anguish than the faster-paced version. On the other hand, the faster pace can suggest nervousness and urgency.

Dialogue *patterns* are important to natural-sounding speech and believable characterization. Although dialogue patterns are inherent in the writing, the author must be equally aware of sound and content. If a character is supposed to be highly educated, then the vocabulary, sentence structure, and speech rhythms should reflect erudition. If a character is being formal, vocabulary and sentence structure should be precise, and speech rhythms should sound even and businesslike. Informality would sound looser, more relaxed, and more personal. An actor playing a 19th-century character should speak with a vocabulary and syntax that evokes that time to late-20th-century ears. But if the character has a modern outlook and temperament, contemporary vocabulary and sentence structure are appropriate.

Emphasis

Emphasis—stressing a syllable or word—is important to all speech, narration and dialogue. It often conveys the meaning of what is being said. On paper the words "How are you" suggest concern for someone's welfare. Often, however, the words are used as another way of saying "Hello" or making a perfunctory recognition, with no expression of concern. Emphasis is what tells you so. Moreover, it is possible to emphasize the "how," the "are," or the "you" and communicate three different meanings. The words remain the same; the emphasis alters the message.

This concept can be applied to longer sentences as well. Take the line "John applied the principles at work." Emphasizing the word "John" tells you it is not Bob or Mary. The emphasis on "applied" indicates that John was definite and positive in his action. Stressing "the" suggests that the principles applied were the best, most significant, or most special. Accenting "principles" indicates that John did not apply theories or speculations. Emphasizing "work" means that John did not apply the principles at home or at the beach.

Inflection

Inflection—altering the pitch or tone of the voice—can also influence verbal meaning. By raising the pitch of the voice at the end of a sentence, a declarative statement becomes a question. Put stress on it, and it becomes an exclamation. Take the sentence "And the bombing continued." As a declarative statement it is a fact. As a question it introduces skepticism or perhaps even anguish. As an exclamation it becomes a statement of devastation or pride.

Aural Mood of Words and Sentences

Sound affects the mood or feeling of words and sentences. The word *fantastic* is a good example. Fantastic means fanciful, unbelievable, bizarre, or eccentric, yet the word is used colloquially as a synonym for *wonderful* and *marvelous*. Its sound, no doubt, helped to generate this new usage. The attack and rhythm of the speech sounds create a sonic uplift, enthusiasm, and excitement that

"feel" like terrific. (This is not to suggest, however, that the meaning of words should be ignored or changed to suit the sound.)

In the line "lurid, rapid, garish, grouped," by poet Robert Lowell, the sounds in each word not only contribute to the overall meaning but are contained in the other words to enhance further the mood of the line.

Take the sentences, "Waves crashed against the rocks" and "Waves hit upon the boulders." They mean essentially the same thing. However, they sound different, and that difference affects their impact. The first sentence contains more of the hard, crisp sounds appropriate to its meaning than does the second sentence. The second sentence contains rounder, gentler sounds that provide less of a sonic complement to the verbal meaning.

In the sentence "He plodded homeward, weary and forlorn," the sound of the vowels and consonants is subdued and "dark." Changing the sentence to "He walked home tired and depressed" makes the sound snappier and dilutes, sonically and semantically, the overall meaning of the words.

Sound Effects

Sound effects can be classified as anything sonic that is not speech or music. In media, sound effects perform two general functions, contextual and narrative, although these functions are not mutually exclusive.

Contextual Sound

Contextual sound emanates from and duplicates a sound source as it is. If a rocket fires, a horse gallops, or paper rustles, that is what you hear; the sound is natural or normal in structure and perspective. In other words, contextual sound is like direct narration.

Narrative Sound

Narrative sound adds more to a scene than what is apparent and so performs an informational function. It can be descriptive or commentative.

Descriptive sound, as the term suggests, describes sonic aspects of a scene, usually those not directly connected to the main action. As a sailboat glides through water, the contextual sound would be the wash of water against the boat and, perhaps, the sail flapping. Adding the sounds of wind, creaking timbers, and sea gulls enhances the scene. A conversation in a hot room with a ceiling fan slowly turning suggests the contextual sound. The sounds of insects buzzing about, ox-carts lumbering nearby, and an indistinguishable hubbub of human activity create atmosphere. In a walk through the woods, various animal sounds can help to describe the atmosphere and activity in the woods.

Commentative sound can also describe, but it makes an additional statement, one that usually has something to do with the story line. For example:

A long-time athlete is let go from the team. As he walks across the playing field for the last time, the wind comes up. Infused in the wind sound is the faint sound of cheering, giving the scene a wistful quality as the athlete reflects on the crowds that will be rooting for him no longer.

A windmill whose sound is more like weeping than creaking comments on a death. An animal howling as lovers kiss is made commentative by having it mock the innocent pleasure of the kiss.

Functions of Sound Effects

Sound effects also have specific functions within the general contextual and narrative categories. Among the most common are de-

fining space, establishing locale, creating environment, emphasizing and intensifying action, depicting identity, setting pace, providing counterpoint, symbolizing meaning, and unifying transition.

Defining Space Sound defines space by establishing distance, direction of movement, position, openness, and dimension. *Distance* — how close or far from you a sound seems to be — is created mainly by relative loudness. The louder a sound, the closer to the listener/viewer it is. A person speaking from several feet away will not sound as loud as someone speaking from a position next to you. Thunder at a low sound level tells you that a storm is some distance away; as the storm moves closer, the thunder grows louder.

By varying sound level, it is possible to indicate *direction of movement*. As a person leaves a room, sound will gradually change from loud to soft; conversely, as a sound source gets closer, level changes from soft to loud. In stereo these gradual changes in loudness can also occur laterally.

With moving objects frequency also helps to establish distance and direction of movement. As a moving object such as a train, car, or siren approaches, its pitch gets higher; as it moves away or recedes, its pitch gets lower. This phenomenon is known as the **Doppler effect** (named for its discoverer, C. J. Doppler, an early-19th-century Austrian physicist).

Sound defines *position* — the relative location of two or more sound sources to each other, whether close, distant, or side to side (in stereo). Position is established mainly through loudness. If two people are speaking and a car horn sounds, the relative loudness of the three sound sources tells you their proximity to one another. If person A is louder than person B and person B is louder

than the car horn, then (assuming monaural sound) person A will sound closest, person B farther away, and the car horn farthest away. If the car horn is louder than person B, then it will be perceived as being between persons A and B. If the aural image is in stereo, relative position will be influenced by how far left or right the sounds are. Here, too, imaging is mainly due to loudness, as lateral perspective is changed by panning. Once the lateral perspective is established, a further change in loudness moves the sound closer or farther away.

Openness of outdoor space can be established in a number of ways — for example, thunder that rumbles for a longer than normal period of time and then rolls to quiet; wind that sounds thin; echo that has a longer than normal time between repeats; ambience that is extremely quiet. These effects tend to enhance the sense of a vast outdoor space.

Dimension of indoor space is usually established by means of reverberation (see Chapter 3). The more reverb, the larger the space is perceived to be. For example, Grand Central Station or the main hall of a castle would have a great deal of reverb, whereas a closet or an automobile would have little reverb.

Establishing Locale Sounds can establish locale. For example, a cawing sea gull places you at the ocean; the almost derisive, mocking cackle of a bird of paradise places you in the jungle; honking car horns and screeching brakes place you in city traffic; the whir and clank of machinery places you in a factory; the crack of a bat hitting a ball and the roar of a crowd place you at a baseball game.

Creating Environment Establishing locale begins to create an environment, but more "brush strokes" are often needed to complete the picture. A cawing sea gull may place you

at the ocean, but the sounds of surf and sea breeze create environment. The crack of a bat hitting a ball and the roar of a crowd may place you at a baseball game, but the hawking of the hot dog vendor and the ebb and flow of crowd noise create environment. Likewise, western music may establish the old West, but sounds of a blacksmith hammering, horses whinnying, wagon wheels rolling, and six-guns firing create environment. A prison locale can be established in several ways, but add the sounds of loudspeakers blaring orders, picks and shovels hacking and digging, grunts of effort, dogs barking, and whips cracking and you have created a brutal prison environment.

Emphasizing Action Sounds can emphasize or highlight action. A person falling down a flight of stairs tumbles all the harder if each bump is accented. A car crash becomes a shattering collision by emphasizing the impact and sonic aftermath — including silence. An animal screeching in fear can highlight an assault on a human being. The creaking of floorboards underscores someone slowly and methodically sneaking up to an objective. A saw grinding harshly, rather than cutting smoothly, through wood emphasizes the effort involved and the bite of the teeth. The sharp click of a heel on cement followed by a relatively long reverberation underscores emptiness or loneliness.

Intensifying Action Whereas emphasizing action highlights or calls attention to something important, intensifying action increases or heightens dramatic impact. For example, as a wave builds and then crashes, the roar of the build and loudness of the crash intensifies the wave's size and power. The slow, measured sound of an airplane engine becoming increasingly raspy and sputtery heightens the anticipation of its

stalling and then crashing. In cartoons music and sound intensify the extent of a character's running, falling, crashing, skidding, chomping, and chasing.

Depicting Identity Depicting identity is, perhaps, one of the most obvious uses of sound. Barking identifies a dog, certain vocal characteristics identify a particular individual, slurred speech identifies a drunk, and so on.

One aspect of using sound to identify may not be quite so apparent, however. That is when sound depicts a personality. The rattle sound of a rattlesnake depicts the villain — every time the rattles are heard, the presence of the villain is anticipated or established. A maniacal laugh or labored, asthmatic breathing may identify an evil character.

Setting Pace Sounds, or the lack of sounds, help to set pace, usually through the presence or absence of sonic energy in the background of the main action. The conversation of two detectives talking at a normal rate in a police station will seem more vital if the activity around them includes such sonic elements as footsteps moving quickly, telephones ringing, papers being shuffled, and a general hubbub of voices. In a scene before a battle, the waiting can be agonizingly slow or frantically excited, depending on the sound. In the first case there may be an absence of sounds, and what sounds there are may be muted, hollow, or thin. In the second case sounds may be diverse, sharp, and constantly changing. Car-chase scenes get most of their pace from the sounds of screeching tires, gunned engines, and shifting gears.

Providing Counterpoint Sounds provide counterpoint when they are different from what is expected, thereby making an addi-

tional comment on the action. For example, a light switch is turned on, but instead of the click, the accompanying sound is a toilet flushing to create a comedic effect; or a judge bangs a gavel to the accompanying sound of dollar bills being peeled off, counterpointing the ideal of justice and the reality of corruption; or a smiling leader is cheered by a crowd, but instead of cheers, tortured screams are heard, belying the crowd scene.

Symbolizing Meaning Sound can be used symbolically. The sound of a faucet dripping is heard when the body of a murder victim killed in a dispute over water rights is found. An elegantly decorated, but excessively reverberant, living room symbolizes the remoteness or coldness of the occupants. A church bell tolls to symbolize marriage or death. A ball team nicknamed "the Bulls" gathers for a road game in a parking lot. As the bus revs its engine, the sound is infused with the bellow of an enraged bull, comedically symbolizing that this is the team bus.

Unifying Transition Sounds provide transitions and continuity between scenes, linking them by overlapping, leading-in, or segued effects. **Overlapping** occurs when the sound used at the end of one scene continues, without pause, into the next scene. For example, a speech being delivered by a candidate's spokesperson ends one scene with the words "a candidate who stands for . . ."; the next scene begins with the candidate at another location, saying "equal rights for all under law." Or the sound of a cheering crowd responding to a score in an athletic contest at the end of one scene overlaps into the next scene as the captain of the victorious team accepts the championship trophy.

A **lead-in** occurs when the audio that introduces a scene is heard before the scene actually begins. As a character thinks about a forthcoming gala event, the sounds of the gala are heard before the scene changes to the event itself. While a character gazes at a peaceful countryside, an unseen jet fighter plane is heard in action, anticipating and leading into the following scene, in which the same character is a pilot in an aerial dogfight.

A **segue** — cutting from one effect (or recording) to another with nothing in between — links scenes by abruptly changing from a sound that ends one scene to a similar sound that begins the next scene. As a character screams at the discovery of a dead body, the scream segues to the shriek of a train whistle; a wave crashing on a beach segues to an explosion; the sound of ripping cloth segues to the sound of a jet roar at takeoff.

Music

Musical language is both more and less complex than verbal language. Unlike speech (and sound effects), its structure is horizontal and vertical and, therefore, at once linear and simultaneous. That is, linear sound provides melody and rhythm; simultaneous sound provides harmony and texture. The entire audible spectrum of sound can be used in an infinite variety of combinations. It is difficult, however, to be objective about the semantics of music, whereas with verbal language the problem of semantics is not nearly so acute.

As we have already mentioned, music has the same basic structural elements common to all sound: pitch, loudness, tempo, tone color, and envelope. But it also contains other characteristics that broaden its perceptual and aesthetic meaning, such as melody and its keys or tonalities; harmony and its qualities of consonance, dissonance, and texture; dynamic range that is quite wide compared to speech and sounds; and style in limitless variety.

Melody

Melody is a succession of pitched musical tones of varied durations. Because each tone has duration, melody also establishes rhythm. Hence, melody has both a tone quality and a time quality; melody cannot be separated from rhythm.

Generally, if a melody moves in narrowly pitched steps and ranges, it tends to be expressive and emotional. If it moves in widely pitched steps and ranges, it tends to be conservative and unexpressive.

Melodies are usually written in *keys* or *tonalities*, designated as major and minor. Subjectively, keys in the major mode usually sound positive, happy, bright, vigorous; keys in the minor mode usually sound darker, tentative, wistful, melancholy.

Although not explicitly defined as such, melody is also considered to be a recognizable pattern of notes that can be characterized in terms useful to the sound designer, such as simple, melancholy, plaintive, sentimental, romantic, and so on.

Harmony

Harmony is a simultaneous sounding of two or more tones, although three or more tones are usually necessary to be classified as a chord. Chords are categorized as consonant or dissonant, and they are important to musical texture.

Consonance in music is produced by agreeable, settled, balanced, stable-sounding chords. *Dissonance* is produced by unsettled, unstable, unresolved, tense-sounding chords.

Texture, as the term suggests, is the result of materials interweaved to create a fabric. In music, melody and harmony are the materials interwoven. Undoubtedly, the infinite variety of musical textures that can be designed is a major reason for music's universal appeal and role in human communication. Subjectively, musical texture can be described as delicate, coarse, dense, airy, brittle, and so on.

Dynamic Range

Because the dynamic range of music can be much wider than the dynamic ranges of speech and sounds, it is possible to create a greater variety of loudness-related effects. Three of these effects commonly used are crescendo, diminuendo, and tremolo.

Crescendo changes sound level from quiet or moderate to loud. It is effective in building tension, drawing attention to a character or action, and increasing proximity, intensity, force, or power.

Diminuendo (or *decrescendo*) changes sound level from loud to soft. It de-emphasizes importance and presence and helps to shift attention, make transitions, and decrease intensity and power.

Tremolo is a rapidly repeated amplitude modulation—encoding a carrier wave by variation of its amplitude—of a sound usually used to add dramatic expression and color to music. Subjectively, it can heighten the sense of impending action or suggest hesitancy or timidity. (Tremolo should not be confused with **vibrato**, which is a frequency modulation—encoding a carrier wave by variation of its frequency.)

Style

Style is a fixed, identifiable musical quality uniquely expressed, executed, or performed. It is that combination of characteristics that makes the Beatles distinguishable from the Rolling Stones, Beethoven distinguishable from Brahms, chamber music distinguishable from jazz, an 18th-century symphony distinguishable from a 19th-century symphony.

Like texture, style is a source of infinite musical variety.

Functions of Music

Music performs many of the same functions in audio design that speech and sound effects perform, plus a few others as well. These similarities notwithstanding, it is music's unique and universal language and vast vocabulary that make it so widely applicable in aural communication.

Establishing Locale Many musical styles and themes are indigenous to particular regions. By recalling these styles and themes or by simulating a reasonable sonic facsimile, music can establish a locale such as the Orient, the American West, old Vienna, Russia, Hawaii, the city, the country, the sea, outer space, and other environments.

Emphasizing Action Music emphasizes action by defining or underscoring an event. The crash of a chord defines the impact of a fall or collision. A dramatic chord can also underscore shock or a moment of decision. A romantic theme defines a particular quality of love or underscores that flash of attraction between a man and a woman when their eyes first meet. Music emphasizes an oil strike by defining the power and upward momentum of the gusher or underscores the strike by conveying a sense of relief, joy, or triumph. A sliding trombone, clanking percussion, or a cawing heckelphone can define a comic highlight or underscore its humor.

Intensifying Action Music intensifies action, usually with crescendo or repetition. The scariness of sinister music builds to a climax behind a scene of sheer terror and crashes in a final, frightening chord. The repetition of a short melody, phrase, or rhythm intensifies boredom, the threat of danger, or an imminent action.

Depicting Identity Music can identify characters, events, and programs. A dark, brooding theme can characterize the "bad guy." Tender music can indicate a gentle, sympathetic personality. Strong, evenly rhythmic music can suggest the relentless character who will destroy the character who is depicted by thin-sounding, syncopated music.

A particular theme played during an event identifies the event each time it is heard. Themes also have long served to identify radio and television programs, films, and personalities.

Setting Pace Music sets pace mainly through tempo and rhythm. Slow tempo suggests dignity, importance, or dullness, while fast tempo suggests gaiety, agility, or triviality. Changing tempo from slow to fast accelerates pace and escalates action; changing from fast to slow decelerates pace and winds down or concludes action. Regular rhythm suggests stability, monotony, or simplicity, while irregular (syncopated) rhythm suggests complexity, excitement, or instability.

Providing Counterpoint Music that provides counterpoint adds an idea or feeling that would not otherwise be obvious. Revelers flitting from party to party in apparent good cheer are counterpointed with music that is monotonous and empty. Football players shown blocking, passing, and running are counterpointed with ballet music to underscore the grace and coordination of the athletes. A man proposing to a woman is accompanied by skittish music to counterpoint the seriousness of the occasion with the frivolous nature of the man's intent.

Unifying Transition Music is used to provide transitions between scenes for the same reasons that sounds are used: to overlap, lead in, and segue. Overlapping music provides continuity from one scene to the next. Leading-in music establishes the mood, atmosphere, locale, pace, and so on, of the next scene before it actually occurs. Segued music changes the mood, atmosphere, pace, subject, and so on, from one scene to the next. By gradually lowering and raising levels, music can also be used to fade out and fade in scenes. Usually, this type of transition makes a definite break in continuity; hence, the music used at the fade-in would be different from the music used at the fade-out.

Fixing Time Among the many uses for musical style is fixing time. Depending on the harmonic structure, the voicings in the playing ensemble, or both, it is possible to suggest the Roman era, the early 1940s, the Roaring Twenties, Elizabethan England, contemporary times, the future, morning, noon, night, and so on.

Recalling or Foretelling Events If music can be used to fix a period of time, it can also be used to recall a past event or foretell a future occurrence. A theme used to underscore a tragic crash is repeated at dramatically appropriate times to recall the incident. A character begins to tell or think about the first time she saw her future husband at a party as the music that was playing during that moment is heard. A soldier kisses his girl goodbye as he goes off to war, but the background music indicates he will not return. A youth, who aspires to be a composer, looks wistfully at a second-hand piano through a pawn shop window as the strains of his most famous composition, yet to be written, are heard.

Evoking Atmosphere, Feeling, or Mood
Perhaps no other form of human communication is as effective as music in providing atmosphere, feeling, or mood. There is a musical analogue for virtually every condition and emotion. Music can evoke atmospheres that are thick, unsavory, cold, sultry, and ethereal. It can evoke feelings that are obvious and easy to suggest such as love, hate, and awe, and also subtle feelings such as friendship, estrangement, pity, and kindness. As for moods, music can also convey the obvious and the subtle: ecstasy, depression, melancholy, and amiability.

Silence

A director was once asked why, after an extremely dramatic, revelatory event in a scene, he chose to have silence. He replied, "Silence was the most awesome sound that we could get." Silence is not generally thought of as sound; to suggest that it is seems like a contradiction in terms. But it is the pauses or silences between words, sounds, and musical notes that help to create rhythm, contrast, and power—elements important to sonic communication.

In situations where we anticipate sound, silence is a particularly powerful element. Thieves break into and rob a bank with barely a sound. As the burglary progresses, silence heightens suspense to an oppressive level as we anticipate an alarm going off, a tool clattering to the floor, or a guard suddenly shouting "Freeze!" A horrifying sight compels a scream—but with the mouth wide open there is only silence, suggesting a horror that is unspeakable. Birds collect on telephone wires, rooftops, and TV aerials and wait silently; absence of sound makes the scene eerie and unnatural. The silence preceding sound is equally effective. For example, out of perfect quiet comes a wrenching

scream. In the silence before dawn, there is the anticipation of the new day's sounds to come.

Silence is also effective following sound. An explosion that will destroy the enemy is set to go off. The ticking of the bomb reaches detonation time. Then, silence. Or the heightening sounds of passion build to resolution. Then, silence.

Functions of Sound in Relation to Picture

The discussion thus far of sound and its influence on communication is applicable to electronic-mechanical media in general; for the most part, it assumes neither the presence nor the absence of picture. When picture is present, however, as it is in television and film, the aural–visual relationship creates certain dynamics that affect their overall meaning.

Implicit in the belief that TV and film are "visual" media is the notion that the information comes only from the picture. Not only is this untrue, but, more often than not, sound provides most of the information conveyed. It would be correct but obvious and, perhaps, somewhat unfair to cite examples using dialogue and narration to support this statement. To make the point more convincingly, let's use sounds and music as the examples in discussing the sound–picture relationship. Basically, there are five relationships: (1) Sound parallels picture, (2) sound defines picture, (3) picture defines sound, (4) sound and picture define effect, and (5) sound counterpoints picture.

Sound Parallels Picture

When sound parallels picture, neither the aural nor the visual element is dominant.

This function of audio in relation to picture may be the best known because it is often misunderstood to be sound's only function. In other words, what you see is what you hear. A character knocks on a door and you hear it. You see a wave breaking and hear it. There is a shot of an orchestra playing and that's what you hear. Two ships are about to collide and the music track follows the action. In a scene showing a raging typhoon, with mountainous waves crashing on a shore and trees bent almost double by fierce winds, the sounds that support those images are virtually mandatory.

This sound–picture relationship should not be dismissed as unworthy just because it is so common; not all shots require special sonic treatment.

Sound Defines Picture

When sound defines picture, not only is audio dominant, but it also often determines the point of view—the subjective meaning of the image(s). Take a scene in which prison guards are standing battle-ready in front of a cell block. A sound track consisting of crashing, breaking, yelling sounds suggests a prisoner riot and casts the guards as "good guys," as protectors of law and order. If the same scene were accompanied by music that suggested oppression, the prisoners would be viewed sympathetically and the guards would become the evil force. The same scene augmented by a distorted rendering of the "Star-Spangled Banner" would not only convey the idea of the guards as oppressors but also add an element of irony.

Consider a picture showing a man apologizing to a woman for his many wrongs. Her look is stern and unforgiving. The music underscoring the scene is gentle and sympathetic, indicating her true feelings. In the same scene, if the music were light and

farcical, both his past wrongs and his pleading would be defined as not very serious. Change the music to sound dissonant and derisive and the woman's stern, unforgiving look becomes nasty and gloating.

Picture Defines Sound

Picture helps to define sound by calling attention to particular actions or images. In a scene where a person walks down a city street, with traffic sounds in the background, cutting to close-ups of the traffic increases impact of the sounds. The sound of metal wheels on a horse-drawn wagon clattering down a cobblestone street is intensified all the more when the picture changes from a medium shot of the carriage to a close-up of one of the wheels. In a bar scene where a character walks to the jukebox and plays a record, the sound is typical and supportive: noisy chatter, raucous laughter, clinking glasses, coins being dropped into the jukebox, and the music playing. As the person walks to the jukebox and puts money into it, close-ups of the footfalls, laughing faces, and coins being inserted into the slot bring out those particular sounds.

Sound and Picture Define Effect

When sound and picture define effect, the aural and visual elements are different, yet complementary. Together, they create an impact that neither one alone can. Take the obvious example of a wave building and then breaking on a beach, accompanied by the swelling and crashing sounds. Separately, neither sound nor picture conveys the overall impact of the effect. Together, they do. Neither sound nor picture is dominant, and although they are parallel, they are reinforcing each other to produce a cumulative effect. Another example would be an elderly man

sitting on a park bench watching a mother playing with her child, lovers walking hand in hand, and teenagers playing touch football, accompanied by a music track that evokes a feeling first of pleasure, then of loneliness, and finally of futility. Sound and picture are complementary, with both contributing equally to an effect that would not be possible if one element were dominant or absent.

Sound Counterpoints Picture

When sound counterpoints picture, both elements contain unrelated information that creates an effect or meaning not suggested by either element alone. For example, the audio contains the sounds of different groups of happy, laughing people, while the picture shows various shots of pollution. The aural–visual counterpoint suggests an insensitive, self-indulgent society. Or the shot is of an empty hospital bed, and the music evokes a sense of unexpected triumph. The aural–visual counterpoint creates the idea that whoever had been in the bed is now, by some miracle, recovered. Change the music to sound spiritual and ascending and the person who had been in the bed will have died and "gone to heaven."

Strategies in Designing Sound

There is no set procedure for designing sound. At the outset perhaps the most important thing to do is to immerse yourself in the material until you can relate to it, then evolve from it a concept, or concepts, that may work. In some cases this might not be necessary; a director or producer will tell you what concept to develop. Regardless of the

mandate, however, you should be aware of the various sonic approaches that are possible in a given piece of material. There is no right or wrong method in this type of creative decision making. Decisions are often made on the intuitive basis of what "feels" best, of what "works." This is not to suggest that sound design is simply "touchy-feely." Reasoned bases should underlie determinations.

The Power of Sound

To provide a context for the types of considerations involved in creating a sound design, let's analyze examples of commonly produced program materials. Perhaps the most effective way to begin is by demonstrating sound's power to influence meaning. This will be done by using a radio commercial and a TV (film) script example. In each case the basic content will remain the same. Only the sound design will change and, thereby, so will the material's impact and meaning.

Radio Commercial Example

In the following radio commercial the Opulent 3QX is an expensive, full-size luxury sedan. The target audience is affluent, suburban, college-educated, in their late 30s to early 60s. The Modest AV is a mid-priced, midsize, family-type sedan. The target audience is in the socioeconomic middle-class, urban-suburban, with at least a high school education, in the mid-20s to late 30s.

MUSIC: IN AND UNDER

ANNOUNCER: Today is a big day at your (Opulent, Modest) dealers. The exciting new 199- (Opulent 3QX, Modest AV) is on display. And as a way of saying "Welcome," your (Opulent, Modest) dealer will give you

an eight-year, 80-thousand-mile full power-train warranty free if you purchase a new (Opulent 3QX, Modest AV) before October first. Even if you decide not to buy, there's a special free gift for you just for coming down to say "Hello." That's at your (Opulent 3QX, Modest AV) dealer now.

MUSIC: UP TO FINISH

The commercial is straightforward, indeed routine. Yet, sound can not only bring it to life but change its impact to suit the two different clients, even though the copy is the same.

The spot calls for an announcer and music. But what type of announcer? What kind of music? First, let's discuss the announcer.

In the early days of radio two main criteria were used to hire announcers: resonance and diction. Over the years, as aural literacy has developed, it has become clear that there is more to speech communication than resonance and diction; voice quality, intonation, and inflection are also important aspects.

Take this line for a product intended to help reduce calories: "WeightLo, only two calories per serving." An announcer with resonance and clear diction delivering the line in a formal manner would communicate only the verbal meaning of the sentence and might create a formal distance between the product and the audience. If the idea is to suggest a doctor–patient relationship, the approach may be appropriate. But let's look at it another way.

It is reasonable to assume that people who use products with fewer calories are concerned about either reducing or controlling their weight. In this case the key to the message is to tell the audience that it can use the product and not worry about weight. So the

line should also say, "Don't worry, use this product with confidence."

Obviously, one way to accomplish this is to have the announcer just say the words. But that is not taking advantage of sound. (It is also wasting time.) To establish confidence, the voice quality of the announcer should be warm and friendly, not formal and aloof. The sense of "don't worry" can be inflected as the words "only two calories per serving" are spoken. For example, say out loud the words "don't worry" as if you are trying to comfort a friend. Now, with the same inflection, say, "only two calories per serving." The warm, friendly delivery and the new inflection have added more meaning to the sentence than a straight delivery, and with no additional words.

In selecting the announcers for the Opulent and Modest commercials, the sound designer must first consider the products themselves. The Opulent is an expensive luxury automobile usually affordable to upper-middle- and upper-class professionals with a college education and social position. The Modest, on the other hand, is generally a lower-middle- to middle-class automobile affordable to a broad group of people including blue- and white-collar workers, some with a high school education and some college-educated, some with and some without social position. These two groups of consumers call for two different announcing approaches.

The announcer delivering the commercial for the Opulent may have a cultured sound: rounded-sounding vowels, deliberate pacing, stable rhythm, somewhat aloof but friendly. Among the important words to be emphasized are "fine," "welcome," "special," "gift," and, of course, the product's name.

The sound for the Modest commercial would be brisker and more excited. The announcer might sound younger than the announcer for the Opulent and more like the person next door—warm, familiar, and friendly. Pacing might be quicker and rhythms syncopated. The important words to emphasize are "big," "exciting," "new," "welcome," "free," "now," and the product's name.

No doubt, there are several other equally valid approaches to the commercial. The point is that, through sound design, the same words have taken on different meanings and addressed different audiences just by changing the announcer and the announcer's delivery.

Music can emphasize the differences even more. For the Opulent, perhaps an orchestra playing a bright, but melodic, sophisticated theme, in moderate tempo, or a small jazz ensemble playing in a light, laid-back, "cool" style would be appropriate. This would not only complement the product's image but also provide compatible counterpoint to the announcer's sound and delivery. What would not be appropriate is a rock or large jazz band, or even an orchestra, with a thick sound playing briskly. For the Modest, however, these alternatives might make more sense. Again, we have the same commercial, but with two different sound designs and two different messages.

TV (or Film) Script Example

In the following scene Mike and Paula, a couple in their mid-20s, in the third day of a camping trip, are emerging from dense woods into a wide clearing.

FADE IN

1 EXTERIOR, WOODS — LATE AFTERNOON
 ON A SUMMER DAY. MIKE AND PAULA
 HAVE BEEN BACKPACKING AND ARE
 EMERGING FROM DENSE UNDERBRUSH
 INTO A CLEARING.

2 MIKE STOPS AT THE EDGE OF THE
 CLEARING TO LOOK AROUND.

MIKE: Wow! This looks like a perfect place to camp for the night.

3 PAULA FOLLOWING FROM UNDERBRUSH STANDS NEXT TO MIKE.
PAULA: It sure is. (*beat*) Seems kind of unusual though, doesn't it?
MIKE: What?
PAULA: To have such a large clearing with no trees or plants in the middle of such dense woods. We've been hiking for almost two days and have barely seen a trail. And now, all of a sudden, this. I mean look at how well manicured it is. Almost as if someone's been caring for it.

4 MIKE TURNS TO PAULA AND SMILES — WALKS FURTHER INTO CLEARING, REMOVES HIS BACKPACK, AND DROPS IT TO THE GROUND.
MIKE: Are you complaining? For the first time in two days we can pitch the tent and not have to sleep in the woods on dead, soggy leaves. To say nothing of the cozier advantages.

5 PAULA WALKS TO MIKE AND THEY KISS — SUDDENLY A HOWL SOUNDS IN THE DISTANCE.
MIKE: What was that?
PAULA: I don't know! Never heard anything like it before.

6 THEY LOOK AROUND SLOWLY, STARING INTO THE WOODS.
PAULA: Brrr. (*beat*) I don't know whether I'm frightened or just getting chilly.
MIKE: It's the wind. Starting to blow up a bit. (*laughs nervously*) That's all we need, wind, then thunder and lightning. The only thing missing is the dark castle on the hill.

7 AS MIKE SAYS LAST LINE, THUNDER SOUNDS IN THE DISTANCE.

This scenario is brief and uncomplicated, yet its many sound cues can be handled in a number of ways. Moreover, most of the scenario's impact depends on the audio. Let's explore a few possible approaches to the sound design in order to convey some idea of the creative possibilities here.

The scene opens in woods with dense underbrush, in the late afternoon of a summer day. Among the elements to consider here are the sounds coming from the woods and the sounds of walking through woods and on underbrush—whether these sounds will be natural and benign, or unnatural and foreboding.

One function that sound performs is creation of an unseen environment. Woods exude a close atmosphere, a thickness of air that should be present in the sound. Woods are filled with sounds in summer: birds twittering, insects buzzing about, perhaps frogs croaking, and, at night, an owl hooting or crickets chirping. By adding such sounds to the audio track, it is possible to "picture" the woods and provide a sense of density without actually showing it.

In this case walking through woods and underbrush requires a few different sounds: clothes scraping against branches, the crunch and crackle caused by stepping on twigs or dry leaves, two pairs of footsteps—one lighter than the other—and, perhaps, increased rates of breathing or panting. The weight, rhythm, and sharpness of the sounds can detail the amount of underbrush and the characters' level of fatigue.

If the purpose of these effects is to provide a contextual sonic complement to the picture, then they should sound natural. If they are to suggest the frightening experience to come, then they should be unnatural in some way, taking on a narrative function (see section on sound effects).

Any number of narrative approaches might work. The animal sounds could be edged, harsh, or screechy. Their rhythms could be chattering and nervous. The buzzing could

increase or decrease in loudness, as opposed to a more natural steady drone, to reflect a sense of impending attack. The animal sounds could take on a nonorganic, not-of-this-world quality. Or there could be no sound at all—perhaps the most unnatural and ominous sound effect of all.

The footsteps could sound bigger than life, setting the stage for the theme of Man, the intruder; or they could sound smaller to establish the characters' vulnerability. The snap of the branches could sound more like a whip, the crackle and crunch of the dry leaves underfoot like bones breaking or squooshy like the crushing of an insect—sonic foretelling of events to come.

Emergence from the underbrush requires a change in ambience, footsteps, and animal sounds (assuming they were present during the previous scene). The change from the closed-in woods to the large clearing would be accompanied by a more open-sounding ambience. The sound of the footsteps would have to reflect the difference between the dry leaves and the firmer but cushioned grassland. The animal sounds may not be so intense, underscoring the difference between being in the woods and in the clearing. They may also sound more distant to emphasize the change even more.

When Mike removes his backpack, it calls for the scrape of the straps on his shirt, maybe a grunt of relief, sigh of satisfaction, or slight "ahh" of anticipated pleasure. There are a few possibilities for the sound of the backpack hitting the ground: a bigger-than-life thud to emphasize its weight; a metallic thud to give a sense of what is inside; a jangly crash to sharply punctuate the quieter, open ambience, to provide a sense of what is in the backpack, and perhaps to foretell the jarring events to come.

Sonically, the kiss could be used to set the stage for the first howl. Before the kiss,

background sound could diminish to silence, then subtly become more intense, climaxing with the howl; or the background sound could change, again subtly, from natural to unnatural.

The howl suggests a number of possibilities not only as a sound but also as a narrative expression. Of course, any determination about it has to be made within the context of the story line. Let's assume the howl is from a creature—half man, half beast—who is looking for revenge after being severely wounded by hunters. The howl should convey these facts. It should sound like a wail to establish the pain but be guttural enough to project the idea of a dangerous animal. The wail could embody human characteristics by being within the frequency range of the human voice and by vacillating expressively to convey both a sense of pain and a cry for help. The guttural edge would also provide a counterpoint to the wail by sounding angry and menacing.

A nonorganic approach could be taken using electronically generated sounds. This approach creates an alien creature, perhaps changing the half-man part to something more fantastic. In any case, not only the condition but also the personality of the creature would be conveyed by the sound.

The wind sound could be designed to convey a number of moods and conditions: mysterious, gloomy, empty, gentle, stormy, cold, and so on. As its frequency increases, wind becomes more active and turbulent.

In this scenario, Paula says "Brrr . . . ," so the wind should be pitched high enough to convey chill; because it has just come up, it should have some low-end sound as well to convey mystery or danger. A gradually increasing shrillness or whistle would suggest the impending storm.

Thunder has several sonic characteristics: ripping attack; sharp, deep-throated crack;

rolling, continuous rumble; and gradually increasing and decreasing loudness as it moves closer and then farther away. In this case, because the thunder sounds in the distance, the sound design calls for a low-throated, continuous rumble. As it comes closer with the storm, its other sonic characteristics would be added.

The wind and thunder also could be generated electronically. This would give the environment an alien quality, particularly if the animal sounds in the woods were also synthesized to suggest the presence of some unworldly beast.

These are only a few possible approaches to the sound design of this brief scenario. Music provides even more alternatives to the informational and emotional content. The possibilities, however, are too numerous for discussion here. On the other hand, an absence of music could enhance the sense of isolation and threat. The role of music in providing and enhancing meaning was discussed earlier in this chapter.

Another important factor in the sound design of this scenario is how the cues are mixed. Mixing layers the sonic elements and establishes their balance and perspective. (These aspects of sound are discussed in Chapter 17.)

Producing sound design for a music recording is somewhat different from producing sound effects. It involves not only shaping sound but, more importantly, musical interpretation and performance. These aspects of musical sound design are difficult to articulate without hearing the music. It is possible, however, to discuss the variety of ways in which musical sound can be shaped in production and postproduction through acoustics, microphone selection, microphone placement, signal processing, and mixing. These subjects are covered in other chapters of the book.

Achieving Effects in Selected Program Materials

The point of the previous examples was to demonstrate sound's power to change the impact and meaning of given content. The discussion assumed that the sound designer had the mandate to originate such changes. In reality, this rarely happens, because interpretation of material is up to the director. Even so, a sound designer still has creative leeway in affecting the overall outcome of program material.

The following examples are common types of assignments a sound designer is called on to handle. Because context and content of the audio in these examples are prescribed, it is up to the sound designer simply to produce it, as is usually the case. The challenge for the sound designer is to see how imaginative he or she can be and still be true to the director's vision.

Action Drama

The action takes place on a deserted city street just after a brutal, late-night assault and robbery. The battered victim lies unconscious on the pavement. The criminal, Joe Badd, is running to his car and making his getaway.

The scene calls for the following sounds: ambience of a city street at night, footsteps, a car door opening and closing, the engine starting, the car speeding off. These are common sounds easily recorded and even more easily obtained from prerecorded sound libraries (see Chapter 13). A typical, unimaginative sonic approach would be to produce the scene on a what-you-see-is-what-you-hear basis.

But without changing the action or the designated sounds, the audio can do more than just be there. The ambience, instead of

simply being present, could be processed to sound dense and oppressive. The footsteps, instead of being those of ordinary shoes hitting the pavement, could be sonically fitted with sharp, lacerating, almost metallic attacks at each footfall. The car door handle could be snapped, the car door wrenched open, then sharply slammed shut with a report sonically similar to a high-pitched gunshot. The ignition could start with a grind, followed by a guttural revving and rasping acceleration of the engine. The drive-off could be punctuated by a piercing, brazen screech of tires. After all, these are not just any sounds, they are the sounds of the nasty Joe Badd.

Cinema Verité Documentary

The school of documentarists producing in the cinema verité style record life without imposing upon it; production values do not motivate or influence content. Whatever is recorded has to speak for itself. Music, produced sound effects, and narration are eschewed. Deciding what is recorded and edited are the only "manipulative" elements in the production process. Even within these guidelines, however, an imaginative sound designer still has creative operating room.

A documentary producer is doing a program about poverty in America. There are shots of various locales in which the poor live, interviews with various poor in their living quarters, and interviews with selected officials responsible for carrying out programs that allegedly help the poor.

Urban and rural neighborhoods where the poor exist are usually depressed, dilapidated, depleted. One approach to recording the ambient sound reflecting such a condition might be to produce an empty, forsaken, desolate quality. Conveying such an ambient quality isn't a matter of simply sticking a micro-

phone in the air and turning on the tape recorder. The imaginative sound designer will select a mic that produces a thin, transparent sound. Placement will be far enough away from reflectant surfaces so that the sound is diffused rather than concentrated and stable. On the other hand, a dense ambience created by placing a microphone with midrange coloration near reflectant surfaces might produce a more saturated, suffocating effect.

Interviews inside the living quarters of the poor could be miked to include room reflections creating an overall hollowness to the sound. The microphone could be one that is flat through the upper bass and low midrange so as not to enhance the frequencies that produce a warm sound. Or the microphone could be one with a peaky midrange response to create a tinny, spare sound.

Interviews with the officials who are dragging their bureaucratic feet in helping the poor could be miked to create a warm, close, secure sound, thereby contrasting the officials' comfortable life style with that of the poor. Or microphone selection and placement could be designed to emphasize a harsh, cutting sound suggesting an insensitivity toward the poor. Miking at a distance might suggest an official's remoteness from the problem. All of these approaches to the sound design enhance overall impact and meaning without compromising the cinema verité style.

Animation

Sound in animated material, particularly cartoons, is especially critical because it defines not only the action but the characters as well. This is particularly true in most TV cartoons produced today in which animated facial expressions and body movements are minimal. In fact, the cartoon is one of the only

forms for which audio customarily is done before the picture is shot (music video is another).

Chasing, stopping, falling, crashing, bumping, digging, and so on are all defined by sound effects or music, or both. Sound, more than appearance, gives most cartoon or nonhuman characters their delineation and personality. Think of Donald Duck, Daffy Duck, Bugs Bunny, Roger Rabbit, Chewbacca, and E.T., to name a few.

E.T., for example, is a defenseless, sensitive creature in an alien world. His hesitant, questioning inflections, as much as any single trait, are what make him so innocent and vulnerable. It can be argued that his huge, disconsolate eyes and the slightly upturned expression of his mouth are fundamental to his character. It can also be argued that a different sound design, one that put a cackly edge to spoken sounds fluidly delivered, for example, would change E.T. into an altogether different creature, disconsolate eyes and facial expression notwithstanding.

Barney Rubble, in "The Flintstones," is a happy-go-lucky character — a sidekick, not a leader. He is not domineering, reprimanding, or loud. His sound, appropriately, is submissive but humorous. Huckleberry Hound has a slow, evenly paced, low-pitched Southern drawl to suggest the sense of control that is central to his characterization.

There can be sonic counterpoint as well. Tweety Bird is also in control, but his high-pitched voice (and size) suggest victimization. Wile E. Coyote's sound suggests sophistication, wit, and culture, yet his actions indicate just the opposite.

Defining the sonic personality of a nonhuman character is usually not the sound designer's decision to make. But the "ear" a sound designer brings to such a determination is invaluable to the director with sense enough to seek such assistance.

Commercial

For this example, let's follow through on the sound design of the commercial comparing electric shavers mentioned in Chapter 1.

1 EFX: ESTABLISH SOUND OF QUIET, SMOOTHLY HUMMING ELECTRIC SHAVER, THEN FADE UNDER ANNOUNCER

2 ANNCR: (*purring with pride*) This is the sound of the [our brand]. The smoothest, closest-shaving electric shaver you can buy.

3 EFX: CUT . . . GRATING SOUND OF FRAGILE, UNEVENLY RUNNING MOTOR . . . UNDER

4 ANNCR: (*with derision*) But [their brand] claims its razor cuts whiskers closer.

5 EFX: OUT

6 ANNCR: A razor that sounds like this . . .

7 EFX: IN . . . GRATING MOTOR SOUND . . . UNDER

8 ANNCR: . . . cuts your beard . . .

9 EFX: UP AND OUT

10 ANNCR: . . . but it won't shave you closer or smoother . . .

11 EFX: UNDER . . . SMOOTH-RUNNING MOTOR SOUND

12 ANNCR: . . . than this.

13 EFX: UP THEN UNDER

14 ANNCR: (*with pride*) The [our brand] — available at fine stores everywhere.

15 EFX: OUT

Uses of sound in this commercial to make the point about "our" brand compared to "their" brand are obvious: the difference in the announcer's inflection when mentioning each brand; the difference between the characterizing sound effects; and the difference

between the verbal content of the copy describing the two products.

The nonverbal opportunities the copy presents may not be so obvious, however. For one thing, note how the word *shaver* is used throughout for "our" brand, whereas the more threatening word *razor* is used for "their" brand. For another, in 2 and 10 most of the sounds are smooth and pleasant; in 4, 6, and 8 the sounds are abrasive and biting — they have more attack. Finally, the announcer can help to emphasize these sonic differences through emphasis and inflection.

Main Points

1. The three stages in the production process are (1) preproduction, (2) production, and (3) postproduction.

2. Creating a sound design and understanding its effects on meaning is an essential part of preproduction planning.

3. Sound can be grouped into three categories: (1) speech, (2) sound effects, and (3) music.

4. Meaning in speech can be communicated verbally and nonverbally.

5. Speech has two basic functions: (1) narration — direct, indirect, contrapuntal — and (2) dialogue.

6. Nonverbal meaning in speech can be communicated through accent, pace, emphasis, inflection, and mood.

7. Sound effects perform two general functions: (1) contextual and (2) narrative. Narrative sounds can be descriptive or commentative.

8. Sounds and music can define space; establish locale; create environment; emphasize and intensify action; depict identity; set pace; provide counterpoint; symbolize meaning; unify transition; and evoke atmosphere, feeling, or mood.

9. Musical characteristics that broaden perceptual and aesthetic meaning are melody, harmony, rhythm, dynamics, and style.

10. Silence can also be used to enhance sonic effect.

11. Sound has several functions in relation to picture. Sound can parallel picture; sound can define picture; picture can define sound; sound and picture can define effect; sound can counterpoint picture.

12. When considering strategies in sound design, remember sound's power to alter the impact and meaning of given content.

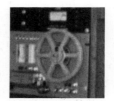

Production

CHAPTER 12

Producing Speech

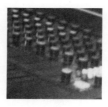

In Chapter 11, we presented an overview of sound's power to communicate ideas and emotions using the three sonic ingredients available to the sound designer: speech, sound effects, and music. Part 4, "Production," and Part 5, "Postproduction," deal with the techniques used to realize those results, beginning with "Producing Speech," "Producing Sound Effects," and "Producing Music."

Sound and the Speaking Voice

The frequency range of the human speaking voice, compared with that of some musical instruments (see the diagram inside the front cover), is not wide. Fundamental voicing frequencies produced by the adult male are from roughly 80 to 240 Hz; for the adult female they are from roughly 140 to 500 Hz. Harmonics and overtones carry these ranges somewhat higher. (Ranges for the singing voice are significantly wider—see Chapter 14.)

Despite these relatively narrow ranges, its harmonic richness makes the human voice a highly complex instrument. Frequency content varies with the amount of vocal effort used. Changes in loudness and intensity change pitch. Loud speech boosts the midrange frequencies and reduces the bass frequencies, thus raising overall pitch. Quiet speech reduces the midrange frequencies, lowering overall pitch.

In relation to the recording/playback process, if speech is played back at a level louder than originally recorded, as is possible in radio and film, the bass frequencies will be disproportionately louder. If speech is played back at a quieter level than originally recorded, as is possible in radio and TV, the bass frequencies will be disproportionately quieter.

Regardless of the dynamic range in voicing sounds, speech must be intelligible while maintaining natural voice quality. Moreover, in audio production speech must also be relatively noise-free. Although background noise does not affect speech intelligibility when the noise level is 25 dB below the speech level, such a signal-to-noise (S/N) ratio is still professionally unacceptable. Even when S/N ratio is acceptable, however, other factors, such as distance between speaker and listener (**inverse square law**), the listener's hearing acuity, reverberation time, and other sounds, can adversely affect speech intelligibility. These factors, as they relate to aural perception in general, are discussed elsewhere in the book. Two other influences on speech intelligibility are level and distribution of spectral content.

Level

Speech intelligibility is at a maximum when levels are about 70 to 90 db-SPL. At higher levels intelligibility declines slightly. It also declines below 70 dB-SPL and falls off rapidly under about 40 dB-SPL. Distance between speaker and listener affects intelligibility, too: As distance increases, intelligibility decreases.

Distribution of Spectral Content

As we know from previous discussions, each octave in the audible frequency spectrum contributes a particular sonic attribute to a sound's overall quality (see Chapter 2 and

Table 12-1 Percentage of contribution to speech intelligibility by various frequency ranges

Band Center Frequency (Hz)	Percentage of Contribution	
	One-Third Octave	*Full Octave*
200 and below	1.2	
250	3.0	7.2
315	3.0	
400	4.2	
500	4.2	14.4
680	6.0	
800	6.0	
1,000	7.2	22.2
1,250	9.0	
1,600	11.2	
2,000	11.4	32.8
2,500	10.2	
3,150	10.2	
4,000	7.2	23.4
5,000 and above	6.0	

Source: From the American National Standards Institute (ANSI).

the diagram inside the back cover). In speech certain frequencies are more critical to intelligibility than others. For example, an absence of frequencies above 600 Hz adversely affects the intelligibility of consonants; an absence of frequencies below 600 Hz adversely affects the intelligibility of vowels.

Various procedures have been developed to evaluate and predict speech intelligibility. One such procedure is based on the relative contribution to intelligibility by various frequencies across one-third and full-octave ranges (see Table 12-1).

Microphone Technique

One of the most important and generally subjective influences on sound shaping is microphone selection and placement. Microphones affect ambience, frequency response,

loudness, signal-to-noise ratio, and texture. In short, they affect the overall quality of recorded or transmitted sound. Because no two sound designers achieve their results in exactly the same way, there can be no hard and fast rules about selecting and positioning microphones. The purpose of discussing microphone technique in this and in subsequent chapters, then, is to suggest guidelines, using as examples the types of situations you are most likely to encounter.

Phase: Acoustical and Electrical

Before we begin a discussion of microphone technique, it is important to say something about phase, which, you will recall, is the time relationship between two or more sound waves at a given point in their cycles, or the relative polarity of two signals in the same circuit. Phase can be either an acoustical (see Chapter 2) or an electrical condition.

Acoustical Phase

Acoustical phase is important to consider in microphone placement. If sound sources are not properly placed in relation to microphones, sound waves can reach the mics at different times and be out of phase. For example, sound waves from a performer who is slightly off center between two spaced microphones will reach one mic a short time before or after they reach the other mic, causing some cancellation of sound. Perceiving sounds that are considerably out of phase is relatively easy: When you should hear sound, you hear little or none. Perceiving sounds that are only a little out of phase, however, is not so easy.

By changing relative time relationships between given points in the cycles of two waves, a **phase shift** occurs. Phase shift is referred to as delay when it is equal in time

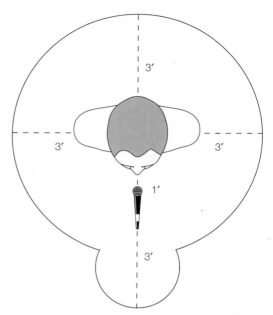

12-1 The three-to-one rule. Most phasing problems generated by improper microphone placement can be avoided by placing no two microphones closer together than three times the distance between one of them and its sound source.

at all frequencies. Delay produces a variety of "out-of-phase" effects that are useful to the sound designer (see Chapter 9). To detect unwanted phase shift, however, listen for unequal levels in frequency response, particularly in the bass and midrange; for slightly unstable, wishy-washy sound; or for a sound source that is slightly out of position in relation to where it should be in the aural frame.

One way to avoid phase problems with microphones is to follow the **three-to-one rule**—place no two microphones closer together than three times the distance between one of them and its sound source. If one mic is 2 inches from a sound source, the nearest other mic should be no closer to the first mic than 6 inches; if one mic is 3 feet from a

sound source, the nearest other mic should be no closer than 9 feet to the first; and so on (see 12-1).

If a sound source emits loud levels, it might be necessary to increase the ratio between microphones to 4 to 1 or even 5 to 1. Quiet levels may facilitate microphone placement closer than that prescribed by a ratio of 3 to 1.

If two microphones are used for one performer, their capsules should be as close to each other as possible and at about a 90-degree angle. This placement creates a wider pickup pattern and permits lateral head movement without phase cancellation. It is useful both in podium setups and for stereo recording (see 14-8a; see also 15-16a).

If two performers using separate directional microphones must work close together, phasing can be minimized by angling the mics away from each other. Make sure the angle is not so severe that the performers are off-axis.

Electrical Phase

The difference between acoustical phase and electrical phase is that signals acoustically in phase are dependent on the behavior of sound waves, whereas signals electrically in phase are dependent on electrical polarity.

A cause of microphones being electrically out of phase is incorrect wiring of the microphone plugs. Male and female XLR connectors used for most microphones have three pins: (1) a ground, (2) a positive pin for high output, and (3) a negative pin for low output. (XLR 5-pin connectors are used for stereo microphones.) Mic cables house three coded wires. All mics in the same facility must have the same number pin connected to the same color wire. If they do not and are used at the same time, they will be electrically out of polarity.

To check whether mics are electrically out of phase, first make sure that both mics are delegated to the same output channel. Adjust the level for a normal reading as someone speaks into a mic. Turn down the pot and repeat the procedure with another mic. Then open both mics to the normal settings. If the VU meter reading decreases when the levels of both mics are turned up, you have an electrical phase problem.

The obvious way to correct an electrical out-of-phase condition is to rewire the equipment, assuming the problem is not in the mic itself. If there is no time for that, however, most multichannel consoles have a phase reversal control that shifts out-of-phase signals by 180 degrees into phase (see 6-9).

Omnidirectional Versus Unidirectional Microphones

In most cases, when you are deciding what microphone to use, you will be choosing between an omnidirectional or a unidirectional mic. Often, circumstances make the decision for you. For example, in a noisy environment a unidirectional microphone discriminates against unwanted sound better than does an omnidirectional mic; to achieve a more open sound, the omnidirectional microphone would be the better choice. If you have the option of choosing between the two microphones, note that each has certain advantages and disadvantages, depending on the demands of a given situation (see Tables 12-2 and 12-3).

Based on the differences detailed in Tables 12-2 and 12-3, it is tempting to conclude that an omnidirectional microphone is superior to a unidirectional mic. In fact, unidirectional mics are far more widely used, which does not necessarily suggest that they are superior. A microphone's suitability must depend on a given situation.

Table 12-2 The omnidirectional microphone

Advantages	Disadvantages
Does not have to be held directly in front of the mouth to provide adequate pickup	Does not discriminate against unwanted sound
Does not reflect slight changes in the mic-to-source distance	Is difficult to use in noisy environments
Gives a sense of the environment	Presents greater danger of feedback in reverberant locations
Is less susceptible to wind, popping, and handling noises	
Is not subject to the proximity effect	
Is natural sounding in rooms with good acoustics	

Table 12-3 The unidirectional microphone

Advantages	Disadvantages
Discriminates against unwanted sound	Must be angled correctly to the mouth or the performer will be off-mic
Gives little or no sense of the environment (which could also be a disadvantage)	May be subject to the proximity effect
Significantly reduces the danger of feedback in reverberant locations	Is susceptible to wind and popping, unless there is a pop filter
	Is more susceptible to handling noises
	Requires care not to cover the ports, if hand-held
	Is less natural sounding in rooms with good acoustics

Space and Perspective: Monaural and Stereo

Audio produced today for radio is either monaural or stereo. In monaural sound aural space is one-dimensional — that is, measured in terms of depth — so perspective is near-to-far. Reverberation notwithstanding, the closer a microphone is placed to a sound source, the closer to the audience the sound source is perceived to be; the farther a microphone is placed from a sound source, the farther from the audience the sound source is perceived to be. If the microphone is omnidirectional, both the closer and more distant sounds are perceived as more open than if the mic is unidirectional; a unidirectional microphone reproduces a more closed, tighter sound.

In stereo sound aural space is two-dimensional — that is, measured in terms of depth and breadth, so perspectives are near-to-far and side-to-side. Moreover, stereo space includes more ambience than does monaural space. Stereo miking involves using either two microphones or a stereo mic. In relation to near-to-far perspective the same principles about microphone placement in monaural sound apply in stereo. The angle or distance between the two microphone capsules determines side-to-side perspective: the smaller the angle or distance between the micro-

phone capsules, the narrower the left-to-right stereo image; the larger the angle or distance, the wider the left-to-right image.

Another sonic effect, applicable to both mono and stereo, relates to microphone-to-source placement. Closer mic-to-source distances reproduce a warmer, denser, bassier, drier, more intimate, more detailed sound than do wider mic-to-source distances. The farther the microphone is from the sound source, the more distant, diffused, open, spacious, reverberant, and detached — and the less detailed — is the perceived sound.

Still another consideration in creating perspective involves microphone positioning of performers with different vocal strengths. If, say, two performers with voices of unequal power are positioned at the same mic-to-source distance (whether they are at one mic or at separate mics), the audience perceives the stronger voice as being closer and the weaker voice as being farther away. To compensate for differences in vocal intensity, a stronger voice should be placed at a farther mic-to-source distance than a weaker voice if they are to be perceived as being the same distance from the audience. If, however, different perspectives are called for, then mic-to-source distances should vary accordingly.

Miking Speech in Radio

In miking for radio, performers are usually stationary. Whether they are seated or standing, microphone positioning changes little. Although radio performers move little, however, there are a number of miking techniques to consider.

Single Speaker

In radio, positioning a microphone in front of a seated performer — disc jockey, newscaster, talk show host, guest — is the most

12-2 Performer using a microphone mounted on a flexible, gooseneck stand

12-3 Performer speaking into a microphone mounted on a desk stand

common miking placement. The mic usually is mounted on a small, flexible stand suspended in front of the performer (see 12-2) or on a table stand (see 12-3).

It is important in selecting and positioning the mic to keep excessive sound that is reflected from room surfaces, furniture, and

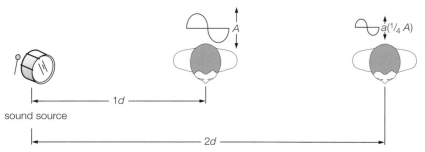

12-4 Illustration of the inverse square law. As the distance (*d*) from a sound source doubles, loudness (*A*) decreases in proportion to the square of that distance.

equipment from reaching the mic. This can result in comb filtering, creating a hollow sound quality.

To minimize sound reflections reaching the microphone, a performer should work at a relatively close mic-to-source distance and use a unidirectional microphone. The directionality of the mic should depend on how much front-to-rear sound rejection is needed. Keep in mind, however, that the more directional the mic, the more restricted the side-to-side movement.

It is difficult to suggest an optimal mic-to-source working distance because voice projection and timbre vary from person to person. Here are some guidelines:

■ Always stay within the microphone's pickup pattern.

■ Ride the voice level so that it peaks between 60 and 100 percent of modulation; some stations like it between 80 and 100.

■ The weaker the voice is, the closer the mic-to-source distance should be.

■ Working too close to a mic, however, may create sound that is devoid of ambience as well as oppressive and unnatural.

■ Working too close to a mic emphasizes tongue movement, lip smacking, and teeth clicks. It could also create proximity effect.

■ Working too far from a mic diffuses the sound quality, creating spatial distance between performer and listener.

■ When the mic-to-source distance is doubled, the sound pressure level drops approximately 6 dB, thus reducing loudness to one-fourth. Conversely, cutting the mic-to-source distance in half increases loudness approximately 6 dB, because of the inverse square law (see 12-4). The precise effect of this law depends on whether a sound source is in an open or enclosed space.

Sometimes, a microphone is positioned to the side of or under a performer's mouth, with the performer speaking across the mic face (see 12-5). Usually this is done to reduce the popping and **sibilance** that often occur when the performer talks directly into a mic.

Speaking across a unidirectional microphone can reduce these unwanted sounds. Unless the mouth-to-mic angle is within the microphone's pickup pattern, however, talking across the mic degrades the response. To eliminate popping and reduce sibilance without overly degrading the response, (1) use a windscreen, (2) use a microphone with a built-in pop filter, or (3) point the mic at about a 45-degree angle above, below, or to the side of a performer's mouth, depending on its pickup pattern (see 12-6). If sibilance

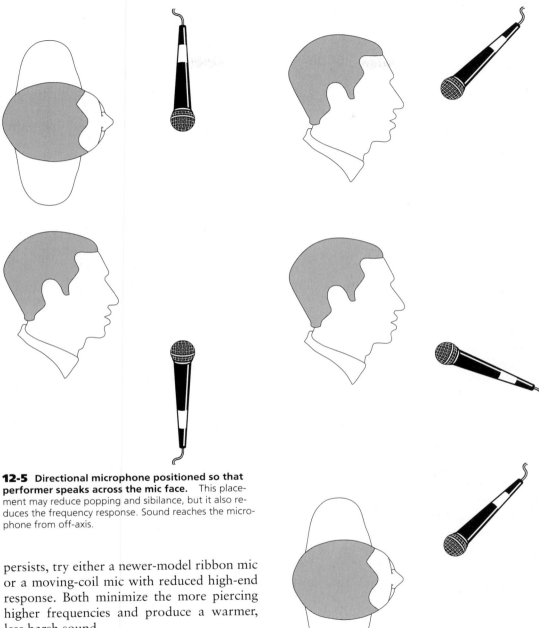

12-5 **Directional microphone positioned so that performer speaks across the mic face.** This placement may reduce popping and sibilance, but it also reduces the frequency response. Sound reaches the microphone from off-axis.

persists, try either a newer-model ribbon mic or a moving-coil mic with reduced high-end response. Both minimize the more piercing higher frequencies and produce a warmer, less harsh sound.

In positioning a mic, make sure that its head is not parallel to or facing the tabletop. As you may recall from Chapter 3, the angle of a sound's incidence is equal to its angle of

12-6 **Speaking at a 45-degree angle into a directional mic.** This reduces popping and sibilance.

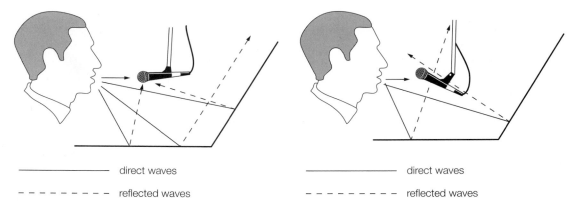

——————— direct waves	——————— direct waves
– – – – – – – – reflected waves	– – – – – – – – reflected waves

12-7 Incorrect placement of microphone. Indirect sound waves reflecting back into a mic cause phase cancellations that degrade the response. To avoid this, a microphone should not be placed parallel to or more than a few inches from a reflective surface.

12-8 **Correct placement of microphone.** Placing a microphone at an angle to a reflective surface reduces indirect sound bouncing back into the mic.

reflectance in midrange and treble frequencies (see 3-7). Therefore, sound waves bouncing from the table will reflect back into the mic's pickup pattern, thereby reducing the sound quality. Any hard surface that is close to a mic, like a copy stand or window, should be angled so the sound waves do not reflect directly into the mic (see 12-7 and 12-8). If changing the microphone's angle presents a problem, cover the hard surface with a soft material to absorb some of the reflections.

Stereo radio transmission and reception have no effect on single-speaker miking; talent is still miked with one microphone. If the performer is not sonically "stage center," localization is disconcerting to the listener. Stereo sound in stereo radio is in the music and quite often in the spot announcements as well, not in the spatial positioning of the talent.

Interview and Panel

When there is more than one speaker, as there is in interview and panel programs, it is customary today to mike each participant with a separate microphone for better sonic

control. Directional microphones, usually cardioid or supercardioid, are preferred. If the participants are sitting opposite each other, the cardioid is sufficient because its off-axis response is greatest at 180 degrees. If the participants are sitting side by side, facing the host, the supercardioid, with its better side rejection, is preferred. The hypercardioid mic would also work in the latter situation but there are the potential problems of restricted head movement due to its quite narrow on-axis pickup and reduced sound quality because of its somewhat poorer rejection at 180 degrees.

In a straight interview, without telephone call-ins, one bidirectional microphone might serve. It is an easier and sonically "cleaner" alternative, but it is not without problems, which is why it is rarely used. Because there is only one fader controlling the microphone's loudness, it is not possible to compensate electronically for differences in loudness between guest and host. If the difference between them is obvious but not great, the interviewer, who is usually a professional, can modulate his or her voice to match more

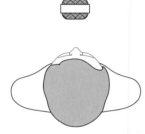

12-9 **Balancing two voices with different loudness.** Positioning the bidirectional microphone closer to the speaker with the quieter voice and farther from the speaker with the louder voice compensates for differences in loudness. If the mic-to-source distance of either speaker is too great, however, each will have a different ambient quality, negating the advantages of this technique.

closely the level of the interviewee's voice; or the louder speaker can sit farther from the mic than the quieter speaker (see 12-9). If the difference between the voices is too great and cannot be balanced by adjusting the positions of the participants, there is little alternative but to use two microphones.

When more than one microphone is used, they must have the same directional pattern. Mics with different polar patterns, say, a bidirectional or omnidirectional mic used with a cardioid or supercardioid mic, may be subject to **leakage**—sound intended for pickup by one microphone that is also picked up by another—which could create phase problems and, therefore, partial sound cancellation.

In miking a radio program with two or more participants, usually either (1) the host

and guest(s) are in the studio and an operator is in the control room or, more commonly, (2) the host operates the control panel in the studio at the table where the guest(s) is sitting (see 4-2). The studio control panel can usually handle telephone feeds for listener call-in, as well (see 12-10). Some radio stations even put a simple control console at the guest station(s) (see 12-11). In both situations, host and guest(s) have their own directional microphones or, in the case of telephone call-in programs, headset mics. A headset mic facilitates the feeding and balancing of all program information to each participant, reduces problems of microphone placement, allows host and guest(s) more freedom of movement, and clears frontal desk space for scripts and note taking.

If the interview or panel program is in stereo, feeding each microphone to a separate channel and positioning the participants in the stereo space through panning is easier and far more practical than trying to stereo-mike each individual or the whole group. In producing a stereo image, however, keep in mind that too wide a stereo space in this situation is disconcerting. The participants should not sound too distant from one another or too far afield. As anchor or coordinator of the discussion, the host should be positioned aurally front and center. Because it is radio, appearance is of no concern except that the participants must be comfortably and sensibly arranged for optimal interaction.

Drama

Most drama produced in radio today is played out in spot announcements. Although the days of bona fide radio drama have long since passed, many of the microphone and production techniques that were used are still with us; some have been updated.

12-10 **Talk Console.**™ This control panel combines a two-channel mixer for host and guest (or any other type of external source, such as CD or tape) with two telephone lines for audience call-in. It also includes two adjustable headphone outputs and remote controls to start a tape recorder or telephone delay system. DIAL/CUE allows the host to dial or answer a telephone line and also talk with a caller off the air. In HOLD, the caller hears the program while off the air. When the host pushes AIR, it sends an alert tone to the caller before going on the air.

12-11 **Talent station.** This unit provides the guest(s) with on–off microphone controls, a cough button, headphone level control, clock, and event timer. The host is provided with those functions and a bank of eight source selector switches to select which audio source (guest, telephone call-in, CD, tape, etc.) will be monitored in the headphones and speaker output. The unit also includes a speaker level control, a talkback switch for host-to-control room communication, and an auto-restart switch allowing slave-restart from the control room console.

Producing drama on radio entails creating a "theater of the mind"; the stimulus of sound compels the listener to "see" mental images. The stimuli that trigger the imagination are words, music, and sound effects, as well as the methods used to produce these elements. Generating illusions of perspective and movement is accomplished, for the most part, through miking.

Single-Microphone Technique

Using one microphone in radio drama involves positioning actors at the mic and having them play to it as if it were the ear of the audience. To make the drama effective, a sense of both perspective and movement must be created. In addition, appropriate microphones must be selected and properly mounted.

Creating Perspective To create perspective acoustically, position the actors at appropriate distances relative to the mic and to each other, as the dramatic action dictates. If an actor is close to the mic, the audience perceives the sound as near or the space as small; if an actor is farther from the mic, the sense of distance increases and the space becomes larger. If a man and woman are on-mic playing opposite each other in a scene that calls for them to be fighting, position the man farther from the microphone than the woman to compensate for the (usually) more powerful male voice. If they are equidistant from the mic, the man will sound closer than the woman (see 12-12). The audience's perspective will be from, and usually their sympathy will rest with, the performer in the closer position.

Maintaining perspective does not always mean keeping voice levels balanced. If a scene requires one character to call to another from a distance, perspective is created by placing the actor who is supposed to be closer **on-mic**, and the one who is supposed to be farther **off-mic**.

Creating Movement If movement is involved, such as someone leaving or entering a room, there are three ways to create the effect: (1) by moving from the live to the dead side of a bidirectional microphone, or vice versa; (2) by turning in place toward or away from the mic; or (3) by walking toward or away from the mic.

Moving the fader up or down—also known as *board fade*—will also create the effect of coming or going, but not so well as having the actors do it. The difference between the two techniques is that using the fader influences not only the actor's voice level but also the room's acoustics. When a person enters or leaves a room, the space does not change; only the person's position within it changes.

Once you determine the proper aural balances, it is a good idea to mark or tape the studio floor so the performers will know exactly where to stand and how far to move. Marking the studio floor also assists in traffic control around a microphone when several performers are in a scene and have to yield and take on-mic position.

Microphone Selection and Mounting The best microphone to use for the single-mic technique is a multipattern capacitor. Capacitors not only provide extremely wide and flat response, they also give the human voice a rich, realistic timbre. Ribbon microphones are good for voice, but older models lack the high-frequency response that gives sound its lifelike quality, assuming the medium reproduces those frequencies.

As for moving-coil microphones, several models have excellent voice response, but almost all are either omnidirectional or unidirectional. Because radio performers usually are grouped around the microphone (in the

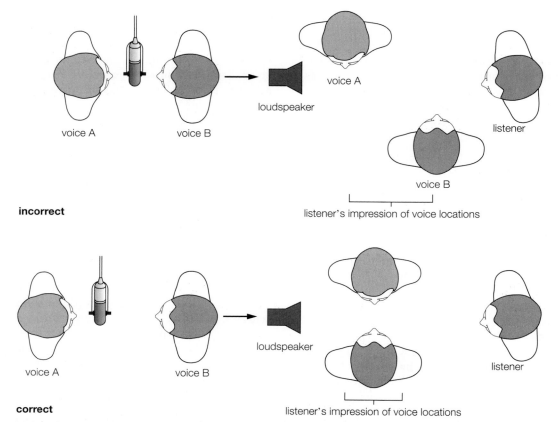

incorrect

correct

12-12 Balancing two voices with different loudnesses. Position the stronger voice farther from the microphone. This keeps the voices in proper aural perspective relative to the listener. But do not position the stronger voice too far from the mic, or it could take on an ambient quality noticeably different from that of the softer voice.

single-mic technique), the most commonly used pickup patterns are omnidirectional and bidirectional. It is easier to set up one multipattern microphone than to change mics every time the situation requires. In the case where a narrator, for example, has a large part, then one unidirectional and one multidirectional mic would be a convenient alternative.

The preferred microphone mount for radio drama is the boom. It gives actors easy access to the mic, there is no floor stand to

get in their way, and, with shock mounting, there is less chance of sound conductance from movement across the studio floor.

Multimicrophone Technique

With modern recording, most directors in radio drama today take advantage of the flexibility that the multichannel console and multitrack tape recorder afford. Performers can be miked separately to allow greater sound control during recording; then the

various performance tracks are combined after recording—that is, in postproduction.

Although added sound control is an advantage of this technique, there are also disadvantages. It is more difficult to obtain natural spatial relationships and perspective between performers and the environment; it reduces the opportunity for talent to interact; and it requires a postproduction session to blend the various tracks into one (mono) or two (stereo) tracks.

Deciding whether to use the single-microphone or multimicrophone technique in radio drama should depend on your aesthetic philosophy and the complexity of the script. All in all, however, single-microphone production, although old-fashioned, has two major advantages: (1) It produces a more believable performance because the actors can interact, and (2) it produces a more realistic sound shape. Having said that, it is only fair to point out that for the sound shaping of individual performances, particularly when using effects, the multimicrophone approach is preferred to the single-microphone technique.

Stereo Microphone Technique

Many of the production techniques applicable to monaural radio drama also apply to stereo. But stereo does bring its own special problems, not the least of which is mono compatibility.

Although stereo has been around for many years, and AM and FM radio transmit in stereo, the audience still generally listens in mono. This means that material recorded in stereo must be capable of also being reproduced in mono.

Stereo requires two discrete signals, A (left) and B (right). To reproduce these signals in mono, they are summed—A + B. Discrete stereo is also referred to as sum-and-differ-

ence stereo because one channel is summed (A + B), and the other channel is subtracted (A − B). If the stereo signals are in phase when they are added, level can increase 3 to 6 dB; if the signals are out of phase in stereo, they cancel in mono. Therefore, it is critical during recording to make sure that problems with stereo-to-mono compatibility are anticipated.

Stereo miking uses two microphones (or microphone capsules) to feed each discrete signal to a separate channel. Sound reaches the microphones with intensity and time differences. The difference in arrival time between the signals reaching the two microphones creates phase problems later when combining the signals to mono. The narrower the angle or space between the mics, the less the difference in arrival time between the signals reaching the mics.

There are a number of ways to mike for stereo (see Chapters 14 and 15). One technique—coincident miking—ensures stereo-to-mono compatibility; another—near-coincident miking—can be mono-compatible if the angle or space between the microphones is not too wide. Coincident and near-coincident arrays are also called **X-Y miking.**

Coincident miking positions two microphones, usually directional, in virtually the same space with their diaphragms located vertically on the same axis (see 14-8). This arrangement minimizes the arrival time difference between the signals reaching each mic. Stereo imaging is sharp and sound localization is accurate.

Near-coincident miking positions two microphones, usually directional, horizontally on the same plane, angled a few inches apart. They may be spaced or crossed (see 12-13; see also 14-11). The wider angle or space between the mics adds more depth and warmth to the sound, but stereo imaging is not as sharp as it is with the coincident array.

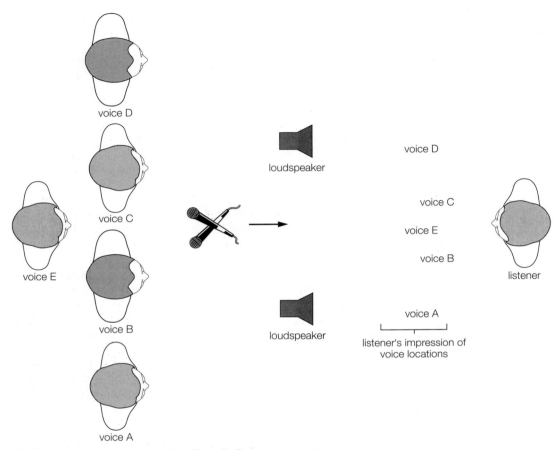

12-13 **Effects of stereo miking technique on listener perception**

In radio drama the angle or space between the mics should not be greater than 90 degrees; not only would this cause problems with mono compatibility, but the stereo image would become more diffuse.

In stereo miking, the lateral imaging of the stereo field is critical. If the angle between the microphones is too narrow, sound will be concentrated toward the center (between two loudspeakers). If the angle between the microphones is too wide, sound will be concentrated to the left and right with little sound coming from the center, a condition referred to as "hole in the middle." The angle between the microphones is contingent on the width of the sound source: the wider the source, the wider the angle; the narrower the source, the narrower the angle. (If a sound source is too wide for the coincident and near-coincident arrays, as may be the case with orchestral ensembles in concert halls, then spaced mics are employed—see Chapter 14.)

In stereo radio drama, performers are usually not widely spaced at the microphones.

The center of the stereo space is where the main action is likely to take place. Too much "ping-ponging" of sound left and right can create dislocation of the sound sources, confusing the listener. Action playing left or right of center is usually not played too wide afield.

Assuming there are no acute acoustic problems, the inclusive angle between the microphones should be between 60 and 90 degrees. At the least, that is a good starting point; further positioning would depend on the number of people in a scene and the size of the aural "set."

Perspective

In positioning actors, care must be taken to ensure that they are in the same position and perspective as the associated voice. If a script calls for conversation among actors in various parts of a room, they cannot be grouped around the mics—some closer, some farther—in stereo drama as in monaural drama. To maintain the stereo perspective, each actor should be in about the same position, relative to the others, as he or she would be if the situation were real (see 12-13).

More studio space is required for stereo radio drama than for mono because the dead sides of the mics cannot be used for approaches to and recedes from the mics. To produce the illusion of someone walking from left to right, an actor cannot simply walk in a straight line across the stereo pickup pattern. If that happened, the sound at the center would be disproportionately louder than the sound at the left and right, and the changes in level would be too abrupt. To create a more realistic effect, an actor has to pass the microphones in a semicircle, always staying the same distance from the mics. Also, studio acoustics must be dead because they are much more apparent with stereo than they are with mono.

Miking Speech for Picture

The techniques used to mike speech for picture in television and film (and to produce sound, in general) depend on whether the production is broadcast live, or live-on-tape, or is taped/filmed for showing at a later date. Usually, productions aired live or live-on-tape—recorded but run as though they were live shows—use the multicamera production method. That is, by employing two or more cameras and feeding the signals to a switching console, a shot from one camera can be broadcast (or taped) while other cameras prepare the next shots; in essence, "editing as you go." Sound is also similarly handled during live or live-on-tape production. Postproduction time is limited due to an imminent or relatively imminent broadcast deadline. Programs such as news, sports, interview, panel, talk, and game shows, situation comedy, most awards shows, and parades are carried live or live-on-tape and, therefore, use the multicamera production method.

Studio and on-location (discussed in Chapter 15) productions that do not have an imminent release deadline, such as TV dramas, commercials, and theatrical films, generally use the single-camera production method. Scenes are shot one at a time—first from a general perspective and then from various individual perspectives. These different views are edited during postproduction into a meaningful sequence of events to build the structure and create the pace. It is also in postproduction that dialogue and sound effects are recorded or rerecorded, if necessary, and music is added.

News and Interview Programs

In news and interview programs the participants are usually seated at a desk or in an open set. The mic almost universally used in these situations is the omnidirectional lavalier. It is unobtrusive and easy to mount; its sound quality with speech is satisfactory (using a moving-coil mic) to excellent (using a capacitor); and an omnidirectional pickup pattern ensures that ambience is natural and that a performer will stay on-mic regardless of how much his or her head moves to one side or the other. If background sound is troublesome, the directional lavalier is a suitable alternative. Generally, for optimal sound pickup, the recommended placement for a lavalier is in the area of the wearer's sternum.

Although the lavalier is unobtrusive (some are smaller than a dime), many directors prefer to make it even more low-profile by hiding the mic cord underneath the performer's clothing (see 12-14). If you do this, use a belt clip to (1) keep the microphone in position, (2) isolate it from the rest of its cord, and (3) reduce the sound of clothes rustling, which the cord often picks up through mechanical conductance (see 12-15). Some directors, however, are not concerned about how much of the mic cord shows. They think the audience accepts it as a natural part of the picture.

Sometimes, the mic itself is hidden underneath clothing. Unless it is important that the mic not be seen, as in drama, however, this is usually not a good idea. Clothing inhibits higher frequencies (shorter wavelengths) from reaching the mic and, thereby, can degrade the sound quality. Also, some lavalier models are even more sensitive to the sound of clothes rustling than is the cord. (See also "Body Microphones" in Chapter 15.) These problems can be avoided if performers wear the proper clothing. Cotton clothing does not

12-14 Hidden microphone cord. Directors concerned with making a lavalier unobtrusive often hide the cord underneath clothing. Some directors think this is unnecessary, because microphones in a shot have become an accepted part of many types of programs.

belt clip

12-15 Mic cord tied down by belt clip. This technique prevents the cord from rubbing against clothing or distracting the viewer.

make much rustling sound; polyester, rayon, and dacron do. Test different clothing samples to determine which generate the least rustling noise. It is also important to keep a lavalier from knocking against jewelry, such as tie clips or necklaces, that may be worn by performers.

12-16 **Two electret capacitor mics mounted on one specially designed clasp.** One microphone is used as backup for the other in case the microphone system fails; only one is active.

You might wonder why some newscasters wear two lavaliers when the general goal is to keep mics unobtrusive (see 12-16). In these instances the microphones are capacitors, and one is simply for backup in case the on-air mic fails.

Because the lavalier and its mic cord can pick up rubbing sounds from movements, you have to be careful when miking a performer, such as a weathercaster, who moves about within a small set. The performer should use a belt clip, leave enough play in the mic cord so it drags across the floor as little as possible, and avoid sudden, wrenching motions. If the mic cord is put underneath a pant leg or dress to keep it out of sight, it is a good idea to tape it to the thigh to reduce rustling sounds.

Having said all this, many directors avoid the problems of visible mic cords, constrained movement due to cord length, and rustling sounds by using wireless microphone systems on the set—if not for each talent, then certainly for the weathercaster. The wireless microphone system is cordless, it can be mounted with a lavalier, and, in a controlled studio environment, it is usually free from interference problems. (See "Using the Wireless Microphone System" later in the chapter.)

In interview programs, the host often sits behind a mic mounted on a desk stand. In many instances, the mic is not live. It is being used as a prop to create a closer psychological rapport between the host and the television audience. The host is live-miked with a lavalier. A desk mic may also be used as a set piece for the open table space in front of the host.

If you do use a live desk mic, keep in mind the following:

- Mount a unidirectional microphone on the desk stand to avoid picking up noises from cameras, technical crew, and others moving about the studio.

- Select a good-looking mic that does not call attention to itself.

- Place the stand to the performer's left or right (right is preferred because it usually balances the frame better) so that sound waves do not hit the mic head-on. This reduces the possibility of picking up popping and sibilance, and the performer's hand and script movements are less restricted.

- Make sure the mic-to-source angle is correct so the performer is not off-mic.

- Use a mic with a built-in shock mount so unwanted noises from hands, legs, or shoes hitting the desk are minimized.

- Advise nonprofessionals of correct microphone procedures and remind them not to handle the mic.

The boom microphone is rarely used in news and interview programs today, not just because the lavalier is so convenient. A boom mic requires another crew person to operate and so is more expensive. It also creates another task for the lighting director, who must make sure that no boom shadow falls across the set. Moreover, during newscasts, with

news sets as wide as they are today, it would be difficult to keep the boom out of the picture in longer shots.

Panel and Talk Programs

Television panel and talk programs employ a few basic set arrangements. When the host or moderator is stationary, guests sit in a line either diagonal to and facing the host, or if an audience is participating in the show, the guests sit in a horizontal line facing the audience and the host moves between them and the audience. Sometimes, the set design is in the shape of an inverted U. The moderator sits at one desk centered between interviewers to the moderator's right and the guest at a third desk to the moderator's left and across from the interviewers. Or panel participants might sit in a semicircle, while the moderator, using a wireless mic system, moves inside the semicircle to query the panelists.

Choosing a Microphone

In most circumstances, for host and guest alike, the *lavalier's* several advantages make it the microphone of choice.

- It is unobtrusive and tends to disappear on camera.

- It is easy to mount.

- It keeps the mic-to-source distance fairly constant.

- It reduces the need for frequent loudness adjustments once the levels have been set.

- It requires no special lighting or additional operator.

- It makes it possible to place participants comfortably in a set without concern for keeping the mic, such as a boom mic, out of the picture.

The lavalier's main disadvantage is that it's a single-purpose microphone. It rarely sounds good used away from the body, particularly when hand-held (see 5-42).

There are situations in panel and talk programs in which microphone mounts, other than the lavalier, are preferred. For a host moving about a set among guests or going into the audience for questions, the *hand-held mic* is the best choice.

The hand-held microphone has these advantages:

- It allows the host to control the audience questioning.

- It allows the host to control mic-to-source distances.

- Like the desk mic, it helps the host to generate a closer psychological rapport with the television audience.

When using the hand-held microphone, make sure it has a built-in pop filter and internal shock mount to minimize sibilance and popping and handling noise. Position the mic about 6 to 12 inches from the mouth, pointing up at about a 45-degree angle. Holding mics subject to proximity effect 3 to 6 inches from the mouth will boost the lower frequencies, adding warmth to the sound—unless the mic has considerable proximity effect, in which case the sound may be too bass-heavy (see 12-17). A disadvantage of the hand-held mic is that it ties up one of the host's hands. This is not a problem with the boom mic, and for some situations that is the mic of choice.

When guests are coming and going during the course of a show, for example, the *boom mic* is often used once they are seated. It is less awkward than having a guest put on and take off a lavalier on camera. Usually no more than three guests are seated on the set at any one time, which allows one boom to

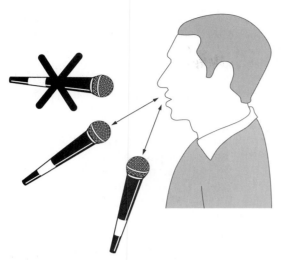

12-17 Hand-held microphone positioning. Ideally, a hand-held microphone should be positioned 6 to 12 inches from the user's mouth, at an angle of 45 degrees or less. Positioning the microphone at an angle of about 90 degrees may result in "popping" sounds when consonants like "P" and "T" are pronounced.

cover the group adequately. In this type of situation, the host often uses a live desk mic, both to set the host apart from the guests and to enhance, psychologically, the rapport with the television audience. If the relationship between a host and guest is intended to be perceived as more informal, such as in an entertainment-oriented interview program, they may sit on living-room-type chairs or a half sofa, proximate enough for one boom mic to cover. In such an environment, even the low-profile lavalier mic could intrude on the intimate surrounding.

Whenever one boom covers two or more people in conversation, the boom operator has to make sure that none of the program's content is inaudible or off-mic. A good boom operator thus (1) quickly learns the speech rhythms and inflections of the people talking, (2) listens to their conversations, (3) anticipates the nonverbal vocal cues that signal a

change in speaker, and (4) when the change occurs, moves the mic from one speaker to another, quickly and silently.

If performers are stationary, there is little need to do anything but rotate the mic itself. If performers are mobile, moving the boom arm and extending and retracting it are also important to good boom operation. (We will discuss this aspect of boom operation later in the chapter in the section on miking dramatic material.)

Controlling Multiple Sound Sources at Once

Individually miking several program participants can be a challenge for the console operator trying to control various levels at the same time, especially when other sound sources such as the announcer, bumper (intro and outro) music, and spot announcement tapes are also part of an operator's program responsibilities. It is best to use as few mics as possible in a given situation to reduce system noise, phasing and coordination problems, but the development of the multi-channel console and sophisticated signal processing has made separate control of each sound source preferable to more conservative miking techniques. To help reduce the problems associated with controlling multiple, simultaneous, microphone voice feeds, the console operator has a number of options.

The most convenient way is to put a moderate limit or some compression on each mic, once levels are set. With the lavalier and hand-held mics, the proximity of the mic to the speaker's mouth is close enough to be a potential problem with loud sound surges and, hence, overloading. Limiting keeps such surges under control, thereby helping to maintain more uniform levels. Also because mic-to-source distance with a lavalier is close, there is little problem with voice levels

being too quiet. Such may not be the case with the boom. With the boom, compression helps to keep both quieter voices above the noise floor and louder voices from overloading.

When omnidirectional lavaliers are used closer than the recommended three-to-one ratio, phasing problems can create a hollow, "tin can" sound. Compression is definitely needed to reduce the dynamic range of each mic. If that is not sufficient, it might be necessary to put adjacent microphones out of phase with each other. When adjacent microphones are out of phase, a null is created between them. The null keeps the same sound from reaching an adjacent mic at slightly different times by canceling the delayed sound. This technique only works if the participants are not mobile and do not lean into the null.

A way to avoid the problems created by omnidirectional lavaliers being too close to each other is to use directional lavaliers. But directional lavaliers, and directional mics in general, produce a drier, more closed sound than omnis, which directors tend not to like for speaking voices in panel and talk programs.

Using a noise gate is still another way to control these phasing problems. It can, however, be a solution that is more trouble than it is worth. It takes time to set precise thresholds, and the gating effect may be audible as microphones are open and closed.

Another way to control multiple sound sources is to use an automatic microphone mixer. For a discussion of the automatic mic mixer see "Multiple Pickups" in Chapter 15.

Miking the Audience

When a talk show (or almost any entertainment program) takes place before an audience, its response becomes integral to the program's presentation. Applause, laughter, and other reactions help to generate a show's spontaneity and excitement. The presence of an audience creates two challenges for the sound designer: (1) the people at home must be able to hear them; and (2) the audience must be able to hear the participants on stage, or wherever they may be in the studio.

For the home audience, the studio audience should sound relatively close and uniform so that the viewer feels part of the action. No single voice or cadence or group of similar sounding voices (that is, high-pitched cackle, halting laugh, children, elderly women, and so forth) should predominate.

Typically, the way to achieve these ends is to mount directional shotgun microphones—usually cardioid or supercardioid—several feet above the audience and distribute them in equal quadrants throughout the audience area (see 12-18). Sometimes, depending on the studio acoustics and the size of the audience, omnidirectional mics or boundary mics with hemispheric pickup patterns are also used to help blend the overall audience sound.

To free the operator's hands for other audio control operations, audience microphones are sometimes controlled by a foot pedal under the console. The pedal is used to open and close the mics.

In order for the audience to hear the program participants, loudspeakers must be mounted in the audience area of the studio. This places microphones and loudspeakers close together, creating the potential for feedback—that high-pitched squeal from a signal feeding from a mic to a loudspeaker, around and around. To avoid feedback, the loudspeakers are placed so their sound is off-axis to the microphone's pickup pattern (see 12-18).

If the loudspeaker is too loud, however, feedback will occur anyway. To minimize

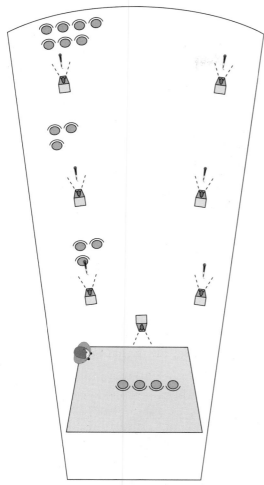

12-18 **Talk show studio with audience area.**
Shotgun microphones are placed above the audience in quadrants for uniform and controlled directional pickup. Above and behind the mics are small directional loudspeakers situated to avoid feeding back into the mics and to cover specific audience areas. A small loudspeaker above the stage feeds audience sound to the guests during questioning. Depending on the layout and studio size, this loudspeaker may be phased so it covers a narrow stage area or to avoid interference with the studio loudspeakers, or both.

this risk, smaller, more directional loudspeakers are used and their levels are kept moderate. If the danger of feedback still exists, still smaller loudspeakers may be used or their sound may be compressed, or both.

Milking the Audience

Audiences usually react in two ways, by laughing and by applauding. Raising the levels of these sounds when they occur adds to their uplift and to the program's overall fun and excitement. This is known as **milking the audience.** But such level adjustments have to be accomplished gracefully, they cannot be abrupt. Skillfully done, increasing the level of laughter can add to its infectiousness, thus reinforcing the impact of a funny line or joke, or, in the case of applause, it can heighten its intensity, perhaps even its enthusiasm.

The audience sound may be controlled by a limiter. When the audience microphones reach the limit level, the limiter kicks in to increase apparent loudness but not the actual peak level.

Audiences do not always react as expected, however. When a funny line or a climactic moment is not greeted with the anticipated intensity of laughter or applause, recorded applause and laugh tracks are sometimes used to reinforce or "sweeten" audience reactions. Cartridge tapes with different types and degrees of audience reactions are **deadpotted** — played with the faders off — on cart machines with the cue tone defeated so that the tapes spool continuously. Alternatively, they can be deadpotted on a cart player, called a **program** or **message repeater**, that is specially designed to spool tapes continuously (see 12-19). The digital program repeater performs the same looping function as its analog counterpart and can record and store effects as well (see 12-20).

12-19 A program repeater with remote fader/mixer. This model is made by MacKenzie Laboratories and is known as a "MacKenzie Machine." It houses five cartridge tape players with separate loudness, bass, and treble controls for each player.

12-20 Digital program repeater used to record and reproduce repetitively occurring program material. In this model, Track and Start buttons control program reproduction, and a LED readout selectively indicates Track selection, reproduction Time of that selection, or the amount of Memory utilized or available.

Laughter and applause sometimes occur relatively close together. When this happens, because applause is louder than laughter, the general guideline is to decrease the loudness level of the applause and increase the level of the laughter.

Dramatic Material

Miking actors in dramatic performances, employing either the multicamera or single-camera production method, usually involves using a boom or wireless microphone system, or both.

Using the Boom

The important decisions in using a boom are logistical and aesthetic. They involve (1) plotting the best microphone positions and angles for each scene in a production to ensure optimal aural balance; (2) keeping the boom out of the lighting pattern so its shadow does not fall across the set; (3) making sure that the boom does not get in the way of the performers; (4) making sure that the boom can move freely; (5) trying to keep cameras and boom out of the audience's sight line as much as possible; and (6) positioning the boom at mic-to-source distances that are relative to the fields of view of the shots to help maintain acoustic perspective between sound and picture.

It is worth noting, however, that because of the logistical and operational concerns associated with using the boom, many directors use the wireless microphone system instead, regardless of whatever sonic advantages the boom may have in a given situation (see "Using the Wireless Microphone System"). Their thinking is that easier is better and more economical; any aesthetic shortcomings can be offset in postproduction.

Reality notwithstanding, always try to take the best aesthetic approach.

Blocking In drama, miking decisions are made in the preproduction planning stages when you block the program—work out the movements of performers, cameras, and sound boom(s). **Blocking** begins with a **floor plan**—a diagram, drawn to scale, showing where scenery, cameras, microphones, and performers will be positioned.

If there is limited physical movement by the performers and the set is small, one boom microphone can usually handle the action, providing the performers are not more than 6 to 9 feet from the mic when they speak (see 12-21). If physical movement is active or the set is large, or both, two booms and sometimes wireless mics are used (see 12-22). Using two booms is standard.

It is also necessary to think about the boom mount when you block. It is large, bulky, and difficult to move quickly over extended distances, especially when cameras, cables, and set furniture are in the way. It is easier to leave the boom mount in place and swing, extend, or retract the boom arm to cover the action (see 5-63). If the boom has to be moved, use boom movers, because it is time-consuming and inconvenient to have the operator come down from the boom seat each time the boom has to be repositioned. If repositioning is a problem and you do not have the luxury of a boom operator, either reblock the action or use the tripod (giraffe) boom (see 5-64).

Although the tripod boom is easier to operate than a perambulator boom, it has its disadvantages. First, because it is lightweight, it is subject to shock and vibration likely to be picked up by the microphone. Therefore, you need to use a lighter mic and a very good shock mount for the mic. Second, it has a limited boom arm reach. Third,

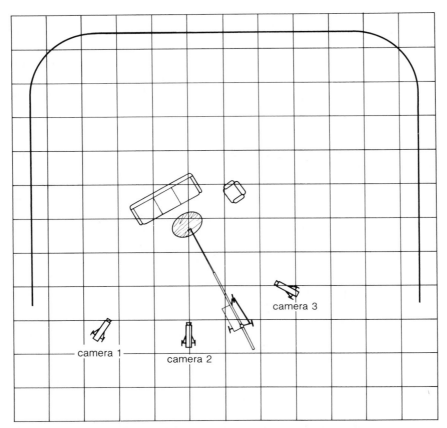

12-21 Floor plan showing boom and camera placement to cover limited action in a small set

once the boom arm has been extended to a particular length, it cannot be extended farther or retracted without interrupting shooting to do so. To change mic-to-source distance during shooting, the entire tripod has to be rolled in or rolled out, and this movement could be audible. Fourth, the height extension is quite limited, presenting the dangers of the boom shadow.

Another concern, and a vital one, is making sure the boom mic is positioned so that it does not get into the shot. Unless you are careful, a boom mic positioned out of the picture in a close-up could show up in a

longer shot (see 12-23). You also need to keep the boom out of an audience's line of sight as much as possible. For example, TV studios usually have several large TV screens for the audience, but it is to the program's advantage to make the audience feel like part of the event, especially with comedy.

If the boom stays just above (or below) the frame line, the acoustic mic-to-source distance should be proportionate to the size of the shot, matching the aural and visual space, which is one of the boom's main aesthetic advantages. Here are a few guidelines to using the boom:

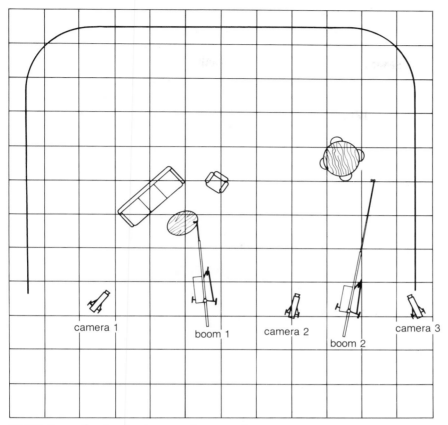

12-22 Floor plan showing boom and camera placement to cover action in a set larger than that shown in 12-21

- Position the boom above and in front of the performer's mouth. Remember, sound comes from the mouth, not from the top of the head.

- Establish mic-to-source operating distance by having the performer raise an arm at a 45-degree angle toward the tip of the microphone and extending a finger; the finger should just touch the mic. Appropriate working distances can be planned from there. For example, if the mic-to-source distance in a close-up is 3 feet, in a medium shot it could be about 6 feet, and in a long shot up to 9 feet.

- Remember that with shotgun microphones, the more directional the front end, the more sensitive the back end. Therefore, do not point the back end toward a source of unwanted noise such as ventilators, parabolic lights, and so on.

- Be aware that directional shotgun microphones compress distance between background and foreground. Aim the microphone directly at the performer(s) so as not to increase background sound.

- Remember that capacitor microphones generally have higher sensitivity than do

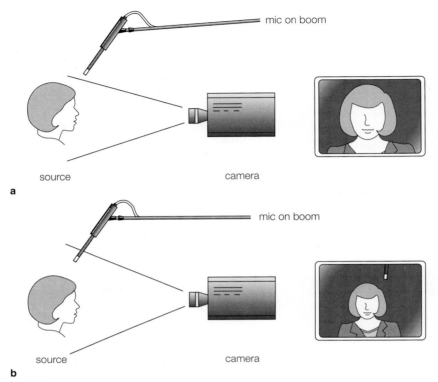

mic on boom

source camera

a

mic on boom

source camera

b

12-23 Microphone positioning. (*a*) Mic-to-source distance adjusted so the boom does not show in the picture. (*b*) Shot changed to a wider angle and the mic-to-source distance not increased; the microphone shows up in the picture.

moving-coil mics and, therefore, can be used at somewhat longer mic-to-source distances without degrading sound quality.

■ To facilitate learning the shot changes in multicamera production, provide each boom operator with cue sheets and a TV monitor placed on the boom (assuming a perambulator boom) or near it, as well as headphones that feed the program sound to one ear and the director's cues to the other ear. Boom dolly movers should also have access to cue sheets. Rehearse each shot so that the exact mic-to-source distances are established.

■ Rehearse all boom operations. Even the slightest movements such as turning the head while talking or bending down can require complicated boom movements. For example, as a head turns while talking, the boom has to be panned and the mic rotated at the same time.

■ Anticipate the performer's movements so that the boom leads, rather than follows, the person.

■ Position the boom's base toward the front of the set, not to the side. From the side it is difficult to judge the microphone's height in relation to the cameras because

12-24 Two performers on the same plane. The easiest way to boom-mic them is to place the microphone equidistant between them and swivel it back and forth.

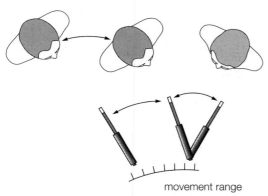

movement range

12-25 Two performers on the same plane but with some movement. One boom mic can be used when there is some movement between performers on the same plane and the distances between them are not wide.

cameras are usually placed in an arc around the front of the set.

Perspective The challenge in operating a boom is to maintain aural perspective while keeping the boom mic out of the picture and the performers in the mic's pickup pattern at the same time. To create a realistic setting, sound and picture must work together; the aural and visual perspectives should match. If you see two performers talking in the same plane, you should hear them at relatively the same loudness; if you see one performer close up engaged in dialogue with another actor farther away, the performer who is closer should sound louder.

Performers in the Same Plane The easiest way to pick up performers talking in the same plane and to maintain their aural relationship is to position the microphone equidistant between them and close enough so they are on-mic (see 12-24). If one performer walks a short distance away, blocking will have determined either how far the boom can follow, keeping the performer on-mic yet remaining close enough to get back in time to cover the other performer, or whether a second boom should be used (see 12-25 and 12-26).

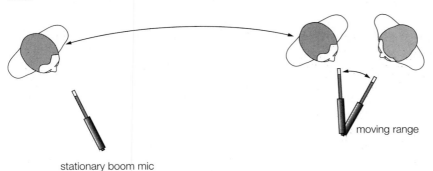

stationary boom mic

moving range

12-26 Two performers on the same plane but with significant movement. Two boom mics may be needed when blocking calls for more dynamic movement, as it often does.

Performers in Different Planes During a scene it is typical for shots to change from, say, a medium shot of a group with performer 1 talking, to a close-up of performer 1, to a close-up of performer 2 responding, to another medium shot of the group, to a close-up of performer 3 talking, and so on. To keep visual and aural perspective consistent, the sound in the medium shot should not be quite so loud as the sound in the close-up.

As we have suggested, in a medium shot compared with a close-up, for example, the boom has to be higher and therefore farther from the actors. In a long shot compared with a medium shot, the mic has to be higher and farther still. The aural difference in the mic-to-source distance, reflected by the acoustic change in the loudness level and the ratio of direct to indirect waves, will match the visual difference in the audience-to-source distance.

Regardless of the visual perspective, the audience must hear the performers clearly. Someone close up should sound more present than someone farther away, but only to a certain extent. A performer in a close-up shot should not sound "on top of the audience," and the audience should not have to strain to hear a performer in a long shot. The mic also has to be close enough to a performer so that it does not pick up too much ambience. You have to "cheat" a bit with mic placement to reduce the unwanted reflections so that the difference in loudness levels is obvious but not disconcerting.

Suppose a scene calls for two performers to talk several feet apart. First, the distance between them has to be within the microphone's range. Second, the mic should be between them but closer to the performer in the foreground (see 12-27). Third, if further changes in the loudness level are necessary, the range of the boom arm should be in-

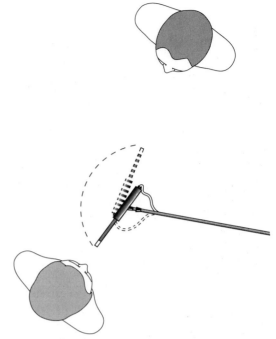

12-27 Two performers on different planes and close enough to be covered by one boom. The microphone should be placed between the performers, but mic-to-source distance should reflect viewer-to-source distance. In other words, the person who looks closer should be louder.

creased to get the mic closer or the performers' positions should be changed. If the performers are too far apart to cover with one boom, use two (see 12-28). Remember, within the same scene and locale, differences in levels of loudness should be apparent but not marked. Do not worry about the slight discrepancies between the visual and aural perspectives. If the audio sounds realistic enough, the psychological effect of the picture's perspective should make up for the difference between the two.

Adjusting Microphone Levels at the Console
Another way to change the aural perspective

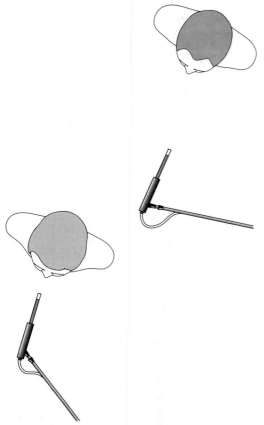

12-28 **Two performers on different planes and too far apart to be covered by one boom.** Two booms should be used. To some extent, mic-to-source distance should complement camera-to-source distance.

is to use the fader; increasing loudness brings sound closer, and decreasing it moves sound farther away. Unless loudness changes are minor, this technique is not recommended. Using the fader to make level adjustments that are obvious not only affects loudness but changes ambient relationships as well.

Background Noise and Acoustics in Dialogue Recording Background noise is an ever-

present annoyance in dialogue recording. Fortunately, there are a number of ways to deal with it.

One method involves using highly directional microphones with good off-axis rejection. Many capacitor mics have high output, so it may be unnecessary to increase their levels appreciably during quiet passages, thereby avoiding a boost in background noise. The output of moving-coil microphones is sometimes too low to pick up quiet levels without noise. Moreover, capacitor mics do not have to be brought as close to a sound source, and so you avoid the dangers of popping and sibilance and avoid getting the microphone in the picture.

Equalization also helps. By rolling off the low frequencies, air conditioning noise and rumbling sounds are reduced. (Some directors have the air conditioning turned off during shooting.) Cutting the high frequencies reduces hiss. With dialogue it is possible to use a relatively narrow frequency range because the vocal frequency is not wide.

Putting gentle compression on a voice raises the quieter levels above the noise floor. Using a noise gate can also reduce ambient noise level, but be careful that its action is not perceptible. A de-esser or relief stressor eliminates sibilance. It is also important to use whatever miking technique or signal processing is necessary to reduce rumble, AC hum, buzz, and hiss.

Whatever other means you employ to increase sonic fidelity, the importance of using noise reduction cannot be overemphasized. A noise reducer should be part of the audio signal chain during each stage of production and postproduction.

A main source of acoustic noise is the sets. Art directors can eliminate many potential noise problems by following a few principles of acoustic design. Construct sets whose

walls are not parallel, use absorptive materials (including sound-absorptive paint), and build flooring so it does not squeak — unless you want this effect.

Directors can also help reduce ambient noise by not blocking action near a flat surface or, worse, a corner. Regardless of how good the microphone and how effective the sound-absorptive materials, it is difficult to avoid signal degradation when sound bounces from walls and corners into a mic at close range. Too much sound absorption is not good either. Heavy carpeting on a set, for example, could dull sound.

Using the Wireless Microphone System

Obviously, using the wireless microphone system does not preclude using the boom, and vice versa. In fact, wireless mics are used on booms (see 15-42).

Before using a wireless microphone system, you should consider a few operational and performance criteria, including frequency assignment, transmission dropout, companding, transmission range, transmitter and antenna, sound quality, and power supply.

Frequency Assignment and Usage Wireless systems are regulated by the Federal Communications Commission (FCC), which assigns frequencies available for wireless operation. The frequency bands used in professional audio are Very High Frequency (VHF) — 150 to 216 megahertz (mHz) — and Ultra High Frequency (UHF) — 400 to 470 mHz and 900 to 950 mHz. The VHF frequencies between 150 and 172 mHz are also used by TV channels 7 through 13. They are the best available for high-quality wireless microphone system operation and are the

most commonly used by professionals. Wireless systems capable of selecting one of several frequencies for use are called *variable frequency* or *tunable* systems.

Clearly, one problem with a wireless system in this VHF range is the potential for interference from using a frequency that a TV station in the area is already assigned to. It is unlikely, however, that even large metropolitan areas have TV stations using every channel between 7 and 13. New York City, for example, does not have a TV station on Channels 8, 10, and 12. But you may require more than three frequencies for a production or you may use a wireless system in different locations.

To help provide an ample number of frequencies for these needs that are not as prone to TV station interference, there are wireless systems that operate between 150 and 171 mHz, below Channel 7. These so-called "traveling frequencies" are not vacant, however. In some coastal areas, navigation buoys and hydroelectric equipment broadcast control signals on some of these frequencies. It is always wise to check on already-allocated frequencies in a given area before you buy or use a wireless system there.

UHF wireless systems are another way to provide an ample number of frequencies for wireless system use. Generally, though, they are more expensive than VHF units and they do have some sensitivity in situations where a VHF system would function without problems.

Fixed frequency wireless systems are also available. They are less expensive than variable systems and serve just as well when they are used in one location where there are no interfering signals from other transmissions.

Low-cost wireless systems are available in the 41 to 49 mHz range but they are not recommended for professional use. They are

subject to interference from radio controlled toys, cordless telephones, and other consumer products that transmit on those frequencies.

Transmission Dropout A wireless microphone system transmits radio waves from a transmitter, through the air, to a receiver. There is the danger, therefore, that the radio waves will encounter obstructions on the way to the receiver, resulting in a **dropout** or null in the transmission. A **diversity receiver** solves the dropout problem. A diversity receiver uses two or more antennas in reception. The antennas are mounted at least a foot or more from each other. The independently received signals are uncorrelated and statistically different. "Smart" circuitry selects the stronger signal at any given moment for processing and rejects or cancels the weaker signals, thereby avoiding dropout.

Generally, diversity reception is available in three designs: *true diversity*; *phase* or *space diversity*; and *antenna diversity*. Because none of the other diversity schemes works as well as true diversity and it is the one preferred by professionals, it serves no purpose to discuss the other systems (except to say that manufacturers continue to offer them because they are less expensive).

When a wireless system is used in a controlled environment, such as a studio, where dropout is often not a problem, a **nondiversity receiver** can be used. Nondiversity systems have a single antenna mounted on the back of the receiver. They are, generally, less expensive than true diversity systems.

It is always wise to check equipment operation before you use it. It is frustrating and expensive to hold up production due to a preventable technical problem.

To make sure your diversity wireless system is operating correctly, switch the system to nondiversity reception. Using one of the two channels (A or B), walk at least 100 feet from the receiver (200 feet, if possible), speaking into the microphone as you go. Mark the places where you hear buzzing and dropout. Then switch the receiver to diversity reception and repeat your first walk.

If the diversity reception is working, the buzzing and dropout you heard on the first walk should disappear. If they do not or if new sonic anomalies occur, or if the diversity switching is audible, then the system is not working effectively.

Companding Because even the best wireless systems are subject to noise inherent in the transmission system, it is necessary to compand the signal — compress it during transmission and expand it when received. For high-quality audio, it is important that the companding circuitry in a wireless system be sophisticated. Such a system is more expensive but the alternative in less sophisticated compander circuits is noise, coloration, and the audible pumping sound caused by compander mistracking.

Transmission Range Because the FCC limits the output power of wireless systems, transmission range for high-quality systems is virtually the same: about 250 feet effective in mediocre conditions up to 1,500 feet effective in optimum conditions. In most controlled studio environments, 150 feet is sufficient operating distance.

Inexpensive wireless systems are 100-feet effective. In optimum conditions, their range can increase up to 250 feet.

Transmitter and Antenna Two other factors affecting transmission and sound quality are how the transmitter and antenna are mounted and positioned. When a wireless microphone is attached to a person's body,

the transmitter usually is as well. Unless the transmitter is protected from perspiration, energy from the transmitter will go to ground instead of being radiated, thus reducing signal power. UHF wireless systems are particularly vulnerable to perspiration. Of course, perspiration is not a problem when a transmitter is positioned away from the body, as it is with hand-held and boom-mounted wireless mics.

The antenna should be fully extended and several feet from any obstruction, including the floor. (The higher the wireless system's frequency, the shorter the antenna.) Avoid taping the antenna to the skin or perspiration will inhibit signal transmission. The antenna should be kept straight up and down for maximum sensitivity and omnidirectional pickup; signal pickup is minimal off the end of the antenna.

Sound Quality A wireless microphone system that satisfies all production needs does not exist. Because wireless systems are expensive, and because they vary considerably in quality, it is wise to know your production requirements and to experiment with a system, in and out of doors, before you make a purchase. Obviously, the better the system, the fewer the problems. In selecting a wireless mic, consider the following points:

- Frequency response can vary widely, from 100 to 12,000 Hz to 20 to 20,000 Hz. Naturally, if a system is used for voice only, it does not require the wide frequency response that a system used for some sound effects and music does.

- Dynamic range can also vary. Some systems may provide a dynamic range of only 65 dB or 70 dB and, therefore, mediocre signal-to-noise ratio. Good systems are now capable of dynamic ranges up to 115 dB. Systems with poorer dynamic ranges need more compression at the transmitter and more expansion at the receiver creating an annoying squeezed sound that results from companding loud levels.

- Microphone output levels differ; capacitor mics generally have higher output levels than dynamic mics, and some capacitors have higher outputs than others. Better wireless systems have high-gain, low-gain, and variable trim controls on the transmitter to help control these differences.

Power Supply Battery lifetime varies widely. The better systems will operate up to 8 continuous hours on a new 9-volt alkaline battery. Some newer systems use AA batteries. Regardless of the voltage a system requires, only the best alkaline batteries should be installed. To reduce power supply problems, batteries should be replaced before they have a chance to run down. It simply is not worth holding up an entire production to save a few cents trying to squeeze maximum life out of a battery, especially if holding up production also means having to disarrange a performer's clothing to get at the transmitter. Fresh batteries should be installed at the start of a production day, replaced during the lunch break, and, if production runs late, replaced again during the dinner break. (For more information on using wireless mics, see "Wireless Microphone Systems" in Chapter 15.)

Applying the Wireless Microphones

Over the years the wireless microphone has evolved from a novelty that sometimes worked into a reliable and indispensable production tool. And, as is usually the case with production tools, wireless mics are most effective only when properly used. This means you must consider such things as aural per-

spective, microphone placement, number of mics, and sound levels.

Aural Perspective A wireless microphone can be used like any conventional microphone: attached to the body, hand-held, or on a boom. In drama it is most often attached to the body. Therefore, aural perspective is close, detailed, and uniform. (Wireless microphones may be hand-held in situations involving M.C.s, interviewers, and singers, or used on a boom.)

The main sonic difference between a body-mounted wireless mic and a boom mic is in creating aural perspective. As noted earlier in the chapter, with a boom, mic-to-source distance must be adjusted with the shot, thereby automatically matching aural-visual perspective (at least in theory). When a wireless mic is attached to the body, mic-to-source distance is close and never varies, regardless of the focal length of the shot, which means aural perspective must be adjusted in postproduction.

Placement When a wireless microphone is body-mounted, small, lavalier-type mics are used. If it does not matter that the mic is visible, it can be attached to clothing and positioned like any lavalier — hooked to a tie, shirt, lapel, or dress in the area of the sternum. Sometimes, the mic may be attached to the collar. Be aware of proximity effect, however — the closer most microphones are placed to the mouth, the bassier the frequency response becomes. The optimum position is 6–8 inches from the chin.

As for less obtrusive microphones, some models are smaller than a dime and some are available in black, which is easier to conceal than shiny metal.

If the microphone must be hidden, as it has to be in drama, then the type of fabric and clothing become important factors in deciding what mic to use and where to place it. For this reason a sound designer should make it a point to consult with the person responsible for wardrobe before miking. Remember, cotton does not make as much rustling sound as do synthetic fabrics such as polyester, rayon, nylon, and dacron. Synthetic fabrics are also more likely to build static electricity, which creates interference, than are wool, suede, cotton, and leather. Leather does, however, make noise.

The type of clothing performers wear is also important. A microphone can be hidden inside a tie, in the seam of a shirt or blouse, in a pocket, in the collar of a jacket or turtleneck sweater, behind a scarf, under a bodice, and so on. Certain mics are less susceptible to interference from rustling, jostling, static electricity, and so on than are others; you have to test to determine which are which. Obviously, a microphone with a built-in pop filter and shock absorber is better than a mic without one or both. Tying a knot in the microphone cable underneath the head of the mic can sometimes, but not always, reduce or eliminate clothing noise.

Clothing style also has something to do with where you hide a microphone — costumes from different periods and cultures pose different challenges. Hiding a mic on a performer playing an 18th-century Austrian prince clothed from neck to ankle in tight-fitting raiment presents one type of problem; hiding a mic on a performer playing Jane (in *Tarzan*) wearing halter and loincloth presents another. Here, again, the person handling wardrobe can help. Maybe a pocket for the microphone can be sewn underneath the prince's vest; the material used for the halter straps can be tubelike so the mic can be placed inside the strap, or of sufficient flatness so the mic can be hidden underneath the strap. It is, of course, easier to hide a microphone in loose-fitting clothes than it is to

hide one in tight-fitting clothes. Loose-fitting garments also reduce the chance of picking up rustling sounds.

If it can be done, the best thing is to get the microphone in the open as much as possible. Try to mount it in the shadow area of a coat lapel, or sew it to the material, or stick it through material to look like a button, tie clasp, or decorator pin.

This raises the question of what to do when the costume, such as a bathing suit on a male lifeguard or chain mail on a knight, makes it difficult to hide a mic. In the case of the lifeguard, cooperation may be needed from the hairdresser. With skill, a wireless microphone can be hidden in the hair; sound does rise and the body does resonate. The chain mail, however, may be too noisy for any successful body miking, in which case either a more conventional approach has to be taken or the dialogue must be rerecorded in postproduction. The point is that, because wireless body mics are not always appropriate, you must maintain flexibility in your approach.

Still another reason for working with wardrobe in preproduction is to arrange with the costumer when to mount the wireless microphone on the performer. The best time is usually when the performer is dressing at the start of the production day, even if the microphone will not be needed right away. By mounting the mic before production starts, the performer has more time to get used to it, and shooting does not have to be interrupted to mount the mic when it is needed. Moreover, a performer has a great deal to think about; disrupting concentration to body-mount a microphone is unwise.

Using Two or More Wireless Microphones When two or more wireless microphone systems are used in the same immediate area, they must be on different frequencies to avoid interference. The wireless systems and microphones should be of similar make and model to ensure sonic uniformity. If this is not possible, and only different systems and mics are available, then each performer should be given the same make and model to use throughout production so at least the individual's sound is consistent.

An ever-present problem with body mics is noise, not only from fabric but from jewelry and props in a pocket that may jingle or rustle, such as coins, keys, or paper. For example, suppose two (or more) performers using wireless mics are exchanging dialogue at relatively close proximity. Performer A is jangling coins and the sound is interfering with the pickup of his dialogue. Assuming the pocket containing the coins is closer to the body mic than it is to his mouth, performer A's dialogue probably is also being picked up in performer B's mic, but with the sound of the coins not as loud. Therefore, in postproduction the recording from performer B's microphone can be used in place of the recording from performer A's mic. This enables continued use of the wireless systems, which may be desirable for logistical or other reasons. This technique also helps solve problems of unwanted or unintelligible overlapping dialogue.

Controlling Levels A frequent problem in recording dialogue is trying to maintain suitable levels when performers are speaking at different and varying loudnesses. If sound is too loud, level is "in the red"; if sound is too quiet, level is "in the mud." Controlling levels both to avoid distortion and to keep sound above the noise floor, yet still preserve the relative dynamics of the performers, is handled in different ways, depending on the miking.

Suppose that in a scene a distraught man is alternately shouting and sobbing at a woman

who is responding in a quiet, controlled voice trying to calm him. In such a scene the level changes would be wide and acute and difficult to ride. Putting a limiter on the sound is not always preferred or recommended because it can reduce sound quality. Nor may it be possible through blocking to place the microphones properly to compensate for the widely fluctuating levels. And it is imprudent to depend completely upon postproduction to fix problems that occur in sound recording during production. By then, the sound may be beyond repair because either it is distorted or the signal-to-noise ratio is unacceptable, or both. Thus, to handle the widely varying sound levels, either boom mics or wireless mics may be employed.

When using the boom, most recordists in a situation like this set the level on the loudest sound emitted, in this case on the man's shouts. If the shouts are set, say, at zero level (100 percent of modulation), it ensures that, at worst, the peaks will only momentarily get into the red. This makes riding levels less critical in situations where the dynamic range is wide and changes quickly, and it keeps both dialogue and ambience in perspective.

Concerning perspective, by setting a maximum loudness level, the woman's level will be quite a bit lower than the man's because she has a less powerful voice and is speaking quietly. Increasing her loudness level during the quiet passages, however, will also increase her ambience disproportionately to the man's. This creates different background noise levels between the two performers and different spatial relationships as well. If quieter levels are at or below the noise floor, slight adjustments in microphone selection or placement, performer placement, or voice projection can be made, or compression can be used. (Another alternative to using the boom is to shoot and mike the scene entirely from the woman's perspective.)

With the wireless microphone, handling the scene is somewhat easier. Because each performer is individually miked, levels can be set and controlled separately. If in the scene the woman also has to shout at the man, perhaps to admonish him to stop feeling sorry for himself, another option is to put two wireless mics on each performer. Levels for one pair of mics would be set for the louder dialogue, and levels for the other pair set for the quieter dialogue. The production mixer then has four faders to worry about, but overall sound quality probably will be better, and the editor will have more to work with in postproduction.

Using Multiple Miking with Different Microphone Mounts

Miking speech for dramatic material, as we have indicated, might involve either the boom or wireless body mic, or both. On the other hand it might require a combination of various types of microphone mounts. A few general approaches are considered here and some are also discussed in Chapter 15, "On-Location Recording and Production."

In single-camera production, for example, a master shot and then various perspectives of the shot are recorded in separate takes. A *master shot* is a single shot of an entire scene from a far-enough distance to cover all the action. Suppose the scene is a party in a large living room, where host and hostess are mingling with guests and exchanging pleasantries. The master shot would be a wide shot of the room and party taking in all the action. Other takes might consist of a group shot with host, hostess, and a few guests, and three-, two-, and one-shots of the host and hostess in a selected exchange with one person in the group.

To take advantage of all the sonic possibilities, sound can be recorded during each

take. By audio recording as many takes as possible, the various sonic qualities and perspectives provide the editor with more options in cutting sound and picture. For example, the master shot could be miked from overhead using boundary mics with hemispheric pickup to capture the overall hubbub. Directional overhead mics could be added for more selective, but still open, pickup of particular interactions between host and hostess and certain guests or groups of guests. Wireless mics attached to host and hostess would record their dialogue for close-ups shot later. In the group shot a boom with an omnidirectional or wide-angle pattern could be used for the overall pickup to provide a more open sonic perspective than that provided by the directional overhead mics. For the tighter three-, two-, and one-shots, body-mounted wireless mics provide the sonic complement to these closer cutaway shots. Also, if a multitrack tape recorder is available, there is no reason not to continue using the overhead mics for each take to provide additional recordings of the overall party sounds.

The point is that in single-camera production, shooting each scene several times to record as many different visual perspectives as possible is part and parcel of the technique. Each shot often requires time to reposition the camera, change the lighting, refluff the performers' clothes, recomb hair, and retouch makeup. If such pains are taken for the picture, similar time and attention should be given to the sound so that the audio recorded also has as many different perspectives as possible. Enlightened directors do this; the problem is that, even today, too many directors still give sound short shrift, to the detriment of the finished product.

By the standards of most multicamera production for television, the length of each continuous shot recorded in single-camera production is often relatively short. Long takes are uncommon because when performer and camera movement change appreciably, it is often also necessary to reposition performers, crew, and equipment. But long takes are done from time to time.

Suppose a director wants to do a continuous take of a scene in which the action is far-flung. An example would be a restaurant setting where two principals meet at the bar, agree to have dinner, walk to their table, and are serenaded by a waiter who moves to the stage, while singing, to introduce the floor show. The challenges here are (1) to hear the dialogue of the principals clearly, (2) to maintain the ambience of the surroundings, (3) to hear the singing waiter within the context of the ambience, (4) to continue his sound to the stage, and (5) to hear the floor show. One approach is displayed in 12-29.

Recording Speech

Recording a good speech sound begins with good acoustics. This statement may seem obvious, but in fact, favorable acoustics are more important to speech than to singing. For one thing, the spectral density and energy generated by the singing voice can somewhat overcome mediocre acoustics. Moreover, other tracks recorded with better acoustics can mask a less than acoustically acceptable vocal track, to say nothing of the "distraction" of a good lyric or performance, or both.

But mediocre acoustics make speech sound boxy, oppressive, lifeless, ringy, hollow, or honky—qualities difficult to mask because a speaking voice, unlike a singing voice, usually is not accompanied by other sonic elements during recording. Even when other sound sources do accompany speech, their acoustics are often different.

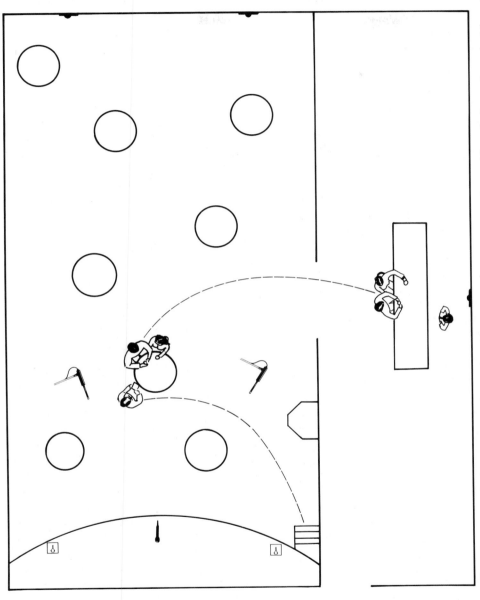

12-29 One approach to a long, continuous take. A boundary mic mounted above the set picks up background sounds at the bar. The two principals are miked with wireless lavaliers to pick up their conversation at the bar and while walking to and sitting at the table. Directional microphones mounted above the dining room set pick up crowd sound, with boundary mics used for blending. The singing waiter uses a wireless lavalier, and boundary mics are used for the stage sound pickup. A mic mounted on a floor stand is on stage for visual purposes when the singing waiter reaches the stage and becomes the M.C.

For example, when an announcer reads a commercial accompanied by recorded music or sounds, the music and sounds usually have ambient qualities different from each other and from the announcer as well. A narration for a documentary is often accompanied by a variety of voices, sounds, music, or all three, each with a different background sound.

Not only are good acoustics important to recording speech, but the acoustics must be neutral as well; that is, they must be free from perceptible ambience and not suggest any environment or locale, unless the performer is supposed to be on location. Furthermore, keeping ambience on the announce track to a minimum helps reduce the building of background noise when it is mixed with other tracks of sonic information.

Narration

Keeping the acoustics neutral does not mean, however, that speech should be recorded devoid of ambience. Under even optimal conditions, room presence is part and parcel of the recording. In fact, adding just a bit of high-quality artificial reverberation to narration increases apparent loudness and energy without distracting from the narration. This is especially effective in dramatic narration.

Slightly compressing narration tightens sound, giving it more punch and attack. Used properly, compression can also help reduce noise. Compression and limiting can help prevent distortion and peaking in the red.

As for the procedure in recording narration, typically it is taped, edited, and then added to the other program elements. Usually, a script does not call for a narrator to speak continuously but to take pauses to allow for other types of aural and visual information. In editing narration, therefore, the natural tendency is to splice in blank, unused magnetic tape or leader tape where the narrator is not speaking or to stop or fade out

the narrator's track during mixing. These techniques cause ambience changes in the narrator's track, however. The changes are often subtle, but they are perceptible as differences in the openness and closeness of the aural space. Even if the narrator is recorded in a quiet studio, the change could be noticeable.

In taping narration (or drama), take time to record the ambience separately; after the narrator finishes recording, "over-roll" the tape—keep it spooling for a while. Then in the editing you can maintain a consistent background sound by splicing in the recorded ambience during the pauses in the narration.

Dialogue

Dialogue is recorded in two ways. It is either taped during production and processed from the original recording in postproduction, or it is rerecorded after production in a special facility known as a **dialogue rerecording** (or **looping**) **studio** (see Chapter 4). (Although dialogue rerecording, or dialogue looping as it is commonly called, is technically a postproduction function, it makes sense to discuss it here.)

It is easier to tape dialogue in the controlled acoustic environment of a recording studio than it is during shooting, either on an in-studio set or on location. Aside from the obvious advantage of expedience, few television studios and sound stages are acoustically quiet. In fact, even under relatively good acoustic conditions, these studios add a perceptible ambience to dialogue. There also may be other sounds that are part of a scene, in addition to the dialogue, such as footsteps echoing, glasses clinking, chairs scraping, matches being struck, and so on. Keeping these sounds and the dialogue in proper perspective is certainly feasible, but it is a challenge. Moreover, if all the sonic action is recorded on one

track, it is difficult to change one sound without affecting the other sounds as well.

Automated Dialogue Replacement

Many directors believe that ambience and leakage from other sounds that are part of the action are natural to the sonic environment, just as shadow is a natural part of light. Therefore, they prefer to use the dialogue and other sounds recorded during production, assuming that pickup is tight enough so that intelligibility and balance are acceptable. Other directors prefer dialogue recorded with a minimum of ambience and absolutely no leakage from other sounds. They want to control separately the ambience and each sonic element—dialogue, music, and effects—in postproduction. In this case dialogue is rerecorded in a dialogue recording studio where reverb time is .2–.3 second, just short of oppressive. This procedure is called rerecording, or **automated** (sometimes called *automatic*) **dialogue replacement** (**ADR**), because dialogue is almost always taped during production to use at least as a reference for syncing and dramatic interpretation during looping. This process generally involves putting the dialogue sequences into short loops so they can be repeated again and again without interruption. The loops are projected from a sound-proof projection room into the studio, where performers, wearing headphones, stand before a microphone or microphones and synchronize their dialogue to their lip movements on the screen. Each short section is rehearsed until it is in sync with the picture and then recorded. This procedure is repeated until all the dialogue being redone has been recorded on magnetic film, audiotape, or disk.

ADR, in particular, is computer-controlled rerecording. The computer is programmed to play the picture and its accompanying dialogue track, between two specified footages,

as often as necessary. When locked to a videotape recorder that has been programmed to repeat, or loop, between the time-coded specified footages, it becomes possible to sync to and record on the VTR. Using a hard disk also makes it possible to review dialogue takes quickly and edit the best parts of each into a single performance.

Ambience, music, and sound effects are handled separately. Ambience is mixed on the dialogue track and subsequently combined with the music and effects tracks in the last stage of postproduction, the rerecording mix (see Chapter 17).

Dialogue Rerecording: Pros and Cons

Dialogue rerecording has freed picture from sound and given the director more flexibility and control. When there is a choice between using the original dialogue or rerecording it, directors and sound designers disagree about looping's benefits. (Sometimes, dialogue must be rerecorded due to noise or logistical problems that prevent getting an acceptable sound take.) The question becomes, Is the added sonic control and assurance of first-rate audio quality worth the loss of spontaneity and the unexpected?

On the one hand, regardless of the subject and style of the material, art is artificial, so there is no reason not to use whatever means necessary to produce the most polished, well-crafted product possible. Every sonic detail must be produced with the same care and precision as every visual detail. Anything less than excellent sound (and picture) quality will reduce the effect of the illusion.

On the other hand, quality of performance is more important than quality of sound; "natural" is more realistic and, hence, more effective. Because performers, as a rule, do not like to re-create their performance in a rerecording studio, dialogue looping is rarely as good as the original performance

recording. Even though lines sound different as a shooting day goes on because the performer's voice changes, the difference between a production line and a looped line is always much greater than the difference between two production lines. (See also "Production Recording" in Chapter 15.)

Production Recording

The responsibility of the production recordist is to tape dialogue and whatever other sounds are required during shooting, regardless of whether the material is to be re-recorded in postproduction. Production recording is extremely important because it preserves the sonic record of the production. Many things happen in life that are difficult to remember, much less re-create — the precise rhythmic nuance of dialogue; the unplanned cough or sputter that furnished a perfect dramatic highlight; the train that happened to go by at exactly the right moment. The live situation is more real and more delicate than the re-created one.

Multitrack Production Recording

It is likely that more than one microphone will be used during production recording. Using the single-camera approach, a scene is recorded a few different times from various perspectives so the principal performer in each take can be taped separately. Multitrack tape recorders are available, of course, should a number of mics have to be recorded at the same time. The problem with doing this in production recording, however, is that if the recordist is monitoring through headphones directly from the tape recorder, only one track at a time can be monitored for discrete control. Therefore, it is difficult to tell if all tracks have been successfully recorded.

Split-Track Production Recording

Split-track recording can help remedy this somewhat. In **split-track recording**, a stereo tape recorder is used as a two-track ATR. Instead of recording a stereo signal, two separate signals are fed, one to each track, thus enabling two performers using separate microphones to have their dialogue recorded on separate tracks. Because one track is fed to each ear of the stereo headphones, the tracks can be more discretely controlled.

Stereo Sound for Picture

Stereophonic sound consists of correlated information, usually between two or more channels, designed to be heard over two or more loudspeakers. It gives the illusion of depth, breadth, and realism to a sonic image. Basically, stereo can be reproduced in two ways: discrete or synthesized. **Discrete stereo**, or *real stereo*, consists of two distinct signals that reproduce sound-source localization, depth, and spaciousness. **Synthesized stereo**, also called *pseudo-stereo*, takes a monophonic signal and processes it in a way that approximates the depth and spaciousness of discrete stereo but does not reproduce the sound-source localization or the realism of discrete stereo (see 12-30). Because most stereo in television and all stereo in film is discrete, the emphasis in the following discussion is on discrete stereo.

The aesthetic demands of television and film differ, not only because of the obvious dissimilarity between the videotape and film media, but also because of the differences between their screen sizes and, hence, sonic and pictorial dimensions. Clearly, film has more space in which to place and maneuver the aural and visual elements than does television. Nevertheless, when it comes to sound, the **localization** — placement — of dialogue,

12-30 Automatic stereo synthesizer. This model is designed to be placed permanently in the program line and can be activated for automatic recognition of a single-channel or two-channel mono signal. The pseudo-stereo effect is created by dividing the audio spectrum into several frequency bands, then directing these bands alternately to the left and right channels. This is done by passing a mono signal through a chain of phase shifters to generate an artificial L minus R signal, which is then added to the mono to obtain the synthesized left channel and subtracted from the mono to obtain the synthesized right channel.

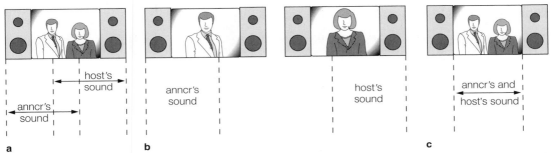

a b c

12-31 Speech localization in a two-shot. (*a*) In this example, as long as the announcer and host remain positioned left and right in a medium shot (MS) and the shot does not change, their sounds can be panned toward the left and right, respectively, with no dislocation. (*b*) If the shot changes, say, to a medium close-up (MCU) shot of the announcer, followed by an MCU of the host, and the stereo imaging remains the same, it will create a Ping Pong effect. (*c*) If one-shots of the announcer and host are planned, then the sound in the original two-shot should be centered for both of them and carried through that way throughout the sequence. To pan the sound with the shot changes is even more sonically awkward than the Ping Pong effect.

sound effects, and music in the stereo frame is similar in both media. (Localization of music is discussed in Chapter 14, "Producing Music," and, along with sound effects, in Chapter 17, "Mixing and Rerecording.")

Localization of Talk and Dialogue

In television and film, talk and dialogue are usually kept at or near the center of the stereo frame. Unless the shot remains the same, trying to match a performer's sonic location to that person's on-screen position can disorient the audience.

For example, in a variety show, if a wide shot shows (from the viewer's perspective) the host center, the announcer left, and the band leader and band right, and the shot doesn't change, then the audio can come

from these locations in the stereo space. If the host and announcer exchange remarks, and the shot cuts to show the host to the right and the announcer to the left in a two-shot, and the shot stays that way, then the host's sound can be panned toward the right and the announcer's sound can be panned toward the left. If during their interchange, however, the shots cut back and forth between one-shots of the host and announcer, the left and right stereo imaging becomes disconcerting because the image of either the host or the announcer is in the center of the frame but the sound is toward the left or right. Therefore, when frequent shot changes occur, the best approach is to keep the overall speech toward or at the center. This is particularly so for a small-screen medium like television (see 12-31).

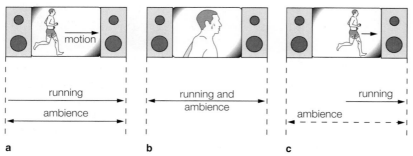

a b c

12-32 Sound localization in a moving shot. (*a*) If a subject is, say, running across screen from left to right and the shot does not change, the stereo imaging can also move from left to right without dislocation. (*b*) Should the shot cut to a close-up to show perspiration on the runner's face, in which case the across-screen movement would be reflected in the moving background, the subject's sound would have to be centered. If the sound continued moving left to right in the CU, the difference between the visual and aural perspectives would be disorienting. (*c*) Cutting from the CU back to the wide shot, the sound once again can move across screen with the runner without disorientation because the perspectives match. However, if throughout the runner's movement across screen there were a few cuts from the wide shot to the CU, the sound in the wide shots would have to be more centered to avoid Ping Ponging.

Film's larger screen size allows somewhat greater flexibility in positioning stereo dialogue, but not that much more when frequent shot changes position the actors at different camera-to-source distances. Even with the very wide screen 70mm film, stereo dislocation can occur.

When a performer is moving in a shot, say, from left to right, and the camera-to-source distance remains the same, the stereo image can be panned to follow the performer's movement without audience disorientation. If, however, the performer's camera-to-source distance changes due to cutting from wider shots to closer shots, or vice versa, or intercutting another actor into the frame, then, even though the first performer's momentum is clearly left to right, dialogue has to be centered to avoid dislocation (see 12-32).

Stereo Miking Dialogue

The microphone arrangement most commonly used in stereo miking dialogue is the coincident array. The two coincident config-

urations most often employed are: M-S (middle-side) and X-Y. M-S has a number of appealing advantages:

- It has the physical advantage of a single mic assembly, with the middle (directional) and side (bidirectional) capsules already in place.

- The stereo spread can be remote controlled, whereas unless an X-Y array is being controlled through a matrix, you must physically move the microphones.

- M-S can reproduce the main cardioid signal of, say, an M.C. or a sports announcer in the center of the stereo image and the audience or crowd sound surrounding the performer, as if the listener were in the studio or the stands. This spaciousness is also effective in M-S recording of sound effects.

- Unlike X-Y stereo, the main sound does not come in off-axis to the microphones. Most microphones add false coloration to off-axis sound, reducing fidelity.

- If a phase reversal occurred in M-S miking, the stereo effect would be lost but not the signal; the signal would be lost in a phase reversal with X-Y miking.

- Using M-S allows more postproduction flexibility than does X-Y miking in avoiding dislocation of the sound–picture relationship. For example, when a shot zooms in from a two-shot to a close-up or pans from left to right, with an M-S recording the left channel can be edged toward the mono position leaving the full stereo spread on the right. Stereo ambience is maintained but dislocation is avoided.

On the other hand, some sound designers feel that M-S does not yield as strong a stereo image as the X-Y array, a concern that may be more critical in film than it is in TV. Even when M-S stereo is satisfactory, it may not be worth the effort because the audio phase match on many videotape recorders in current use is insufficient to reproduce faithfully the original stereo signal. Furthermore, the M-S signals require matrixing, which means another device to worry about.

This is not to suggest that using one miking technique mutually excludes using another. M-S and X-Y can be used at the same time, perhaps M-S for host and audience and dialogue, and X-Y for added sonic fill. In fact, as long as any combination of microphones and placements meets a production need, it is appropriate. Well, almost. If a stereo recording is also being reproduced in mono, the miking/mixing concern of stereo-to-mono compatibility becomes a factor that influences microphone usage.

Stereo to Mono Compatibility

Most viewers will be listening to TV on monophonic receivers for at least the next decade, so that anything produced for TV in stereo must also be mono-compatible.

Not too long ago an opera recorded for TV and FM stereo simulcast was mixed and monitored in stereo only. When it came time to record the announcer, he too was mixed and monitored in stereo only. When the opera was telecast, viewers listening either to TV stereo or FM stereo heard music and announcer in proper perspective with no problem. Those listening in mono, however, heard only the music; the announcer was out of phase and, when played in mono, was sonically canceled.

The problem is that in mono, in-phase signals add, while out-of-phase signals cancel. Unless phase relationships in stereo are mono-compatible, additions can increase level as much as 6 dB, and cancellations can be nearly total.

Both the M-S and coincident X-Y techniques are mono-compatible, but M-S is mono-identical, because the side-facing mic gets canceled. Therefore, sound coming from the sides that was heard in stereo is not there in mono. In M-S the mic takes care of stereo-to-mono compatibility, although the aesthetic result may not always be completely acceptable.

In X-Y miking, however, stereo-to-mono compatibility is not automatic. If the angle between the microphones is too wide in relation to the sound source, if the array is not placed at a proper distance from the sound source, or if acoustics are poor, then all or part of the stereo information these mics pick up may be derived from perceptible differences in arrival time and the sound will not be fully mono-compatible.

Stereo-to-mono compatibility is less of a problem in recording one or a few speakers than it is in recording music and in mixing. With a speaker, mic-to-source distance is usually not wide and, therefore, not as critical acoustically. An announcer, host, guest, and the like usually do not emit very loud levels when speaking, so fewer reflections are

generated. Therefore, fewer sound waves are being picked up, reducing the potential for time differences between them. Because stereo-to-mono compatibility is somewhat more complex in music recording and in mixing, it will be considered further in Chapters 14 and 17.

Mono Miking Dialogue for Stereo

Some directors, knowing in advance that dialogue will be completely centered in the stereo frame, do not bother with stereo-miking the actors and the resulting concern of stereo-to-mono compatibility. They record dialogue in mono using a single mic. To produce the stereo "feel" of spaciousness, synthesized stereo is added to the dialogue track(s) in postproduction.

Main Points

1. The frequency range of the human voice is not wide compared with that of other instruments. Due to its harmonic richness, however, its timbre changes as loudness and intensity change, particularly in the singing voice, thus making microphone selection and placement challenging.

2. Acoustical phase refers to the time relationship between two (or more) sound waves. Electrical phase refers to the relative electrical polarity of two signals in the same circuit. When these waves or polarities are in phase — roughly coincident in time — their amplitudes are additive. When these waves or polarities are out of phase — not coincident in time — their amplitudes are reduced.

3. In monaural sound aural space is one-dimensional — measured in terms of depth so perspective is near-to-far.

4. In stereo sound aural space is two-dimensional — measured in terms of depth and breadth so perspectives are near-to-far and side-to-side.

5. The closer a microphone is placed to a sound source, the closer to the audience the sound source is perceived to be, and the warmer, denser, bassier, drier, more intimate, and more detailed is the perceived sound.

6. The farther a microphone is placed from a sound source, the farther from the audience the sound source is perceived to be, and more distant, diffused, open, spacious, reverberant, and detached, and the less detailed, is the perceived sound.

7. In stereo miking, the angle or distance between the two microphones (or microphone capsules) determines side-to-side perspective. The smaller the angle or distance between the mics, the narrower the left-to-right stereo image; the larger the angle or distance, the wider the left-to-right image.

8. In selecting and positioning a mic keep excessive sound that is reflected from room surfaces, furniture, and equipment from reaching the mic or comb filtering can result.

9. In disc jockey, interview, or panel programs the participants should sound as if they are coming from the front of the aural space. With more than one participant, using one microphone, the weaker voice(s) should be closer to the mic and the stronger voice(s) farther away if all are to sound as if they are coming from the same place. If individual microphones are used, which is the preferred technique, the levels of loudness for the participants must be similar if the sound is to seem as if it is coming from the front of the aural space.

10. Using one microphone in radio drama involves having actors play to it as if it were the ear of the audience. Perspectives are created by positioning actors at and moving them relative distances nearer to or farther from the mic. When one mic is used for each actor, most perspectives are created in postproduction during the mix.

11. In stereo radio drama the coincident and near-coincident microphone techniques usually are employed. Coincident and near-coincident microphone arrays commonly use two separate directional mics (or microphone capsules). A coincident array is mounted so the mics' diaphragms occupy approximately the same space on a common vertical axis, with the mics angled apart. Near-coincident mics are angled apart symmetrically on either side of center on a horizontal plane and spaced a few inches apart. Coincident and near-coincident arrays are also called X-Y miking.

12. In recording speech, acoustics should be appropriate to the material. Otherwise, ambience must be adjusted in postproduction.

13. The techniques used to mike speech for picture in television and film (and to produce sound, in general) depend on whether the production is broadcast live, or live-on-tape, or is taped/filmed for showing at a later date.

14. In radio a microphone can be placed anywhere without regard for appearance. In television, if a mic is in the picture, it must be good-looking and positioned so that it does not obscure the performer's face. If it is not in the picture, it must be positioned close enough to the performer so the sound is on-mic.

15. Generally, for optimal sound pickup, the recommended placement for a lavalier is 6 to 8 inches below the wearer's chin.

16. Hiding a lavalier under clothing requires that the mic and mic cable be insensitive to rustling sounds and that the clothing be made of material that is less likely to make those sounds.

17. In television, a desk mic is used mainly as a prop. If the desk mic is live, make sure it does not block the talent's face, interfere with the talent's frontal working space, or pick up studio noises.

18. The hand-held mic allows the host to control audience questioning, mic-to-source distance, and, like the desk mic, helps to generate closer psychological rapport with the audience.

19. A boom, like the lavalier hidden under clothing, is usually used when mics must be out of the picture. Often, one boom mic covers more than one performer. To provide adequate sound pickup, the boom operator must anticipate when one performer is about to stop talking and another to start in order to move the boom at the right time to the right place. In drama, using the multicamera approach, two boom mics are customary.

20. Different techniques are used in controlling levels, leakage, and feedback of mic feeds from multiple sound sources. They are: following the 3-to-1 rule, moderate limiting or compression, noise gating, or using an automatic microphone mixer.

21. If an audience is present, it must be miked to achieve an overall sound blend and prevent one voice or group of voices from predominating.

22. Increasing audience laughter or applause, or both, by using recorded laughter or applause tracks is called milking the audience.

23. In drama it is essential to block the action to ensure that the microphone(s) can pick up all the sound from a relatively close mic-to-source distance. A microphone should be able to move freely with the action without getting in the way of either the performers or the camera(s).

24. When using a boom mic to record drama, mic-to-source distance must be adjusted with the shot, thereby automatically matching aural–visual perspective.

25. Factors to consider when using a wireless microphone are: frequency assignment, transmission dropout, companding, and transmission range.

26. Using a wireless microphone gives a performer freedom of movement; mic-to-source distance remains uniform, however, and must be adjusted in postproduction.

27. Recording dialogue may be done during actual production or afterward, in postproduction, during automated dialogue replacement (ADR).

28. Production recording is important, regardless of what is rerecorded in postproduction, because it preserves a sonic record of the production.

29. In addition to mono and stereo recording during production, multitrack and split-track recording techniques are also employed.

30. Stereo can be produced in two ways: discrete or synthesized. Discrete stereo consists of two distinct signals that reproduce sound source localization, depth, and spaciousness. Synthesized stereo takes a monophonic signal and processes it in a way that approximates the depth and spaciousness of discrete stereo but does not reproduce the sound source localization or the realism of discrete stereo.

31. In stereo TV, speech and sound effects usually are positioned in the center of the stereo image, although sound may be recorded in stereo to give it a stereo "feel." Sometimes, if the focal length of a shot remains constant, a sound may move with the action. Music, audience, and crowd sound are usually imaged in stereo.

32. Material recorded in stereo must be mono-compatible because most of the audience still receives it in mono. The middle-side (M-S) and X-Y coincident stereo microphone arrays guarantee mono-compatibility; the X-Y near-coincident array does so if the angle between the mics is not too wide.

CHAPTER 13

Producing Sound Effects

In Chapter 11, "Creating the Sound Design," we considered the variety of ways sound effects can be used to communicate cognitive and affective information. In this chapter, we discuss the sources and production of sound effects.

Generally, there are three sources of sound effects: prerecorded, live, and electronically generated. Prerecorded sound effects, once issued on tape and record, are now distributed on compact disc. Live sounds are obtained in three ways. They can be created and synchronized to picture in postproduction in a studio often specially designed for that purpose, recorded on the set during shooting, or collected in the field throughout production or between productions. Electronically gen-

erated sounds are usually produced with a synthesizer or a computer. Electronic effects are also produced by using other electronic audio devices such as tape recorders, signal processors, and samplers. Sound effects can be built using one or any combination of these approaches. In the interest of clarity, each approach will be considered separately.

Prerecorded Sound Effects Libraries

Sound effects libraries are collections of recorded sounds that can number from several dozen to several thousand, depending on the

distributor. The distributor has either produced and recorded the original sounds or collected them from other sources and obtained the rights to sell them, or both.

The major advantage of sound effects libraries is that for one buy-out fee you get many different sounds for relatively little cost, compared to the time and expense it would take to produce them yourself (see 13-1 and 13-2). *Buy-out* means that you own the library and have unlimited, copyright-cleared, use of it.

Most broadcast stations and many production houses use libraries because they do not have the personnel or the budget to assign staff to produce sound effects. Think of what it would involve to produce, for example, the real sounds of a forest fire, a torpedo exploding into an aircraft carrier, stampeding cattle, and the like.

Working with Disadvantages of Prerecorded Sound Effects

The disadvantages of prerecorded sound effects libraries are that (1) you give up control over the dynamics and timing of an effect, (2) the ambiences in the various recordings, when edited together, may not match one another or those you require in your production, and (3) the effects may sound **canned**, that is, obviously recorded.

Control

One reason that sound editors prefer to create their own effects, rather than use libraries, is to have control over the dynamics of a sound, particularly effects generated by humans. For example, thousands of different footstep sounds are available in effects libraries. But you might need a specific footfall that requires

a certain-sized woman walking at a particular gait on a solidly packed road consisting of dirt and stone granules. Maybe no library can quite match this sound. Timing is another reason why many sound editors prefer to create their own effects. To continue our example, if the pace of the footfall has to match action on the screen, trying to synchronize each step in the prerecorded sound effect to each step in the picture could be difficult.

Ambience

Matching ambiences could present another problem with prerecorded sound effects. Suppose in a radio commercial you need footsteps walking down a hall followed by a knock on a door that enters into that hallway. If you cut together two different sounds to achieve the overall effect, take care that the sound of the footsteps walking toward the door has the same ambience as the knock on the door. If the ambiences are different, the audience will perceive the two actions as taking place in different locales. Even seeing the action, the different ambiences could disconcert the audience.

To offset this problem, some sound effects libraries provide different ambiences for specific applications: footsteps on a city street with reverb to put you in town among buildings, and without reverb to put you in a more open area; or gunshots with different ricochet ambiences to cover the various environments in which a shot may be fired. Some libraries provide collections of ambient environments, allowing you to mix the appropriate background sound with a given effect (see 13-3). When you do this, however, be sure that the prerecorded effect has very little, or no, ambient coloration of its own. Otherwise, the backgrounds will be additive or clash, or both.

THE ELEMENTS

Thunderstorm • Thunder Distant • Rain: In Street • On Soft Surface • Rain Against Window • Rain/Hail on Tin Roof • Wind Against Window • Wind Heavy • Wind Across Open Ground • Wind in Trees • Sea (Various) • Underwater Bubbles • River • Stream • Waterfall • Fire (Interior) • Fire Exterior

BIRDS, INSECTS & ANIMALS

Birds: Sparrows • Swifts/Housemartins • Crows • Seagulls • Thrush • In Woodland • Urban • Starlings • Wood Pigeon • Doves • Wing Flaps • In Nest. Insects: Crickets • Cicadas • Flies. Animals: Goats • Dogs Barking • Dog At Night • Dog Howling

INTERIORS WITH PEOPLE 1

Brasserie • Restaurants (Various) • France • Hong Kong • Cafe Large/Small • Pubs/Bars (Various) • Schools: Senior/Junior • Classrooms • Babies • Baby Cries • Studio Audience • Applause • Laughter • Pop Concert

INTERIORS WITH PEOPLE 2

Airport Lounge • France • Various • Train Stations • Ticket Hall • Subway Station • Business/Shopping Complex • Hall/Lobby • Shopping Mall • Art Gallery • Museum • Library • Shop • Supermarket • Amusement Arcade • Police Station • Prison • Hospital • Corridors • Large Buildings • Bank

EXTERIORS WITH PEOPLE

Crowds (Various) • School Playground • Beach • Swimming Pool • Fairground • Markets • Footsteps (Rush Hour) • Street Atmosphere • Beer Garden • Group Chatter/Parties • Demonstration/Riot • Outdoor Events • Firework Displays

SKYLINES & CITY SOUNDS

Skylines: Morning • Evening • London • New York • Hong Kong • Middle East • Harbor • Wasteland • Bells • Church Bells • Construction Sites • City Night • Emergency Vehicles • Sirens

TRAFFIC

London • New York • Hong Kong • Cairo • Rome • Barcelona • Sidewalk • Slow-Moving Traffic • Emergency Vehicles • Subway/Underpass • Motorway/Freeway • Wet Weather Traffic • Traffic Jam • Taxicab Interior • Car Interiors (Various) • Tires On Road Surfaces

QUIET ROOMS & OTHER WORLDS

Room Interiors: Summer • Morning • Night • With Rain • With Distant Traffic • Church Interiors • Attic Room/Loft • Kitchen • Cave. Other Worlds: Weird Atmospheres • Eerie Wind • Breaths • Jungle • Metallic Twang • Chimes

TRAVEL & TRANSPORT

Airport Exteriors • Helicopter • Jet Aircraft Interiors • Cockpit Interior • Ocean Liner • Ferry • Speed Boat • Bus Interiors (London/New York) • Train Station Exteriors • Trains (Various) • Steam Train • Freight Train • Subway Trains

13-1 Examples of categories and effects in a recorded sound library

Track	Sound Effect	Mode	Duration	Description/ Remarks
42	Firework/ pyrotechnic	M-S	00:11	Explodes on water. Thunderflash explodes on water in reverberant environment.
HUMANS				
43	Chinese stirfry kitchen, Asian location	ORTF	01:22	Sound of food sizzling in woks, Asian voices.
44	Street market, Hong Kong	ORTF	01:57	Asian voices and automobiles. Busy street market scene.
45	Busy restaurant	ORTF	02:15	People in busy restaurant, voices, crockery, cutlery, bottle opened. Busy restaurant atmosphere.
46	Air terminal building, departure lounge	M-S	02:58	Voices, footsteps, aircraft, announcement calls, cash register.
47	Airport terminal, US Customs Hall	M-S	04:06	Voices, footsteps, bags and luggage wheeled, trolleys and bell.
48	Cigarette	M-S	00:47	Cigarette lit, match struck, cigarette with drawback, match thrown into glass ashtray. Female lights cigarette.
49	Kiss	M-S	00:02	Male kisses female, short.
50	Kiss	M-S	00:04	Passionate sloppy kiss.

13-2 Example of a detailed alphabetical listing of effects by category in a recorded CD sound library. The Mode refers to the way the sound effect was recorded, using the middle-side or the ORTF miking technique (see Chapter 14).

CD #-Tr-Ind	Title	Description	Time	Code
Compact Disc Number : 3002				
3002-01-01	PARK,CITY	-LOOKING OUT OVER CITY,TRAFFIC RUMBLE,BIRDS	04:00	DDD
3002-02-01	PARK,CITY	-CHILDREN YELLING & PLAYING,TRAFFIC & CITY RUMBLE	04:00	DDD
3002-03-01	PARK,CITY	-CITY RUMBLE,FOUNTAIN,PEDESTRIANS	04:00	DDD
3002-04-01	PARK,CITY	-FOUNTAIN,CITY RUMBLE	04:00	DDD
3002-05-01	PARK,CITY	-WIND THROUGH TREES,BIRDS,CITY IN B/G	04:00	DDD
3002-06-01	PARK,RESIDENTIAL	-WIND THROUGH TREES,BIRDS,VOICES & FOUNTAIN IN B/G	04:00	DDD
3002-07-01	PARK,RESIDENTIAL	-PLAYGROUND,WIND & TRAFFIC	04:00	DDD
3002-08-01	CONSTRUCTION,CITY	-GENERAL SITE AMBIENCE,HAMMERS & SAWS	04:00	DDD
3002-09-01	CONSTRUCTION,CITY	-GENERAL SITE AMBIENCE,MACHINERY	04:00	DDD
3002-10-01	CONSTRUCTION,CITY	-GENERAL SITE AMBIENCE FROM BALCONY,HAMMERING	04:00	DDD
3002-11-01	CONSTRUCTION,RURAL	-JACKHAMMER & COMPRESSOR,BIRDS	04:00	DDD
3002-12-01	CONSTRUCTION,RURAL	-HAMMERING,TRAFFIC,VOICES,BIRDS	04:00	DDD
3002-13-01	HARBOR,CITY	-BOATS,VOICES,SEAGULLS,CITY RUMBLE IN B/G	04:00	DDD
3002-14-01	HARBOR,CITY	-BOATS,WATER,INDUSTRIAL HUM IN B/G	04:00	DDD
3002-15-01	HARBOR,CITY	-MAST RIGGING,CRICKETS,BIRDS, TRAFFIC RUMBLE	04:00	DDD
3002-16-01	HARBOR,COUNTRY	-LIGHT BREEZE,OCCASIONAL VOICES & BIRDS	04:00	DDD
3002-17-01	HARBOR,COUNTRY	-MAST RIGGING,BIRDS,PLANES	04:00	DDD
Compact Disc Number : 3003				
3003-01-01	JUNGLE,DAY	-TROPICAL BIRDS,INSECTS,CRICKETS	04:00	DDD
3003-02-01	JUNGLE,DAY	-SINGING BIRDS,WATERFALL IN B/G	04:00	DDD
3003-03-01	JUNGLE,DAY	-HEAVY CRICKET SOUND,BIRDS IN B/G	04:00	DDD
3003-04-01	JUNGLE,NIGHT	-CRICKETS, VARIOUS OTHER INSECTS	04:00	DDD
3003-05-01	JUNGLE,NIGHT	-FROGS,INSECTS,BIRDS	04:00	DDD
3003-06-01	SWAMP,NIGHT	-VARIOUS INSECTS & BIRDS	04:00	DDD
3003-07-01	SWAMP,NIGHT	-FROGS,INSECTS,BIRDS	04:00	DDD
3003-08-01	DESERT,DAY	-LIGHT BREEZE,BIRDS,DISTANT THUNDER	04:00	DDD
3003-09-01	DESERT,NIGHT	-CRICKETS,BRUSH MOVEMENT,DISTANT DOG BARK	04:00	DDD
3003-10-01	MOUNTAIN,DAY	-WIND THROUGH GRASS & TREES,TRAFFIC RUMBLE IN B/G	04:00	DDD
3003-11-01	MOUNTAIN,DAY	-WIND THROUGH TREES,BIRD CHIRPS & CAWS	04:00	DDD
3003-12-01	FOREST,DAY	-BIRDS,LIGHT BREEZE,TRAFFIC RUMBLE IN B/G	04:00	DDD
3003-13-01	FOREST,DAY	-BIRDS,BREEZE THROUGH TREES	04:00	DDD
3003-14-01	FOREST,DAY	-BIRDS,CICADAS,LIGHT BREEZE,DISTANT TRAFFIC	04:00	DDD
3003-15-01	FOREST,DAY	-LIGHT BREEZE,CICADAS,FEW BIRDS	04:00	DDD
3003-16-01	FOREST,DAY	-BIRDS,INSECTS,DISTANT TRAFFIC	04:00	DDD
3003-17-01	FOREST,DAY	-QUIET,LIGHT BREEZE,FEW BIRDS	04:00	DDD

13-3 Examples of ambient sound effects

Canned Sound

Canned sound is less of a problem since sound effects libraries became available on compact disc. With analog tape and record, sonic deficiencies in the presence or brilliance ranges that created a dull, lifeless sound sometimes made it obvious that a sound effect was recorded. (Tape noise and scratch from the record were other tip-offs that a sound effect was canned.) The lifeless sound quality was usually caused by either a poorly made recording or the loss of fidelity that occurs when analog recordings are copied (dubbed) several times. Record and tape wear caused by frequent use was another factor. With CDs, the canned sound is no longer a concern as long as the original sound effect was recorded digitally. If the effect on CD was transferred from an analog recording and sounded canned, then it will sound the same on CD, except that the digital recording process will bring out its poor sonic quality even more. To clean up this problem, many sound libraries use signal processing, including noise reduction, when transferring analog effects to digital. As with all matters involving sound, let your ear be the judge.

Based on the preceding discussion, it would seem that the disadvantages of prerecorded sound effects outweigh their one major advantage. But given their convenience, relatively modest cost, improved fidelity on CD, and widespread availability, that one major advantage cannot be overestimated. For the demanding sound designer, however, nothing quite equals creating sound effects from scratch and recording them live. (See "Live Sound Effects" later in the chapter.)

Getting the Most from a Sound Effects Library

Once a sound effect has been recorded, any number of things can be done to alter its sonic characteristics, thereby extending the usefulness of a library.

Altering Playing Speed

Because pitch and duration are inseparable parts of sound, it is possible to change the character of any recorded sound by varying its playing speed. This technique will not work with all sounds; some will sound obviously unnatural—either too drawn out and guttural or too fast and falsetto. For sounds with sonic characteristics that do lend themselves to changes in pitch and duration, however, the effects can be remarkable.

For example, the sound effect of a low-pitched, slow, mournful wind can be changed to a ferocious howl of hurricane force by increasing its playing speed. The beeps of a car horn followed by a slight ambient reverb can be slowed to become a small ship in a small harbor and slowed still more to become a large ship in a large harbor. Hundreds of droning bees in flight can be turned into a squadron of World War II bombers by decreasing the playing speed of the effect, or turned into a horde of mosquitos by increasing playing speed. Decreasing the playing speed of cawing jungle birds will take you from the bush to an eerie world of science fiction. A normal gorilla can be turned into King Kong by decreasing the recording's playing speed. The possibilities are endless, and the only way to discover how flexible sounds can be is to experiment.

Playing Sound Backward

Another way to alter the characteristics of a sound is to play it backward. Some tape recorders have a "Reverse Play" function. On those that do not, you can play a tape backward by threading it around the capstan and pinch roller so that the tape feeds from right to left (see 13-4).

13-4 Threading technique used to play tape backward

Using Tape Loops

Sometimes, you may need a continuous effect that has to last several seconds, such as an idling car engine, wind, a drum roll, or crowd sound. Because many prerecorded effects last only a few seconds, there are three alternatives. If the recorded effect is, say, 5 seconds long and you need 60 seconds of it, you can (1) dub it to a cartridge tape recorder, defeating the primary tone so the effect plays continuously, (2) dub the sound effect to a message repeater (see Chapter 12), or (3) make a tape loop.

To make a tape loop, dub a few seconds of the effect to open-reel tape, cut the tape at the beginning and end of the recording, and splice the two ends together. Be sure to follow the editing guidelines presented in Chapter 16 and make the edit at a point where it will not be aurally conspicuous. Figure 13-5 shows one way to play a tape loop.

Take three precautions in using a tape loop. First, the tape length, before splicing, should be no longer than a few feet; other-

wise, the loop will be unwieldy on the tape recorder. Second, regardless of how good the edit and splice are, if the loop plays too long it will become evident that the effect is not continuous but repetitious. Third, be sure the loop is played back in the same head-to-tail manner it was recorded, or else it will sound backward. An arrow may be inscribed with a marking pen on the base side of the tape to indicate the direction of travel.

Working with a tape loop can be cumbersome. Once a loop is made, it may be easier to dub the sound to cartridge tape or a message repeater. Short sequences also may be handled by digital sampling, which is discussed later in this chapter.

Other ways to extend a sound effects library involve using signal processing devices. By feeding a sound effect through analog or digital signal processors, such as a delay unit, phaser, flanger, or pitch shifter, it is possible to create a virtually infinite number of effects.

Choosing Sounds from the Titles

Titles in sound libraries are often not precise enough to be used as guides for selecting material. For example, what does "Crowd reaction at a soccer game," "Laughter," "Washing machine," or "Window opening," actually tell you about the sound effect, besides its general subject and application? Most good libraries provide short descriptions of each effect to give you an idea of its content (see 13-2). Even so, always listen before you choose.

Using a Data Base to Organize Sound Effects

It is not unusual for an audio facility to have thousands of recorded sounds in its collection. Although libraries come with an index, timing information, and, often, descriptions of the cues, it can be time-consuming to

13-5 A tape loop and one way it can be played. Longer loops can be wound around an empty feed reel or take-up reel, or both.

locate and audition an effect. Data-base systems have been developed that enable you to search, locate, and audition a sound effect within seconds.

Generally, the search feature provides four ways to find a sound effect: by category, word, synonym, and catalog number (see 13-6). The data-base system can be interfaced with a multidisc CD player so that once an effect has been located, it can be auditioned from the start of the track or cued to within a split second anywhere in the track.

Live Sound Effects

Although prerecorded sound libraries are readily available, some of which are quite good, many audio designers prefer to produce their own effects because doing so allows complete control in shaping a sound to

meet a precise need. In addition, if the effect is taken from the actual source, it has the advantage of being sonically authentic. Also, sound designers are sometimes called on to create effects that do not already exist. They prefer to build these from live sources.

Live sound effects are collected in three ways: by manually creating them in a studio and — in television and film — synchronizing them to picture at the same time; by recording them on the set during shooting; and by recording them directly from the actual source, usually in the field, either during or between productions.

Foley Sound Effects

Of the three ways to produce live sound effects, manually creating them in the studio is the technique most commonly used. This approach goes back to the days before

a

b

13-6 A Search Screen (*a*) and Category Look-Up Table (*b*) in one type of data base used to organize a sound effects library

television when drama was so much a part of radio programming. Surrounded by the "tools of the trade"—door frames, telephone ringers, bells, buzzers, water tubs, car fenders, cutlery, cellophane, coconut shells, virtually anything that made a sound—the effects people, usually situated in the same studio with the performers, produced many of the sounds called for in the script. (Effects that were difficult to produce in a studio were taken from recordings.) Many ingenious ways were devised to create effects in the studio (see Appendix, "Manually Produced Sound Effects").

The term now applied to this technique is *Foleying*. It is derived from Jack Foley, a sound editor with Universal Pictures for many years. Given the history of radio drama and the fact that other Hollywood sound editors had been producing effects in the studio for some time, clearly Jack Foley did not invent the technique. His name became identified with it in the early 1950s when he had to produce the sound of paddling a small survival raft in the ocean. Instead of going out and recording the real sound, he did it in the studio and in sync with the picture. The inventiveness and efficiency he showed in both producing the effect and simultaneously recording it to picture—saving the sound editor still more time in postproduction—impressed enough people that Foley's name has since become associated with the technique. Today, the primary purposes of Foleying are still (1) to produce sound effects that are time-consuming and expensive to mike and record during production, such as far-flung action scenes like a car chase and battlefield fighting, or large-scale movement of people and materiel; and (2) to make producing sound effects easier, more convenient, and more controlled in a regulated studio environment.

This is not to suggest that Foleying and sonic authenticity are mutually exclusive. In Cecil B. De Mille's *The Ten Commandments*, two Foley artists worked in a large tank of water and mud to create the effect of the Israelites making bricks for a pyramid. When the microphone also picked up their clothing sounds, De Mille had them create the sound nude.

Foleyed sound effects can be produced in any acoustically dry sound studio, but, preferably, they are recorded in a specially designed facility commonly known as a Foley stage (see 4-9). As previously indicated, a principal reason for recording live sounds in a studio is control. Another purpose is to redo sounds recorded during production that are unacceptable because of problems with fidelity, timing, perspective, ambient quality, or interpretation.

Foley stages are designed to be acoustically "dead." Most have reverb times of anywhere between .02 to .04 seconds. As with dialogue recording, appropriate ambiences are added later.

Foleyed effects are produced in sync with the visuals. The picture is shown on a screen in the studio, and when a foot falls, a door opens, a paper rustles, a floor squeaks, a man sits, a girl coughs, a punch lands, or a body splashes, a Foley person generates the effect at the precise time it occurs on the screen. Such a person is sometimes called a *Foley walker* because Foley work often requires performing many different types of footsteps.

The keys to creating a sound effect are analyzing its sonic characteristics and then finding the sound source that contains similar characteristics. For example, take the sound of a growing rock. There is no such sound, of course. But if there were, what would it be like? Its obvious characteristics would be stretching and sharp cracking sounds. One solution is to inflate a balloon and scrape it with your fingers to create a high-pitched scraping sound. If the rock is

huge and requires a throatier sound, slow down the playback speed. For the cracking sound, shellac an inflated inner tube. Once the shellac hardens, sonically isolate the valve to eliminate the sound of air escaping and let the air out of the tube. As the air escapes, the shellac will crack. Combine both sounds to get the desired effect.

There are hundreds of examples of created sounds. Here are a few.

- Thunder in many Disney productions was created by recording a screen door closing sharply through a phonograph pickup coil preamplifier assembly attached to the door frame. Another way of creating thunder is to frame copper screening and attach a contact mic to the frame. The thunder effect is produced by striking the copper screening with a mallet. (Using different types of strikers, such as a drumstick or a hammer, produces other types of explosive sounds.)

- Many of the "boings" that are so much a part of cartoons are produced using a boing box (see 13-7).

- In the original *Airport*, after the explosion, the sound of the plane's tortured steel was created by bolting sheet metal to a lever and pulling it.

- The "nipper" creatures in *Ice Pirates* were children's giggles raised in pitch and compressed.

- In *Back to the Future III*, the basic sound of galloping horses was created using plungers on different types of surfaces. The sound was then recorded and processed in various ways to match the screen action.

- The sound of the giant boulder careening toward the frantically running Indiana Jones in *Raiders of the Lost Ark* was created with a compact car rolling down a

13-7 **A boing box is a rectangular wooden box, open on one side, with a handle on top and a wooden slide mounted inside.** A guitar string, usually G (but whatever is needed), is attached from the handle down the inside of the box to an electronic pickup head usually positioned at the bottom of the box. The pickup head is connected to a loudspeaker. As the wooden slide is adjusted to shorten or lengthen the string, the pitch is raised or lowered, accordingly. The *boing* sound is made when the string is plucked and the handle is tightened.

gravel road, in neutral, with the engine off.

- In *Abyss*, the script called for "an ungodly screeching sound." The molecular reaction caused by putting a large chunk of dry ice on a metal table produced the desired effect.

- The sound of the insects coming out of the heat duct in *Arachnophobia* was produced by recording Brazilian roaches walking on aluminum. The rasping sound a tarantula makes rubbing its back legs on the bulb-like back half of its body was created from the sound of grease frying mixed with high-pressure air bursts.

- The leg-movement sounds of the big Kane monster in *RoboCop 2* were built on the servo (hydraulic) sound of a 1968 LTD convertible top.

- Luke Skywalker's landspeeder in *Star Wars* was the roar of a Los Angeles freeway recorded through a vacuum cleaner pipe.

- The sounds of the spaceship *Millennium Falcon* in *Star Wars* included tiny fan motors, a flight of World War II torpedo planes, a pair of low-frequency sine waves beating against each other, variably phased white noise with frequency nulls, a blimp, a phased atom-bomb explosion, a distorted thunderclap, an F-86 jet firing afterburners, a Phantom jet idle, a 747 takeoff, an F-105 jet taxiing, and a slowed-down P-51 prop plane pass-by. Various textures were taken from each of these sounds and blended together to create the engine noises, takeoffs, and fly-bys.

- In *Jurassic Park* the sounds of Tyrannosaurus Rex were made up of the trumpeting sound of a baby elephant, an alligator growl, and the growls of 15 other creatures, mostly lions and tigers. The inhale of T. Rex's breathing included the sounds of lions, seals, and dolphins; the exhale included the sound of a whale's blowhole. The smashing, crashing sound of trees being cut down, particularly Sequoias, was used to create the footfalls of the larger dinosaurs. The sounds of the reptilian dinosaurs were built from the sounds of lizards, iguanas, bull snakes, a rattlesnake (flanged), and horse-like snorts. A Synclavier 9600 (a highly sophisticated synthesizer and sampler) was used to process many of these sounds, including some of the dinosaur footsteps and eating sounds.

Components and Context of a Foleyed Sound Effect

Being ingenious in creating a sound effect is not enough. You also have to know the components of the effect and the context in which the effect will be placed. Let us use two different examples as illustrations: a car crash and footsteps.

The sound of a car crash generally has five components: (1) the skid, (2) a slight pause just before impact, (3) the impact, (4) the grinding sound of metal and the shattering of glass just after impact, (5) silence.

The sound of footsteps consists of three basic elements: (1) the impact of the heel, which is a fairly crisp sound, (2) the brush of the sole, which is a relatively soft sound, and (3) sometimes, heel or sole scrapes.

But before you produce these sounds you need to know the context in which they will be placed. For the car crash, the make, model, and year of the car will dictate the sounds of the engine, the skidding, and, after the impact, the metal and glass. The type of tires and road surface will govern the pitch and density of the riding sound; the car's speed is another factor that will affect pitch.

The location of the road—for example, in the city or country—will help determine the quality of the sound's ambience and reverb. If the car is swerving, then tire squeals may be required. Of course, what the car crashes into will also affect the sound's design.

As for the footsteps, the height, weight, sex, and age of the person will influence the sound's density and the heaviness of the footfall. Another influence on the footfall sound is the footwear itself—shoes with leather heels and soles, pumps, spiked heels, sneakers, sandals, and so on. The choices here may relate to the hardness or softness of the footfall, and the attack of the heel sound, or lack thereof. Perhaps you would want a suction-type or squeaky-type sound with sneakers; maybe you would use a flexing sound of leather for the sandals. The gait of the walk—fast, slow, ambling, steady, or accented—will direct the tempo of the footfalls. The type of walking surface—cement, stone, wood, linoleum, marble, or dirt—and whether it is wet, snowy, slushy, or muddy will be sonically defined by the sound's timbre and envelope. The amount of reverberation added to the effect will depend on where the footfalls occur.

Miking and Perspective in Recording Foley Sound Effects

The capacitor microphone is most frequently used in recording Foley effects because of its ability to "hear" subtleties and capture transients—fast bursts of sound, such as door slams, gunshots, breaking glass, and footsteps—that constitute so much of Foleying. Directional capacitors—super-, hyper-, and ultracardioid—are preferred because they pick up concentrated sound with little ambience. Also, these pickup patterns provide more flexibility in changing perspectives. Moving a highly directional microphone a

few inches will sound like it was moved several feet.

Microphone placement is critical in Foleying because the environment on screen must be replicated as closely as possible on the Foley stage. In relation to mic-to-source distance, the closer the microphone is to a sound source, the more detailed, intimate, and drier is the sound. When the microphone is farther from a sound source, the converse of that is true, but only to a certain extent on a Foley stage because the studio itself has such a short reverberation time. Nevertheless, if a shot calls for a close environment, baffles are used to lower the room size. If the screen environment is more open, then the object is to operate in as open a space as possible.

Another must in Foleying is to use a good microphone pre-amp because of dynamic range and noise floor factors. Recording loud bangs or crashes or soft nuances of paper folding or pins dropping requires the capabilities to handle both a wide variety of dynamics and considerable gain with almost no additional noise. Many standard in-console pre-amps are not up to the task. Limiting and compression are rarely used in Foley recording; except for noise reduction, processing is usually done during the final stages of postproduction.

Foley effects are most often recorded in mono. This allows the rerecording mixer the option to control and place the sound effect's imaging should stereo be called for in the final stage of audio postproduction.

Recording Sound Effects During Production

Some directors eschew Foley effects, preferring to capture authentic sounds either as they occur on the set during production or by recording them in the field separately, or both. These directors are willing to sacrifice,

within limits, the controlled environment of the Foley stage for the greater sonic realism and authenticity of the actual sound sources produced in their natural surroundings. Still, a number of factors have to be taken into consideration to obtain usable sounds.

If sounds are recorded with the dialogue as part of the action—a table being thumped, a match being struck, a toaster being popped—getting the dialogue is always more important than getting the sound effect; the microphone must be positioned for optimal pickup of the performers.

When a director wants sound recorded with dialogue, the safest course of action is to record it with a different mic than the one being used for the dialogue. If the dialogue mic is a boom, use a plant (stationary) mic for the sound effect; if the dialogue microphone is a wireless body mic, use a boom or plant mic for the sound. This facilitates recording sound and dialogue on separate tracks and, therefore, provides flexibility in postproduction editing and mixing.

If for some reason only one mic is used, a boom would be best. Because its mic-to-source position changes with the shot, there is a better chance of capturing and maintaining perspectives with it than with a body or plant mic. Moreover, in single-camera production, a scene is shot at least a few times from different perspectives, so there is more than one opportunity to tape a usable sound–dialogue relationship.

This point should be emphasized. It is standard in single-camera production to shoot and reshoot a scene. For each shot, time is taken to reposition camera, lights, and crew, to redo make-up, primp wardrobe, and so on. During this time the sound crew also should be repositioning mic(s). *Take advantage of every opportunity to tape audio on the set.* The more takes of dialogue and sound you record, the greater the flexibility

in editing and mixing. If dialogue or sound effects are unusable because of mediocre audio quality, it is still wise to preserve the recording because it is often useful in dialogue rerecording and Foleying as a reference for timing, accent, or expressiveness.

You never want to mask an actor's line with a sound effect, or any other sound for that matter, or to have a sound effect call attention to itself (unless that is the intent).

If sound effects are not taped with the action but recorded on the set before or after shooting, try to do it just before shooting. Everyone is usually in place on the set, so the acoustics will match the acoustics of the take. If an effect has to be generated by the actor, it can be. And all sounds should be generated from the sound source's location in the scene.

Also, there has to be absolute quiet; nothing else can be audible: a dog barking far in the distance, an airplane flying overhead, wind gently wafting trees, crockery vibrating, lights buzzing, crew shuffling, actors primping. The sound effect must be recorded "in the clear" so that it carries no sonic baggage into postproduction.

This brings us back to the question: If all these added concerns go with recording sound effects on the set, why bother? Why not save time, effort, and expense and simply Foley them? To reiterate, many directors do not care for the controlled acoustics of the Foley studio or for artificially created sound. They want to capture the flavor or "air" of a particular location and preserve the unique characteristic of a sound an actor generates, or fuse the authenticity of and interaction between sounds as they occur naturally.

This creates considerable challenge in moving-action scenes, such as chases, that take place over long distances. These scenes are usually covered by multiple cameras, and although multiple microphones may not be positioned with the cameras, using them will

capture the sounds of far-flung action. The mics can be situated at strategic spots along the chase route with separate mixer/tape recorder units at each location to control the on-coming, passing, and fading sounds. In addition, if possible, a mic mounted on the means of conveyance in the chase helps greatly in postproduction editing and mixing. For example, on a getaway car mics can be mounted to the front fender, level with the hubcaps, and aimed at a 45-degree angle toward where the rubber meets the road; or a fishpole boom can be rigged through the rear window and rested on a door for support. In a horse chase a mic can be mounted outside the rider's clothing or fastened to the lower saddle area and pointed toward the front or rear hooves.

Another advantage to multiple-miking sound effects is the ability to capture various perspectives of the same sound. To record an explosion, for example, positioning mics, say, 25, 50, 100, and 500 feet away provides potential for a number of sonic possibilities when editing and mixing. Another reason it is a good idea to record extremely loud sound from more than one location is that the sound can overmodulate tape to the point that much of it may not record. That is why, for example, loud weaponry that is recorded sounds thinner and weaker than the actual sound.

The obvious microphone to use in many of these situations may seem to be the wireless because of its mobility. As good as wireless systems can be, however, they are still subject to interference from RF, telephone lines, and passing cars (especially older ones without spark suppressors), which causes spitting and buzzing sounds. A directional capacitor microphone connected to a good mic pre-amp is the most dependable approach to take here. In these applications use very strong shock mounts and tough wind-

screens. And do not overlook the importance of wearing ear protection when you are working with loud sounds. Do not monitor these sounds directly — use your eyes and the VU (or ppm) meter instead of your ears.

Collecting Sound Effects in the Field

Live sound collected away from the set for a specific production or between productions to build effects libraries is usually collected in the field. As with most field recording, utmost care should be taken to record the effect in perspective, with no unwanted sound. It cannot be overemphasized that any recording done away from the studio also requires first-rate, circumaural headphones for reliable monitoring.

As with most sound effects miking, the directional capacitor is preferred for reasons already noted. That said, the parabolic microphone system, using a capacitor mic, is also employed for recording sounds in the field. It is quite effective in concentrating pickup and rejecting ambience. This is particularly important when recording weaker sounds, such as insects, certain types of bird calls, or rustling leaves. Parabolics are essentially midrange instruments, so it is probably unwise to use them on sound sources with significant defining frequencies in the bass range. The longer bass waves tend to diffract around the parabolic dish and so are not picked up by the microphone. For stereo, the M-S and stereo mics are more commonly used because they are easier to set up than coincident or spaced stereo microphones and are more accurate to aim at a sound source.

A key to collecting successful live effects in the field is making sure that the recorded effect sounds like what it is supposed to be. Placing a mic too close to a babbling brook could make it sound like boiling water or

liquid bubbling in a beaker. Miking it from too far a distance, on the other hand, might destroy its liquidity. A flowing stream miked too close could sound like a river; miked too far could reduce its size. Applause might sound like rain or something frying. A spraying fountain might sound like rain, applause, or something frying. Specifically, a spraying fountain often lacks the identifying liquid sound. To get that sound, it might be necessary to mix in a watery-type sound like a river or a flowing, rather than babbling, brook. A yellow-jacket bee flying around a box could sound like a deeper, fuller-sounding bumblebee if miked too close, or a mosquito if miked too far. A gunshot recorded outdoors, in open surroundings, sounds like a firecracker; some types of revolvers sound like pop guns.

Keep three other things in mind when recording sounds in the field: be patient, be inventive, and, if you really want authenticity, be ready to go to almost any length to obtain an effect. For example, in the film *Glory*, the sound designer wanted the effects of Civil War weaponry to be as close to authentic as possible, even to the extent of capturing the sound of real Civil War cannonballs and bullets whizzing through the air.

Specially made iron cannonballs were shot from cannons forged for the film; this was recorded at 250 yards and a quarter-mile downrange. These locations were far enough from the initial explosion that it would not contaminate the sound of the projectile going by. The two distances provided a choice of whiz-by sounds and also the potential for mixing them, if necessary. Because the cannons could not be aimed very well at such distances, not one acceptable whiz-by was recorded during an entire day of taping.

For the bullet whizzes, modern rifles would not have worked because the bullet velocity is not slow enough to produce an audible air whiz-by. Using real Civil War bullets, a recordist sat in a gully 400 yards downrange and taped the whiz-bys as the live rounds flew overhead. In the end, the cannonball whiz-bys had to be created by playing the bullet whiz-bys in reverse and slowed down.

Finally, when collecting sounds in the field, do not necessarily think literally about what it is you want to capture. Consider a sound's potential to be built into another effect. For example, the basic sound of Chewbacca the Wookiee in *Star Wars* was the growl of a real bear. Among the many different laser sounds in the film, some incorporated the buzz of inductance recorded by passing a microphone behind a television set or the guy wire twang of a transmitter tower. Other examples of transforming sound effects have been cited throughout this chapter.

Electronically Generated Sound Effects

High-quality sound effects can be generated electronically with synthesizers and computers. With improved technology, this technique has become more popular. It is cost-efficient and unlimited in the sounds that can be created. However, it sometimes lacks the "reality" directors desire.

Synthesized Sound Effects

A **synthesizer** is an audio instrument that uses sound generators to create waveforms. The various ways these waveforms are combined can synthesize a vast array of sonic characteristics that are similar to, but not exactly like, existing sounds and musical instruments. They can also be combined to generate a completely original sound. In

13-8 A page of one synthesizer's library of sounds

other words, because the pitch, amplitude, timbre, and envelope of each synthesizer tone generator can be controlled, it is possible to build synthesized sounds from scratch.

In addition to being able to create synthesized effects, preprogrammed sound from libraries designed for specific synthesizer brands and models are available. These collections may be grouped by instrument category such as string, brass, reed, and keyboard sounds, or may include a range of sounds from many types of instruments that also can be used to synthesize sound effects (see 13-8). These libraries come in various formats, such as floppy disk, plug-in memory cartridge, and cassette.

One complaint about synthesized sound has been its readily identifiable electronic quality. With the advent of improved synthesizer designs and software, this has become less of a problem in recent years. Take

care, however, to make sure that the synthesizer and sound library you use will produce professional-quality sound; many do not.

The operational aspects of synthesizers and their programs are beyond the purview of this book. Even if they were not, it is extremely difficult even to begin to describe the sonic qualities of the myriad of effects a synthesizer can generate. Suffice it to say, almost anything is possible. The same is true of computer-generated sound effects.

Computer-Generated Sound Effects

A principal difference between the synthesizer and the computer is that the synthesizer is a device specifically designed to create and produce sounds; the computer is not. The computer is completely software-dependent. With the appropriate software, the computer,

"mee . . ." surface noise ". . . meep"

0.0 0.1 0.2 0.3 0.4 0.5

time (seconds)

13-9 Computer-generated waveform of Road Runner saying "MeeMeep"

like the synthesizer, can also store pre-programmed sounds or create them from scratch, or both. (It is also possible to edit sound using computers and synthesizers. Editing is discussed in Chapter 16.) Many computer sound programs make it possible not only to call up a particular effect but to see and manipulate its waveform and, therefore, its sonic characteristics (see 13-9).

Sampling

An important sound-shaping capability of many electronic keyboards and computer software programs is **sampling**. Sampling is a process whereby digital audio data representing a sonic event, acoustic or electroacoustic, is stored on disk or into a memory. The acoustic sounds can be anything a microphone can record—a shout, motor sputter, splashing, song lyric, trombone solo, whatever. Electroacoustic sounds are anything electronically generated, such as those a synthesizer produces. The samples can be

of any length, as brief as a drumbeat or as long as the available memory allows.

A sampler, which is basically a specialized digital record and playback device, may be keyboard-based, making use of musical keyboard controllers to trigger and articulate sampled audio (see 13-10). It may be a rack-mountable unit, without a keyboard, which is controlled by an external keyboard or a **sequencer** (see 13-11). A sequencer is a device that stores messages, maintains time relationships among the messages, and transmits the messages when they are called for from devices connected to it. The sampler system may also be computer-based.

With most sampling systems, it is possible to produce an almost infinite variety of sound effects by shortening, lengthening, rearranging, looping, and signal processing the stored samples. A trombone can be made to sound like a saxophone, an English horn, or a marching band of "76 Trombones." One drumbeat can be processed into a thunderclap or built into a chorus of jungle drums. The crack of a baseball bat can be shaped

13-10 **Keyboard-based sampling recorder.** This particular model has a hard disk drive and supports up to 16 megabytes of sample memory. Among its other features are time compression and expansion, digital effects processing, and sequencing.

13-11 **Sampler.** Among this model's features are four sampling rates — 48 kHz, 44.1 kHz, 24 kHz, 22.05 kHz — with a 2-megabyte memory, expandable to 16 megabytes; up to three minutes of sampling time; built-in hard disk and 3½-inch floppy disk drives; and a built-in small computer system interface (SCSI) allowing simultaneous use of up to eight devices (including the two built-in disk drives), such as magneto-optical disk and removable hard disk drive units.

into the rip that just precedes an explosion. Chirping birds can become a gaggle of geese. A metal trashcan being hit with a hammer can provide a formidable backbeat for a rhythm track. The squeal of a pig can be transformed into an unearthly human scream.

In solid-state memory systems, such as ROM (Read Only Memory) or RAM (Random Access Memory), it is possible to instantly access all or part of the sample and reproduce it any number of times. The difference between ROM- and RAM-based samplers is that ROM-based samplers are factory programmed and reproduce only; RAM-based samplers allow you to both reproduce

and record sound samples. The number of samples you can load into a system is limited only by the capacity of the system's storage memory.

The Samplefile

After a sample is recorded or produced, or both, it is usually saved in a storage medium, most commonly a floppy disk, hard disk, or compact disc. The stored sound data is referred to as a **samplefile**. Once stored, of course, a samplefile can be easily distributed. As a result, samplefiles of sounds are now available to production facilities in the same

No.	Name	No.	Name	No.	Name	No.	Name
11	MAOS LAYER	31	Big B.Sect	51	DLM Synth	71	D70 MGAMoog
12	Wichita st	32	Trump Ens.	52	RUMBBOOG	72	Syn Bass
13	Stac Heaven	33	Funk Stab	53	Breathy Chf	73	Slap!
14	Harpsynchd	34	Wind Layer	54	Percstring	74	Market Bass
15	Sfz Orch.	35	One Finger	55	Beholder	75	TURBASS
16	Orch.Layer	36	4 Saw Brass	56	4 V C O	76	Spike Bass
17	Folklore	37	Shanghai	57	Melodicann	77	FQ BASS
18	Nylon A.	38	Wet Synth	58	Trilogy C1	78	Click Bass
21	Impression	41	Reso Split	61	Fantasy Too	81	Moonlight
22	Snd. Trkish	42	Tropical	62	The Jewel	82	OUCH! DLM
23	Str/Vc.Pan	43	Twin Peaks	63	Earthbell	83	LA 2001
24	Melotronnn	44	BASS and EG	64	Chase	84	BRAINSTORM
25	Cathedral	45	From Peru	65	Bride Organ	85	ST STRINGS
26	Bright Strg	46	HAWAIATM	66	Rockin ORG	86	Thunder
27	Stratos	47	Ethnic	67	Breath Orgn	87	Big Ben
28	Pizzagogo	48	Fine Split	68	JS ORGAN	88	Orion

13-12 Example of a samplefile list

way that sound effects libraries on CD are available (see 13-12).

The floppy disk is most often used to store short samples and remains popular because it is a readily available, low-cost format. Hard disks have several advantages over the floppy disk, however — greater storage capacity, speedy search and retrieval of files, and, in some systems, a removable hard disk drive pack. Because compact discs and players are far less expensive than computers and synthesizers, enough samplefiles are stored on CD already that they constitute an extremely large, easy-to-access data base of sampled sounds. Other storage mediums are also used for samplefile distribution, such as CD-ROM, erasable and write-once optical disks, and tape. Samplefiles are also available through computer bulletin board services.

You should take two precautions before investing in a samplefile library. First, make sure they are in a format that is compatible with your sampler. Recently, steps have been taken to increase standardization of sample-file formats for computer-based systems. Second, make sure the sound quality of the samples is up to professional standards; too many are not.

Tips for Recording Samples

In recording samples from whatever source — acoustic or electronic — it is vital that the sound and reproduction be of good quality. Because the sample may be used many times in a variety of situations, it is disconcerting (to say the least) to hear a bad sample again and again. Moreover, if the sample has to be rerecorded, it might be difficult to reconstruct the same sonic and performance situation.

Miking

The same advice that applies to miking for digital recording (see Chapter 14) also applies to miking for sampling. Only the highest-quality microphones should be used,

which usually means capacitors with high sensitivity and low noise. If percussion recorded at close mic-to-source distances requires a moving-coil mic, it should be large-diaphragm and a top-quality model.

Time

Recording a good sample takes time. The digitized sample might bring out many sonic nuances that are not readily apparent acoustically. A particular sample might only be realized by combining certain sounds. There might be a need to sculpt the sample by processing it with filtering, looping, phasing, and so on. With sampling, as with much of sound, simply recording it is not enough.

Sampling and Copyright

Sampling has made it possible to take any recorded sound, including copyrighted material, process it, and use it for one's own purposes. The practice has become so widespread that it has created a major controversy about royalty and copyright infringement — specifically, about who owns portions of the rights to the new performances that are based on previously released samples and that might have been taken from already copyrighted material.

Also, copyright laws that have been based on melody need to be modernized to adequately address the issue of sampling copyrighted material without permission. As it stands currently, short samples (within a few milliseconds) of prepublished material do not *technically* violate the author's copyright, but they do violate the record company's copyright.

Simply stated, using any copyrighted material without permission is unethical at best and illegal at worst. Copyright infringement affects everyone. Consider your reaction if someone profited from material created by your time and talent without sharing any of the earnings with you.

Live Versus Electronically Generated Sound Effects

With the advent of synthesized and computer-generated sound effects and sampling, it has been predicted that the demise of Foleying is only a matter of time. These prognosticators are assuming that electronically generated sound effects will replace live production instead of, more far-sightedly, regarding these new sound sources as additions to the world of sound production. On the one hand, an electronically generated sound, randomly accessed and retrieved, is a powerful creative tool. On the other hand, in creating Foley sounds a person can capture a "feel" that a machine cannot.

Main Points

1. The three main sources of sound effects are prerecorded, live, and electronically generated.

2. Prerecorded sound effects that can number from several dozen to several thousand are available in libraries. The major advantage of sound effects libraries is that for relatively little cost many different, perhaps difficult to produce, sounds are at your fingertips. The disadvantages are: no control over the dynamics of the effect, possible mismatches in ambience; and the effects may sound canned.

3. Sound effects libraries can be "enlarged" by varying a sound's playing speed, altering it through signal processing, playing it backward, and creating a tape loop.

4. Sound effects collections can be organized into data bases to facilitate cataloging, locating, and auditioning them.

5. Producing live sound effects in the studio goes back to the days of radio drama but is commonly known as Foleying, after former film soundman Jack Foley.

6. The keys to creating a sound effect are analyzing its sonic characteristics and then finding the sound source that contains similar characteristics, whatever it may be.

7. The capacitor microphone is most frequently used in recording Foley effects because of its ability to "hear" subtleties and capture transients.

8. Some directors shun using studio-created effects, preferring to capture authentic sounds either as they occur on the set during production or by recording them in the field separately, or both.

9. Sound effects also are created by generating them electronically with a synthesizer or computer. A synthesizer is an audio instrument that uses sound generators to create waveforms. Computer sound effects can be generated from preprogrammed software or software that allows sounds to be produced from scratch.

10. An important sound-shaping capability of many synthesizers and computer software programs is sampling: a process whereby a section of digital audio representing a sonic event, acoustic or electroacoustic, can be signal-processed into a different sound or expanded to serve as the basis for a longer sonic creation.

11. In recording samples, it is important to record them with the highest fidelity and take your time.

12. Sampling has made it possible to take any recorded sound, including copyrighted material, process it and use it for one's own purposes. Using any copyrighted material without permission is at least unethical and usually illegal.

Producing Music

Producing music means three things: programming recorded music to create a certain pace and mood, which is essential in so much of today's radio; choosing music from prerecorded libraries specially created to enhance spot announcements or underscore dramatic material; and recording live music.

Programming Recorded Music

In radio, a station depends on its **format**— the mix and arrangement of ingredients in its overall sound—to attract a particular au-

dience. On a music station, that sound depends on the type of music played, of course. But it also depends on how the various music selections are arranged. (Other factors, such as the style of announcing, commercials, jingles, and news delivery contribute to a station's sound as well.) Consequently, sequencing music becomes as much a matter of production as it is a matter of programming.

There are more than a dozen different music formats in radio today, and they are changing all the time. Regardless of their differences, however, programming essentially involves grouping selections in a particular order to create a specific effect and integrating announcements. The effect may be related to

music in this key will segue with →	first choice	second choice	third choice	fourth choice
A	A	D	E	F♯/G♭ minor
A♯(B♭)	A♯(B♭)	D♯(E♭)	F	G minor
B	B	E	F♯	G♯/A♭ minor
C	C	F	G	A minor
C♯(D♭)	C♯(D♭)	F♯(G♭)	G♯(A♭)	A♯/B♭ minor
D	D	G	A	B minor
D♯(E♭)	D♯(E♭)	G♯(A♭)	A♯(B♭)	C minor
E	E	A	B	C♯/D♭ minor
F	F	B♭	C	D minor
F♯(G♭)	F♯(G♭)	B	C♯(D♭)	D♯/E♭ minor
G	G	C	D	E minor
G♯(A♭)	G♯(A♭)	C♯(D♭)	D♯(E♭)	F minor

14-1 **Compatible or consonant music keys**

pace, mood, similar sounding songs, style of the artists, type of ensemble, year the music was popular, or any combination of these themes. Regardless of design, if selections are played in relatively close order or segued — played with no announcement in between — the sonic compatibility or harmoniousness of one song following another is important to the station's overall sound.

Sonic Compatibility Between Music Selections

Music is composed in keys or tonalities (see Chapter 11). When songs are played in close order or segued, their tonalities should sound compatible or consonant. If they do not, the effect of the segue is dissonant or unpleasant.

One way to avoid unpleasant transitions between musical selections is to use a chart that lists keys that are sonically consonant with one another (see 14-1). Then the opening and closing keys can be written next to

each selection on the CD jacket, or cartridge disc or tape label, so an announcer with no musical background can produce harmonious-sounding song sequences. Of course, someone who knows music must put together this information in the first place.

Transitions Between Music Selections

In most pop music radio, the transition from one piece of program material to another affects a format's pace, variety, and interest. Transitions to and from musical selections, spot announcements, news, and feature programs are as important a consideration in producing a format as is music programming. There are too many transitional possibilities to detail here. But a few examples of transitions from one disc selection to another should provide an idea of their general importance in helping to maintain a format's tightness (see 14-2).

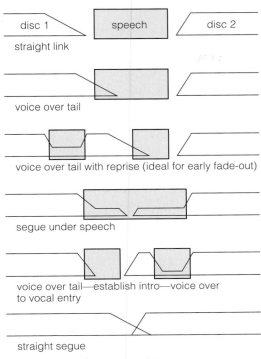

14-2 Six types of disc transitions

Choosing from Prerecorded Music Libraries

Prerecorded music libraries, like prerecorded sound effects libraries (see Chapter 13), are convenient and less expensive alternatives to live production. They are used for bumpers, commercials, and underscoring dramatic material. They provide original music composed to evoke a wide range of human emotions and information: happiness, conflict, melancholy, liveliness, danger, the future, the 18th century, the Far East, the bustling city, and many others.

Music libraries provide music in a variety of styles and textures. Compositions are arranged for orchestras of various sizes, dance and military bands, rock and jazz groups, solo instruments, synthesizers — virtually any voicing or combination of voicings necessary to evoke an idea or emotion (see 14-3).

Using Familiar Music

Each selection in prerecorded music libraries is original. Familiar music tends to trigger memories associated with it, which could compete with or distract from the main information. Also, familiar music usually does not compel the attention on the part of the listener that unfamiliar music does, which could reduce the overall impact of the communication. Sometimes, using familiar music is justified and effective, but the decision to use it should come only after careful consideration. It should not be used because it is an easier way to provide **underscoring** — informational or emotional enhancement. Another factor in using familiar music is that it usually comes from commercially released recordings, so obtaining copyright release could be costly. Copyright is discussed later in this chapter.

Avoiding "Canned" Music

As with analog sound effects libraries, a problem with analog music libraries is that sometimes the music sounds obviously prerecorded, or canned (see Chapter 13). This canned sound may be due to sonic deficiencies in the presence or brilliance ranges, too much midrange, stilted and mechanical performances, or bad composing and arranging.

Now that music libraries are available on CD, problems with sound quality have been

MCT-CD 518 **FROM SEA TO SKY**
Inventive Atmospheric Scores for Panoramas, Space, Underwater, Mystery, Hi-Tech, and Slow Motion. 20 Tracks.

MCT-CD 519 **POSITIVE**
Upbeat, Confident Themes in Inventive Instrumentations for Sports, Industrial, Hi-Tech, and Urban Scenes. 21 Tracks.

MCT-CD 520 **BEATS AND NEWS**
Energetic Compositions Conveying the Importance and Urgency of Broadcast News. Full Versions, Underscores and Tags. 56 Tracks.

MCT-CD 521 **PRIME TIME**
Energetic Themes Reinforcing the Urgency of News and Industrial Subjects. Full Versions, Commercial Lengths and Tags. 45 Tracks.

MCT-CD 522 **ARCHI JAZZ**
Authentic Big Band Jazz, Rich Orchestrations and Inventive Solos. Perfect for Night Life and Urban Scenes. 12 Tracks.

MCT-CD 523 **CHARM**
Melancholic, Warm, and Tender Moods by Small Groups and Orchestra Featuring Soprano Sax, Piano, Strings, and Guitar. 24 Tracks.

MCT-CD 524 **CITIES**
Accented Musical Backgrounds Describing Urban Action, Machinery, Mechanical Process, and Positive Obstinacy. 18 Tracks.

MCT-CD 525 **GAGS**
Zany Compositions in Various Orchestration for Cartoons, Circus, Children, Silent Movies, Comedy, and Funny Situations. 45 Tracks.

MCT-CD 526 **WAR**
Depictions of Battle, Doom, Strife, Danger, Fright, Pomp and Circumstances for Contemporary and Historical War Subjects. Large Orchestra and Percussions. 30 Tracks.

MCT-CD 527 **FILM TRACKS**
Richly Orchestrated Themes and Underscores for Romance, Nostalgia, Drama, Suspense, Panoramas, and Anxiety. 22 Tracks.

MCT-CD 528 **BAROK**
Delicate, Elegant and Colorful Music Pieces in Baroque Style by Modern Sampling Keyboards. Very Appropriate for Fashion, Documentaries, Romance, Happiness. 21 Tracks.

MCT-CD 529 **MOYEN-AGE/RENAISSANCE**
Musical Anthology of the Middle Ages and the Renaissance Eras Performed on Authentic Period Instruments. Featuring Great Film Composers Such As Vladimir Cosma (*Tall Blond with One Black Shoe, Mistral's Daughter, To Catch a Cop*), and George Delarue (*Twins, Agnes of God, Biloxi Blues, Platoon*). 46 Tracks.

MCT-CD 530 **PIECES FOR THE PIANO**
Superb Performances of Solo Piano Pieces by or in the Styles of Rachmaninoff, Debussy, Satie, Schuman, Scriabine, Prokofiev, Liszt, Brahms, Mozart, Bach, Granados, De Falla, Chopin, and Marcello. 22 Tracks.

MCT-CD 531 **DIGITAL TIPS**
Electrifying Pop, Salsa, Jazz, Blues, and Rock in the Styles of Superstar Performers. Piano, Guitar, Brass Rhythm Section, Percussion, and Strings. 16 Tracks.

14-3 Examples of titles and descriptions in a CD music library

eliminated for the most part. You still have to be wary, however, of mediocre composing, arranging, and performance, which have nothing to do with the recording format. Because music libraries vary in creative and sonic quality, ask to hear a demonstration disc before you buy.

Using a Data Base to Organize Music Libraries

To better organize and more speedily retrieve the hundreds, even thousands, of selections an audio facility may have in its music collection(s), data base systems are available similar to those used for sound effects collections. Most systems word search—match a specific word that exists as part of the description; category search—match the description from a category/subcategory table; synonym search—match thesaurus words from a synonym table; and catalog number search—match the code number for a CD and generate a sequential listing of all tracks on that disc (see 14-4).

Working with Copyrights

By law, any recorded material with a **copyright** may not be played over the air, copied (dubbed), or used for most nonprivate purposes without permission from the licenser—that is, the company or individual(s) holding the rights to the recorded material. Broadcasters, for example, pay fees to such major licensers as Broadcast Music, Inc. (BMI) and the American Society of Composers, Authors, and Publishers (ASCAP) for the right to play commercially recorded music on the air. The rights to music libraries, however, usually belong to the companies that distribute them. Fees are paid to these companies.

When you buy a music library, you pay an annual set fee for it. (You usually have the option of buying all or part of a collection, including discs added to the collection during the contract period.) Your right to use that library for profit or public performance, however, is another matter. Depending on the distributor, you acquire usage rights for another fee determined either on the basis of **needle**, or **laser**SM, **drops**—the number of times you use music from any selection or any portion of a selection (see 14-5)—or a fee that gives you unlimited usage rights for one or a number of years (see 14-6). Sometimes, the laser-drop fee may be applied to the buy-out cost. When the buy-out cost has been paid in laser-drop fees, unlimited long-term usage is granted.

If you are paying on the basis of laser drops, you must fill out a clearance form listing all the laser drops used in your production. You pay whatever fee the licenser's rate card indicates. The licenser will then send you written permission to use, for profit, its music in your production. If you use any of the same music in another production, you have to pay another laser-drop fee.

Often, a production contains so many laser drops that the copyright fee is prohibitively expensive. In such cases many licensers charge a flat rate.

Some organizations, such as educational institutions, small production companies, and many broadcasting stations, do not generate enough in copyright fees to make the rental of a music library worthwhile to the licenser. Therefore, many licensers rent their libraries to such organizations for a lower, flat, yearly rate. This clears the music for blanket use. Such an arrangement may be renewed each year; when it terminates, most licensers require return of the library.

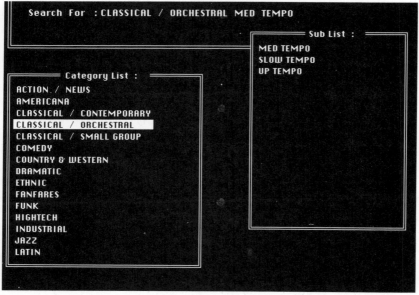

```
┌─────────────────────────────────────────────────────────────────────────┐
│  Search For    ACTION / NEWS MED TEMPO                    Search End      │
│ ┌──────────────┐                                                          │
│ │ Found = 0265 │                                          ┌─────────────┐ │
│ └──────────────┘                                          │  Up  PgDn   │ │
│  Lib:CAV Cat#:CAV01  CD:001   Time:02:55  Trk/In:02/01    └─────────────┘ │
│                                                                           │
│ PACEMAKER : POWERFUL PIANO & STRINGS OVER CONSTANT EXCITING RHYTHM        │
│                                                                           │
│ ┌══════════════════════ Search by Category ════════════════════════════┐ │
│ │ 0001  INT:ACTION / NEWS:MED TEMPO:GEO GRAPHIC : POWERFUL SUSPENSE SE 01:52│
│ │ 0002  INT:ACTION / NEWS:MED TEMPO:GEO GRAPHIC : UNDERSCORE : POWERFU 01:31│
│ │ 0003  INT:ACTION / NEWS:MED TEMPO:GEO GRAPHIC : MAIN  TITLE : POWERFU 00:59│
│ │ 0004  INT:ACTION / NEWS:MED TEMPO:GEO GRAPHIC : MAIN  TITLE : POWERFU 00:29│
│ │ 0005  INT:ACTION / NEWS:MED TEMPO:GEO GRAPHIC : MAIN  TITLE : POWERFU 00:15│
│ │ 0006  INT:ACTION / NEWS:MED TEMPO:GEO GRAPHIC : STING : POWERFUL SUS 00:06│
│ │ 0007  CAV:ACTION / NEWS:MED TEMPO:PACEMAKER:POWERFUL PIANO & STRIN...02:55│
│ │ 0008  CAV:ACTION / NEWS:MED TEMPO:LYNX : DRAMATIC : FORCEFUL THEME 02:46│
│ │ 0009  CAV:ACTION / NEWS:MED TEMPO:MEATY BITS : SOLID THEME OVER CHUN 02:33│
│ │ 0010  CAV:ACTION / NEWS:MED TEMPO:FAST : FORWARD : BRIGHT : OPTIMISTIC 02:50│
│ │ 0011  CAV:ACTION / NEWS:MED TEMPO:COLISEUM : HEAVY : INTRUSIVE RHYTH 02:20│
│ │ 0012  CAV:ACTION / NEWS:MED TEMPO:LYNX   : DRAMATIC FORCEFUL THEME 02:46│
│ │ 0013  CAV:ACTION / NEWS:MED TEMPO:INTERNATIONAL RESCUE SYNDICATE : M 03:13│
│ │ 0014  CAV:ACTION / NEWS:MED TEMPO:INTERNATIONAL RESCUE SYNDICATE : J 00:30│
│ │ 0014  CAV:ACTION / NEWS:MED TEMPO:INTERNATIONAL RESCUE SYNDICATE : J 00:30│
│ └──────────── Move with Arrow keys, F1 for Help , Press Esc to Exit ──────┘
└─────────────────────────────────────────────────────────────────────────┘
```

a

```
┌─────────────────────────────────────────────────────────────────────────┐
│  Search For  : CLASSICAL / ORCHESTRAL  MED  TEMPO                         │
│ ┌──────────────────────────────────────┐ ┌══════ Sub List : ═══════════┐ │
│ │                                       │ │ MED TEMPO                    │ │
│ │                                       │ │ SLOW TEMPO                   │ │
│ │ ┌═════ Category List : ════════┐      │ │ UP TEMPO                     │ │
│ │ │ ACTION / NEWS                │      │ │                             │ │
│ │ │ AMERICANA                    │      │ │                             │ │
│ │ │ CLASSICAL / CONTEMPORARY     │      │ │                             │ │
│ │ │ CLASSICAL / ORCHESTRAL       │      │ │                             │ │
│ │ │ CLASSICAL / SMALL GROUP      │      │ │                             │ │
│ │ │ COMEDY                       │      │ │                             │ │
│ │ │ COUNTRY & WESTERN            │      │ │                             │ │
│ │ │ DRAMATIC                     │      │ │                             │ │
│ │ │ ETHNIC                       │      │ │                             │ │
│ │ │ FANFARES                     │      │ │                             │ │
│ │ │ FUNK                         │      │ │                             │ │
│ │ │ HIGHTECH                     │      │ │                             │ │
│ │ │ INDUSTRIAL                   │      │ │                             │ │
│ │ │ JAZZ                         │      │ │                             │ │
│ │ │ LATIN                        │      │ └─────────────────────────────┘ │
│ │ └══════════════════════════════┘      │                                │
│ └──────────────────────────────────────┘                                 │
└─────────────────────────────────────────────────────────────────────────┘
```

b

14-4 Examples of (*a*) Word Search and (*b*) Category Search screens in a data base used for a music library

LICENSING PRICE SCHEDULE

CLEARANCE	LASERDROP FEE
BROADCAST	
Local TV or Radio Commercial (includes PSA's & Infomercials)	$ 85.00
Regional TV or Radio Commercial (Aired in N.Y.C., L.A., or CHI)	$ 110.00
Network TV or Radio Commercial (includes Promos)	$ 140.00
TV or Radio Program	$ 85.00
Production Blanket (does not include commercials)	Blanket #2
CABLE or SUBSCRIPTION TV	
Local Commercial (includes PSA's & Infomercials)	$ 85.00
Program	$ 85.00
Network Commercial (includes Promos)	$ 140.00
Production Blanket (does not include commercials)	Blanket #2
Pay Per View	$ 175.00
Pay Per View Production Blanket (does not include commercials)	Blanket #3

CLEARANCE	LASERDROP FEE
NON-BROADCAST	
A/V, Film, Video, Multi-image or Audio Cassette	$ 60.00
Production Blanket	Blanket #1
PRODUCTION FOR SALE (to the general public)	
Audio Cassette	$ 85.00
Production Blanket	Blanket #2
Commercial	$ 175.00
Video Cassette or Disc	$ 175.00
Production Blanket	Blanket #3
PRODUCTION FOR SALE (limited market)	
Corporate Production (Video Cassette, Disc or Audio Cassette) . .	$ 85.00
Production Blanket	Blanket #2
THEATRICAL PRODUCTION	
Trailer or Commercial	$200.00
Trailer or Commercial (All Rights)	$450.00
Film or TV	$300.00
All Other Rights	Upon Request
ANNUAL BLANKET	Upon Request

NOTE: 1. WHEN APPLYING FOR MORE THAN ONE LASERDROP CLEARANCE AT THE SAME TIME, A 20% DISCOUNT IS ALLOWED FOR ALL BUT THE INITIAL CLEARANCE.

2. APPLICATION FOR LICENSING OF KILLER TRACKS MUSIC MUST BE MADE IMMEDIATELY UPON SYNCHRONIZATION OR DUBBING.

3. KILLER TRACKS MUSIC MAY NOT BE PUBLICLY PERFORMED, COPIED OR RERECORDED FOR ANY PURPOSE WITHOUT WRITTEN LICENSE FROM KILLER TRACKS.

4. ALL LICENSES ARE GRANTED WORLDWIDE.

5. RATES ARE SUBJECT TO CHANGE WITHOUT NOTICE.

PRODUCTION BLANKET FEES
(Fees apply to unlimited use of music in any one production)

Production Blanket #1 — Non-broadcast
Production Blanket #2 — Broadcast, Cable or Audio Production for Sale
Production Blanket #3 — Video Production for Sale or Pay Per View Cable

PROD. LENGTH	BLANKET #1	BLANKET #2	BLANKET #3
Up to 10 min.	$ 210	$ 300	$ 625
10+ to 15 min.	270	380	800
15+ to 20 min.	350	500	1100
20+ to 30 min.	450	640	1375
30+ to 45 min.	630	895	2000
45+ to 60 min.	810	1150	2375
60+ to 90 min.	1020	1450	2975
90+ to 120 min.	1200	1700	3500

NOTE: WHEN APPLYING FOR MORE THAN ONE PRODUCTION BLANKET CLEARANCE AT THE SAME TIME, A 20% DISCOUNT IS ALLOWED FOR ALL BUT THE INITIAL CLEARANCE.

14-5 **Example of a licensing price schedule**

PROMUSIC inc.

ANNUAL LICENSE RATES

BROADCAST: ONE YEAR LICENSE - UNLIMITED USE

10	DISCS		$850	*$815
30	DISCS	(or 25 · 5)	$1225	$1150
50	DISCS	(or 40 · 10)	$1850	*$1750
100	DISCS	(or 85 · 15)	$3100	*$2950

(Excludes network programming, national television and radio spots)

NON-BROADCAST: ONE YEAR LICENSE - UNLIMITED USE

15	DISCS	(or 10 · 5)	$825	*$795
30	DISCS	(or 25 · 5)	$1075	*$1025
50	DISCS	(or 40 · 10)	$1600	*$1525
100	DISCS	(or 85 · 15)	$2600	*$2500

EDUCATIONAL: ONE YEAR LICENSE - UNLIMITED USE

15	DISCS	(or 10 · 5)	$675
30	DISCS	(or 25 · 5)	$925
50	DISCS	(or 40 · 10)	$1375
100	DISCS	(or 85 · 15)	$2100

* - THREE YEAR CONTRACT: PAYABLE ANNUALLY

14-6 Example of annual license rates for a music library

Sampling and Copyright

In Chapter 13, we touched on the problem of sampling and copyright. It is a thorny enough issue to warrant our discussing it again in the context of music libraries, in particular, and recorded music, in general.

Suppose that a production company leases a music library and in that library are portions of selections — accents, phrases, beat combinations — that are particularly suitable for sampling. The company redesigns them to make a new music cue. Clearly, the sampled material belongs to the copyright

holder. Unfortunately, the issue is more complex than that.

When is sampling a production tool and when is it stealing? Current copyright law has no provisions for sampling technology. Even within the audio recording and production industries there is disagreement about what is an acceptable amount of sampling and what constitutes copyright infringement. In fact, a number of producers and studios include indemnification clauses in their contracts holding them harmless should they be sued for using copyrighted samples unwittingly.

Until there is copyright law covering sampling technology, it still remains an ethical issue. As we pointed out in the previous chapter, copyright infringement affects everyone. Put yourself in the position of having put time and talent, to say nothing of any financial investment, into material that someone else uses for profit with no share of earnings going to you.

Sampling has made it possible to take any recorded sound, including copyrighted material, process it, and use it for one's own purposes. The practice has become so widespread that it has created a major controversy about royalty and copyright infringement. Specifically, who owns portions of the rights to the new performances that are based on previously released samples and that may have been taken from already copyrighted material?

Using Music in Spot Announcements

As discussed in Chapter 11, music is one of the most powerful forces in human communication. Its effects on remembrance and emotion are well documented. For these reasons music is a staple in *spot announcements* — commercials, public service announcements (PSAs), promotional announcements (promos), and jingles. The majority of spot announcements produced incorporate music in some way. Too often, however, due to lack of imagination, time, or understanding of its potency, music for spots is chosen or composed carelessly to the detriment of the message. For example, a producer using a music bed will simply grab a CD, start it playing at the beginning of the copy, and fade it out when the copy ends. Such short-sightedness is a particular handicap in a medium like radio, which has only one sensory channel to exploit.

Well-selected music can enhance the effectiveness of a spot announcement in a number of ways:

1. *Music creates mood and feeling.* The purpose of most spots is to have emotional appeal. Nothing reaches the emotions as quickly or as comprehensively as music.

2. *Music is memorable.* Music in spots should have a simple, short, melodic line or lyric, or both — something that sticks in the memory and can be easily, even involuntarily, recalled.

3. *Music gets the audience's attention.* A musical spot should grab attention at the start with a compelling musical figure. It can be a catchy rhythm or phrase, percussive accents, an electronic effect, a sonic surprise, or a lyrical statement that impels an audience to listen to its resolution.

4. *Music is visual.* Music provokes visual images. It can set scenes in the country, at the seashore, on shipboard, on the ski slopes, and so on. By so doing, music saves precious copy time spent evoking such scenes verbally.

5. *Music can be directed to the taste of a specific audience.* The type of music in a spot announcement can be suitable both to the audience to which the message is

aimed and, if appropriate, to the radio station's musical format. This makes the sound of the spot at once comfortable and familiar.

6. *Music unifies.* In a series of spots emphasizing different copy points about a single product or message, the same music can be used as a thematic identifier to unify the overall campaign. Music also bonds the various elements in spots with, say, multiple copy points and two or more voices.

Music in spot announcements is not always recommended, however, for several reasons: (1) More copy points can be covered in a spoken announcement than in one that is sung; (2) a spot with music usually has to be aired several times before the music is remembered; and (3) music can place an announcement in a less serious light than can the spoken word.

Recording Live Music

For the sound designer trying to capture the nuances of sound—timbre, tonal balance, blend, and so on—recording live music is a most demanding challenge. The ways to shape the sound of music are as infinite and individual as music itself. Because there can be no firm rules about music production, and because artistry in recording technique never compensates for lack of artistry in musicianship, you must trust your creative judgment and your ear.

Basic Techniques of Miking Music

Two basic techniques of miking live music are (1) **distant miking**—using two or a few microphones (or capsules) to record an entire ensemble in stereo—and (2) **close miking**—using one microphone to record each sound source or group of sound sources in an ensemble on separate tracks and mixing it to stereo. The technique you choose depends on several factors: the spatial environment you wish to create, the complexity of the music and arrangement, the type of music, and whether all the musicians record at the same time. Close miking is used more in pop music recording, and distant miking more in orchestra recording, but each approach has its advantages and disadvantages (see Tables 14-1 and 14-2).

Distant Miking

Usually, distant miking is employed when all sounds or voicings in an ensemble have to be, or can be, recorded at the same time and it is important to do so in natural acoustics to preserve the ensemble sound. Orchestral music, choruses, and certain types of jazz and folk are examples of music that use distant miking.

Distant miking of music attempts to reproduce the aural experience that audiences receive in live concerts, whether the recording is made in a studio or in a concert hall. There are different techniques of distant miking, but they all have three main goals: (1) to ensure that each instrument is reproduced in the same relative location as it was during recording; (2) to reproduce reverberation as it would be heard from a particular seat such as in the center of the hall, toward the front or rear of the hall; and (3) to achieve the same musical blend that is heard by the conductor.

Basic Considerations in Distant Miking

Five major considerations in distant miking are (1) critical distance, (2) air loss, (3) phase, (4) localization, and (5) stereo-to-mono compatibility.

Chapter 14: Producing Music **369**

Table 14-1 Advantages and disadvantages of distant miking

Advantages	Disadvantages
More closely reproduces the way we hear in an acoustic environment	Requires adjustment of the microphones and may even require repositioning the musicians, in studio recording, to accomplish the music blend
Requires fewer mics and so fewer faders to control; reduces electronic noise	Requires a retake by all musicians for a mistake by one, because all instruments are recorded at once
Can record entire ensemble at the same time	Makes it difficult to isolate instruments for solos
May spark performance from interaction because everyone plays at once	Requires a recording environment with excellent acoustics

Table 14-2 Advantages and disadvantages of close miking

Advantages	Disadvantages
Allows greater control of each element in the recording	Makes it difficult to create the nuances of each sound's interaction with the other sounds and with the acoustic environment
Increases separation of sound sources	Requires artificial production of acoustics and spatial placement
Usually means multitrack recording, so musicians can be recorded separately, a few musicians can do the work of several, and a mistake by one musician does not always require rerecording the entire ensemble	Increases phasing problems
	Means greater effort and more time for mixdown

Critical Distance Recall the inverse square law, which states that when distance from a sound source is doubled, loudness is reduced 6 dB. In an enclosed space such as a recording studio or concert hall, where acoustics are fairly evenly distributed, this is not quite the case. There is a point where sound no longer loses loudness. At this point, known as the **critical distance**, the amount of energy the microphone receives from the direct sound source and from the room reflections is equal. A mic placed in front of the critical distance is in the room's direct and reverberant sound field; a mic placed beyond the critical distance is in the room's reverberant sound field. Locating a room's critical distance, which must be done before mics are situated, is accomplished by using various technical methods, as well as your ear.

Air Loss **Air loss** relates to the friction of air molecules as sound waves move across distance through an elastic medium. All frequencies begin converting to heat, but higher frequencies get converted faster. The result is that the farther from a sound source you get, the duller the sound becomes. On the one hand, this works for you because music is not meant to be heard with your ear at, say, the bridge of a violin or under the lid of a piano. On the other hand, a microphone too far from an ensemble will reproduce a dull, lifeless sound.

Phase Stereo microphones improperly placed relative to the angle or space between them, or to their distance from an ensemble in relation to a room's acoustics, can create sound cancellations. These phasing problems

result from the sound waves reaching the microphones at significantly different times.

Localization Localization is the accurate reproduction of the instruments — front-to-back and left-to-right — in relation to their placement during recording. If the angle or distance between the stereo pair of microphones is too narrow, sound will be concentrated toward the center (between two loudspeakers) and the stereo image will lack breadth. If the angle or distance between the stereo pair is too wide, sound will be concentrated to the left and right with insufficient sound coming from the center. This condition is often referred to as "hole in the middle" (see 14-7).

Stereo-to-Mono Compatibility When a mono version is being made from a stereo recording, the type of microphone array used directly affects compatibility of the two formats. Therefore, it makes sense to discuss stereo-to-mono compatibility in the context of the three types of miking used for distant music recording — coincident, near-coincident, and spaced.

Coincident Miking

You will recall from the section on stereo miking in Chapter 12 that coincident miking, also called X-Y miking, employs two matched, directional microphones mounted on a vertical axis — with one mic diaphragm directly over the other — and angled apart to aim approximately toward the left and right sides of the ensemble. The degree of angle depends on the width of the ensemble, the mics' distance from the group, and the pickup pattern of the microphones: the greater the angle between the microphones, the wider the stereo image (remember that too wide an angle creates a hole in the mid-

dle). If the stereo pair is cardioid, the included angle may be from 90 to 135 degrees. If it is hypercardioid, the included angle must be narrower — because the on-axis pickup is narrower — to ensure a balanced center image. The frontal lobe of coincident hypercardioids can extend to 130 degrees (see 14-8 and 14-9). Due to the hypercardioid's tighter pattern, however, a stereo pair can be placed farther away from the sound source than can cardioids.

A stereo pair must be matched to ensure a uniform sound, and the mics should be capacitors. Miking at a distance from the sound source, particularly with classical music, requires high-output/high-sensitivity microphones, and capacitors are the only type of microphone that meets this requirement. Moreover, the microphone preamps should be high-gain, low-noise.

Another coincident technique utilizes a crossed pair of bidirectional microphones with a useful frontal lobe of 90 degrees—45 degrees to the left of center and 45 degrees to the right of center (see 14-10). This approach, the earliest of the X-Y techniques, is also called the **Blumlein technique** (named after British scientist Alan Blumlein, who developed the technique in the early 1930s). Because the later development of the M-S (middle-side) approach (described in the following paragraphs) was a direct result of Blumlein's research, the bidirectional X-Y array is also known as the *double M-S*.

The stereo microphone provides the same coincident pickup as the stereo pair but with two directional microphone capsules housed in a single casing. The upper element can rotate up to 180 degrees relative to the lower element. Some stereo mics enable control of each capsule's polar pattern (see 5-25).

The M-S (middle-side) technique most commonly uses two coincident microphones in a single housing; separate microphones

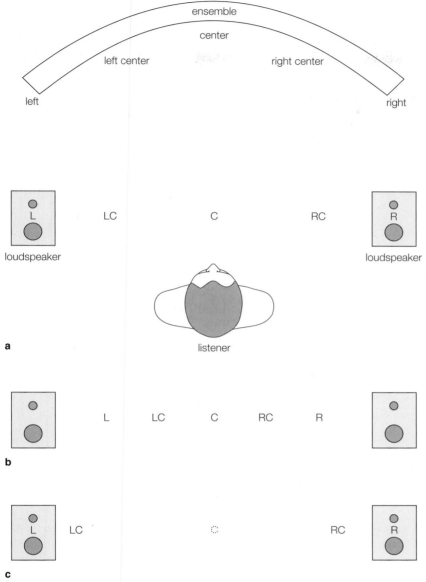

14-7 **Location of elements in an ensemble during recording (*top*).** (*a*) If the stereo microphones are in optimal proximity to each other and to the ensemble, stereo imaging during playback should be accurate. (*b*) If the stereo microphones are at too narrow an angle or spaced too close to each other, stereo imaging will be too narrow. (*c*) If the stereo microphones are at too wide an angle or spaced too far apart, stereo imaging will be too wide to the left and right, creating a "hole in the middle."

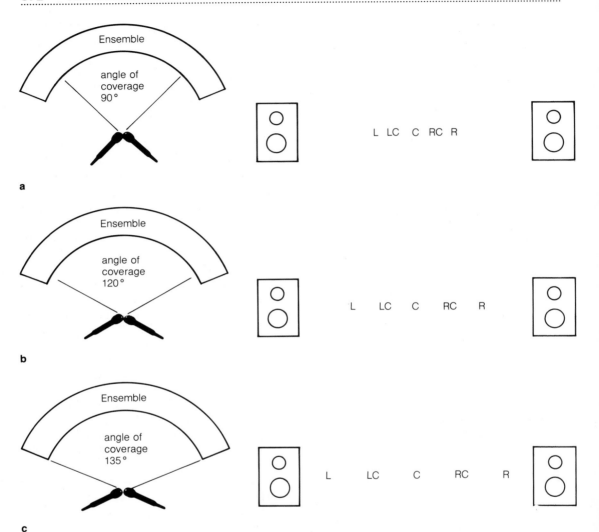

14-8 Coincident miking. Relative comparisons of stereo imaging using X-Y coincident angles of (a) 90 degrees, (b) 120 degrees, and (c) 135 degrees.

also may be used. One mic, which can be either cardioid or omnidirectional, is aimed toward the ensemble; the other mic, which is bidirectional, is aimed at the sides. Whether the mic capsules are in one housing or separate, M-S miking requires matrixing to sum and difference the mics' outputs to provide the discrete left and right channels (see 5-28). Unlike most X-Y miking, M-S lets you change the stereo spread during or after recording by adjusting the middle-to-side ratio. Some M-S systems can be adjusted to X-Y.

Coincident microphone arrays produce level (intensity) differences between channels

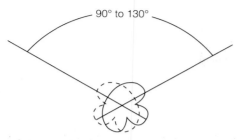

14-9 Coincident hypercardioid microphone array

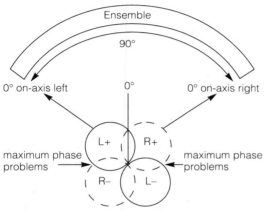

14-10 **Blumlein technique.** Two coincident bidirectional microphones are positioned at a 90-degree angle.

and minimize differences in arrival time. This has two sonic advantages: (1) Localization of instruments between the loudspeakers is sharp, and imaging corresponds to their placement during recording, giving you a conductor's balance; and (2) the stereo signals are mono-compatible because the two microphones occupy almost the same space, meaning their signals are in phase at all frequencies. With M-S miking all it takes to make it mono-compatible is to cancel the sides, which means the middle information is really mono-identical.

Although coincident miking provides sharp imaging and mono compatibility, it tends to lack spaciousness and sound flat and dry. The Blumlein pair rectifies this problem somewhat, but the center imaging is not as strong as it is with M-S and more directional X-Y miking. Near-coincident techniques address these shortcomings.

Near-Coincident Miking

Near-coincident miking angles two directional microphones, spaced horizontally, a few inches apart. The few inches difference between the near-coincident and coincident arrays adds a sense of warmth, depth, and "air" to sound. The mics are close enough to retain intensity differences between channels at low frequencies, yet far enough apart to have sufficient time delay between channels for localization at high frequencies. The stereo spread can be increased or decreased with the angle or space between the mics. The time delay between channels creates a problem, however: the greater the delay, the less the chance of stereo-to-mono compatibility.

A number of different approaches to near-coincident miking have been used with varying results. Among the better known are the ORTF, NOS, DIN, stereo 180, and Faulkner arrays.

The **ORTF** (Office de Radiodiffusion–Télévision Française, the French broadcasting system) **microphone array** mounts two cardioid microphones on a single stand spaced just under 7 inches apart at a 110-degree angle, 55 degrees to the left and right of center (see 14-11). The mics can also be crossed. The **NOS** (Nederlandsche Omroep Stichting, the Dutch broadcasting organization) **microphone array** places two cardioid microphones at a 90-degree angle about 12 inches apart. The **DIN** (Deutsche Industrie-Norm, the German standard) **microphone array** also places the stereo pair at a 90-degree angle but reduces the distance

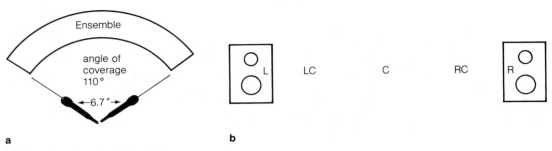

14-11 (*a*) ORTF array and (*b*) its effect on stereo imaging

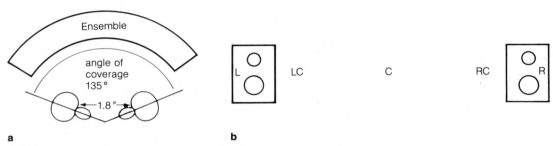

14-12 (*a*) Stereo 180 array and (*b*) its effect on stereo imaging

between the microphones to just under 8 inches. All three arrays produce similar results.

Another method, called the **stereo 180 microphone array**, uses two hypercardioid microphones, with excellent front-to-rear rejection, spaced just under 2 inches apart at a 135-degree angle (see 14-12). It creates the illusion that sound is coming from the sides of the room, or outside the loudspeakers, as well as from between them.

The **Faulkner microphone array** (named after British engineer Tony Faulkner) uses two bidirectional microphones spaced just under 8 inches apart but facing directly toward the ensemble and placed farther from it than is usual with coincident pairs (see 14-13). This configuration combines the sonic reinforcement of the Blumlein pair with the depth and openness of the near-coincident array.

Spaced Miking

Spaced miking employs two (or three) matched microphones several feet apart, perpendicular to the sound source, and symmetrical to each other along a centerline. Although any pickup pattern can serve, the two most commonly used are omnidirectional, which is the more popular, and cardioid.

Spaced microphones reproduce a more spacious, lusher, bigger sound than any of the near-coincident arrays, but at a cost. Stereo imaging is more diffused and, therefore, less detailed. Instrument locations tend not to be clearly defined and can vary considerably as mic-to-source distance changes. Instruments may cluster left and right at the speakers, blurring the center image. Also, because so much of the sound reaching the mics derives its directional information from time differences (in addition to intensity

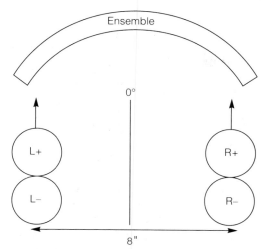

14-13 Faulkner bidirectional microphone array

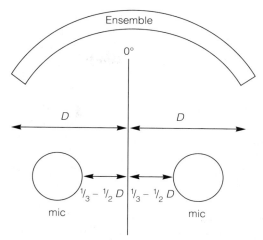

14-14 Spaced omnidirectional microphone array

differences), stereo-to-mono compatibility is unreliable.

Spaced omnidirectional microphones have less off-axis coloration and flatter overall response than cardioids, especially in the low frequencies. Capacitors are almost always used. Spacing is determined by the width of an ensemble and by mic-to-source distance. With omnis, spacing has to be wide enough to reproduce a stereo image. If it is too wide, however, separation is exaggerated and may produce a ping-pong effect between speakers; if spacing is too narrow, the stereo image will lack breadth. A good place to begin situating each omni is one-third to one-half the distance (D) from the centerline of the ensemble to its outer edge (see 14-14). If this creates a hole in the middle or if center imaging is diffused, a third mic placed between the outer pair should fill the hole and focus the center image. For a center mic to stabilize stereo imaging, however, its output must be split equally to the left and right channels.

Spaced cardioid microphones are arrayed similarly to spaced omnidirectionals, but their directionality produces a different sonic outcome. Spaced cardioids tend to emphasize

the voicings that are most on-axis. They also show the effects of coloration, particularly from reverb. Placement is critical to producing acceptable results with any spaced miking, but even more so with cardioids than with omnis. Spaced cardioids do provide a better chance for mono compatibility, however, because each microphone is picking up less common information, reducing the chance of phase cancellations.

Spaced boundary microphones used as the main stereo array have become a popular miking technique since the development of the Pressure Zone Microphone™ (PZM). Their pickup is similar to that of omnidirectionals, although around the boundary surface the polar pattern is hemispheric. If there is a choice, most recordists prefer using omnidirectional mics due to their superior sound quality.

Accent (or Fill) Miking

In many orchestral situations **accent**, or **fill**, **miking** may be necessary to supplement overall sound pickup. Weaker-sounding sections of an orchestra, or a soloist, or a chorus

situated behind an orchestra, may not be heard so well or at the same time as louder sound sources and sound sources closer to the main microphone array.

The outputs of accent microphones are handled separately from the stereo pair and blended or panned into the stereo field at the position of the sound source it is picking up. There are two dangers in accent miking: (1) If the accent sound is too loud it will stick out; and (2) the time delay between the closer mic-to-source distance of the accent mic(s) and the more distant mic-to-source distance of the main array has to be compensated for, or the sound source(s) picked up by the accent mic(s) will be unblended and perceived as being in front of the ensemble. One way to compensate for this time difference is to delay the signal from the accent mic(s) electronically using a digital delay device. This facilitates the blending of the sound from the accent mic(s) with the overall ensemble.

Ambience Microphones

Although stereo miking implies two (or three) microphones, accent mics notwithstanding, more microphones are actually employed, usually for ambience. **Ambience microphones** add depth and spaciousness to a recording, particularly if the main stereo array is located forward in the direct sound field or if it is coincident. For example, with M-S miking, although the side pickup is dedicated to the room reflections, overall sound is not as spacious as with near-coincident or spaced arrays. By facing an ambience microphone toward the rear of the room, additional reflections not heard by the M-S mic are picked up because it is dead at the rear.

Ambience microphones are usually mounted as a stereo pair. Omnidirectional mics are preferred if the room can accommodate them; otherwise, cardioids are used (see 14-15; see also 15-33). If phasing prob-

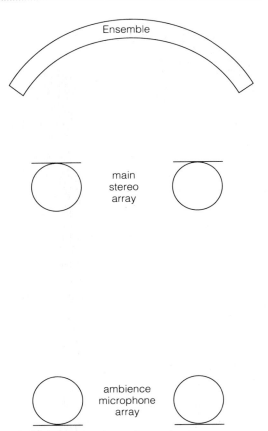

14-15 Ambience microphone placement

lems are to be avoided, the placement of the ambience microphones is very important.

Binaural Miking

The mic technique that produces the most realistic spatial effect employs the **binaural microphone head** (also known as *artificial head* or *dummy head* [Kunstkopf] stereo). Although stereo is more realistic than mono, it still does not reproduce sound the way humans actually hear it (see Chapter 3). Whereas our ears are separated by our head, stereo recording separates the mics but places

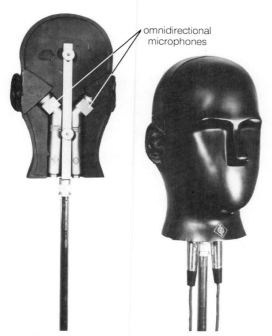

omnidirectional
microphones

14-16 **The so-called dummy head.** Two omnidirectional capacitor microphones mounted in "ear" cavities reproduce binaural sound. To hear the binaural effect, it is necessary to listen with headphones.

nothing between them. Therefore, the phase relationship of sound waves as humans hear them—binaurally—differs from the phase relationship of sound waves that reach a stereo microphone array.

To produce a binaural recording, you have to use a specially designed artificial head with an omnidirectional capacitor microphone at each ear (see 14-16). Although binaural sound is an extraordinary listening experience because it reproduces the illusion of both the horizontal and vertical planes, it is only possible to get its full effect through stereo headphones; loudspeakers will not do. Another problem is that directionality is sometimes difficult to perceive.

To record music binaurally, position the artificial head and the microphones for opti-

mal overall sound pickup in relation to the studio acoustics. If possible, put the head on top of a seated mannequin rather than on a table or chair so that the reflections of the sound waves are more realistic.

Although binaural recording is mainly experimental, attempts have been made to capture a sense of the binaural listening experience by recording with two omnidirectional microphones placed on either side of a sound-absorbing baffle about as far apart as the width of the human head.

The most successful attempt so far at binaural system design and recording is the **AachenHEAD**, developed by Dr. Klaus Genuit at the Technical University of Aachen, Germany (see 14-17). The Dummy Head, constructed of fiberglass, is a detailed representation of a human head constructed through statistical averaging of variations in real human heads, and features felt hair and shoulders to simulate the characteristics of hair and clothing. The microphones are mounted only a little more than .15 of an inch inside the ear canal to prevent ear canal resonances from being recorded. The most striking result of the AachenHEAD system is that the binaural effect is apparent on conventional loudspeakers, although headphones are required to hear the full benefits of binaural spatial imaging.

Ambisonic Sound

The factor that helps to make binaural sound so impressive is the sonic addition of height, which provides surround sound to the sound imaging. Because binaural sound requires headphones to fully appreciate its effect, other ways of reproducing three-dimensional sound have been attempted. The most successful technique is ambisonic or **surround sound,** due, in part, to the development of a unique microphone called the soundfield microphone (see Chapter 5). The soundfield

14-17 AachenHEAD binaural recording system, including the (*a*) Dummy Head, (*b*) Binaural Mixing Console, and (*c*) HEADphone Playback

microphone contains four mic capsules mounted as a tetrahedron. The outputs of these elements are fed into a matrix network that can be controlled to reproduce a number of different pickups.

The four outputs, known as the A-format, feed the high left-front–right-rear and the low right-front–left-rear information into the matrix network. After the signals are mixed, they are converted into the so-called B-format, from which the signals can be manipulated to produce a variety of pickups (see 5-31). The operation is complex, but the resulting three-dimensional sound is worth the trouble, especially because ambisonic sound does not require headphones for listening. It does, however, require four loudspeakers, two in front of the listener and two to the rear.

Other Surround Sound Recording Systems
There have been a number of other attempts to use surround sound methods in recording.

Transaural stereo takes the signals from a dummy head during recording and processes them back through loudspeakers to cancel the acoustic crosstalk around the head. That is, to cancel the signal from the left loudspeaker that reaches the right ear and the signal from the right loudspeaker that reaches the left ear. The result enables the listener to hear a quasi-binaural sound through loudspeakers.

B.A.S.E. (Bedini Audio Spacial Environment) separates a stereo signal into sum and difference components. During recording, a center image can be panned forward, backward, or side to side. The result does not produce true surround sound but it does enhance spaciousness and depth. The B.A.S.E. system also has a consumer unit that allows the user to control the spatial imaging of commercial recordings. (Systems that do not process surround sound during recording but do it either in the mixdown or during playback through decoding are discussed in Chapter 17.)

ITE™/PAR™ (In The Ear/Pinna Acoustic Response) inserts two probe mics with low noise and wide frequency response and dynamic range in the pressure zone of the eardrum of a human listener during recording. During playback, two loudspeakers are placed in front of the listener, for normal stereo, and two loudspeakers are placed on either side aimed directly at the listener's ears. The function of the side loudspeakers is to mask opposite-ear crosstalk. The result is similar to hearing through headphones and allows the listener to enjoy a surround sound

effect from a binaural recording through conventional loudspeakers.

Dimensional Stereo Recording (DSM℗) takes identical, high-quality electret capacitor microphones and mounts them, using rubber loops, to each temple piece of a pair of eyeglasses close to the outer ear canal pointing face-front. DSM recording "hears" live sound with a 360° ambient view that is psychoacoustically conditioned by the shape of the listener's head and upper torso and that can be reproduced through surround sound loudspeakers or stereo headphones.

3-D Audio, although worthy of mention, is too complex to describe here. The effect, applied during recording, is produced by a large computer from a program that is the result of a complex process modeled on human localization mechanisms.

Close Miking

Whatever the advantages of distant miking, not much of today's music is recorded that way. Many recordists are quite willing to sacrifice the more realistic sense of sonic space for greater control in recording the nuances of each musical element. This means close-miking practically each instrument or group of instruments in an ensemble. Reverberation, spatial positioning, and blend, which occur naturally with distant miking, are lost in close microphone recording and must be added artificially in the postproduction mixdown. Positioning and blending may be applied to a few instruments during recording.

Close miking is used in most popular music recording for a number of reasons: The difference in loudness between electric and acoustic instruments can be very difficult to balance with distant miking; the sound from each instrument, and sonic leakage from other instruments, is better controlled; a pop music ensemble usually does not have to be recorded all at once; much of pop music is played loudly, with acoustics added in the mixdown, so close-miking prevents the music from being awash in reverberation during recording.

Before getting into specific applications of close miking, it may be helpful to recall three important principles:

1. The closer a microphone is to a sound source, the more detailed, drier, and, if proximity effect is a factor, bassier the sound; the farther a microphone is from a sound source, the more diffused, open, and reverberant the sound.

2. The higher the frequency, the more directional the sound wave; the lower the frequency, the more omnidirectional the sound wave.

3. Although close miking may employ a number of mics, more may not always be better. Each additional microphone adds a little more noise to the system and means dealing with another input at the console.

Most of the discussion that follows assumes the use of directional microphones. Remember, the main reasons for close miking are better sonic control of each instrument and reduced leakage. If acoustics and recording logistics permit, however, omnidirectional mics should not be overlooked. The better omni capacitors have extraordinarily wide, flat response, particularly in the lower frequencies, and little or no off-axis coloration. Also, omnis are not as subject to proximity effect, sibilance, plosives, and breathing sounds as are directional mics.

Drums

Perhaps no other instrument provides as many possibilities for microphone combinations, and therefore as much of a challenge,

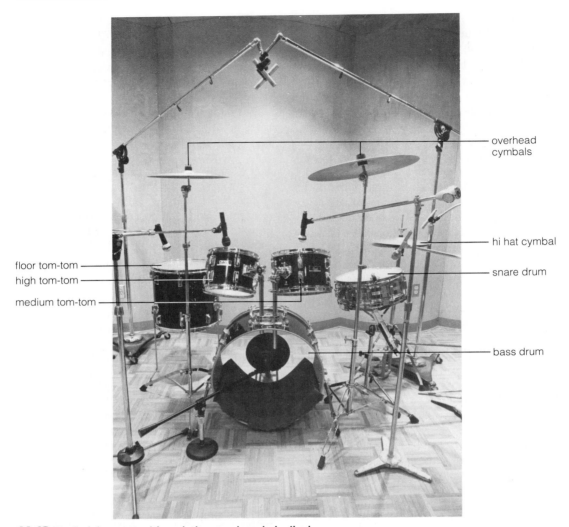

floor tom-tom

high tom-tom

medium tom-tom

overhead cymbals

hi hat cymbal

snare drum

bass drum

14-18 Typical drum set with each drum and cymbal miked

as the drums. Several different components make up a drum set—at least a bass drum, floor (low-pitched) tom-tom, medium (-pitched) tom-tom, snare drum, hi hat cymbal, and two overhead cymbals. A third tom-tom would be high-pitched (see 14-18). The set must be miked so that the instruments sound good individually and blend as a unit.

There are many ways to mike drums (see 14-18 through 14-25). The approach you take will depend on (1) how much sound control you want and (2) what type of music you are recording. Explaining how to deal with sound control is relatively easy: the more components you want to regulate, the more mics you use (although this can have its

14-19 One directional microphone placed at the drummer's position so the mic hears what the drummer hears. The problem is that the drummer does not usually hear a balanced sound.

14-20 Two directional microphones placed over the left and right sides of the set for direct stereo pickup. The danger with this arrangement is that the bass drum may sound too distant.

14-21 Three directional microphones, one each over the left and right sides of the set and one at the bass drum for greater control of its sound. Make sure that the sounds of the snare and hi hat are balanced with the sounds of the rest of the drum set.

14-22 Four directional microphones. Three are placed as suggested in 14-21, and the fourth is placed either on the snare drum or between the snare and the hi hat cymbal. This gives greater control of the snare and the hi hat. The overhead mics, however, may pick up enough of the snare/hi hat sound so that the snare/hi hat mic may be needed only for fill.

drawbacks — possible phasing, for one). Achieving a particular drum sound for a certain type of music involves many variables and is more difficult to explain.

Generally, in rock-and-roll and contemporary music, producers like a tight drum sound for added punch and attack. Because this usually requires complete control of the drum sound, they tend to use several microphones for the drums. In jazz, however, many styles are loose and open; hence, producers are more likely to use fewer drum mics to

14-23 **Five directional microphones.** Four are placed as suggested in 14-22, and the fifth is placed between the two tom-toms for added control of the tom-toms.

14-24 Two directional microphones for the overhead cymbals and a separate directional mic on each of the other components

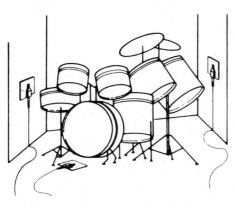

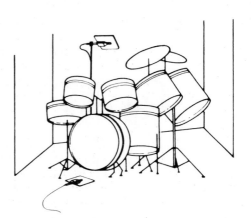

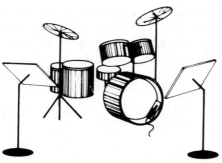

14-25 Three ways to mike drums using boundary mics

achieve an airier sound. Remember, however, that a good drum sound begins with the musicianship of the drummer and the quality and tuning of the drum set. No miking technique will save the drum sound of an incompetent drummer or low-quality drum set.

Therefore, before drums are miked, they must be tuned. This is critical to achieving the desired drum sound. Many studios have their own in-house drum set always tuned and ready to go, not only to ensure the drum sound but also to avoid having this necessary and time-consuming procedure cut into recording time.

Tuning the drums is important to the sound of individual drums and also to the overall sound. For example, pitching the bass drum low enough leaves room in the upper bass and midrange for the tom-toms and snare drum. If the bass drum is pitched too high, it pushes too close to the toms, which in turn get pushed too close to the snare drum, making the drum sound smaller. Moreover, by not separating the individual drum sounds, little room is left for such instruments as the bass and guitar.

One problem with even the best of drum sets is ringing. **Damping** the drums helps to reduce ringing, and undesirable overtones as well. To damp a bass drum, place a pillow, blanket, foam rubber cushion, or the like, inside the drum (see 14-26). To damp a tomtom and snare, tape a cotton or gauze pad near the edge of the drum head so it is not in the way of the beating drum stick (see 14-30).

Make sure the damping does not muffle the drum sound. It helps to leave one edge of the damping material untaped so it is free to vibrate. To reduce cymbal ringing, apply masking tape from the underside of the bell to the rim in radial strips.

Where the drum set is placed in a studio also affects its sound. Isolated in a drum booth (to reduce leakage into other instru-

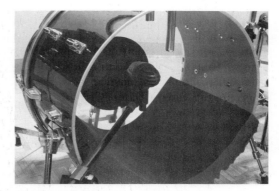

14-26 A directional microphone pointed at the drum head produces a fuller sound. Foam rubber padding is placed in the drum to reduce vibration.

ments' microphones), the overall sound will take on the acoustic properties of the booth. For example, if it is live, the drums will sound live; if the booth is absorptive, the drums will sound tight. On a hard floor the drums sound live and bright. On a carpet they sound tighter and drier. In a corner they sound boomier because the dominant lower frequencies are more concentrated. Often, drums are put on a riser that can resonate to reduce low-end leakage.

Bass Drum The bass drum (also called the *kick drum*) is the foundation of the drum set because it provides the bottom sound that, along with the bass guitar, supports the other musical elements. Because the bass drum also produces high levels of sound pressure and steep transients, large-diaphragm moving-coil microphones (e.g., AKG D-112, Electro-Voice RE-20) work best. In fact, large diaphragm microphones are generally preferred for low-end instruments because they are better able to handle the longer bass wavelengths. (Conversely, small diaphragm mics are better suited for the shorter wavelengths of high end instruments.)

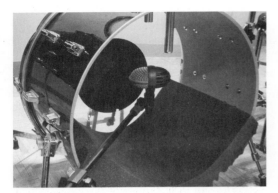

14-27 A microphone pointed to the side of the drum produces more of the drum's overtones

As for mic placement, the common technique is to use the hole often cut in the front drum head or remove it entirely and place the mic inside. This usually gives the sound of the bass drum more punch. Pointing the mic perpendicular to the back drum head produces a fuller sound (see 14-26), and pointing it toward the side of the drum picks up more of the drum's overtones (see 14-27). Placing the mic close to the beater picks up the hard beater sound and, if you are not careful, the action of the beater pedal as well.

When using the multiple miking technique on the drums, the mics are usually directional to increase sound separation and reduce leakage from the rest of the drum set. An omnidirectional mic can be effective in a bass drum, but it has to be isolated from leakage from the other drums. To separate the bass drum even more, use a low-pass filter, shelving, or parametric equalizer to cut off or reduce frequencies above its upper range. Be careful, though — the perceived punch of the bass drum goes into the midrange frequencies. In fact, boosting from 1,600 to 5,000 Hz adds a brighter, sharper snap to the bass drum sound. And the dull,

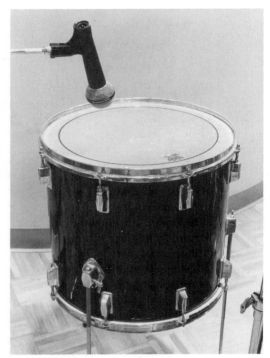

14-28 Miking a floor tom

thuddy, cardboard sound the bass drum tends to produce can be alleviated by attenuating between 300 and 600 Hz.

Although recording session procedures are discussed later in the chapter and the mixdown is treated in Chapter 17, some brief comments about equalizing during recording are included here. First, equalization should not be used as a substitute for good microphone technique or to correct poor mic technique. Second, if you must equalize, make sure you know exactly what you are doing. Even if mistakes in equalizing during recording can be undone in the mixdown, the additional noise and possibly distortion created in passing a signal through an electronic device cannot.

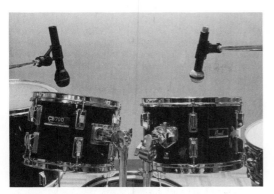

14-29 Miking the high tom (left) and medium tom (right)

Tom-Toms Tom-toms come in a variety of sizes and pitches. Typical drum sets have three toms: the low-pitched, fuller-sounding floor tom, the middle-pitched medium tom, and the higher-pitched, sharper-sounding high tom.

Although toms produce loud transients (all drums do), they are not as strong as those the bass drum produces; therefore, you can mike them with moving-coil, capacitor, or the newer ribbon mics. Placement, as always, depends on the sound you want. Generally, the mic is placed from 1 to 10 inches above the tom and is aimed at the center of the skin. It is usually mounted just over the edge of the rim to avoid interfering with the drummer's sticks (see 14-28 and 14-29).

The mic-to-source distance depends on the low-frequency content desired from the drum sound itself. If it has little low-frequency content, place a directional mic with proximity effect close to the drum skin to boost the lower frequencies. Placing a mic inside the drum gives the best isolation, but it also produces a closed, dull sound. Whatever technique you use, remember the sonic relationships of the toms must be maintained; using the same make and model microphone on each tom helps.

Snare Drum Of all the components in a drum set, the snare usually presents the biggest problem in miking. Most producers prefer a crisp snare drum sound. Miking the snare drum too close tends to produce a lifeless sound, whereas miking it too far away tends to pick up annoying overtones, ringing, and leakage from the other drums.

Another problem is that the snare drum sometimes sounds dull and thuddy, more in the range of a tom-tom. In this instance the problem is most likely the drum itself. Two ways to add crispness to the sound are to (1) use a mic with an extended high-frequency response and (2) equalize it at the console. Boosting at around 5,000 Hz adds crispness and attack. The better alternatives are to retune the drum set and, if that does not work, to replace the drum head(s).

Moving-coil or capacitor microphones work well on the snare drum; the moving-coil mic tends to give it a harder edge, and the capacitor mic tends to make it sound richer or crisper. To find the optimal mic position, begin at a point 6 to 10 inches from the drum head and aim the mic so that its pickup pattern is split between the head and the side of the drum (see 14-30). This picks up the sounds of the snares and the stick hitting the head. To get the snares' buzz and the slight delay of the snares' snap, use two mics: one over and one under the drum (see 14-31).

Hi Hat Cymbal The hi hat cymbal produces two sounds: a clap and a shimmer. Depending on how important these accents are to the music, the hi hat can either share the snare drum's mic or have a microphone of its own. If it shares, place the mic

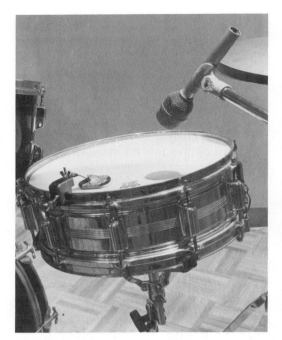

14-30 Miking a snare drum. The pad on the skin of the drum reduces vibrations.

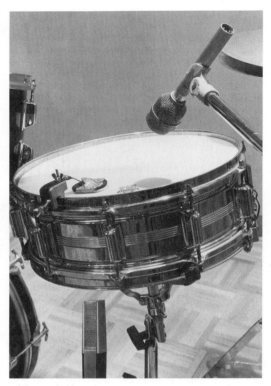

14-31 Miking a snare drum over and under

between the hi hat and the snare and adjust the sound balance through placement of the mic (see 14-32). The hi hat, like the snare, can take either a moving-coil or a capacitor microphone.

If the hi hat has a separate mic, the two most common positions for it are 4 to 6 inches above the center stem with the mic pointing straight down (see 14-33), and off the edge (see 14-34). Sound is brightest over the edge of the cymbal. Miking too close off the center produces ringing, and miking off the edge may pick up the rush of air produced each time the two cymbals clap together (see 14-35). Equalize by rolling off the bass to reduce low-frequency leakage, but only if the hi hat is miked separately. If the mic is shared with the snare drum, rolling off the bass adversely affects the low-end sound of the snare.

Overhead Cymbals Two types of overhead cymbals are the ride, which produces ring and shimmer, and the crash, which has a splashy sound. In miking either cymbal, the definition of the characteristic sounds must be preserved. To this end, capacitors usually work best; and for stereo pickup, the coincident, near-coincident (see 14-18), or spaced pair can be used (see 14-36). When using the spaced pair, remember to observe the three-to-one rule to avoid phasing problems. For mono compatibility, however, the coincident arrays are safest.

The overhead microphones usually blend the sounds of the entire drum set. Therefore, they must be at least a few feet above the

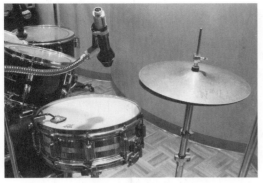

14-32 Miking the hi hat cymbal and the snare drum

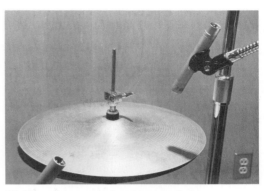

14-33 Miking over the hi hat cymbal

14-34 Miking at the edge of the hi hat cymbal

14-35 A microphone aimed at the point where the cymbals clap may pick up the rush of air as they come together

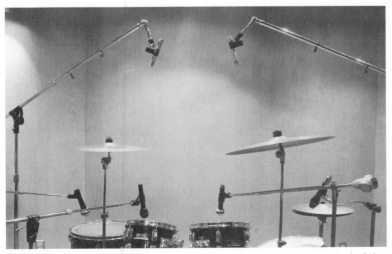

14-36 A spaced pair of directional microphones to pick up the sound of the overhead cymbals and add spaciousness to the overall sound of the drum set

cymbals. If they are too close to the cymbals, the drum blend will be poor, and the mics will pick up very annoying overtones that sound like ringing or gonging, depending on the narrowness of the mic's pickup pattern. If blending the drum sound is being left until the mixdown, and it is important to isolate the cymbals, roll off the low frequencies in the cymbal microphones.

Electric Instruments

Three techniques are used to record an electric instrument such as a guitar or bass: (1) plugging the instrument into an amplifier and placing a mic in front of the amp's loudspeaker, (2) **direct insertion** (D.I.), or plugging the instrument directly into the mic input of the console through a direct box, or (3) both miking the amp and using direct insertion.

Electric instruments are usually high-impedance, whereas professional-quality audio equipment is low-impedance. Not surprisingly, high- and low-impedance equipment are incompatible and produce sonic horrors if connected. The **direct box** is a device that matches impedances, thus making the output of the instrument compatible with the console's input (see 14-37).

Although this chapter deals with microphone technique, it is important to know the differences between miking an amp and going direct. Deciding which method to use is a matter of taste, practicality, and convenience (see Tables 14-3 and 14-4).

When miking an amp loudspeaker, the moving-coil mic is most often used because it can handle loud levels without overloading. With the bass guitar the directional moving-coil is less susceptible to vibration and conductance, especially with a shock mount, caused by the instrument's long, powerful wavelengths. Due to its powerful low end, however, the bass is usually recorded direct

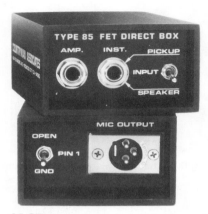

14-37 Direct box. A direct box has an isolated transformer that is less vulnerable to damage, distortion, grounding problems, volume loss, and changes in tone quality. This particular direct box can be battery or phantom powered. To improve sound quality further, many direct boxes are transformerless.

to obtain a cleaner sound. With an electric guitar a directional moving-coil adds body to the sound. But if it is necessary to reproduce a subtler, warmer, more detailed sound, a capacitor or one of the more rugged ribbon mics may be used.

As for placement, the closer the mic is to an amp loudspeaker, the greater is the ratio of direct to indirect waves and, hence, the tighter the sound. If you aim the microphone directly at and on an axis with the amp's loudspeaker cone, the sound will be brighter because it includes the higher frequencies (see 14-38a). If the mic is aimed off center to the speaker cone, the sound will have less hiss and be mellower because some of the high frequencies are lost off-axis (see 14-38b). The decrease in highs gives the impression of a heavier, bassier sound. Hanging a small microphone over the amp emphasizes a guitar's midrange and reduces leakage. If leakage is not a problem, close miking with an omni works well.

In their continuing effort to achieve new sounds, some producers record both amp

Table 14-3 Advantages and disadvantages of miking an amplifier loudspeaker

Advantages	Disadvantages
Adds interaction of room acoustics to sound	Could leak into other mics
Captures more midbass for added punch	Could be noisy due to electric problems with amp
Creates potential for different sound textures	
Gives musician greater control over an instrument's sound output	Level of amp can make it difficult for musicians to hear less powerful instruments
Permits other instrumentalists more chance to hear what the electrical instruments are playing so that the acoustic players can interact better with electrical instruments	Distortion

Table 14-4 Advantages and disadvantages of direct insertion

Advantages	Disadvantages
Has a cleaner sound	Has a drier sound—no room ambience
Captures more high and low frequencies	May use a transformer, which adds another electronic device to the sound chain
Allows more sound control at the console	Too present
Eliminates leakage	
Does not require an amp	

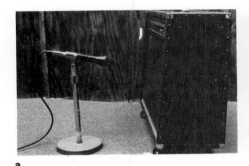
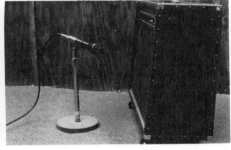

a b

14-38 Miking an amplifier loudspeaker. (*a*) Aiming a directional microphone at the loudspeaker produces a brighter sound. (*b*) Aiming a directional microphone at an angle to the loudspeaker produces a fuller but less bright sound.

loudspeaker and direct insertion feeds simultaneously. This technique combines the drier, unreverberant but crisp sound of direct insertion with the acoustic coloring of the amplified sound. The amp and D.I. signals should, however, be recorded on separate tracks. This provides more flexibility in the mixdown

when the two sounds are combined, or if you decide not to use one of the tracks.

It should be noted that direct recording of guitars does not necessarily guarantee a leakage-free track. If a guitar pickup is near or facing a loud instrument, it will "hear" the vibrations. By turning the musician away

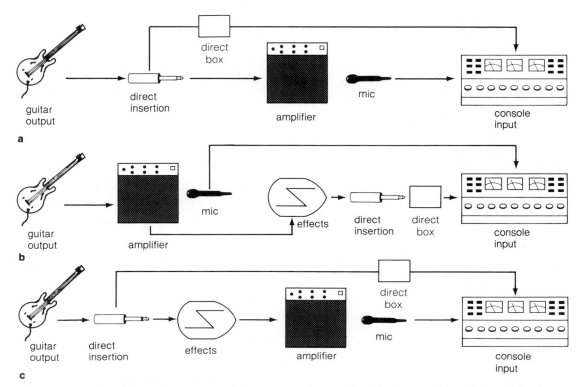

14-39 **Techniques used to record direct and amplified signals simultaneously.** (a) The signals are recorded on separate tracks. (b,c) Special effects boxes can be used; c shows the usual technique, and b illustrates an alternate technique.

from the direct sound waves or by putting a baffle between the instruments, leakage is reduced.

With the electric guitar, special effects boxes are often used to add to the sonic possibilities (see 14-39). Here, too, the various signals should be recorded on separate tracks, if possible, to allow flexibility in the mixdown.

Recording electric bass presents a particular challenge. If there is too much bass, the sound is muddy. In the mix this could mask the fundamentals of other instruments and result in a thickening and weighing down of the overall sound. Among the ways to improve clarity are to have the bassist increase treble

and reduce bass on the guitar or to equalize in the control room by attenuating around 250 Hz and boosting around 1,500 Hz.

Compression is commonly used in recording the electric bass. It helps to reduce noise, smooth variations in attack and loudness, and tighten the sound. Be careful in setting the compressor's release time. If it is too fast in relation to the decay rate of the bass, the sound will be organlike. A slower release time maintains the natural sound of the instrument. Too slow a release time muddies the sound.

Musicians' Amplifiers An amp often produces annoying hum. Using a microphone

14-40 **Miking a Leslie amplifier loudspeaker.**
One way is with two directional microphones, one to pick up the highs and the other to pick up the lows. The greater the mic-to-source distance, the less the chance of picking up the rotor sounds and increased tremolo and the better the sound blend. To record stereo, use either a top and bottom pair of mixed mics left and right or just single mics panned toward the left and right. If the sound of the rotating horn is desired, place a boundary microphone inside the cabinet.

with a humbuck coil can help reduce hum but not always enough. It also helps to turn up the loudness control on the guitar and turn down the volume on the amp and to use guitar cables with extra shielding. Moving the musician around the studio until a spot is located where the hum is reduced or disappears is another solution. If it is possible, convince the musician to use a smaller, lower-powered amp than is used in live concerts. There may be a problem here, however, because the change in amp produces a change in sound.

Leslie Loudspeaker Cabinet The Leslie amplifier loudspeaker, usually used with an electric organ, is almost an instrument in itself (see 14-40). It is not a loudspeaker in the normal sense but is designed especially to modify sound. It contains a high-frequency loudspeaker (the tweeter) in the upper portion and a low-frequency loudspeaker (the woofer) in the lower portion. The two loud-

speaker systems rotate, creating a vibrato effect.

Plucked Acoustic String Instruments

Among the more commonly used instruments in this category are the guitar, mandolin, and banjo. The guitar and mandolin are similar in construction; therefore, miking techniques applicable to one usually produce about the same results with the other. Because the guitar is a dominant instrument today, we will focus on it. The banjo's action is somewhat different and is discussed separately.

A main difference between an electric and acoustic guitar, aside from the obvious one, is that the acoustic guitar produces more intimate, subtle sounds. Miking, therefore, calls for more precision. Because most of the sound comes from the hole in the guitar body, centering a microphone at the middle of the hole should, theoretically, provide balanced sound. But if a mic is too close to the hole, sound is bassy or boomy. If it is moved closer to the bridge, detail is lost. If it is moved closer to the neck, presence is reduced; if it is moved farther away, intimacy is destroyed. On the other hand, if a guitar lacks bottom, mike closer to the sound hole; if it lacks highs, mike closer to the neck; to increase midrange, aim a mic at the bridge.

A difference between a plucked and a bowed acoustic string instrument is that the pluck creates a quick attack. Using a dynamic mic, which has slower transient response than a capacitor microphone, can slow the attacks and diminish detail, particularly in the bass frequencies. If a capacitor mic brings out too much crispness, however, a good moving-coil microphone can reduce it.

No doubt dozens, perhaps hundreds, of methods have been used to mike the guitar. A few general techniques are discussed here,

14-41 **Miking an acoustic guitar.** Aiming a micro-
phone at the center of the guitar hole 1 to 3 feet away
produces a sound with balanced highs, middles, and
lows.

14-42 **Miking an acoustic guitar.** A microphone
placed about 6 inches above the bridge and even with
the front of the guitar brightens the natural sound of
the instrument.

but keep in mind that many factors affect a
guitar's sound: how the instrument is made,
what a player's technique is, what the strings
are made of, whether they are plucked with
fingers or with metal or plastic picks.

One way to achieve a natural, balanced
sound (without the need for signal process-
ing) is to position the microphone about 1 to
3 feet from the sound hole. To set more high-
or low-frequency accent, angle the mic either
down toward the high strings or up toward
the low strings. To brighten the natural
sound, place the microphone above the
bridge and even with the front of the guitar,
because most high-frequency energy is ra-
diated from a narrow lobe at right angles to
the top plate (see 14-41 and 14-42).

Another way to achieve natural sound is
to place a microphone about 8 inches to
1 foot above the guitar, 1 to 2 feet away,
aimed between the hole and bridge. A good-
quality capacitor mic reduces excess bottom
and warms the sound.

A microphone perpendicular to the sound
hole about 8 inches away reduces leakage
from other instruments but adds bassiness.
Rolling off the bass creates a more natural

sound. If isolation is critical, move the micro-
phone closer to the sound hole. In this posi-
tion bassiness increases and sound becomes
boomy or muddy; bass roll-off definitely
would be needed.

A microphone about 4 to 8 inches from
the front of the bridge creates a warm, mel-
low sound, but the sound lacks detail; this
lack is beneficial if pickup and string noises
are problems.

For a classical guitar, which requires acous-
tic interaction, place the microphone more
than 3 feet from the sound hole. Make sure
mic-to-source distance is not too great or
the subtleties of the instrument will be
diminished.

Clipping a microphone to the tip of the
sound hole facing in toward the center or
placing the microphone inside the guitar
gives good isolation and added resonance. A
mic attached inside the sound hole also
reproduces more bass and less string noise
(see 14-43).

The banjo differs from the guitar and
mandolin because its strings are attached to
a head across which sounds are distributed.
The fundamental frequency is louder near

a b

14-43 **A guitar miked with a clip-on miniature mic.** (*a*) Mounted to the lip of the sound hole, it gives good isolation and added resonance. The microphone must be of high quality if the guitar's broad frequency range and its overtones are to be captured faithfully. (*b*) Same mic mounted on a violin (see section on bowed string instruments).

the center of the head, and the harmonics are louder near the edges.

A microphone placed 1 to 2 feet from the center of the head produces a natural and balanced sound. Sound begins to get bassy closer than a foot from the head's center, and roll-off is usually necessary; leakage is reduced, however. Miking a few inches from the edge of the head produces a brighter sound.

A natural part of most plucked string instruments' sound is the screechy, rubbing noises called *fret* sounds caused by the musician's fingering. Some musicians are more heavy-handed than others. When a musician is heavy-handed, it usually brings to a head the problem of whether the fret sounds, which are a natural part of the instrument's sound, should be part of the recording. Personal taste is the determining factor. If you do not care for the fret sounds, mike farther from the instrument or use a supercardioid or hypercardioid mic placed at a slight angle

to the neck of the instrument (see 14-44). This puts the mic's dead side facing the frets. Make sure the mic's angle is not too severe, or the sound from the instrument will be off-mic. There are also strings specially designed to reduce finger noises.

Bowed String Instruments

The bowed string instruments — violin, viola, cello, bass — resonate at the top, bottom, front, and back of the body, reinforcing their strings' vibrations. Their dynamic range is not as wide as most other orchestral instruments, nor is their projection as strong (see 14-45). Sound has to be reinforced by using several instruments or multiple miking, or both, depending on the size of the sound required. Overdubbing, discussed later in the chapter, is another method used to reinforce string sound. The need for reinforcement is compounded by the dearth of competent string players in many communities, to say

fret

14-44 **Microphone placement to reduce loudness of fret sounds.** Place the dead side of a supercardioid or hypercardioid mic opposite the guitar's neck to reduce fret sounds without interfering with the overall frequency response.

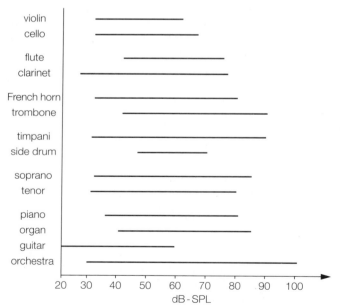

14-45 Dynamic range of selected musical sound sources

a

b

14-46 Miking a violin or viola. (a) Placing the mic several feet above the instrument, aimed at the front face, tends to produce an open, natural sound. (b) To produce a country fiddle sound, place the microphone closer to the bridge but not close enough to interfere with the bowing.

nothing of the cost of hiring very many of them where they do exist in sufficient numbers.

With the violin and viola, the radiating pattern is spherical in the lower frequencies and then progressively narrower in the higher frequencies and harmonics. The playing angle directs most high frequencies upward. Fundamental frequency ranges for the violin and viola, respectively, are 196–2,500 Hz and 130–1,050 Hz.

Individually, miking a violin or viola a few feet above the instrument, aiming the mic at the front face, produces an open, natural sound, assuming fairly live acoustics (see 14-46). Although sound radiation is uniform up to 500 Hz, depending on the microphone,

a single mic may not hear sufficient low end and, therefore, not reproduce a robust sound. Miking "over and under" assures that the highs, which are concentrated above 500 Hz and radiate perpendicularly to the sound board, are picked up from above the instrument and the lows are picked up from both above and below. This technique also tends to make one instrument sound like a few and a few sound like several (see 14-47). Overdubbing will accomplish this with greater effectiveness, however.

Miking a few inches from the side or above the strings of a violin produces a country fiddle sound; the closer a microphone is to the strings, the coarser or scratchier the sound. Be careful, however, not to interfere with the musician's bowing when close-miking over bowed instruments.

The fundamental frequency range for the cello is 65–520 Hz; for the acoustic bass it is 33–250 Hz. Generally, for either instrument, miking off the bridge 2 to 3 feet produces a brighter sound and miking off the f-hole produces a fuller sound. A miniature mic wrapped in foam padding taped behind the bridge produces a closed, tight sound (see 14-48).

With a plucked bass, used in jazz, some producers like to clip a mic to the bridge or f-hole for a more robust sound. A danger with this, however, is getting a thin, midrange-heavy sound instead. Close-miking a plucked bass will pick up the attack. If close-miking also produces too boomy a sound, compress the bass slightly or roll off some of the low end, but beware of altering the characteristic low-frequency sound of the instrument.

Capacitor and ribbon microphones work particularly well with bowed string instruments. Capacitor mics enrich the string sound and enhance detail. Ribbon mics produce a resonant, warm quality, although

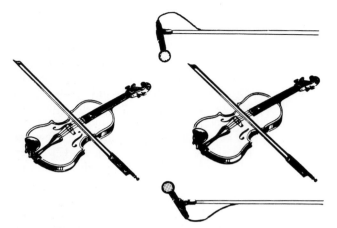

14-47 Enlarging the sound of a violin or viola. Place one microphone several feet over the instrument(s) and one microphone under the instrument(s). This tends to make one instrument sound like a few and a few sound like several.

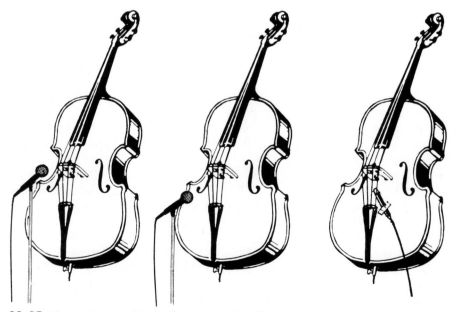

14-48 Three ways to mike a cello or bass. (*a*) Off the bridge produces a brighter sound. (*b*) Off the f-hole produces a fuller sound. (*c*) A mic behind the strings, near or at the bridge, taped to the body of the instrument, produces a more resonant sound, which could also be dull and devoid of harmonics.

there may be some loss of high-end detail. As for plucked strings, capacitors are preferred because of their excellent transient response.

Piano

The piano is another instrument that offers almost unlimited possibilities for sound shaping. More than with many other instruments, however, the character of the piano sound is dependent on the quality of the piano itself. Smaller grand pianos may have dull, wooden low-end response. Old or abused pianos may sound dull or ring or thump. Steinways, generally, are built to produce a lyrical sound. Yamahas produce crisp sound with more attack. The Bosendorfer aims for additional sonority by adding semitones in the bass range.

Mic technique and signal processing cannot change a piano's voicing from dull to bright, from thin to rich, or from sharp to smooth, but they can alter a piano's existing sound. There are several common miking techniques for the grand piano (see 14-49) and the upright piano (see 14-50).

Although the techniques displayed in Figure 14-49 are among the common ones used in miking a grand piano, they do not address the fact that you have to be some distance from the piano to get its full sound—close distances yield only partial sound—because its dynamic range can be so wide. In studio recording there is the additional problem of leakage in the piano mics from other instruments, thus necessitating closer mic-to-source distances. Because there is more piano sound across the bridge–rail axis than horizontally along the keyboard, try miking along the piano instead of across it (see 14-51). This should reproduce a more spacious, full-bodied sound. A clear low–high stereo image is sacrificed, however, because the sound is more blended.

Brass

Brass instruments—trumpet, trombone, French horn, baritone, tuba—are the loudest acoustic musical instruments and they also have the widest dynamic range (see 14-45). Hence, they require care in microphone placement and careful attention in adjusting levels at the console. Their range of fundamental frequencies are: trumpet, 165–1,175 Hz; trombone, 82–520 Hz; French horn, 62–700 Hz; tuba, 29–440 Hz.

Brass instruments emit the most directional sound; high-frequency harmonics radiate directly out of the bell. But the most distinctive frequencies of the trumpet and trombone are in the harmonics around 1,200 Hz and 700 Hz, respectively, which are radiated from the sides of the bell. Below 500 Hz, radiation tends to become omnidirectional. Therefore, close-miking brass instruments with a directional microphone does not quite produce their full frequency response. A directional mic close to and in front of the bell produces a bright, biting quality. Miking at an angle to the bell or on-axis to the side of the bell produces a more natural, mellower, more hornlike sound (see 14-52).

About 1 to 5 feet is a good working mic-to-source distance. Closer placement gives a tighter sound, although miking too close to a brass instrument could pick up spit and valve sounds. More distant placement makes the sound fuller and more emphatic.

For the French horn, a mic-to-source distance of at least 5 feet is recommended. Although the French horn is not the most powerful brass instrument, its harmonics can cut through and overwhelm louder instruments, and its levels fluctuate considerably. To increase control and to minimize French horn leakage, move the instrument away from the ensemble (see 14-53).

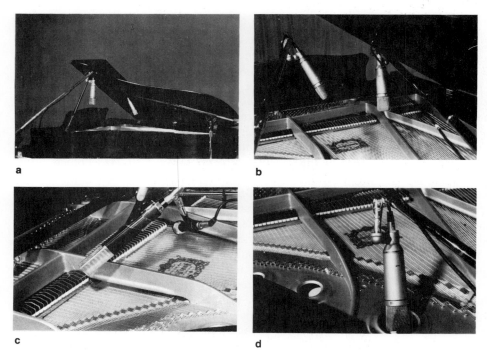

14-49 Miking the grand piano. (*a*) Two directional microphones, one pointed at the piano's sounding board mainly to pick up direct sound and another a few feet away facing the raised lid to pick up reflections from the lid, produce a natural sound that is also open and, if acoustics are suitable, spacious. (*b*) One directional microphone above and facing the high strings and one directional microphone above and facing the low strings produce a good stereo blend with more discrete high and low frequencies. Adjust the mics to compensate for the time and intensity differences between the low and high frequencies. (*c*) Positioning microphones just above the hammers adds the "kiss" of hammer and string to the piano sound. In this particular arrangement a ribbon microphone picks up the low-frequency sounds to enhance their warmth, and a microphone with a transparent aural quality picks up the high-frequency sounds to enhance their clarity. This technique may also pick up annoying pedal action. (*d*) A microphone positioned in a sound hole (middle) produces a dull, close sound, although it is good for isolation. A mic in the high-end (smaller) sound hole and one in the low-end (larger) sound hole produce good stereo separation. These approaches require careful placement to avoid, if possible, unwanted ring and lack of detail. To reproduce the full potential of the piano's dynamic range, techniques *b*, *c*, and *d* require additional mics at least a few feet from the sounding board.

In miking brass sections, trumpets and trombones should be blended as a chorus. One microphone for each pair of instruments produces a natural, balanced sound and provides flexibility in the mixdown. If you try to pick up more than two trumpets or trombones with a single mic, it has to be far enough from the instruments to blend them, and the acoustics have to support the technique. Of course, leakage will occur. Mike baritones and tubas individually from above (see 14-54).

The type of microphone you use can also help shape the sound of brass. The moving coil can smooth transient response; the ribbon can add a fuller, warmer tonality; and

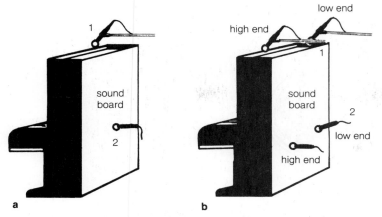

14-50 Miking an upright piano. (*a*) For mono, position a mic over an open top (1) for a natural sound, or behind the sound board (2) for a fuller, tubby sound. (*b*) For stereo, position two microphones, one for low-end pickup and the other for high-end pickup, over an open top (1) or behind the sound board (2). Mics also can be placed inside the piano to pick up the hammer sound. When spacing the mics, remember the three-to-one rule.

14-51 Miking across the bridge–rail axis. This produces a spacious, full-bodied sound, but at the expense of low end–high end stereo imaging

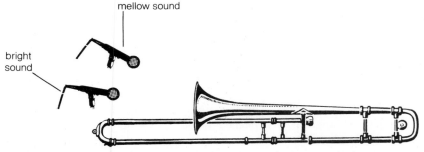

14-52 Miking off the bell. Mike trumpets, trombones, baritones, and tubas at an angle to the bell for a natural, mellower sound, being careful to avoid close mic-to-source distances so the air flow and spit sounds are not heard. Miking in front of the bell produces a brighter sound.

14-53 Miking the French horn. (*a*) To control leakage, place the musician away from the ensemble and the microphone near a soft baffle pointing at the bell. (*b*) If this arrangement creates a blending problem due to the French horn's lack of presence, placing a hard baffle a few feet from the bell should carry the sound to the mic in sufficient proportions.

the capacitor can produce accurate transient response.

Woodwinds

Woodwind instruments (and their range of fundamental frequencies) include the flute (247–2,100 Hz), clarinet (145–1,570 Hz), oboe (233–1,400 Hz), bassoon (58–520 Hz), and saxophone (alto saxophone—138–820 Hz). Woodwind instruments, such as the flute, clarinet, and oboe are among the weaker-sounding instruments and have a limited dynamic range. Alto, tenor, and baritone saxophones are stronger-sounding. But the higher-pitched woodwinds—flute, clarinet, soprano saxophone—can cut through the sound of more powerful instruments if miking and blending are not properly attended to (or if the sound designer intends it).

14-54 Miking the baritone and tuba from above the bell

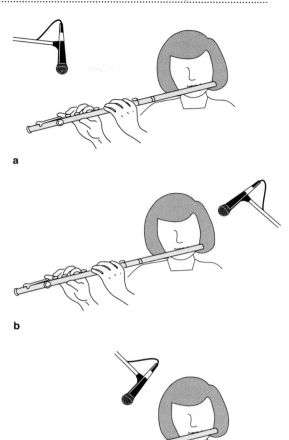

a

b

c

14-55 **Miking flute and piccolo.** (*a*) Placing a microphone over the finger holes nearer the bell picks up most of the sounds these instruments emit and does not pick up the breathy sounds that miking the mouthpiece produces. (*b*) Some producers feel that these sounds are part of the instruments' overall aural character, however, and mike the mouthpiece to produce a thinner-textured sound. (*c*) If unwanted breath sounds persist, place the microphone behind the musician's head and aimed at the finger holes.

Because most woodwinds are not powerful instruments, the tendency is to close-mike them, but, due to their sound radiation, this results in an uneven pickup. They should be miked far enough away so the pickup sounds blended and natural.

With the flute and piccolo (a smaller, higher-pitched version of the flute) sound radiates in shifting patterns sideways and from the instruments' end hole. As a result, close miking, or, worse, contact miking, tends to miss certain frequencies and emphasize others. Moreover, dry, less reverberant sound can distort some tonalities.

For the flute, mic-to-source distance depends on the music. For classical music, it should be about 3 to 8 feet; for pop music, about 6 inches to 2 feet. Microphone positioning should start slightly above the player, between the mouthpiece and the bell. To add the breathy quality of the blowing sound, mike toward the mouthpiece—how close de-

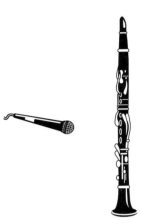

14-56 Miking clarinet and oboe. Place a microphone over the finger holes toward the bottom third, because most of the sounds come from this part of the instrument. In miking the keys of any instrument, avoid close mic-to-source distances; otherwise, the sound of the moving keys will be heard.

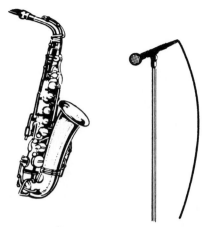

14-57 Miking a saxophone. Aiming a microphone at the holes from above the bell produces a natural, blended sax sound. Miking too close to the instrument may pick up blowing, spit, or key sounds.

pends on how much breath sound you want. If breath noise is a problem regardless of where the mic is placed, and you want to eliminate it, try placing the microphone behind the player's head, aiming it at the finger holes (see 14-55). This technique also reduces high-frequency content. A windscreen or pop filter reduces unwanted breath noise, too. In miking a flute or any woodwind, be careful not to pick up the sound of the key action.

Microphone positioning for the clarinet and oboe must take into account the narrowing of high frequencies radiating in the vertical plane in front of the player and floor reflections from the bell being aimed downward. Close-miking tends to emphasize these disparities. If close-miking is unavoidable, position the mic to the side of the bell rather than straight at it. This should smooth most of the sonic anomalies. Miking off the bell also tends to reduce leakage and makes the sound brighter and harder. Another possibility is to mike toward the bottom third of the instrument and far enough away to blend the pickup from the finger holes and bell (see 14-56).

Saxophones radiate more sound from the bell and some sound from the holes. The proportion of sound radiating from holes and bell constantly changes, however, as the keys open and close. Miking saxophones off the bell produces a bright, thin, hard sound. Miking too close to the bell further accentuates the high frequencies, making the sound piercing or screechy. Miking off the finger holes adds fullness, presence, and warmth. Aiming a microphone at the holes from above the bell produces a natural, more blended sound (see 14-57).

In an ensemble woodwinds should be miked closer than the louder instruments. It may be necessary to put a separate microphone on each woodwind or have no more than two woodwinds share a single mic.

Vocals

Although the speaking voice has a comparatively limited frequency range, the singing voice does not (see 14-58). And whereas the speaking voice is comparatively straightforward to mike and record, the singing voice

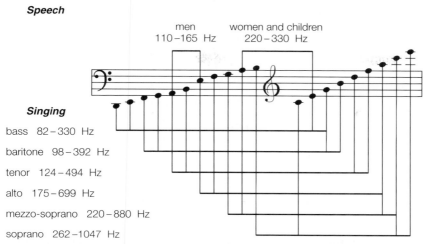

Speech

men
110–165 Hz

women and children
220–330 Hz

Singing

bass 82–330 Hz

baritone 98–392 Hz

tenor 124–494 Hz

alto 175–699 Hz

mezzo-soprano 220–880 Hz

soprano 262–1047 Hz

14-58 **Fundamental frequency ranges for speech and singing in the human voice**

can place a severe test on any microphone. The singing voice is capable of almost unlimited and subtle variations in pitch, timbre, and dynamic range. There are also **plosives** and sibilance—annoying popping and hissing sounds—to deal with.

Timbre In choosing a vocal mic, the most important consideration is the singer's timbre—how edged, velvety, sharp, mellow, or resonant the voice sounds. The microphone should enhance a voice's attractive qualities and minimize the unattractive. For example, if a voice sounds mellow, a ribbon mic may enhance the mellowness, but if a voice sounds low-pitched, the ribbon mic could muddy its quality. If a voice sounds too sharp or edged, the ribbon mic would smooth the sound, but a moving-coil or capacitor mic could make the voice sound more cutting. A capacitor mic may add richness to a voice that is soft and has little projection; a moving-coil type may help to thin out a voice that sounds too full.

Generally, assuming there are no serious problems with tone quality, most producers prefer to use capacitor microphones for vocals because they can better handle the complicated pattern of overtones in the human voice, and overall sound quality is the most natural.

Dynamic Range Controlling the dynamic range—the quietest to loudest levels a sound source produces—is another tricky problem. Well-disciplined singers can usually control wide fluctuations in the dynamic range themselves. But many singers cannot; their voices barely move the needle on the VU meter during soft passages and pin it during loud ones. In miking these vocalists, a producer has three alternatives: (1) ride the level, (2) adjust the vocalist's microphone position, or (3) use compression.

Riding the level works but it requires an engineer's full attention, and this may be difficult considering everything else that goes on in a recording session. Also, less-gifted singers may handle dynamic range differently each time they sing, which means that riding the level is a matter more of coping than of aiding.

The preferred methods are to use microphone technique to adjust for irregularities in a vocalist's dynamic range or to use compression, or both. In pop music, vocals are often compressed 10–15 dB. To do so, however, requires that a sound designer know how to compensate after compression.

One placement technique is to situate the singer at an average distance from the mic relative to the loudest and softest passages sung; the distance depends on the power of the singer's voice and the song. From this average distance you can direct the singer how close to move to the mic during quiet passages and how far for the loud ones. The success of this technique depends on the vocalist's microphone technique — the ability to manage the song and the movements at the same time.

Breathing, Popping, and Sibilance The closer to a microphone a performer stands, the greater is the chance of picking up unwanted breathing sounds, popping sounds from p's, b's, k's, and t's, and sibilance from s's. If the singer's vocal projection or the type of music permits, increasing the mic-to-source distance significantly reduces these noises. Windscreens also help, but they tend to reduce the higher frequencies. Other ways to reduce popping and sibilance are to have the singer work slightly across mic but within the pickup pattern or to position the mic somewhat above the singer's mouth (see 14-59). If this increases nasality, position the mic at an angle from slightly below the singer's mouth. If leakage is no problem, using an omnidirectional mic permits a closer working distance because it is less susceptible to breathing, popping, and sibilant sounds; but sound will be less intimate because an omnidirectional microphone picks up more indirect sound waves than does a directional mic. But the closeness of the singer will

14-59 Eliminating unwanted vocal sounds. Positioning the microphone slightly above the performer's mouth is a typical miking technique used to cut down on unwanted popping, sibilance, and breathing sounds.

often overcome the larger amount of indirect sound picked up.

Mic-to-Source Distance Versus Style Generally, the style of the music sets the guidelines for mic-to-source distance. In popular music vocalists usually work close to the mic, from a few inches to a few feet, to create a tight, intimate sound. Classical and jazz vocalists work from a few feet to several feet from the mic to add room ambience, thereby opening the sound and making it airy (see 14-60).

When close-miking be careful of proximity effect. Rolling off the unwanted bass frequencies may be one solution, but it almost certainly will change the delicate balance of voice harmonics unless it is very carefully and knowledgeably effected.

It should be emphasized that regardless of the type of microphone or quality of singer, using a mic just about touching the lips, as some vocalists are seen doing on television, and which unfortunately is imitated in the recording studio, rarely produces ideal sound. Indeed, if the microphone is not up to it, such mic technique rarely produces usable sound. If the distortion does not get you, then the oppressive lack of "air" will. Singers should try to keep 6 inches away from the mic. Most singers on TV who "eat the microphone" do so as part of the visual dynamics of the act — sometimes the mic is not live; the live mic is body-mounted and wireless. When

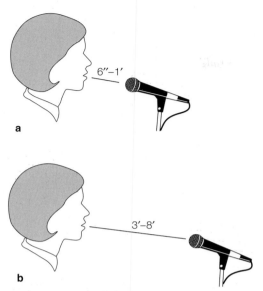

a

b

14-60 **Mic-to-source distance and music style.**
Distances vary with the vocalist and the music. Gener-
ally, (a) pop singers prefer closer working distances than
do (b) classical singers due to differences in style, loud-
ness, and projection.

the mic is live, it almost certainly has a built-
in pop filter and shock mount and can take
loud sound pressure levels without distor-
tion. If it is a capacitor mic, the pad is often
used. Some reverb is also added to the sound.

Backup Harmony Vocals Once the lead vo-
cal is recorded, the accompanying backup
harmony vocals are overdubbed. Often, this
involves a few vocalists singing at the same
time. If they have their own individual micro-
phones, mic-to-source distances are easier to
balance, but this also adds more mics to
control and could require using extra tape
tracks. Another technique groups the vocal-
ists around a bidirectional or omnidirec-
tional microphone. This reduces the number
of microphones and tape tracks involved, but
it requires greater care in balancing and
blending harmonies. Backup vocalists must

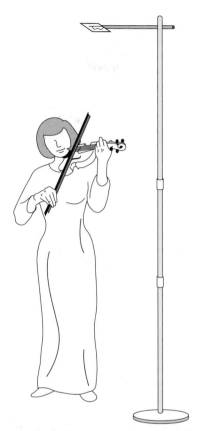

14-61 **Boundary mic positioned over a violin (or
viola).** To stereo-image the instrument the PZM SASS
mic could be used instead of the single mic.

be positioned to prevent any one voice or
harmony from being too strong or too weak.

Boundary Microphone Techniques

A boundary microphone with a hemispheric
polar pattern is not good for spot or isolation
miking due to its pickup pattern. The newer,
directional boundary microphones can be
used in spot-miking situations, however. Fig-
ures 14-61 through 14-65 display a few appli-
cations of boundary microphone techniques
in music recording.

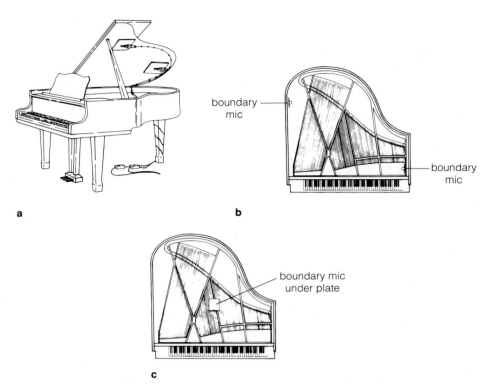

14-62 Miking a piano with boundary mics. (*a*) A pair of spaced boundary mics for stereo pickup are attached to the piano lid, one mic over the high strings and one mic over the low strings. (*b*) If the lid is removed, a pair of mics can be taped (with masking tape, not duct tape) to the inside of the frame, one near the high strings and one near the low strings. (*c*) For mono pickup a boundary mic faced down over the intersection of the high and low strings should provide a balanced sound. Taping a boundary mic to the piano lid and closing it produces a sound much like that of an upright.

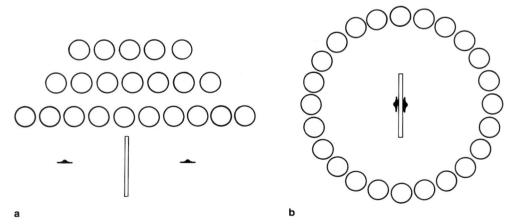

14-63 Two arrangements for stereo miking a chorus. (*a*) Two boundary mics are placed in front of the group and separated by a baffle. (*b*) Two boundary mics are attached to and separated by a sheet of Plexiglas surrounded by the chorus. In (*a*) the PZM SASS mic could be used instead.

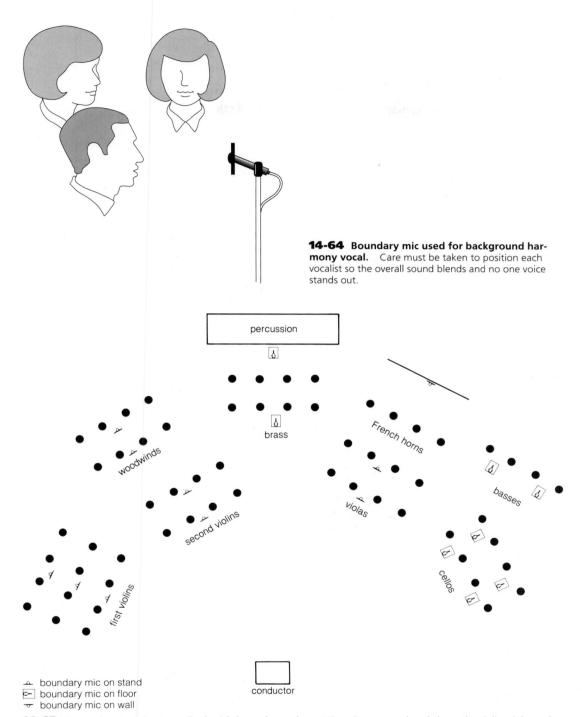

14-64 Boundary mic used for background harmony vocal. Care must be taken to position each vocalist so the overall sound blends and no one voice stands out.

percussion

brass

woodwinds

French horns

second violins

violas

basses

first violins

cellos

conductor

⊥ boundary mic on stand
⊡ boundary mic on floor
⊤ boundary mic on wall

14-65 A symphony orchestra miked with boundary mics. Microphones are placed above the violin, viola, and woodwind sections; on the floor in front of the brass, cello, bass, and percussion sections; and on the wall (or curtain) behind the French horns.

Miking Studio Ensembles

Except for a few comments about sectional miking, this discussion of close miking has centered on the individual instrument, because so much of today's music records one at a time or else a few voicings in an ensemble at one time. There are studio situations, however, in which ensembles record as a group; this situation requires that individual instruments or sections, or both, be miked all at once. It also requires isolating them as much as possible to avoid sonic confusion, yet blending them so that they sound cohesive. Figures 14-66, 14-67, and 14-68, as well as Figure 14-72, show a few ways to mike studio ensembles.

Miking Music for Digital Recording

As clear and noise-free as digital sound can be, there are valid complaints about digital recordings: that the high end is strident, thin, and shrieky, or that there is too much unwanted noise from amplifiers, pedals, keys, bows, tongue, teeth, lips, and so on. Many of these problems can be traced to two causes: the microphones and the miking techniques that were used.

Microphones in Digital Recording

Many microphones used in analog recording are selected for their rising high-end response; these mics help to deal with problems associated with analog reproduction, the most serious being the potential loss of high-frequency information during disc mastering and copying. There is little such loss in digital recording, copying, or mastering. (Uneven quality in the manufacture of CDs is, alas, another story altogether.) Therefore, using such mics for digital recording only

makes the high frequencies more biting and shrill. To avoid this problem, use microphones with smooth high-end response.

Capacitor microphones have preamplifiers, which generate noise. In analog recording, this noise is usually masked. In digital recording, if preamp noise is loud enough, it will be audible. Therefore, high-quality, large-diaphragm capacitors are preferred because their self-generated preamp noise is very low level.

The newer, more rugged ribbon microphones have become popular in digital recording. Their response is inherently nontailored, smooth, warm, and detailed, without being strident.

Microphones used in digital recording should be linear — that is, output should vary in direct proportion to input. The mic should not introduce unwanted sonic information because, in digital sound, chances are it will be audible. Of course, this is the case in analog recording as well; it is just more critical in digital recording.

Also, mics used in digital recording should be high-quality, carefully handled, and kept in clean, temperature- and humidity-controlled environments. The dust, moisture, and rough handling that may not perceptibly affect mic response in an analog recording may very well sully a digital recording.

Microphone Technique in Digital Recording

In analog recording, close miking was employed virtually pro forma, because vinyl records usually smoothed the rough spots resulting from close miking by burying some of the harshness in background surface noise. In digital recording, no such masking occurs. For example, in analog recording, when close-miking an acoustic guitar, no one is concerned about noise that might be generated by the guitarist's shirt rubbing against

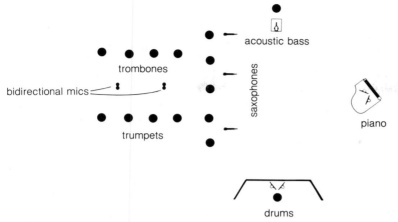

14-66 **Miking a jazz band when all voicings are recorded at the same time.**
Notice trumpets and trombones are miked with bidirectional microphones and that
the piano, acoustic bass, and drums are miked with boundary mics. Bidirectional
mics are particularly useful in reducing leakage. For example, by facing the mic
straight down in front of each saxophone, each mic's nulls are directed toward
sound coming from the sides and rear. This is especially effective when woodwinds,
or other weak instruments, are in front of brass, or other strong instruments. A high-
ceilinged room is necessary for this technique to work, however.

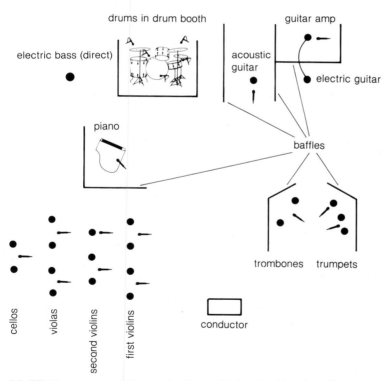

14-67 **One way to position and mike a mixed ensemble when all
voicings are recorded at once**

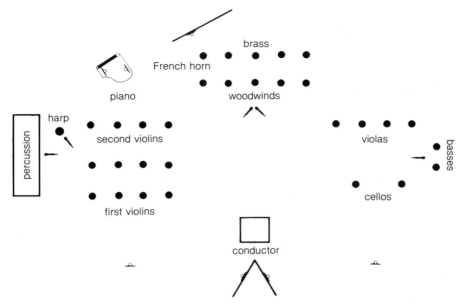

14-68 **One setup and microphone arrangement for studio recording a symphony or-chestra.** Boundary mics are mounted in front of the violins and cellos/violas, and a stereo pair of boundary mics are mounted above and behind the conductor for overall blending, as well as on the piano and behind the French horn. Coincident mics are positioned in front of the woodwinds/brass.

the instrument. By contrast, in digital record-ing, the rubbing sound may be heard if the guitar is close-miked. In addition, in analog recording, noise from a musician's amplifier may get lost in tape hiss. That will not be the case in digital recording, regardless of the mic used.

Even if mic-to-source distance is accept-able for digital recording, microphone place-ment may not be. For example, the upper harmonics of a violin radiate straight up in two directions. If a microphone is placed di-rectly in one of these paths, the digital sound will be too crisp and shrieky, even though the mic is at an optimal distance from the violin. By placing the mic more in the path of the lower-frequency radiations, the digital sound should flatten.

High frequencies of brass instruments are radiated straight ahead in a relatively narrow

beam. Placing a microphone directly in front of the bell will produce a harsh digital re-cording. Placing the mic at more of an angle to the bell, to pick up a better blend of the lower frequencies, should smooth the sound.

Knowing the physics of musical instru-ments is critical to producing any music re-cording, but it is especially so in producing digital sound. This subject, however, is be-yond the purview of this book. A few fine references on the subject are listed in the bibliography.

Producing Live Music

Today, live music can be produced in two ways: (1) conventionally, by taping and mix-ing the performances of an ensemble of mu-sicians, and (2) by employing **MIDI—Musi-**

cal Instrument Digital Interface. With MIDI a single player/operator can perform and produce an entire recording, in any combination of voicings, using several devices at the same time, without the need for a recording studio or audiotape. Therefore, in this section we examine both conventional studio music production and MIDI production.

Pressure and Diplomacy

Studio recording is physically, mentally, and emotionally draining. Sound quality cannot be masked behind audience din or the loudness of the full ensemble playing together. Everything is heard. In some ways the difference between concert and studio work is analogous to the difference between a long shot and a close-up. In a long shot subtle action goes unseen; in a close-up even the slightest twitch is perceived. The studio is like a laboratory and can be as sterile, even if lighting and decor have been enhanced. Stopping and starting to get things right and overdubbing (see section on overdubbing techniques) break concentration. Repetition drains spontaneity and inspiration. Long sessions are creatively and physically wearing. There is no audience reaction to pump up adrenaline. Tension and pressure are exacerbated by the need to use time as economically as possible because studio (and musicians) costs are high. In short, studio recording requires mental discipline and physical endurance.

Therefore, before we talk about the recording session itself, a word about an extremely important, but often forgotten, aspect of "creating by committee": tact. It often makes or breaks a performance.

Studio sessions should be enjoyable and loose. Bantering, joking, remembering common courtesies such as "please" and "thank you," paying compliments when they are deserved, and being diplomatic when they are not, all help to keep pressure from building,

squabbles from erupting, and confidence from collapsing.

Dealing with egos is complicated enough, but when they belong to creative people, you almost have to feel what they are trying to communicate, verbally and musically, to be effective. Moreover, the musicians must have confidence in your commitment to their "vision" and in your ability to help them achieve it. Remember: A comfortable musician is a better musician.

Preparation

Being prepared goes a long way toward making the most of studio time and ensuring a successful recording session. Although each session is different, the following checklist of preparatory procedures serves most situations.

- *Make sure that you and the musicians know what a facility can do.* Recording studios vary greatly in their acoustics and equipment. Before a studio is booked, be sure it can provide the appropriate sonic environment and technical capability to produce your recording.

- *Make sure the musicians know session procedures.* Making a studio recording is tedious, demanding, exacting, tiring work. Moreover, the ways in which the ensemble is recorded—overdubbing, positioning of musicians, use of isolation booths—differ greatly from the act of playing before an audience. Musicians caught unaware could perform poorly, wasting time and money.

- *Study the sheet music or chord charts.* If they do not exist or if you do not read music, thoroughly familiarize yourself with the music by listening to rehearsals before the recording session and make reference charts (see 14-69).

SONG - " . . . "

FORM	Reel Time
Tape starts	00 00
Intro	00 10
Verse 1	00 28
Verse 2	00 56
Chorus 1	01 24
Bridge	01 55
Verse 3	02 20
Chorus 2	02 48
Outro	03 19
End	03 25

a

SONG - " . . . "

Tape starts	Intro	Verse 1	Verse 2	Chorus
00 00	A1	B1	B2	C1
	00 10	00 28	00 56	01 24

Bridge	Verse 3	Chorus 2	Outro	End
D1	B3	C2	E1	03 25
01 55	02 20	02 48	03 19	

b

c

14-69 Three ways to chart or blueprint a pop song for recordists who do not read music

■ *Make sure the musicians and singers are thoroughly rehearsed.* Studio time is too expensive to waste working out performance problems. Be certain the musical group has worked together before and collectively practiced the repertoire to everyone's satisfaction, in a rehearsal studio or elsewhere, prior to a studio session.

■ *Note any personal or musical idiosyncrasies.* A musician may like to hum along while playing or tap a foot to the beat. These sounds cannot be made if they are picked up by the microphone. Some musicians warm up fast and give a better performance early in a session; others take a while to get hot. There are musicians who perform better without thinking about interpretation, and there are those who must consider every phrase. One performer may need constant encouragement; another may require more frequent breaks because of fatigue. An instrument may need restringing or may squeak, buzz, or ring. Such sounds may be masked in a concert, but in a studio they are usually audible.

■ *Draft a recording schedule.* Everyone concerned should have an idea of when particular voicings will be recorded and about how long the process will take. If the vocalist, for example, records last and is not needed until, say, three hours into the session, waiting could be boring and draining. Also, be sure to schedule break times. They are important if listening fatigue is to be avoided and if ears are to be "restored." If the session involves union musicians, union regulations will stipulate the length and frequency of breaks.

■ *Make the track assignments.* In multitrack sessions know the voicing or group of voicings to be recorded on each track. It usually does not make much difference which elements are assigned to which

track, but it is a good idea to record information that is particularly valuable or difficult to rerecord on the inside tracks of the tape, away from the outer edges. Sometimes, the edges can fray from scraping against improperly aligned tape guides or the sides of defective tape reels. On an 8-track tape, this would damage tracks 1, 2, 7, and 8; on a 16-track tape, tracks, 1, 2, 15, and 16 could be lost; and so on. Deciding which tracks are more important depends on the recording, but it is usually obvious. Drums are trickier to record than, say, trumpets; it would be more difficult to rerecord a soloist who has flown in for a session than to rerecord performers who live in the vicinity; a vocalist usually requires more time and attention than most instruments.

It is also helpful to put the same instruments or groups of instruments on adjacent tracks, such as the various parts of a drum set, strings, woodwinds, and rhythm instruments. This makes it easier to see and coordinate their relative levels of loudness (see 14-70).

■ *Anticipate the physical demand.* Be well rested and well fed before the session. Avoid exposure to loud sounds and prolonged listening to music. And no alcohol or drugs! They affect perception and make it impossible to hear and evaluate sound with any consistency.

■ *Keep a record of important information about the session.* This includes such things as track assignments, microphones and EQ used, type of noise reduction employed, if any, name and time of song, type of tape used, slate information, and any abnormalities such as someone bumping a mic on take 7, track 14, at 2:13. Also, it is a good idea to chart the session in preproduction and update it during recording (see 14-71). You never know when you

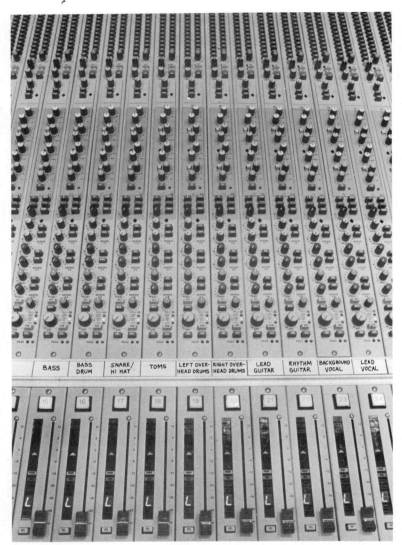

The labels on the console channels read: BASS, BASS DRUM, SNARE/HI HAT, TOMS, LEFT OVER-HEAD DRUMS, RIGHT OVER-HEAD DRUMS, LEAD GUITAR, RHYTHM GUITAR, BACKGROUND VOCAL, LEAD VOCAL.

14-70 **Making track assignments.** Putting similar instruments or groups of instruments on adjacent channels makes it easier to coordinate console operations.

may have to return to a session to finish it, redo a part, or fill in a section. Even if that does not become necessary, good record-keeping in the recording session makes the mixdown session easier.

The Recording Session

The modern recording studio can be likened to an electronic toy shop. It is filled with devices that perform so many sonic functions

STUDIO #3

TRACK SHEET

CLIENT:_____ DATE: _____ REEL __of __

ARTIST:_____ SPEED:_____ips TRACKS: _____

PRODUCER: _____ TAPE TYPE:_____

ENGINEER: _____ AST. ENG.: _____ NR: () Dolby SR ()

()MASTER TAPE ()COPY TIMECODE: ()Trk.#_____

SONG TITLE: _____ LOCATER TIME: _____ LENGTH: _____

TRACK 1	TRACK 2	TRACK 3	TRACK 4	TRACK 5	TRACK 6	TRACK 7	TRACK 8
TRACK 9	TRACK 10	TRACK 11	TRACK 12	TRACK 13	TRACK 14	TRACK 15	TRACK 16
TRACK 17	TRACK 18	TRACK 19	TRACK 20	TRACK 21	TRACK 22	TRACK 23	TRACK 24 ()TC

NOTES

14-71 **Four examples of track charts used to keep records of studio music sessions.**
Every studio either designs a form or uses a computer program to meet its own particular record-keeping needs.

that the temptation to "play" with and incorporate them into a recording is strong. As sophisticated as music recording has become, however, the age-old KIS philosophy is still valid: Keep It Simple. (Some prefer to add an "S" to make the point emphatic: Keep It Simple, Stupid.) In either case, remember that *less is more*. Special effects and gimmicks can be justified only if there is a genuine need for them. If you wish to experiment,

Project: **Rick's Homemade Album**

Title: _We all Live in a Yellow Unterwasserboot_

Client: _Rick_ Artist: _Rick_

Producer: _Rick_ Date: _2/2/_

Studio: _Rick's House_

Start Time: **01:00:00:00** Stop Time: **01:02:39:06** Length: **00:02:39:06**

1 Kick ⏱ Bar 5 Beat 1	2 Hat ⏱ Bar 5 Beat 1	3 Maracas ⏱ Bar 5 Beat 1	4 Side Stick ⏱ Bar 5 Beat 1
	⟸ Slightly Stereo ⟹		
5 Conga ⏱ Bar 5 Beat 1 Boost during verse	6 Timbale ⏱ Bar 4 Beat 3 Boost during verse	7 Guiro ⏱ Bar 17 Beat 3 Verses only	8 Cowbell ⏱ Bar 17 Beat 2 Verses only
9 Ride ⏱ Bar 65 Beat 1 Starts at fade	10 Crash ⏱ Bar 65 Beat 1 Only note is at top of fade	11 Bass ⏱ Bar 5 Beat 1	12 Mute Guitar ⏱ Bar 5 Beat 1
13 Rhy Guit 1 ⏱ Bar 5 Beat 1	14	15	16
17 Piano LH ⏱ Bar 5 Beat 1	18 Piano LH ⏱ Bar 5 Beat 1	19 Piano RH ⏱ Bar 1 Beat 1 Adds hi octave double at fade	20 Piano RH ⏱ Bar 1 Beat 1 Adds hi octave double at fade
⟸ L Stereo R ⟹		⟸ L Stereo R ⟹	
21 Vocal ⌨ Bar 9 Beat 1	22 Vocal ⌨ Bar 9 Beat 1	23	24 Time Code ⏱ Bar 1 Beat 1 Fifteen second pre-roll
⟸ L Stereo R ⟹			

Page 1

14-71 _(continued)_

STUDIO #3 MIXER INPUT SETTINGS

PRODUCER: _____ DATE: _____

DATE: _____ TAPE TIMER: _____ CUT#: _____

ENGINEER: _____ ARTIST/GROUP: _____

INSTRUMENT	FADER LEVEL	MONITOR LEVEL	L/R PAN	SEND 5/6 PAN	SEND #6 LEVEL	SEND #5 LEVEL	SEND #4 LEVEL	SEND #3 LEVEL	SEND #2 LEVEL	SEND #1 LEVEL	FREQ (HPF)	LO PASS FIL	HI PASS FIL	Ø SWT	(EQ IN)	LO FREQ PK	LO FREQ	LO FREQ EQ LEV	MID 1 FREQ	MID 1 EQ LEV	MID 2 FREQ	MID 2 EQ LEV	HI FREQ PK	HI FREQ	HI FREQ EQ LEV	MIC GAIN	LINE TRIM	BUS TRIM	BUS PAN	MIXER CONTROL
																														1
																														2
																														3
																														4
																														5
																														6
																														7
																														8
																														9
																														10
																														11
																														12
																														13
																														14
																														15
																														16
																														17
																														18
																														19
																														20
																														21
																														22
																														23
																														24

Time Line #1 – Demo Track Chart 2

Running Free Tempo 132.60
Meter
Bar

1 Kick Band In at Bar 5
2 Hat
3 Maracas
4 Side Stick
5 Conga
6 Timbale
7 Guiro
8 Cowbell
9 Ride

01 :00 :00 :08

14-71 (continued)

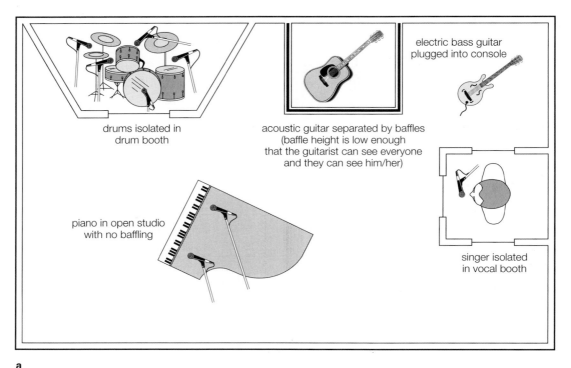

a

14-72 Two ways to arrange musical groups for studio recording. (a) Musicians are isolated from one another to prevent sound from one instrument leaking into the microphone of another instrument, yet are still able to maintain visual contact. It is possible, in this arrangement, that the acoustic guitar sound will leak into the piano mics and vice versa. However, leakage can usually be reduced by supercardioid mics on both instruments rejecting sound from the sides and rear, the piano lid blocking sound coming from the front guitar baffle, and the guitarist's body blocking the piano sound coming from the back of the studio. (b) Another example of arranging a musical group in a studio to control leakage.

do not take valuable time during the recording (and mixdown) session to do it.

Before Setting Up

Before musicians and production personnel enter a facility, make sure the studio is clean, and put microphones, cables, chairs, baffles, and so on out of the way. Clean the control room as well. All console controls should be in neutral or off. Tape recorders should be aligned, and the heads demagnetized and cleaned. In addition, if you know what instruments are being assigned to which channels (and submixers if you are doing submixes), label the console with this information. It not only saves time during the session but helps to organize board operations more quickly.

Recording All at Once or Overdubbing

You can record an ensemble all at once or in sections at different times. Recording all at once requires that the microphones be far

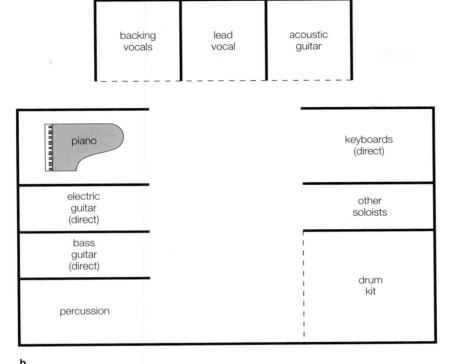

b

14-72 (continued)

enough apart to avoid phase problems or that the musicians be separated to reduce leakage, if controlling leakage is important.

Using the three-to-one rule should take care of most acoustic phase problems. To reduce leakage, follow these steps: (1) Use directional microphones and place them so their rejection sides are pointed to the other instruments; (2) use acoustic baffles to separate the instruments; and (3) use the isolation booth(s) that most recording studios have for instruments with sound levels that are very high (for example, drums and amplifiers) and

for sound sources that must be recorded with absolutely no leakage (for example, vocals) (see 14-72). Although positioning the musicians to avoid phasing and leakage is important, they should be able to see each other for cueing and other visual communication; they usually play better that way, too.

But most popular music today is recorded in sections at different times. In this way leakage and phase problems are considerably reduced by overdubbing—recording new material on a separate track or tracks while listening to the replay of a previously recorded

track or tracks in order to synchronize the old and new material. Sel Sync (see Chapter 7) has made overdubbing one of the most convenient and most often used production techniques in audio. Its advantages and disadvantages are listed in Table 14-5.

Building a Recording

Although overdubbing allows flexibility in scheduling performers, the order in which you tape them is often not so flexible. You should tape certain instruments before others.

Standard procedure is to record the rhythm tracks first to ensure that everyone's timing will be the same. If there is a vocal, record the rest of the background or accompaniment during the next stages of the session. The vocal is usually taped last, because it is most likely the focus of the music and needs the other elements in place for proper tonal balance and perspective. Sometimes, a dummy (or scratch) vocal is recorded with the rhythm and other tracks to help overall performance and then rerecorded after all the tracks have been recorded.

Anticipating the Mixdown

Although the mixdown (see Chapter 17) is done after recording, you cannot plan a recording session until you have some idea about the objectives of the mix. One of the most important elements to plan in advance is positioning of the voicings in the stereo field. For example, if a piano is to be stereo, the lower frequencies must be recorded on one track and the higher frequencies on another. For drums to be stereo they must be recorded on at least two tracks. If piano or drums are recorded on one track, it is difficult to spread the image across the stereo field. It can be placed at any position in the stereo field by panning, but its image is still monaural.

Placing two different sound sources on the same track makes it impossible to separate them later in a stereo field. If an electric guitar is going direct and its amp is miked, the signals should be recorded on different tracks if there is any thought of panning them in the stereo field or dispensing with one of them during mixdown.

Sometimes, the very highest or lowest frequencies of a particular instrument are important to a recording. If they are not captured during taping, the information will not be available for the mix.

Signal Processing During Recording

Anticipating the mixdown during recording raises an important question: How much signal processing—EQ, compression, reverb, and so on—should be used during recording? There is no one reply that satisfies all producers or addresses all conditions. The best answers are (1) leave the tracks as dry as possible for the mix, (2) work only from knowledge and experience, and (3) do not do anything during recording that cannot be undone in the mixdown. Once the musicians leave the studio, you are "stuck" with whatever is on the tape.

Earlier in the chapter we mentioned that, in equalizing, if a signal is boosted 4 dB at 1,000 Hz, the EQ can be neutralized by attenuating 4 dB at the same frequency. Nevertheless, noise from passing the signal through an electronic device twice is difficult to reduce.

Compressing the bass guitar during recording is a standard procedure. Yet, again, if it is not well done, it creates problems in the mixdown. Once reverb has been recorded, it cannot be "unrecorded." That restriction also applies for delay, phase, and

Table 14-5 Advantages and disadvantages of overdubbing

Advantages	Disadvantages
Possible to tape various voicings separately and at different times	Overall creative interaction and spontaneity among ensemble members is lost
Facilitates a greater degree of sound control over each track	Performance can be mechanical and uninspired
Allows a few performers to do the work of many	An ensemble's studio sound may be noticeably different from its concert sound
Alleviates the need to have all voicings ready at the same time	Sonic differences in acoustics or equipment, or both, between studios may be perceptible if the recording is taped in more than one studio
Allows the various elements in a recording to be taped at different studios	The increased number of tape passes wears the tape faster
	Usually more expensive

flanging. These effects can be recorded on a separate track, however, providing a wet effects track and a dry main track. But make sure the main track and the effects track are in phase.

Musicians may insist that an effect, such as reverb, must be heard during recording to get a better idea of the actual sound in a more realistic context. Most of today's production consoles allow you to feed effects through the foldback system without their being recorded (see Chapter 6). If this is not possible, routing effects from the input system to foldback, by patching, usually works.

Setting Up and Recording

Let's go through the various procedures for a modest eight-track pop music session that includes drums, electric bass, acoustic guitar, and vocal. We will assume the session requires overdubbing.

The first things to do are tune the instruments, position the musicians, mike the instruments, and note in the production notebook and on the console which mics feed to which channels.

Because the voicings are being overdubbed, rhythm instruments are recorded

first—in this case drums and bass. There are two alternatives here: (1) Record them at the same time or (2) record them separately. Recording them at the same time is no problem if the bass is going direct. If it is not, the bass amp and microphone must be isolated to reduce leakage, even if the drums are in a booth. The advantage in playing together is that it usually produces a more cohesive, stable rhythm track. It is difficult to maintain a consistent beat alone or for an extended period of time. Without the foundation of a good rhythm track, the rest of the recording will be tenuous, at best.

If drums and bass are recorded separately, drums are usually recorded first, sometimes using a click track to help timing. A **click track** plays the appropriate rhythm(s) from the sound of a metronome or electronic rhythm machine (which is less boring than a metronome) recorded on one of the available tape tracks or fed live. The sound is routed to the performer's headphones through the foldback system. The click track is erased after the basic rhythm tracks are recorded.

A click track is also essential when the basic rhythm instruments do not come in until after the music has begun, when the beat is not well defined, or when syncing a

music track to rigidly timed material such as a commercial jingle or a motion picture. In recording film sound the click track is often on magnetic film loops. Each loop has a rhythmically different click track recorded on it.

Sometimes, a drummer provides the click track by hitting the drum sticks together. This technique serves well in providing the tempo and lead-in just before the musicians begin playing, but it is difficult to maintain a precise rhythm if the drummer has to keep it up for very long.

From the standpoint of providing a more dependable beat and saving time, it is better to record drums and bass together. If they need to reference the rhythm part to a lead part, let a lead instrument or the vocalist accompany the rhythm instruments. This is accomplished by miking, isolating, and then feeding the accompaniment through the foldback system. This way, the accompaniment is not recorded.

Once the drums and bass have been miked, it is time to test the sound and get levels. For this session, let's assume the drum mics are on the bass drum, between a floor and medium tom-tom, between the snare and hi hat, and above each of the two overhead cymbals. To eliminate leakage, the electric bass will go direct.

Start with the bass drum sound because it is the foundation of the overall drum sound and its pitch influences the relative pitches of the other drums. Then proceed to the toms, snare, hi hat, and overheads. As each drum sound is shaped, blend it with the previously shaped drum sounds to make sure they work together. A good drum sound begins with (1) getting each component to sound acceptable and (2) blending all the components as a unit.

As the drums are blended, additional sonic adjustments to individual components may be necessary. The final result may be a drum or two that does not sound satisfactory by itself but blends well with the rest of the set.

Many producers like the bass drum pitched just above and working with the bass. The important thing is to make sure the two instruments do not mask each other or muddy the sound. Each must be clearly defined even though they have many of the same frequencies in common.

Track assignments will have been decided by this point in the session. Because the bass, guitar, and vocal must have their own tracks, it leaves five of the eight tracks for drums: one track each for the bass drum, tom-toms, snare/hi hat, and the two overhead cymbals. This is an ideal situation because it facilitates separate control of each musical component not only during recording but in the mixdown as well.

Mixing During Recording (Premixing)

It is not always possible to assign one voicing per track, particularly with drums. For example, suppose this eight-track session also included another guitar, a (mono) piano, and a harmony vocal. Because each of these voicings requires its own track, it leaves just two of the eight tracks to record the five drum mics. Such predicaments are not uncommon even with 16-, 24-, and 32-track recordings. If a shortage of tracks exists, a **live mix** of certain voicings is done during recording.

In this case the drums would be live-mixed to two tracks to permit stereo imaging. If the drums are mono, they would be mixed down to one track. Although the tape recorder may have only eight tracks, the console probably will be able to handle more than eight inputs and feed at least four outputs at the same time. Therefore, it is possible to assign each drum mic to a separate channel and delegate

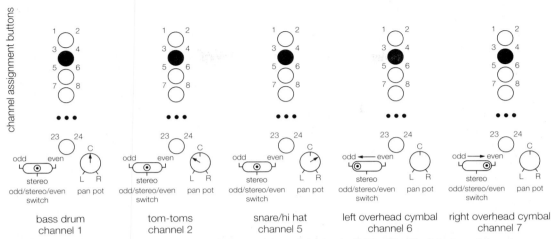

14-73 **Using several channels to facilitate "live" mixing of drums, individually miked, to two channels.** Here the bass drum is delegated to channels 3 and 4 and kept centered. The tom-toms, also delegated to channels 3 and 4, are panned to the left. Snare/hi hat delegated to channels 3 and 4 are panned right. The left drums and overhead cymbal are delegated to channel 3, and the right drums and overhead cymbal are delegated to channel 4.

the channel to one or both of the two drum tracks. The bass drum mic would be delegated to both drum tracks because the bass drum is usually positioned at the center of the drum set. The tom-toms would also be delegated to both drum tracks but panned to the left or right depending on their desired position in the aural frame. The snare and hi hat are also delegated to both tracks but panned to the opposite side of the toms to balance the overall drum sound. The mics above each overhead cymbal pick up not only the left and right cymbal sound but also sounds from the left and right sides of the drum set. To help create a wider stereo perspective, one overhead cymbal mic is delegated entirely to one drum track and the other overhead cymbal mic is delegated entirely to the other (see 14-73 and 14-74).

It should be noted that this explanation is an example. The tom-toms are usually recorded on separate tracks so they can be panned across the stereo field; the snare and

hi hat are also recorded on separate tracks to facilitate placement.

A live mix can be tricky, so you have to know what you are doing. As noted earlier, once the musicians leave the studio, it is too late to change what is on the tape; unlike the other tracks, the drum tracks are already in place.

Bouncing Tracks

Instead of doing a live mix at the console, some producers prefer to assign each channel to a separate track, mix them afterward, and **bounce tracks** — combine them onto a single unused track.

Suppose you have an eight-track machine and want to record 12 instruments separately: bass drum, snare drum, tom-toms, hi hat cymbal, overhead cymbals, bass, guitar, piano, violin, viola, French horn, and vocal. By bouncing tracks, you can first record the drums onto, say, tracks two, three, four, five,

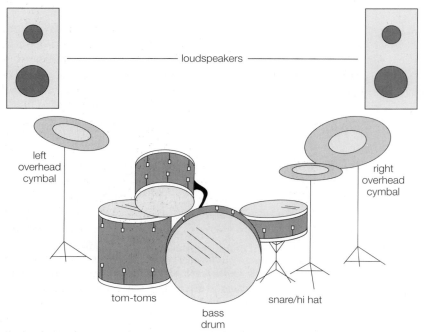

left
overhead
cymbal

loudspeakers

right
overhead
cymbal

tom-toms

bass
drum

snare/hi hat

14-74 Spatial distribution of the live drum mix discussed in 14-73

and six, and then rerecord and combine them onto a single available track (assume the drums are mono). You combine them by (1) putting tracks two through six into Sel Sync, monitoring them from the record head;* (2) feeding each track to a separate channel at the console for balancing and mixing; (3) assigning each channel to the same open track, say, track eight; and (4) recording. This frees tracks two through six, and by adding tracks one and seven, you have enough open tracks to record the seven other instruments.

*With state-of-the-art recorders there should be no discernible loss in sound quality in reproduction from the record head compared with the playback head. With older machines the playback quality of the record head is 2,000 to 5,000 Hz poorer than the quality from the playback head.

If you bounce tracks, do not use adjacent tracks for the transfer. In the previous example, you would not bounce tracks two, three, four, five, and six to either track one or seven.

The separation between tracks of a multitrack tape recorder is not wide. If you put a track in "Record" that is next to one of the tracks playing back, it could result in the live record head picking up unwanted crosstalk from the adjacent playback track, especially if the signal level is high. Furthermore, if the live head is picking up sound across the head from the adjacent track and also internally via the normal recording process (that is, through the head), it may create a feedback loop and thus a squeal.

If you are using a four-track recorder and several bounces are necessary to record all the voicings, sound quality deteriorates with

each bounce. To maintain as much sound quality as possible, (1) boost the high end before bouncing and (2) record the most important voicing or voicings with widest dynamic range and frequency response last. This is recommended even though, as in the case of the drums, it changes the recommended order of overdubbing parts.

Doubling Up on Tracks

Another way to handle the more-voicings-than-tracks problem is to *double up* — record two sound sources on one track. However, this is not generally recommended. If two instruments have many of the same frequencies in common, equalizing one instrument will affect the sound of the other. Moreover, once two instruments are on the same track, they cannot be separately panned, faded, equalized, and so on.

Two sound sources are usually put on the same track only if their frequency ranges do not conflict, as in the case of a piccolo and a bass, if they are to occupy the same position in the aural frame, or if they play at different times. EQ must be changed for each or left alone. Also, when combining sound sources with separated frequency ranges, be careful of intermodulation distortion.

Overdubbing Techniques

Once the basic rhythm tracks have been recorded, the accompanying and lead tracks are overdubbed — in this case guitar and vocal. Overdubbing usually involves recording one (or a few) instrument(s) at a time. The tape tracks already recorded are put into Sel Sync and the track to be recorded is put in "Record." All tracks feed through the console. To facilitate syncing, the levels of the previously recorded tracks are balanced with the level of the sound source being over-

dubbed and fed through the foldback system to the performer's headphones. This way the performer hears what has been and what is being recorded at the same time, balanced as he or she prefers. Regardless of the level balances preferred by the performer, in control room monitoring it is a good idea to maintain a higher level on the track being recorded than on the playback tracks. This enables closer scrutiny of the new material.

In overdubbing one sound source at a time, leakage is not a problem. Care should be taken, however, to ensure that sound from the headphones is not picked up by the microphone. Use headphones with cushions that fit tightly around the ears.

Another reason to be careful of the foldback level through headphones is the effect it could have on performance. Some performers like the sound level in the headphones to be loud, particularly with high-energy music. This could have a detrimental effect on the intensity of the performance. As the loudness in the headphones increases, performers (without realizing it) have the tendency to "lay back," reducing their own output level.

If you run into this problem, provide whatever foldback levels are wanted; but, after the playing begins, gradually reduce the loudness to a comfortable level. Usually, the energy of the performance will increase proportionately and the performer will be none the wiser. Loud foldback level also desensitizes hearing and hastens listening fatigue.

Some studios prefer to fold back sound not through headphones but through a pair of small matched loudspeakers placed the same distance from the microphone so that the three form the points of an equilateral triangle. One loudspeaker is wired 180 degrees out of phase with the other. The signal fed to them should be mono. The mic, being "one-eared," will not hear the out-of-phase sound. The vocalist, being "two-eared," will

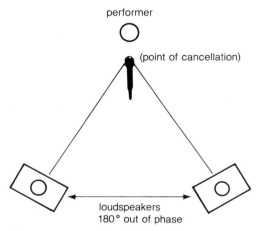

performer

(point of cancellation)

loudspeakers
180° out of phase

14-75 An alternative technique to feeding a foldback mix through headphones

hear the foldback mix (see 14-75). But make sure the mic does not move.

If the part being overdubbed is not continuous, the musician must be quiet when not performing. During mixdown it is easier not to have to worry about opening and closing the pots to avoid unwanted sound, especially if more than one voicing has been overdubbed. If an extraneous sound should occur, erase it at the earliest opportunity. It is time-consuming and unnerving to deal with these noises during the mixdown.

The section or sections of music being overdubbed can be recorded over and over until the performance is correct. If a good take is recorded but a better one is possible, keep the good take and use another track for the new attempt. If enough tracks are available and a few takes are recorded, the best overall performance may not be any particular take but portions of a few takes. Therefore, a composite track can be put together by bouncing the appropriate portions of the recorded tracks to a new track. To avoid high-frequency track-to-track oscillation,

keep at least one track between the track you are recording from and the track you are recording to. After the composite track is approved, the overdubbed tracks can be bounced if you have room or erased and reused for other voicings.

The acoustic guitar should be overdubbed with the widest dynamic range and frequency response possible. The sound should be bright, but not brittle, so that it cuts easily through the other voicings. The low end should be warm without being muddy. Overall, the sound should round out the bottom, add punch to the rhythm, and provide high-end accent. It is important to shape as many of these sounds as possible without equalization.

The vocal track in this (as in most) recording is taped last, or next to last if there is a harmony vocal. Before attending to the sound, it is important to make the vocalist feel at ease and comfortable. The music stand set up, a glass of water handy, and a comfortable chair nearby go a long way in making a performer feel cared for.

Vocalists should sing standing straight to facilitate opening the throat, breath control, and sound support from the diaphragm. Vocalists with limited studio experience may feel uncomfortable standing in front of a stationary microphone. Providing them with a hand-held mic may help them to perform more naturally but may also introduce cable or hand noise.

It is usually not a good idea to stop for a mistake if a performer—especially a vocalist—is well into a take. It is unnerving and breaks concentration, making it difficult to start up again with the same emotion and intensity. If the pressure of making mistakes is adversely affecting performance, let the vocalist loosen up by rehearsing more. If you think the rehearsals sound good, tape one

without letting the singer know. You may get a take.

Punching In

If something goes wrong during a take and there is no extra track to try recording again, or there is not enough time, or another take would not improve the overall performance, then rerecording just the subpar section is possible by using the technique known as punching in. Conventional cut-and-splice editing (see Chapter 16) is not possible with multitrack recording, because there is no way to cut into any one track without cutting into the other tracks as well. Most multitrack recorders have electronic means of **punching in**—rerecording any portion of any track without affecting the rest of the recording.

You punch in by putting the recorded tracks into Sel Sync; playing them back to the performer(s) through headphones; and, when it is time to rerecord over the defective portion of a track, switching that track to "Record." After the appropriate section has been rerecorded, take the track out of "Record" either by stopping the machine or by switching the track back into Sel Sync or "Play." Punching in is a clean way to edit electronically. It is quick and usually leaves no extraneous sound pulses on the tape. It does require perfect timing, however, or some of the good material could also be erased. Levels must match between punched-in and retained material.

Sometimes, musical accents or vocal harmonies are punched in here and there on an open track. For convenience some recordists start in "Record" at the beginning of the tape and let it play through that way, letting the musicians handle the cues. If virgin tape is being used, this technique can add about 3 dB of noise to the recording. Although it requires more work, it is better to punch in and out at the appropriate times during this type of overdubbing or to use the fader.

Recording Ambience

Even with the many artificial reverberation devices available today, there is still no substitute for the sound of natural acoustics. Many producers try to add natural acoustics to overdubbed recordings by placing one or a few microphones several feet above and away from a sound source and taping just the ambience on a separate track or tracks. In the mix the desired amount of ambience can be blended into individual voicings or into the overall mix without affecting those tracks you wish to keep dry for other purposes.

Slating

It is important to keep not only written or disk encoded records in a recording/mixdown session but certain oral records as well. Such information as the name of the group, song, take number, and lead-in cue beat should be recorded or *slated* on the tape. Most recording consoles have a control in the talkback system that feeds slating information to the performers' headphones and the tape recorder simultaneously. In this way a producer is able to keep an oral record of how many takes were recorded and which is which. Other slate information is usually kept in the written notes or on a computer disk (see Table 14-6).

Cues When Recording

Each time a recording is made, the producer or engineer should give the same spoken cues to studio and control room personnel so that everyone knows when to stand, be quiet,

Table 14-6 Slate information usually kept in the production notebook

Abbreviation	Explanation
HS (head slate)	The voice announcement recorded at the beginning of the tape. On the tape itself it is preceded or followed by a low-frequency tone so that on an analog recorder in "Fast Forward" the audible beeps indicate the beginning of a take.
FS (false start)	The take started but for some reason had to stop before it got under way.
LFS (long false start)	The take was a good way through before it had to stop.
INC (incomplete)	The take had almost reached the end when it had to stop.
C (complete take)	
PB (play back)	The take(s) played back to the producer or client.
M (master)	The take chosen by the producer or client.
TS (tail slate)	A slate recorded after a take.
EOT (end of tape)	The point at which not enough tape is left for another take.
NS (no slate)	No slate was recorded before or after the take.

and record. Following is an example of one procedure:

PRODUCER TO OPERATOR(S): "Stand by please. Roll tape and record."

OPERATOR TO PRODUCER: "Rolling and recording."

PRODUCER INTO TALKBACK/SLATE: "'SEND IN THE CLOWNS,' MARDI GRAS, TAKE 3."

The take number is the cue to the musicians to begin playing when they are ready.

Recording Calibration Tones

A recording session usually takes several hours; very often it takes several days. Although equipment, like any "instrument," should be fine-tuned before each session, with use over a long period of time it can "go out." Moreover, sometimes, the people who do the mixdown may not have been involved in the recording, or the mixdown may be done in a different studio. To ensure that the console(s) and tape recorders being used throughout recording and mixdown are aligned with one another, and to provide the means with which to reset original levels, calibration or reference tones are recorded on the multitrack master. (Tones are recorded on subsequent masters as well—see Chapter 17.)

Reference tones are pure tones (sine waves) generated by an oscillator (see Chapter 6) and recorded at 0 VU (100 percent of modulation). It is usually best to record three tones: a low-frequency tone (50 or 100 Hz), a midrange tone (1,000 Hz is standard), and a high-frequency tone (10,000 Hz is preferred, but it may be 12,000 or 15,000 Hz). Some recordists use only the 1,000-Hz tone. If you use Dolby SR or A noise reduction, add the tone generated by the Dolby unit. For dbx Type I noise reduction, add an encoded tone. During playback use the tone to align the tape recorder with the Dolby or dbx units. Do not encode the original three tones with noise reduction.

There is no special length of time for a calibration tone. Generally, 20 seconds for each is adequate.

MIDI (Musical Instrument Digital Interface)

Not too long ago, in a recording session featuring one of America's best and most artistically demanding singers, four musicians playing music synthesizers provided the entire "orchestral" accompaniment. The singer usually worked with the real thing. In giving credit to the players, the singer remarked on how extraordinary it was that they could reproduce so authentically and artfully the sound of 60 musicians playing the full range of conventional orchestral instruments. What made this possible was Musical Instrument Digital Interface, or MIDI, for short.

Conventional music production usually depends on a number of people—producer, musicians, recordist, mixer, engineer, among others—working in a studio to make a tape recording. But imagine one person being able to perform all these functions and more, including the capability to produce any musical sound, sonic effect, or combination of sounds, in any musical genre, for any size and type of ensemble—without the need for a studio or a tape recorder. Such is the capability at anyone's fingertips today because of MIDI (pronounced mi′dee).

What MIDI Is

In Musical Instrument Digital Interface, the *Digital* refers to a set of instructions in the form of digital (binary) data, like a computer program, that must be interpreted by an electronic sound-generating, or -modifying, device, such as a synthesizer, that can respond to the directions. *Interface* is the link permitting the control signals generated by commands from one synthesizer or controller to trigger other synthesizers and equipment. Thus, one person can "play" several synthesizers, thereby having the capability to create

an infinite variety of combined sounds that would otherwise be impossible. In other words, MIDI does not embody actual sound; instead, it contains instructions controlling how and when devices, such as synthesizers, produce sound.

MIDI was developed in 1981 to help musicians overcome the thin and obviously electronic sound generated by synthesizers. These synthesizers were, for the most part, monophonic, capable of producing only one sound at a time. One way to approach reproduction of the complex timbres of traditional musical instruments was by trying to synchronize two or more synthesizers to play at the same time or by overdubbing them. With MIDI, however, different voicings from various MIDI synthesizers can be layered to reproduce virtually any sonic structure; different MIDI devices can be synchronized; and most MIDI synthesizers can be made compatible with most others because the entire electronic industry has adopted the MIDI specification.

MIDI is still mainly a creative tool for the musician, although synthesizers and computer programs are available that enable even a person with little or no knowledge of how to compose music or play a musical instrument, but who has a "good ear" and perseverance, to create music using MIDI. MIDI software is available in a number of categories: (1) performance—software that lets you compose, orchestrate, arrange, and perform music; (2) productivity—programs that help you transcribe, data base, and print your music using any MIDI setup; (3) editing—for editing digital samples; (4) patch librarians—for storing synthesizer settings, or "patches"; and (5) instruction—software for learning music and MIDI operations.

A detailed discussion of all of these elements is beyond the scope of this book. As a sound designer and, perhaps, potential MIDI

user, however, it is important to have some idea of how MIDI works and what a typical MIDI studio includes.

How MIDI Works

MIDI enables synthesizers, computers, rhythm machines, sequencers, and other signal-processing devices to be interconnected through an interface. The interface is based on a standard convention, or protocol, devised by the International MIDI Association (IMA) and agreed to by manufacturers of MIDI hardware and software.

MIDI data is communicated digitally throughout a production system as a string of MIDI messages. MIDI messages may be grouped into two categories: **channel messages** and **system messages**. A channel message applies to the specific MIDI channel named in the message. A system message addresses all the channels.

Channel Messages

MIDI has the ability to send and receive messages on any of 16 discrete channels. Channel messages give information on whether an instrument should send or receive and on which channel. They also indicate when a note event begins or ends and control information such as velocity, attack, and program change. Channel messages are grouped into channel mode messages and channel voice messages.

Channel Mode Messages Because not all MIDI devices respond to channel messages in the same way, MIDI reception modes have been specified. Some instruments are monophonic — able to produce only one note at a time — some are polyphonic — able to produce more than one note at a time but only

on one channel — and some are polyphonic and polytimbral — able to produce more than one note at a time on more than one channel. MIDI reception modes facilitate response to channel messages appropriate to monophonic, polyphonic, or polytimbral processing. The MIDI reception modes are Omni On/Off and Poly On/Off. In the Omni On mode, a MIDI device responds to all channel messages that are transmitted over all MIDI channels. In Omni Off, a MIDI device responds to a single channel or group of assigned channels. In the Poly On mode, an instrument can produce more than one note at a time and can respond to data from any MIDI channel. In Poly Off, an instrument can produce more than one note at a time and can respond to data from one or more than one channel. A Mono mode is for devices that can generate only one note at a time. These modes have been specified as follows: Mode 1 — Omni On/Poly, Mode 2 — Omni On/Mono, Mode 3 — Omni Off/Poly, Mode 4 — Omni Off/Mono.

Channel Voice Messages To transmit performance data throughout the MIDI system channel voice messages are generated whenever the controller of a MIDI instrument is played. There are seven types of channel messages.

- **Note On** indicates the beginning of a MIDI note. It includes velocity information describing how fast or hard the note is played.

- **Note Off** turns off a given note.

- **Channel Pressure** messages, sometimes referred to as After Touch, are sent by devices that can sense overall pressure put on keys but not individual pressure put on a single key. Whichever key is pressed hardest determines the channel pressure value for the entire keyboard.

- **Polyphonic Key Pressure** communicates individual pressure messages that affect only that note.

- **Program Change** changes the currently active program number in pre-programmed devices.

- **Control Change** messages can alter, in real time, the parameters, such as amplitude and modulation, of a note in progress. The message may call for a single control change or multiple changes and are transmitted by controllers such as foot pedals, modulation wheels, and pitch bend wheels.

- **Pitch Bend** transmits new settings for a pitch bend controller raising or lowering pitch from a central, or no pitch bend, position.

System Messages

System messages affect an entire device or every device in a MIDI system regardless of the MIDI channel. They give timing information such as what the current bar of the song is and when to start and stop, as well as clocking functions that keep a MIDI sequencer system in sync. There are three System Message types: System Common Messages, System Real-Time Messages, and System Exclusive Messages.

1. **System Common Messages** transmit MIDI time code, tune request, song select, song position pointer, and end of exclusive cues. Two other system common messages are part of the MIDI specification but at this writing are still undefined.
 - MIDI time code (MTC) translates SMPTE time code into a format that MIDI devices recognize.
 - Tune Request directs all devices receiving this message to tune themselves.
 - Song Select selects a completed sequence ready for playback. The "song" may be a series of drum beats from a drum machine or developed MIDI material.
 - Song Position Pointer permits synchronization of a drum machine or sequencer to an external source, such as a tape recorder. Synchronization can begin at any point in the program material.
 - End of Exclusive (EOX) indicates the end of a system exclusive message. (See System Exclusive Message later in this chapter.)

2. **System Real-Time Messages** coordinate and synchronize the timing of clock-based MIDI devices such as drum machines, synthesizers, and sequencers. System real-time messages are Timing Clock, Start, Stop, Continue, Active Sensing, and System Reset.
 - Timing Clock is the system message used to synchronize the internal timing clocks of each MIDI device in the system. Timing clock messages are sent at the rate of 24 per quarter note (ppq). The master sequencer, for example, is able to transmit tempo and duration information by adjusting the rate at which it sends Timing Clock messages.
 - Start instructs all MIDI-connected devices to start play from the beginning of their stored material once the timing clock message is received.
 - Stop halts play of all MIDI-connected devices at their present position.
 - Continue instructs the devices to begin playing again from the point at which they stopped.
 - Active Sensing is sent every 300 milliseconds when no other MIDI data is being transmitted. It is a way of telling the MIDI devices in the system that they are still actively connected.

- System Reset returns the device receiving the message to its default settings.

3. **System Exclusive (SysEx) Messages** customize MIDI messages between MIDI devices. It communicates device-specific data that are not part of standard MIDI messages.

MIDI System Signal Flow

MIDI instruments are connected using a standardized cable with five-pin DIN connectors at each end. While they all share the same type of jack, there are three types of MIDI connectors on electronic devices: MIDI IN accepts MIDI signals from another device; MIDI OUT sends signals generated within a device to the MIDI IN of other devices; MIDI THRU passes information arriving at a device's MIDI IN connector to other devices without regard for internally generated MIDI data.

To connect two MIDI devices, the MIDI OUT from the designated master is connected to the MIDI IN of the slave. Basically, such a connection allows a performer to control the slave from the master. In MIDI language all notes have a standard code or address so that when, for example, a middle C is played on the master, it will cause middle C to sound on the slave. This allows the layering of timbres from two or more instruments. The MIDI THRU connection permits more than one slave to be controlled by a master device. The MIDI OUT from the master is routed to the MIDI IN of the first device, and the MIDI THRU of each device is connected to the MIDI IN of the subsequent device. The practical limit of a MIDI THRU chain is approximately three devices. Longer chains require a MIDI THRU box that splits the MIDI signal into multiple MIDI OUT jacks (see 14-76).

There are several other MIDI devices; among them are: MIDI Thru Box, MIDI Switcher, MIDI Patchbay, MIDI Interface, and the Sequencer.

The MIDI Thru Box takes the incoming signal from the MIDI IN port and replicates it to the MIDI THRU ports throughout the system. The MIDI Switcher facilitates the selection between two or more MIDI sources without having to manually reconnect cables. The MIDI Patchbay selectively routes data within a MIDI system. It is particularly useful in multiple-device MIDI systems. MIDI Interface is what allows MIDI devices to be connected to one another. MIDI synthesizers, keyboard controllers, and samplers have MIDI interfaces built into them.

Sequencer

The sequencer is the brain of a MIDI studio. It resembles a "multitrack" recorder for MIDI data. It receives information from MIDI devices and stores it in memory as separate "tracks." Once information is in a sequencer's memory, it can be edited and transmitted to other MIDI instruments for playback.

The advantages of MIDI sequencing over conventional recording are: performance and orchestration are completely shapeable in MIDI form, there is no generational loss in copying or manipulating MIDI data, and the amount of data needed to represent MIDI performance is comparatively inconsequential compared to that of digital audio (see Table 14-7).

What the MIDI Studio Includes

MIDI has made most of the procedures and techniques associated with much of music recording obsolescent. With MIDI you no longer need to tie up a studio for days to record a song, commercial, sound track, and so on. Instead, you can sit at home or in a

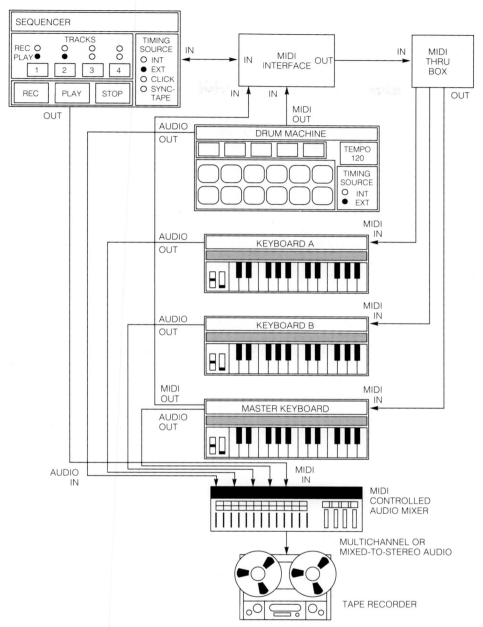

14-76 Example of the components and signal flow in a MIDI studio. The MIDI interface permits the sequencer to use MIDI language to "talk" with the rest of the system. Sequencers and drum machines run according to an internal clock that determines their tempo, and for these devices to run in sync their clocks must run at the same rate. In this particular signal flow the clock output of the drum machine drives the sequencer. In turn, the sequencer controls the keyboards through the MIDI junction box, which sends signals to all keyboards at the same time. The master keyboard controls all other keyboards. Once all tracks are recorded in the sequencer, it activates the keyboards and whatever other signal processors have been interfaced in the MIDI system, and their audio outputs are fed into a multichannel console. From the console the separate channels are recorded onto either a multitrack audiotape recorder or mixed down to a two-track audiotape recorder.

Table 14-7 Advantages and disadvantages of MIDI

Advantages	Disadvantages
Virtually any sampled sound can be made to sound like another. For example, a violin can be made to sound like a guitar.	Depending on the capability of the sequencer, separate synthesizers may be needed for each voice to be played back. In conventional multitrack recording, the same synthesizer can be overdubbed any number of times.
Voicings can be changed instantly. For example, a trombone line can be changed to sound like a tenor saxophone, or back again, if you do not like the change.	With conventional multitrack recording, one signal processor can be used again and again for different tracks. With MIDI recording, each track to be processed requires its own signal processor.
Parts of a song can be performed separately and chained together for the final version simply by flipping a few switches.	In transferring MIDI to audiotape, the more MIDI "tracks" there are, the more inputs are needed on the recording console (although premixing is possible).
All voicings have first-generation sound quality, no matter what processing they go through or how many times information is bounced, and also have perfect replication.	MIDI "lag" — lack of synchrony — is possible if too many channels are processing too much data.
No noise reduction is needed unless and until the final transfer to audiotape is effected.	The MIDI clock can be outrun by extremely fast players.
If one rhythm line is off, it can be brought quickly into sync with the other rhythm lines at the touch of a switch.	Some applications could require more than 16 channels.
Tempos can be changed at any time without affecting pitch.	Rhythms are often mechanical or metronomic.
Harmonies can be performed and instantly duplicated, copied, and changed to any other harmonic interval.	The greater the MIDI capability, the costlier the financial investment. This disadvantage may be relative, however, because MIDI may reduce or eliminate the need for and maintenance costs of a studio and some of the equipment that goes with it, as well as the need for musicians and other production personnel.
No time-consuming rewinding of tape is necessary because all data is stored in computer memory for instant access.	
Several digital sound sources can be controlled synchronously.	
Editing is fast, efficient, and precise. Depending on the sequencer, down to as little as a 32nd note of one instrument on one track can be edited.	

comfortable workplace and create virtually any type of sonic imaging you wish. An audiotape recorder is not even necessary (though it is usually employed for the master mix) because creative output can be computer encoded.

MIDI facilities vary with need and size of bank account. Figure 14-76 depicts a modest MIDI studio and explains its operation.

Music in Television

Several different types of TV productions use live music, including variety, concert, and some entertainment-type talk programs. Three basic considerations are involved in miking all of them: (1) whether the musicians are seen on camera, (2) the acoustics, and (3) the type of music.

Musicians On or Off Camera

Getting the best possible sound is the primary goal of every sound designer. If the musicians are seen on camera, however, it can be disturbing to an audience to have them blocked by, and the picture cluttered with, microphones. Mics have become an accepted part of the TV picture, but unless they are selected and positioned with care, they can ruin a shot. Fortunately, a variety of mics produce excellent sound and are also good-looking. Even windscreens and cables now come in various colors.

If musicians are off camera, mike them in whatever way is best with little concern for appearance. Keep in mind that the musicians have to be able to see the conductor, if there is one.

Whether musicians are on or off camera, you will most likely use directional mics to cut down not only on leakage but on feedback as well. Many large studios and theaters have loudspeakers so the audience can hear the performance better. Singers need loudspeakers on stage to hear the music blend, especially when they are not near the accompanying ensemble. With loudspeakers and microphones in the same vicinity, not only are directional mics almost a necessity to avoid feedback, but so are directional loudspeakers.

Acoustics

The types of studios used for large-scale TV productions, particularly with an audience present, are acoustically adequate for speech but sometimes not so for music. Therefore, most sound designers use multiple microphones instead of the minimal-microphone approach. Sound control is much better; even if the acoustics are excellent, much of today's popular music requires multiple miking.

Type of Music

The type of music can influence TV miking. Classical music audiences may not care to see a symphony orchestra, or string quartet for that matter, draped with microphones, but they tolerate it. They are accustomed to hearing music in excellent acoustic settings where mics are not necessary to carry the sound. Their objection is not so much that mics are in the picture but rather that mics are being used at all.

This is one reason concert broadcasts typically originate from concert halls and not from studios. In controlled acoustic environments the sound designer can hang a few mics to achieve a natural sound blend and also keep the mics out of the picture. Even so, some of the newer concert halls have been designed with electronic enhancement built in. Loudspeakers are strategically placed either to make up for certain response deficiencies at various locations in the hall or to make frequency and loudness response uniform throughout the hall.

Popular music usually requires a mic for each sound source (or direct insertion) plus electronic enhancement. It would be impractical to use only a few mics to pick up, say, a rock ensemble, because it would change the entire character of the sound, to say nothing of the difficulty in matching the loudness of acoustic and electric instruments.

Techniques for Miking Music in Television

For some of the common techniques used in miking music for television, see Figures 14-77 through 14-81. It is important to note that an ensemble must first be arranged to be pleasing to the eye and then miked within the constraints established by visual requirements.

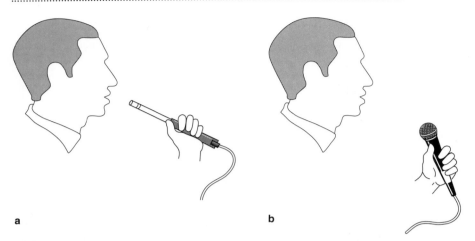

a b

14-77 Miking vocals for TV. (*a*) A singer using a hand-held directional microphone should hold it at about a 45-degree angle to the mouth to stay within the pickup pattern but not block the face. (*b*) Hand-held omnidirectional mics can be held at chest level. A hand-held microphone should contain a pop filter and be shock-resistant, easy to hold, and good-looking.

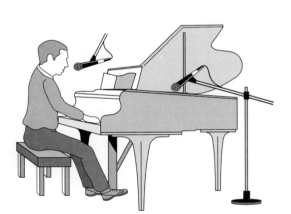

14-78 Miking a singer–pianist. One microphone is required to pick up the vocal and one or more are required to pick up the instrument. Contact mics can be used to keep microphones out of the picture.

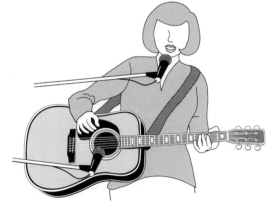

14-79 Miking an instrumentalist. Mike a guitarist who plays and sings with two directional microphones: one to pick up the voice and the other to pick up the guitar. Another approach is to use a lavalier for the vocalist and a contact mic on the guitar. Wireless mics would be more convenient.

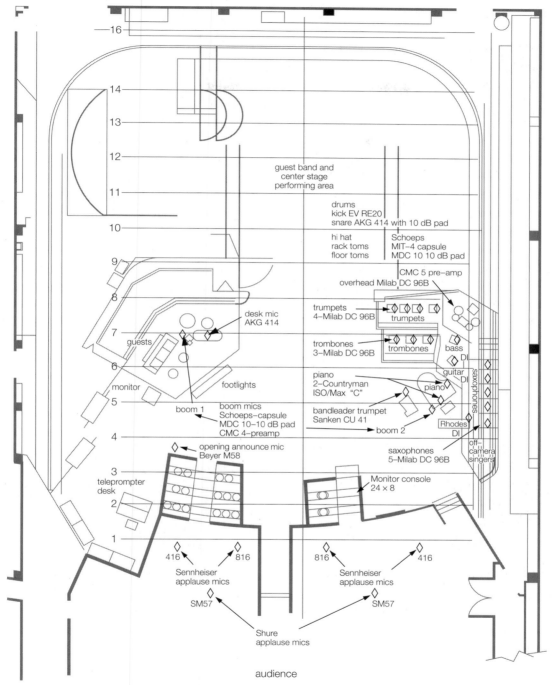

14-80 Example of a stage and microphone setup for a television variety–talk show

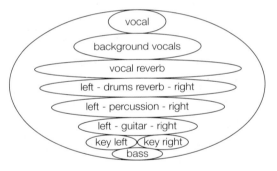

drums
kick AKG D112
snare-top B&K 4011
snare-bottom B&K 4011
hi-hat, toms Schoeps colette
 MK4 capsule
 MD21010 dB pad
 CMC preamp
overhead B&K 4011

finger cymbals Shure SM 98
triangle Shure SM 98
bell tree 1 Shure SM 98
bell tree 2 Shure SM 98
tamborine Shure SM 98
hand percussion B&K 4011
timbale B&K 4011
congos 2 Sanken CU32

drums riser | percussion riser
bass ◊ | BG singers riser | □ AMP ◊ guitar
elec. piano | BG singers riser | keyboard
| | ◊ lead vocal

all vocals
AKG 535

bass, guitar,
piano, keyboard
all D.I.

a center stage setup

vocal
background vocals
vocal reverb
left - drums reverb - right
left - percussion - right
left - guitar - right
key left ✕ key right
bass

b pans

14-81 (*a*) **Stage and microphone setup for a pop music group, (*b*) including panning**

Music in Film

The microphone technique used in recording music for film is similar to the techniques used in recording studios: Ensembles are miked using individual microphones on instruments or groups of instruments. Because the ensemble is not in the picture, it doesn't matter if microphones block players from view or clutter the stage.

Main Points

1. Although almost all the music radio stations play has been produced elsewhere, its arrangement and the arrangement of other ingredients, such as commercials, jingles, and announcing style, are audio production matters because they relate directly to a station's overall sound.

2. Among the production considerations in programming music in a radio station are the sonic compatibility between music selections and the transitions between music selections.

3. Prerecorded music libraries provide a relatively inexpensive way to use original music to underscore the ideas and emotions in a script.

4. Most recordings are copyrighted and may not be used unless a fee is paid to the licenser. In the case of music libraries, the fee usually is based on the number of needle, or laser, drops in a production. With sound libraries, and some music libraries, fees are established for blanket use.

5. Music in spot announcements creates mood and feeling, is visual and memorable, gets the audience's attention, provides unity, and can be directed to the taste of a specific audience.

6. Two basic approaches to miking live music are (1) distant miking—using a main array of two microphones (or capsules) to record an entire ensemble in stereo—and (2) close miking—using one microphone to record each sound source or group of sound sources in an ensemble on separate tracks and mixing it to stereo.

7. Five major considerations in distant miking are (1) critical distance, (2) air loss, (3) phase, (4) localization, and (5) stereo-to-mono compatibility.

8. Three arrays used in distant miking are (1) coincident, (2) near-coincident, and (3) spaced.

9. With coincident miking the stereo effect is produced by intensity differences between channels; stereo imaging is sharp; and the stereo is mono-compatible.

10. With near-coincident miking the stereo effect is produced by intensity and time differences between channels; stereo imaging is usually sharp; sound is more open than it is with coincident miking; and, as the angle or space between the mics increases, so do time differences between the channels, which reduces stereo-to-mono compatibility.

11. With spaced microphones the stereo effect is produced by time differences between the channels; left and right stereo imaging is diffused; the ensemble tends to sound spread out (if the spread is too exaggerated, a third mic is added to the main pair); sound is spacious and warm; and the stereo is not mono-compatible.

12. The angle or the space between mics set up for stereo recording must be positioned in relation to the ensemble so that it is neither too narrow nor too wide. Otherwise, in reproduction the ensemble sound will be either too concentrated toward the center of the stereo image (between the loudspeakers) or so wide that sound will be concentrated to the left and right with little sound coming from the center of the image.

13. The M-S array, the X-Y array, the stereo microphone, the Blumlein technique, and the Soundfield microphone system are all variations of coincident microphone arrays.

14. Variations of the X-Y array such as the ORTF, NOS, DIN, stereo 180, and Faulkner techniques are types of near-coincident miking.

15. Spaced miking employs two (or three) microphones several feet apart, perpendicular to the sound source, and symmetrical to each other along a centerline.

16. Accent (or fill) mics, in addition to the main stereo array, may be necessary to supplement overall sound pickup of weaker-sounding instruments, sections, or soloists.

17. In addition to the main microphone array and accent mics, ambience microphones are used to pick up the reverberant sound field.

18. Because close miking involves miking most of the instruments in an ensemble, it means that (1) microphones should be no closer together than roughly three times the distance from any mic to its sound source to avoid phasing problems; (2) mic-to-source distances are usually close, thus reducing the interaction of music with acoustics and requiring the addition of artificial reverberation; and (3) each sound source usually requires a separate tape channel to better control the various microphone inputs.

19. The closer a microphone is to a sound source, the more detailed, drier, and, if proximity effect is a factor, bassier is the sound. The farther a microphone is from a sound source, the more diffused, open, and reverberant is the sound.

20. The higher the frequency, the more directional the sound wave; the lower the frequency, the more omnidirectional the sound wave.

21. If two or more musicians in a recording session are using separate microphones and if controlling leakage is important, baffles or isolation booths are used to keep the sound of one instrument from leaking into the microphone of another instrument.

22. No one close miking technique is necessarily better than another. Microphone selection and positioning depend on many factors: the music, the musician, the quality of the instrument, the acoustics, the blend, and so on.

23. Some electric instruments, such as the bass and guitar, can be recorded either by miking their amplifier loudspeaker or by direct insertion — plugging the instrument into the console.

24. Recording a vocalist is a severe test for any microphone, because the mic must be able to handle the nuances of the vocalist's timbre and dynamics, as well as any breathy, popping, and sibilant sounds. Mic selection and placement depend on voice quality, style of music, and microphone presence.

25. Because digital recording often reproduces sounds not audible in analog recording, the microphones used for digital recording must be of very high quality, generate very low self-noise, be carefully handled, and kept in clean, temperature- and humidity-controlled environments.

26. Because production in general and music recording in particular are so trying, tact and preparation go a long way toward ensuring the success of a performance.

27. Overdubbing facilitates greater control over each sound element, alleviates the need to record all elements at the same time, and allows a few performers to do the work of many. But it can also inhibit spontaneity and creative interaction.

28. If there are more sound sources than available tracks to record on, do a "live mix" of selected elements or bounce tracks.

29. If you signal process during recording, make sure that you know what you are doing. Once recorded, most signal processing cannot be "unrecorded."

30. It is important to keep formal records during production, whether written or on a computer disk, as well as oral records — slating information — on the master tape(s).

31. Musical Instrument Digital Interface (MIDI) enables synthesizers, computers, rhythm machines, sequencers, and other signal-processing devices to be interconnected through an interface that allows them to communicate with and/or control one another.

32. Microphone placement for a music performance on TV depends on a combination of factors: whether the musicians are on camera, what type of music is being played, how good the acoustics are, and where the stage monitor loudspeakers are located.

On-Location Recording and Production

Production is frequently done on location to cover news and sports, to produce a disc-jockey program promoting a sponsor, to heighten realism in a drama, to add authenticity to a setting, or to provide a surrounding that is difficult or impossible to reproduce in a studio. Going on a **remote** — outside the controlled studio environment — has become commonplace because of the development of highly portable equipment, the ease with which a broadcast signal can be transmitted across town or across the world, and the sophisticated technology and techniques of postproduction.

The functions of the equipment and many of the techniques used in on-location production are the same as in studio production: to transduce, amplify, mix, process, transmit, and record sound or picture, or both, with optimum fidelity. The type, complexity, and function of the equipment and production techniques, however, depend on the program material and the medium. These factors are grouped into two categories (three if you include film): **electronic news gathering** (ENG) and **electronic field production** (EFP). Both terms originated in television during the 1970s, but they have broadened to include radio, audio field production, and satellites. (Because satellite news gathering (SNG) relates more to transmission and delivery than to production, it is not covered here.)

Electronic News Gathering (ENG)

Electronic news gathering refers to radio or TV news that is gathered in the field with portable electronic equipment and, if necessary, beamed via a telephone line, microwave, fiber optic circuit, or satellite to the studio for live broadcast or recording. ENG has made it possible to cover and broadcast news as it is happening.

Basic ENG Equipment for Radio

The basic equipment used for electronic news gathering in radio consists of microphones, tape recorders, microphone mixer, a mobile unit, and headphones.

Microphone

Because ENG (often abbreviated RENG for radio) usually involves one reporter delivering a story or a reporter doing an interview, the hand-held, omnidirectional, moving-coil microphone with pop filter is preferred. A hand-held mic requires no special mounting and takes no time at all to set up. Field reporting is often done outdoors, and a pop filter is better at reducing unwanted wind sound than a windscreen; nevertheless, it does not hurt to use a pop filter and a windscreen just to be safe. If wind, or traffic rumble, is severe, a high-pass filter can be plugged into the mic line to diminish bassy noise (see 15-1). But conditions should justify using the high-pass filter because it may also attenuate desired low frequencies. On-location EFP and film productions that require more critical noise reduction and have the time to set up the appropriate equipment, use a background noise suppressor to reduce wind and

15-1 High-pass filter. This device can be plugged into a microphone line to reduce unwanted low-frequency sounds. A similar-looking low-pass filter is also available to reduce unwanted high-frequency sounds.

traffic rumble. (See "Noise Reduction in the Field" later in this chapter.)

An omnidirectional microphone maintains a sense of environment. The body blocks sounds coming from behind the reporter, reducing the overall level of background sound. Mic-to-source distance can be adjusted by moving the microphone closer to or farther from the mouth to compensate for noisy environments. If a locale is too noisy, use a cardioid pattern, either a moving-coil type or one of the new, rugged, capacitor types with pop filter. But be careful: Pressure-gradient mics are especially prone to wind noise.

Tape Recorder

The cassette is the most often used audiotape recorder in RENG. It is lightweight, small, and easily carried. One reporter can manage microphone and tape recorder, eliminating the need for additional personnel. Cassette ATRs made for radio news have features not found on most nonprofessional cassette recorders, thus adding to their other conveniences (see 7-23). At the studio, cassette reports are dubbed to cartridge or open-reel ATRs for ease of editing and handling and, with signal processing, to improve playback sound quality. Some cassettes are equipped with a "Pause" control to facilitate electronic editing (see Chapter 16) when the sound is transferred to cartridge or open-reel tape.

Sound (and picture) quality are important to any professional. In news, however, gathering, producing, and reporting the story take precedence over production values. For this reason, and also because of the added expense, R-DATs have been slow making inroads into RENG. There are two other reasons why analog audio continues as the format of preference in radio news: (1) Digital sound quality is not necessary to news coverage and, even if it were, the sonic improvement would not be that perceptible on most home receivers. (2) It's cheaper.

Microphone Mixer

When one microphone is being used for reporting in the field, it is a simple matter to plug it directly into the tape recorder. If two mics are needed, a stereo cassette recorder with two mic inputs would suffice. When you require more microphones than the tape recorder can handle, however, you need a microphone mixer—a device with three or more mic inputs that feed to a master output. Mic mixers are available in mono and stereo and may have features such as low-cut filters, phantom power, tone oscillator, and slate tone (see 15-2). Clearly, a console would also meet the need for multiple microphone inputs. But a console, even a highly portable, suitcase-sized model (see 15-11), is more than most radio reporters require; it is also neither as lightweight nor as compact as a mic mixer.

Mobile Unit

In radio a **mobile unit** can be anything from a small car to a van carrying a reporter with microphone, tape recorder, two-way communications device, and other support equipment. The obvious advantage in a mobile unit is the ability to get to a news event quickly and cover it first-hand. Mobile units also make it possible to feed live or taped material directly to the station. Four systems are commonly used for this purpose: two-way radio, mobile telephone, cellular telephone, and remote transmitter.

The *two-way radio*, used in police, taxi, and other types of dispatching, consists of a base station at the studio and a microphone and transceiver in the mobile unit. A mixer may be wired in the mobile unit to facilitate feeding reports from the mic or a tape recorder. Sound quality in many two-way radios is poor—from 300 to 3,000 Hz—although better units can range from 40 to 7,500 Hz, which accommodates most speech. With more sophisticated, affordable transmitting systems available, the two-way radio is less commonly used today. In addition to sound quality, two-way radios have another disadvantage: The competition can listen in on your reports.

The *mobile telephone* is a radio unit connected to telephone equipment that sends the signal to phone wires for transmission to the station. The advantage of mobile telephones over two-way radios is that you can call anyone, anywhere. Sound quality is no better than that of the two-way radio, however. Moreover, mobile telephones are vulnerable to interference from radio waves and telephone lines.

The *cellular telephone* is similar to a mobile telephone, but instead of sending signals over wires, it sends them over radio waves through a computer-controlled network of ground stations. Areas in a locale are divided into cells, and as a mobile unit passes from one cell to another, calls are automatically transferred from one ground station to another. Among the advantages of cellular telephones are improved sound quality and greater flexibility in feeding material to the

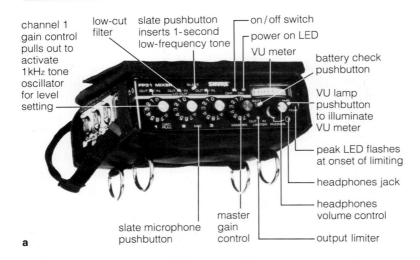

channel 1
gain control
pulls out to
activate
1kHz tone
oscillator
for level
setting

low-cut
filter

slate pushbutton
inserts 1-second
low-frequency tone

on/off switch

power on LED

VU meter

battery check
pushbutton

VU lamp
pushbutton
to illuminate
VU meter

peak LED flashes
at onset of limiting

headphones jack

headphones
volume control

output limiter

slate microphone
pushbutton

master
gain
control

a

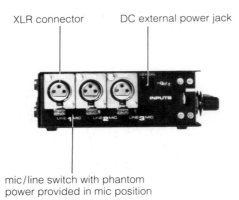

XLR connector

DC external power jack

mic/line switch with phantom
power provided in mic position

b

15-2 Microphone mixer. (*a*) Front, (*b*) side.

station. Hand-held cellular phones that re-
quire no link to a mobile unit are also used
(see 15-3).

The *remote transmitter*, more commonly
called the *remote pickup*, *RPU*, or *Marti*,
after a leading RPU manufacturer, is a trans-
mitter that allows a reporter freedom of
movement. It may be used for direct broad-
cast from the remote unit, or it can be re-
moved from the vehicle and operated on AC
current. It also has better sound quality than
the three other types of mobile transmission;

in some units frequency response extends
from 20 to 15,000 Hz. RPUs have inputs for
at least one microphone and one line source,
such as a cassette tape recorder. Many also
include a basic mixer, which, in effect, con-
verts a mobile unit into a ministudio on
wheels. The disadvantages of RPUs include
their vulnerability to interference; their in-
ability to entirely cover large metropolitan
areas, which means they must be supple-
mented with a cellular telephone; and their
sound quality, which makes it seem as if

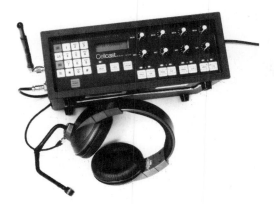

XLR mic input

a

15-3 **Cellular telephone system.** This unit contains a four-input mixer selectable as microphone or line or a combination of both. A manual gain control is provided for each channel for input level and headphone level. A speaker output jack provides for feeding an external monitor or recorder. There are two sets of programming features, mode and cellular. Mode includes mic and line inputs options and choice of cellular or landline operation. Cellular includes specific parameters needed for cellular operation. On a fully charged set of batteries, continuous cellular operation is 1¼ hours. Audio quality varies with cellular phones; board operators should be ready with EQ and gain boost for live broadcasts.

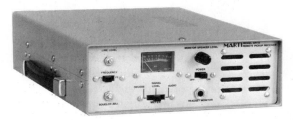

b

15-4 (*a*) **Hand-carried transmitter and** (*b*) **mobile relay receiver.** The transmitter sends the signal to the receiver. This unit weighs 7 pounds and includes 2.5 watts of continuous output, dual frequency provision, internal battery charger and AC supply, compressor-limiter, and one microphone and one line level input with individual mixing controls. The receiver relays a broadcast to the base station, usually in the newsroom. This unit weighs 5½ pounds and has dual frequency capability, monitor speaker, noise reduction, and terminals for feeding telephone lines.

reports were done in the studio. Fully portable RPUs are also available (see 15-4). In fact, an RPU can be used for local sports broadcasting, thereby saving on transmission line charges.

Because even modest radio news operations are using more equipment in news vehicles, equipment flexibility and mounting have become increasingly important. In addition to meeting a reporter's typical transmission needs, mobile units have been designed to facilitate the producing, packaging, and broadcasting of stories in the field. The two-way mixer with some or all of the following features helps to make this possible.

- A microphone preamplifier with wide dynamic range and sensitivity

- At least one input for audio cassette
- The ability to listen to cassette audio for previewing, editing, and cueing
- Push-to-talk capability at the mic input
- Excellent immunity from radio frequency (RF) interference
- A cue audio input from the car radio or RPU channel
- VU metering, not only to monitor levels but also to aid visibility—LEDs are difficult to see in sunlight
- An external limiter

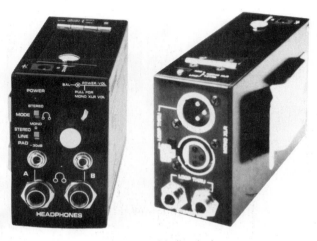

front view side/back view

15-5 Stereo headphone amplifier

Headphones

We must especially emphasize an extremely important piece of equipment often overlooked in on-location production — headphones (see Chapter 10). Regardless of the medium — radio, TV, film, or disc — the purpose of the production, or its scale, headphones are as important on location as loudspeakers are in the studio. *Headphones are the only reference you have to sound quality and balance.* Use the best headphones available, study their frequency response, and get to know their sonic characteristics. First-rate headphones are expensive, but worth it. They have a wide, flat response; they are sensitive; they have superb channel separation (for stereo); and their cushioned earpieces keep outside sound from leaking through. All these characteristics are essential in producing audio on location, when loudspeakers are unavailable.

It is also to your advantage to have a headphone amplifier handy (see 15-5). It gives you the ability to monitor a mix at a conve-

nient level without affecting the original signal sources. This is particularly useful when the loudness of background sound makes it difficult to hear program audio. By plugging headphones into a headphone amplifier and plugging the amplifier into the mixer/console headphone output, the headphones can be driven to the desired loudness level.

Basic ENG Equipment for Television

In radio the reporter can handle the microphone and the tape recorder. Union regulations in larger cities may require an audio operator to accompany the reporter. In television, however, one or two persons, in addition to the reporter, are needed to operate the equipment, union regulations notwithstanding. ENG crews usually consist of at least one camera/VCR operator or one camera and one VCR operator. The VCR operator generally monitors sound. Sometimes, simple lighting is necessary in TV ENG; un-

less union rules call for a separate lighting person, the camera operator is responsible for that as well.

Camera

The camera can be one of the portable, lightweight, battery-powered, hand-held or shoulder-borne models developed for on-location operation. Automation is an important feature of these cameras, for news reporting allows little time to adjust and set up the camera for shooting.

Videocassette Recorder

Like the TV camera, battery-powered video recorders have been designed for portability. Videocassette recorders (VCRs) are used for ENG because they are quick to load and easy to handle. Most VCRs used today in ENG are part of a combined camera–recorder system called a **camcorder**. The unit is either self-contained or the recorder is separate from but dockable to the camera. In either case, combined, camera and VCR weigh less than 20 pounds.

Although ¾-inch is the preferred format for high-quality ENG, the ½-inch videotape formats — Betacam SP, MII, and S-VHS — have gained increasing popularity because of their competitive picture quality, comparatively lighter weight, and lower cost. Depending on the format, field recording time runs from 20 minutes per cartridge up to 2 hours. (Sound quality on analog and digital videocassette tape is discussed in Chapters 7 and 8, respectively.)

Microphone

As in RENG, the hand-held, omnidirectional, moving-coil microphone with pop filter is still the microphone of choice for TV

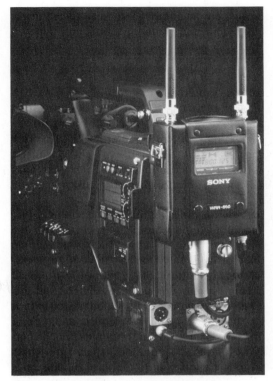

15-6 Portable camera recorder with wireless system diversity receiver

ENG because the omni pickup pattern provides a sense of sonic environment and the reporter can control mic-to-source distance. If the environment is too noisy, a directional mic is more suitable. The mic may be wired or, as is more likely today, wireless. The reporter carries the transmitter and the receiver is mounted on the camera (see 15-6).

In TV news care has to be taken to keep the microphone from being obtrusive. In brief stand-up reports and interviews this usually is not a problem. But if an interview is lengthy, it is probably better to take the time to set up two lavaliers. It could be annoying to the audience (and interviewee) to see one hand-held mic moved back and forth

between reporter and guest for several minutes. Most analog VCRs used for ENG have two mic inputs. The ½-inch formats have four audio tracks, two of which are digital. If more audio inputs are required, then a portable microphone mixer would be necessary.

A portable TV camera with a microphone built in allows one person to operate audio and video simultaneously. Although the built-in microphone is usually directional and can pick up sound from several feet away, any mic mounted on a fixed stand cannot adequately handle shots that change from one focal length to another. Unless you move the camera itself, it is difficult to adjust the sound for a change from, say, a medium shot to a close-up or a long shot. Also, the mic may pick up sound from a zoom lens motor or a hum from the monitor and has to be pointed straight at the sound source to reduce unwanted sound.

Power Supply

Most portable TV cameras and videotape recorders are powered by either batteries or standard AC. In some units the videotape recorder supplies power to both the VTR and the camera; in other units the power supplies are separate. Several recorder units also come with a battery charger.

Battery lifetimes differ. The camera battery can provide up to two hours of continuous power before it requires recharging.

Mobile Unit

As in RENG, the TV ENG mobile unit can be a car that transports the reporter, technical crew, and equipment (although the reporter often travels separately). But if live transmission to the studio is required, then a microwave-equipped van is necessary.

Because ENG cameras and tape recorders are powered by battery, a mobile unit must be able to charge batteries in the field. ENG vehicles, therefore, can take power from a 120-volt AC, 20-amp current, if it is available, or from a generator in the unit that may be powered by the vehicle's engine.

ENG Production

The main purpose of ENG is to facilitate fast access to the news scene, quick setup time, uncomplicated production, immediate distribution, if necessary, and simple postproduction. In news the immediacy is more important than the aesthetics, but this is not to say that news producers ignore production values. They simply do the best they can under the circumstances.

Preproduction

Preproduction planning in ENG is obviously difficult because news can occur anywhere, anytime. The best you can do is always be prepared. In audio, preparation means making sure that the following items are available and ready:

- Nondirectional and directional moving-coil and capacitor microphones; hand-held and lavalier mics; and a parabolic mic, if necessary
- Fresh battery supplies in all capacitor mics, tape recorders, mic mixers, and wireless microphone systems
- Extra battery supplies
- A backup tape recorder
- Extra microphone cables
- Plenty of recording tape
- Head cleaner and cotton swabs
- XLR, phone, phono, and miniplugs and adapters (see 15-7)

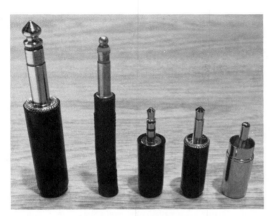

15-7 Commonly used connectors for audio. (Left to right) ¼-inch phone plug (stereo), Bantam phone plug (stereo), mini plug (stereo), mini plug (mono), RCA or phono plug. (See 5-55 for XLR connectors, not shown here.)

- Alligator clips and leads
- Headphones
- Portable microphone mixer
- Line-to-mic adapters to match impedance from auditorium amplifiers
- Pads (40 dB) if line-to-mic adapters are insufficient to lower level
- High-pass filters to insert into the mic line to cut low-frequency noise
- Clamp-on mic stand for a podium
- AC extension cords
- Duct and masking tape
- Tool kit
- Log sheet to write down time, location, and content of recorded information

Production

On-location production always presents the problem of background sound interfering with the intelligibility of the on-mic/camera reporters. In Chapter 12 a few techniques directors use to minimize the problem were discussed. In news, however, sense of locale is important to reports from the field, particularly in radio. In fact, some radio news producers do not want the sound quality of actualities — reports from the field — upgraded to studio quality precisely in order to preserve location presence.

Miking the Stand-Up News Report The omnidirectional, moving-coil, hand-held microphone is used most often in stand-up news reports from the field. It picks up enough background sound to provide a sense of environment in normal conditions without overwhelming the reporter's sound. It is possible to control the balance of background-to-reporter sound by moving the microphone closer to or farther from the speaker. The closer the mic-to-source distance, the more the background sound is reduced (see 15-8).

Another advantage of the omnidirectional microphone is that it can be held comfortably below the mouth and in a relatively unobtrusive position on camera. For interviews, the mic can be situated between reporter and interviewee without necessarily having to move it back and forth for questions and answers (see 15-9).

In noisy environments an omnidirectional microphone may not discriminate enough against unwanted sound even at a close mic-to-source distance. In such a situation use a directional microphone. The sound balance between reporter and background can still be maintained by moving the mic closer to or farther from the reporter's mouth. Remember, however, that directional mics must be held at an appropriate angle to be on-axis to the mouth (see 15-10). Moreover, during interviews the microphone must be moved back and forth between interviewer and interviewee if the sound is to be on-mic. In television do not obstruct the mouth with the microphone.

a

b

15-8 Reducing background sound. (a) Holding an omnidirectional microphone at chest level usually creates an optimal mic-to-source distance. (b) If background noise is high, its level can be reduced by decreasing the mic-to-source distance.

15-9 Using an omnidirectional microphone for on-location interviews. It can be positioned between the principals, usually with little need for repositioning, at least in quiet surroundings.

Split-Track Recording Another way to control the audio balances between reporter and background sounds or in an interview is by using split-track recording. Recall that split-track recording employs either a two-track stereo ATR, or ACR or a VCR with two audio tracks. Two microphones are used; each feeds a separate channel. The purpose of this technique is to do a mini-multitrack, rather than a stereo, recording to better control the audio quality and mix of two sound sources.

In a stand-up report, for example, the speaker can hold the microphone close to the mouth to reduce background sound to a minimum. The other microphone is used just to record background sound. With each element separately recorded, they can be balanced properly in the mix under controlled conditions.

In an interview either the two principals can be miked separately or one mic can be used between them, with the second mic used to pick up background sound. In either case the two microphone feeds facilitate more control over the sound balance.

Split-track recording may not be possible or necessary on an everyday basis, but the improvement in audio quality and control is worth the time, if you have it. Not only is this technique useful in ENG, but it can also be applied in any type of field recording.

Recording Background Whether you record using the split-track method or tape all the audio on one track, make sure you record enough background sound (indoor or outdoor) by itself by running the tape recorder in "Record" for a while either before or after

a

b

15-10 **Miking when on-location background noise is too loud.** Use a directional microphone (a) either several inches from the mouth (b) or close to it, depending on the performer's voice projection. Because the microphone is directional, it must be held at the proper angle if the performer is to be on-mic.

taping. Background sound is useful in post-production editing to bridge transitions or cover awkward edits (see Chapter 16).

Most VCRs used in ENG have at least two audio channels. Recording background may be a problem in TV, however, if it means wasting the picture portion of the videotape unless a number of cutaways — shots other than the main action — are taken. It is a good idea, therefore, to bring either an open-reel or cassette audio recorder with a microphone to record additional background sound separately.

Using Automatic Gain Control (AGC)
Avoid using automatic gain control (AGC) on location. AGC is a feature on some recorders that automatically boosts the level when loudness falls below a preset (built-in) level. If you are recording background sound, the AGC brings up the noise level as it seeks volume. Also, if a reporter makes slight pauses during recording, it may be possible to hear the increases in background sound level as the AGC automatically increases volume. AGC should not be confused with a built-in limiter, which can be useful.

Electronic Field Production (EFP)

The major differences between ENG and electronic field production (EFP) are scale, time, and purpose; however, in principle they are the same. They both make it possible to produce program material away from the studio. But whereas ENG is designed to cover news events quickly, EFP is used to produce, more deliberately, material such as entertainment programs, drama, sports, documentaries, and commercials. Therefore, EFP generally requires more equipment, takes more time in planning, production, and postproduction, and results in a technically and aesthetically superior piece.

Small-Scale EFP

The main differences between small- and large-scale remotes are the amount of equipment and personnel used and the complexity of the production. Commercials, documentaries, and disc jockey programs can be produced with a minimum of hardware and people, whereas a football game, parade, concert, or the Academy Awards cannot.

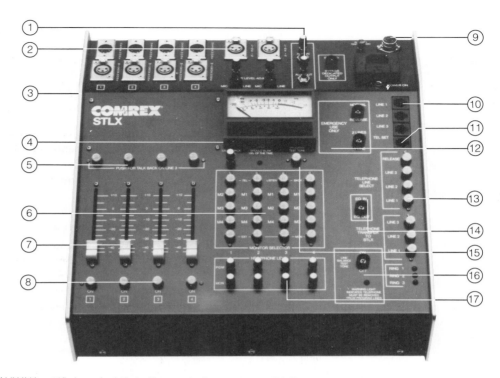

(1) AUX IN is a ¼" phone jack that will accept a line level source such as a stadium sound system or off-air monitor. This audio does not mix to program but appears at the headphones when EXT MON is pushed in the monitor matrix. AUX OUT provides balanced, −20 to 0 dBm program audio to feed a stadium PA system, external tape recorder, etc.

(2) Channels 3 and 4, which operate from line level inputs. There are two separate 3-pin XLR female connectors, which become active when the toggle switch is placed in the line position. Input level controls are provided.

(3) The console will accommodate four microphones and four headphones. You may use either a combined "sportscaster" type with two headphones or separate microphones and headphones.

(4) The listen back level controls the level of the Line 3 communications line into the headphones.

(5) When pushed in, the talkback buttons remove the associated microphone from program audio and connect that mic to the Line 3. This provides a telephone connection, separate from program, for communications through the headphones and mics.

(6) The monitor selector allows you to listen selectively to any of the audio inputs to the console as well as to the Line 3 communications line. Program output is fed into the left headphone while the monitor mix appears at the right headphone. Any headphone may be internally jumpered to hear program only in both headphones.

(7) Faders

(8) When a channel on button is pushed in, that channel is mixed to program. Microphone outputs will appear on the monitor mix, even if the channel is not on, as long as there is some level set on the fader. It is therefore possible to communicate through the headphones without that audio appearing on air — a useful feature for "spotter" type applications.

(9) This is for connection of an optional external battery pack that will run the console for about 1.5 hours.

(10) Lines 1 and 2 are used to transmit program. Line 3 provides a separate telephone communications line back to the receiving site.

(11) This is for connection of a standard telephone set.

15-11 Console designed for use at sports remotes

(12) The emergency use section allows you to reverse your program lines in the event that Line 1 drops and to switch to one-line operation until the second program line can be re-established.

(13) These buttons select the line to be dialed. Once the lines are established, they can then be transferred to the console. There are visual ringing indications for all three lines.

(14) The EQ may be switched in to compensate for telephone lines with high frequency rolloff.

15-11 (*continued*)

(15) This is a conventional 1000 Hz program test tone that feeds onto the program lines for level setting of program audio.

(16) This sends setup tones down both program lines so that the receive site can bring the lines to equal levels.

(17) The headphone level knobs provide separate level control for the program and monitor feeds to each of the headphones.

Note: The AC power plug is on the back of the console.

Small-scale EFP is closer to ENG; large-scale EFP is more like a major studio production.

Radio

Electronic field production in radio is usually limited to personality programs such as disc jockey and talk shows, as well as sports. Sometimes, it may involve a live concert.

The absence of the visual component drastically cuts down on the amount of equipment you need in radio, compared with TV and film, and on the time needed for preproduction planning. In sports, for example, a few microphones, a mixer or portable mixing console, and RPU or transmission line are sufficient (see 15-11). A disc jockey program can be mounted with a self-contained remote unit consisting of microphone, CD and cartridge players, and small console.

Vans are also used in radio remotes. They may be ENG units equipped with CD players and tape recorders or EFP units with removable side panels so the personalities can be seen.

Transmission

Remote radio broadcasts carried by a local station use wired telephone services if they must be transmitted across distances too far for RPU transmission, or if they would be difficult to carry by microwave because of the hundreds of relay stations needed to get the signal from one area to another. Using a satellite to beam signals for long-range transmission also solves this problem, although the solution does not come cheap. Generally, satellites are used for global and continental transmission by networks and syndicated programmers.

There are several wired telephone services, analog and digital. They range from an inexpensive and relatively poor-quality dial-up voice line for radio remotes, to more expensive, higher quality voice lines, to digital transmission with very high quality and greater data capacity. The number of services and their technical parameters are the domain of the engineer and beyond the purview of this book.

There is one useful bit of information about telephone lines for remote broadcasting to pass on, however. When a line is installed, one terminus will be at the broadcast station. The other terminus — called the *telco drop* — will be at the remote site. Make sure you know where the phone company has left that terminal block, otherwise valuable and frantic time could be spent searching for it.

Television

Small-scale television remotes require more equipment and planning than do radio remotes.

back front

15-12 **Hand-carriable sound system.** This model is battery-operated with multiple inputs and outputs including a built-in tape player and wireless microphone system.

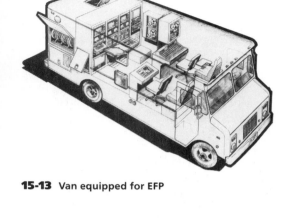

15-13 **Van equipped for EFP**

Cameras Cameras used in EFP are hand-held or shoulder-mounted like those used in ENG. Indeed, the same lightweight, portable cameras are often used for both types of production. When better-quality images are required, higher-quality EFP cameras are employed. These cameras may be mounted on tripods to achieve more controlled and better-composed shots, because time is not as critical in EFP as it is in ENG.

Videotape Recorders EFP incorporates most analog and digital VTR formats, including ½-, ¾-, and 1-inch tape. Also, 8mm is being used. One-inch tape is preferred because the picture and sound are of the highest quality, particularly in the digital format. With the advent of metal tape and digital VTRs in the ¾- and ½-inch formats, sound and picture quality can range from acceptable to quite good for EFP.

Audio Because small-scale EFP usually involves productions in which microphones should be unobtrusive and directional, shotgun mics mounted on fishpoles or booms, lavaliers, and wireless systems are generally

preferred. It is also likely that a few microphones will be used that require a mic mixer or a small audio console inside the van. Some directors use recorded music or sound effects to give the performers a better idea of the flavor or pace of the script, to aid in the timing of cues, or to save production time. Some EFP mobile units are therefore equipped with cartridge, R-DAT, or open-reel tape recorders, or a portable sound system (see 15-12).

Small-Scale EFP Mobile Units Small-scale EFP mobile units, like those used for ENG, can vary from a station wagon to a van. But unlike ENG units, EFP vehicles carry more equipment, have more storage space (because microwave is unnecessary), and have a more elaborate video/audio control center (see 15-13).

Large-Scale EFP

Large-scale electronic field production involves taping or broadcasting an event, such as a football or baseball game, a parade, or an awards program, on the spot. As major

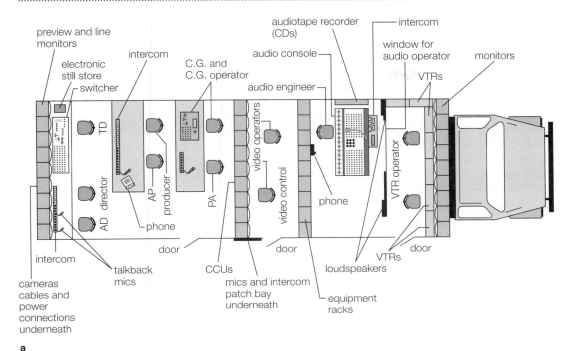

preview and line monitors

electronic still store

switcher

intercom

C.G. and C.G. operator

audiotape recorder (CDs)

intercom

audio console

window for audio operator

monitors

VTRs

audio engineer

TD

video operators

audio console

VTR operator

AD director

AP

producer

PA

video control

phone

VTRs

phone

intercom

cameras cables and power connections underneath

talkback mics

CCUs

mics and intercom patch bay underneath

door

door

loudspeakers

equipment racks

VTRs

door

a

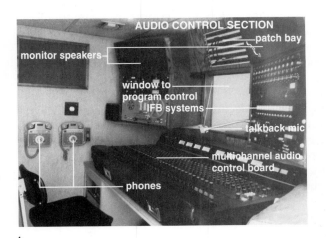

AUDIO CONTROL SECTION

patch bay

monitor speakers

window to program control

IFB systems

talkback mic

multichannel audio control board

phones

b

15-14 Remote truck. (*a*) The remote truck represents a complete control center. It contains program, audio, and technical control centers and a VTR section. It also has connections for the power cables and rather extensive audio and intercom patchboards that are accessible from the outside of the truck. For especially complex remotes, a second remote truck contains the equipment for instant-replay operations. (*b*) Audio section of a television production remote truck.

productions these events require the same technical support on location that large-scale productions require in the studio. A huge trailer (sometimes more than one), literally a studio-type technical facility on wheels, and the dozens of engineering and production personnel to go with it provide that support (see 15-14). The trailer contains all the equipment necessary to process and route signals from the many cameras and microphones that cover the event outside the truck and from the video and studio sources, such as

instant replay, slow motion, and sound carts, inside the truck.

Increasing attention to the production of quality sound and the ever-growing audio technology have led to the development of sophisticated audio-only mobile units. These units, modeled after EFP vans, contain the types of equipment found in recording studio control rooms—multichannel console, multitrack and stereo tape recorders, and the commonly used signal processors (see 4-15). Audio mobile units are used for on-location concert production and in TV and film shoots to support the video EFP or film unit.

Multicamera EFP

Events produced in the field are either covered or staged. A covered event occurs regardless of media, and production conforms to the event. Sports, parades, and concerts are examples of covered events. Staged events, such as drama, variety, and awards programs, are produced especially for the media and are more tightly controlled. The production approach to an event depends on the type of event it is.

Covered events usually require the multicamera TV approach. Several cameras feed a switcher, several microphones feed a mixer, and all signals feed to tape or broadcast, or both. Shots are selected as the event progresses, and there is little or no postproduction. Staged events can be produced using the multicamera TV, single-camera film, or multicamera/multirecorder approach. The event is constructed in postproduction.

Preproduction

Before actual production gets underway, decisions about the production site, the equipment, and any special needs are made. Some of these decisions may be out of the sound person's control. But even as a consultant, the sound person can facilitate the preparation and production of audio by anticipating problems and needs and being ready to provide knowledgeable advice when asked. The importance of proper preparation for on-location production cannot be emphasized too strongly. Consider the loss of time and money, to say nothing of the inconvenience to all the people involved, if you have to hold up production because someone brought the wrong microphone, forgot the batteries for the tape recorder, neglected to pack the tool kit, planned to mount a heavy camera crane on soil too soft to hold it, chose a shooting site several days in advance of production without realizing that a building nearby was slated for demolition on the day of recording, scouted the shooting site at noon although the script called for the scene to take place at dusk, or selected a shooting site filled with ragweed without checking whether any of the key people were allergic to pollen. Planning to shoot on location is a careful, meticulous procedure involving more than just decisions about production.

Selecting a Location

In selecting a site, sound designers prefer one with suitable acoustics indoors and no distracting sounds outdoors. However, these qualities are rarely found away from the controlled environment of the studio. The first thing to understand about choosing a location is that you must be prepared to deal with unwanted sound. If possible, try to reduce the difficulties by suggesting to the director those sites with the fewest sound problems. But keep in mind that where you shoot is determined by the demands of the picture, not by the demands of the sound.

The main challenge in doing a production on location is to record the principal sound source with little or no sonic leakage from

either the acoustics or other sound sources. Therefore, you must judge a recording site on your ability to neutralize unwanted sound.

Dealing with Unwanted Sound

Unwanted sound is generated by many sources. Some are obvious, and some not so obvious: the low-frequency rumble from traffic that becomes midrange hiss on a wet day, blowing sound from wind, clatter from a nearby office, buzz from fluorescent lights, excessive reverb from rooms that are too live, jet roar from planes that fly over the production area, noise from construction, church bells that ring every hour on the hour, a far-off foghorn, clanking pipes, creaking floorboards, whine from an air conditioner, chirping from birds, barking from dogs, and so on.

Being aware of the problems is not enough; you have to know what, if anything, to do about them. For example, you can usually roll off low-frequency rumble from traffic, but the midrange hiss from wet tires on a wet surface is difficult to equalize out. Gentle wind presents little problem for a mic equipped with a pop filter and windscreen, but these filters will not completely offset the effect of noise from strong winds. If a room is reverberant, you can make it less reverberant by placing a lot of sound-absorbent material in the area and using tight, highly directional miking; but these techniques may not work in large, extremely reverberant spaces. If the director insists on a site where sound problems cannot be neutralized, plan to record the audio in the studio during postproduction.

Two other considerations in choosing a production site with audio in mind are (1) the available space — make sure the boom or fishpole operator has enough room to move with the action and still keep the microphone out of the picture; and (2) the

power supply — if the production site does not have enough power outlets or wattage, plan to bring the main and backup power supplies.

Microphone Selection

Most productions and broadcasts today use directional microphones to isolate sound sources and keep ambience to a minimum. Directional microphones have different characteristics, not only among pickup patterns but also among models with the same pickup pattern. As a result, planning microphone selection requires matching a particular mic to a particular need.

For example, if a set is particularly live, the hypercardioid pattern is more suitable because its on-axis response is narrow. On the other hand, if more room sound is desirable, then the wider on-axis response of a cardioid or supercardioid pattern may be better. If two or three people are sharing a mic, a wide on-axis pickup is essential; perhaps even a bidirectional or omnidirectional mic could be used. If microphones are to be used in relatively close proximity, they should have good off-axis rejection for minimal sound leakage and optimal sound separation.

If music is being produced and will generate loud levels, then microphones with pads or a high overload threshold should be used. If wind is a factor, mics with built-in pop filters make sense. If mics are to be handheld, they should be shock absorbent and easy to manage.

Sometimes, a microphone can be chosen to complement voice quality. A mic with mediocre high-end response will mellow a harsh-sounding voice; a mic with high-end boost can bring life to a dull voice; and a mic with selected midrange frequencies boosted may add clarity or presence to a voice needing such enhancement.

If microphones are in the picture, they should be unobtrusive, even attractive. If several mics are visible, they should be arranged so that they do not clutter the picture.

If microphones are to be used over considerable distances, then wireless mics may be appropriate. Or if there is need for long-reach pickup at sporting events, then the parabolic microphone system should be considered.

Microphone Mounts and Placement

This chapter and Chapters 5, 12, and 14 detail the various aspects of mounting and placing microphones in productions. These are matters for preproduction planning as well.

If a mic is to be boom-mounted, make sure that there is enough room for the boom to operate. If a mic is to be placed on a desk, be sure that it is not in the way of the speaker. If several wireless microphones are to be used, check that their frequencies do not interfere with one another and are not subject to interference from other transmissions in the area.

If a number of people are in a set, be sure that enough microphones are placed to cover all sound and movement, without picking up too much unnecessary ambience, causing phase problems, or getting in the way. Also, avoid mic shadows on the performers and set from microphones mounted at angles inappropriate to the lighting, and beware of mic cables getting in the way of camera or performer.

Prerecorded Material

Any prerecorded announcements, sound effects, or music used during production must be included in preproduction planning. Also plan for the equipment to be used to play them: disc player, open-reel tape recorder, cartridge player, and so on.

Other Equipment and Materials

Anticipating the need for less obvious, but nevertheless important, equipment and materials is also part of preproduction planning. Among the important items to have handy are:

- AC power checker
- Adjustable wrench
- Back-up microphones and mic accessories, such as cables and connectors
- Batteries for every piece of equipment using them
- C-clamp and pony clips
- Clip leads
- Cotton swabs
- Demagnetizer
- Drill and drill bits
- Editing materials
- Flash- or lantern light
- Fuses
- Head cleaner
- Headphones and headphone amp
- Knee bench
- Log sheets to record time, location, and content of production information
- Lubes and glues
- Multi-meter
- Nut drivers
- Oscillator
- Oscilloscope
- Pens and paper
- Pocket knife
- Recording tape

- Rope
- Scripts and rundown sheets
- Soldering pencil
- Stopwatch
- Tape — duct and masking
- Tape measure
- Tool kit with ruler, needle nose and regular pliers, wire cutters, Phillips and conventional screwdrivers, hammer, awl, file/saw
- Vise grip

Remote Survey

To address the logistics of, among other things, what equipment will be needed and where it will be positioned, a remote, or site, survey is a must. A *remote survey* is an inspection of a production location by key production and engineering personnel, and the written plan they draft based on that inspection. The plan helps to coordinate the ordering and setting up of production equipment, and the communication hookup between the key production people during shooting or broadcast. A remote survey can take whatever form suits a particular need. Figure 15-15 displays one example.

In surveying a remote site, clearing access to the site and acquiring police permits and written permissions from property owners are also necessary. *Visuals* — diagrams and photographs — of the various shooting areas at the production site are often required and always helpful. At a glance, camera and microphone positions, cable and power runs, signal feeds, and other equipment locations can easily be seen.

Production meetings are also essential, particularly after the remote survey has been completed. If something is to go wrong, and it usually does, it is more likely to occur on location than in a studio. In production meetings key personnel coordinate their responsibilities, explain their needs, discuss shots, and resolve problems. The remote production schedule, including setup and rehearsal times, is also planned. Scheduling production meetings sounds like common sense. You would be surprised, however, how many remote productions proceed without them. As you might expect, Murphy's Law notwithstanding, these particular productions are apt to be more nerve-racking, to run over schedule, to cost more, and to be aesthetically inferior. In this business of communications, communication is sometimes the element that is overlooked.

How to determine audio needs in a remote survey is, perhaps, better understood in the context of the actual production situations and therefore will be explained in the sections on production of speeches and news conferences, sports programs, music shows, and single-camera field production, respectively. But first we will look at IFB — interruptible foldback.

IFB (Interruptible Foldback)

An often-overlooked but critical aspect of on-location production is feeding cues, such as takes and wraps, last-minute updates in program content, and timing, from the director to the talent and production crew. You will recall from Chapter 14 that the foldback system in a console allows performer and operator to hear program and cue information through a headphone monitor feed without tying up other monitor or master routing systems. Without foldback, getting cue information to appropriate personnel would require a separate communications channel, thereby requiring extra ears to receive it. On remotes, **IFB** — interruptible foldback —

REMOTE SURVEY FORM

SURVEY DATE _____ PROGRAM _____
LOCATION SITE _____ AIR DATE & TIME _____
LOCATION SITE ADDRESS _____ PRODUCER _____
_____ DIRECTOR _____
SET UP DATE(S) _____ TD _____

CAMERAS

NUMBER	LOCATION	TYPE	LENS	CABLE RUN

VIDEOTAPE

VTR DESIGNATION	TYPE	FUNCTION	VID FEED	AUD FEED

MICROPHONES

TYPE/MODEL	LOCATION	CABLE RUN/WIRELESS

15-15 Example of a remote survey form for television

makes it possible to piggyback verbal cues onto the foldback channel. When someone speaks over it, the foldback drops out, which is why it is called interruptible. The cues may be received in-the-ear (ITE) through an earpiece or over-the-ear via one headphone in a mic headphone system.

Production of Speeches and News Conferences

Recording someone speaking from a podium at an event such as a press conference, dinner, awards ceremony, and the like is almost an everyday assignment in broadcasting. In pre-

REMOTE SURVEY FORM (cont.)

PROGRAM _____

LIGHTING

TYPE LOCATION AVAILABLE LIGHT IN FC

IFB DELEGATION

DESIGNATION CHANNEL LOCATION FEEDS

POWER

LOCATION ELECTRICIAN CONTACT _____

POWER REQUIREMENTS _____

AC OUTLETS (VOLTAGE/CONNECTOR TYPE/LOCATION)

LOCATION CONTACTS

NAME TITLE/JOB NUMBER

SPECIAL INSTRUCTIONS

15-15 (continued)

paring for such an assignment, it is impor-
tant to know whether you will be taking the
sound from your own microphone(s), from
the house public address (PA) system, or
from a common output feed, other than the
PA system, called a multiple (also known as
a press bridge).

Setting Up Your Own Microphones

The directional microphone is usually the
best one to use for a speaker at a podium.
Its on-axis response focuses the sound from
the speaker, and its off-axis cancellation re-
duces unwanted room and audience noises
(see 15-16).

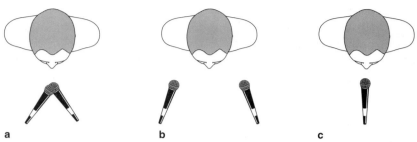

a b c

15-16 Commonly used techniques when miking a podium speaker with two directional microphones. (a) This mic placement provides a wide, smooth response and allows comfortable side-to-side head movement, but is often unnecessary. (b) This array is not recommended because it requires the speaker to remain between the mics to ensure smooth response. (c) In many situations a single cardioid or supercardioid is sufficient. Two parallel microphones, one above the other (see 5-62a), or three triangularly arrayed mics are often used in podium setups for redundancy.

Cardioid microphones are most frequently used at a podium due to their wider on-axis response and—because the audience faces the back of the mic—their 180-degree off-axis rejection. Supercardioids may be better, however. Their acceptance angle is at least 120 degrees, wide enough to permit normal side-to-side head movement with little adverse effect on response. Moreover, their off-axis rejection is wider than a cardioid mic's and, therefore, reduces unwanted audience sound coming not only from the rear of the microphone but from the sides as well.

The advantages of setting up and using your own microphones are that you have control of the sound quality and exclusive use of the content. Nevertheless, there are situations in which you have little or no say in these matters and have to take your sound from a common source.

Public Address Pickups

Talks delivered in many rooms and halls require a public address system so the audience can hear the speaker. The miking for the PA

system is at the podium. On occasion, adding your mics to those already at the podium could create a clutter that may be visually distracting and also obscure the speaker from some of the audience. In such instances you may have to take the audio feed from the PA system.

This entails patching into an output jack in the PA amplifier or PA control panel and feeding the signal to your mixer or console. It should not interfere with the loudspeaker sound because the PA feed from the podium mics should be split into two separate routing systems. Because many PA loudspeaker systems are not noted for their sound quality, this arrangement gives you some control over the audio. If the house technicians control the sound feed, however, which is often the case, it is necessary to coordinate your needs with them in advance.

Splitting Microphones

An alternative to public address pickups is splitting the microphone feed. This is manageable if your station or company is the only one, or one of a few, covering an event.

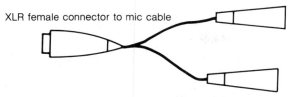

XLR male connector to PA mixer

XLR female connector to mic cable

XLR male connector to recording mixer

15-17 Y-adapter

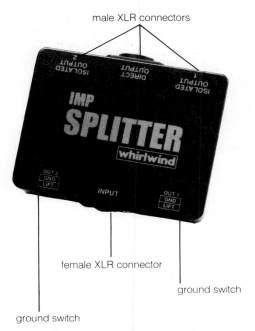

male XLR connectors

ISOLATED OUTPUT 2
DIRECT OUTPUT
ISOLATED OUTPUT 1

IMP
SPLITTER
whirlwind

OUT 2 GND LIFT
INPUT
OUT 1 GND LIFT

female XLR connector

ground switch

ground switch

15-18 Transformer-isolated microphone splitter

Otherwise, microphone and cable clutter could result.

Microphone splitting is accomplished in two ways: using a Y-adapter (see 15-17) or a transformer-isolated microphone splitter (see 15-18). The Y-adapter splits the microphone signal to the PA system and your microphone

mixer. This arrangement sometimes causes hum unless both the PA and mic mixer are plugged into the same AC outlet or strip. A better alternative is the microphone splitter because it isolates the two microphone feeds, reducing the possibility of hum. Still another alternative is the Crown Triundant capacitor mic, which contains three supercardioid microphone capsules, with pop filter, in a single housing (see 15-19). Instead of one microphone feeding a splitter, the Triundant mic feeds an interface with three transformer-isolated outputs that can be routed to a mixer or console.

Multiple Pickups

Several stations or networks often cover the same event. If they all set up microphones at the podium, not only would the clutter be unsightly, but also a good sound pickup might depend on how lucky the producer was in getting a mic close enough to the speaker. Although this often happens at news conferences, sometimes because the speaker believes a clutter of mics makes the event appear important, it is not ideal or preferred. If the facilities exist, it is better to take the sound from a multiple, or "mult" for short (see 15-20). A **multiple** (not to be confused with the multiple that interconnects jacks on a patch panel) is a distribution amplifier—an

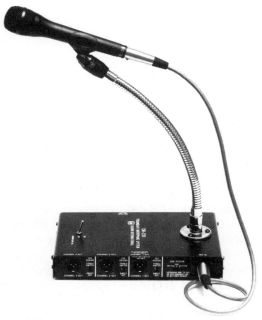

15-19 Triundant microphone

15-20 A mult box with 18 outputs

amplifier with several individual line and mic level outputs. Each station then obtains a separate, quality sound feed without struggle by patching into one of the amplifier's output connectors. This type of feed is usually agreed on in advance by those involved and set up either cooperatively by them or by the sound people who operate the inhouse audio system. This type of multiple is also known as a **presidential patch**. Microphones used for questions from the audience are connected to the multiple as well. Thus, all networks and stations get the same high-quality feed from the few mics used.

A challenge periodically encountered on remotes is the need to mike several speakers at a conference, symposium, press parley, and the like. The obvious way to produce such a program is to use a multichannel console and control the mic levels of each participant manually. But, depending on the number of participants, this could become unwieldy, especially if the operator has to handle other sound sources such as announcer and cart players. Moreover, with the possibility of a number of mics being open at the same time, comb filtering, ambient noise, reverberation buildup, and, if there is a PA system operating, feedback could occur.

For several years automatic microphone mixers have been available. Operating like a noise gate, they automatically open and close mics when sound level rises above or below a preset threshold. The problem with using them for broadcast has been the perceptible action of the gating as the mics were opened

Table 15-1 Suggested solutions for multiple open-microphone problems

Problem	Indicators	Tips
Comb filtering	Thin, hollow sound	Reduce number of mics Observe 3-to-1 rule
Excessive ambient noise and reverberation	Distant, washed-out sound	Reduce number of mics
	Loss of clarity and intelligibility	Reduce mic-to-source distances
Feedback	Feedback before the system is loud enough for the audience to hear it	Reduce number of mics
		Reduce mic-to-source distances
		Increase mic-to-loudspeaker distances

and closed. Also, it was difficult for some automatic mixers to discriminate between background noise and low-level speech reaching an adjacent mic.

Recently automatic microphone mixers have been developed in which the gating action is relatively seamless and noise adaptive threshold settings activate a microphone for speech and not background sound. These automatic mic mixers can also be used in concert reinforcement (see "Production of Pop Music" later in this chapter; also see 15-21). An automatic mic mixer can do only so much, however. Table 15-1 lists a few tips to reduce the most common multiple open-microphone problems.

Production of Sports Programs

In most sports broadcasts audio provides three essential aural elements: (1) the sound of the announcers, (2) the sound of the crowd, and (3) the sound of the game action. To achieve the best results, mike each element separately and balance the levels of loudness at the mixer or audio console.

Miking the Announcers

In sports broadcasting, the announcers have to be heard clearly, whether they project their voices over the constant din of a large, vocal crowd or speak quietly during a golf or tennis match. No microphone is better suited to meet both these demands than the headset mic (see 5-48). Its design allows the mic to be positioned close to the announcer's mouth for optimal pickup of normal and quieter-than-normal speech. Its moving-coil element and built-in pop filter can withstand loud speech levels without overloading the mic, although limiting and compression are usually necessary. The unidirectional pickup pattern reduces sound leakages from outside sources, and the omnidirectional pattern adds more background color to the sound. Each earpiece can carry separate information—the director's cues on one and the program audio on the other—and the space in front of the announcer can be kept clear for papers, TV monitors, and other paraphernalia.

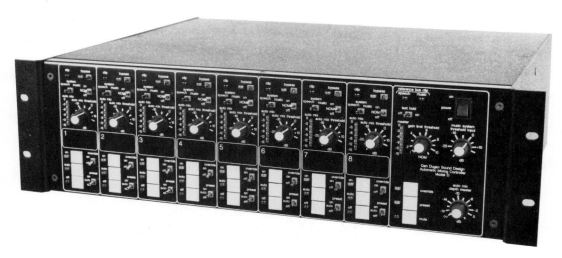

a

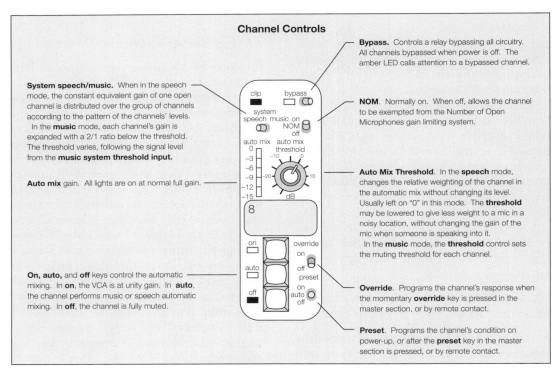

Channel Controls

Bypass. Controls a relay bypassing all circuitry. All channels bypassed when power is off. The amber LED calls attention to a bypassed channel.

System speech/music. When in the speech mode, the constant equivalent gain of one open channel is distributed over the group of channels according to the pattern of the channels' levels.
 In the **music** mode, each channel's gain is expanded with a 2/1 ratio below the threshold. The threshold varies, following the signal level from the **music system threshold input.**

NOM. Normally on. When off, allows the channel to be exempted from the Number of Open Microphones gain limiting system.

Auto mix gain. All lights are on at normal full gain.

Auto Mix Threshold. In the **speech** mode, changes the relative weighting of the channel in the automatic mix without changing its level. Usually left on "0" in this mode. The **threshold** may be lowered to give less weight to a mic in a noisy location, without changing the gain of the mic when someone is speaking into it.
 In the **music** mode, the **threshold** control sets the muting threshold for each channel.

On, auto, and **off** keys control the automatic mixing. In **on,** the VCA is at unity gain. In **auto,** the channel performs music or speech automatic mixing. In **off,** the channel is fully muted.

Override. Programs the channel's response when the momentary **override** key is pressed in the master section, or by remote contact.

Preset. Programs the channel's condition on power-up, or after the **preset** key in the master section is pressed, or by remote contact.

b

15-21 (*a*) Automatic microphone mixer with (*b*) its channel and master control functions and (*c*) its effects on speech and music mixing

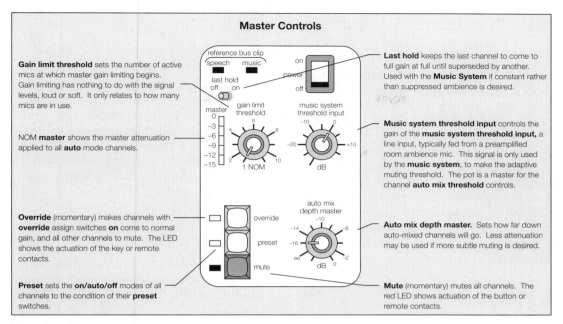

Master Controls

Gain limit threshold sets the number of active mics at which master gain limiting begins. Gain limiting has nothing to do with the signal levels, loud or soft. It only relates to how many mics are in use.

NOM **master** shows the master attenuation applied to all **auto** mode channels.

Override (momentary) makes channels with **override** assign switches **on** come to normal gain, and all other channels to mute. The LED shows the actuation of the key or remote contacts.

Preset sets the **on/auto/off** modes of all channels to the condition of their **preset** switches.

Last hold keeps the last channel to come to full gain at full until superseded by another. Used with the **Music System** if constant rather than suppressed ambience is desired.

Music system threshold input controls the gain of the **music system threshold input,** a line input, typically fed from a preamplified room ambience mic. This signal is only used by the **music system,** to make the adaptive muting threshold. The pot is a master for the channel **auto mix threshold** controls.

Auto mix depth master. Sets how far down auto-mixed channels will go. Less attenuation may be used if more subtle muting is desired.

Mute (momentary) mutes all channels. The red LED shows actuation of the button or remote contacts.

b (*continued*)

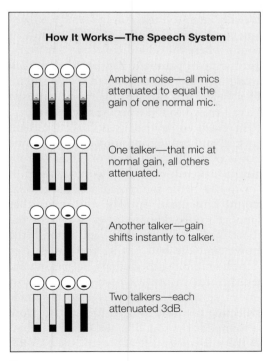

How It Works—The Speech System

Ambient noise—all mics attenuated to equal the gain of one normal mic.

One talker—that mic at normal gain, all others attenuated.

Another talker—gain shifts instantly to talker.

Two talkers—each attenuated 3dB.

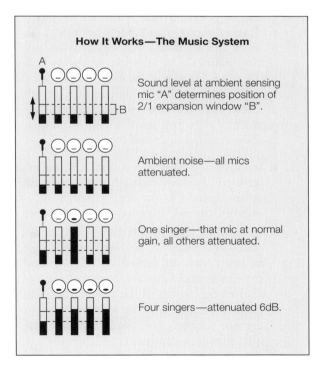

How It Works—The Music System

Sound level at ambient sensing mic "A" determines position of 2/1 expansion window "B".

Ambient noise—all mics attenuated.

One singer—that mic at normal gain, all others attenuated.

Four singers—attenuated 6dB.

c

Miking the Crowd

The sound of the crowd is essential to the excitement of most sports events. The cheers, boos, and general hubbub punctuate the action, adding vitality to the event and making the home audience feel a part of things.

Usually, the best microphone to use is a rugged moving-coil type with an omnidirectional pickup pattern, a pop filter, and, to be safe, a windscreen. This microphone can be exposed to any kind of weather. The omnidirectional pattern is preferred because (1) it blends the overall crowd sound, instead of concentrating it as would a unidirectional mic, and (2) it picks up more of the crowd's din, thus adding to the excitement and presence of the event.

With a crowd, as with any sound source, proper microphone placement directly influences the quality of the pickup. This makes a location survey mandatory, because each stadium and arena has its own acoustics and seating patterns. In addition to the typical needs considered in a location survey, such as type of microphones, designation, length of cable required, and so on, there are a number of steps you need to take in making decisions related to crowd pickup.

- Identify points where sound is more intense or live, or both. Sound-collecting points, usually at the concavities of stadiums and arenas, are good places to begin.
- Remember that sound is more concentrated and louder in enclosed venues than in open ones. In domed stadiums sound collects at and bounces from the concave roof to the crown of the playing surface. If microphones near the playing surface are not properly positioned, their sound quality will be degraded.
- Avoid dead spots where crowd sound will be hollow, thin, and unexciting.
- If attendance is likely to be less than capacity, know which seats will be filled and place the crowd mic(s) in that area(s).
- Be aware that home-team fans are likely to far outnumber those of a visiting team. To help maintain excitement no matter which team generates it, position a mic(s) in front of or nearby the section where the visiting fans are seated, particularly if the game is important or involves a heated rivalry, or both.

Microphone Placement

In baseball, football, and soccer stadiums the crowd mic is usually hung outside the press box because it is centrally located and therefore easy to get to, and it is also usually situated at a good sound-collecting point. If one mic is not sufficient to capture the crowd's intensity, use more. The key to getting good crowd sound is placing the mics at points where the sound collects. Sometimes, directional or parabolic mics are used to pick up a fuller, more concentrated crowd sound. This helps to intensify the more diffused overall crowd sound when mixed with it.

In enclosed arenas used for basketball, hockey, and boxing, position the crowd mic at one of the balcony levels or hanging from the scoreboard or rafter, as long as it is not too far from the crowd. For basketball, mount directional mics on the struts that support the backboard at each end of the court. These pick up the sound of both the crowd and the ball hitting the basket (see section on miking the action). Because sound reverberates in an enclosed space, almost any place near the crowd is a good sound-collecting point as long as it is not so close as to muddy the sound, make sound too loud in the announcers' headphones, or pick up sound from individuals. Sometimes, crowd sound is so intense that one omnidirectional microphone is sufficient. If the mic is too far

from the crowd, however, the sound will decay significantly by the time it reaches the mic, thereby losing its punch, liveliness, and presence.

In golf and tennis, crowd response is different from that in baseball, football, basketball, hockey, and boxing. In golf and tennis silence during play is the rule, and when the crowd does react, it is more often with polite applause than with shouting, cheering, and the like.

Most golf broadcasts cover the last few holes of a round. Golf crowds follow the action by moving from hole to hole with a particular group of players. Out in the open, sound does not collect, so it is difficult to mount crowd mics at reinforcing points, let alone place them for optimal sound pickup from groups of people whose number and position are always changing. Golf crowds are usually miked with directional microphones to isolate and concentrate crowd reaction.

Tennis crowds usually sit either surrounding the court or to one side of it. They can be heard with the omnidirectional umpire's mic and, if needed, an omnidirectional mic hung in the open from an overhang away from the public address system. No microphone should be placed near a PA system because it is difficult to separate and balance the sound of the system with the sound of the crowd (or with any other sound).

One problem with crowd sound outdoors is wind. Strong winds can dramatically affect the level of crowd sound. This can be disconcerting to the announcers who, in one instance, hear little crowd sound and, in the other instance, have a hard time hearing themselves.

One solution to this problem is to provide the announcers with a selective feed to their headphones. The feed can come from a mic or mics placed where changes in wind direction and velocity least affect the intensity of the crowd sound.

Crowd sound indoors can be so loud (because of the acoustics) that program level to the headphones must be kept loud or the announcers will not be able to hear the program or their cues. The headphone mix must be comfortable to the announcers, however, or it will become fatiguing during the broadcast.

Philosophies vary about how crowd sound should be mixed in the overall sound design of a sports event. Among the more commonly used approaches are the following:

- Keeping crowd level lower during periods of inaction and increasing crowd sound during exciting plays to add to the drama of an event's natural pace.

- Keeping crowd level constant throughout the broadcast to maintain interest.

- Burying the announcers' voices in the crowd sound to make the announcers part of the event and to unify overall intensity.

- Keeping the announcers' voices out in front of the crowd sound to avoid masking the play-by-play and color commentary and to reduce audience fatigue engendered by too much sonic intensity over a long period. Sometimes, this is done by compressing crowd sound.

- Compressing the sounds of the announcers, crowd, and action to control their dynamic ranges and give each element more punch. Compressing one or more sonic elements also creates a layering effect.

Miking the Action

The sound of the action itself adds impact to a sports event—the crack of the bat on the ball in baseball, the signal calling of the quarterback and the crunch of hitting linemen in football, the slamming of bodies against the boards in hockey, the bouncing ball and squeaking sneakers in basketball,

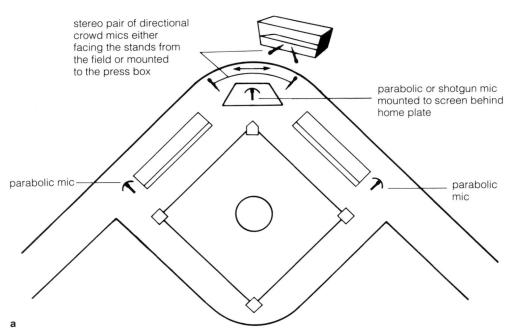

stereo pair of directional crowd mics either facing the stands from the field or mounted to the press box

parabolic or shotgun mic mounted to screen behind home plate

parabolic mic

parabolic mic

a

15-22 **Two approaches to stereo miking baseball.** (a) For crowd pickup, a stereo pair of directional microphones is mounted outside the press box, usually a good sound-collecting point, or mounted to the screen behind home plate facing the stands. The crowd mics are panned left and right to provide the main stereo effect. The field mics are positioned to pick up the action at the main camera locations, which are usually behind home plate and at first and third bases. (b) In a more elaborate setup to create a surround sound "feel," boundary mics are used for the crowd sound and are panned hard left and right. An M-S mic is mounted behind home plate for center and left/right ambience pickup from the field area and stands around home plate. The field mics at first and third bases and in the outfield are mixed as indicated in the diagram.

and so on. To capture these sounds, separate microphones, other than the crowd mic(s), are used. The mics are mounted close to the area of play and pointed toward the action. Examples of microphone placements for picking up action and crowd sounds in the various sports, including miking for stereo, are displayed in Figures 15-22 through 15-31.

Stereo Sound

As with stereo TV in general (see Chapter 12), producing stereo sports involves providing sonic spaciousness or depth while dealing with localization and stereo-to-mono compatibility. Of the three audio components in-

volved—announcers, crowd, and action—the crowd is often the principal or only stereo element.

Announcers present the least problem. Because they are the primary source of information and are stationary during an event, it is natural that they be positioned in the center of the stereo image, although their voices can be fed through a stereo synthesizer so they sound more a part of the overall sonic setting instead of separate from it.

The crowd can be either miked or mixed in stereo. Primary crowd pickup should come from a main microphone array and assigned full left and right. The fan at home must feel that he or she is "sitting in one seat," not

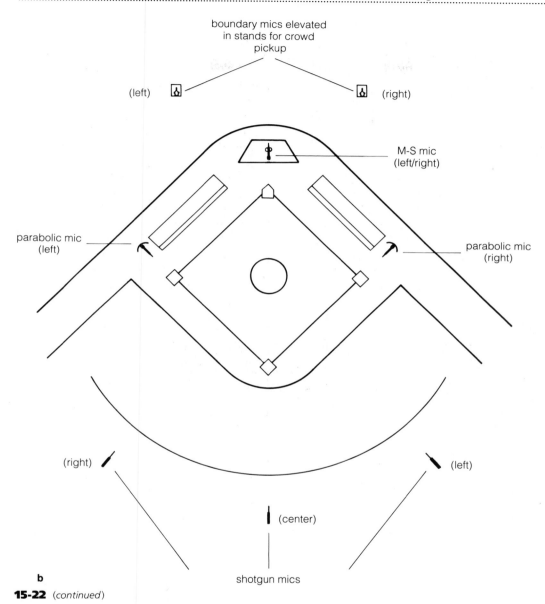

boundary mics elevated
in stands for crowd
pickup

(left) (right)

M-S mic
(left/right)

parabolic mic
(left)

parabolic mic
(right)

(right) (left)

(center)

b
15-22 (continued)

shotgun mics

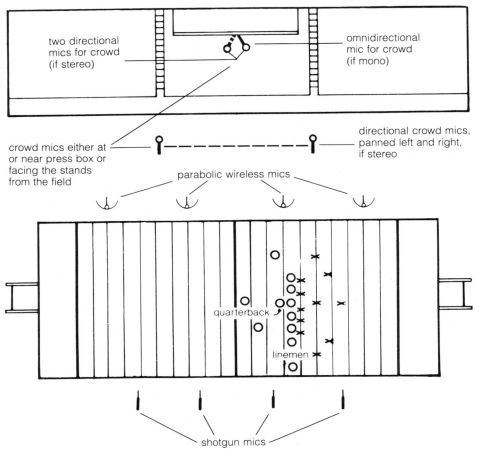

15-23 Miking football. Crowd microphones are either positioned from the field facing the crowd or mounted at or near the press box. Sometimes both approaches are used. For stereo, two directional mics are arrayed and panned hard left and right to provide the main stereo effect. Sounds from the playing field are covered by shotgun mics — cardioid, supercardioid, or hypercardioid, depending on how wide or narrow the coverage of the general game action is to be. To pick up focused sound for added realism, such as the quarterback signals and hitting linemen, parabolic mics are used.

moving around with the shot. If additional crowd mics are used, they should be for fill, not for emphasis to coincide with a shot.

Action sounds are handled in two ways: either straight down the middle or somewhat localized. Sound panned to the center gives an up-front feeling to coincide with the gen-

erally tighter shot it accompanies. Localized sounds are picked up by one mic and panned slightly to the left or right to coincide with their relative position in the playing area. This means that the action mics must be very directional and be precisely aimed to make stereo imaging easier for the mixer. But even

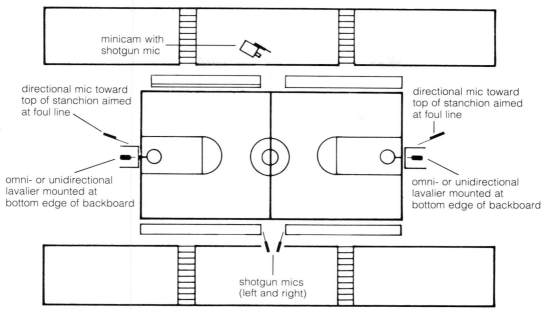

15-24 Stereo miking basketball. A stereo pair of cardioid or supercardioid microphones for sufficiently wide left and right imaging of game action and crowd sound is mounted in a V configuration at center court. A stereo mic can be used instead. If more crowd sound is needed, stereo fill-mics can be hung from the rafters, far enough away from the top of the building to avoid sound concentration, or at or near the announcer's position. An omni- or unidirectional lavalier is mounted at the bottom edge of each backboard to pick up the sound of the ball hitting the basket and swishing through the net. Near the top of each backboard stanchion are mounted directional mics aimed at their respective foul lines to pick up sneaker sounds, dribbling, and comments from the referees. A minicam(s) mounted with a shotgun mic is used to pick up a coach–player strategy talk at the bench. (Note: In most sports, permission must be obtained to place a mic near the players' bench.) In any indoor arena, controlling crowd level is a problem because the sound is concentrated. This problem can be controlled by opening and closing certain mics (not the stereo pair), depending on where the play is. For example, if the action is on the right side of the court, the mics on that side are kept open while the mics on the left side are brought down. This must be done smoothly, however, or the changes will be apparent to the viewer.

in ideal circumstances, trying to localize sound, especially moving sound, with shot changes is difficult. The mixer must constantly anticipate a director's shot change. Even if synchronization is achieved, camera angles may cut across the 180-degree axis creating "reverse angle" audio. See Figures 15-22, 15-23, 15-24, and 15-28 for examples of stereo miking in sports.

Clearly, as with much of stereo TV, many problems in sports audio have yet to be worked out. Undaunted, however, producers press onward, moving beyond stereo to surround sound audio in sports (see 15-30).

Production of Music

Music produced on location almost always involves an audience, whether the music is part of a staged event such as a variety or awards program or part of a covered event

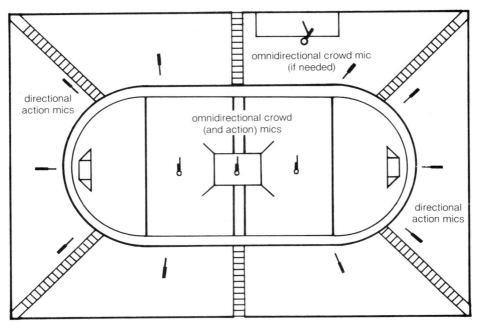

15-25 Miking hockey. Omnidirectional microphones hung over the playing surface pick up the sounds of the crowd and some of the action. If it is not possible to mount these mics, then a crowd mic can be placed outside the broadcast booth or hung from a rafter in the stands. Directional action mics are placed around the rink, preferably taped to the boards, to pick up stick, skate, and puck sounds from the ice and the impact of players hitting the boards. Microphones around the rink have to be opened and closed as they pick up the action or there will be too much crowd sound and ambience. This illustration shows optimal miking around the rink. In most situations economic and logistic realities would reduce the number of rink mics used.

such as a concert. Providing music to an audience presents at least three different challenges to the audio designer: (1) the sound the live audience hears, (2) the sound the stage musicians hear, and (3) the sound that is broadcast or recorded.

In venues where acoustics are good, these considerations are taken care of naturally. Large halls (halls that seat 2,000 or more) may require **electronic enhancement**—a system of microphones and small loudspeakers strategically located around the hall to ensure uniform sound dispersion—when it is difficult to disperse sound naturally. These locations usually are used for classical music.

In pop concerts, regardless of acoustics, getting sound to audience and musicians must be done electronically, for three reasons: (1) These concerts are usually held in large venues, often outdoors, and it is the only way to ensure that the music reaches the audience at relatively the same time, with the same loudness, and with the widest possible frequency response; (2) the combination of electric and acoustic instruments must be premixed before their sounds reach the audience, or the acoustic instruments will be barely audible; (3) the music must be mixed and fed to stage monitors to enable the musicians to hear themselves without its

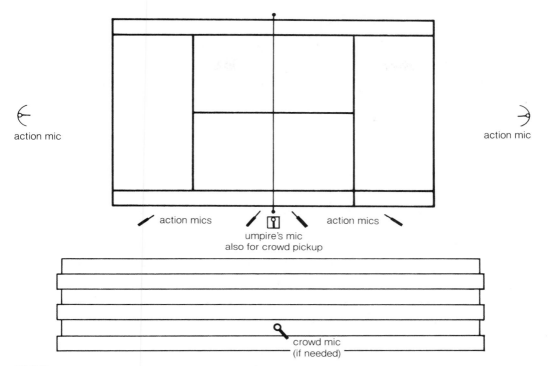

15-26 Miking tennis. An omnidirectional microphone is set up next to the umpire to hear his calls, the players talking to him, and crowd sound. Two directional mics are positioned on either side of the net pointing at the court to pick up the sounds of the ball when it hits the net on a service, the ball hitting the strings of the tennis racket, and players' comments near midcourt. Directional mics are aimed at the service lines to pick up the "whopping" sound when the player connects with the ball. Parabolic mics placed behind each baseline pick up the string sound on the racket when the ball is hit deep and the players' grunts and groans when they hit the ball. If the crowd mic at the umpire's location does not pick up enough crowd sound, another crowd mic is mounted from an overhang in the stands.

feeding back into the stage microphones. This aspect of audio design is called **concert reinforcement.**

A fourth challenge the sound designer may face in dealing with live music on location, and the one that concerns us here, is producing the music for recording or broadcast. How this is accomplished depends on the way in which the house sound is handled.

The techniques used to get live music from location to tape or air are, in some ways, the same as those used in a studio, although they

are more similar for classical music than for pop. Feeds are taken from the microphones, mixed at a console, and then recorded or broadcast.

Production of Classical Music

Classical music recorded on location usually originates from a concert hall. Hence, reasonably good acoustics often can be assumed, and therefore, distant miking is the approach commonly taken, although many

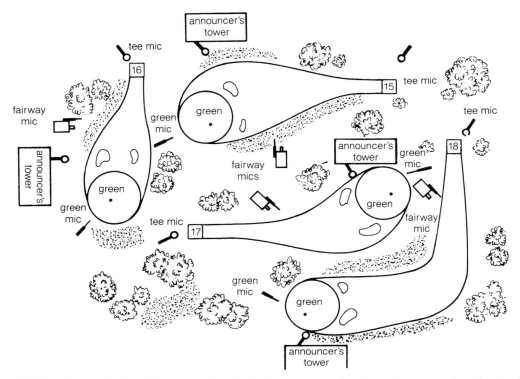

15-27 Miking golf. Omnidirectional or directional microphones are placed near the tees to pick up the sound of the drive and crowd sound. In the fairways directional mics, either handheld or mounted on minicams, pick up fairway shots and conversation between golfers. At the greens directional mics pick up the sound of the putt and crowd sound. Wireless microphones are placed in the cup, with the transmitter aerial wrapped around the outside, to pick up the sound of the ball falling into the cup. At each hole are announcers' towers with omnidirectional microphones outside the towers to pick up crowd sound and general ambience. Other wireless mic operators wander about to cover shots where balls are in bad positions.

producers prefer to use close miking for extra sonic control and sacrifice the realism that distant miking produces.

Because distant miking is the more aesthetically satisfactory of the two techniques, and because the clarity of digital recording is better served employing it, this discussion will focus on that approach. There is another reason for doing so. Even though audiences have become used to seeing microphones at classical concerts, they do detract from an event if they are too conspicuous. It is easier to mount distant mics so that they do not get in the way of the audience's line of sight to the orchestra, or in the line of sight between orchestra and conductor.

Although the theory and techniques of distant miking are covered in Chapter 14, a few principles that also relate to on-location miking are worth repeating here.

■ Critical distance is the point in an enclosed, reflectant space where the direct and reverberant sound fields are at equal

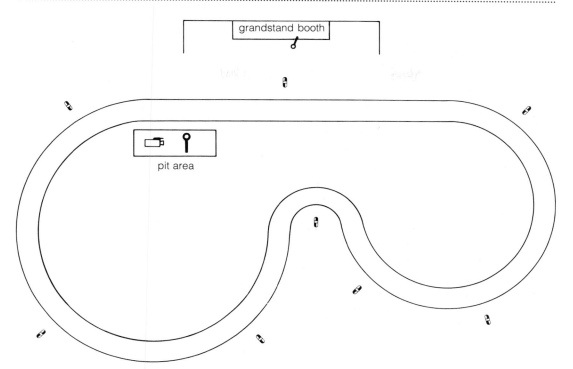

15-28 **Stereo miking auto racing.** Although coincident pairs of microphones can be used, it is far easier to deal with stereo mics because: (1) the pickup angle between the capsules is easier to adjust relative to the mic's position on the track and the angle of the turns; (2) controlling levels and perspective is easier; and (3) it gives the effect of the race cars' going right through the living room. The track mics are placed at each turn, which is usually where the fixed camera positions are. At these locations, the mics pick up not only the engine sounds but also the shifting of gears. In the pit area, a directional handheld mic is used for interviews; otherwise the roar of the cars racing around the track would drown out the speaking. The minicam shooting the interview is mounted with a shotgun mic to pick up track sounds, which are mixed with the interview. An omni- or undirectional mic to pick up crowd sound is situated at or near the grandstand booth. But unlike other sports, crowd reaction, although desirable, may not be audible above the engine roar.

levels and where the amount of energy the microphone receives from each field is equal. As you move farther from the sound source in the reverberant field, there is little additional loss of sound level. Not only should the main stereo array be placed at the critical distance, it should be positioned somewhat lower in the hall — on a line with the conductor and the appropriate number of rows back in relation to critical distance — for a fuller, richer sound because lows tend to "hug" the bot-

tom of the hall. Miking high will yield thinner, more high-end sound. Ambience mics should be placed higher, however, to get a more homogenous applause sound; the lower-placed mics tend to pick up concentrated, selected applause.

■ Air loss relates to the friction generated by the interaction of air molecules and sound waves as the waves move across space through an elastic medium. Because higher frequencies are converted to heat

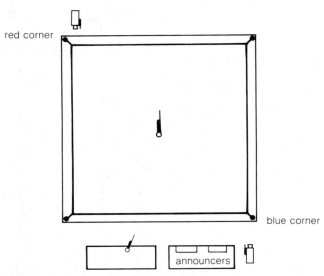

red corner

blue corner

announcers

15-29 Miking boxing. Above the ring or near the announcers' area, or both, is an omnidirectional crowd mic. Minicams with directional microphones are positioned at the fighters' corners to pick up conversation between rounds and the slap of punches during rounds. A handheld directional mic near the announcers' area may also be used for this purpose.

faster than are lower frequencies, the farther from a sound source a mic is placed, the duller the sound it picks up.

■ Phase is less of a problem with coincident and near-coincident miking than it is with the spaced microphone technique. Spaced miking produces a more spacious sonic image, however.

■ Localization of voicings is more defined using coincident and near-coincident miking but is more difficult to perceive with spaced miking. Also, if the angle or distance between microphones is too narrow, sound will be concentrated toward the center when reproduced. If the angle or distance between microphones is too wide, the sound, when reproduced, will be concentrated to the left and right with little or no sound coming from the center.

■ Stereo-to-mono compatibility is more assured with coincident miking, particularly using the M-S miking technique. It is somewhat less assured with near-coincident miking, and least assured with spaced miking.

■ Accent microphones should be placed on an instrument playing a solo passage within an orchestral score if the loudness and presence of the instrument does not stand out enough to be adequately captured by the main stereo array.

■ Ambience microphones should be placed at a greater mic-to-source distance than the main array to pick up the reflected sound—usually toward the rear of the hall. Mixed with the main stereo array, the added ambience can provide a deeper, more spacious atmosphere.

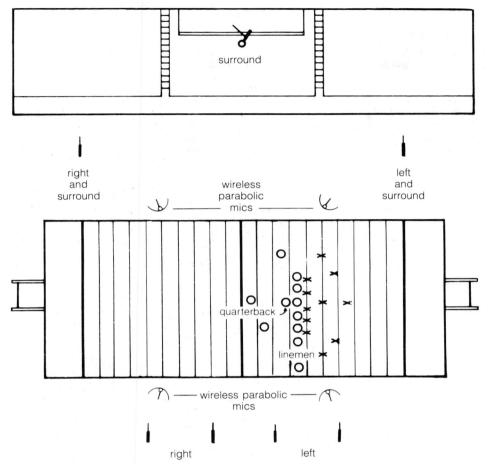

15-30 Surround sound miking for football. For overall crowd sound, four supercardioid shotgun mics (for wider pickup) are positioned on the far side of the field — across from the press box — spaced in pairs on the 20- and 40-yard lines for the main left and right pickup. The near-side supercardioid shotgun mics are for more immediate left and right crowd sound and, along with the directional mic facing down from the press box, are fed into the surround channel. The wireless parabolic mics are omnidirectional and are used to capture field sounds. Their outputs are fed to a stereo synthesizer to add depth of sound and to better integrate the overall mix.

Microphones High-quality microphones are essential for classical recording in general, and digital recording in particular. Use capacitors with wide, flat response and very low self-noise. Microphones used in arrays — main and ambience — should be the same make and model within a given array. Accent microphones should also be capacitors, but may be of a different make and model depending on the instrument and the need for isolation. As for the advantages and disadvantages of various pickup patterns in stereo miking, see Chapter 14 and the list that follows.

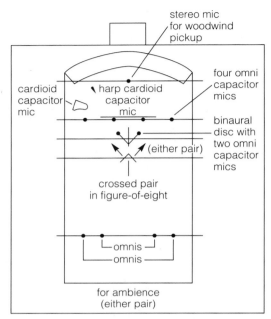

15-32 **One way of miking a classical music concert**

15-31 **Miking bowling.** Due to the usually high ambient levels in bowling alleys, directional microphones are preferred. Because action shots of the bowlers and pins are closeups much of the time, shotguns would be too apparent; parabolics would be even more so. A directional boundary mic aimed where the bowler drops the ball at the front of the alley and one or two cardioids (on either side) aimed at the pins at the back of the alley pick up the important action sounds. For crowd mics, shotguns are usually used if the crowd is large and sits over a comparatively wide area; an omnidirectional mic is used if the crowd is small and more clustered.

Microphone Placement Techniques There are a number of approaches to microphone placement in a concert hall. In general, however, three microphone setups are employed to cover the concert hall: the main stereo array, ambience mics, and accent mics. For the main stereo array, a number of configurations are popular in concert recording, particularly the X-Y, ORTF, NOS, spaced omnis (two or three), and boundary mics attached to a common mount or spaced. Figures 15-32 and 15-33 display two approaches.

A number of studies have been done comparing standard stereo microphone techniques. Alphabetically condensed excerpts from two of those studies follow.*

*From Benjamin Bernfeld and Bennett Smith, "Computer-Aided Model of Stereophonic Systems," Audio Engineering Society Preprint, February 1978; and Carl Ceoen, "Comparative Stereophonic Listening Tests," *Stereophonic Techniques Anthology*, Audio Engineering Society, 1986.

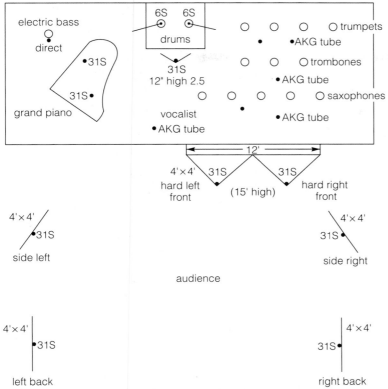

15-33 One way of miking a jazz band using PZM® boundary mics. The stereo array closest to the stage blends the trumpets, trombones, and saxophones. The arrays in the middle and rear of the room are for ambience and surround sound. Stereo arrays are also at the drum and piano locations. The 31S is used for its deeper low end and warmer, smoother high end. The 6S is designed for increased high-end articulation and minimum visibility. The AKG tube is used for instrumental and vocal soloists and for its mellow, warm sound.

- Blumlein (coincident bidirectionals at 90°): Good, sharp stereo imaging

- Blumlein (coincident bidirectionals at 90° with shuffler circuit*): Very good stereo imaging and stereo spread

*Shuffling**, or spatial equalization, increases spaciousness so that coincident and near-coincident microphone arrays can sound as spacious as spaced microphone arrays. It also aligns the low frequencies and high frequencies of the sounds, thereby creating sharper stereo imaging. Shuffling is accomplished with a low-frequency shelving boost of the $L - R$ (difference) signals and a low-frequency shelving cut of the $L + R$ (sum) signals.

- Coincident cardioids angled 90° apart: Very good stereo imaging, but a very narrow stereo spread

- Coincident cardioids angled 120° apart: Fair stereo imaging with a narrow stereo spread

- Coincident hypercardioids angled 120° apart: Imaging fair because frequencies around 3 kHz have a wider spread than low frequencies

- Coincident hypercardioids angled 120°

apart (with shuffler circuit): Excellent stereo imaging and stereo spread

- Middle-Side microphone: Lacked spaciousness, intimacy, and warmth

- ORTF (cardioids angled 110° and 7 inches apart): Good stereo imaging but with low frequencies narrowly spread and high frequencies wider spread

- ORTF (hypercardioids angled 110° and 7 inches apart): The same as the ORTF cardioids angled 110° and 7 inches apart but with wider separation

- Two omnis spaced 9½ feet apart: Poor stereo imaging and exaggerated stereo separation

- Three cardioids spaced 5 feet apart: Poor stereo imaging and exaggerated stereo separation at high frequencies

Tape Recorders The tape recorder (and tape) also should be of highest quality, whether it is two-track or multitrack, analog or digital. In addition to conventional, high-quality open-reel audiotape recorders, good to excellent response can be obtained using R-DAT, Hi8mm, and digital videocassette tape recorder formats. The key to good recording in digital, remember, is not as much in the tape recorder you use (although it certainly has to be up to professional standards) as it is in using the highest quality capacitor mics with extremely low self-noise.

Signal Feed In simplified terms the signal feed is routed from the microphone outputs to the console, to the signal processors (noise reduction, at least), and then to the tape recorder. It is usually more complex than that in practice, however (see 15-34). The equipment may be located in a control room at the concert hall or in an audio mobile unit, or both. If microphones are fed to a house en-

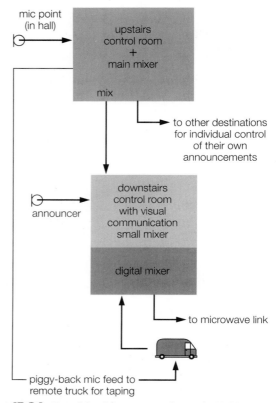

15-34 Signal feed from setup shown in 15-32

hancement system or to a control room for in-house recording, then either mic splitters are used to accommodate the two separate feeds or the recording company/station/network feed may be taken from the in-house control console. In the latter instance the in-house recordist may control the sound. A variation of this approach is when each microphone feeds to a separate channel, with no signal processing, straight through to the truck where the operator in the truck can mix the mics and process the sound as needed for broadcast.

A major consideration in broadcasting classical music (or any music, for that matter) is maintaining frequency response and a

wide signal-to-noise ratio. Not only must you use the highest-quality transmission system, but you must also use noise reduction before transmission. Some stations prefer to use a microwave link from concert hall to station because the quality is better than that of a telephone line. Nevertheless, noise reduction is still used before transmission.

If an album is being made from the concert, there is usually a separate, direct feed from the microphones to a fully equipped audio mobile unit with multitrack ATR, regardless of any feed going to the house control room. This gives the album producer a studio-type environment in which to oversee a controlled recording.

Production of Pop Music

Unlike remote recording of classical music, which may be done by taking a direct feed from the microphones or a straight-through feed from the house console and which is designed by the record company/station/ network producer, remote recording of pop music must be taken from a separate microphone feed directly to the console in the truck and is a cooperative effort between the concert and record producers. The challenge for the recordists in the remote truck is to derive their feeds and do the taping with a minimum of disruption to the concert reinforcement design.

Remote recording requires feeds to three separate mixers: the house or main loudspeaker array mixer, the stage monitor mixer, and the recording console in the truck. Double-miking each instrument is one way around the problem — feeding one microphone group to the house and monitor systems and the other group to the audio truck. But this method has drawbacks and is rarely used. Vocalists tend to move around while singing. Handholding two mics is a problem,

15-35 Microphone splitter system

although one mic could be a wireless lavalier. Drums are often multimiked; doubling the number of mics would clutter the drum area and could make it difficult for the drummer to play.

The more commonly used method is to employ splitter boxes (see 15-35) to route microphone feeds to the house mixer, stage monitor mixer, and the recording truck (see 15-36). This method allows the recordists to tape multitrack copies of the stage concert without depending on or interfering with the house mix. The requirements of a house mix are different from those of the recording anyway, so using it for taping would be sonically inappropriate.

In the truck the taping proceeds as it would in a studio. Voicings are recorded separately on a multitrack tape with a minimum of signal processing and are mixed down in a studio at another time.

Another alternative, although not as good as recording a discrete feed, is to take the feed from the band's sound reinforcement mix and record it. The advantages to this method are convenience, lower cost, and less equipment to worry about; it is also faster.

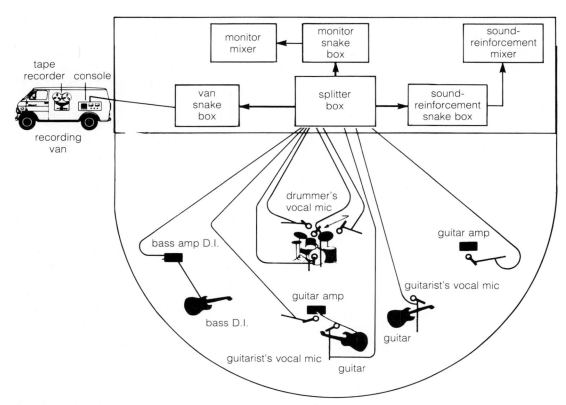

15-36 **Example of feeds in a concert being recorded (or broadcast) on location.** All microphone feeds (and D.I.) are connected to a splitter box. Signals from the splitter box are then distributed to the van snake box and recording van for taping; to the monitor snake box and monitor console for mixing the stage monitors; to the concert-reinforcement snake box and concert-reinforcement console for mixing the house loudspeaker arrays. (Not shown in this illustration are the positions of the stage monitors and house loudspeaker arrays, or the power distribution setup.)

The disadvantage is that the mix is a result of what the mixer hears, which is a combination of the band's live sound and the reinforced sound. The live music is not mixed to sound good by itself but, rather, to supplement the reinforced sound. This usually results in a mix that is too weak in the bass and too strong in the vocal(s).

Location Survey Responsibility for surveying and setting up a pop concert venue usually falls to the sound reinforcement people. Nevertheless, it is advisable to be in on the

location survey or to do one yourself. Most of the items to check out are similar to those important in any location survey for audio and include the following:

- *Acoustics.* Even though your feed will be either split off directly or taken from the stage mix, it is a good idea to become familiar with stage and room acoustics. Determine whether there are sound-collecting points that will generate unwanted reinforced sound that could include standing waves, or nulls where

sound could lose intensity. Plans might call for ambience mics. Therefore, it is useful to know the reverb characteristics of the venue. Record the room sound and listen to it during planning. If the sound reinforcement system is in place, so much the better. Turn it on, listen to it, recheck the acoustics, check for hum, and record.

■ *Microphone locations and noise.* Check out the mic locations to make sure they are not near any noise sources such as an air conditioner, generator, or noise from another part of the building.

■ *Cable runs.* Make sure that you have access to the required cables, that they are long enough to meet your needs, and that they have the proper connectors.

■ *Power.* The number and voltage of AC power outlets, whether house-supplied or provided by you, must be sufficient to meet electrical needs, especially if you are using a remote vehicle.

■ *Parking.* If a remote truck is involved, make sure there is adequate parking space for it and that it will be secure from curious on-lookers, or worse.

■ *Notes and diagrams.* Put your observations in writing. Sketch appropriate areas, diagram cable runs and connections, and make charts of the signal flow.

Microphone Selection and Placement Microphone selection and placement are usually dictated by the demands of the live concert and venue. Inevitably, the two most important considerations are keeping feedback from the monitors and leakage from other instruments to a minimum. Even with good miking practices, limiting is often needed to prevent levels from becoming unmanageable, and equalization is used to attenuate troublesome frequencies, from other instruments and the stage monitors that are being rein-

forced by the acoustics. Table 15-2 lists possible approaches to miking selected instruments in pop concerts aimed at minimizing feedback and leakage.

Additionally, in relation to the tips in Table 15-2:

■ Mic close to the sound source.

■ Use contact and noise-canceling mics to reduce feedback problems. (A noise-canceling microphone is a directional mic, usually cardioid, with extremely good rear rejection.)

■ Use mini mics to reduce on-stage clutter or try the small, lightweight wireless headphone microphone systems designed for stage performers. The wireless headphone mic not only reduces stage clutter but has the additional advantages of giving the performer mobility and being highly effective in reducing feedback.

■ Use fewer mics.

■ If wireless mics are employed, use only the highest quality systems.

■ Keep mic cables separated from lighting and power cables to prevent hum and buzzing.

■ Keep stage-monitor levels as low as possible to reduce feedback and use EQ to notch out feedback frequencies.

■ Use horn-loaded stage monitors because they tend to be more directional than other types and, therefore, reduce feedback. If the performer moves around, a monitor with too narrow a dispersion angle will not work; either side-fill monitors or a floor monitor with wider dispersion will be necessary.

Setting Up the Console The key to success in audio production, aside from creativity and imagination, is organization. In setting up the console for a live recording and in

Table 15-2 Examples of microphone techniques for on-location recording to reduce leakage and feedback

Drum Sets: Position a coincident pair of capacitor microphones over the center of the drum kit. Move them upward to adjust for too loud a cymbal sound. If the drums are being hit relatively hard, the overhead mics should pick up a fairly balanced left-to-right image. The bass drum will require a mic, however, because the drum's front and rear heads produce out-of-phase sound waves and will not be picked up by the overhead mics. If you want a drum to sound closer, brighter, or fuller in the overall mix, use spot miking.

Tom-Toms: The best way to increase isolation and guard against feedback is to place the mic inside the drum. This provides a fuller sound but with little stick attack. A mic outside the drum, near the rim, produces a sharper, more percussive sound.

Snare: A mic under the snare isolates the drum and considerably reduces the chance of feedback. It also produces a sizzly sound. A mic over the drum, close to the head, produces a fuller, snappier sound.

Hi Hat: Aim the mic straight down at the top cymbal; equidistant between the inner bell and outer edge is a good position to start with in finding the desired sound.

Bass: An electric bass should go direct; D.I. is always the best way to reduce leakage and minimize feedback, particularly when powerful bass waves are involved. With an upright bass, if possible, also use a direct feed from the pickup. In addition to the advantages of eliminating leakage and minimizing feedback, it gives an upright the bite of an electric bass without reducing its clarity. If the upright loses too much of its acoustic sound quality, a miniature capacitor mic clipped to the f-hole or wrapped in foam rubber and stuffed in it rounds out the sound.

Grand Piano: Position coincident cardioids over the middle-C strings and close to the hammers for a sharp, percussive sound. Angle the mics to suit the desired stereo spread. If there is too much hammer and pedal noise, raise the mics or add some reverb, or both.

Brass: A mic aimed at the bell brightens sound; one aimed off-axis to the bell mellows it. The combination of relatively close miking and the sound levels brass emits helps reduce leakage from other instruments.

Woodwinds: Woodwinds are usually located in front of the far more powerful brass instruments. An effective way to reduce leakage from brass and other instruments is to aim bidirectional microphones over the instruments so the nulls face left and right and the tops of the mics face rear. One live side faces directly toward the instrument; the other live side faces straight up toward the ceiling. This technique is effective only if the ceiling is high enough not to return reflections directly back to the microphones. As for microphone placement, woodwinds' high frequencies radiate from the bell, whereas low and midrange frequencies radiate from the keys.

Strings: Strings also can be overwhelmed by more powerful instruments. To reduce leakage from surrounding instruments, bidirectional mics positioned as recommended for woodwinds also work for strings. Miking to the side of the instrument produces a warm sound; miking above it produces a bright sound, which becomes more fiddlelike the closer to the instrument the mic is moved.

Guitar Amp: Guitar amps are usually miked, rather than taken direct, to preserve the musician's sound. Mic placement should center on one amp speaker and be fairly tight to reduce the chance of feedback.

Vocal: A directional microphone held close to the mouth is the obvious recommendation here and, in many situations, the only practical one if feedback and leakage from stage monitors are to be controlled. But if loud levels are not blaring from stage loudspeakers and the audience can hear pianissimo as well as fortissimo, try using an omnidirectional capacitor microphone. Compared with a directional mic, it has smoother response (especially off-axis), absence of proximity effect, less susceptibility to popping and breathing sounds, and a more open sound.

doing the mix, develop a procedure and follow it. Here are some tips:

1. Listen to the monitor system to make sure that it is noise-free (or as noise-free as possible).

2. Listen to each mic, one at a time, to check for noise. It is better to do this as you plug in each one (with the fader down, remember). That way, if there is noise, the problem is easier to track down.

3. Clearly label all assigned faders, monitor mix controls, and meters. A color, or some other graphic, scheme may help to highlight routing assignments.

4. If signal processing is being used, particularly reverb, check each channel, dry and wet, for noise. That way, if noise is present, it is easier to isolate whether or not the problem is in the signal processor.

5. Make a test recording. Listen for localization of instruments. Are vocals, violins, drums, lead guitar, and so on where they should be in the stereo space? Are the left and right channels correct and not reversed? If accent mics are being used, are the proportions and positions realistic in relation to the rest of the ensemble?

Performing the Mix Before the mix begins, you must know in advance what you want to hear in relation to production style, depth and breadth of imaging, localization, spectral balance, blend, reverberation value, and so on. Then, as the mix proceeds, you can make adjustments accordingly until it conforms to the sonic design you imagined.

Too many mixers feel compelled to constantly fuss with the console controls. No matter how sublime the mix may be, they must be touching and tweeking faders, buttons, and knobs. By the time you are ready to mix, if you have prepared properly, only finesse adjustments should be required. If a modification is necessary, make it slowly, imperceptibly. Avoid anything drastic.

If you hear something you do not like, determine what it is before you lunge for a control; do not go on "fishing expeditions" trying to locate the problem. For example, in EQing, know what the frequency ranges of the instruments are and where the fundamental and other defining frequencies reside. Also, remember that boosting reduces headroom, whereas attenuating does not. When a change is made, be sure that you can hear it and that it makes the difference you anticipated.

As you listen to and evaluate the mix, take your hands off the console. For some reason that helps you relax and sharpens your perceptions, so you hear that much better.*

Single-Camera Production

Many of the differences between multi- and single-camera field production, such as the amount of equipment required, the number of cameras and audio feeds used, and the type of material produced, are obvious. One not-so-obvious difference is the lesser number of audio personnel usually used for a single-camera shoot. Because miking and production recording are often left to a few people, this puts more pressure on a sound crew. They have to set up, tear down, relocate, set up again, and work in close proximity to others on the production crew. They must be prepared to record after shot and set changes, always ready to deal with the inevitable exigencies of Murphy's Law, which seem to occur in direct proportion to the

*Some of this material has been adapted from a presentation entitled "Popular Music Recording," made at the 79th AES convention.

number of miles from the security of a studio the shooting site is. Directors are understanding if time has to be taken preparing to shoot the picture; most, however, are less than sanguine if a delay results because of a need to rerecord the audio. Therefore, when going on location, be prepared!

Single-camera field production generally involves staged material such as drama and commercials. Therefore, you should select the equipment and plan for the miking and production recording with the dialogue, background sound, and sound effects in mind.

Equipment

The sound crew is responsible for selecting and packing the audio equipment used on location. In deciding what to bring, every operational and technical need must be anticipated in relation to the shooting requirements of the day.

Microphones and Mic Accessories

Microphones in the accessory kit should include high-quality, high-sensitivity capacitor shotguns with cardioid, super-, and hypercardioid directional patterns; capacitor lavaliers, both omnidirectional and cardioid; a good system mic with omnidirectional and various unidirectional capsules; boundary mics, both lavalier and plate-mounted, with hemispheric and directional pickup patterns; and a sufficient number of wireless systems. If stereo is involved, prepare M-S or X-Y microphones and their mounts so they are ready for placement.

Shock mounts and windscreens should be available for as many of the mics as possible. Mic cable should be sufficiently long to cover the longest shot—and several more feet of cable should be added to whatever the distance is just to be sure. There should be a plentiful supply of fresh batteries, and they should be changed at meal breaks, whether they need to be or not.

Boom selection is also important. The boom used on location is usually a **fishpole boom**—a long aluminum tube that is hand-held (see 5-65). It should be lightweight, but not to the point of bowing under the mic's weight.

Mixer and Tape Recorder

Have handy a multiple-input mixer with two or more output channels and low self-noise microphone preamps adequate for capacitor mics, even if the plan is to record direct from the mic to the tape recorder—you never know when more inputs than the tape recorder can handle will be needed. Even if recording stereo effects is not in the plans, split-track recording may come in handy.

The tape recorder should be high-quality, with time code, in 1/4-inch mono, and either stereo or two-track; you may also use a multitrack ATR or a VTR for audio-only recording. Remember that the tape, too, must be high-quality (see 8-12 and 15-37, 15-38, 15-39, and 15-40).

Headphones

Headphones should be top-of-the-line and circumaural, that is, airtight against the head for acoustical isolation. Bring a mono and stereo pair, and make sure you are thoroughly familiar with their frequency response. Also, have a headphone amplifier handy.

Tool Kit

A well-stocked tool kit is also essential. It should contain various types of screwdrivers, an all-purpose knife, cable, wire, connectors, adapters, batteries, power supplies, backup

15-37 High-quality field recorder with time code

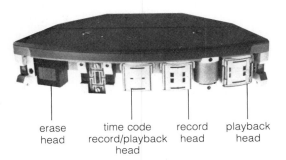

erase
head

time code
record/playback
head

record
head

playback
head

15-38 Head configuration of the Nagra ATR with
time code in 15-37

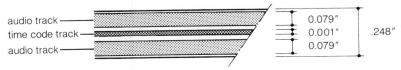

audio track

time code track

audio track

0.079″

0.001″

0.079″

.248″

15-39 Track configuration of the two-track Nagra with time code in 15-37

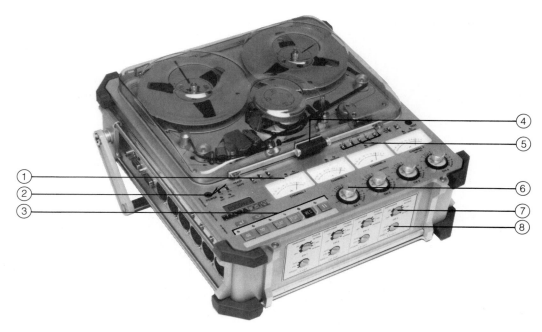

(1) Audio levels are shown on the microprocessor-driven level indicators. These guarantee real modulometer ballistics at low temperatures and are easy to read even in extremely brightly lit situations. In addition, microprocessor control means that you can display maximum recorded levels at any time by pressing "test."

(2) Lockout for either pair of channels can be selected during recording.

(3) The main function keys are all easily accessible and can be operated when wearing gloves.

(4) The hermetically sealed, transparent cover protects the tape and transport system from dust and moisture, but still allows easy access and a fast visual inspection of the mechanics.

(5) Selection of the signal to the headphone outputs can be made via the phones' switches.

(6) Level adjustment is via two concentric potentiometers for each channel; the outer ring for input sensitivity, the inner ring for fade control—recording the control signal on the tape gives a nondestructive fade-out.

(7) Each channel is equipped with an individual direct amplifier—permitting emphasis and phase switching.

(8) Three-position, low-cut filters are available on each channel.

15-40 High-quality four-channel open-reel digital audio tape recorder for field recording

parts for critical equipment, masking, duct, and electrical tape, and so on. (Also see Other Equipment and Materials earlier in this chapter.)

Miking Dialogue

In miking and production recording for dialogue, you have three goals: (1) to tape usable dialogue in any way possible or, if that is impossible, to go for the best track you can secure even if it is only to be used as a guide in ADR; (2) to tape dialogue in matching perspective with the focal length of the shot; (3) to tape as many usable sound effects, live, as you can (see Chapter 13). Because microphones cannot be visible in the picture, they are usually positioned in one of three ways: (1) on a fishpole boom, (2) on the body using a wireless microphone system, (3) planted (fixed).

Fishpole Booms

Fishpole booms come in various lengths, and most of them have a telescoping tube that can be extended or retracted. Shorter fishpoles can extend from 16 inches out to more than 6 feet and weigh as little as 11 ounces; medium-sized fishpoles can extend from 23 inches out to 8 feet and weigh about 14 ounces; longer fishpoles can extend from a little less than 3 feet out to more than 16 feet and weigh a little over a pound.

They are used on location because they are more mobile, are easier to manage, and take up less space than wheeled booms. (Sometimes, fishpoles are used in studios when larger booms cannot negotiate small spaces.) A fishpole is handheld and, therefore, can be moved about in a set with relative ease (see 15-41).

The fishpole boom does present a few problems, however. It gets heavy if it has to be carried about the set or held for any length of time, particularly if the mic it carries is a heavy one. It can be difficult to control precisely, particularly in wider shots when it has to be held high. Furthermore, handling noises can be heard if the fishpole operator is not careful.

Here are some operational tips when using the fishpole boom:

- Use directional microphones for virtually all situations. Remember, the narrower the pickup pattern, the greater the reach and the more compressed the background-to-foreground sound. For that reason hypercardioids are preferred for use outdoors; indoors they tend to capture more reverberation. Wider-angle directional mics—cardioid and supercardioid—have a shorter effective range but tend to pick up a less concentrated background sound indoors than do hypercardioids.

- Always use a windscreen, especially with directional capacitors, which are particularly sensitive to even minute air movement; barrier, mesh-style windscreens are quite effective (see 5-39c), especially with a windjammer (see 5-39e).

- Always use a shock mount. Quality microphones, particularly capacitors with high sensitivity, are apt to pick up sound conductance through the metal tube. It is a good idea to tape foam rubber around the tube a few inches above the handgrip and below the microphone mount to inhibit sound conductance.

- Use quality headphones when operating a fishpole boom mic. Except for the recordist, who may be some distance away, you have no other way to tell what sounds are being picked up or how they are balanced, particularly in relation to the foreground and background sounds.

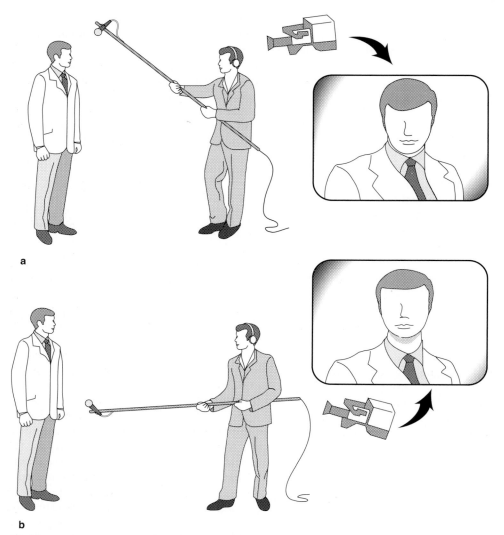

15-41 Using a fishpole with a directional microphone pointed at the performer's mouth from (a) above or (b) below. The mic's position depends on the focal length and angle of the shot. Better sound is usually obtained by positioning the mic above the performer.

■ If the fishpole operator must move with the performer(s), make sure that there is enough cable and cleared space on the floor. To avoid the cable problem altogether, boom-mount a wireless mic (see 15-42).

■ Have the fishpole operator remove all jewelry before recording and wear gloves to help damp handling noise.

■ If the fishpole has to be held for any length of time, tie a flag-holder around the oper-

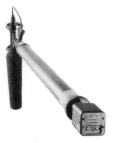

15-42 Wireless boompole with mounted transmitter

ator's waist and sit the pole end in its pocket. Some longer fishpoles come with a handle grip on the pole to help support it against the body.

The advantage of the boom-mounted microphone on location, as in the studio, is that by varying its distance to the sound source you can make it reflect the focal length of shots. This advantage applies especially in the field, where there is more likely to be background sound whose relationship to the principal sound source often helps to establish overall sonic environment. This technique is called "perspective miking" because it establishes audio viewpoint. Moreover, it helps to convey the mood and style of a production.

If a scene takes place in a seedy hotel room, for example, aiming the microphone at a slight angle to the performer's mouth so that it also picks up more room sound will "cheapen" the sound, thereby better articulating the visual atmosphere. If a scene is to convey an anticipatory atmosphere, widening mic-to-source distance, even in a tight shot, creates an open sound that encompasses background sounds such as a clock ticking, board creaking, drink pouring, owl hooting, siren screaming, and so on.

Fishpole booms also permit microphone changes to alter perspective. In a scene that shows a car pulling up to a curb, a person

getting out, walking a few steps, and stopping to light a cigarette, a supercardioid might pick up the car door slam, the match strike, and traffic sounds. A hypercardioid would pick up not only those sounds but also the footsteps, the match flare, and the drag on the cigarette. If sonic detail were to be downplayed in the scene, the supercardioid mic would suffice. If sonic detail enhanced the scene, the hypercardioid microphone would be the choice.

If there is a problem handling a strong voice against a weak one, aim the mic so it favors the weak voice on-axis and picks up the strong voice slightly off-axis.

In addition to perspective and flexibility, overhead miking in general tends to provide a crisp, natural sound compared to body mics, which are often sterile in texture (see "Body Microphones" later in this chapter). Keep in mind, however, that individual boom mics vary in sound quality and in reach.

To provide examples of these differences, let us compare a few of the popular boom mics used on-location. (The mics discussed here are included merely to provide comparisons. This list is not inclusive, nor does it constitute an endorsement or recommendation.) The mics are: Sennheiser MKH 416 and MKH 816 (see page 111); Neumann KMR 82i (see page 111); and the Schoeps CMC/MK-41—the hypercardioid capsule in the Colette system microphone (see page 108).

The Sennheiser MKH 416, although technically a supercardioid mic, is cardioid in the lower and middle frequencies and more directional in the higher frequencies. The result is better dialogue isolation. It has superior reach for a supercardioid and captures crisp, full-sounding dialogue. The Sennheiser MKH 816 is similar to the 416 but with more directionality across the frequency spectrum and, therefore, greater reach. Both microphones are better for outdoor than indoor

use because their interference tubes tend to increase perceived room echo in smaller, hard-walled venues.

The Neumann KMR 82i is extremely flat and transparent and tends to make dialogue sound warmer. (*Transparent* describes a wide, flat response and strong sensitivity to all sounds.) It has good reach and is especially effective in larger enclosed areas; smaller, hard-surfaced rooms tend to create echo problems because of the mic's interference tube. The KMR 82i is sensitive to rough handling and severe climatic conditions.

The Schoeps, with moderate reach, is good for interiors, especially hard-walled rooms, because it is without an echo inducing interference tube. The Schoeps is characterized by a rich quality and transparent, natural sound. Vocal presence is subtle, which, depending on the level of background ambience, may be either an advantage or disadvantage.

Body Microphones

Body mics are attached to a performer's clothing. A body mic is often a minilavalier connected to a wireless microphone system. As noted in Chapter 12, the advantage of this technique is that dialogue is clear and present, with a minimum of background sound. The disadvantages are that sonic perspective, regardless of a shot's focal length, is the same and the sound tends to be sterile.

These drawbacks can, however, be compensated for to some extent. There are two basic types of lavaliers: proximity-prone and transparent. Until recently, most lavaliers were proximity-prone — they tended to add presence to close dialogue and reject background sound. Newer miniature lavaliers have a more transparent sound and pick up more ambience. The advantage is that sound from a minilavalier can be blended more naturally with boom and plant mics. The disadvantage is that it passes more ambience. Additionally, of course, there is the sound quality of the body mic. As we did with boom mics, let us review some of the popular omnidirectional, capacitor lavaliers in relation to their effectiveness as body mics (see 15-43).

The PSC MilliMic is very small and easy to conceal. It has very high output and low noise with excellent resistance to electromagnetic interference. It has good isolation from handling noises and clothes rustle and is packaged with a versatile array of mounts to facilitate attaching it to clothes, such as a leather tape-down mount and a "turtle" clip to better hide the mic. The MilliMic has an open, clean sound that makes it blend nicely with overhead mics when it is used as a plant mic (see Plant Microphones later in this chapter).

The Tram TR-50 has a natural, open sound that makes it suitable as either a body mic or a plant mic. It is very small and easy to conceal and has decent isolation against handling noises and clothes rustle.

The Crown GLM-100 is another easily concealed mini-mic with transparent response that makes it suitable for either body or plant miking. It has minimal off-axis coloration and low feedback.

The Sony ECM-77 has a transparent sound resulting in audio that sounds more open and natural than with conventional lavaliers. Off-axis drop off is minimal when a performer's head turns from side to side. Due to its open, natural sound and its ability to remain consistent over distance, the ECM-77 matches well with sound recorded from overhead mics. Hence, it is probably better suited as a plant mic than a body mic. The ECM-77's disadvantages as a body mic are its comparatively large size, which makes it difficult to conceal; it sometimes hears too well in that it does not isolate the voice from the ambience; and it is quite sensitive to clothing noise.

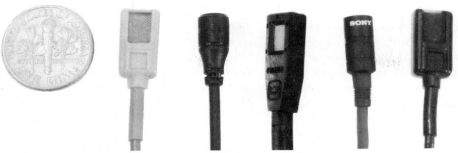

15-43 **Commonly used body and plant microphones.** From left to right: PSC MilliMic, Tram TR-50, Crown GLM-100, Sony ECM-77, and Countryman EMW.

The Countryman EMW lavalier is another mini-mic that is easy to conceal. It is available in three frequency responses, all of which deliver a warm, smooth sound. "F" response is flat and uncolored. "S" response provides a rising response between 2 and 15 kHz to compensate for the absorption of the higher frequencies by the body and clothing. "P" response provides a sharp curve at 12 kHz to enhance intelligibility when the mic is hidden under costumes. Handling and cable noise are low. The Countryman EMW also comes with versatile mounts, such as the "viper grip clip" that pins to clothing at every angle and "iron on," a cloth backing coated with hot-melt adhesive.

The Sonotrim (not shown in 15-43) looks similar to the Tram but with an extremely good open, natural sound. It features a 3 dB boost in the dialogue range.

Directional lavaliers have not proved practical as body mics. They have to be pointed precisely in the direction of the sound, which, in body miking actors or in using plant mics, is not practical. Also, remember that sound-cancelling ports are what make a mic directional. Clothes or mounting tape could block some of the ports, thereby degrading pickup.

Rigging a body microphone requires time and tact because the soundperson usually has to work inside the performer's clothes. The microphone capsule can either be secured outside of clothing or hidden under it; the cable and connector are almost always routed under clothing.

If the mic is mounted outside of clothing, a tie clasp–style mic clip can be used. Loop the cable from the head of the mic, in a J shape, through the bend or hinge of the clip. The cable continues up and around, behind the garment, to complete the circle. The cable, although it is secured in the clasp, has strain relief. The remainder of the cable is run behind clothing so that the XLR connector can be secured at a convenient point, such as at the waist (to a belt or pocket pack) or ankle. Regular mic lines can then be connected easily when it is time to shoot, as well as disconnected easily to free the performer between takes.

An externally mounted lavalier can be made inconspicuous by camouflaging it to match wardrobe. Marking pens can be used to color small strips of tape or foam windscreens, or both, which are then attached to the mic and clasp, thereby subduing their appearance. An alternative is to use small patches of felt or cloth to cover the mic.

Two types of clothes noise often encountered are contact and acoustic. Contact clothing noise is caused by a garment flapping

into or rubbing across the mic capsule. The solution is to carefully immobilize all clothing that may create this problem by taping down everything on either side of the mic. Try sandwiching the mic between two sticky triangles of tape (formed by folding a strip of tape like a flag, sticky side out). Because contact noise can also be caused when clothing rubs against the mic cable, form a loop near the mic for strain relief, and then apply a few lengths of tape along the cable. Try double-faced tape or sticky triangles to immobilize clothing and keep it from rubbing.

Acoustic noise can be generated by clothing rubbing against itself; treating the clothing with static guard generally solves the problem. A light spray of water can soften starched fabrics. Because synthetic fabrics are much noisier than naturals, they should be avoided whenever possible.

It is very important never to allow the mic line and the antenna to cross when rigging a wireless mic, and also to keep the antenna rigid and not looped over itself. A good way to keep the antenna rigid is to affix a rubber band to the tip and then safety-pin the rubber band to the clothing. If the antenna has to run in a direction other than straight up and down or to the side, invert the transmitter pack and let the mic cable, rather than the antenna, loop. And check the performer regularly to make sure the mic and cable are still secure — tape tends to loosen from moisture and costumes tend to shift from movement.

Plant Microphones

Plant microphones, also known as fixed mics, are positioned around a set to cover action that cannot easily be picked up with a fishpole or a body mic or to provide fill sound. A plant mic can be either a conventional-size or, preferably, a miniature capacitor. Plant mics can be hidden practically anywhere —

in flowers, on a desktop nameplate, in a doorway, on the edge of a window sill, or on an automobile visor.

Because a plant mic is almost always used along with the main boom or body mic, beware of phasing from overlapping sound. Also, if possible, try to match the perspective sound quality of the main and plant mics; that will probably be easier to do with a boom mic than with a body mic.

Wireless Microphone Systems

When using wireless mics away from the security of the studio, plan their use wisely and take extra precautions. Here are a few tips:

- When complex movement problems are called for, do not automatically choose a wireless body mic before considering whether good boom work can meet the challenge. Remember a boom-mounted microphone produces a more realistic sound.

- Because wireless microphones are subject to interference from noise, avoid using them in heavy traffic areas, such as downtown streets, parking lots, major highways, airports or in areas where there are frequent RF transmissions.

- Place the receiver properly — in line of sight with the transmitter and as close as possible to the set.

- Separate the two remote antennas of a diversity system by at least 10 feet for optimum reception. This better enables antennas to discriminate the strengths of the signals reaching them.

- Check transmission frequencies to make sure no one else in the area is using your band(s)

- Do a sound check by walking around the same area(s) the performers will be using

- Adjust the transmitter's gain control for the individual performer

- Always power down; that is, do not turn off the transmitter without turning off the receiver. Otherwise, the receiver will keep looking for a signal and could lock into most unpleasant VHF white noise.

- Bring backup wireless systems and plenty of fresh batteries

Production Recording

Production recording was discussed in Chapter 12, and many of the same considerations that apply to studio recording also apply to field recording, including the challenge of having to get the sound right with little leeway to experiment with it, refine it, or, should something go wrong, fix it. Perhaps one difference between studio and field production recording is the additional pressure that comes from being away from the security of the studio, particularly when a director insists that there will be no ADR, that the original sound will be used in the final mix. Being flexible and imaginative in solving problems is essential to good production recording.

Suppose a director wants to shoot a scene with constrained action in a very large stone and marble room using a boom, but does not want to rerecord the dialogue in postproduction. The reverberation is so dense, however, that the actors cannot pick up cues from one another. Clearly, the walls and ceiling cannot be acoustically treated; the room is far too large. What the production recordist did in this actual situation was to devise a canopy secured to four extendable legs and position it over the action. In addition, a rolling, absorbent baffle 20 feet high was used to reduce the length of the room and therefore the reverberant space. It should be noted, however, that this type of solution would not have worked had the scene required a lot of movement. In that case the director might have had to use body mics.

It should also be noted that signal processing is rarely used during production recording except for bass roll-off and a slight midrange boost to help punch dialogue. Anything else should be done in postproduction. Productions shot with a single camera are done out of sequence and with different takes of most scenes; prematurely processing sound on the set could cause a myriad of matching problems, particularly when stereo recording. Left—right imaging should be done in postproduction. To attempt it during production recording makes little sense because there is no way to know how a scene ultimately will be edited. Record for stereo with two separate mono signals or in a completely mono-compatible format.

The only "processing" that should be done in production recording is riding mic level with smooth and imperceptible changes and balancing the loudness extremes of each actor with a top-quality mixer whose controls are easy to see and get at. Slight gain adjustments on mixers of mediocre quality are too often apparent on the track.

Actors generally prefer the natural environment and interactions on the set to the sterile environment of the ADR studio. As good as postproduction can be, many believe it cannot quite capture the dozens of tiny sounds that correspond to physical movements, such as soft exhales of anxiety, the caress of a touch, the rustling of a shirt, or an arm brushing against a tree branch. Although ADR may save time and money, it is not a substitute for the real thing. The actor Robin Williams put it this way. "Sometimes you're trying to get that one spontaneous moment, and there are things that are very difficult to duplicate, because it's not just the situation—it's the room, the people, and all the ambient elements that affect you. There's

something very special about getting it at that moment, in that place, that's unique. Often in a performance you're not worried about how it sounds [only how it plays]. But when you're getting back into it again [in an ADR studio], it has to sound a particular way. So you're not really acting it, because you're worried about that."*

Split-Track Recording

By split-track recording, it is possible to use the fishpole boom, the wireless microphone system, or plant mic to their advantages. By miking a performer with a lavalier and a boom and recording each signal on separate tracks, the tighter sound of the close shots and the more open sound of the longer shots are covered at the same time as each shot is taken. This saves time without reducing flexibility in postproduction editing and mixing. This also comes in handy when dialogue and sound effects, particularly loud effects, have to be recorded at the same time. Close-miking the performer(s) and the effects and feeding them to two separate tracks keep the sounds from interfering with or even drowning out the dialogue. When in doubt, however, remember that the first priority of production recording is to record usable dialogue.

Multitrack Recording

As the sections on plant microphones and split-track recording imply, additional microphones and available tape tracks on a set provide considerable flexibility in production recording. With the advent of the audio mo-

bile unit, the synchronizer, the multitrack recorder that can be used in the field, and time code, such flexibility is possible. Whether multiple cameras are feeding picture through a video switcher to tape (or filming) or to separate video recorders, sound can be routed either directly to the VTR(s) or to one or more ATRs, including multitrack. If one camera is being used, the picture can be routed directly to tape (or filmed), but the sound can be routed to either the VTR or ATR, or both. Such versatility facilitates various miking arrangements and therefore allows better control of dialogue, background, and sound effects recording. It also takes more time to plan and set up, but the sound control in editing and mixing can make it worthwhile.

Take a simple outdoor scene where a couple is walking in the countryside and focal lengths vary from wide shots to close-ups. Instead of worrying about how to cover the scene with a fishpole, you could use two hidden wireless lavaliers for the couple and a separate microphone — omnidirectional or, better, boundary mic — to pick up background sound. Recording the three tracks separately not only allows control of each sonic element during production and postproduction but also reduces the need for the extra step of dialogue rerecording.

In producing drama, scenes are often shot a few times from different perspectives. In the preceding example the scene may be shot three times: as a master scene of the couple, then as close-ups from the man's and woman's perspectives. This allows an editor to cut from shots of the couple to individual shots of their interaction.

As for miking, because the master scene would be shot wider than the one-shot close-ups, clip-on boundary mics could be used as the hidden wireless microphones. The audio would be more open and would include more

*Quoted in "The Importance of Production Sound," by Cary Pepper, *Studio Sound*, May 1993, p. 49.

background sound than would that of the typical omnidirectional lavalier, thus better reflecting the wider focal lengths of the shot. During the one-shots the boundary mic could be changed to an omnidirectional or directional lavalier to sonically articulate the closer focal lengths and reduce background sound. A separate microphone to record background sound could still be employed for added flexibility in mixing. The microphone's pickup pattern may be omnidirectional, directional, or hemispheric, depending on the quality of the background sound required. Indeed, all three pickups may be recorded on separate tracks to further increase flexibility in the mix.

Multiple miking is also possible in complex scenes. Moreover, it may permit continuous shooting in scenes that would otherwise be shot in segments. Take a scene in which a couple is driving and talking in a car; the car stops, the woman gets out, walks into a department store, asks directions to the elevator, walks to the elevator, and gets in. One way to cover all the audio and maintain maximum control in recording and editing is to put plant mics in the car. This would pick up some interior car sound as well. If more car sound is desired, another microphone can be mounted facing away from the performers to reduce the chance of their voices leaking into the mic. When the woman gets out of the car, a fishpole boom can follow her from the car to the store entrance. The fishpole mic will pick up the footsteps and, depending on the mic's directional pattern, more or fewer traffic sounds. Another microphone can also be used to pick up traffic sounds separately. Ambience microphones can be placed inside the department store to pick up the general hubbub. When the woman asks directions, either a boom or body mic can be used. As she walks to the elevator, a fishpole can follow, picking up the footsteps, the opening

of the elevator door, and the movement of the woman and other people entering the elevator.

Even though multiple miking makes it possible to control the relationship between dialogue and background sound in the recording and the mix, using different microphones at various mic-to-source distances creates the problem of matching the sounds of dialogue sequences and backgrounds so that differences in their sonic qualities are not jarring. Matching is handled in postproduction, but the production recordist must provide the editor and mixer enough to work with.

Obviously, there is a difference between the sounds of traffic — or an auto interior and exterior. But the quality of the sounds should be consistent; overall frequency response of the various pickups must be relatively uniform. For example, one sound with highs, another sound without highs, or sounds that vary in low-frequency content will not do.

Blocking and Rehearsing

Despite the considerable flexibility that modern technology provides in producing drama, scenes are still shot one at a time, out of sequence, and often in segments. Each shot is blocked and lit, and camera movements are rehearsed. Just as the visual elements must be painstakingly planned and practiced, so too must the audio. For each shot, microphone positions are blocked, movements are rehearsed, and sound balances are determined.

The responsibilities of the sound people, in some ways, are perhaps greater than those of the crew responsible for producing the picture. The sound crew is often left on its own, not because the director does not care (although this sometimes is the case) but because audio is usually the one major production component of film and TV a director is

processor and
power supply/
control units

remote control

15-44 **Background noise suppressor.** In this modular system, low- and high-frequency faders adjust the amount of noise suppression above and below dominant mid-frequency signals such as dialogue. A control also permits varying the preset operating level for recording at unusually high or low levels, although overall gain of the unit remains fixed. A remote control module can be operated up to 50 feet from the control unit.

likely to know least about. As a result, blocking and rehearsing become all the more important for the audio people. The director may proceed with shooting when the pictorial elements are in place and assume that, or not bother to check if, sound is ready. It had better be! Too many directors who would understand a delay if a light had to be repositioned would have little patience if a similar delay were due to an audio problem.

Noise Reduction in the Field

The value of noise reduction throughout the production process cannot be overemphasized, especially in relation to field recording. Most venues, no matter how carefully chosen with sound in mind, have background noise problems from wind, traffic, ventilating units, and so on. Bringing a background noise suppressor on-location to reduce broad-band noise is a good idea (see 15-44). Although the

point has been made before, it bears repeating: most background noise, once it becomes part of a recording, is difficult, if not impossible, to remove without altering the sound quality of the program material.

Main Points

1. On-location, or remote, production is almost as common as studio-based production. Thanks to small, lightweight equipment it is possible to record sound for radio, television, music, and film productions on location with almost the same facility as recording productions in a studio.

2. In broadcasting, on-location recording involves producing material for either electronic news gathering (ENG) or electronic field production (EFP) using port-

able microphone mixers, consoles, cameras, audio- and videotape recorders, high-quality headphones, and mobile units. The main difference between ENG and EFP is that ENG covers news events, whereas EFP is employed with the types of productions that take time to plan and produce and usually require more equipment.

3. The two-way radio, the cellular telephone, remote pickup, and microwave transmission from a mobile unit or via telephone line make it possible to transmit from the location to the radio and TV station for recording or direct broadcast.

4. Due to the flexibility of production and postproduction equipment and time code, it is possible to record on location using the multicamera or single-camera production style regardless of the medium for which the production is being made.

5. Preproduction planning is essential for most on-location broadcasting or recording. Preparation requires selecting a location with a minimum of noise problems (if you have the choice) and determining what to do about the problems that exist; making sure where the power will come from; deciding who will take care of the equipment, program, and administration details; drafting a remote (site) survey, planning the IFB system, and bringing to the production site the essential tools and backup supplies.

6. Three ways to record someone speaking from a podium are to (1) set up and use your own microphones, (2) patch into the public address (PA) system, or (3) patch into a multiple pickup.

7. When several speakers have to be miked, an automatic microphone mixer may be more convenient to use than having one operator try to control all of the mic levels.

8. Miking sports events requires sound pickup from the announcers, the crowd, and the action.

9. In miking and mixing sports events in stereo, the announcers are centered, action sounds are either centered or somewhat localized, and crowd sound is assigned full left and right.

10. Miking music on location depends on the type of music being played and/or the acoustics of the venue. Classical music is usually distant-miked, with a main stereo array, ambience, and accent mics. Pop music is close-miked with care being taken to avoid feedback from stage monitors.

11. If music is being transmitted from a location site to a mobile unit for recording or direct to broadcast, a split feed is set up so the sound can be sent separately to the audience and to the mobile unit or broadcast.

12. Single-camera field production usually involves material such as drama and commercials, and therefore, miking and production recording are mainly concerned with dialogue, background sound, and sound effects (see Chapter 13).

13. In miking dialogue, three setups are used: (1) the fishpole boom, (2) the body microphone, and (3) the plant mic.

PART **5**

Postproduction

Editing

Postproduction is the final stage in the production process, when all previously recorded material is edited and mixed. What has been recorded is shaped and put into its final form, and all the aural (and visual) elements are combined. Postproduction increases flexibility in decision making not only during recording but afterward as well. This flexibility is made possible in no small measure by editing.

The art of editing demands the ability to see a whole and build toward it while it is still in parts. It requires manual or computer dexterity, a good "ear," and sensitivity to the aesthetics of sound. Yet, with all these abilities, the editor seldom gets recognition, except professionally, because a good edit is never heard. Editing helps to create coherence and pace in a production, but the audience is usually not cognizant of it.

To be a successful editor, you should understand the purposes of editing and be able to use (1) the tools and materials of the trade, (2) the procedures needed to make a simple edit, and (3) the techniques and aesthetic principles that govern the editing of speech, sound effects, and music. You must also have patience, a keen sense of detail, and the ability to perceive sonic relationships.

Generally, there are several reasons for editing. Program segments may need to be rearranged, shortened, or cut out altogether.

Suppose a comedian ad libs so well about halfway through the taping of a show that the director wants to open with that segment. Editing makes such switches possible. Directors commonly record elements of a program out of sequence; editing makes this possible. It also makes it possible to record a segment several times and choose the best parts of each take. Editing can improve the pace as well as the timing of a program; it can eliminate mistakes, long pauses, coughing, "ahs," "ers," "ums," and other awkwardness. Parts of words can be transposed, music can be restructured, the character of a sound effect can be changed, the quality of dialogue can be improved, and sound effects can be added to lend a sense of realism or feeling to scenes.

Until recently, tape editing was a linear process. In **linear editing** recorded material is edited successively: One section at a time is cut from one part of a tape or magnetic film and spliced to another part, or taped material is electronically transferred from one tape to another. The material may be edited sequentially or inserted at a particular point in the tape. In either case, final assembly is sequential. Although linear editing is still very much a part of postproduction today, since the development of nonlinear editing in the early 1980s, it is now possible to edit recordings using the formidable power of data storage and processing techniques.

Nonlinear editing is a digital process that allows you to assemble hard-disk-based material in or out of sequence and take it from any part of a recording and place it in any other part of the recording at the touch of a button. It is possible to audition the edit at any stage in the transfer and also alter its sonic characteristics because of the **digital signal processing (DSP)** capability that is part of most nonlinear editing systems. In addition, the original segment can be restored to its former position quickly and seamlessly.

Linear Editing

The two methods used in linear sound editing are (1) **cut-and-splice editing** tape and (2) **electronic editing** — transferring information from one tape to another. Audiotape and magnetic film are edited by cutting and splicing; videotape and often audiotape are edited electronically.

Cutting and Splicing Analog Audiotape

The cut-and-splice method is an economical way of editing that works well on analog audiotape recordings.

Equipment

For cutting and splicing audiotape, you need the following items:

- *Metal block.* The cutting tools most often used are the metal block and razor blade (see 16-1). The metal block has several advantages over other types of splicers: (1) durability, (2) speed and accuracy of cutting and splicing, (3) easy visibility of the tape for close editing, (4) capacity — the block can hold at least 4 inches of tape at once — and (5) no necessity for trimming the splicing tape.

- *Razor blade.* With the metal cutting block, use a single-edge razor blade to cut tape. Replace the blade often during lengthy editing sessions, before it gets dull and cannot cut cleanly. Razor blades also become magnetized after a period of time. Then, every time a magnetized blade touches the tape, it affects the magnetic information at that point on the tape. Whenever such a splice passes across the playback head, you hear a click or pop.

- *Marking pen or pencil.* To mark the edit point on recording tape, use a very soft

16-1 Various cutting angles on ¼-, ½-, 1-, and 2-inch splicing blocks

lead pencil or an indelible felt-tip pin. A bright color shows up best. Avoid hard lead and grease pencils or any marking instruments that crumble or tend to leave residue; the particles could stick to or collect in the working parts of the tape recorder.

■ *Splicing tape.* **Splicing tape** (and no other type of adhesive tape) is specially made to stick to recording tape without the adhesive's bleeding to other tape layers or onto the tape recorder heads. Most splicing tape comes in rolls for use with a dispenser. Individual, precut tabs of splicing tape are also available (see 16-2). These tabs stick well, they can be used with any type of recording tape, and they speed up splicing.

The width of splicing tape used with ¼-inch recording tape is ⁷⁄₃₂ inch. It is ¹⁄₃₂ inch narrower than the recording tape so it will not be exactly parallel to the edges of the recording tape. This means the splicing tape does not have to be seated precisely across the ¼-inch tape width,

thus reducing the chance of the adhesive sticking to an adjacent layer of tape or to the heads (see 16-3).

■ *Flat, clean surface.* Have a flat, clean surface available near the editing area. Save deleted parts of the recording tape until your editing is finished. On a flat surface you can keep bits of deleted tape in order and right side up, so that if you need a fragment, you can find it quickly and be sure the sound is flowing in the right direction. To be even safer, write on a slip of paper what each piece of tape contains and put the slip beside the appropriate tape fragment. Be sure the working surface is clean; dust and dirt on tape can interfere with response and clog or damage the tape recorder's heads.

Sometimes, you also need these items:

■ *Empty reel.* Keep empty reels handy to store the outtakes (material deleted from a tape or film) until a project is done. You never know whether you will need some piece of deleted material, particularly if it

16-2 **Precut splicing tab.** With this type, pulling the dark end of the plastic cover lifts the splicing tape from the tab sheet. Once the splicing tape is pressed onto the recording tape, thus completing the edit, pulling the transparent end of the plastic cover separates it from the splicing tape.

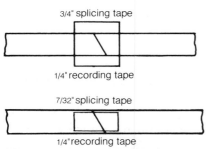

16-3 **Splicing tape widths.** The 7/32-inch splicing tape leaves 1/64 inch between its edges and the edges of the recording tape; the 3/4-inch splicing tape overlaps and must be trimmed.

is controversial. Also, label the contents of each reel.

■ *Leader tape.* **Leader tape** is nonmagnetic plastic or paper tape used primarily for threading and cueing. When spliced between segments of recording tape, it provides an easy visual reference that allows you to spool quickly to the cut you want instead of having to listen for a cue point by constantly starting and stopping the tape (see 16-4). Leader tape can also be spliced to both ends of recording tape to preserve these vulnerable points.

16-4 **Light-colored leader tape visible between the tape segments**

When you use leader tape for cueing, be sure that the beginning of the recorded sound starts immediately after the leader (see 16-5). When you do so, an engineer can cue a tape without having to search for the first point of sound. This is particularly helpful in situations when time is at a premium. If time pressure is not a problem, then starting the sound an inch or two after the splice is a good precaution to take. If the splice has to be redone or the tape edge is damaged, the first point of sound will not be affected.

You can use certain types of leader tape for timing (see 16-6). For example, if program material is on one reel and commercials are being played from another sound source, you can place a timed leader in the program tape to coincide with the length of the commercials. With this technique you do not have to stop and recue the program tape during commercial breaks.

Another feature of most timed leader tape is the arrows just before every other plaid marking. You can use the arrows to indicate the head end of the tape—that is, the direction in which the sound is going. The arrows are appropriate only for recordings that have all sound going in one direction.

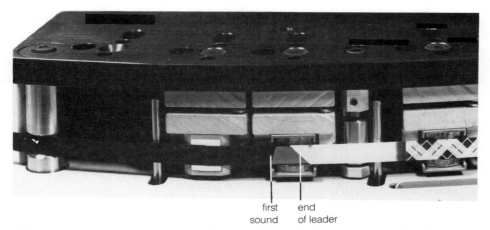

first end
sound of leader

16-5 **Leader tape serving as a visual reference to the beginning of a sound.** Providing the
sound is there, it makes cueing a tape easier and faster.

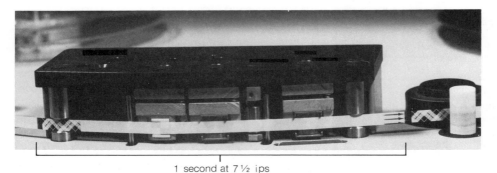

1 second at 7 ½ ips

16-6 **Plastic leader tape that can also be used for timing**

As mentioned, leader tape is available
in both plastic and paper. Paper is used
mainly when extremely high sound quality
is vital because, unlike plastic leader tape,
paper tape does not build up static elec-
tricity when it is wound excessively. Static
electricity can affect magnetically encoded
information if it builds to strong enough
proportions. A problem with paper leader
tape, however, is that it tears easily. Avoid

using transparent plastic leader tape, be-
cause it is sometimes difficult to detect
when it becomes twisted; also, it cannot
be used for timing. But it is useful on tape
transports that automatically stop when
there is no opaque tape in the threading
path.

Leader tape also comes in various
colors. Studios often use a certain colored
leader tape at the head of a reel, another

```
        "We have to be ~~aware, more aware than we have ever been before,~~
as aware as we can, that protecting our rights as handed down by the
founders of this great, ~~proud, and diligent~~ democracy is essential
to ~~the~~ future ~~of~~ (our) ~~country.~~ "
```

```
Outtakes
        aware, more aware than we have ever been before--
        proud, and diligent--
        the--
        of--
        country--

Intro-- We have to be as aware . . .
Outro-- . . . is essential to our future.
```

```
Running time--0:09
```

16-7 **Sample cue sheet used when editing tape.** It can be laid out in any way that is convenient. The important information to have at your fingertips — either on paper or computer — is what has been edited, what has been cut out (in case it is needed for legal purposes or to repair a faulty edit), the intro and outro lines, and the segment time.

color at the tail of the reel, still other colors to indicate the beginning and end of program segments within a reel.

- *Cue sheet.* Use a cue sheet when editing. Although there is no standard format, it should contain such information as (1) where edits have been made, (2) how long each outtake is, (3) where rearranged segments were originally located in the reel (assuming a long program), and (4) what segment and running times are (see 16-7).

Basic Procedures

Before cutting any tape, make a duplicate — called a *dub* — of the original or master tape. Store the master, tails out, in a safe place, and use the dubbed tape for cutting and splicing. Then, if you make any serious mistakes in cutting, you can make another dub from the master. Of course, a dub is second-generation and loses something in sound quality (see Chapter 17). If you use high-quality, well-maintained equipment for dubbing, however, the loss in sound quality will be minimal and the trade-off — a slight loss in response for the sure safety of the original material — is worth it.

Master tape, audio and video, or original film, should not be used in editing — cut-and-splice or electronic. The reason, when using the cut-and-splice method, has just been discussed. Although electronic editing does not require physically cutting the tape, it does necessitate running it across the tape heads over and over again. Each pass wears the magnetic coating. The more passes a tape

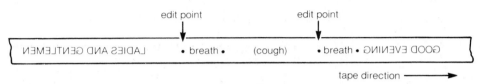

16-8 **Representation of sound spread on tape at three different speeds.** The faster the tape recorder speed, the more spread out the sound on the tape and the easier to edit.

16-9 **Sounds to be cut and spliced with edit points indicated**

makes, therefore, the more the quality of sound and picture is degraded.

Try to record the master tape at, at least, 15 ips; if you cannot, then dub it at that speed. The faster a tape travels across the heads, the more spread out is the sound and the easier it is to edit (see 16-8). Sound quality is better at faster speeds, too.

Let's go through the basic procedures, step by step, for making a simple edit, cut, and splice. A speaker greets an audience with "Good evening, (cough) ladies and gentlemen." The editing task here is to cut the cough. Once you decide what to edit, the next steps are to (1) determine exactly where the edit points will be and (2) locate those points on the recording tape.

Assume that the speaker took two breaths, one after "evening" and one after the cough. For reasons that will be explained later, the edit points should fall after the first breath and immediately before "ladies" (see 16-9). Once the edit points are chosen, you are ready to proceed with the cutting and splicing (see 16-10 through 16-21).

Splicing tape properly is important. Figure 16-22 contains graphic examples of defective splices commonly encountered.

Cutting and Splicing Digital Audiotape

Cutting and splicing digital audiotape is possible if the digital ATR is stationary head and designed for it. Rocking a tape back and forth across the playback head to listen for the edit point is not possible with a digital signal because the decoding system does not function at so slow a tape speed. Therefore, either an analog head or dedicated circuitry must be built in. Also, the flow of coding data is momentarily disrupted, creating a perceptible noise at the edit point. To neutralize this problem, the digital ATR effects an electronic crossfade at the edit point, interpolating the average level of the included signals to create a smooth, noiseless transition. Length of crossfade varies with the digital format: DASH is 10 milliseconds, PRODIGI is 2.5 milliseconds.

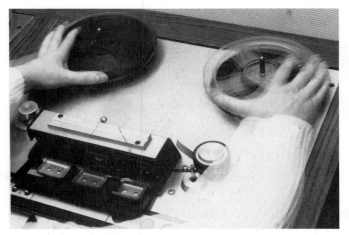

16-10 Locating the first edit point. After the tape has been threaded and wound close to the edit point, put the tape recorder in "Stop." In "Stop" (some machines have a pause, cue, or edit button) the playback head is "live." This allows you to hear what is on the tape and manually control the tape speed as you locate the precise edit point. You are making the initial cut after the first breath. With the edit point at the playback head, put your left hand on the feed reel and your right hand on the take-up reel. Then rock the tape back and forth until you hear exactly where the first breath ends, just before the sound of the cough. Some tape recorders have a manual control to facilitate rocking the tape (see 7-6).

16-11 Marking the first edit point. When you locate the edit point, mark it with a marking pen or pencil. Make sure the mark is visible.

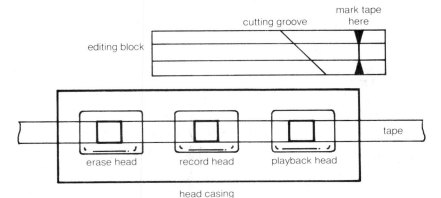

16-12 Another way to mark the editing point. You saw in 16-11 one way to mark tape — at the playback head. Unless you are highly skilled, this technique could result in the head being nudged out of alignment or, worse, damaged. A safer marking procedure is to establish a measured point close to the playback head and mark the tape there.

16-13 Marking the second edit point. With the first edit marked, wind the tape to the second edit point and rock it until you locate the point just before you hear the "l" in "ladies." After locating the second edit point, mark it. Now you are ready to cut the tape.

a

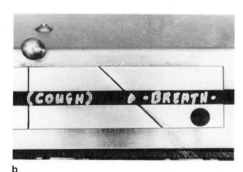

b

16-14 Using the cutting block. (*a*) Gently lift the tape from the playback head, and (*b*) place it in the channel of the cutting block with the first edit point on the diagonal groove.

16-15 Cutting the tape. Using a razor blade, cut the tape diagonally, drawing the razor angled through the slot without bending the tape ends into the cutting groove. A diagonal cut gives the sound a split second to become established in our hearing. A vertical (90-degree) cut hits the playback head all at once, and we sometimes hear the abrupt change from one edit to another as a pop, click, or beep. Also, the diagonal cut exposes a longer tape edge than a 90-degree cut, thereby ensuring a stronger splice.

16-16 Making the second cut. Gently remove the cut tape from the channel of the cutting block, find the second edit point, place the tape back in the channel over the diagonal groove, and cut on the mark.

16-17 Cuts completed. Now you are ready to splice the two edits together.

16-18 **Marking fragments.** Once you make the cuts, lay the deleted tape on a flat, clean surface. Write on a tab what has been edited and place the tab next to the fragment. Put an arrow on the tab to indicate the head end of the deleted tape.

16-19 **Joining tape ends.** Take the two tape ends and butt them together. Make sure that there is no overlap or space between them.

16-20 **Splicing.** Take a piece of splicing tape roughly ½-inch long, and place it so that ¼ inch covers each tape end. Do not use less than ½ inch of splicing tape or the splice may break. Using your finger or a blunt instrument, press the splicing tape firmly onto the recording tape to ensure a strong splice. Make sure that no white "bubbles" remain on the splicing tape; they indicate that the splicing tape is not bonded firmly to the recording tape. Gently remove the tape from the cutting block and play it to check the edit.

16-21 **Undoing a splice.** If you need to undo a splice, grasp each end of the splice point with the magnetic side of the tape facing you, form a small loop, and work the tape back and forth until one side of the splice begins to loosen. Then peel away the recording tape. Do not reuse the splicing tape.

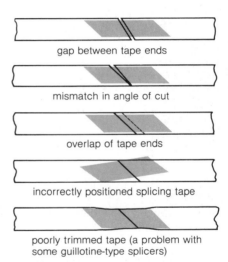

gap between tape ends

mismatch in angle of cut

overlap of tape ends

incorrectly positioned splicing tape

poorly trimmed tape (a problem with some guillotine-type splicers)

16-22 **Common splicing defects**

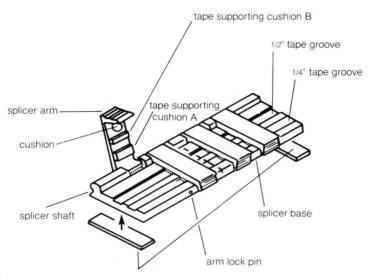

tape supporting cushion B

1/2" tape groove

1/4" tape groove

splicer arm

tape supporting cushion A

cushion

splicer shaft

splicer base

arm lock pin

16-23 Digital tape splicer

The angle of edit on digital tape should be 90 degrees due to the high density of encoded information. Because digital ATRs use extensive error detection, tape and system irregularities resulting from a 90-degree cut are usually corrected.

Digital tape must be handled with greater care than analog tape because it is thinner and packs high-density information that can be easily sullied. Keep handling to a minimum, and use white cotton gloves and splicers specially designed for use with digital audiotape (see 16-23).

Cut-and-splice editing has a major advantage over electronic editing—it is less expensive. Electronic editing requires at least two digital ATRs, whereas the cut-and-splice method is accomplished with one machine. Considering the cost of digital ATRs, this is no small advantage. That said, with improved technology in electronic editing systems and the emergence of hard disk editing, cut-and-splice editing is going the way of the Long Playing (LP) record.

Electronic Editing of Audiotape

With electronic editing (see 16-24), the tape recorder you dub from—sometimes called the **master**—contains the original material, or **master tape**, and, when the recorders are synchronized, also controls the tape recorder you are dubbing to—called the *slave*, which contains the **slave tape**. The simplest and least reliable way to accomplish electronic editing of audiotape is by manual control.

Assume a reporter has recorded a news story in the field but the segments were taped out of order. The tape begins with an interview between, say, the mayor and the reporter, followed by a statement the mayor made that sets up the interview, followed by the reporter's open and close. Based on what the finished story should sound like, the taped segments are in a 3, 2, 1, 4 order.

To put these segments in the proper sequence by means of manually controlled electronic editing, you need two open-reel tape recorders and a clean tape. You can also

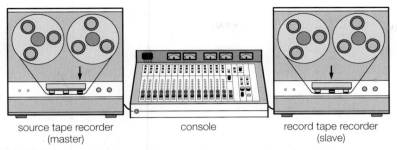

source tape recorder console record tape recorder
(master) (slave)

16-24 Electronic editing. This method involves dubbing segments that are out of order from one tape or tapes to another tape in the proper sequence. The tape-to-tape feed is usually done through a mixer or a console.

use cassette and cartridge recorders, but they are more cumbersome to work with. They do not edit as precisely as open-reel machines do, and the pulse tone on the cartridge recorder you dub to must be defeated (disconnected) or the tape will stop after each segment is played.

The procedure is as follows:

1. Thread the tape with the recorded material on one recorder (call it TR 1) and the blank tape on the other recorder (TR 2). Because you will dub from one machine to the other, they must be connected through a console, by patching, or by direct cable.

2. Ready TR 1 for "Playback" and TR 2 for "Record."

3. Cue the tape on TR 1 to the beginning of cut 3, the reporter's opening to the story. Try to leave a split second before the sound begins. Most professional-quality audiotape recorders take at least that much time to reach full speed. By leaving a slight space before the first sound, you avoid starting it with a wow—that is, unless background sound is also on the tape. In that case you have to preroll the playback tape to avoid wow. Prerolling involves starting the tape a few seconds be-

fore the cue so it has time to reach full speed. When it reaches the cue point, begin recording on the other machine.

4. Assuming the tape on TR 1 has no discernible background sound and that it is cued, start TR 2 in "Record," then start TR 1 in "Playback." Once cut 3 has been dubbed, stop both machines.

5. Recue TR 1 to the beginning of cut 2.

6. This time TR 2 must start recording at the point just after the conclusion of the reporter's open or there will be dead air between the segments. Put TR 2 in "Playback," cue the tape to the last sound in the reporter's open, put TR 2 back into "Record," and start both recorders at the same time.

7. Stop both recorders after cut 2 has been dubbed.

8. Recue TR 1 to the beginning of cut 1 and perform steps 5, 6, and 7. Repeat the same procedure with cut 4.

Assemble Editing

The type of electronic editing used in the preceding example is known as **assemble editing**—adding each program segment to a master tape in sequential order.

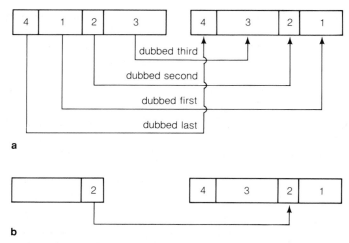

a

b

16-25 (*a*) **Assemble and** (*b*) **insert editing.** In assemble editing, segments are dubbed in sequential order. In insert editing they are not. However, the insert from the playback recorder and the location on the master tape to which it is dubbed must be the same length.

In the reporter's story just edited, suppose that the mayor wants to update the introductory statement, segment 2 on the assembled master, and that both versions, the update and the original, take the same amount of time. (To insert edit, the segment you insert and the one you replace must be exactly the same length.) Instead of assemble editing the entire story again, you can dub the new segment 2 in place of the old one without disturbing the other segments. To insert edit, the following steps are taken:

1. Cue the new segment 2 on a tape recorder and keep the recorder in "Playback."

2. On another recorder cue the master to the beginning of the old segment 2 and then put the machine into "Record."

3. Start both recorders at the same time.

4. Stop the tape recorder with the master at the precise instant at which segment 2 ends; otherwise, the machine will continue in "Record," erasing segment 3.

Insert Editing

It is also possible to **insert edit** — replace segment(s) on a tape without altering the other recorded material (see 16-25).

If the space between segment 1 and the old segment 2 on the assembled master tape is too small to permit the tape recorder to reach full speed before recording, you will have to preroll the master — start it in "Playback" a few seconds before segment 2, and then **punch in** "Record" precisely at the point when segment 2 begins. Punching in is the technique of putting a tape recorder in "Record" as it is spooling in the playback mode and taking it out of "Record" at the point where the inserted segment ends.

On most audiotape recorders, you punch in using the following procedure:

1. Start the machine in "Playback."

2. Hold in the "Start" or "Play" button until the insert point.

3. Press the "Record" button at the insert point.

4. Stop the recorder, or take it out of "Record," after the insert has been dubbed.

Suppose, however, that the insert runs longer than the segment it is replacing. Let's say that the mayor's updated statement included some introductory remarks and that these remarks can be cut without detracting from the statement's overall meaning. Also suppose that the space on the tape between the end of the introduction and the beginning of the updated statement is too small to use as a cue point without wowing in the sound. To get a wowless insert edit, you will have to preroll not only the master tape but the insert tape as well.

This procedure requires that you do the following:

1. Rewind both tapes a sufficient distance so that they first reach full speed, and then hit the cue point simultaneously.

2. Start both recorders in "Playback" at the same time.

3. Punch in "Record" at the edit point on the master.

4. Punch out of "Record," or stop the master, once the insert has been dubbed.

This is not a complicated procedure, but unless the two tape recorders run synchronously, which is unlikely even with the best machines, especially for several minutes, it is difficult to do precise dubbing.

Although manually controlled electronic editing of audiotape is possible, success depends on four factors: (1) The edit points are far enough apart with little or no audible background so the sounds do not wow in, (2) the tape recorders reach full speed quickly, (3) the machines can run synchronously if they have to, and (4) the start and record buttons do not transmit clicking sounds onto the tape when they are activated. A fifth factor may be the speed of the operator's reflexes. Even if person and machine work well together, however, it is difficult to make tight, precise electronic edits manually.

Most of these problems have been worked out since the development of tape synchronizers, time code, and automatic and computer-assisted electronic editing. These significant advances were motivated by problems in electronic editing of videotape that were similar to, but more serious than, those encountered in electronic editing of audiotape and, therefore, are better understood in that context.

Electronic Editing of Videotape

There are two significant differences between audiotape and videotape recording that make electronic editing of videotape more difficult.

One difference is the control track (see Chapter 7) that synchronizes video playback. In assemble editing on videotape, each segment's audio and video are dubbed to the master along with their control track (see 16-26). Because the control track works like sprocket holes on film, it must be recorded precisely to mark the beginning and end of each edit; otherwise, the picture will tear or roll as it passes from one edit point to another.

During insert editing, however, the control track on the insert is not dubbed but is recorded onto a blank master tape before dubbing. This process is known as *recording black* (see 16-27). It increases the possibility of trouble-free control tracks by making the control track at each edit point uniform, thus ensuring more stable edits.

Insert editing enables you to dub video and audio separately, something that is not

16-26 **Assemble editing of videotape.** Each segment that is dubbed has its control track transferred also.

16-27 **Insert editing of videotape.** (*a*) A uniform control track first must be recorded on the videotape. (*b*) This helps to ensure that the stability at the beginning and end of each insert will be the same.

possible with assemble editing. A disadvantage of insert editing is the long time it takes to record the control track before you can begin editing: A 30-minute tape takes 30 minutes; a one-hour tape takes one hour to prepare; and so on. The disadvantage is minor, though, compared to the advantages of insert over assemble editing. Most television production facilities have a stock of "black tape" on hand to meet day-to-day needs.

The other significant difference between electronic editing of videotape and audiotape is the time it takes the recorders to reach full speed. Modern, professional audiotape recorders take a split second, but even the best videotape recorders take several seconds to preroll to ensure that the picture stabilizes.

This means that (1) the master and slave tapes must run in sync for several seconds before reaching the edit point regardless of how much space is between edits; (2) they must start at the same instant; and (3) the record button on the record VTR must be punched in exactly at the beginning of the

edit. "Laying down" a control track and insert editing a tape may reduce the chance of getting an unstable edit, but it does not overcome the problem of recorders running slightly out of sync, or an operator not punching in and out precisely at the right edit point.

Automatically Controlled Electronic Editing

A number of devices—generally called **edit controllers** (also called *edit programmers*)—allow you to perform these functions automatically. The edit controller is connected to the transports of the master and slave VTRs. In fact, any automatically controlled electronic editing system, video or audio, simple or complex, requires a device to control or synchronize the operations of the tape machines involved in the editing operations (see 16-28).

Edit controllers vary widely in performance features. Most, however, are capable

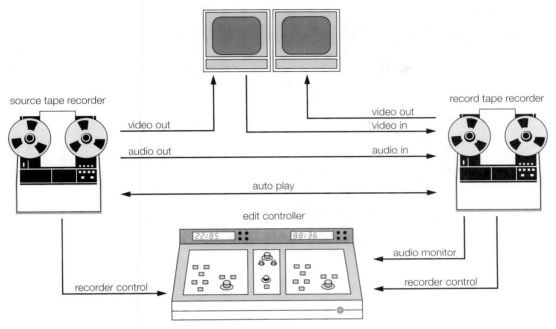

16-28 Typical system flow of a single-source automatically controlled editing system

of the same basic operations. By putting the appropriate command pulses on a track of audiotape or on the control, cue, or audio track of a videotape, the edit controller directs (1) the operations of the master and slave machines, (2) the place where the edit points punch in and out, (3) the preroll starting point, and (4) preroll, forward, and reverse speeds. It also enables assemble and insert edits and separate or simultaneous editing of audio and video.

Encoding with Control Track Systems

There are two ways videotape can be encoded for editing: using (1) the control track (also called pulse-count, back space, and frame-count) method or (2) the time code

method. Audiotape is encoded using the time code method, which will be covered next.

With the control track system, edits are performed by using as references the frame pulses encoded on the control track during recording. These frame pulses, generated at the beginning of each video frame, are used to identify video track locations. The location of each pulse is translated into elapsed time—hours, minutes, seconds, and frame numbers—and displayed on the edit controller as an eight-digit number in the form 00 00 00 00. There are 30 frames per second, so each frame number is equivalent to $^1/_{30}$ second.

Operational Functions Most control track editors have similar operational functions (see 16-29). Names and positions of control

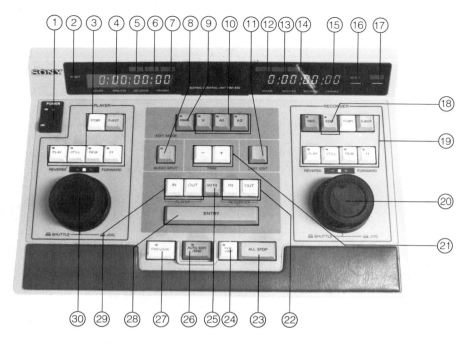

(1) **POWER switch**
ON: Turns on the power
OFF: Turns off the power

(2) **PLAYER RESET button**
Resets the time counter and the entered edit points

(3) **PLAYER button group**
The function of these buttons is the same as those on the player VTR
STDBY (Standby) button
EJECT button
PLAY button
STILL button
REW (Rewind) button
FF (Fast Forward) button

(4) **Time counter for the player**
The unit counts the CTL pulses or time code on the tape of the player and displays the result in hours, minutes, seconds, and frames

(5) **PLAYER SERVO indicator**
This indicator lights when the servo-mechanisms of the player are not locked during the automatic editing and preview operation

(6) **PLAYER IN indicator**
When the IN point of the player VTR is entered, this indicator lights

(7) **PLAYER OUT indicator**
When the OUT point of the player is entered, this indicator lights

(8) **AUDIO SPLIT button**
Press this button and make it light to enter the audio IN point during the split editing

(9) **ASMBL (Assemble) button**
Press this button for assemble editing

(10) **INSERT select buttons**
These buttons select the input signal during insert editing

(11) **LAST EDIT button**
This button recalls the previous edit points on the time counter

(12) **RECORDER IN indicator**

(13) **RECORDER OUT indicator**

(14) **RECORDER SERVO indicator**

(15) **Time counter for the recorder**

(16) **RECORDER RESET button**

(17) **TOTAL button and lamp**
The lamp blinks when the button is pressed. Then press the RECORDER RESET button to reset the time counter of the recorder to 00:00:00:00, so that you can know the tape running time from after that point.

(18) **EDIT button**
For manual editing, press this button and the PLAY button (19) simultaneously. When only this button is pressed, the picture from the player will be monitored on the recorder monitor.

16-29 Control track editing controller and its functions

Table 16-1 Advantages and disadvantages of the control track system

Advantages	Disadvantages
It is less expensive than time code editing.	The control track system is not completely accurate. It will lose a few frames during cueing—when the VTRs backspace and roll for an edit.
Editing of less complex material, such as that recorded in television ENG, is quicker.	
No special code has to be recorded on the tape because the control track is always a part of the recording.	Once the edit controller is turned off or the tapes are removed from the VTRs, the frame count is lost.
It is an inexpensive way to perform two-track audio editing because the second audio track does not have to be used for coding.	It is not possible to locate a cue point automatically. An editor must search through the tape to locate it.

keys may vary, but generally, an edit is performed by using the following procedures:

1. Locate the beginning and end of the edit on the playback VTR, and press the "Player In" and "Player Out" buttons on the controller unit at each edit point.

2. Locate the beginning of the cue point on the edit/record VTR and press the "Recorder In" and "Recorder Out" buttons. Some controllers also require an "Enter" or "Return" keystroke to input the edit in point. Also, it is possible to perform an *open-ended edit*—an edit without an out point—and a *split edit*—using separate audio and video entry or exit points during one edit event. For example, you might begin the video in an interview over the audio of the previous shot (see 16-60).

3. If the controller has a preroll control, it will automatically rewind both tapes to their preroll points. If it does not, the tapes must be cued manually.

4. Because edit functions are programmed, rehearse the edit before recording to determine whether it is correct. If in or out cues have to be adjusted, pressing " + " or "−" enables frames at an edit point to be added or subtracted.

5. Once you are satisfied the edit is correct, press "Execute." This starts both VTRs from the preroll point in sync and in "Playback." At the end point the record VTR will automatically switch into "Record." At the end of the edit, it automatically switches back into "Playback" or stops to avoid erasing any material already on the tape.

"Audio/Video" controls on most edit controllers permit execution of audio-only, video-only, or audio and video edits. Some systems also have keys that enable separate assignment of the audio track to be recorded.

Even with the proliferation of more exotic and versatile edit controller systems, including those employing computer-assisted operation, the control track system is still used for some postproduction editing. The control track system has advantages as well as disadvantages (see Table 16-1). Most of the disadvantages are not serious problems in day-to-day broadcast operations, particularly news, because deadlines necessitate compromises. But when precise editing is required and several different tapes, involving several tape recorders, are being edited or combined at the same time, then the time code system must be used.

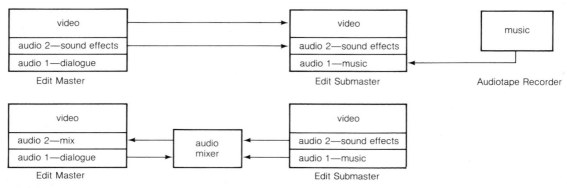

16-30 One method for recording and mixing audio on videotape

Editing Audio Using Control Track Systems
Editing sound when there is only one audio track of dialogue or narration is fairly straightforward. However, sound effects and music may accompany the speech track. It is possible to combine these three elements if equipment facilitates the use of two audio channels.

Speech is usually recorded with picture and put on audio track 1. Sound effects, if they are taped at the same time as the speech track, are put on audio track 2 in sync with picture and audio 1. Music is recorded separately on an ATR. In combining the three sound tracks, speech should undergo as few dub-downs as possible to maintain its audio quality. Therefore, audio 2 of the edit master has to be the mix track.

Because speech and effects are already in sync on the edit master, take a new tape, the edit submaster, and dub to it picture and effects. Put the effects on audio 2. Then lay in music on audio 1 of the submaster. Now speech is on audio 1 and effects are on audio 2 of the edit master, and music is on audio 1 and effects are on audio 2 of the edit submaster. Feed the master and submaster audio through a sound mixer to control separately the levels of each track, and mix them onto

audio 2 of the edit master, erasing the first effects track (see 16-30 and Chapter 17).

Usually, you will not be fortunate enough to record speech and effects together, let alone in sync. Therefore, both effects and music have to be mixed onto the edit master and combined with the speech track. One way to accomplish this is by laying in effects on track 2 of the edit master in sync with speech as you edit the picture. Then proceed as in the example just discussed.

In following these procedures, keep three things in mind:

1. A countdown slate should be placed at the head of the edit master and dubbed to the edit submaster so the VTRs can be synchronized.

2. Because videotape machines operate on the same current (60 Hz, 120 volts), they will usually run in sync if they are started at the same time. Once rolling, they cannot be stopped until dubbing is completed or sync will be lost. Should sync be lost, the tapes have to be started again from the beginning.

3. Before dubbing, decide which element is least affected by being dubbed a few generations. Unfortunately, except for the

speech track, music and effects will be at least third generation by the time mixing is completed. Of the three elements, sound effects usually suffer least from the loss in quality.

Encoding with Time Code Systems

Time code systems have three main advantages over the control track system.

1. Time reference is precise; each frame has its own time code address.

2. Tapes may be interchanged between other time code systems because the code is recorded on the tape.

3. Tape recorders and digital sequencers (two or more) may be synchronized — video to video, video to audio, audio to audio.

The convenience and precision that time code affords has not only led to significant changes in audio but in single-camera and multicamera production as well. Now film picture can be transferred to videotape and sound can be dubbed to multitrack audio during or after production, edited and mixed in postproduction, and transferred back to magnetic film for rerecording. TV sound can be recorded directly onto a multitrack ATR, facilitating more control of the audio tracks during editing and mixing before they are dubbed to videotape (see "Sweetening" in Chapter 17).

SMPTE time code (pronounced "semp-ty") is a high-frequency electronic digital signal consisting of a stream of pulses produced by a time code generator. It is recorded along the length of an audio channel (or cue track of a videotape) in the same way a conventional sound track is recorded.

Time code was originally developed to make videotape editing more efficient; hence, its identifying code numbers are broken down

into hours, minutes, seconds, and frames (see 16-31). (Videotape has 30 frames to the second; 29.97, to be exact.) Each $\frac{1}{30}$ of a second of audiotape or each frame of videotape is tagged with a unique identifying code number called a **time code address**. By decoding the time code address with a time code reader, an operator can select the appropriate code numbers that instruct audio- or videotape recorders, or both, to locate a certain point and begin playing in sync from there.

Audiotape recorders with built-in time code generator and reader and a special time code head are readily available (see 7-6). Time code is also available with videotape recorders and even many video cameras are capable of generating time code. Time code may be recorded during or after production.

SMPTE time code is also called **Longitudinal Time Code (LTC)**. This is to differentiate it from **Vertical Interval Time Code** (**VITC**, pronounced "vit-see").

LTC is limited with videotape by its ineffectiveness at slower shuttle speeds and at still-frame, modes that are often used in videotape editing. For this reason, it is sometimes necessary to display time code over the video image in the tape being edited by "burning" it in (see 16-31). Such a videotape copy is called a window dub. Another problem with LTC on videotape is that it requires a dedicated cue, address, or audio track, thereby taking up space.

VITC carries the same information as LTC but it is used with videotape and encodes its information vertically within the video signal, outside the visible picture area. Because VITC is part of the video signal, it can be read at slow tape speeds and in still-frame. Other advantages of VITC include the following: It does not require a dedicated audio track; it is accurate to 1 second, which is twice the accuracy of LTC; and it can be converted to LTC for equipment that requires it.

16-31 Window dub with SMPTE time code "burned in"

VITC also has its disadvantages. Many VCR systems cannot read the code at all shuttle speeds, and it is difficult to encode the signal over previously recorded video; this often requires dubbing down one generation.

Of the two time code systems, LTC is preferred. Both are usually employed in complex video production, however.

MIDI time code (MTC) was incorporated into the MIDI Protocol in 1987 as a way to translate SMPTE time code into MIDI messages. SMPTE time code is an absolute timing reference that remains constant throughout a program. In MIDI recording, timing references are relative and vary with both tempo and tempo changes. Because most studios use SMPTE time code addresses (as opposed to beats in a musical bar) as references, trying to convert between the two timing systems to cue or trigger an event would be tedious and time-consuming. MTC allows MIDI-based devices to operate on the SMPTE timing reference independent of tempo. In MIDI devices that do not recognize MTC, integrating an MTC sequencer is necessary. Converting SMPTE to MIDI time code is straightforward: SMPTE comes in and MIDI time code goes out.

The most recent addition to time codes is referred to as the **IEC** (*International Electrotechnical Commission*) **standard.** As the term suggests, it is an attempt to standardize time coding. The IEC standard code is the time code system used in DAT recorders as agreed to by all manufacturers of DAT machines, thus ensuring compatibility among all DAT equipment.

The main difference between IEC DAT code and the other time codes is that the IEC code provides more flexibility in adjusting frame rates during playback. The IEC time code DAT machines extract time code information and put it on tape without it being

contained in the frame rate. This makes it possible to set the playback machine's output to whatever frame rate you want (see 8-13). If a playback machine is equipped with an Auto-Detect mode, it will automatically output the recorded time information at the same frame rate that the code came in.

Drop Frame and Nondrop Frame Another videotape-related problem associated with SMPTE time code is that SMPTE time code generators operate in one of two modes: *drop frame* and *nondrop frame*. Color television's frame rate is not exactly thirty frames per second. Over the length of an hour, for instance, the SMPTE code would be off a little more than 3 seconds compared to real or running time. To make up for this discrepancy, the drop frame mode automatically drops two frames every minute except for the tenth minute. Therefore, it agrees with actual clock time.

Drop frame code is necessary when precise timing is critical and when synchronizing audio to video. But in most other production, nondrop code is used because it is easier to work with. It is a point worth remembering that the two modes are incompatible. All tapes used in any given production must use one mode or the other.

Using Time Code When encoding SMPTE time code, set the generator to the preferred starting time. Although time code readout is in hours, minutes, seconds, and frames, it is easy to confuse them if any numbers are duplicated on the same tape or on other tape belonging to the same production. To avoid this confusion, time code is used, employing either the zero-start or time-of-day logging method.

Zero start indicates the lapsed time of a recording. The first tape begins at zero and

each successive reel begins at 01:00:00:00, then 02:00:00:00, 03:00:00:00, and so on. For example, if the first tape segment starts at zero and ends at 00:00:02:46, the second segment could start at 00:00:02:47. However, it would be wiser to spool the tape ahead several frames to make the segments easier to access and also to avoid accidental erasure.

Time-of-day numbering is synchronized with clock time. This is a handy way to keep track of when events are recorded. But tapes used day to day must be clearly marked with the date to avoid any confusion about inevitable duplication of coding times.

Recording SMPTE Time Code on Audio- and Videotape On audiotape, you should record time code on the highest-number edge track—on an 8-track tape that would be track 8, on a 16-track tape that would be track 16, and so on. Record level should be −5 VU to −10 VU. To prevent crosstalk between the time-code signal and program material, leave the track adjacent to the time code blank—on an 8-track tape that would be track 7, on a 16-track tape that would be track 15, and so on. Do not record the time-code signal at a lower level; otherwise synchronization is adversely affected.

In fact, recording time code onto analog tape can be difficult, even at recommended levels, because it tends to distort. The problem becomes particularly acute when dubbing tapes (see Chapter 17). By the second or third generation, distortion can be so great that the code becomes unreadable. Most time code generators have features designed to reduce or alleviate problems in reading time code. The two most commonly used are called jam sync and freewheel.

Jam sync produces new time code during dubbing either to match the original time

code or to regenerate new address data, thereby replacing defective sections of code. **Freewheel** mode allows the bypassing of defective code without altering the speed of the synchronized tape transports.

Frame rate is usually set next. For audio-only productions, use thirty frames per second. Start recording time code 20–30 seconds before the program material begins to allow sufficient time for the tape machines to interlock. Once recording commences, it must be continuous and without pause. Tapes should be coded simultaneously. If that is not possible, then a **time code editor** will be needed to correct offsets in the synchronization.

On 1-inch videotape, time code is recorded on either the cue track or audio track 3 at −5 VU to −10 VU. On ¾-inch videotape it is recorded on either the time code track or audio track 1 at −5 VU to 0 VU. Newer format VCRs include a dedicated cue/time code track. As for time code levels on the newer format VCRs, because of the various differences in format and tape coercivity it is best to consult the recorder and tape specifications and then run tests to determine the optimum time code level. If a tape recorder has an automatic gain control it should *not* be used for recording time code or the time code signal will distort; gain should be set manually. In video, time code must be synchronized to the picture material, and as with audiotape, encoding should begin before the program material starts.

Synchronizers

Although time code permits the accurate interlocking of audio, video, and film equipment, any time two or more transports must run together simultaneously, frame for frame, a device called a synchronizer is nec-essary. A **synchronizer** controls the position and speed of the "slave" transport(s) to lock to the "master" machine's transport using time code as its reference.

Synchronization systems using time code vary widely in sophistication, from those that synchronize one master machine to one slave, to those that synchronize several transports at once and perform a variety of other computer-assisted functions as well (see 16-32, 16-33, and 16-34).

Most synchronizers have available two types of locking modes: *frame lock* and *phase lock*. Frame lock locks the master and slave units using time code so that any variations in the master reference are passed on to the slave. Phase lock (also referred to as *sync lock*) prevents sudden speed variations in the master, such as wow and flutter, from being passed to the slave.

Other synchronizer features include automatic switching from play mode to cue mode that allows the slave transport to "chase" the master whenever it is rewound and resync to it when it is again put into play. Offsets can be set between machines allowing a tape to be "slipped" out of sync, by less than one frame if necessary. Synchronizers control transport record/edit functions, enabling "In" and "Out" record points to be repeated accurately to as little as 1/100th of a frame in some units. To isolate themselves from speed changes during time-code dropouts, synchronizers can "freewheel," passing over time-code loss at a constant speed.

Basic Editing Operations Using a Synchronizer

Although synchronizers come in a variety of models, they perform similar basic functions. Using the digital audio synchronizer in 16-32 as an example, let us review those functions.

(1) **Player Select keys**
Select the player to be used from the four players connected to the editor

(2) **Function keys**
Bring up the menu programs on the display. When the main display is shown, these keys correspond to the functions shown at the bottom of the display.

(3) **Offset key**
Provides time offset to the editing point via the search dial

(4) **Cursor keys**
Move the cursor on the display

(5) **Numeric keys**
Used to enter numeric values when setting user-programmable parameters

(6) **Balance/Fader controls**
Adjust the output level and channel balance of the player

(7) **Tape Control keys**
Control tape transport functions of the recorder and the player. The MARK key enables presetting of the tape position for auto locate.

(8) **Edit Mode keys**
Allow selection of the editing mode

(9) **Monitor Select keys**
Select between the recorder and the player for the output to be monitored

(10) **Edit Point Set keys**
Used to set or modify the edit points

(11) **Memory Rehearsal keys**
Enable selection of the memory rehearsal mode and speed

(12) **Execute keys**
Execute previewing, automatic editing, and reviewing

(13) **Search dial**
Provides variable speed search

16-32 **Digital audio editor synchronizer.** This unit can control up to four digital audiotape recorders — R-DAT, S-DAT, or both.

16-33 Edit controller in a self-contained R-DAT editing system. (This system uses time code instead of control track editing.)

16-34 Example of a synchronization system flowchart

1	2	3	4	5	6	7
01	10	V	C	04:23:37:08	2:30	Est. shot of terrain
02	03	VA2	C	00:00:35:28	1:35	Zoom to 2 shot
03	04	VA2	C	03:44:06:10	0:28	1 shot, Bob
04	05	V	D020	02:53:14:15	0:45	Chalet
05	01	A1	C	01:20:46:21	0:10	Music #1

16-35 Sample hand-logged edit decision list

The edit point is entered by pressing the EDIT POINT key. The numeric keys can also be used if the tape time of the edit point is known in advance. The information is stored in a memory. Modification of the edit point can be performed by rotating the search dial in the jog mode, just like rocking the reels by hand on an open-reel tape recorder. If the memory rehearsal repeat mode is selected, the edit point can also be shifted in either direction with the search dial. Once the edit points for the recorder and the player are exactly defined, it is possible to preview the edited portion. If the edit is acceptable, press the EDIT and PREVIEW keys simultaneously to automatically execute the edit. The final edit can be reviewed and, because the original edit is still in the memory, re-edited if necessary.

Edit Decision List

Another important advantage of more advanced synchronizers is that they provide an **edit decision list** (EDL). An EDL is a list of edits performed during editing. On control track editing systems it must be hand-logged. On time code systems using synchronizers with memory, the list can be stored and printed.

If the EDL is hand-logged, the following basic information is needed (see 16-35):

1. Numbers for each event in consecutive order

2. The reel number from which the event comes

3. The edit mode—whether it is video or audio only, or video and audio—and the audio track number for videotape; the track number, for audiotape

4. The type of transition (cut, dissolve, wipe, if video; cut, crossfade, fade out-fade in, if audio)

5. The code of the edit start point

6. The time of the edit

7. A description of the edit content to facilitate reference

Stored edit decision lists (see 16-36) conform to ASCII (for American Standard Code, pronounced "as-key") format. ASCII has ten fields of information:

■ Field 1 lists the event or edit number.

■ Field 2 lists the source of the edit, which could be VTR, ATR, auxiliary (AX)—such as a character generator or color bars, black (BL), or isolated camera (ISO).

■ Field 3 lists the edit mode: video only (V), audio only and the audio track (A, A1, A2), or video and audio (AV, also shown as B for both). In audio-only systems, audio tracks are listed by number.

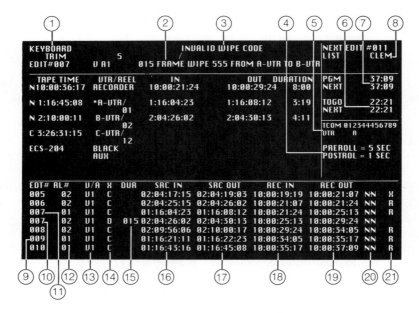

16-36 Edit decision list status display

(1) Intensified keyboard when active
(2) Active edit description
(3) Error messages initialization
(4) Preroll and postroll times
(5) Program mode and TCOM display
(6) Time-to-go display
(7) Overall program length
(8) Active function area displays present mode
(9) Edit #
(10) 7-line scroll edit block
(11) Center intensified edit line(s)
(12) 6-char reel #
(13) Individual video/audio select

(14) Edit type: C = cut
 W = wipe
 D = dissolve
 K = key
(15) Transition duration
(16) Source "in" edit point
(17) Source "out" edit point
(18) Record-in edit point
(19) Record-out edit point
(20) Drop frame/nondrop frame indication for source & record
(21) Status of edit

■ Field 4 lists the type of transition: cut (C), dissolve (D), wipe (W), key or matte (K).

■ Field 5 lists the duration of a transition. It is used for a crossfade, dissolve, wipe, or key. It may also contain an F, signifying a fade to or from black or silence. If the transition is a cut, field 5 is left blank because the transition is virtually instantaneous.

■ Field 6 lists the playback ATR's or VTR's start time.

■ Field 7 lists the playback ATR's or VTR's stop time.

■ Field 8 lists the record ATR's or VTR's start time.

■ Field 9 is for convenience because the information is not needed by the computer.

It may list either the record ATR's or VTR's stop time or the duration of the edit.

■ Field 10 consists of information needed only by the computer to begin reading the next edit.

To generate an edit decision list, each videotape and audiotape recorder is designated by a letter or number so it can be identified by the system controller. If there are, say, four playback VTRs, two playback ATRs, and a record VTR, the designations could be A-VTR, B-VTR, C-VTR, D-VTR, 1-ATR, 2-ATR, R-VTR.

Edit points are determined and entered basically in two ways. The first is "on the fly." As the tape recorder plays back at normal speed, the editor presses the "Mark In" or "Mark Out" button (or similarly designated control) at the edit point. The second is to manually enter into the keyboard the time code numbers that indicate the edit points. To do this the editor presses the "Set In" or "Set Out" button (or similarly designated control). Keyboard entry requires that the tape be previewed and edits predetermined.

The edit is checked or previewed to make sure that it is satisfactory before it is actually performed. If it is not, the edit can be trimmed by pressing "Trim In" to change the beginning of a shot or "Trim Out" to alter the end.

Once the edit decision list has been completed, and before final assembly can proceed, the EDL must be "cleaned." The cleaning, called "list management," is done by the computer. It checks to make sure that the information on the EDL conforms to the source tape.

After the list management stage, final assembly is automatic. The computer assembles the master tape, although some edits may be done manually if the need arises. There are two types of automatic assembly: (1) A-mode or sequential assembly and (2) B-mode or checkerboard assembly.

A-mode (sequential) assembly places edits in sequence. It starts at the first edit and continues until an event calls for a playback reel that has not been mounted. At that point the system stops until the new reel is put up. A-mode assembly is ideal for projects that require few reel changes. It is also easier to make changes using A-mode assembly. An edit decision list that has not been cleaned cannot be edited in the B-mode and must use the A-mode to avoid edit overlaps.

B-mode (checkerboard) assembly is faster and more efficient. It completes all of the edits that can be performed from the mounted reels. Any edit requiring an unmounted reel is skipped and a hole for it is left in the master reel, checkerboard style. B-mode assembly does require the EDL to be cleaned before editing.

Editing of Sound Film

Sound film is edited by cutting and splicing. The difference between cutting and splicing tape and film is that the editing of sound film must coordinate with the editing of picture film.

Equipment

The equipment used to cut and splice magnetic film includes the following (see 16-37):

■ *Editing table.* This table must (1) be large enough to hold all the editing equipment without the equipment being cramped; (2) provide some storage space for film, film reels, and other materials; and (3) be stable enough not to wobble.

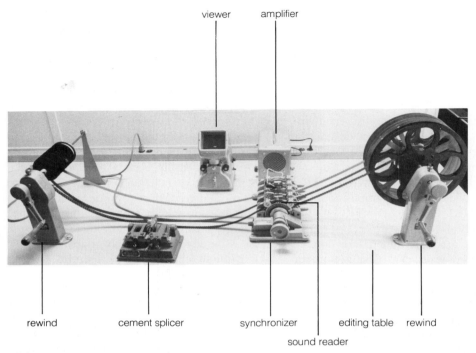

16-37 16mm film editing equipment

- *Rewinds.* These are hand-operated film winders with metal shafts that hold the film reels.

- *Viewer.* A small projector that displays the film images on its screen serves as viewer. You pull the film mounted on the rewinds through the viewer, forward or backward, at whatever speed you like.

- *Synchronizer.* This device with ganged, sprocketed wheels locks in the film strips and keeps them in sync when winding and rewinding. A **synchronizer** also has a counter that measures the film in feet and frames.

- *Sound reader.* This audio/playback device is either contained in the viewer or attached to the synchronizer. A **sound reader**

includes a playback head for magnetic and/or optical sound, and a small amplifier–speaker.

- *Moviola.* With this device picture and sound can be run in sync backward or forward at any speed to allow shots to be seen and heard, and individual frames can be marked for editing (see 16-38).

- *Horizontal editor.* This more flexible version of the moviola, also called a *flatbed editor*, uses a motor to drive multiple film reels in sync with sound for edit review and marking (see 16-39).

- *Film splicers.* These devices cut and splice film. The two types are **tape splicer** and **cement splicer**.

parent tape and can be undone without damaging the film; frame loss is minimal. The major drawback of tape splicing picture film is that when it is projected, the splices are visible. Therefore, after final editing, the picture film must be permanently bonded with cement splices to make edits invisible. Tape is used only on work prints.

Magnetic film is edited only with tape, because visible splices are not a problem. Also, magnetic film, like audiotape, is cut on the diagonal, not on the vertical as is picture film (see 16-40 through 16-45).

Editing Double-System Sound

Editing magnetic film is similar in technique to editing ¼-inch audiotape: You locate the edit, rock the film back and forth on the sound head to find the precise cutting point, and then mark, cut, and splice it. The main difference between editing audio film and editing audiotape is that film audio must be cut to sync with the picture.

To sync sound and picture, use the following steps:

1. Thread the picture film through the viewer, find the point where the clapsticks first come together, and mark the frame with an "X." The clapslate contains information about which scene and take it is.

2. Wind the magnetic film through the sound reader until you hear the corresponding scene and take announced. Then listen for the snap of the clapsticks coming together and mark the frame with an "X."

3. Align the rolls of film in the synchronizer and lock them in place (see 16-46).

Now if you cut or add frames of sound, you can read the frame counter and cut or add a like number of frames of picture, always maintaining sync.

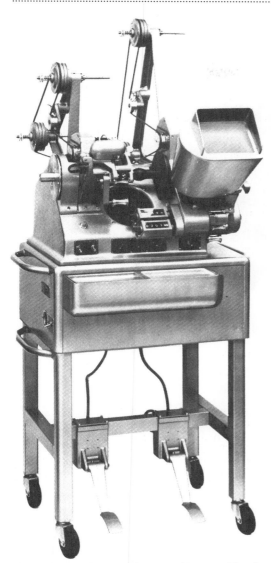

16-38 Moviola® film editing machine capable of magnetic or optical sound playback

Film Splicing

Tape splicing is done during rough editing to make temporary splices in picture film. It is easy and fast. Splices are bound with trans-

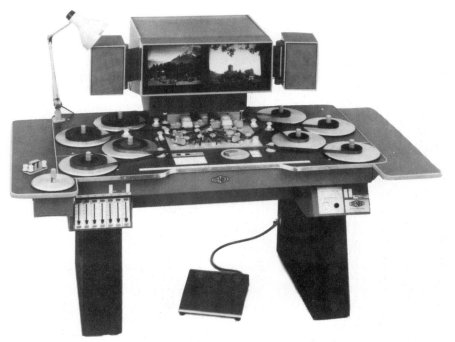

16-39 Horizontal or flatbed film editor. This unit holds picture and sound film reels and has a two-picture screen. This enables the editor to preview an edit before cutting the film. It is available in 16mm and 35mm or in a combination of the two formats.

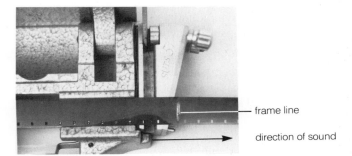

frame line

direction of sound

16-40 Editing magnetic film. Mark the first edit point (assume the sound is in a head-to-tail direction) to the right of the frame line. Place the sprocket hole on the frame line directly over the diagonal cutting edge of the tape splicer.

16-41 Using the guillotine blade to cut the magnetic film

16-42 **Marking the second edit to the left of the frame line.** Place the sprocket hole directly over the diagonal cutting edge. Then cut the film.

16-44 **Trimming the splice.** Press the two cutting blades in the handle of the splicer through the splicing tape.

16-43 **Butting the cut edges of the film together.** Set the sprocket holes on each strip across the registration pins at the bottom of the cutting plate. The edit marks indicate that the splice point is properly aligned. Splice the film with transparent mylar splicing tape.

16-45 **Checking the splice.** Remove the film from the splicer to check the splice for strength and to make sure the edges were trimmed cleanly.

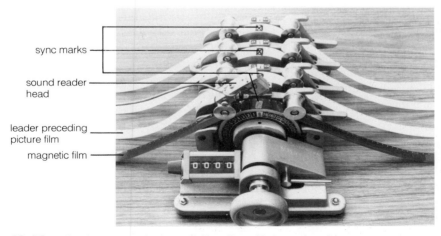

sync marks

sound reader head

leader preceding picture film

magnetic film

16-46 **Rolls of picture and magnetic film aligned in a synchronizer**

Processing Film Sound

Two procedures are used to process film sound—that is, to edit and combine the various sonic elements.

One has been used for many years. Dialogue is recorded on audiotape during double-system filming or afterward during dialogue rerecording. Effects are recorded either on audiotape or magnetic film, depending on convenience. Music is recorded on audiotape.

All sound recorded on audiotape is transferred to magnetic film for editing. This transfer often involves dozens of reels. Eventually, these reels are combined into discrete dialogue, music, and effects reels that are then combined into a mono or stereo master mix.

Time code, synchronization, and computer-assisted editing have led to the development of a method of handling film sound known as the *film-tape-film process* or **post audio processing** (**PAP**). In the film-tape-film process all sound is transferred to multitrack audiotape and synchronized with picture that is transferred to videotape. Editing of all dialogue, effects, and music tracks is accomplished in this mode and then mixed onto discrete dialogue, effects, and music tracks. These tracks are then transferred to magnetic film and rerecorded into a mono, stereo, or surround sound master mix.

This procedure is more complex than is indicated here. But, overall, in editing film sound, it has provided more flexibility at less cost than the traditional method has.

Nonlinear Editing

As we indicated at the beginning of this chapter, nonlinear editing allows you to retrieve, assemble, and reassemble digital disk-based material quickly and in any order, regardless of the material's location on the disk. The term *random access editing* is often used synonymously with nonlinear editing. Of course, all editing is random access. You access a sound or picture in one part of a recording, then you go to another sound or picture in another part of the recording, and so on. What is usually meant by random access when it is applied to nonlinear editing is quick access to randomly selected points in a recording. This is not to quibble with terminology but to clarify more precisely what nonlinear editing is.

Another confusion about nonlinear editing derives from the number of different digital editing systems on the market. There are stereo, four-channel, and multichannel systems. Most of them use hard-disk, others are optical-based. Hard-disk systems are either IBM-, Macintosh-, or Atari-based, or they use their own hardware—software interface. Some systems provide basic editing functions only, others include digital signal processing (DSP). There are dual-purpose hard-disk systems that are capable of both recording and editing in stereo or multitrack. And then there is the digital audio workstation (DAW). DAWs incorporate most of the features found in advanced hard-disk editing (and recording) systems. What makes the DAW different is its ability to integrate with and control other audio, video, and MIDI sources. In other words, the DAW is a multifunctional production system.

Another factor that fuels the confusion about hard-disk nonlinear editing is the absence, so far, of standardized terminology. Companies use different terms for similar functions in an effort to make their own programs distinctive.

The following section is a distillation of the basic functions found in most hard-disk editing systems. It is intended to give you an operational overview of nonlinear editing. Although all the terms are explained, some are more commonly used than others. In some

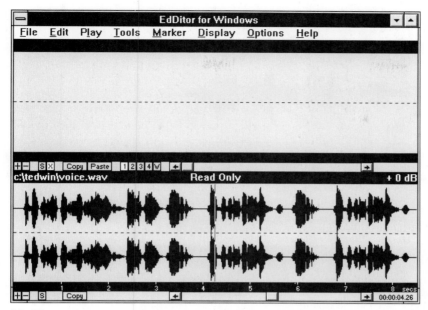

16-47 Soundfile and Menu display. In this editing program the bottom window displays the original soundfile. The top window is the Modify window where most editing operations are performed. In other words, a new soundfile in the Modify window is constructed using portions of the soundfile from the Read Only window so that the original recording is not altered (see "Destructive and Nondestructive Editing" later in this chapter). The narrow vertical line at the center of the waveform is the edit cursor. When a stereo sound is displayed, the left channel is shown above the right channel, with a horizontal dotted line separating the two. When a mono sound is displayed, a single waveform appears in the window.

cases, their familiarity may depend on your knowledge of a particular editing system.

Hard-Disk Nonlinear Editing

In a hard-disk editing system, audio that is encoded onto the disk—speech, sound effects, music—takes the form of a **soundfile**. The soundfile contains information about the sound such as amplitude and duration. When the soundfile is opened, that information is displayed as a waveform on the monitor screen. Also displayed is the editing program Menu (see 16-47).

The waveforms are displayed in two configurations, as a *symmetrical amplitude display* or as a *nonsymmetrical peak ampli-*

16-48 Peak amplitude display

tude display. A symmetrical amplitude display shows a sound's profile, in both a positive and negative direction, in relation to a zero-level reference line (see 16-47). A nonsymmetrical peak amplitude display rises in a positive direction from a zero-level reference line (see 16-48). These displays profile a sound's amplitude over time. By being able to "see" a sound, you can easily spot the loud

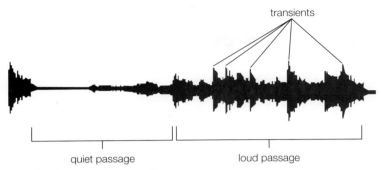

16-49 **Dynamics of a waveform**

16-50 **Zoom function.** The section from 2.4 seconds to 3.2 seconds in the Read Only soundfile is detailed in the Modified window. The lighter sections are the *defined regions*, that is, the part of the waveforms selected for editing. The zoomed section is a "Harrumph" that interrupted a sentence in a speech (see 16-52).

and quiet passages (see 16-49). It is also possible to see greater detail in a waveform by zooming in, a feature that facilitates extremely precise editing (see 16-50). Once the soundfile is retrieved and its waveform is displayed, it can be auditioned to determine which of its sections is to be defined for editing. As the sound is played, a play cursor, or playbar, scrolls the waveform enabling the editor to see precisely the part and shape of the sound that is playing at any given moment. In some systems, if the soundfile is

16-51 **Example of markers placed in a soundfile**

longer than the screen can display, then as the scroll moves to the end of the visible waveform, approaching the off-screen data, the screen will be redrawn or *refreshed*, showing the entire updated waveform.

When the editor determines what part of the sound is to be edited, the segment is highlighted in what is known as a *defined region*. Once a region is defined, the selected edit (or DSP) will be performed only in that section of the waveform (see 16-50). The region can be cut from the waveform display, moved to another part of the waveform or to another waveform. It can also be inverted, changed in level, envelope, frequency, and so on.

A *marker* or *identification flag* can be placed anywhere in the waveform to facilitate jumping the play cursor at will to the desired marker points. The marker can be a graphic identifier using a number, letter, or text (see 16-51).

At any time in the editing process the soundfile can be auditioned in a number of ways: from beginning to end; from the defined region; from marker to marker; and at increased or decreased speed in either direction. This latter operation is called **scrubbing**.

Scrubbing is similar to rocking tape in cut-and-splice editing or using the jog mode in electronic editing. It lets you move the play cursor through the defined region at any speed and listen to the section being scrubbed at the same time. Unlike rocking a tape or jogging, with scrubbing you can au-

dibly and visibly locate the in- and out-point of a defined region.

Suppose you want to pinpoint a series of horses' hooves located in one section of a soundfile and use the same sound effect at the end of the soundfile. By moving the cursor to an area close to the horses' hooves, you can slowly scrub the area until you find the precise location at the beginning of the first hoof beat. This will be the first point in the defined region. Continue scrubbing until you locate the precise end point of the last hoof beat and mark it as the end of the defined region. Then, as you would in word processing, copy the defined region and paste it at the proper point near the end of the scene.

Scrubbing to reproduce a waveform can be accomplished in two ways: by jogging and shuttling. Unlike jogging in electronic editing, in this application the **jog mode** reproduces scrubbed samples in direct relation to the movement of the cursor over a region. In **shuttle mode** the initial direction and speed of the cursor is used as a reference and the rest of the scrubbed section is reproduced in the same direction and at the same rate with no further movement of the cursor necessary. Moving the cursor again will change the direction and speed of reproduction analogous to the new movement.

As we suggested, there are operations in nonlinear digital editing that are similar to those in word processing when you delete a word entirely, or cut or copy it from one part of a sentence and insert or paste it elsewhere

16-52 Cutting in hard-disk editing

in the same sentence or into another sentence. This is known as *cutting and pasting*. Once a region is defined, the *Cut* or *Delete* command removes it from its original location and copies it to the computer's memory for temporary storage. This section of computer memory is sometimes referred to as the *clipboard*. Using the *Copy* command, the defined region is added to the clipboard but is not cut from its original position. The *Paste* command copies the defined region from the clipboard and inserts it into the waveform immediately after the position of the cursor.

There are also *Shuffle* and *Replace* commands in nonlinear editing that are similar to the "Insert" and "Typeover" operations in word processing. *Shuffle* moves the audio that originally followed the cursor to a point immediately following the newly inserted segment. *Replace* overwrites the audio immediately following the cursor.

To use a specific example, refer to 16-52 and 16-53 for the following discussion. The sentence, in the Read Only window, in which the cut is to be made has been defined and copied to the Modified window for editing. The segment to be deleted is the "Harrumph" that occurs from 2.4 seconds to 3.20 seconds. It has been defined in the Modified window. To make sure that the edit cursor has marked each edge of the defined region precisely, zoom in to the "Harrumph" (see 16-50). This view reveals a small amount of unselected data on either side of the actual "Harrumph." Scrub the edit cursor to better define the edges of the "Harrumph." Then select the *Cut* command to remove the offending sound. If for some reason the "Harrumph" is to be moved to the end of the sentence for, let us say, comic emphasis, the "Harrumph" will have been saved to the clipboard. Move the edit cursor to the end of the

16-53 Pasting in hard-disk editing

sentence in the waveform and then use the *Paste* command to insert the "Harrumph" at that point.

Other Types of Screen Displays

In addition to being displayed and edited as a waveform, a soundfile can also be displayed and edited in graphic form, as a playlist, or by defined and named regions (see 16-54, 16-55, and 16-56).

Digital Signal Processing (DSP)

The ease, convenience, and speed of non-linear editing becomes even more power-ful when digital signal processing (DSP) is added to the editing system (see 16-57). Not all hard-disk editing systems offer DSP. Those that do provide the editor with sound-shaping capabilities, in a self-contained unit,

that would take the interfacing of several separate devices to duplicate. The signal pro-cessing itself—equalization, compression, limiting, expansion, noise gating, pitch shift-ing, and MIDI interface, is not new. What is new is that these various signal-processing functions are accessible, quick, and can be implemented with the touch of a button, the movement of a mouse, or the stroke of a light-pencil.

Destructive and Nondestructive Editing

Still another advantage of hard-disk editing is that the edits you make can be nondestruc-tive. **Nondestructive editing** does not alter the original soundfile regardless of what ed-iting or signal processing you effect. **Destruc-tive editing**, on the other hand, permanently alters the original soundfile by overwriting it.

16-54 Graphic editing display. The screen provides a graphical representation of sound cues as if they were pieces of multitrack tape moving past a fixed tape head.

16-55 Playlist editing display. In this program the upper-left-hand corner of the screen shows the playlist, the list of sounds that will be played in order. For each sound on the list, the start time, end time, and duration are given. In the upper-right-hand corner is the region library, the list of sounds that are available to place onto the playlist. At the bottom of the screen is the waveform display.

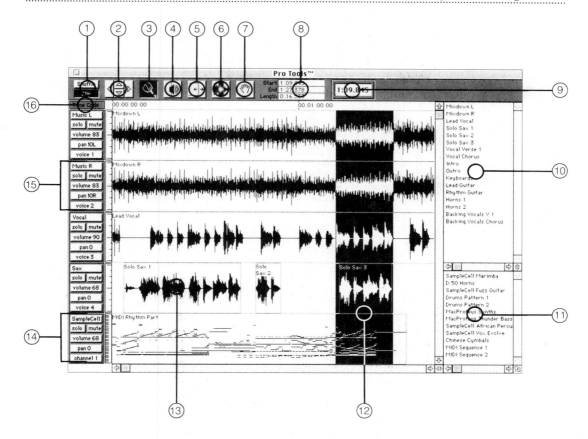

16-56 Editing display by defined and named regions

(1) **Slip/Shuffle indicator** Use Slip mode to move regions freely within a track, even overlap other regions; shuffle mode lines up regions end to end for rapid assembly

(2) **Display scale arrows** allow you to adjust waveform display

(3) **Magnifying Tool** lets you view the waveform at any resolution

(4) **The Scrubber** offers two modes: Varispeed forward and backward scrubbing (like rocking tape heads) for pinpoint accuracy and Loop scrubbing to preview the beat in musical edits

(5) Use **the Trimmer** tool to "fine tune" your selection

(6) **The Selection Tool** is used to define regions of audio & MIDI

(7) The **Grabber Tool** moves regions and tracks in a single step

(8) **Selection and Position indicators** shows you exactly where you are in your selection

(9) **Current Time indicator**

(10) **Audio Regions List**

(11) **MIDI Regions List**

(12) Select across multiple tracks of audio and MIDI

(13) Slip regions freely within or across tracks

(14) **MIDI Tracks** can be edited in blocks along with audio

(15) Each **Audio Track** is a graphic playlist with controls for volume, panning, solo/mute—and voice priority—giving visual feedback for rapid, accurate editing

(16) **Time Scale indicator** lets you view a session in Minutes: Seconds, Bars & Beats, or SMPTE

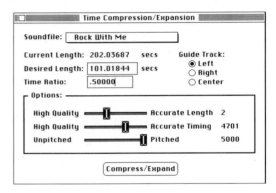

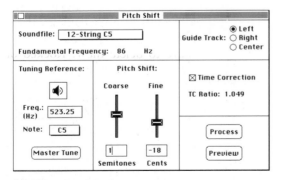

16-57 Examples of DSP Menus

This raises the question: Why employ destructive editing when you can process a soundfile in any way you wish and still preserve the original? The answer is that destructive editing is necessary, for example, when a memory is limited — it is easier to save a single soundfile than both the original and duplicate soundfiles — and when the edited soundfile is to be downloaded to another system.

Techniques and Aesthetic Considerations

As we've noted throughout this book, sound design and production involve aesthetic decisions as well as mastery of technical procedures. This is especially true in editing.

Editing is matching — ambience, inflection, loudness, rhythm, key, and content. For instance, in a previous example, "Good evening, BREATH (cough) BREATH ladies and gentlemen," the cuts were made after the first breath and before "ladies." Why not cut after "evening" and before the second breath? A breath would still be there to preserve the rhythm. Does it matter which breath we use?

The difference is in the ambient sounds of the two breaths. For one thing the cough is percussive, whereas "evening" is not. Thus, the reverberation after the first breath sounds different from the reverberation after the second breath. If "evening" were spliced to the breath after the cough, it would sound unnatural; the ambience does not match.

Editing Speech

The first thing to learn in editing speech is to recognize sounds at slow speeds — a skill you acquire only with experience, but that is made easier by waveform editing. A *w* may sound like "woo," an *f* like a slight rush of wind, and an *s* like a low-pitched hiss when they are rocked slowly across the playback head or scrubbed.

Some sounds are easier than others to recognize. The easiest are those with striking power, such as *d*, *k*, *p*, and *t*: sounds with a pronounced attack identified sonically by a click or pop and visually by a spike in the waveform. A voiced consonant such as *v*, *g*, *z*, or *b* is formed of vocal tone as well as breath; a voiceless consonant such as *f*, *k*, *s*, or *p* is formed only of breath. The presence or absence of vocalization creates less of spike in the waveform but is detectable when tape is rocked or the waveform is scrubbed at slower speed. The vowels *a*, *e*, *i*, *o*, and *u* are the most difficult to identify and separate, because they lack any attack and usually blend with the other sounds in a word. When vowels begin phrases in connected speech, their sound is more readily apparent when rocked or scrubbed at a slower speed.

One way to locate vowels, or any sound that is difficult to perceive, is to listen and look for differences in pitch. Suppose you want to cut between the *i* and *a* in *diamond*. If you pronounce the word "dī′əmənd," the *i* is higher in pitch than the *a*, and you can make a cut just before the pitch change.

Sometimes, sounds are run together and cannot be separated in the usual way. If the word *deem* were mispronounced "dreem," you would have to delete the *r*. Rocked or scrubbed forward, however, the sound of the *r* runs into the sound of the *e* and is difficult to hear clearly. However, the waveform might show a slight rise at the *r*. If you play the sound backward, the point where the "ee" changes to the lower-pitched and more guttural "r" may be more apparent.

Another technique used to cut between compound sounds does require the eye. If you are using a VU meter, remember that it responds to changes in voltage induced by

acoustic energy. Thus, if you are unable to perceive a sound transition aurally, the VU meter might be able to display it. For instance, in the word *appoint*, the *i* is often pronounced with somewhat more intensity than the *o*, but it may be difficult to hear exactly where the change in level occurs. If the VU meter detects it, the needle will jump slightly at the transition between the *o* and *i*, enabling you to see the edit point. In a waveform there should be a slight height difference at the transition between the *o* and *i*. This assumes, however, that the nonlinear editing program you are using can display this kind of detail.

Matching Speech

Editing speech is matching similar or dissimilar sounds. Matching dissimilar speech sounds is easier, however, because they are usually distinct and flow more naturally.

Consider the sentence "Sound is both challenging and creative." If we delete *both*, the edit will be made after *is* and before *challenging*. The *s* will be spliced to the *ch* and, because they are different sounds, you will hear a distinct and natural rhythmic transition between *is* and *challenging*.

Such is not the case with speech sounds that are similar. Suppose a speaker says, "I am, as you already know, more than happy to be here," and you want to remove "as you already know." At first glance, after the *am* and before *more* appear to be the edit points. But this could alter natural speaking rhythm, because most people do not pronounce separately adjacent words that begin and end with the same letter, such as "am more." The tendency is to slur them together so, in effect, one "m" serves both the "a" and the "ore": "amore." (You can test this by saying "and Donna" or "Joe's soda.") Therefore, one of the "m's" should be dropped to maintain the natural sound and rhythm. Probably the best

place to edit is in the word *am*, just after the "ă" and before the lips come together to form the "m" sound. Cutting between the *m* and *o* in "more" would be difficult and awkward.

This example assumes the speaker enunciated the "I" and "am" distinctly. What if the two words have been run together and the beginning of the "ă" sound is inaudible? As long as it does not change the speaker's style, cut the *m* in "am," making the contraction "I'm" sound more natural.

You can think of this technique as *editing on*, or *to, the same sound*. Another way to handle similar sounds that are adjacent is to *cut within a sound*. Suppose someone says, "Nothing means more to me than my muse, or I should say, music." Obviously, the intention was to say, "Nothing means more to me than my music." A quick look at the problem points to a cut between *my* and *muse* as the simplest edit. It could be; however, for the sake of illustration, let's assume "my muse" is so slurred that there is no way to cut between the words. By editing within the sound common to both words, "zĭ," you can maintain the natural sound and rhythm. Cut through the *s*'s in *muse* and *music*, and splice "mus̸" to "s̸ic." Of course, the "mu" sound in both words helps to make this edit possible.

Matching Emphasis or Inflection

Still another common but difficult problem for the sound editor is matching emphasis or inflection. Suppose you are editing a play or speech and the speaker says, "How are you?" with the emphasis on "you" to express concern. For some reason the "you" is garbled, and without this word it is not possible to use the phrase. If it is unimportant, there is no problem, but if it has to be kept, three alternatives are to (1) ask the person to deliver the line again, which may be impractical

if not impossible; (2) go through the recording to hear whether the person said "you" elsewhere with the same or almost the same inflection; or (3) construct the word from similar sounds the speaker uttered.

To construct the word, you would have to listen for a "yoo" sound. Perhaps, with luck, the speaker may have said the word *unique*, *unusual*, or *continue*. The "yoo" sound is part of each word, and if the phoneme and the inflection match, one of these "yoo's" may suffice.

As for matching inflection, suppose two characters exchange these lines:

CHARACTER 1: Does it have to be that way? It doesn't have to.

CHARACTER 2: I just don't know.

CHARACTER 1: Well, it shouldn't have to be that way.

The director decides that Character 1 should not ask a question first but make a definite statement: "It doesn't have to be that way." Character 1 has said already, "It doesn't." So we need a "have to be that way." Character 1 says "have to" three times. To take it from Character 1's question and add "be that way" would mismatch the intended inflection and keep the statement a question, and an awkward one. To take the second "have to" would also sound unnatural because the *to* would probably be pronounced "tu." The third *to* would most likely be pronounced "tə," which is more natural. So the final edit would butt the "It doesn't" from Character 1's first statement and the "have to be that way" from Character 1's second statement.

Matching Backgrounds

Editing speech recorded in different acoustic environments requires not only maintaining continuity of content and matching the speech sounds but also matching the background sounds. For example, in editing two statements from the same speech when one was delivered over applause and the other over silence, or when one was delivered in a room full of people and the other was delivered after most of the audience had left, the edit will be obvious unless something is done to match the different backgrounds.

One way to make the transition from one statement/background to the other is by diverting the listeners' attention. In the second of the preceding examples, if the ambience during one statement was quiet when the room was filled with people, and the ambience during the second statement was reflectant when the room was almost empty, you could try to locate in the recording a cough, a murmur, someone accidentally hitting the microphone, or some other distraction. Splice the distractor between the two statements (the distractor would also contain some room background) so attention momentarily is called to it instead of to the obvious change in background sound.

Another technique used to match backgrounds is to mix one background with another to even them out. This assumes, however, that they were recorded "in the clear" before or after the event, which, by the way, should be standard procedure.

Still another approach that works well in dialogue editing is the *backfill technique*. Assume a scene cuts from a close-up (CU) of Character 1 to a CU of Character 2, then back to a CU of Character 1, with a noticeable change in background sound in CU 2. Say the drone of a plane, audible in shots 1 and 3, drops out in shot 2. The in-and-out effect of the edit will draw attention to the change in sound.

Go through dialogue tracks until you find the same sound with no one talking. Edit it down or extend it by rerecording and editing so that it conforms to the length of shot 2.

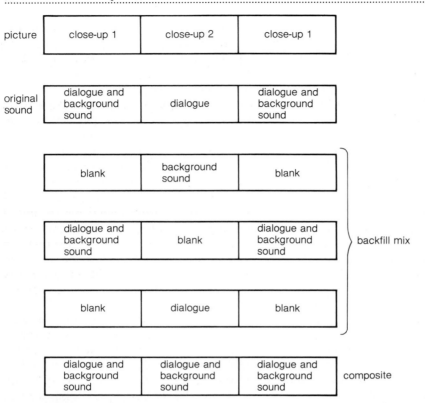

16-58 Backfill editing technique

Take blank tape (or magnetic film or an unmodulated section of a soundfile) and splice it to the beginning and end of the noise track for shot 2 so that the total tape length equals that of the three shots. Take the original dialogue track containing the background sound and cut blank tape the exact length of shot 2 between shots 1 and 3. Edit a third strip of tape consisting of blank stock for shot 1, the dialogue without the background sound for shot 2, and blank stock for shot 3. Then mix all three tracks with picture so the same background sound is continued through the scene (see 16-58).

If there are rhythmic sounds in the background, such as a motor or a clock, take care to preserve these rhythms when editing. You may need a "chug" or a "tick" from another part of the tape to prevent any noticeable break in the background rhythm. Again, try to record the background sound separately to give you flexibility in editing.

Another way to overcome problems with backgrounds that do not cut together smoothly is to use a more diagonal cut. Cutting tape at a greater than 45-degree angle provides a split-second fade-in on a background just before a dialogue line starts.

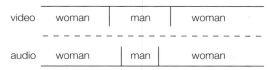

video	woman	man	woman
audio	woman	man	woman

16-59 Seamless editing smoothes the differences in ambience by cutting sound and picture at slightly different times

A technique frequently used to smooth a potentially awkward transition between two ambiences is to have the sound and picture cut at slightly different places in the shot change. For example, a man and woman in two different rooms (say, a bathroom and an adjoining bedroom) are talking to each other. Cutting the audio and picture from the man to the woman at the same time would sound abrupt, if not jarring, given the obvious differences in ambience between the two rooms. To smooth the transitions, the shot of the man can begin slightly before the woman stops talking and the dialogue of the woman can begin slightly before she is shown (see 16-59). This technique is referred to as **seamless editing**.

On-location broadcasting is so common that the audience, to some extent, has grown used to abrupt changes in background sound and levels within the same program. Nevertheless, change should be motivated and not unnecessarily jarring. With dialogue, however, audiences are more apt to be annoyed by uneven background sound. *The best thing to do during the recording is to anticipate the editing.*

Dialogue Processing

In dialogue processing three problems typically occur: (1) ring-off, (2) additive ambience, (3) defective or unusable dialogue.

Ring-off occurs when a dialogue line ends with the ambient ring of a room and another line begins with that ring decaying under it. This can be a problem, for example, when someone is entering a room and the ring-off is decaying under the line of the entering actor. In editing, cut the ring-off and either mix it with digital reverb on a controlled basis, thereby trying to blend the ambient qualities of the two dialogue lines so continuity is maintained underneath, or drop the ring-off and create the appropriate background values using digital reverb only. If, when cutting to the entering actor, ring-off of the old word is still perceptible under the new word, even with doctoring of the digital reverb, then use a sound effect to cover the transition, with the director's concurrence, of course.

Additive ambience occurs when a few or more actors are recorded at the same time on separate tracks of a multitrack ATR and the multiple room sounds become cumulative when the tracks are mixed. To avoid additive ambience, in the editing cut from one track to another to keep the single room sound on each track. In the case of overlapping dialogue, try to close down the room sound through digital reverb. Failing that, or if too many voices overlap, making the digital reverb processing sound too unnatural, dialogue looping probably would be the best alternative.

Defective or *unusable dialogue* occurs when, for example, actors are body-miked and stand very close to one another or hug, covering words; or when an unwanted sound, such as clothes rustling, an object being bumped, or the voice "cracking," masks a word. If there is no time to retake a scene, or if these problems go unnoticed and re-editing the material is not worth the time or expense, there are alternatives. Editing in

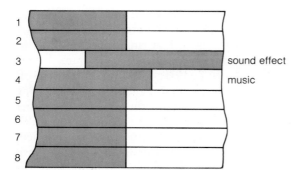

16-60 Example of split-editing. The sound effect on track 3 is brought in early to allow for its attack. Only decay would have been heard if it had been started at the original edit point. The music on track 4 is continued beyond the original point to prevent its decay from being cut off. Split editing helps in making smoother transitions.

the same syllable(s) or word(s) from another part of the track is one alternative. Another is to extend the syllable(s) or word(s) so that they overlap the defect. In both cases, ambience would have to be processed so it matched the original.

To facilitate editing dialogue, "split off" the dialogue track into two or more separate tracks. This makes it easier to extend lines that may have been cut too short during picture editing, to overlap voices, and to carry over lines from one scene to the next. It also makes it easier to adjust levels in the mix.

Split edits are easiest to accomplish on multitrack tape and magnetic film. They are useful in editing music, as well (see 16-60).

Editing Sound Effects

The main consideration in editing sound effects is to match perspective. If you splice the screech of tires to a car crash, the crash should sound as if it came out of the screeching tires. It sometimes happens, however, that the screech is heard close up and the crash

far away, as if the sounds, although related, occurred in two different locations. The same thing happens in editing a police car or ambulance siren to the sounds of a screech and stop. The siren is heard in one perspective and the screech and stop are heard in another because either the levels or the ambiences are different.

Another example is editing rain and wind or wind, rain, and thunder to build a storm. Storms have varied intensities, and the force of each component should match; violent thunder and wind hardly go with a drizzle.

Here are some other guidelines that may prove helpful in editing sound effects. *

- Cut the effect as close to the first point of sound as possible. The effect may be preceded by low-level ambience or tape hiss, the click of a channel being opened, or some extraneous sound associated with the effect.

- Most sounds have a natural decay or *tail*. A sound may start at once but does not stop that way; even transient sounds have some trail-off. Cutting into the tail will be noticeable unless another sound comes in over it and "washes it out," or it is crossfaded with another sound, or if the cutoff occurs with a shot change to an entirely different scene.

- When editing in a sound effect that occurs off-screen, it is usually distracting to lay it over dialogue. Spot the effect between the dialogue.

- When a sound effect has a definitive stop, such as a thud or an engine being turned off, sometimes it is easier to lay in the effect by syncing it to the shot's end point and backing it into the sound-effects reel.

*Based on Marvin A. Kerner, *The Art of the Sound Effects Editor*. Boston: Focal Press, 1989.

- Sometimes it is necessary to splice in an effect slightly out of sync with the picture. If you have to choose, splice it in slightly early rather than slightly late. Syncing a sound effect early is not as obvious as one out of sync late. If it is too far out of sync, of course, then the point is moot.

- In the section, "Editing Sound to Picture," later in this chapter, it is suggested that an abrupt sound cut will not be as jarring if it is covered by an equally abrupt picture cut. Some sound effects editors prefer to avoid such a sharp change in sound by overlapping a split second or two of background on either side of the transition.

- In fight scenes, it is not uncommon to see an actor's head jerk occur before the attacker's fist is close enough to the face. The choice is to match the sound of the chin sock to the head-jerk or at the point where the fist is closest to the chin. Neither choice will be completely satisfactory. Therefore, the sound effect should be placed on the basis of where it looks best.

Editing Music

Editing music is difficult to discuss in any detail because it involves using one language—the printed word—to explain another language—the notes, chords, rhythms, and other features of abstract, temporal sound. Although there is some similarity between editing speech and music, such as aural matching of space, rhythm, loudness, and inflection (intonation), there are also differences. Music contains so many simultaneous sonic elements that matching sounds is more complex and slight mistakes in cutting are more easily detected. In editing two pieces of music, you have to consider cutting on the right accent to maintain rhythm, tonality, relative loudness, and style. If any

of these elements are aurally incompatible, the edit will be obvious.

You should have a good ear to edit music successfully. Assuming that, a few guidelines and techniques may be helpful. Generally, edits that heighten intensity cut together well, such as going from quiet to loud, nonrhythmic to rhythmic, or slow to fast. A transition from a seemingly formless or meandering phrase to one that is obviously structured and definite also tends to work.

Cutting to Resolution

Perhaps one of the most useful guidelines is to cut before an accent, downbeat, or resolution. Think of the final chord in a musical phrase or song. Although it resolves the music, it is the chord before it that creates the anticipation and need for resolution; it sets up the last chord. Edit on the anticipatory note, the one requiring some resolution, however brief, so that it leads naturally to the note being joined.

Preserving Rhythm

Most Western music has a time signature—2/4 ("two-four" not "two-fourths"), 3/4, 4/4, 3/8, 6/8, and so forth. The first number indicates the number of beats in each measure, the second number indicates the value of the note that receives each beat. For example, in 4/4 time there are four beats to a measure and each quarter note receives a whole beat; in 3/8 time there are three beats to the measure and each eighth note receives a beat. In editing music you have to preserve the beat or else the edit will be noticeable as a jerk or stutter in the rhythm. If you cannot read music or no music sheet exists, try to get a sense of the rhythm by concentrating on the beat to determine the accents.

Regardless of the number of beats in a measure, some beats are strong and some are weak. When you tap your foot to a song, it usually comes down on the strong or down beat and lifts on the weak or up beat.

A song in 3/4 time, known as waltz time, is characterized by a strong beat followed by two weak beats—**one**, two, three, **one**, two, three. Beats in 2/4 time follow a **one**, two, **one**, two, strong beat–weak beat pattern. To be sure, this is a rudimentary explanation of what can be a complex subject. The point is that when editing rhythm you have to be aware of preserving the number of beats per measure as well as the accents. For example, in a piece in 3/4 time, if you cut after the first beat in a measure, the beat you cut to should be a weak beat and another weak beat should follow; if you cut after the third beat in a measure you would cut to a strong beat with two weak beats to follow. Of course, preserving a rhythm in music editing is not an isolated consideration. Other factors, such as key signature and musical style and texture, cannot be ignored.

Repetitive Measures

One way to shorten or lengthen audio material through editing is to use repetitive measures in the music. These measures can be cut out to shorten material, which is obvious. To lengthen the audio, repetitive measures can be extended by dubbing them to another recorder and cutting them back into the original recording. If the recording is analog, however, the dubbed material could lose sound quality that would make the difference between the original and copied audio perceptible (see "Dubbing" in Chapter 17).

A better way to lengthen audio using repetitive measures is either to use digital-to-digital dubbing or to have another identical mix available and intercut the appropriate measures from it.

Matching Keys

Just as most music has a time signature to regulate its rhythm, it also has a key signature—E major or B minor, for example—that determines its overall tonality. Some keys are compatible; when you change from one to the other, it sounds natural or "in tune" (see 14-1). Other keys are not, and splicing them together is jarring or sounds "out of tune," like the editing in some of the album offers on TV. Unless it is for effect, or if the picture justifies the change (discussed later in this chapter), edited music should sound consonant in order not to be noticed.

Another way to cover a bad key change in an edit is with pitch shifting. Usually it is easier to try bringing one of the offending keys into musical compatibility with the other key than it is to look for a sonic compromise between the two.

Using an attention-grabber in the dialogue such as a cough or a distracting sound effect can also cover an unmusical edit.

Matching Style and Texture

Each type of music and musical group has a unique style and texture. This distinguishes the style of jazz from rock, or the texture of one voice from another although both may have identical registers, or one group from another although both may play the same instruments and music.

Editing from the same piece of music usually does not present a problem in matching style and texture as long as you follow the other guidelines for editing. If the music is from different sources, however, matching elements can be a problem.

Normally, you would not edit different styles — a piece of classical music to rock music just because they had the same rhythm, or a dance band to a military band just because they were playing the same song. The differences in sound would make the edits conspicuous and distracting.

Editing music of different textures is possible if there is some similarity in the music, instrumentation, and intensity. Cutting from one large orchestra to another or from one small ensemble to another can work if their sound intensities are similar, even if their playing styles and, to some extent, their instrumentation are not.

Split-Editing Music

Just as the split-edit technique can be used to facilitate dialogue editing, it is also useful in editing music (see 16-60).

Editing Sound to Picture

In editing sound to picture, what has been said about matching applies only if it complements what is seen. Ordinarily, editing loud, fast symphonic music to a soft, quiet trio would be disconcerting, but if a picture cuts from a scene of violent destruction to one of desolation, the edit would make sense. In fact, it would make sense to cut from loud, jarring music to silence.

Changing from a dull tonality to a bright one is not recommended generally, but if the edit is played behind a change from night to day, the picture could justify it.

Editing two different styles, perhaps the most awkward type of change, is acceptable if the picture covers it. Cutting from hard rock and roll to Indian raga normally offends our sensibilities, but not if the picture cuts from a shot of Hell's Angels riding through town to a shot of oxen being driven through an Indian village.

Transitions

In editing, sequencing two sounds (or shots) involves creating a transition. Transitions help to establish pace. In audio three techniques are used to make transitions: segue (pronounced "seg′way") or cut, crossfade, and fade-out–fade-in.

Segue and Cut

Segue is a musical term that means "follow on." In radio it has come to refer to the playing of two or more recordings — tape or disc — with no live announcing in between. In a broader sense, segue is analogous to the term **cut** used to describe transitions in TV and film. In this context cutting from one element to another means establishing a picture or sound immediately after the previous picture or sound stops and doing it all at once, not gradually. In discussing the effects of this particular type of transition, we will use the broader term *cut*.

The cut is standard language for a small related change within the same time, place, or action, such as cutting from someone waking up, to washing, to eating breakfast; or cutting from a striking match and the eruption of a flame to an alarm sounding at a fire station. Cutting creates transitions that are sharp and well defined, picking up the rhythm of sequences and giving them a certain briskness. Cutting also tightens the pace of a production because the change from one sound (or picture) to another is quick. Due to its aesthetic value, the cut is also used for larger transitions, such as cutting from a person walking out the door at the beginning of the day to coming back in at the end of the

day, or from the eruption of flames to some charred remains.

The cut, in effect, butts two different sounds or groups of sounds together; in that regard it is like a tape edit. Like the edit, you have to give some thought to whether the effect is natural. Cutting from a fast, loud sound to one that is very slow and quiet, or vice versa, may be too abrupt; segueing two songs in keys that are incompatible may create a transition that has unwanted dissonance; or cutting from a commercial for beer to a public service announcement for Alcoholics Anonymous may raise questions of taste.

Dramas and documentaries provide more of an opportunity to make unnatural cuts because the action or picture can cover the transition, like cutting from a furious storm to the quiet calm of its aftermath, or from a deeply moving love scene to a raucously funny bachelor party. The cut has both an informational and an aesthetic function, and either purpose justifies its use.

Crossfade

The **crossfade**—gradually fading out one sound as you fade in another—is another transition used for smaller changes in time, locale, and action, although you can vary the length of these changes somewhat by increasing or decreasing the duration of the crossfade. Informationally, the crossfade accomplishes the same thing as the fade-out–fade-in, but aesthetically it is softer, more fluid, and more graceful. It also maintains, rather than breaks, rhythmic continuity and pace.

You can produce the crossfade in a number of ways depending on the loudness levels of the sounds when they cross. Usually, it is more aesthetically satisfying to cross the sounds at the moment they are at full and equal loudness. This keeps audience attention "stage center" with no loss of focus or gap in continuity, which could occur if the crossfade were made at lower levels. Crossfading at too low a level could sound like a sloppy fade-out–fade-in.

Fade-Out–Fade-In

The **fade-out–fade-in** is a transition used to make a clearly defined change from one time, place, and action to another. Aesthetically, it is gentler than the cut, and it gives a stronger sense of finality to a scene that is ending and a sense of new possibilities to the scene beginning.

In TV and film the rate of the fade-out–fade-in depends on the picture. Generally, however, the type of fade you use provides not only an aesthetic effect but an informational one as well. A slow fade-out and fade-in with silence between suggests a complete break from one action to another. The change is rather marked because it so obviously and deliberately stops one scene and starts another, and also because it changes the pace or rhythm of the material. You could use this type of transition to bridge the time between a student going off to college as a freshman and graduation, or to link a police car's hot pursuit of bank robbers trying to get away and the thieves being booked at the police station.

Faster fades suggest shorter lapses of time, smaller changes of location, or fewer events in a series of actions. They still provide a definite break in the presentation, but their quicker rate implies that less has happened. You should not, however, consider these guidelines as prescriptive. There are no formulas for how long transitions should be relative to the scenes they bridge; it is a matter of what "feels" right.

Persistence of Sound

Our ability to retain precise visual information is far better than our ability to retain precise auditory information. This makes editing sound, particularly music, more difficult than editing picture. If you try to remember the pitch or rhythm of musical segments in two different parts of a tape, by the time you wind from one to the other, the pitch will be different or the rhythm will be off.

This can be called *persistence of sound*, and with most humans it is very limited. A few things can be done to lessen the problem. Make rough cuts of the music segments you are editing, splice them together, and put them on a single reel. This reduces the distance and hence the time between them. Another technique is to make separate tapes of the two pieces of music and use two recorders. When the tape you are editing is at one point in the edit, cue the second tape to the other edit point. In checking to make sure the edit works and in trying to determine the exact cutting points, by having the edits cued you can play them almost as they would sound if spliced. Of course, hard disk editing makes these procedures quick and easy and persistence of sound less of a problem.

Listening Fatigue

Editing for long periods of time can create *listening fatigue* — reduced ability to perceive or remember the nuances of sound. (This type of psychological fatigue can occur during any long listening session.) If you suffer from listening fatigue during editing, then rhythm, inflection, tonality, and other features of sound are continually mismatched, cuts are slightly off, and it is difficult to keep track of what should be edited to what.

One way to extend the time before listening fatigue sets in is to work in a quiet acoustic environment, with no predominance of midrange frequencies because they tend to tire the listener faster. If a recording or loudspeaker system has too much midrange, equalize the monitor playback by slightly boosting the lower frequencies anywhere between 50 and 150 Hz and the frequencies above 10,000 Hz. This balances the sound and reduces its harshness and intensity. You can also attenuate the frequencies between 1,000 and 3,500 Hz, but this may reduce the sound's intelligibility. It is also important to remember to bring down playback gain after turning it up, as is often required, to hear an edit point better. Finally, take regular "ears" breaks.

Main Points

1. Editing tape and film permits the rearranging, shortening, or deleting of elements in a production. It allows elements to be recorded out of sequence and as often as necessary.

2. The process of editing is either linear — the edits are made successively — or it is nonlinear — they can be made in any order.

3. Two ways to edit sound linearly are cutting and splicing and electronic editing — transferring information from one tape to another.

4. The tools used to cut and splice tape are a cutting block, a razor blade, a marking pen or pencil, and splicing and leader tape.

5. The equipment used to edit tape electronically includes two tape recorders, one to play back and one to record and

play back; a master tape containing the material to be edited; and a clean slave tape used to record the material during editing. (In addition to the tape recorders, a synchronizer and console are usually employed.)

6. Cutting and splicing are done manually. Electronic editing can be done manually or automatically. In automatic electronic editing, tape recorders can be programmed to start and stop on cue and perform the edit.

7. Digital audiotape can be cut and spliced or edited electronically. When using the cut-and-splice method, take extreme care in handling the tape.

8. Electronic editing involves either assemble editing or insert editing. To assemble edit videotape, the control track on the playback tape can be used to stabilize the picture at the edit points. To insert edit, it is necessary to record a control track on the blank master tape before dubbing, thus creating more stable edits.

9. Two coding methods used to edit videotape are control track and time code. Four types of time code are SMPTE, or longitudinal (LTC); vertical interval (VITC); MIDI time code (MTC), which is used to make SMPTE time coded material compatible with MIDI encoded information; and the IEC Standard used in R-DATs.

10. Control track editing uses as references the frame pulses encoded on the control track during recording.

11. SMPTE time code is a high-frequency signal consisting of a stream of pulses produced by a time code generator. These pulses, unlike those in control track editing, are encoded on the tape,

permitting tapes to be interchanged between time code systems.

12. VITC carries the same information as SMPTE time code but encodes it vertically within the video signal, outside the visible picture area.

13. Control track and time code pulses are read out in an eight-digit number: hours, minutes, seconds, frames.

14. Although time code permits the accurate interlocking of audio, video, and film equipment, any time two or more transports must run together simultaneously, frame for frame, a synchronizer is necessary to ensure that they do.

15. A synchronizer directs the transports of slave machines to copy the operations of the master machine's transport.

16. An edit decision list (EDL) is a list of edits performed during off-line editing. The EDL navigates on-line editing.

17. Film is edited by cutting and splicing using an editing table, rewinds, viewer, synchronizer, sound reader, horizontal editor or moviola, and film splicer.

18. Magnetic film is spliced with tape.

19. Nonlinear audio editors are available in stereo, four-channel, and multichannel systems. Most are hard-disk systems, others are optical-based.

20. Audio encoded onto a hard disk takes the form of a soundfile, which is displayed in a waveform showing the sound's amplitude and duration.

21. Waveforms are shown in either a symmetrical amplitude display or a nonsymmetrical peak display.

22. The waveform segment highlighted for editing is called the defined region.

23. Scrubbing the waveform is similar to rocking tape in the cut-and-splice method or the jog mode in electronic editing.

24. When an edit is cut or copied, it is also copied to a section of computer memory called the clipboard.

25. In addition to waveform displays, other displays include graphic, playlist, and defined and named regions.

26. In some audio digital editing systems, digital signal processing (DSP) is included. DSP is quick and does the work of several different types of signal processors.

27. Destructive editing permanently alters the original soundfile by overwriting it. Nondestructive editing does not alter the original soundfile regardless of what editing or signal processing you effect.

28. The key to editing audio is matching sound: speech, inflection, rhythm, pitch, loudness, style, texture, and other features.

29. In editing dialogue three typical problems to be dealt with are (1) ring-off, (2) additive ambience, and (3) defective or unusable dialogue.

30. In editing music attention must be paid to cutting to resolution, preserving rhythm, matching keys, and matching style and texture.

31. Mismatching of sound makes an edit obvious unless the sound is being edited to a picture and the picture justifies the edit.

32. Generally, edits that heighten intensity will work, such as cutting from quiet to loud, nonrhythmic to rhythmic, slow to fast, formless to structured, or atonal to tonal.

33. Transitions used in audio editing include segue or cut, crossfade, and fade-out–fade-in.

34. It is critical to avoid listening fatigue during editing; take "ears" breaks.

Mixing and Rerecording

Up to now, the elements that go into producing audio have been considered separately. However, the audiences of radio, television, film, or CDs are usually not aware of what has gone into the sound shaping. They hear only the result of the last phases of audio production: mixing and rerecording. The procedure in getting to the mix may differ among the media, but the purpose is the same: to combine the parts into a natural and integrated whole.

During mixing, the separately recorded tracks are combined and, in TV and film, rerecorded into stereo, mono, or surround sound. This process may involve a straight-forward mix of an announcer and prerecorded music, an involved music mix, or an intricate rerecording mix for theatrical TV or film. Regardless of the challenges, mixing and rerecording have the same goals. In addition to combining tracks into stereo or mono, they are:

1. to enhance or sweeten audio by adding music and sound, signal processing, and style to existing tracks
2. to blend the sounds
3. to balance levels
4. to add special effects

5. to create the acoustic space artificially (if necessary)

6. to localize the sounds within the aural frame

7. to establish aural perspective

8. to maintain the definition of each sound regardless of how many sounds are heard simultaneously

9. to keep all essential sonic information within the frequency and dynamic ranges of the medium for which the mix (or rerecording) is being made

Mixing for Various Media

Before proceeding with a mix, it is necessary to know what type of delivery system it will be reproduced on. It is difficult to create an optimum mix for all systems (see Chapter 10).

Radio

In doing a mix for radio, two considerations are the frequency response of the medium — AM or FM — and the wide range of receivers the listening audience uses, from the car radio to the upscale stereo component system. Although AM radio may transmit in stereo and play music from compact discs, its frequency response is mediocre — roughly 100–5,000 Hz. FM's frequency response is considerably wider, from 20–20,000 Hz. Therefore, it would seem that mixing for AM requires care to make sure the essential sonic information is within its narrower frequency band and that in mixing for FM there is no such problem. Both statements would be true if it were not for the broad assortment of radio receivers that vary so greatly in size and sound quality, and for the myriad of listening conditions in which radio is heard. There is no way to do an optimum mix, for either AM or FM, to satisfy listeners with a portable radio the size of a hand, a boom box at the beach, or a stereo in an automobile with cushioned, sound absorbent seats and high noise floor from engine, wind, air conditioner, and highway sounds. The best approach is to mix using loudspeakers that are average in frequency response, size, and cost, and to keep all essential sonic information — speech, sound effects, and music — within the 150 Hz to 5,000 Hz band, which most radio receivers can handle. With AM radio's limited frequency response, it often helps to compress the sound to give it more power in the low end and presence in the midrange. For FM mixes, also check the sound on high-quality loudspeakers to make sure that the harmonics and overtones beyond 5,000 Hz are audible to the listener using a high-quality receiver.

Videotape

The frequency response of analog videotape can be as wide as 40–15,000 Hz; the frequency response of digital audio on videotape can be even wider. Moreover, TV audio transmission goes to 15,000 Hz. But in television, as in radio, mixing has to conform to the limitations of the home TV receiver (see Chapter 10). Another limitation is that the sound on an edited analog master videotape may be from second-, third-, or even fourth-generation dubs. Digital sound on videotape does not appreciably degrade with dubbing.

Important information (dialogue and effects as well as music) should be mixed between roughly 150 and 5,000 Hz. Boosting around 700 Hz should tighten the bass, and at around 4,000 to 5,000 Hz should enhance clarity and presence. Gentle limiting, to prevent overmodulation, and/or compressing

overall sound is often a good idea, especially with digital sound, which has no headroom.

Monitor on average-type bookshelf loudspeakers most of the time. For overall referencing, occasionally switch to the big loudspeakers and small mono loudspeaker. For a TV mix the mono loudspeaker mix is crucial, because this is what most of the audience listens to.

Mixing for television and radio is different from mixing for compact disc (see "Compact Disc" later in this chapter). Few people listen to TV and radio on decent stereos the way they do with CDs. Avoid going for a big, deep low end or tingly, shimmery high-end sounds, because most viewers will not hear them. Make sure the essential sonic information is audible on the mono loudspeaker.

For TV, and also for radio, keep your stereo mix mono-compatible by not hard-panning anything to the extreme left and right. If you use reverb, make it wetter in the mix than you normally would because TV transmission diminishes reverb.

The top priority on television is what is on the screen. If there is a close-up of a singer or lead guitarist, this is what the audience expects to hear; do not be afraid to exaggerate these or other featured elements.

Film

Dynamic range is less on an optical sound track than it is on videotape, particularly in 16mm film. Although 35mm film sound is better than 16mm, it is still not as good as sound on videotape, analog and digital. That said, Dolby Stereo in theatrical films has been responsible for remarkable enhancements in 35mm sound. These enhancements can be enjoyed in the home when viewing Dolby-stereo-encoded films by using a surround sound decoder (see "Surround Sound" later in this chapter).

But, as it must in all media, the delivery system has to be considered. Some theaters have excellent sound systems; others are less than adequate. The result is that considerable sonic information is lost in films played at theaters with inferior sound systems.

In mixing music for film, it may be best to do a partial mix and let the rerecording mixer make the final adjustments when dialogue and effects are added. To this end, one of two approaches is usually taken: (1) not restricting too severely low-end and high-end roll-offs and leaving some "play" for adjustments in laboratory processing, or (2) using the "unisound" approach, which cuts out all sound below 100 or 200 Hz and above 5,000 or 6,000 Hz. This technique is preferred by some mixers because there is not much work to do and there are fewer problems with rumble and hiss. When Dolby Stereo is employed, however, the concern about narrow frequency response becomes less of a factor.

Typical mixes for 16mm optical sound should be between 150 and 5,000 Hz with a dynamic range of 15 to 20 dB. Conventional 35mm optical sound, which has become obsolescent in theatrical film making, should be mixed between 100 and 6,000 Hz with a dynamic range of 30 to 40 dB. Dolby stereo has wider frequency response and dynamic range than conventional 35mm sound.

Compact Disc

In mixing an album for Compact Disc, three important factors are digital edge, distortion, and the total playing time of the music. There may be other considerations as well, such as applying the Red Book and Orange Book standards (see Chapter 8).

"Digital edge" is the overly bright sonic by-product of the digital recording process that too often spoils the sound quality in a CD. Usually, it is the result of either improper

miking and recording techniques (discussed in Chapter 14) or inappropriate EQing during mixing, or both. It may also be the result of poor CD mastering, but that discussion is beyond the scope of this book.

In analog sound, reasonable boosts in the upper midrange and lower treble ranges may turn out to be sonically satisfactory. But due to the pristine clarity of digital sound, the same boosts in EQ in the same ranges may result in making these frequencies overly apparent to the point of annoyance.

Distortion can be another problem in mixing digital sound. As we have pointed out, there is no headroom in digital recording; levels have to be watched carefully. Once you reach zero level, you have run out of headroom—there is no place to go. In analog recording, assuming the use of high output tape, you usually have at least 4 dBs of headroom when you reach zero level.

Trying to pack too much program material into a CD music album can create problems in mastering and reproduction. A CD can hold more than 70 minutes of data and in today's marketplace discs sell on the basis of length as well as content. (The term *time queen* was coined to describe the CD buyer whose primary concern is the length of material on a CD, not its musical or sonic qualities.)

In a CD that has much more than 60 minutes of material, the spiral traces of the data track are pushed closer together. This makes laser tracking more difficult and can cause skipping.

Generally, a compact disc is mixed with one of three types of playback systems in mind: (1) a high-quality system with amplifier/loudspeakers capable of reproducing wide dynamic range and frequency response; (2) a medium-quality system capable of reproducing a fairly wide frequency response and dynamic range; or (3) a low-quality system with limited dynamic range and frequency response.

Dubbing

Dubbing is the procedure of transferring sound from one tape or disk to another. Dubbing is often part of the mixing process.

Dubbing Analog Sound

Transferring, or dubbing, analog sonic material from one medium to another is common in audio production. For example, many radio stations dub spot announcements and jingles to cartridge tape or disc to facilitate on-air production; field recording done on analog cassette tape has to be dubbed to cartridge or open-reel tape to improve fidelity (with intervening signal processing) and to ease editing and cueing; and a recording on open-reel tape may be dubbed to cartridge to tighten production, ease handling, or simplify cataloging. (Dubbing is also used in electronic editing, discussed in Chapter 16.)

Dubbing from Vinyl Record to Tape

Should it be necessary to dub an analog recording from vinyl record to analog tape, each transfer of material loses a generation, worsening signal-to-noise ratio (see 17-1). A recording that has lost one generation has been copied (dubbed) from the original recording (the first-generation recording). A copy of that recording is third generation, and so on. The loss in signal-to-noise (S/N) ratio is more acute when dubbing from record to tape than when dubbing from tape to tape, because the sound on a record is already several generations down due to the several generational steps in the mastering process. On the one hand, therefore, dubbing

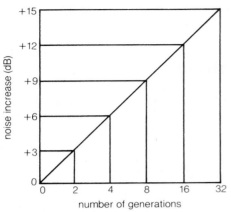

17-1 The effect that dubbing analog recordings has on sound quality

a record to tape brings it down still one more generation. On the other hand, if it is important to preserve the record, it is worth dubbing to tape for general use. The record's use and the resulting susceptibility to scratches, clicks, and pops will reduce its sound quality even more than by dubbing it to tape.

Dubbing to Cartridge Tape

When dubbing from analog record to tape or from tape to tape, you have a choice of two formats (not including cassette): cartridge and open-reel. If the program material is not long, cartridge tape or disc is easier and faster to work with (see Chapters 7 and 8). If material is longer than about 3 minutes, however, instead of dubbing it to cartridge tape, consider dubbing it to open-reel tape. Remember that with some cartridge tape machines, once a cart is put into "Play" (or "Start"), it has to wind through its entire length to get back to the starting point. This could be time-consuming during rehearsals and sound-level checks and when mistakes are made. With quick-cueing random access digital cart machines, this is not a problem.

Sound that is the same and continuous, such as a background of ocean waves during a beach scene or crowd noise during a game, does not present a cueing-retrieval problem with analog or digital carts. Such recorded sounds can be stopped and started at any point during play without sounding unusual. To facilitate this technique, you can defeat the cue tone on the cart machine. This allows continuous play until the "Stop" button is pressed. Or you can use program repeaters for continuous play (see Chapter 12).

Dubbing to Open-Reel Tape

In dubbing to open-reel tape, it is best to begin recording the sound a few seconds after the tape has started spinning in order to prevent the sound from wowing in—gradually reaching full speed. Any open-reel recorder, no matter how good, takes at least a split second to reach full speed.

When playing back tape on open-reel recorders, it may be difficult to use a preset roll-down time because older machines may have no footage or time counter; you can use a clock, of course. One technique recordists use to make sure the audiotape hits the heads at the proper speed is to splice timing leader tape to the magnetic tape (see Chapter 16). The distance between each timing mark is 7½ inches, or 1 second at 7½ ips. This also allows material to be visually cued.

Professional open-reel audiotape recorders are fast-starting, so the recorded material need be placed only an inch or so to the left of the playback head prior to starting the machine. Automated cueing, which is more precise and dependable, is also possible. Count-down-to-start and stop cue points are preset, and tape operations are automatically controlled, ensuring exact in-and-out transfer of sound (see Chapters 7 and 16).

Dubbing Digital Sound

Dubbing a digital recording (CD or tape) to another CD or digital tape may only slightly reduce the virtually noise-free sound and wide dynamic range of the original recording regardless of how many generations it goes through. Dubbing from a CD or digital tape recording to analog tape means the process begins with virtually noise-free sound and a wide dynamic range. Once digital sound is transferred to the analog format, the problems with sonic fidelity related to analog sound discussed previously apply.

Using Calibrated Equipment

In dubbing or mixing, when you record an analog or digital signal on tape or disc, it usually goes through the console first. Make sure the VU meters on the console and on the recording devices are calibrated to show the same readings. **Calibration** adjusts equipment parameters into conformance with a known standard. If equipment is not calibrated, you have no idea, in this case, whether the signal level passing through the console is the same as the one being recorded, and vice versa. This could result in a poor signal-to-noise ratio, a signal being over- or undermodulated, or a signal being out of stereo balance.

Mixing for Radio

Many of the techniques used in mixing for radio are also applicable to mixing and rerecording the TV and film sound track and to the music mixdown, and vice versa. Some techniques may be more frequently employed in one medium than another, however.

Voice Over Background Music or Sound Effects

An announcement or narration is recorded and eventually mixed with other elements in a production so it is voiced over them. In recording spot announcements such as commercials and promos, an announcer often voices over music or effects, or both. Because the announcement is usually short, the sonic elements may be mixed at one sitting.

A typical spot may call for music to be attention-getting at the open, then faded under during the announcement, returned to the opening level when the spoken part of the announcement concludes, and either faded out or played to its conclusion. This format is called a **donut**—fading the music after it is established to create a hole for the announcement and reestablishing it later at its former full level.

In voice–music balances of this type, the most pleasing results are obtained if the voice peaks 4 to 6 dB lower than the music. Another approach is to set the announce level at −2 VU and then raise the level of the background music until it begins to mask or compete with the voice. Then lower the music level to taste. If signal processing is used, these factors may have to be adjusted.

The problem with fading music, or any sound, is that the high and low frequencies and overall ambience are faded as well, thus dulling the music. Using equalization, it is possible to cut a hole (instead of fading a hole) in the music by attenuating the mid-range frequencies that clash with or mask the announcer. This creates sonic room for the announcer while maintaining the music's presence, low- and high-end response, and ambience.

The procedure involves selecting the band of frequencies in the music that conflicts with

the announcer's intelligibility and attenuating the frequencies the necessary amount. During the announcement, when the announcer speaks, the music EQ is switched in; when the announcer is not speaking, it is switched out.

Another technique used to balance levels between an announcer and music, or between an announcer and other sounds such as crowd noise and traffic, is to feed each sound through a limiter and set one limiter to trigger the response of the other. In the case of a voice-over-music announcement, the limiter controlling the music would be set to reduce the music level to a preset point when it is triggered by the limiter controlling the announcer's sound. As soon as the announcer speaks, the limiters' actions automatically reduce the music level. When the announcer stops speaking, the announcer's limiter triggers the music's limiter to restore the music to its preset louder level. This can also be done with a limiter and a compressor.

This technique has been used for years, but you have to be careful when setting the limit levels. If they are not precise, you will hear the limiters' annoying pumping action as they increase and decrease levels.

When an announcer or narrator is mixed with background music or sound effects, the copy is the most important element. This is why the performer's voice is in the foreground. If the music or effects become as loud as, or louder than, the performer, it forces the audience to struggle to focus attention on one of the competing elements, thereby inhibiting communication. This does not mean that the music and effects must remain in the background. During a pause in the copy, the background can be increased in level or, if it is kept under the announcer, it can be varied to help accent the message, thereby providing sonic variety to heighten interest and pace. In audio production it is worthwhile to remember that sonic variety attracts the ear. In fact, whether it is audio or video, the human perceptual system likes change. Shifts in focus, directed by the production, hold audience attention. This is not to suggest that confused, cluttered, frenetic production is advised. Obscuring the intent of a message because of production pyrotechnics is poor communication practice.

For example, instead of using the donut approach to production, take the time to produce the spot. It makes the station sound better and the client happier. As illustrated in the following commercial, all it takes is a little variety and focus. (Also see the second radio commercial example in Chapter 11.)

MUSIC IN AND UNDER: SOMBER WITH A SLOW, EVEN BEAT

ANNCR: Facing another night at home watching the same old television programs? Not if you have . . .

MUSIC UP THEN UNDER: MELODIC SWIRL

ANNCR: . . . the Classic Films channel. This week the four-star features are *The Searchers* with John Wayne . . .

EFX: SHORT FILM BITE EXCERPT . . . END WITH MUSIC PUNCTUATOR

ANNCR: . . . *Tootsie* with Dustin Hoffman . . .

EFX: SHORT FILM BITE . . . END WITH MUSIC PUNCTUATOR

ANNCR: . . . and the epic *Doctor Zhivago* . . .

EFX: SHORT FILM BITE . . . END WITH MUSIC PUNCTUATOR . . . SEGUE TO OPENING MUSIC . . . CROSSFADE WITH EXCITING MUSIC

ANNCR: TV can be exciting again with the Classic Films channel. (Close with subscription information.)

MUSIC: EXCITING MUSIC UP TO END

Backtiming and Dead Rolling

Using prerecorded music to underscore or end a spot announcement, narrative, dialogue, or a program theme song may involve **backtiming** and **dead rolling** to ensure that it ends at the appropriate time. Prerecorded material has a fixed total time; it may be 3:13, 1:22.5, :11, or something else. Suppose in the above commercial the section of music used to end the spot is 18 seconds long but only the last 11 seconds of it is needed. To get the music to end when the commercial ends, assuming a 30-second spot, the music has to start 12 seconds into the commercial. Subtracting the time of an individual item from the total time of a program or program segment is known as backtiming.

To get the music to end when the spot ends, begin playing the music 12 seconds after the spot begins, just do not raise the fader. The music recording will dead roll—play with no sound feeding through—until you are ready for it. At that point, fade it in; because it started at the right time, it will also end on time. And ending music is usually a more effective close than fading it out.

Music Mixdown

There is a common misunderstanding about the music mixdown; namely, that it is the stage in music production when everything that went wrong in the recording session is put right. No doubt this unfortunate notion has been nurtured in recording sessions that have not met expectations when producers have glibly reassured clients, "Don't worry, we can fix it in the mixdown."

The mixdown certainly is very important to the finished product, but keep its importance in perspective. The mixdown cannot change a mediocre performance into a good one, compensate for poor microphone technique, or make a sloppy recording precise. In most instances it is the quality of the recording session that determines the overall quality of the mix.

Nevertheless, the mixdown should not be taken too lightly. A good mix cannot salvage a bad recording, but a poor mix can ruin a good recording.

Suggested Procedures

There are probably as many approaches to mixing music as there are producers. But most producers generally include the following operations in proceeding with a mixdown:

1. The tape recorder heads are demagnetized and cleaned.
2. The meters on the console and tape recorders are calibrated.
3. The inputs on the console are set to receive the signals from the multitrack tape recorder.
4. One master monitor channel is assigned or panned to the extreme left and another is assigned or panned to the extreme right (for stereo). If the stereo mix must be mono-compatible, the monitor system also is set up for A-B—stereo-mono—referencing. A stereo display processor is often used to reference stereo-to-mono compatibility (see 17-18).
5. The stereo master fader (or two submasters) are turned up so the left and right signals feed to the proper tracks of the master record ATR.
6. Individual channel faders are turned up.
7. Individual channels are assigned to the left or right mix bus, or both, and pro-

portioned between them using the pan pots.

8. Levels and localizing of the voicings are temporarily set.

9. The rough, unprocessed mix is listened to for as long as it takes to decide what needs to be done in relation to equalization, reverberation, and other signal processing.

10. Individual voicings are then equalized and, at the same time, are referenced to the overall mix to check blending and positioning. Usually, the rhythm tracks are done first, then the accompanying tracks, and finally the vocal tracks.

11. Other signal processing, such as compression, delay, and flanging, is added where appropriate, sometimes before equalizing.

12. Reverberation is then added and equalized.

13. The mix is checked for blend, balance, definition, and positioning.

14. Reference tones are recorded on the stereo master.

15. The final mix is recorded on the stereo master.

16. The stereo master is assembled and labeled.

17. Backup copies are made as required.

Auditioning the Rough Mix

It is not good policy to mixdown a recording on the same day that you complete it. Regardless of what you may think a recording sounds like immediately after taping, in a day or so it will sound different. It is essential to take some time between sessions to regain perspective and renew "ears." Therefore, before you begin a mix or make any final decisions about localizing, signal processing, special effects, and so on, refamiliarize yourself with the recording by auditioning it.

To do this, set the relative level and location of each voicing to achieve approximate, but satisfactory, overall loudness and positional balances. Here is one approach:

1. Set the level of the loudest or most prominent sound first, leaving plenty of headroom on the VU meter. For example, if the loudest sound is a support voicing, such as the bass drum, set the level at −10 VU; if the sound is a prominent lead voicing, such as a vocal, set the level higher, at, say, −5 VU. Leaving headroom is important because mixing almost always involves adding level during signal processing through EQ, reverb, and so on. (As discussed later in this section, too much boosting without compensating attenuation can create a number of sonic problems.)

2. Turn up the monitor level so it is comfortably loud; 85 dB-SPL is usually considered optimal. Because what is considered comfortably loud depends on personal taste, musical style, and hearing acuity, however, 85 dB-SPL is at least a good level to start with. It is critical not to set the monitor level too loud. Loud levels desensitize hearing, or in the vernacular of audio, "fry" ears, to say nothing of the potential for hearing loss. Once monitor loudness is set, try not to change it; otherwise, the reference you are using to determine sonic values and proportions will change as well.

3. Add all other tracks relative to the level of the first voicing. If you started with drums, add bass, the rest of the drum set, the other accompanying instruments, and the vocal(s). If you started with the lead or most prominent instrument, bring in the other tracks one at a time, starting with

the rhythm instruments and followed by the rest of the accompaniment. Another approach is to set all instruments equally loud. Then increase levels of the lead voicings and decrease levels of the support instruments.

4. Position each instrument in the stereo space approximately where you planned to put it in the final mix.

5. Readjust fader levels to compensate for loudness changes resulting from these positional alignments.

Once you have refamiliarized yourself with the recording and have reconfirmed its design, you are ready to do the actual mixdown. It is likely that during the mix, as various sonic alterations are made, some of the original decisions about the mix will change. This is natural. Be flexible, and go with your instincts.

Signal Processing

Signal processing is so much a part of audio production that sound shaping seems impossible without it. Moreover, dependency on signal processing has created the myth that just about anything can be done with it to ensure the sonic success of a recording. These notions are misleading. Unless special effects are required or MIDI is involved, signal processing in the mixdown should be used to touch up the aural canvas, not to repaint it. The greater the dependency on signal processing in the mixdown, the more likely the poorer the recording session. Nevertheless, signal processing is important, and sometimes critical. The purpose of this section, therefore, is only to suggest possibilities and techniques. It is not intended to imply that because signal processing offers so many options to the sound designer, all of them should be used. Remember: *Less is more*.

Equalizing: How Much, Where, and When?

One question often asked of a sound designer is: "What kind of a sound will I get on this instrument if I equalize so many decibels at such and such a frequency?" The question suggests that there are ways to predetermine equalization. *There are not!* Consider the different things that can affect sound. For example, for a guitar you might ask: "What is it made of? Is it acoustic or electric? Are the strings steel or plastic, old or new, played with a metal or plastic pick or with the fingers? Is the guitarist heavy- or light-handed? Are there fret sounds? Is the guitar miked and, if so, with what type of microphone? How are the acoustics? What type of song is being played? What is the spatial placement of the guitar in the mix?" These influences do not even include personal taste, the most variable factor of all.

The best way to approach equalization is to (1) know the frequency ranges of the instruments involved, (2) have a basic idea of what each octave in the audible frequency spectrum contributes to the overall sound, (3) listen to the sound in context, and (4) have a good idea of what you want to achieve before starting the mixdown.

Also remember the following:

- Equalizing will alter a sound's harmonic structure.

- Very few people, even under ideal conditions, can hear a change of 1 dB or less, and many people cannot hear changes of 2 or 3 dB.

- Large increases or decreases in equalizing should be avoided.

- Equalizing should not be used as a substitute for better microphone selection and mic placement.

- Only a certain number of tracks in the same frequency range should be increased or decreased. For example, on one channel you may increase by 4 dB at 5,000 Hz the sound of a snare drum to make it crisper, then on another channel you increase 2 dB at 5,000 Hz to make a cymbal sound fuller, and on a third channel you increase 3 dB at 5,000 Hz to bring out a vocal. If you consider each channel separately, there has been very little equalizing at 5,000 Hz, but the cumulative boost at the same frequency could unbalance the overall blend.

- Equalizing often involves boosting frequencies, and that can mean more noise. Therefore, be careful, particularly when increasing some of the unpleasant frequencies in the midrange and high end, especially with digital sound.

- Because boosting frequencies on one track often necessitates attenuating frequencies somewhere else, attenuation should be considered first. For example, if a sound is overly bright, instead of trying to mellow it by boosting the appropriate lower frequencies, reduce some of the higher frequencies responsible for the excessive brightness.

- Frequencies above and below the range of each instrument should be filtered to reduce unwanted sound and improve definition. Be very careful not to reduce frequencies that are essential to the natural timbre of an instrument.

- To achieve a satisfactory blend, the sounds of individual elements may have to be changed in ways that could make them unpleasant to listen to by themselves. For example, the frequencies between 1,000 and 3,500 Hz make most vocals intelligible. One way to improve the clarity of a vocal and make it stand out from its instrumental accompaniment, while maintaining the overall blend, is to boost it a few decibels in the 1,000- to 3,500-Hz range and decrease the accompaniment a few decibels in the same range. Together they should sound quite natural. Separately, however, the vocal will be harsh and thin and the accompaniment will sound muddy and lifeless.

If a voice is powerful and rich with harmonics in the 5,000-Hz range, the sound is clear and full. Male singing voices, particularly in opera, have this sonic characteristic; female vocalists usually do not.

Voices deficient in the 5,000-Hz range can be enhanced by a boost of several decibels in this area. Not only is the definition of such sounds as "t," "s," "ch," and "k" increased, but a 6-dB increase at 5,000 Hz gives an apparent increase of 3 dB to the overall mix. Be wary of digital edge when mixing digital sound using these EQ values, however.

- An absence of frequencies above 600 Hz adversely affects the intelligibility of consonants; an absence of frequencies below 600 Hz adversely affects the intelligibility of vowels.

- Equal degrees of equalizing between 400 and 2,000 Hz are more noticeable than equalizing above or below that range, especially in digital sound (remember the equal loudness principle).

- Most amplified instruments do not have ranges higher than 7,500 Hz; boosting above that frequency usually adds only noise.

- Equalizing must be done with an awareness of the frequency limits of the medium in which you are working.

Equalization and Semantics

A major problem in equalization is describing what it sounds like. What does it mean, for example, when a producer wants "sizzle" in a cymbal sound, "fatness" in a snare sound, "brightness" in an alto saxophone sound, or "edge" to a vocal? Not only is there a problem of semantics, but you must identify the adjustments needed to achieve the desired effect. The following list should aid you in this process.

- Low-frequency boost under 200 Hz adds power or weight to sound. A boost between 200 Hz and 300 Hz can make sound woody or tubby.

- Low-frequency boost below 500 Hz can make sound fat, thick, warm, or robust. It can also make sound muddy, boomy, thumpy, or barrellike.

- Flat, extended low frequencies add fullness, richness, or solidity to sound. They can also make sound rumbly.

- Low-frequency roll-off thins sound. This can make it seem clean, cold, tinny, or anemic.

- Midfrequency boost between 500 Hz and 7 kHz (5 kHz area for most instruments, 1.5 to 2.5 kHz for bass instruments) can add presence, punch, edge, clarity, or definition to sound. It can also make sound muddy (hornlike), tinny (telephonelike), nasal or honky (500 Hz to 3 kHz), hard (2 to 4 kHz), strident or piercing (2 to 5 kHz), twangy (3 kHz), metallic (3 to 5 kHz), or sibilant (4 to 7 kHz).

- Flat midfrequencies sound natural or smooth. They may also lack punch or color.

- Midfrequency dip makes sound mellow. It can also hollow (500 Hz to 1,000 Hz), muffle (5 kHz), or muddy (5 kHz) sound.

- High-frequency boost above 7 kHz can enhance sound by making it bright, crisp, etched, or sizzly (cymbals). It can detract from sound by making it edgy, glassy, sibilant, or sizzly (voice).

- Flat, extended high frequencies open sound, making it airy, transparent, natural, or detailed. They can also make sound too detailed or close.

- High-frequency roll-off mellows, rounds, or smooths sound. It can also dull, muffle, veil, or distance sound.*

In relation to specific instruments, the equalization values in Table 17-1 may help to refine semantics. Note that frequencies and frequency ranges listed in the table are general and only intended to provide a point of departure for more refined sound shaping.

Compression

In Chapter 9, we discussed a number of uses compression has in sound shaping. Here are some general guidelines to use in applying compression to selected instruments. They should not be followed, however, without listening and experimenting.

- *Drums.* A long-to-medium attack time reduces the percussive effect. A short release time and wide ratio create a bigger or fuller sound.

- *Cymbals.* Medium-to-short attack and release times and an average ratio reduce excessive ringing.

- *Guitar.* Short attack and release times and a wide ratio increase the sustain.

*Adapted from *Modern Recording and Music*, Nov. 1982, by permission of *Modern Recording and Music Magazine* and Bruce Bartlett.

Table 17-1 Approximate equalization values for selected instruments

Bass Drum: Bottom ranges between 60 and 80 Hz; attenuating between 300 and 600 Hz reduces dullness, thuddiness, and cardboardlike sound; boosting between 1,600 and 5,000 Hz adds brightness, attack, and snap.

Low (Floor) Tom-Tom: Fullness ranges between 80 and 120 Hz; brightness and attack is in the 4,000 Hz range.

Higher (Rack) Tom-Toms: Fullness ranges between 220 and 240 Hz; brightness and attack is in the 5,000 Hz range.

Snare Drum: Bottom ranges between 120 and 160 Hz; fatness ranges between 220 and 240 Hz; crispness ranges between 4,000 and 5,000 Hz.

Cymbals: Dullness — clank and gong — ranges between 200 and 240 Hz; brilliance, shimmer, and brightness range from 7,000 Hz and up.

Bass Guitar: Bottom ranges between 60 and 80 Hz; cutting around 250 Hz adds clarity; attack ranges between 700 and 1,200 Hz; string noise is around 2,500–3,500 Hz.

Electric Guitar: Fullness ranges between 210 and 240 Hz; edge or bite ranges between 2,500 and 3,500 Hz; upper harmonic limits do not range much beyond 6,500 Hz.

Acoustic Guitar: Bottom ranges between 80 and 140 Hz; fullness and body range between 220 and 260 Hz; clarity ranges between 1,600 and 5,000 Hz with sound becoming thinner as these frequencies get higher. Steel strings are 5–10 dB louder than nylon strings.

Piano: Bass ranges between 80 and 120 Hz; body ranges between 65 and 130 Hz; clarity and presence range between 2,000 and 5,000 Hz with sound becoming thinner as these frequencies get higher. The most robust sound is obtained from a concert grand; sound is less robust in a baby grand, and least robust in an upright.

Strings: Generally, sound from the bridge of a violin, viola, cello, and acoustic bass is brighter compared to sound coming from the f-holes, which is fuller. Bowing close to the bridge produces a louder, brighter tone; bowing farther from the bridge produces a less brilliant, gentler tone. Fullness ranges between 220 and 240 Hz; edge or scratchiness ranges between 7,000 and 10,000 Hz.

Brass: Frequency ranges that give the trumpet its particular sound are 1,000–1,500 Hz and 2,000–3,000 Hz. Fullness ranges between 160 and 220 Hz; edge or bite ranges between 1,500 and 5,000 Hz. A *straight mute* — a mute that fits inside the bell — acts as a high-pass filter, letting through frequencies above 1,800 Hz; a *cup mute* — a mute that fits over the bell — passes frequencies in the range of 800–1,200 Hz and dampens frequencies above 2,500 Hz. Frequencies that give the trombone its particular sound are 480–600 Hz and around 1,200 Hz. The upper limit is 5,000 Hz with medium-loud playing; it may reach 10,000 Hz with loud playing. Fullness ranges between 100 and 220 Hz; brightness and edge ranges between 2,000 and 5,000 Hz. Frequencies that give the French horn its broad, round quality are around 340 Hz, between 700 and 2,000 Hz, and around 3,500 Hz. Fullness ranges between 120 and 240 Hz; bite-to-shrillness ranges upward from 4,500 Hz.

Woodwinds: The flute's fundamental range is from about 250–2,100 Hz. Mellowness is toward the lower end of that range; brightness begins toward the upper end of that range; bite-to-shrillness extends into the harmonics from 2,500 to 3,500 Hz. The clarinet's characteristic frequencies are between 800 and 3,000 Hz. Mellowness and body ranges between 150 and 320 Hz; throatiness ranges from 400 to 440 Hz. Fundamental ranges of the most familiar saxophones are roughly 130–880 Hz (alto), 100–650 Hz (tenor), 65–650 Hz (baritone). Body is at the lower ends of these registers; fullness toward the middle ranges; and brightness in the harmonics, above the upper fundamentals.

Vocal: Depending on the vocal range and whether the vocalist is male or female, generally: intelligibility ranges between 1,000 and 2,500 Hz; fullness between 140 and 440 Hz; presence between 4,000 and 5,000 Hz; sibilance between 6,000 and 10,000 Hz. A powerful way to accentuate a vocal sound, and sounds in general, is to locate and boost the formant regions. A *formant* is the resonance band in a vibrating body that mildly increases the level of the specific frequencies in that band. In men's voices a strong formant is centered around 2,800 Hz, plus or minus a few hundred Hz to compensate for individual differences. For female voices, the formant region is roughly 3,200 Hz. Low formant areas for the human voice are in the areas of 500 Hz for males and 1,000 Hz for females.

- *Keyboards.* A medium-to-long attack time, a medium-to-short release time, and a wide ratio give a fuller sound.
- *Strings.* Short attack and release times and an average ratio add body to the sound.
- *Vocals.* Medium-to-short attack and release times and an average ratio reduce sibilance.

Here are some specific applications of compression on selected instruments.

- *Drums.* Ratio: 2:1 to 3:1 or 4:1 to 8:1; Attack time: fast; Release time: medium to fast; Threshold: set to compress loudest peaks 4 to 6 dB or 6 to 8 dB. Compressing drums allows you mix them at a lower level and still retain their impact.
- *Bass.* Ratio: 4:1; Attack time: medium; Release time: medium to fast; Threshold: set to compress loudest peaks 2 to 4 dB. One main reason recordists compress the bass is its low frequency energy that tends to eat up so much of the mix's overall headroom. One cautionary note: Watch out for distortion that can be introduced by overly quick release times.
- *Rhythm Instruments* (guitar, sax, synthesizer, etc.). Ratio: 4:1 to 6:1; Attack time: medium; Release time: medium; Threshold: set to compress loudest peaks 3 to 5 dB. Moderate compression can enrich texture and help to make rhythm instruments forceful without letting them dominate the mix.
- *Vocals.* Ratio: 3:1 to 4:1; Attack time: fast to medium; Release time: medium to fast; Threshold: set to compress loudest peaks 3 to 6 dB. The amount of compression on a vocalist depends on the singer's technique; that is, does the singer back off slightly when hitting loud notes and lean in slightly to compensate for softer ones—

which is good technique—or does the singer not compensate for dynamic range or, worse, "eat" the microphone? If the music track is dense and the vocals need to be heard, compression will have to be more aggressive. For delicate singers, use more sensitive threshold levels and smaller ratios. For screamers, you may need to compress 6 to 8 dB to get the proper texture. Beware that high compression levels bring out sibilance and background noise.

There are many other approaches to compression. Also, those listed here are not intended to imply that all, or even most, voicings should be compressed. If you do decide to employ compression, these suggestions may prove to be good starting points.

Reverberation: Creating Acoustic Space

Due to the common practice of miking each sound component separately (for greater control) and closely (to reduce leakage), many original multitrack recordings lack a complementary acoustic environment. In such cases the acoustics usually are added in the mixdown by artificial means using signal-processing devices such as reverb and digital delay (see Chapter 9).

If you add acoustics in the mixdown, do it after equalizing (because it is difficult to get a true sense of the effects of frequency changes in a reverberant space) and after panning (to get a better idea of how reverb affects positioning). Avoid giving widely different reverb times to various components in an ensemble, or it will sound as if they are not playing in the same space, unless it is for special effect.

The quality of the reverberation depends on the musical style. Most types of popular music work well with the sound of digital

reverb or a reverb plate. Jazz usually requires a more natural-sounding acoustical environment; classical music definitely does.

In determining reverb balance, adjust it one track at a time (on the tracks to which reverb is being added). Reverb in stereo mixes should achieve a sense of depth and breadth. Reverb can be located in the mix by panning; it does not have to envelop an entire recording.

With reverberation, some equalizing may be necessary. Because plates and chambers tend to generate lower frequencies that muddy sound, attenuating the reverb between 60 and 100 Hz may be necessary to clean up the sound. On the other hand, if muddiness is not a problem, boosting lower frequencies gives the reverb a larger and more distant sound. Boosting higher frequencies gives reverb a brighter, closer, more present sound.

Less expensive reverberation systems lack good treble response. By slightly boosting the high end, the reverb will sound somewhat more natural and lifelike.

If any one voicing is inevitably assigned to reverb, it is the vocal. Yet there is often the danger that the reverb's midrange will interfere with the harmonic richness of the vocal's midrange. Attenuating or notching out the reverb's competing midrange frequencies will better define the vocal and help to make it stand out.

Other effects, such as *chorusing* and *accented reverb*, also can be used after reverberation. By setting the chorus for a delay between 20 and 30 milliseconds and adding it to the reverb, sound gains a shimmering, fuller quality. Patching the reverb output into a noise gate and triggering the noise gate with selected accents from a percussive instrument such as a snare drum, piano, or tambourine can heighten as well as unify the rhythm.

Before making a final decision about the reverb you employ, do an A-B comparison. Check reverb proportions using large and small loudspeakers to make sure the reverb neither swallows sound nor is so subtle that it defies definition.

Digital Delay: Enhancing Acoustic Space

Sound reaches listeners at different times, depending on where a listener is located relative to the sound source. The closer to the sound source you are, the sooner the sound reaches you, and vice versa. Hence, a major component of reverberation is delay (see Chapter 3). To provide more realistic reverberation, therefore, many digital reverbs include *predelay*, which sets a slight delay before reverb. If a reverb unit does not include predelay, the same effect can be generated by using a digital delay device before reverb. In either case predelay should be short; 15 to 20 milliseconds usually suffices. On some delay devices, the longer the delay time, the poorer the signal-to-noise ratio. Predelay adds a feeling of space to the reverberation. (A millisecond is equivalent to about a foot in air.)

Post-delay—adding delay after reverb—is another way to add dimension to sound, particularly to a vocal. In the case of the vocal, it may be necessary to boost the high end to brighten the sound or to avoid muddying it, or both.

Another handy use of delay is *stereo separation*. By feeding a mono signal through a delay to one output channel, say, the left, and the same signal directly to the right channel, you can simulate the signal as stereo. Use short delay times—15 to 20 milliseconds—however, or the delay will be obvious and the stereo imaging may be skewed.

Synchronizing delay to tempo is yet another effect that can heighten sonic interest.

This technique involves adjusting rate of delay to the music's tempo by dividing the tempo into 60,000—the dividend is the number of milliseconds per measure to which the digital delay is set.

It is also possible to create *polyrhythms*— simultaneous and sharply contrasting rhythms—by using two delays and feeding the output of one into the input of the other. Varying delay time of the second unit generates a variety of spatial effects.

In using a digital delay, there is one precaution: It should have a bandwidth of at least 12 kHz. Given the quality of sound being produced today, however, 15 kHz and higher is recommended.

Two features of digital delay, feedback, or regeneration, and modulation, can be employed in various ways to help create a wide array of effects with flanging, chorusing, doubling, and slapback echo. *Feedback*, or *regeneration*, as the terms suggest, feeds a proportion of the delayed signal back into the delay line, in essence, "echoing the echo." *Modulation* is controlled by two parameters, *width* and *speed*. Width dictates how wide a range above and below the chosen delay time the modulator will be allowed to swing. You can vary the delay by any number of milliseconds above and below the designated time. Speed dictates how rapidly the time delay will oscillate.

Localizing the Musical Elements in Stereo Space

In multitrack recording, each element is recorded at an optimal level and on a separate track. If all the elements were played back in the same way, it would sound as if they were coming from precisely the same location. In reality, of course, this is not the case. Therefore, you have to position each musical component in an aural frame by setting the levels of loudness to create front-to-back perspective or depth and panning to establish left-to-right stereo perspective. In setting levels, the louder a sound the closer it seems, and conversely, the quieter a sound the farther away it seems. Frequency and reverb also affect positioning (see section on signal processing). In panning stereo, there are five main areas: left, left center, center, right center, and right (see 6-7).

There are many options in positioning various elements of an ensemble in an aural frame, but three factors are usually considered in the decision: (1) the aural balance, (2) how the ensemble arranges itself when playing before a live audience, and (3) the type of music being played. Keep in mind, however, that each musical style has its own values. Popular music is usually emotional and contains a strong beat. Therefore, drums and bass should be well focused in the mix. Jazz and classical music are more varied and require different approaches. The mixer must have a clear idea of what the music sounds like in a natural acoustical setting before attempting a studio mix.

Sounds and where they are placed in aural space have different effects on perception. In a stereo field these effects include the following: (1) The sound closest to the center and to us is the most predominant; (2) a sound farther back but still in the center creates depth and a balance or a counterweight to the sound that is front and center; (3) sound placed to one side usually requires a similarly weighted sound on the opposite side or else the left-to-right aural space will seem unbalanced; and (4) the more you spread sound across the aural space, the wider the sound sources will seem.

This is not to suggest, however, that all parts of aural space must be sonically balanced or filled at all times; that depends on the ensemble and the music. A symphony

orchestra usually positions first violins to the left of the conductor, second violins to the left center, violas to the right center, and cellos to the right. If the music calls for just the first violins to play, it is natural for the sound to come mainly from the left. To pan the first violins left-to-right would establish a stereo balance, but it would be poor aesthetic judgment and it would disorient the listener. This does not mean that the first violins must necessarily be panned to the extreme left either.

To illustrate aural framing in a stereo field, assume that a pop music group was recorded on eight tracks as follows:

Track 1 — Bass
Track 2 — Bass drum
Track 3 — Left side of drum set
Track 4 — Right side of drum set
Track 5 — Low end of piano
Track 6 — High end of piano
Track 7 — Vocal
Track 8 — Guitar

For a few ways to position this ensemble, see Figures 17-2 through 17-4. In reality, the music has to be the determining factor. Compared to many mixes, these illustrations show a simplified explanation. Figure 17-5 depicts a more complex mix; the following text explains the arrangement.

Background vocals are two distinct signals. A wall of sound effect [Eventide effect] is achieved by running them through a stereo Harmonizer.® The vocal track on the left is pitched a little flat at 99.6 percent pitch shift, and the signal on the right has a slight delay of 20 milliseconds. This creates the illusion that they are connected by a solid line, yet they can be heard as two separate tracks. It makes the vocal thick.

The lead vocal is in the center of the mix and up front, but it must have depth to it. What helps with that aspect is a digital reverb. A very short reverb time gives the vocal resonance in a natural room sound. On top of that, a short echo is used, just enough to give the vocal some depth but not too much where it will run into the background vocals that are making the line behind it.

Sometimes the lead vocal and backgrounds end up just a little too close to each other. That placement is good to make the vocals blend with the group. But if they are to sound like two distinct parts, time delay is increased to 25 milliseconds on the left and 45 milliseconds on the right for the vocals in back. In essence, it is like placing the singers a few steps back.

The farther back anything goes, the more mushy it becomes. Therefore, the rear vocals require some EQ to make them sound cleaner and more intelligible. Fewer low frequencies and more highs help to achieve that.

The string sound, which is sustained, works best as a long, smooth line way in the back. The effect requires a long echo or digital delay.

Acoustic piano works well up front— dry with no effects—and positioned as though it were being viewed from the audience. The acoustic piano is panned to the 7 o'clock and 5 o'clock positions; any tighter and it would start to sound mono.

The mono Fender Rhodes (electric piano) is also spread and set right on top of the acoustic piano, but not to the extreme left and right; the setting is more like 9 o'clock and 3 o'clock. For contrast, the chorus effect is run on the right side. If the chorus effect were run on the left, much of it would be masked by the high

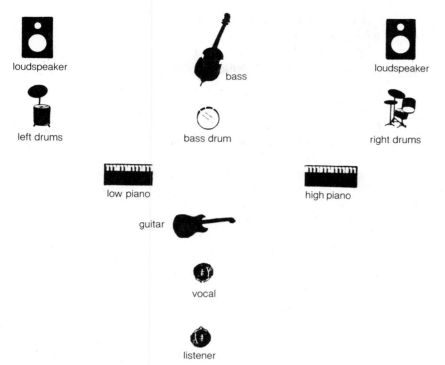

17-2 A spatial arrangement that takes full advantage of stereo spacing. It places sound sources wide and deep, and the sound will be open and airy. Notice that the bass and bass drum are positioned center rear and together to anchor the sound and enhance their blend. The piano is behind the guitar on the assumption that it accompanies through-out the song. The guitar is behind the vocal to provide accompaniment and be close enough front and center for solos when the vocalist is not singing. (Note: In reality there is no "hole" in the sound of the piano or the drums. Also, the left and right drums are sometimes reversed. See also 17-3.)

acoustic piano. The chorus effect stands out better against the low acoustic piano.

Rhythm guitar fills the space about 9 o'clock and 3 o'clock. A lead guitar, sax, or synthesizer fits just to the left or right of center. The lead instrument is kept a short distance from the bass and central drums.

The bass and kick drum go in the middle of the mix, along with the snare that sits right on top of the kick. These are the three most important elements in a good mix; they are the first impression of the song a listener gets. The hi hat is placed off to the right side. The tom-toms and cymbals are panned across the stereo field from the audience's perspective.*

*From "The Production and Musical Perspectives of Humberto Gatica," by Robert Carr, *Recording Engineer/Producer*, Oct. 1981. Copyright © 1981 Gallay Communications, Inc. All rights reserved. Reprinted by permission.

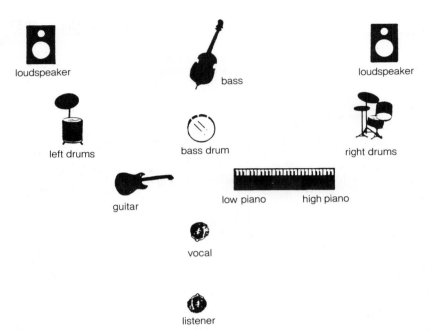

17-3 A spatial arrangement that maintains stereo perspective. This arrangement repositions the guitar and piano for a better balance if they both play solos as well as accompany.

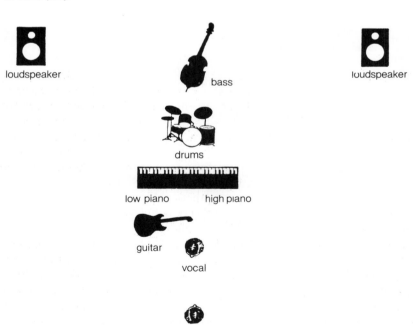

17-4 A closer arrangement. This arrangement changes the open sound for a tighter, more intense sound. The piano also could be positioned to one side of the vocal.

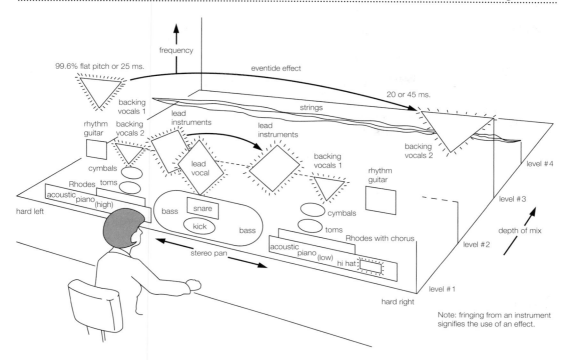

17-5 **Visual representation of a more complex mix.** (See text for discussion.)

Three-Dimensional Sound Imaging

Almost from the beginning of recorded sound attempts have been made to increase the dimensionality of sonic reproduction. Years before stereo became viable recordists were experimenting with miking techniques to make sound more spacious. Binaural recording has been around for several decades but only relatively recently have there been breakthroughs in reproduction that eliminate the need to wear headphones in order to enjoy at least a sense of the binaural experience. Several years ago the commercially failed quadraphonic sound increased the depth of sonic space by using loudspeakers to the rear as well as in front of the listener. Today a number of approaches applied dur-

ing recording or mixing, or both, are being used to bring sound reproduction closer to the live listening experience (see Chapter 14). To treat three-dimensional sound imaging inclusively, that is, as it applies to music recording, film, and television, we discuss it in "Spatial Manipulation of Sound," later in this chapter.

Keeping a Record

Keeping a record in a mixdown of the take you used, the settings for levels, EQ, reverb send, reverb return, compression, limiting, and so on is essential. It may take several sessions to complete a mix, and any adjustments previously made must be reset precisely. Moreover, perceptions of a mix have a strange way of changing from one day to the

next, and so it is critical to be able to reference the sound to the setting.

Information in automated and computer-assisted mixdowns is usually stored automatically. It may be recalled for visual display or printed out in a hard copy. This convenience notwithstanding, it is always wise to make a backup copy of all computer-encoded information.

Mixing for Video and Film

Generally, the process of mixing sound for video and film is accomplished during the premixing and rerecording stages. **Premixing** is when the various dialogue, sound effects, and, to some extent, music tracks are processed for rerecording. The rerecording mix is the final stage in postproduction when the premixed tracks are combined into stereo, mono, or surround sound. The differences in technology and release formats between television and film may account for differences in the sequence and type of operations during mixing and rerecording, but the purposes of both stages are the same for each medium: to produce a finished soundtrack.

Sweetening

Sweetening is the postproduction stage in television and film when sound from videotape, magnetic film, or audiotape is dubbed to multitrack audiotape, or disk, for mixing, signal processing, and the recording of additional elements. It is then rerecorded back to videotape as a final mix or to magnetic film in a form ready for the rerecording mix.

Using video as an example, sweetening is accomplished by transferring sound, usually dialogue and sometimes sound effects, from

the edited master videotape to multitrack audiotape or hard disk. Other audio tracks, such as music and additional sound effects, are added to the multitrack tape as needed. These tracks are then processed, mixed, and rerecorded back to the edited master videotape. In film, sound is transferred to multitrack from audiotape or magnetic film, or both. This procedure usually occurs in four stages: (1) layover (or laydown), (2) prelay, (3) premix, and (4) layback.

1. *Layover.* During **layover**, also called **laydown**, the audio tracks from the edited master videotape are dubbed to a multitrack audiotape or hard disk along with time code from the edited master. At the same time, a videocassette window dub of the edited master is made.

 The audio from the edited master videotape is usually put on tracks 1 and 2 of the multitrack audiotape or hard disk (assuming there are two tracks of audio on the videotape master). Time code is recorded on the last tape track with the adjacent track left blank to avoid interference from the time code track, which is normally recorded hot. Because this procedure requires four tracks, at least eight tracks are needed: one track each for music and effects, and one track for the overall mix, two if it is a stereo mix. Sixteen tracks or more gives you added, and usually needed, leeway in sweetening.

 In film, the various sound tracks that have already been recorded are dubbed from audiotape or magnetic film to multitrack. Picture is copied to videotape with time code for referencing.

2. *Prelay.* During **prelay** the other remaining synchronized audio elements are recorded onto separate tracks. They may be music, sound effects, or additional dialogue. Pre-

lay also includes editing the various audio tracks to usable lengths when dubbing them to multitrack. This is to ensure that there is enough material to cover long fades, crossfades, and split-track mixing.

3. *Premix.* Premixing is the stage when all the separate tracks on the multitrack recording are smoothed, signal processed, and mixed to two other tracks (for stereo), or one track (for mono), of the multitrack tape or disk with the window dub being played in sync.

 In film, the premix is preparatory to rerecording when dialogue, sound effects, and music receive their final mix. Therefore, dialogue, sound effects, and music are prepared for dubbing to separate reels of magnetic film instead of being combined into a stereo mix at this stage.

4. *Layback.* During **layback** in video, the composite mix is transferred to the edited master videotape, replacing (and erasing) the old audio track(s) (see 17-6). In film the dialogue, sound effects, and music tracks are dubbed to separate reels of magnetic film for the rerecording mix.

If elaborate sweetening is unnecessary or not in the budget, there is another alternative possible with formats that provide at least two good-quality audio channels when only one has been used.

Let's assume the announce or dialogue track is on audio track 1 of the edited ¾-inch video master, and music and effects have to be added. Place the effects audiotape on an audiotape recorder. Feed it and the speech track (audio track 1) on the videotape through a console to audio track 2 on the same videotape. The separate feeds permit control of each element in the first pass of the mix. With speech and effects combined on track 2 of the videotape, place the music

on an ATR and feed it and track 2 through the mixer to audio track 1 of the videotape, balancing levels during this second, and final, pass (see 17-7).

Premixing the Sound Track

The premix is the stage in postproduction during which dialogue, sound effects, and, to some extent, music are prepared for the final rerecording mix.

Cue Sheets

Cue sheets are essential throughout production but they are indispensable during the premix and rerecording mix stages. The forms vary from studio to studio; they may be handwritten or computer generated, but they must contain at least the information outlined in the following list (see 17-8, 17-9, and 17-10).

- *A column of time cues.* This may be designated in time code, real time, or footage, depending on the medium and format. By using one column to serve all tracks, it is easy to see at a glance the relationship of cues.

- *What the sound is.* Each cue must be identified. Identification should be both brief to avoid clutter and precise to give the mixer certainty about what the cue is.

- *When a sound starts.* The word or words identifying a sound are written at the precise point it begins. With dialogue or narration, entry points may be indicated by a line or the first two or three words.

- *How a sound starts.* Unless otherwise indicated, it is assumed that a sound starts clean. That is, the level has been preset before a sound's entry. If a cue is faded in,

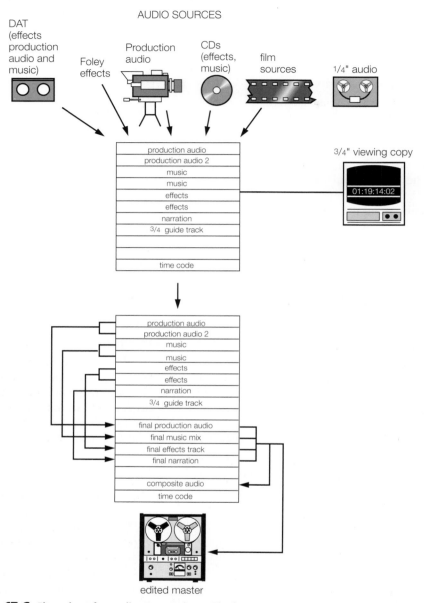

17-6 Flow chart for audio sweetening. The four separate tracks — production audio, narration, sound effects, and music — are saved for remixing for revisions, syndication, and foreign distribution.

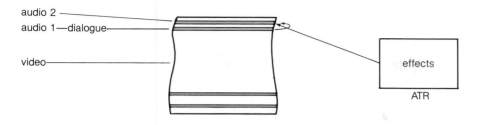

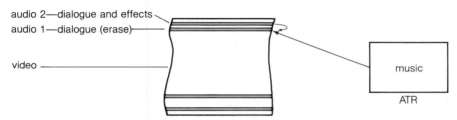

17-7 Shortcut audio sweetening process

faded in slowly, crossfaded with another sound, and so on, that must be indicated on the cue sheet.

■ *The duration of a sound.* From the point at which a cue begins to the point at which it ends is its duration. The simplest way of indicating this is to draw a straight line between the two points. Avoid using different-colored markers, double and triple lines, or other graphic highlights. The cue sheet or screen should be clean and uncluttered. If the cues are handwritten, pencil is better than ink in case changes have to be made.

■ *When a sound ends.* This can be indicated by the same word(s) used at the entry cue accompanied by the word *out* or *auto* (for *automatically*). This tells the mixer that the end cue is clean and has been handled in the premix.

■ *How a sound ends.* If a sound fades, crossfades, and so on, this should be indicated at the point when the sound must be out or crossfaded. The mixer then has to decide when to begin the out cue so it has been effected by the time indicated.

Dialogue

In most situations dialogue (or any speech for that matter) must be prominent and clear, whether it is by itself or mixed with other sounds. Various techniques are used to process speech, depending on the medium, voice quality, and competing sounds. Regardless of which techniques you employ, maintaining both the sonic integrity of the voice and intelligibility of speech is most important.

Clear dialogue begins with a good master recording, whether it is the production recording or the automated dialogue recording.

ADR

ELECTRONIC POST SYNC
AUTOMATED DIALOGUE RECORDING
CUE SHEET

CUE SHEET

JSR #1-12

REEL # _____ 1 _____ ¼" REEL # _____ 1 _____ PAGE # _____ 1 of 2 _____

PRODUCER _____ EDITOR _____

PRODUCTION _____

JOB # _____ PROD # _____ DATE _____

CHARACTER JOEY, SR.	FOOTAGE START STOP	MIXER NOTES	CHANNELS				DIALOGUE
			1	2	3	4	
JSR #1	187 05 199 03						YOUR BEST FRIEND WROTE AND TOLD ME (BREATH)
							YOU HAD TEARDROPS IN YOUR EYES
JSR #2	201 11						(BREATH) DADDY'S HOME (LAUGH)
	220 03 PIX OUT						DADDY'S HOME TO (LAUGH) STAY
	USE NATURAL OUT CUE						
JSR #3	350 11						I'M NOT A THOUSAND MILES
	360 01						AWAY
JSR #4 (OPTIONAL)	440 11 444 14	NO STREAMER					LET'S GO, LET'S GO, (LAUGH) LET'S GO
JSR #5	446 06						THERE'S A HOUSE PARTY
	450 10						WAY CROSS TOWN
JSR #6	450 07 451 09						(LAUGH) I GUESS

17-8 Example of a cue sheet used for dialogue rerecording

That means using the highest-quality microphones and recording equipment. In addition, noise reduction should be used throughout recording, premixing, and rerecording; the value of noise reduction cannot be overstated. The other techniques include the familiar signal processing of equalization, filtering, compression, limiting, noise gating, reverberation, and, sometimes, the aural exciter and delay.

In addition to the familiar uses of equalization in dialogue premixing—to make

SOUND EFFECTS – (Foley FX)

Triplicate: Editor — Mixer — Recordist

Production Number	Reel	Title	FX Editor	Telephone

Detailed Description and Remarks

Channels: 1 | 2 | 3

Footage Start & Stop

Mixer Notes

Cue No.

Start / Stop (repeated)

17-9 Example of a cue sheet used for recording Foley effects

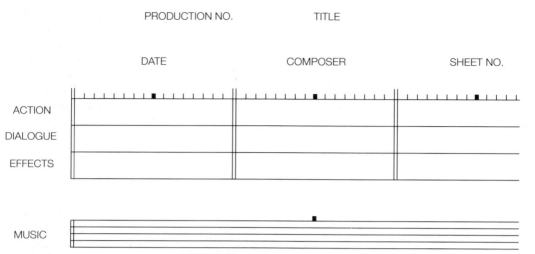

PRODUCTION NO. TITLE

DATE COMPOSER SHEET NO.

ACTION

DIALOGUE

EFFECTS

MUSIC

17-10 **Example of a cue sheet for music underscoring**

speech intelligible and agreeable-sounding—it can be employed to smooth or match any differences between dialogue on different tracks or reels. It helps to overcome anomalies in frequency response due to varying microphone techniques used during production, body microphones hidden under clothing, proximity effect, the recording system, or dubbing. Equalization also helps to improve the imbalance in reverberation when the reverb time in the bass is longer than it is in the midrange and treble. Filtering helps to reduce system and background noise.

Compression and limiting are commonly used to ensure that the dialogue stays within the dynamic range of the reproducing system. Remember, in recording and mixing, the important factor is how the audience will hear the sound, not the sonic capabilities of the recording or transmitting systems. Compression is also used to keep dialogue above the ambience and the noise floor of the combined tape tracks, or both. Compression helps to keep other sonic elements, such as sound effects and music, from interfering with the dialogue's intelligibility. It is better

to compress individual tracks, as opposed to compressing the overall dialogue mix, because the risk of distortion, audible pumping, and a clustered, blurred sound is considerably less.

De-essing smoothes the sibilance in speech, which can be a boon in digital recording. It also helps optical-track sound when sibilant distortion results from problems in lab processing.

Noise gates help to reduce ambient noise and keep dialogue tracks relatively free of leakage from other dialogue lines and sound sources. But using too many noise gates might add, rather than reduce, noise, and if they are not top-of-the-line units or are not set properly their gating actions will be audible.

Reverberation, in addition to its familiar use of providing acoustic definition to a space, helps to match the reverberant characteristics of different ambiences that may be part of the various dialogue tracks. One type of reverberation is known as **worldizing**. In worldizing, a microphone and loudspeaker are set up in a room, in a way that is similar

to their arrangement in an acoustic reverberation chamber (see Chapter 9). The room sound is recorded to add the sound of that space to a dry recording or to use it to enhance or smooth ambient backgrounds that are already part of a dialogue track.

The aural exciter can add clarity to a dialogue track and help the voice to stand out at a quieter level. Short delays can add depth and apparent loudness to the voice, but be careful here. It takes only a bit more delay than necessary for the delay to become obvious and, if it is inappropriate to the narrative material, ludicrous.

Sound Effects

The same considerations that pertain to premixing dialogue also apply to premixing sound effects, although the degree and application of signal processing often differs. For example, it is more likely that sound effects will be manipulated to a greater extent than dialogue. EQing dialogue using a significant amount of boost or cut would change voice character dramatically, whereas with a sound effect dramatic alteration may be quite appropriate. More liberties can be taken with sound effects because they are not as familiar to our ears as the human voice, particularly sound effects that emanate from science-fictional creatures or situations. But paying attention to sonic clarity, preventing distortion, and keeping an effect within the prescribed dynamic range are no less important for sound effects premixing than they are for dialogue premixing. This is sometimes easier said than done because sound effects tend to be mixed "hot." There are also three other notable differences between dialogue and sound effects premixing.

Sound effects premixing usually includes effecting most, or all, of the fades. It sometimes also includes setting the relative differences in level that are to occur in the final mix.

As we discuss later in this chapter, dialogue in film and television is usually centered in the stereo mix, and underscored music is mixed left, center, and right. These operations are done in the rerecording mix. Sound effects are often placed in a particular screen space or moved with the action in the picture. Panning sound effects is done in the premix.

Music

Music is handled differently than dialogue and sound effects in a premix in that very little, if anything, is done at that stage to prepare it for rerecording. Musical knowledge is integral to music mixing and not all sound people have that knowledge. Also, it is important that the music track undergo as few dubs as possible to maintain its original sonic integrity. Of the three elements in the sound track—dialogue, sound effects, and music—music is the most structurally complex and spectrally and dynamically varied. Another reason that little premixing is done with music is that by the time a music track is ready for the premix, most of what a premix would accomplish has already been done. If the music undergoes any signal processing at the premix stage it may be some high-end boosting to compensate for high-frequency loss during subsequent processing, and compression if the music is conflicting with the dialogue that it is underscoring.

The Rerecording Mix

The purpose of the rerecording mix is to blend the premixed dialogue, music, and effects tracks into a seamless stereo, mono, or surround-sound recording. The rerecording mix is the culmination of audio production and postproduction. Depending on market level, budget, and union regulations, it may be handled by the same sound people who

recorded, edited, or premixed the sound, or by people who have not yet heard the track or seen the picture.

On one hand, the rerecording mix should be relatively straightforward, assuming the premix has been well produced. Gross changes should be unnecessary. On the other hand, if the rerecording mix is unsuccessful, all of the previous work goes just about for naught. It is particularly important, therefore, that the premixed tracks are free from technical problems so that the rerecording mixer can concentrate on aesthetic points. (There may be one, two, or three rerecording mixers, depending on the scale and complexity of the material. Two mixers usually divide duties between dialogue/music and effects; three mixers handle each component separately. The dialogue mixer is usually in charge of rerecording.)

All extraneous sounds should be deleted during editing, and certainly no later than the premix. The three composite tracks should be clean at the beginning and end of each sound or sequence. Each track should be cut as close to the beginning and end of a sound as possible without cutting off soft attacks or decay.

In addition, entry and exit points of each cue must be precise—a rerecording mixer cannot be expected to pinpoint cues. A well-laid-out cue sheet is mandatory (see 17-11).

Layering Sound

We have referred to the combining of sounds as mixing, which it is. But a mix suggests a blend in which the ingredients lose their uniqueness in becoming part of the whole. Although blending is important, in relation to the rerecording mix the term *layering* is more to the point.

When sounds are combined, you have to (1) establish the main and supporting sounds to create focus or point of view, (2) position the sounds to create relationships of space and distance, (3) maintain spectral balance so the aural space is properly weighted, and (4) maintain the definition of each sound. These considerations relate more to layering than to mixing. Layering involves some of the most important aspects of aural communication—balance, perspective, and intelligibility.

When many sounds occur at once, unless they are mixed properly in the rerecording session it could result in a loud sound drowning out a quiet sound; sounds with similar frequencies muddying one another; sounds in the same spatial position interfering with focus; and sounds that are too loud competing for attention. The challenge of mixing a number of sonic elements is to make them defined and distinct.

Usually, when elements in a mix are muddled, it is because too many of them are sonically alike in pitch, tempo, loudness, intensity, envelope, timbre, or style. In mono, working out this problem is more difficult because it is one-dimensional (depth only), whereas stereo provides two dimensions (depth and breadth), and surround sound expands the two-dimensional space.

Imagine the sound track for a gothic mystery thriller. The scene: deep night, a sinister castle on a lonely mountaintop high above a black forest, silhouetted against flashes of lightning. You can almost hear the sound: rumbling, rolling thunder; ominous bass chords from an organ, cellos, and double basses; low-pitched moan of wind.

The layering seems straightforward, depending on the focus: music over wind and thunder to establish the overall scariness, wind over thunder and music to focus on the forlorn emptiness, and thunder over wind and music to center attention on the storm about to break above the haunting bleakness.

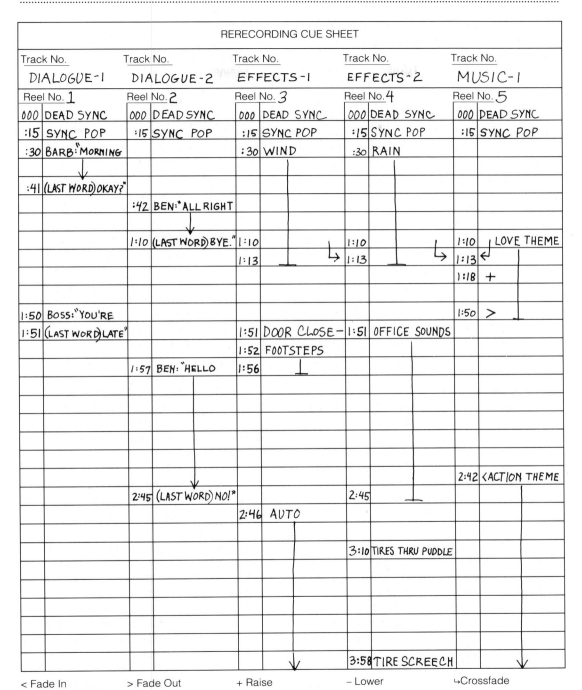

17-11 Rerecording cue sheet

With this particular mix, however, setting the appropriate levels may be insufficient to communicate the effect. The sounds are so much alike—low pitched and sustained—that they may cover one another, thereby creating a combined sound that is thick and muddy, lacking in clarity. The frequency range, rhythm, and envelope of the sounds are too similar: low-pitched, legato, weak in attack, and long in sustain.

One way to layer them more effectively would be to make the wind a bit wilder, thereby sharpening its pitch. Instead of rolling thunder, start it with a sharp crack and shorten the sustain of the rumble to separate it from any similar sustain in the music. These minor changes would make each sound more distinctive, with little or no loss in the overall effect on the scene.

This technique also works in complex mixes. Take a war scene: soldiers shouting, cannons booming, rifles and machine guns clattering, jet fighter planes diving to the attack, and intense orchestral music dramatically underscoring the action. Although there are six different elements, they are distinctive enough to be layered without losing their intelligibility.

The pitch of the cannons is lower than that of the rifles and machine guns; their firing rhythms and sound envelopes are also different. The rifles and machine guns are distinct because their pitch, rhythm, and envelope are not the same either. The pitch of the jets may be within the same range as that of the rifles and machine guns, but their sustained, roaring type of whine is the only sound of its kind in the mix. The shouting soldiers have varied rhythms, regardless of any similarities in pitch, envelope, and intensity; and the timbres of the human voices are easily distinguishable. As for the music, its timbres, blend, and intensity are different from the other sounds. Remember, too, that the differences in loudness levels will help to contribute to the clarity of this mix. And appropriate signal processing can always be employed.

In relation to loudness and the frequency spectrum two useful devices in maintaining intelligibility are the compressor and equalizer. Compressing certain sounds increases flexibility in placing those sounds because it facilitates tailoring their dynamic ranges. This is a more convenient and sonically better way to place sounds than by simply using the fader. Through modest and deft equalization, attenuating or boosting sounds can cut or fill holes in the aural frame, thereby also facilitating placement without affecting intelligibility.

Too many loud sounds present another problem: annoyance. In a scene with thunder claps, very heavy rain, a growling monster crashing through city or countryside on the attack, kids yelling, people screaming, and cars crashing, there is no sonic relief. It is loud sound on loud sound; every moment is hard. The rerecording mix can be used to create holes in the constant loudness without diminishing intensity or fright, and can provide relief from time to time throughout the sequence. For example, the rain could be used as a buffer between two loud sounds. After a crash or scream, bring up the rain before the next loud sound hits. Or use the growl, which has low frequency relief, to buffer two loud sounds.

Also, be wary of sounds that "eat up" certain frequencies. For example, water sounds in general and rain in particular are so high-frequency-intense that they are difficult to blend into a mix and the presence of other high frequency sounds only exacerbates the problem. Deep, rumbly sounds like thunder present the same problem at the low end of the frequency spectrum. One way to handle such sounds is to look for ways to change their perspectives. For example, with the rain, have it falling on cars, vegetation, pave-

ment, and in puddles. With the thunder, make it louder or quieter as the perspective of the storm cloud changes in relation to the people in the scene.

Perspective

In layering, some sounds are more important than others; the predominant one usually establishes the focus or point of view. In a commercial the announcer's voice is usually louder than any accompanying music or effects, because the main message is likely to be in the copy. In a racing scene with the sounds of speeding cars, a cheering crowd, and dramatic music defining the excitement, if you want to focus on the race, the sound of the speeding cars should dominate. The crowd and the music should be in the middle ground or background with the music substantially under to provide the dramatic support. To establish the overall dramatic excitement of the event, the music probably would create that point of view best. Therefore, the speeding cars and cheering crowd should be layered under the music as supporting elements.

Whatever the combination of effects, establishing the main and supporting sounds is fundamental to good rerecording—indeed, to good dramatic technique. In audio you create the focus or point of view by balancing levels—making their perceived loudness or softness and positioning in the aural frame relative to their importance, thereby establishing *perspective*—the relationship of sounds to each other and to the overall communication. But because of the psychological relationship between sound and picture, perspectives between what is heard and seen do not necessarily have to match but rather complement one another. In other words, you can "cheat" in handling perspective.

For example, take a scene in which two people are talking as they walk in the countryside and stop by a tree. The shot as they are walking is a long shot (LS), which changes to a medium close-up (MCU) at the tree. Reducing the loudness in the LS to match the visual perspective could interfere with comprehension and be annoying because the audience would have to strain to hear and the lip movements would be difficult to see. When people speak at a distance, the difficulty in seeing lip movements and the reduced loudness inhibit comprehension. A better technique would be to ride the levels at almost full loudness and roll off low-end frequencies, because the farther away the voice, the thinner the sound. Let the picture also help to establish the distance and perspective. Psychologically, the picture establishes the context of the sound. This also works in reverse.

In the close-up there must be some sonic change to be consistent with the shot change. Because the close-up does not show the countryside but does show the faces better, you can establish the environment by increasing ambience in the sound track. In this case the ambience establishes the unseen space in the picture. Furthermore, by adding the ambience, the dialogue will seem more diffused. This creates a sense of change without interfering with comprehension, because the sound is louder and the actors' lip movements are easier to see.

Spatial Manipulation of Sound

Over the years many systems have been developed that attempt to enhance the spatial dimension of sound and reproduction of natural-sounding spatial environments (see Chapters 3 and 14). Many have been either impractical for widespread professional use or unfeasible for the consumer market.

In film and television audio and in music recording during the past several years, spatial enhancement systems have emerged that have proved to be practical and affordable to the audio professional and marketable to the consumer. These systems fall roughly into two groups: 3-D (three-dimensional) sound and surround sound. Broadly speaking, **3-D sound** increases the breadth and depth of the audio field using the conventional two-loudspeaker stereo array in front of the listener. **Surround sound** produces a soundfield in front of, to the sides of, and behind the listener by positioning loudspeakers either front, side, and rear or front and rear.

Before we discuss the applications of 3-D and surround sound to mixing sound tracks and music, we should consider the conventional stereo sound mix in film and television. (Stereo mixing and placement in music recording were addressed earlier in this chapter.)

Stereo Placement

Natural assumptions in placing elements in a stereo mix for film and television are that dialogue and effects are positioned in relation to their on-screen locations and that music, if there is no on-screen source, fills the aural frame from the extreme left to the extreme right. For the most part, these assumptions are imprecise. Placement depends on the screen format, the reproduction system, and the type of material being produced.

Film

Conventional stereo sound tracks in 35mm film are reproduced on three channels — left, center, and right. At least three channels are necessary because of the screen's width and the size of the audience area. Without a center channel people sitting at the left and right would hear only the loudspeaker closest to them and receive no stereo effect.

As a general rule, on-screen dialogue is placed in the center. If a character moves about and there are several cuts, it can become annoying to have the sound jump around, particularly if more than one character is involved. On the other hand, if characters maintain their positions in a scene, even though shots change from wide to close or vice versa, stereo imaging can be effected without disorienting the audience.

Sound effects also tend to be concentrated toward the middle. If they are stationary or move across a wide distance, they may be located and panned without distracting. Too much movement clutters and muddies the sound, however. Sometimes, to create the sense that an effect is positioned relative to the action, the effect is reverbed. Most of the dry effect is placed at or near center screen and the wet part is used to convey its placement in the frame.

Music is distributed across the left, center, and right channels. It is usually mixed so that it frames dialogue and effects (see 17-12). If there is no music, and sometimes when there is, background sounds and ambience are mixed to the left and right to create overall tone. In the 70mm, large-screen format, aural perspective is somewhat more realistic.

Television

The aesthetic challenges in mixing for stereo television are twofold. They are scale and perspective.

Scale Until the advent of stereo TV, the television loudspeaker was smaller than the screen, but together, the scale of picture and sound images have seemed proportional. No doubt conditioning has had something to do with this perception.

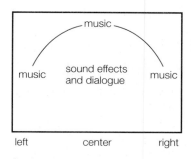

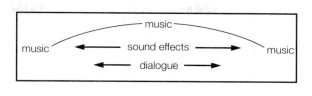

left center right

a b

17-12 Distribution of sound in film. (a) Film sound mixed for standard 35mm screen formats usually maintains dialogue and sound effects in the center and music left to right, framing dialogue and effects. (b) Sound mixed for large-screen formats (70mm) can be placed more realistically. Dialogue and effects are often positioned from left center to right center with music framing them.

With stereo TV, loudspeakers are mounted in two ways, either attached to the left and right sides of the set or detached. Permanently attached speakers can be no farther apart than the width of the TV set. This is a limiting factor in creating a stereo image because the aural space is so narrow. Detachable speakers can be situated an optimal distance apart; 6 feet is usually recommended to reproduce a more realistic stereo image. In fact, when sound is more spacious because of stereo, the picture seems bigger. As has been suggested so often throughout this book, what we hear affects what we see.

Perspective Television is a small-screen medium and will be for the foreseeable future. It relies on close shots to enhance impact and to show detail that otherwise would be lost. Speech, therefore, is concentrated in the center. Trying to match movement with sound would be more chaotic in TV than it would be in film.

Handling of sound effects also should be conservative. Obvious movement should be selective and occur mostly with effects that make pronounced crossing movements (see Chapter 12). The extent of the movement has to be carefully controlled so it is not greater than the visual dimension.

Ambiences certainly can be fuller than they are in mono TV. Undoubtedly, the significant perceptible difference between mono and stereo TV is in the fuller and deeper ambience.

Underscoring music should be mixed across the stereo field with the left and right sides framing the overall stereo image. In other words, mixing for stereo TV is much like mixing for film due to the constraint of audience disorientation.

The key to the stereo "feel," if not the imaging, is in how reverberation is mixed. For example, voices can be kept in the center but their reverb can come from the sides. The aural focus remains centered but the reverb gives it more dimension. This technique is employed in film as well.

3-D Sound

3-D sound increases the illusion of depth and width in aural space using frontally positioned stereo loudspeakers. Before its demise,

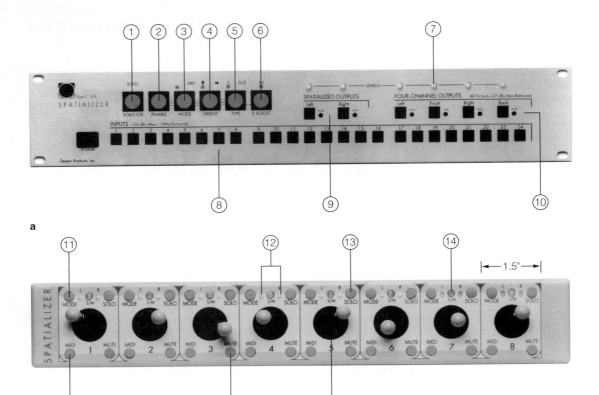

a

b

(1) Clears all stations from solo mode into normal function mode

(2) This lock-out button must be pushed in conjunction with any of the right four buttons

(3) Places each station in calibrate or mixdown mode

(4) Electronically rotates all joystick controls 90° for vertical or horizontal use

(5) Places entire Spatializer in Type C (for original microphone recording) or Type D/E (for mixdown)

(6) Provides additional expansion energy for use with very narrow stereo sources

(7) Tri-level LEDs indicate:
> Yellow = signal too low
> Green = signal OK
> Red = signal clipping

(8) TT style input plugs provided on front panel for ease of connection to patch-bay. Optional parallel-wired connectors located on rear panel

(9) Stereo outputs processed in spatialization

(10) Discrete (nonspatialized) outputs for left, front, right, and back signals. Front output is useful for dialogue and is isolated from the left or right outputs with joystick in front position

(11) Selects Spatialization Types D, E_L, or E_R, or places station off-line
> Type D is a directional function for use with mono sources
> Type E is an expansion function used with stereo sources
> E_L is for use with the left side of a stereo input
> E_R is for use with the right side of the same stereo input

(12) Mode (L & R) LEDs
> C = both amber
> D = both green
> E_L = left red
> E_R = right red

(13) Places station in solo-in-place

(14) Solo/Mute (S/M LEDs)
> Solo = steady green
> Mute (Local) = steady red
> Mute (by Solo) = flashing red

(15) Writes all functions of station to MIDI

(16) Places station in mute

(17) Moves mono sources 350° seamlessly, or scales stereo sources to any size within the soundfield

17-13 **3-D audio processing system.** (*a*) Processor. (*b*) Controller unit.

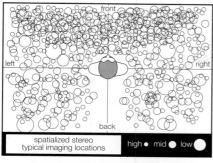

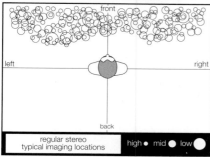

17-14 Comparison of 3-D audio processing and conventional stereo in relation to spatial imaging

the best known example of 3-D sound was *QSound*. A number of CD albums were made using this process, which effectively brought the depth and width of the stereo image to the outermost edges of the sound field on a plane with the listener situated several feet in front of, and centered between, the loudspeakers. QSound, however, involved complex algorithms and other problems with usage that made it difficult to market to the professional. Newer, easier to use systems have made 3-D mixing more convenient to employ.

One such system consists of two components: (1) a processor that is connected into a studio's existing signal flow through the patch panel and (2) a portable controller unit (see 17-13). The system, used during the mixing stage, makes it possible to control each

track's scale and size and near/far and front/rear positioning (see 17-14). Spatial manipulation can be applied to film and TV soundtracks and in music recording. The system is both mono and surround-sound compatible (see "Stereo-to-Mono Compatibility" later in this chapter).

Surround Sound

Surround sound is a production process that involves encoding the spatial, or positional, information from the composite audio production tracks during rerecording and decoding that information during reproduction. It was not too long ago that surround sound processing was available only in theatrical film audio production. Today, it is available to any sound facility producing film or television audio. Until roughly the early 1980s, the only way the general public could conveniently experience surround sound in film was at a motion picture theater that had the equipment to decode it and the loudspeaker system to reproduce it. With the development of surround-sound decoders for the consumer market that can be interfaced with a stereo TV receiver, videocassette player, and additional loudspeakers, it is now possible to enjoy surround-sound-encoded television programs and films in your home. In fact, audio professionals widely believe that surround sound in the home theater will become a major focus of postproduction.

Surround sound production systems require an encoder and a decoder to handle channel matrixing. The Dolby system uses **Dolby Stereo**™ to record surround sound and **Dolby Surround**™ to reproduce it in a 4–2–4 format. (There are consumer systems available that are designed to decode Dolby Stereo.) Four channels—left, center, right, and surround—are combined into two channels during recording. During playback the

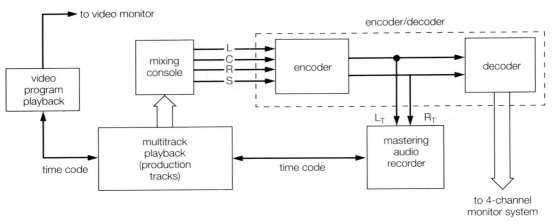

17-15 **Surround sound matrix in a postproduction application.** The surround sound mix encodes the discrete left, center, right, and surround inputs in the required left and right two-channel program and provides a means by which the program mixer can monitor the entire encode/decode process.

two channels are separated back into the four original channels. Therefore, the encoder unit is 4:2, the decoder is 2:4 (see 17-15).

Generally, the left, center, and right channels contain the principal audio—dialogue, sound effects, and music—and the surround channel is dedicated to ambience. Specifically, with the addition of the center and surround channels to conventional stereo reproduction, stable center and ambient imaging are created. The center loudspeaker is more important with television sound than it is with film sound because the TV image takes up a smaller spot in the field of view. Hence, the center loudspeaker helps to localize dialogue toward the center of the screen. Also with surround sound, audio can be moved not only across the front sound stage but between front and back as long as it does not create audience dislocation.

To monitor surround sound during rerecording, the frontal loudspeaker array should be positioned left, center, and right, and two loudspeakers should be placed behind the operator (see 17-16). It is all to the better if additional loudspeakers are positioned to the sides in the monitoring environment (see 17-17).

Since surround sound has become a part of audio postproduction some general observations about mixing surround have emerged.

- The matrixing format, as opposed to the discrete format, can create localization problems; therefore, mix the most dominant elements first. (In a discrete format each channel remains separate throughout the recording and reproduction stages.)

- Before doing the surround mix, do the left, center, and right mix first.

- When using compression or limiting on dialogue or vocals, do not process any additional ambience signal through the

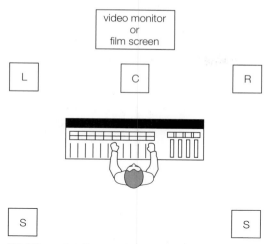

17-16 Audio monitoring for surround sound production with a front and rear loudspeaker array

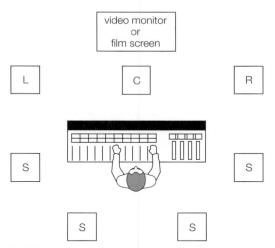

17-17 Audio monitoring for surround sound production with a front, side, and rear loudspeaker array

same compressor-limiter. This reduces the potential for the dominant sound to cause the ambience to "pump."

- When using signal processing, use separate processing devices for each element. Using the same processor for more than one element could, among other things, smear sonic imaging.

- Unless it is for special effect or to be gimmicky, it is usually disconcerting to place major program elements behind the listener. It is one thing to position a listener in a spacious sonic environment with the action across the front and at the edges; it is another thing to put the listener in the midst of the action. To make the example another way: most people do not listen to music sitting among the musicians. Reproducing that kind of listening experience has been found to be disconcerting. (To be sure, because of human binaural hearing we are in the middle of our sonic environment all the time. Perhaps it is a matter of conditioning from years of listening to frontally imaged sound that disconcerts an audience when it is surrounded artificially by sonic action.)

- In sports broadcasting, when the announcer's sound often competes with the crowd sound, or in music recording, when a vocalist and ambience compete, it helps to widen the voice by panning it toward the surround sound position. Another technique is to add a small amount of synthesized stereo to the left and right channels.

Monitoring 3-D and Surround Sound

When monitoring 3-D and surround sound there are a few questions you should ask to help evaluate the cohesiveness of a mix. One

major problem with surround sound has been that it sounds disjointed.

Consider: Does the sound emanate from the appropriate loudspeaker location or does it seem detached from it? When you move around the listening environment, how much of the positional information, or sonic illusion, remains intact? How robust does that illusion remain in another listening environment? If there are motion changes—sound moving left-to-right, right side-to-right front, and so on—are they smooth? Does any element call unwanted attention to itself?

All in all, the advantages of multidimensional manipulation of sound far outweigh its problems. (1) Dialogue and sound effects can be accurately localized across a wide or small screen for almost any audience position; (2) specific sound effects can be localized to the surround sound loudspeakers; (3) ambience and environmental sounds can be designed to reach the audience from all directions; and (4) panning of sound can occur across the front sound stage and between front and sides/rear locations.

Stereo-to-Mono Compatibility

Although stereo-to-mono compatibility has been considered in Chapters 12 and 14, it is important enough to warrant a reminder here in relation to conventional stereo mixing. In surround sound, stereo-to-mono compatibility is not as much of concern because the systems in use are mono-compatible.

Stereo discs, stereo radio, stereo TV, and stereo films notwithstanding, except for home component music systems and visits to the motion picture theater, most people still receive mediated information in mono. In virtually anything you stereo-master, there-

fore, its monophonic playback must be considered.

The preferred way to produce stereo for mono compatibility is to do two different mixes, one for stereo and one for mono. Although this best-of-all-worlds approach takes time and costs more in terms of extra studio and mastering fees, it is done. For example, in music production for TV commercials, a three-channel stereo mix—ensemble, lead vocal, backup vocals—is mastered to a four-track ATR (the fourth track is used for time code). At the same time, a mono mix is mastered to a two-track ATR with time code.

When producing two separate mixes is not feasible, stereo-to-mono compatibility must be checked and rechecked throughout the mixdown. What sounds good in stereo may be less than acceptable in mono. A wide and satisfactorily balanced stereo recording played in mono may be too loud. For example, a 0 VU reading at the extreme left and right in stereo is equivalent to +6 in mono. Anything assigned to the center in the stereo mix may be too loud in mono and out of context with the rest of the sound. Moreover, placing voicings extreme left or right in stereo results in a 3-dB or greater loss in their level(s) relative to the rest of the spectrum when played in mono.

So the problem of stereo-to-mono compatibility is twofold: too much sound in the center and not enough of the left and right sound. The reason, briefly stated, is that signals in phase in stereo add in mono, and signals out of phase in stereo cancel in mono.

Certain devices, such as the phasing analyzer or stereo display processor, can be used to indicate stereo-to-mono compatibility during a mix (see 17-18). Many of today's pan pots are designed with either a 3 dB- or a 6 dB-down notch that facilitates mono-compatibility.

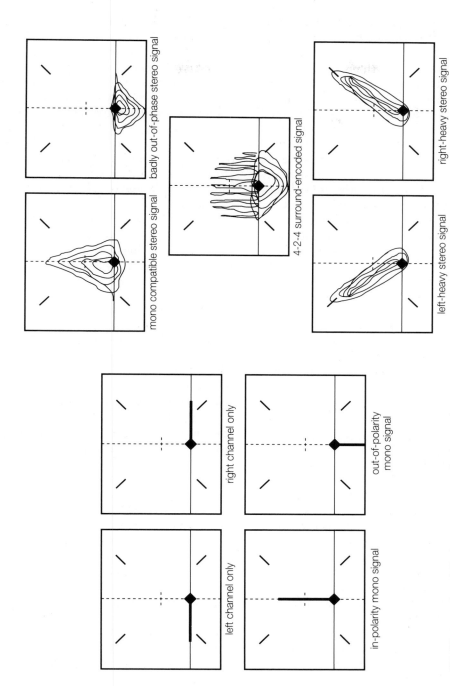

badly out-of-phase stereo signal

mono compatible stereo signal

4-2-4 surround-encoded signal

right-heavy stereo signal

left-heavy stereo signal

right channel only

out-of-polarity mono signal

left channel only

in-polarity mono signal

17-18 Examples of displays on a stereo phasing analyzer

Two other techniques are also used. One is not to put anything dead center or at the extreme left or right in a stereo mix. This reduces both center channel build-up and loss of some of the left and right information when playing stereo recordings in mono. But the stereo image may not be as wide as it should be, and center imaging could be awkward.

The better technique is to be very careful of in-phase and out-of-phase signals during recording and signal processing, especially with reverb, and to constantly A-B between stereo and mono playback during a mix using both your ears and a phasing analyzer. In the A-B comparisons, always check to make sure that nothing is lost due to phase, that nothing stands out inordinately, and that the overall blend is maintained.

Recording Calibration Tones and Assembling the Master Audio Tape

The final steps in the production process are recording the master and preparing it for disc cutting, dubbing, the film processing in laboratory, broadcasting, or shipping. Discussing preparation of the final master tape would become too involved if we included the procedures used in radio, film, television, and music recording and also considered analog and digital tape, to say nothing of hard disk. Using analog tape as an example should provide you with an understanding of the overall process.

Recording Tones

As noted in Chapter 14, recording calibration or reference tones on master tapes is essential, for two reasons: (1) They serve as a

check to ensure that console and tape recorder VU meters are aligned and will be consistent throughout recording, mixing, and mastering; and (2) they provide a reference for anyone calibrating console and tape recorder levels at any stage in the recording or mixdown, whether that person is involved in all or only part of the project. Different procedures are used in recording tones, but the idea is to give an engineer adequate information to permit proper calibration and alignment of equipment.

Before recording tones, slate the master. Tones are recorded at the beginning of the master tape on each channel. They are generally recorded at 0 VU (100 percent of modulation) and for 20 to 40 seconds each. One recommended order is to start with a 1,000-Hz tone, then group the following tones: 50 Hz, 100 Hz, 1,000 Hz, 10,000 Hz, and 15,000 Hz. These tones should be recorded without noise reduction. If noise reduction is used, then record the Dolby SR or A tone or a dbx-encoded tone.

During playback the 1,000-Hz tone is used to set overall level and balance the channels. To align the playback head, 10,000 or 15,000 Hz is used. The other tones are used to set playback equalization.

When one tone is used, as it sometimes is for recordings not being processed for further mastering and for preliminary videotape editing, it is 1,000 Hz. To be safe, however, record at least three tones—low-frequency, 1,000 Hz, and high-frequency.

Assembling the Master

After the calibration tones have been recorded and the final mix has been dubbed to the master, it is time to assemble and label the master. Again, techniques may vary with

the project and the medium, but essentially, whatever is on the master must be readily apparent to anyone handling it.

With audiotape, splice 4 to 6 feet of leader tape to the front and tail ends of the magnetic tape to protect the recording at these exposed and vulnerable points and provide a suitable length of tape to thread the machine prior to the presence of any sound signal. Use color-coded leader tape to tell which end is which. Some studios use red leader tape at the head of the audiotape and blue leader tape at the tail, although paper leader tape may be used for mastering. Separate different segments within the audiotape with white or yellow leader tape to provide a visual means of identifying where material begins and ends (see 16-4). If a reel of audiotape contains different selections of program material and reference tones, the order of elements should be as follows (keeping in mind that footage and times will vary with the project):

1. 4 to 6 feet of leader tape
2. Slate
3. 10 to 15 seconds of leader tape
4. Reference tones
5. 10 to 15 seconds of leader tape
6. Cut 1
7. 10 to 15 seconds of leader tape
8. Cut 2
9. Repeat steps 1–8 until the last cut
10. 4 to 6 feet of leader tape (spliced after the last sound decays)

The final step in tape preparation is *labeling* — putting the essential information about the recording preferably on and in the tape box and attaching some identification to the reel. The information should include the following:

1. Title of program, song, cuts, and so on
2. Producer or director
3. Artist or client
4. Duration of the material
5. Tape speed
6. Recording format — analog or digital
7. Track format (full-track mono, two-track stereo, four-track stereo, and so on)
8. Tape type and thickness
9. Tape wind — heads or tails out
10. Location, frequencies, order, and duration of test tones
11. Location of the highest peak level on the tape
12. Type of noise reduction (Dolby, dbx), if any
13. Any peculiarities

If the recording requires a cue sheet or other documentation, attach it to or place it inside the tape box but make sure it accompanies the tape in some way. Be sure the printed material is complete and clearly transcribed. The cue sheet should include such information as the first and last lines of segments that contain speech, the type of segment stops (an abrupt cut, fade, and so forth), the segment time or the total time, any sudden changes in loudness level, and other peculiarities.

Finally, try not to use reels smaller than 7 inches; 5- and 3-inch reels could create problems with tape tension and result in an uneven wind. Also, put on a reel only the tape containing the recording, not any left-over blank tape. And remember, the sound on a tape recording obviously should be as good as possible. Figure 17-19 shows what one broadcast operation looks for in its analog tape recordings.

NATIONAL PUBLIC RADIO QUALITY CONTROL REPORT FORM

2025 M Street, N.W. • Washington, D.C. 20036 • (202) 785-5400

SERIES NAME: _____ PROGRAM TITLE: _____ No._____ of _____

SOURCE: _____ FOR: ☐ NPR ☐ ST-Mono ☐ ST-Stereo ☐ Ordered ☐ Speculation

TYPE: ☐ Live ☐ Tape ☐ Cart ☐ Cassette ☐ Disc ☐ Mono ☐ Stereo ☐ Full ☐ ½ 'A' ☐ ½ 'B'

RESULTS:
☐ Accepted for Technical Quality
☐ Rejected for Technical Quality (see below)
☐ Accepted If Certain Items are Fixed (see "must fix" below)
☐ Accepted, Some Items could be Improved in the Future (see "could fix" below)

	REJECTED	MUST FIX	COULD FIX	GOOD		REJECTED	MUST FIX	COULD FIX	GOOD
'BOOMY'	☐	☐	☐	☐	TAPE STOCK	☐	☐	☐	☐
'PEAKY'	☐	☐	☐	☐	INTELLIGIBILITY	☐	☐	☐	☐
'MUDDY'	☐	☐	☐	☐	SIGNAL TO NOISE	☐	☐	☐	☐
BASS EQUALIZATION	☐	☐	☐	☐	BUZZ OR HUM	☐	☐	☐	☐
TREBLE EQUALIZATION	☐	☐	☐	☐	POOR LIMITING	☐	☐	☐	☐
CONTROL OF LEVELS	☐	☐	☐	☐	COMPRESSION	☐	☐	☐	☐
MIKING	☐	☐	☐	☐	AMBIENT NOISE	☐	☐	☐	☐
WOW AND FLUTTER	☐	☐	☐	☐	ERASURE	☐	☐	☐	☐
NOISE	☐	☐	☐	☐	DROP OUTS	☐	☐	☐	☐
TAPE HISS	☐	☐	☐	☐	'POPS AND CLICKS'	☐	☐	☐	☐
PRE OR POST ECHO	☐	☐	☐	☐	TIMING	☐	☐	☐	☐
DISTORTION	☐	☐	☐	☐	WARPING	☐	☐	☐	☐
STEREO PHASING	☐	☐	☐	☐	DOUBLE AUDIO	☐	☐	☐	☐
STEREO BALANCE	☐	☐	☐	☐	'UP-CUTTING'	☐	☐	☐	☐
EDITING	☐	☐	☐	☐	SPEED	☐	☐	☐	☐
SPLICING	☐	☐	☐	☐	CROSSTALK	☐	☐	☐	☐
HEAD AZIMUTH	☐	☐	☐	☐	HEAD CONFIGURATION	☐	☐	☐	☐
ROOM ACOUSTICS	☐	☐	☐	☐	LEADERING	☐	☐	☐	☐
MIXING	☐	☐	☐	☐	PRESENCE	☐	☐	☐	☐

REPAIR METHOD: ☐ EQ ☐ Notch ☐ Remix ☐ Re-edit ☐ Rerecord ☐ Dub/Fix Gain
☐ Boost HF ☐ Cut HF ☐ Boost Mid. ☐ Cut Mid. ☐ Boost LF ☐ Cut LF

COMMENTS: _____

Audition By: _____ Date: _____ Corrected By: _____ Date: _____
Audition By: _____ Date: _____ Accepted By: _____ Date: _____

RETURN TO SOURCE

17-19 A quality-control report form listing several elements that are important to a well-prepared tape recording

Evaluating the Finished Product

Implicit in Figure 17-19 is the idea of quality control. In producing audio, sound quality should be evaluated every step of the way. It is after the final mix, though, when the moment of truth arrives.

But what makes good sound? Ask 100 sound designers to evaluate the same sonic material and undoubtedly you will get 100 different responses. That is one of the beauties of sound: It is so personal. Who is to tell

you that your taste is wrong? As a listener, if it satisfies you, that is all that matters. When sound is being produced for an audience, however, professional "ears" must temper personal taste. To this end, there are generally accepted standards that most sound designers agree are reasonable bases for artistic judgment.

Before discussing these standards, a word about the monitor loudspeakers is in order. Remember that the sound you are evaluating is influenced by the loudspeaker reproducing it. Therefore, you must be thoroughly familiar with its frequency response and how it otherwise affects sonic reproduction. If a sound is overly bright or unduly dull, you have to know whether it is the result of the recording or the loudspeaker. A good way to familiarize yourself with a loudspeaker's response is to take a few well-produced recordings with which you are thoroughly familiar and listen to them on the monitor system until you know its response characteristics.

Intelligibility

It makes sense that if there is narration, dialogue, or song lyrics, the words must be intelligible. If not, meaning is lost. But when working with material over a long period of time, the words become so familiar that it might not be apparent that they are muffled, masked, and otherwise difficult to make out. Therefore, in evaluating intelligibility it is a good idea to do it with fresh "ears," as if you were hearing the words for the first time.

Tonal Balance

Bass, midrange, and treble frequencies should be balanced; no one octave or range of octaves should stand out. Be particularly aware of too much low end that muddies and masks sound; overly bright upper midrange and treble that brings out sibilance and noise; absence of brilliance that dulls sound; and too much midrange that causes the harshness, shrillness, or edge that annoys and fatigues.

The timbre of the voice, sound effects, and acoustic instruments should sound natural and realistic. Music and sounds generated by electric and electronic instruments do not necessarily have to sound so.

Ensemble sound should blend as a whole. As such, solos or lead voicings should be sonically proportional in relation to the accompaniment.

Spatial Balance and Perspective

All sonic elements in aural space should be unambiguously localized; it should be clear where various sounds are coming from. Their relationships—front-to-back and side-to-side—should be in proper perspective. Dialogue spoken from the rear of a room should sound somewhat distant and reverberant; an oboe solo should be distinct yet come from its relative position in the orchestra; a vocal should not be too far in front of an ensemble or buried in it; background music should not overwhelm the announcer; crowd noise should not be more prominent than the sportscaster.

Positional and loudness changes should be subtle and sound natural. They should not jar or distract by jumping out, falling back, or bouncing from side to side (unless the change is justified in relation to picture).

Definition

Each element should be clearly defined—identifiable, separate, and distinct—yet, if part of an ensemble, blended so that no one

element stands out or crowds or masks another's sound. Each element should have its position in, and yet be a natural part of, the sound's overall spectral range and spatial arrangement.

Dynamic Range

The range of levels from quietest to loudest should be as wide as the medium allows, making sure that the quietest sounds are easily audible and the loudest sounds are undistorted. If compressed, sound should not seem squeezed together, nor should it surge from quiet to loud, and vice versa.

Cleanness

A clean recording is as noise- and distortion-free as possible. Hum, hiss, leakage, phasing, smearing, blurring from too much reverb, and harmonic, intermodulation, and loudness distortion — all clutter and thicken sound, adversely affecting clarity.

Airiness

Sound should be airy and open. It should not sound isolated, stuffy, muffled, closed-down, dead, lifeless, overwhelming, or oppressive.

Acoustical Appropriateness

Acoustics, of course, must be good, but they must also be appropriate. Classical music and jazz sound most natural in an open, relatively spacious environment; acoustics for rock-and-roll can range from tight to open; a radio announcer belongs in a less reverberant, intimate acoustic environment; the space in which a character is seen and the acoustic dimension of that space must match.

Production Values

The degree to which you are able to develop and appraise production values is what separates the mere craftsperson from the true artist. Production values relate to the material's style, interest, color, and inventiveness. It is the most difficult part of an evaluation to define or quantify, because response is qualitative and intuitive. Material with excellent production values grabs and moves you. It draws you into the production, compelling you to forget your role as objective observer; you become the audience. When this happens, it is not only the culmination of the production process but its fulfillment.

Main Points

1. Mixing and rerecording are the phases of postproduction when the separately recorded elements are combined into a natural and integrated whole.

2. In proceeding with a mix, it is necessary to know on what type of delivery system it will be reproduced. Radio, television, film, and compact discs have different sonic requirements.

3. Dubbing is the procedure of transferring sound from one source to another.

4. Each time an analog tape recording is dubbed it loses a generation and sound quality suffers. When dubbing digital sound — CD or tape — to another digital source, there is negligible generational loss of sound quality.

5. When sound is fed from one electronic device to another, such as console to tape recorder, the levels of both sources must be calibrated to make sure the VU meters on each show the same readings.

6. One procedure in voicing over recorded music is called a donut—fading the music after it is established and reestablishing it later at its former full level to create a hole for the announcement.

7. When voicing over music or sound effects, try to vary the background dynamics to help direct focus and create interest through sonic variety.

8. Subtracting the time of an individual item from the total time of a program or program segment is known as back-timing.

9. Playing sound with the fader off is known as dead rolling.

10. In a music mixdown one procedure is to evaluate the positive and negative attributes of the recording, working with one track at a time but building on the tracks already processed. When each track sounds acceptable in the context of the overall mix, blend and balance the sounds together. This may involve changing individual settings in favor of the overall mix.

11. When equalizing, avoid large increases or decreases in equalization, do not increase or decrease too many tracks at the same frequency, and do not use equalizing as a substitute for better microphone selection and placement. Equalizing between 400 and 2,000 Hz is more noticeable than equalizing above and below that range. Be sure to equalize with an awareness of the frequency limits of the medium in which you are working.

12. The quality of reverberation added to a recording in the mix depends, to a considerable extent, on musical style. Classical, jazz, and some types of folk music usually require natural-sounding acoustics; various reverberant environments may be appropriate for popular music.

13. Add artificial reverberation after signal processing and panning because it is difficult to get a true sense of the effects of frequency and positional change in a reverberant space. Also, avoid giving widely different reverb times to the various components in an ensemble or sound track unless they are supposed to sound as if they are in different acoustic environments.

14. Factors involved in placing musical components in the stereo frame are (1) the aural balance, (2) the arrangement of the ensemble when performing, and (3) the type of music being played.

15. Record keeping, whether handwritten or entered into a computer memory, is important in any type of mixing and rerecording. You never know if it will be necessary to redo a part of the mix or the entire thing.

16. Sweetening is the postproduction stage in television and film when sound from videotape, magnetic film, or audiotape is dubbed to multitrack audiotape or disk, for mixing, signal processing, and the recording of additional elements. It is then rerecorded back to videotape or to magnetic film in a form ready for the rerecording mix.

17. Sweetening is a four-step process that involves layover (or laydown), prelay, premix, and layback.

18. Cue sheets are essential throughout the production process but they are indispensable during the premix and rerecording mix stages.

19. In the premix, dialogue, sound effects, and, to some extent, music are prepared for the final rerecording mix.

20. The purpose of the rerecording mix is to blend the premixed dialogue, sound effects, and music into a seamless stereo, mono, or surround sound recording.

21. In layering sound, you have to (1) establish the main and supporting sounds to create focus or point of view, (2) position the sounds to create relationships of space and distance, (3) maintain spectral balance so the aural space is properly weighted, and (4) maintain definition of each sound.

22. To help maintain definition, as well as intelligibility, in a mix, the various sounds should have different sonic features. These features can be varied in pitch, rhythm, loudness, intensity, envelope, timbre, style, and so on.

23. In layering sounds, it is important to establish perspective. Some sounds are more important than others; the predominant one usually establishes the focus or point of view.

24. 3-D sound increases the breadth and depth of the audio field using the conventional, frontally positioned two-loudspeaker stereo array.

25. Surround sound produces a soundfield in front of, to the sides of, and behind the listener by positioning loudspeakers either front and rear, or front, sides, and rear.

26. Surround sound production systems use the 4–2–4 format. Four channels—left, right, center, and surround—are matrixed into two channels during recording and separated back into the original four channels during reproduction.

27. Stereo placement in film and in TV usually positions dialogue and sounds in the center and music left, center, and right. Large-screen film positions dialogue in the center with limited lateral movement, sound effects across a somewhat wider space but still toward the center, and music left, center, and right.

28. In mastering stereo sound that may be reproduced on monophonic systems, the material must be mono-compatible.

29. When assembling a master tape, the tape should have calibration tones, be properly leadered, be clearly labeled, and list any instructions or problems.

30. In evaluating a final product, factors that should be considered include intelligibility, tonal balance, spatial balance and perspective, definition, dynamic range, cleanness, airiness, and acoustical appropriateness.

31. Production values relate to the material's style, interest, color, and inventiveness.

Manually Produced Sound Effects

As referred to in Chapter 13, this is a list of selected sound effects and how to produce them. Since these effects are simulated, they may require some refinement beyond the suggestions provided.

AIRPLANE Prop: Hold stiff cardboard against an electric fan. **Jet**: Turn on a high-pitched vacuum cleaner or electric sweeper.

*****ANIMALS Cat**: This is easily done vocally. Listen and try to imitate. **Cow**: Do vocally or with a small bellows-type toy. **Dog**: Do vocally. **Horse**: *Hooves*: Clap halved coconut shells together or on a packed surface. *Snorting*: Take a deep breath, close the lips lightly, and as you force the air out of the lungs, relax the lips and allow them to vibrate freely. *Whinny*: Do vocally. **Monkey**: Dampen the cork from a smooth-sided bottle and rub the side of the bottle with the cork in hard, fast, short strokes.

(A word of caution about vocally produced sound effects: They have to be performed with no discernable human vocal quality to be convincing.)

ARROW Through Air: Swish a stick through the air. **Hitting Target**: Throw darts into a dart board.

BABY CRYING This is done by a high-pitched voice crying into a pillow.

BASEBALL HIT WITH BAT Strike a thick, hollowed-out piece of wood with another piece of wood.

*****BELLS Church, Fight, Fire, School Bell:** These can all be made on an old automobile brake drum. Set the drum on a piece of wood so that the flange is facing up and is free to vibrate. Try striking with various wooden and metal strikers for different tones; also strike in various rhythms to get the effect of various bells. **Dinner Bell and Emergency Bell:** These are usually rung much faster than the other bells. To get the speed necessary, suspend by a cord a piece of strap iron or small-diameter pipe bent into a U shape. With a small piece of metal, rapidly strike back and forth inside the inverted horseshoe. **Electric Bells:** These may be purchased inexpensively and should be mounted on wood for greater resonance. The dry-cell setup is handy, but the batteries eventually run down. An AC setup is good but calls for an AC cord to an outlet.

BIRD CALLS Bird calls can be made by an imitator. A warbling sound that simulates the twittering of a canary can best be done with a small bird whistle of the type that holds water.

BIRD WINGS (FLAPPING) Flap flat pieces of canvas near the microphone.

*****BLOOD PRESSURE SPHYGMOMA-NOMETER** The sound of the gadget that is strapped on the arm to take blood pressure is easily simulated by placing a finger over the nozzle end of an atomizer, then rapidly squeezing the bulb. Work close to the mic on this.

BLOWS On the Head: (1) Strike a pumpkin with a mallet. (2) Strike a large melon with a wooden mallet or a short length of garden hose. (3) Strike a baseball glove with a short piece of garden hose. **On the Chin:** (1) Lightly dampen a large powder puff and slap it on the wrist close to the mic. (2) Hold a piece of sponge rubber in one hand and strike with the fist. (3) Slip on a thin leather glove and strike the bare hand with the gloved fist. (4) Hang a slab of meat and punch it with a closed fist.

BOAT Row Boat: *Oar locks:* Use real oar locks or a rusty hinge. *Rowing:* Dip a wooden paddle into a tub of water or blow lightly and rhythmically into a glass of water through a straw. **Canoe:** Sound of paddling is the same as rowing. **Ship:** *Gangplank:* Use a ratchet wrench. *Anchor:* Rattle a chain; let an object fall into a tub of water. *Flapping sails:* Flap a piece of canvas or paper near microphone. *Creaking of boat:* Twist a leather belt. *Putting up sails:* Run rope through a pulley, occasionally flap a piece of cloth.

BONES RATTLING A good effect may be produced by suspending wooden sticks with strings from a board. Manipulate the board so that the sticks clank together for the macabre illusion of rattling bones.

BOTTLE To open, (1) press two plungers together and pull suddenly apart; or (2) open mouth, snap cheek with finger.

*****BREAKING BONES** (1) Chew hard candy close to the mic. (2) Twist and crunch wooden boxes. (3) Snap small-diameter dowel rods wrapped in soft paper. (4) Snap small pieces of hardened isinglass.

*****BREAKING EGGS** Take a 6-inch square of very coarse sandpaper and fold the corners in toward the center, the rough side up. Lay in the palm of the hand and suddenly squeeze.

BREEZE Fold two sections of newspaper in half, then cut each section into parallel strips. Sway the strips gently close to the mic.

BROOK BABBLING Blow air through a

straw into a glass of water. Experiment by using varying amounts of water and by blowing at varying speeds.

BULLET For a bullet hitting a wall, strike a book with the flat side of a knife handle.

CAMERA CLICK Snap the switch on a flashlight.

CHOPPING WOOD Chop a piece of 2-by-4 wood with a small hatchet near the microphone.

CIGARETTE For lighting a cigarette, draw a toothpick against sandpaper.

*****CLOCKS** (1) Use various clocks. (2) Use a metronome for a steady beat. (3) Collect striker mechanisms for a variety of tones. (4) A cuckoo-clock effect is produced by a whistle or a small bellows mechanism. (5) Strike a suspended and undamped steel spring with a padded mallet.

COAL CARS The sound of small loaded cars approaching can be made by rolling a pair of roller skates over a piece of iron, starting off-mic and bringing them as close as desired. A little gravel sprinkled on the iron may help the effect.

*****COCKTAIL** Shake some bits of broken glass in a small amount of water in a closed coffee can.

COINS CLINKING Some coins cannot be used because they produce a high-frequency sound that may be lost in transmission. Use nickels, quarters, half-dollars, and dollars. Lead washers are used successfully sometimes.

COLLISION **Fenders Colliding**: Drop a knife into a slightly tipped tub so that the knife will rattle a little after landing. **Locomotive and Automobile**: (1) Let air out of a tire. (2) Shake broken glass in a small box. (3) Crush wooden boxes. (4) Drop a stove pipe on its end into a tub. **Old Truck and Streetcar**: Drop broken glass from a height into an empty tub that is slightly suspended.

COW BEING MILKED Squirt a water pistol into an empty metal container.

*****CRASHES** (1) Metallic crashes can be done by piling a collection of tin and metal scraps into a large tub and dumping. To get a sustained crash, shake and rattle the tub until the cue for the payoff crash. (2) Wooden crashes can be done by smashing large wooden containers close to the mic. The impact must come before the crash.

*****CREAKS** (1) Twist and squeeze a Dixie cup close to the mic. (2) Mount a rusty hinge between two blocks of wood. Twist so that the hinge binds, then slowly open or close the hinge. (3) For the creak of a ship rubbing against a wharf, rub an inflated rubber balloon close to the mic.

*****CRICKETS** Run a fingernail along the fine teeth of a pocket comb. Remember, the sound should alternate—loud then soft.

CROWDS Let several people stand at a distance from the microphone, and several closer to bring through "front" speeches. Be careful not to let the sound of the crowd increase too regularly. Film extras used to use the nonsense word **walla** to create ambient crowd sound. Today wal-lawers actually engage in conversation for a more realistic ambient crowd sound. Take care, however, not to have the conversations intelligible or call attention to themselves.

*****CURTAINS** The principal sound of drawn curtains is the sound of rings sliding on rod, not the fabric. String several washers or wooden or metal rings on a 2-foot length of dowel or metal rod. Space the rings evenly apart, then sweep them together from one end to the other.

DESTRUCTION NOISES General destruction noises can be simulated by crushing and breaking wooden boxes close to the microphone. In the background you may

want the sound of breaking glass (drop a box filled with broken glass).

*DIGGING AND SHOVELING Fill a small wooden box with several inches of dirt and add several small rocks for realism. Use a small shovel or fireplace ash scoop. Force the shovel into the dirt with a slanting motion. The bottom of the box (inside) should be covered with an old piece of carpet to cut down on wood resonance.

DISHES Use whole dishes in a natural way. The common advice to shake or rattle broken pieces does not prove satisfactory. For washing dishes, swish dishes in water.

DOORBELL Use a real doorbell.

DOOR KNOCKER Screw one side of a large door hinge to a block of wood. Rap the wood with the loose wing of the hinge.

*DOORS Squeaky Door: Use rusty hinges, if possible, attached to a miniature door, or twist a leather belt or billfold. Some old wooden chairs will give the squeak you need. Smashing Door: Crush a wooden box. Closing Door: Use a miniature or close a real door very lightly. Have regulation catches attached to the miniature. Iron Door: For the hollow clang of iron doors opening, draw an iron skate over an iron plate. Rattling a heavy chain and a key in a lock adds to the effect. The principal sound heard on a door close or open comes from the lock and jamb. Half-size doors may be built, paying particular attention to the hardware for different types. Elevator Door: Run a roller skate over a long, flat piece of metal. Jail Door: The characteristic sound of an iron door is the noise when it clangs shut. For this, clang two flat pieces of metal together, then let one slide along the other for a moment, signifying the bar sliding into place. Screen Door: The distinctive sound comes from the spring and the rattle of the screen on the slam. Secure an old spring, slap it against a piece of wood, then rattle a window screen. Or use a miniature, including screen and catches. Stone Doors: Slide a large block of cement on a large flat slab of cement. At the end of the slide, tip the block to one side and then let it fall back. This signifies the close of the door. Swinging Doors: These can be simulated by swinging a real door back and forth between the hands. Let the free edge strike the heels of the hands. Watch the timing.

*DRAWERS Slide two pieces of wood together. Put a small crosspiece on one so that the other will hit it at the end of the slide, indicating the close.

*ECHOES (1) Suspend a solid wastepaper basket or any other good-sized container horizontally so that the open end faces the diaphragm of the microphone. The performer then stands behind the mic so that most of his or her voice goes into the container and then is reflected back into the microphone. (That part of the voice which is reflected lags enough behind the sound waves that go directly into the microphone to give a muffled hollow effect.) (2) To give the voice a hollow ghostlike sound, place one end of a 10-foot length of 2-inch pipe about 2 feet from the microphone. The performer will then speak into his or her hands, which have been cupped over the other end of the pipe.

*ELECTRIC MOTORS (1) Remove the bag from a vacuum cleaner and run the motor. (2) Use an electric mixer or juicer. (3) Sometimes a hair dryer sounds satisfactory.

*ELECTRIC SPARK Rub two blocks of sandpaper-covered wood together in one long, fast stroke.

ENGINES A toy steam engine operated near the mic gives a fairly good imitation of a large steam engine.

FALLING BODY (1) Dropping a squash provides the dull, sickening thud of a body hurtling to the sidewalk. (2) By dropping a sack half filled with sand on the studio floor, you can produce the sound of a body or a heavy object falling to the ground or floor.

*FALLING INTO WATER** The important thing is to get the impact of the hit on the surface of the water. To simulate this effect, however, reverse the procedure this way. Secure a large washtub or wooden tub. Fill it about three-quarters full of water. Get a very large can or a bucket. Sink the bucket until it is full of water, then turn it over but keep it submerged. With the bottom side up, yank it sharply out of the tub. If it is necessary to keep the hands dry, get a 3-foot length of pipe and at one end fasten a round disc of wood about 1 foot in diameter. Place the end with the wood in the bottom of the tub, then yank sharply upward.

FIRE (1) Crumple stiff paper or cellophane near the mic or pour salt from a shaker on stiff paper. (2) For the roar of flames, blow lightly through a soda straw into liquid at the mic. (3) The breaking of the stems of broom straws or the crushing of wrapping paper gives various effects of crackling fire.

FIRE ENGINES Use sirens, horns, clanging bells, and the like.

*FISHING** (1) To indicate fishing, use the occasional "sing" of the reel. Clamp the reel to some surface near the mic, then take the string and rapidly run it out as needed. (2) To indicate a caught fish, flop about an empty hot-water bottle or a folded inner tube.

FLOOD Blow into a glass of water through a soda straw.

*FOOTSTEPS** **Cement:** Use hard-heeled shoes on composition stone. **Gravel:** Fill a long shallow box with gravel and have someone actually walk on it. **Leaves:** Stir corn flakes in a small cardboard box with fingers. Match the rhythm of walking. **Mud:** In a large wash pan, place several crumpled and shredded newspapers. Paper towels work fine. Leave very little water in the pan. Simulate walking by using the palm of the hand for footsteps. **Snow:** Squeeze a box of cornstarch with the fingers in the proper rhythm. The effect works better if cornstarch is put into a chamois bag. **Stairs:** Use just the ball of the foot in a forward sliding motion. Do not use the heel.

*GAMBLING SOUNDS** (1) Use cards and chips. (2) For a crap table, roll dice inside an open violin case.

*GEIGER COUNTER** Twist the knob of a heavy spring lock.

*GLASS CRASHES** Place an accumulation of broken glass and crockery in a flour sack. Drop it on the floor and then shake.

GLASSES The clinking of glasses can be made by setting glasses down on wood at intervals. Water poured into them gives the effect of a bartender filling them up.

GUN COCK (1) Use a real weapon, unloaded. (2) For pistol, snap open a pair of pliers.

HAIL Drop rice onto glass, tin, or a thin board.

HANDCUFFS To lock or unlock, turn the key in a flimsy padlock, or scrape a nail against a hinge or another nail or piece of metal.

*HAND PRESS** A small hand-operated printing press may be simulated by holding a wooden folding chair by the back and rhythmically opening and closing the seat of the chair. An old rattly chair works best. This same effect may be used for a hand loom.

HARNESS Rattle a belt buckle.

HINGES SQUEAKING Squeaking noises can be made by turning wooden pegs in holes drilled in a block of wood to make a snug fit; twisting a cork in the mouth of a bottle; or twisting a piece of leather.

HOOF BEATS Horse on a Hard Road: A pair of coconut shells clapped together in proper rhythm gives the "clippety-clop" sound. **Horse Crossing Bridge:** Hold mouth open, snap cheeks with fingers. **Horse on Soft Ground or Turf:** Rubber suction cups or half coconut shells clapped slowly in a box containing earth give a very satisfactory effect. Eraser on a pencil bounced on a book also gives a good sound.

HORSE AND WAGON Run roller skates over fine gravel sprinkled on a blotter of beaverboard.

ICE CRACKLING Styrofoam crumpled near a mic gives the effect of crackling ice.

ICE JAM CREAKING Twist an inflated balloon.

KEY GRATING If possible, use a large key in an actual lock. The more rusty the lock, the better.

*****KNIFE THROW** The sound of a knife being thrown and hitting the wall a couple of inches from the hero is done in three parts: (1) The flight through the air is done by a swish stick. (2) The thud of the knife hitting is done by sharply stabbing a bayonet or large heavy knife into a block of soft wood. (3) The quiver of the knife after it hits is made by placing a flexible table knife on a flat wooden surface or table so that about 2 inches of the blade rests on the table, with the rest of the blade and handle extending over the edge. Press the table end of the knife firmly against the table, then sharply hit the free end so that it will vibrate. Practice will determine the right pressure on the blade and the amount of overlap on the table. The three steps must be done very rapidly.

LETTER To open, tear a piece of paper.

LIGHT SWITCH Snap fingers or use an old light switch.

LOCKS Use real locks or a nail against a hinge.

MACHINERY, HEAVY (1) A motor mounted on a light board and placed close to the mic gives the effect of much larger mechanisms at work. (2) Run roller skates across a desk or table. (3) Roll a heavy can on a table. (4) Fasten a wooden wheel with rough edges in a frame. Turn it by an attached handle, and grind this against wood. (5) Use a lawnmower.

MOTORBOAT Certain rattles of the ratchet type used on Halloween if operated slowly and near the mic produce a satisfactory sound of a motorboat.

*****PHONE BOOTH DOOR** Unfold and fold the leg of a metal card table.

PORCH SWING Rock an old swivel chair rhythmically.

*****POURING A DRINK** (1) Always touch the edge of the glass with the bottle to establish the sound. (2) For a comedy effect, use the long glass tube that covers the paper cups on a water cooler. A pitcher of water used with this tube gives a terrifically big drink.

RAIN (1) For mild rain, rub the microphone stand with excelsior. (2) Let salt or fine sand slip through fingers or through a funnel onto cellophane, or pour water from a sprinkling can into a tub with some water already in it.

RAPPING Strike a desk with an ordinary gavel.

RIVETING MACHINE Hold stiff paper firmly against the blades of a cheap fan.

ROAR OF RIVER Fill a large washtub half full of water and draw a flat paddle

through the water. A little experimenting will determine the speed and vigor necessary to give the proper volume and quality of sound. As a precaution against getting a metallic sound, line the tub with a piece of canvas.

*ROBOT For a robot walking, use a 3-by-5 metal file case. Hold it in a vertical position with the open end up, and bang it against a walking surface in a slow definite rhythm. Leave the drawer in the case.

ROCK CRASHING Drop rocks onto other rocks in a box. To lengthen a crashing sound, have more than one person drop the stones.

*ROULETTE WHEEL (1) A toy or party roulette wheel works very well. (2) To improvise, cut a circular piece the size of a biscuit cutter out of the bottom of a large wooden salad bowl. Insert a tin biscuit cutter open side up in the hole. Place a marble in the wooden bowl and rotate briskly. On cue, slow down the speed of the rotation and allow the marble to drop into the biscuit cutter.

SHIP Moving Ship: Twist the resined screw handle of a broom into and out of a socket; flap a cloth lightly for a sailboat. Ship Sailing on Water: With a little ingenuity, you can rotate an ordinary hair brush on the surface of a bass drum to give the sound of the waves breaking away from the boat. Ship Signal Bells: Pull back the hammer of a doorbell and snap.

SHOTS (1) Close a book smartly. (2) Shots are usually done with a small tambourine-like frame with a membrane, to which is attached a pliable metal spatula. When the spatula is bent back away from the membrane and then quickly snapped against it, the sound is like a shot. (3) Another good way is to strike a padded leather cushion with a thin, flat stick or with a

whip. (4) Prick a balloon with a pin. (5) A shot similar to that of heavy artillery may be produced on a bass drum or tympani. (6) If the whistling sound of the bullet or shell is desired, it may be produced vocally by whistling close to the mic.

SHUTTERS (1) To close, drop a small board lightly against a wooden box. (2) To flap, at irregular intervals, slam two pieces of wood together twice.

SIDEWALK To walk on a sidewalk, sprinkle fine gravel lightly on a blotter, walk lightly.

*SIZZLE To get the sound of a sizzle like someone backing into a hot stove, put a heated electric iron into a very shallow pan of water. The same may be done with a soldering iron. (Unplug it first.)

SLAP A slap is easily made by slapping the hands together. Be careful not to get this too close to the mic, or it will sound like an explosion.

SNOW For walking in snow, squeeze cornstarch in a gloved hand.

SPLASH Drop a flat block of wood into a tub of water off-mic.

*SQUEAKS (1) Twist a leather wallet close to the mic. (2) Use a squeaky swivel office chair. (3) Twist a Dixie cup in a sideways motion. (4) Draw a violin bow across the edge of a Styrofoam container. (5) Twist a dampened tight-fitting cork in a bottle.

*SQUEAL The dominant sound of a squeal is caused by friction. (1) Twist a metal cup (like the top of a thermos jug) on an unglazed pottery plate. (2) Twist and scrape various bits of metal against metal.

SUBWAY TURNSTILE Use a ratchet wrench.

*SURF (1) Rub a stiff scrubbing brush with a rotary motion over the head of a drum or tympani. (2) Also try rolling a few beans on a window screen or drum head.

(3) A splash cradle could be used for this effect. It consists of a watertight box mounted on rockers and containing 2 or 3 inches of water. Rock the cradle back and forth slowly, allowing the water to swish from side to side.

SWORD (1) Clash and scrape knives. (2) A dueling scene can be made more convincing by clashing iron rods together.

TELEGRAPH INSTRUMENTS Use real ones or use a manual typewriter. In using a telegraph key, remember that sending an intelligible message as part of a radio broadcast is prohibited by law.

TELEPHONE Filter frequencies below 400 Hz and above 4,000 Hz.

THRESHING MACHINE Use roller skates, motor, electric fan, geared motor, or other metallic sounds combined with a baby rattle.

THUNDER (1) Rumble a large sheet of tin easily. (2) Beat stiff parchment, stretched on a frame, with a bass drum stick.

TIME BOMB Use a ticking alarm clock.

TOM-TOM (1) Beat the end of an oatmeal box with a dull instrument. (2) Beat a tambourine or drum dully. (3) Beat stiff parchment on a frame.

UNDERBRUSH NOISES Twisting a bundle of straw, excelsior, or recording tape near the mic gives the effect of something astir in the underbrush.

WAGON Move a box filled with loose blocks of wood.

WATERFALL (1) Rustle tissue paper. (2) Tear paper evenly. (3) Blow through a straw into a glass of water. (4) Let water fall from a small hose into a tub. (5) Pour water evenly from a teakettle.

*__WHIP CRACK__ Sharply slap two thin boards together.

WHISTLE For a steamboat whistle, there are square boxlike whistles about a foot long on the market that are used in major studios for this effect. If one of these is not available, try cupping your hands over your mouth and making a "who-o-ing" sound several times some distance off-mic to simulate this effect. Also, by blowing into an ordinary section of pipe held just below the lower lip, a ship's whistle may be effected. Of course, the "blower" must vocalize the correct tone while blowing.

WIND A flywheel of wands rotated by a high-speed electric motor gives a fairly good effect.

*__WINDOW__ Slide one block of wood on another.

WOOD SPLINTERING Crush wooden boxes or crates.

Glossary

AachenHEAD Binaural System Binaural recording system that includes an artificial head with the contours of the human head and shoulders, two highly sensitive capacitor microphones in each ear canal entrance, a binaural mixing console, and a HEADphone playback system.

Accent miking A microphone placed close to a sound source to supplement the mix from distant microphones with added presence and balance.

Acoustical phase The time relationship between two or more sound waves at a given point in their cycles.

Acoustics The science that deals with the behavior of sound and sound control. The sound qualities of a studio.

Active crossover network A crossover network in which the crossover precedes the power amplifier. *See also* **Passive crossover network.**

Additive ambience When the ambience of each track becomes cumulative in mixing a multitrack recording.

Address track The track on videotape (usually in the 1-inch C and ¾-inch formats) that contains the control data and is recorded at the same time picture is recorded.

Air loss The friction of air molecules as sound waves move across distance through an elastic medium that causes their conversion to heat.

Ambience Sounds such as reverberation, noise, and atmosphere that form a background to the main sound.

Ambience microphone A microphone placed far enough from the sound source to pick up ambience for mixing with the sound picked up by the main mics placed in the close sound field.

Ambisonic Term to describe the Soundfield microphone's "surround sound" pickup.

A-mode (or sequential) assembly Editing videotape in sequential order. *See also* **B-mode assembly.**

Amplifier A device that boosts the power of an electric signal.

Amplitude The magnitude of a sound wave or electric signal.

Amplitude processor A signal processor that affects a sound's dynamic range.

Analog recording A method of recording in which the wave form of the recorded signal resembles the wave form of the original signal.

Anti-aliasing Filtering of erroneous frequencies created during analog-to-digital conversion.

Assemble editing Dubbing segments from one tape or tapes to another tape in sequential order.

Attack (1) The way a sound begins—that is, by plucking, bowing, striking, blowing, etc. (2) The first part of the sound envelope.

Attack time The length of time it takes a limiter or compressor to respond to the input signal.

Attenuator Another term for potentiometer, fader, gain control, or loudness control.

Audition (1) A system on the console through which sound can be fed and heard without its going on the air. (2) A talent tryout.

Auditory canal The channel that directs sound from the outer ear to the eardrum.

Auditory nerve The nerve in the inner ear that transmits sound waves to the brain.

Auto-locator A device that makes it possible to control a tape recorder's transport to stop, start, go to, and locate specified positions on a tape recording.

Automated dialogue replacement (ADR) A technique and device used to rerecord dialogue in synchronization with picture in postproduction. The picture is automatically replayed in short "loops" again and again so the performers can synchronize their lip movements with the lip movements in the picture before dialogue recording.

Automatic dialogue replacement *See* **Automated dialogue replacement.**

Automatic double tracking (ADT) *See* **Doubling.**

Azimuth Alignment of the record and playback heads so that their centerlines are parallel to each other and at right angles to the direction of the tape motion passing across the heads.

Backtiming Method of subtracting the time of a program segment from the total time of a program so that the segment and the program end at the same time.

Balanced line A line (or circuit) with two conductors of equal voltage.

Band-pass filter A filter that attenuates above and below a selected bandwidth, allowing the frequencies between to pass.

Bandwidth The difference between the upper and lower frequency limits of an audio component. The upper and lower frequency limits of AM radio are 535 and 1,605 kHz; therefore, the bandwidth of AM radio is 1,070 kHz.

Bandwidth curve The curve shaped by the number of frequencies in a bandwidth and their relative increase or decrease in level. A bandwidth of 100 to 150 Hz with 125 Hz boosted 15 dB forms a sharp, narrow bandwidth curve; a bandwidth of 100 to 6,400 Hz with a 15-dB boost at 1,200 Hz forms a more sloping, wider bandwidth curve.

Basilar membrane Structure in the inner ear whose vibrations stimulate the hair cells, producing nerve impulses that carry sound information to the brain.

Bass The low range of the audible frequency spectrum; usually from 20 to 320 Hz.

Bass roll-off Attenuating bass frequencies. The control—for example, on a microphone—used to roll off bass frequencies.

Bass trap A diaphragmatic absorber that absorbs low-frequency sound waves. *See also* **Diaphragmatic absorber.**

Biamplification Dividing the audio bandwidth with a separate amplifier for low and high frequencies.

Bias current An extremely high-frequency AC current, far beyond audibility, added during a tape recording to linearize the magnetic information.

Bidirectional microphone A microphone that picks up sound to its front and back and is dead at its sides.

Binaural hearing Hearing with two ears attached to and separated by the head.

Binaural microphone head Two omnidirectional capacitor microphones set into the ear cavities of an artificial head, complete with pinnas. This arrangement preserves binaural localization cues during recording and reproduces sound as humans hear it, three-dimensionally. *See also* **AachenHEAD.**

Binaural sound Sound recorded using the binaural microphone head, or a similar miking arrangement, and reproduced through two separate headphone channels.

Blast filter *See* **Pop filter.**

Blocking Plotting performer, camera, and microphone placements and movements in a production.

Blumlein technique In stereo miking, placing two bidirectional microphones at a 90-degree angle to each other.

B-mode (or **checkerboard**) **assembly** Performing all edits from one videotape reel before moving onto the next reel. *See also* **A-mode assembly.**

Board Audio mixing console.

Boom A long, counterbalanced, projectable steel pole mounted on a special tripod or pedestal with a microphone on one end and an operator at the other end.

Boost An increase in level.

Bounce tracks To transfer two or more previously recorded tape tracks to a single track, thus allowing rerecording on the previously used tracks.

Boundary microphone A microphone whose capsule is mounted flush with or close to, but a precise distance from, a reflective surface so that there is no phase cancellation of reflected sound at audible frequencies.

Bulk eraser A demagnetizer used to erase an entire roll of magnetic tape without removing it from its reel. Also known as a **degausser.**

Bus A mixing network that combines the outputs of other channels.

Calibration Adjusting equipment—for example, a console and a tape recorder—according to a standard so that their measurements are similar.

Camcorder A handheld video camera with a built-in or dockable videotape recorder.

Canned Any audio that sounds obviously recorded.

Capacitor A device capable of storing an electric charge.

Capacitor microphone A microphone that transduces acoustic energy into electric energy electrostatically.

Capstan The shaft that rotates against the tape, pulling it across the heads at a constant speed.

Cardioid microphone A unidirectional microphone with a heart-shaped pickup pattern.

Cartridge The plastic housing for a disc or continuous-loop tape.

Cartridge disc recorder A device specially designed to record and/or reproduce sound on a compact disc or 3½ inch floppy disk.

Cartridge tape A continuous-loop audiotape or videotape.

Cartridge tape recorder A device specially designed to record and/or reproduce sound or sound and picture on a cartridge tape.

Cassette tape A reel-to-reel audiotape or videotape enclosed in a plastic container.

Cassette tape recorder An audiotape or videotape recorder specially designed to play cassette tape.

CD *See* **Compact disc.**

CD-E Erasable compact disc.

CD-MO Magneto-optical compact disc.

CD-R Recordable compact disc.

CD-WO Write-once compact disc.

Cement splicer A splicer used to bond film splices permanently.

Center frequency The frequency at which maximum boost or cut occurs.

Ceramic microphone A low-quality, high-impedance microphone with a ceramic element.

Channel A conduit through which the signal flows.

Channel message A channel message applies to the specific MIDI channel named in the message. It gives information on whether an instrument should send or receive and on which channel, when a note event begins and ends, and other control information. *See also* **System message.**

Checkerboard assembly *See* **B-mode assembly.**

Chorus effect Recirculating the doubling effect to make one sound source sound like several. *See also* **Doubling.**

Clapslate A slate used in synchronizing sound and picture during filming and editing. The slate carries information such as scene and take number, production title, location of shot—e.g., indoors or outdoors, and, in some models, time code. A pair of hinged boards on top of the slate clap together producing the sound that is used to synchronize picture and sound.

Click track A specially recorded track of rhythmic measurements used to maintain the beat and timing of musicians or conductor. In film and television sound the click track is applied to the audio recording to facilitate synchronization of the musical tempo with the visual action or frame rate.

Close miking Placing a microphone close to a sound source to pick up mostly direct sound and reduce ambience and leakage.

Cochlea Snail-shaped organ of hearing in the inner ear that transduces mechanical vibration into electrical neurological signals.

Coding Converting voltages into binary digits (bits) composed of a series of pulses.

Coercivity The magnetic force field necessary to reduce a tape from saturation to full erasure. This value is expressed in oersteds.

Coincident microphones Two microphones, usually unidirectional, crossed one above the other on a vertical axis with their diaphragms.

Combining amplifier An amplifier that combines two or more signals before routing them to their destination.

Combining network A network that combines two or more signals before routing them to their destination.

Commentative sound Descriptive sound that makes a comment or interpretation.

Compact disc (CD) A digitally encoded disc 4.7 inches in diameter, capable of containing more than 60 minutes of audio, that is encoded and read out by a laser beam.

Compact disc player A disc player that reads out the encoded digital information of a compact disc by means of a laser beam.

Compander Contraction of the words *compressor* and *expander* that refers to the devices that compress an input signal and expand an output signal to reduce noise. Also refers to a noise reducer.

Compression (1) Reducing a signal's output level in relation to its input level to reduce dynamic range. (2) Drawing together of vibrating molecules, thus producing a high-pressure area. *See also* **Rarefaction.**

Compression ratio The ratio of the input and output signals in a compressor.

Compression threshold The level at which a compressor acts on an input signal and the compression ratio takes effect.

Compressor A signal processor with an output level that decreases as its input level increases.

Concert reinforcement Area of sound design concerned with music performance before an audience.

Condenser microphone *See* **Capacitor microphone.**

Console An electronic device that amplifies, processes, and combines input signals and routes them to broadcast or recording.

Constructive interference When sound waves are partially out of phase, and partially additive, increasing amplitude where compression and rarefaction occur at the same time.

Contact microphone A microphone that attaches to a sound source and transduces the vibrations that pass through it.

Contrapuntal narration Juxtaposes narration and action to make a statement not carried by either element alone.

Control room Room used by the audio operator, who is sometimes the performer, or the director and staff to control and process audio and video signals during a production.

Control room, postproduction *See* **Postproduction studio.**

Control track The track on a videotape that controls and synchronizes the video frames. It is essential for videotape editing.

Copyright The exclusive legal right of an author, composer, playwright, publisher, or distributor to publish, produce, sell, or distribute his or her work.

Coverage angle The off-axis angle or point at which loudspeaker level is down 6 dB compared to the on-axis output level.

Critical distance The point in an enclosed space where the direct and reverberant fields are at equal level.

Crossfade Fading in one sound source as another sound source fades out. At some point the sounds cross at an equal level of loudness.

Crossover frequency The frequency at which the high frequencies are routed to the tweeter(s) and the low frequencies are routed to the woofer(s).

Crossover network The device that separates the high and low frequencies for routing to the tweeter(s) and woofer(s). *See also* **Active, Passive crossover network.**

Crosstalk Unwanted signal leakage from one signal path to another.

Crystal microphone A low-quality, high impedance microphone with a crystal element.

Crystal synchronization Synchronizing the operating speeds of a film camera and an audiotape recorder by using a crystal oscillator in both camera and recorder. The oscillator generates a sync pulse tone.

Cue (1) To prepare a disc or tape for playback and to start at the first point of sound. (2) A verbal command or hand signal to begin. *See also* **Audition.**

Cue tone A pulse recorded onto a cartridge tape that stops the tape, after recueing, at the beginning of the recording.

Cue track The track on videotape used to record the information that codes the video frames for editing.

Cut (1) An instantaneous transition from one sound or picture to another. (2) To make a disc recording. (3) A decrease in level.

Cut-and-splice editing Editing tape or film by physically cutting the material and joining the cut ends with splicing tape. The term is also used in computer hard disk editing when segments are removed

and joined, although there is no physical cutting and splicing of the material.

Cycles per second *See* **Hertz.**

Damping Suppressing vibration (usually unwanted vibration such as ringing or buzzing) with a physical restraint.

DASH format *See* **Digital Audio Stationary Head format.**

Dead rolling (or **dead potting**) Starting a disc or tape with the fader turned down all the way.

Decay The decrease in amplitude after a stimulus has been removed from a vibrating object.

Decay, rate of The evenness or unevenness with which a sound decays.

Decay time *See* **Reverberation time.**

Decibel A relative and dimensionless unit to measure the ratio of two quantities.

De-esser A compressor that reduces sibilance.

Defined region The section of a samplefile that has been selected for editing.

Degausser *See* **Bulk eraser.**

Delay The time interval between a sound or signal and each of its repeats.

Descriptive sound Describes sonic aspects of a scene not connected to the main action.

Destructive editing Permanently alters the original sound or soundfile. *See also* **Nondestructive editing.**

Destructive interference When sound waves are partially out of phase, and partially subtractive, decreasing amplitude where compression and rarefaction occur at different times.

Dialogue looping *See* **Automated dialogue replacement.**

Dialogue rerecording (or **looping**) **studio** A studio in which dialogue is rerecorded and synchronized to picture. *See also* **Automated dialogue replacement.**

Diaphragmatic absorber A flexible panel mounted over an air space that resonates at a frequency (or frequencies) determined by the stiffness of the panel and the size of the air space.

Diffraction The spreading or bending around of sound waves as they pass an object.

Diffusion The scattering of sound waves.

Digital Audio Stationary Head format (DASH) A format agreed to by Sony, Studer, TEAC, and Matsushita to standardize digital recording.

Digital cartridge system *See* **Cartridge disc recorder.**

Digital recording A method of recording in which samples of the original analog signal are encoded on tape as pulses and then decoded during playback.

Digital signal processing (DSP) In hard disk recording or editing, digital signal processing of audio through the use of algorithms (programs that perform complex calculations according to a set of controlled parameters).

DIN microphone array A stereo microphone array in which the two microphones are at a 90-degree angle and just under 8 inches apart. DIN stands for Deutsche Industrie Normen — German Industrial Standards.

Direct box A device that matches impedances by converting a high-impedance, unbalanced signal into a low-impedance, balanced signal. Used to connect an amplified instrument directly to the microphone input of the console.

Direct insertion (D.I.) Taking the signal from an electric instrument and plugging it directly into the console.

Directional microphone Any microphone that picks up sound from one direction.

Direct narration Describes what is being seen or heard.

Direct sound Sound waves that reach the listener before reflecting off any surface.

Discrete stereo *See* **Stereophonic sound, Synthesized stereo.**

Disk-based audio recording Using a computer disk or CD, instead of tape, to record sonic data.

Distant miking Placing a microphone(s) far enough from the sound source to pick up most or all of an ensemble's blended sound including room reflections. *See also* **Close miking.**

Distortion The appearance of a signal in the reproduced sound that was not in the original sound. *See also* **Harmonic distortion, Intermodulation distortion, Loudness** (or **overload**) **distortion, Transient distortion.**

Diversity receiver Multiple antenna receiving system for use with wireless microphones. *See also* **Nondiversity receiver.**

Dolby Stereo™ The recording system used for surround sound film tracks.

Dolby Surround™ The playback system for Dolby Stereo. ™

Donut An announcement in which music is established, faded under the announcer, and reestablished after the announcer finishes reading the copy.

Doppler effect The perceived increase or decrease in frequency as a sound source moves closer or farther from the listener.

Double-ended noise reduction Two-step noise reduction that prevents noise from entering a signal by compressing it during recording and expanding it during playback. *See also* **Single-ended noise reduction.**

Double-system recording Filming sound and picture simultaneously but separately with a camera and a tape recorder. *See also* **Crystal synchronization.**

Doubling Mixing slightly delayed signals (15−35 milliseconds) with the original signal to create a fuller, stronger, more ambient sound. *See also* **Chorus effect.**

Dropout (1) A sudden attenuation of sound or loss of picture due to an imperfection in the magnetic coating. (2) Sudden attenuation in a wireless microphone signal due to an obstruction or some other interference.

Dry sound A sound devoid of reverberation. *See also* **Wet sound.**

Dual-entry ports Two ports in a directional microphone tuned to cancel low and high frequencies from unwanted directions.

Dubbing Transferring sound from tape or disc to another tape or disc.

Duration How long a sound lasts before another sound occurs or until it falls to silence.

Dynamic microphone A microphone that transduces energy electromagnetically. Moving-coil and ribbon microphones are dynamic.

Dynamic range The range between the quietest and loudest sounds a sound source can produce without distortion.

Early reflections Reflections of the original sound that arrive at the listener within 10 to 20 milliseconds.

Echo Sound reflections of 50 milliseconds or greater that are perceived more and more as discrete repetitions of the direct sound.

Echo chamber More accurately a reverberation chamber, it is a specially built room with reflectant surfaces and a loudspeaker through which sound feeds, reverberates, and is picked up by a microphone that feeds the reverberant sound back into the console.

Edit control The control on a tape recorder that disengages the take-up reel but keeps the rest of the tape transport system working, thus enabling unwanted tape to spill off the machine.

Edit controller A device that connects to a playback and edit/record tape recorder and automatically controls their operation

in preroll cueing, edit auditioning, and performing the edit by punching in and punching out.

Edit decision list (EDL) A list of edits, computer- or handwritten, used to assemble a production.

Editing The process of adding to, subtracting from, or rearranging material on a tape or disc recording.

EFP *See* **Electronic field production**.

Elasticity The capacity to return to the original shape or place after deflection or displacement.

Electret microphone A capacitor microphone with a permanently charged element.

Electrical phase The relative polarity of two signals in the same circuit.

Electronic editing Editing by dubbing from a playback or "master" tape or disk recorder to a record/edit or "slave" tape or disk recorder.

Electronic enhancement In a concert hall or theater, a system of microphones and small loudspeakers strategically located to ensure uniform sound dispersion.

Electronic field production (EFP) Video production done on location involving program materials that take some time to produce.

Electronic news gathering (ENG) Video production done on location, sometimes taped and sometimes live, but usually with a news-type deadline.

Emulsion The light-sensitive coating on film that produces the image.

ENG *See* **Electronic news gathering**.

Equalization (EQ) Altering the frequency/amplitude response of a sound source or sound system.

Equalizer A signal-processing device that can boost, attenuate, or shelve frequencies in a sound source or sound system.

Equal loudness curves Graphs that indicate the sensitivity of the human ear to various frequencies at different loudness levels. Also known as Fletcher-Munson curves. *See also* **Robinson-Dadson curves**.

Equal loudness principle The principle that confirms the human ear's nonlinear sensitivity to all audible frequencies: that midrange frequencies are perceived with greatest intensity and that bass and treble frequencies are perceived with lesser intensity.

Erase head Electromagnetic transducer on a tape recorder that automatically demagnetizes a tape before it reaches the record head when the recorder is in the record mode.

Ergonomics Designing an engineering system with human convenience in mind.

Expander An amplifier whose gain decreases as its input level decreases.

Fade-in Gradually increasing the loudness of a signal level from silence (or from "black" in video).

Fade-out Gradually decreasing the loudness of a signal level to silence (or to "black" in video).

Fade-out–fade-in A transition usually indicating a marked change in time, locale, continuity of action, and other features.

Fader A device containing a resistor that is used to vary the output voltage of a circuit or component.

Faulkner microphone array A stereo microphone array that uses two bidirectional mics spaced just under 8 inches apart and facing directly toward the ensemble.

Feedback A loud squeal or howl caused when the sound from a loudspeaker is picked up by a nearby microphone and reamplified. Also caused when an output is fed back into its input.

Fill miking *See* **Accent miking**.

Film A flexible, cellulose-base material with a light-sensitive emulsion containing

sprocket holes. *See also* **Magnetic film, Multistripe film, Silent film, Sound film.**

Filter An electric network that attenuates a selected frequency or band of frequencies above, below, or at a preset point.

Fishpole boom A handheld boom containing a lightweight, aluminum, telescoping tub with a microphone mount at one end.

Fixed-frequency equalizer An equalizer with several fixed frequencies usually grouped in two (high and low) or three (high, middle, and low) ranges of the frequency spectrum.

Flanging Combining a direct signal and the same signal slightly delayed, and continuously varying their time relationships.

Flat Frequency response in an audio system that reproduces a signal between 20 and 20,000 Hz (or between any two specified frequencies) that varies no more than 3 dB.

Floor plan A scale drawing of a studio showing the location of cameras, microphones, lights, sets, and props for a production.

Flutter Generally the result of friction between the tape and heads or guides resulting in loudness changes. *See also* **Wow.**

Flutter echoes Echoes between parallel walls that occur in rapid series.

FM microphone Wireless microphone.

Foldback The system in a multichannel console that permits the routing of sound through a headphone monitor feed to performers in the studio.

Foley stage An area containing various types of surfaces and physical objects used to create and record sound effects.

Footage counter An indicator on a tape recorder that displays the amount of tape that has been used. It may or may not measure in actual feet. *See also* **Tape timer.**

Format (1) Physical specifications of hardware and software. (2) The selection and order of materials a station broadcasts to appeal to a particular audience.

Four-way system loudspeaker A loudspeaker that divides the high frequencies in two and the low frequencies in two.

Freewheel A mode in a synchronizer that allows stretches of poorly encoded time code to be passed over without altering the speed of the slave tape recorder's transport.

Frequency The number of times per second that a sound source vibrates. Now expressed in hertz (Hz); formerly expressed in cycles per second (cps).

Frequency response A measure of an audio system's ability to reproduce a range of frequencies with the same relative loudness; usually represented in a graph.

Fundamental The lowest frequency a sound source can produce. Also called "primary frequency" and "first harmonic."

Gauss A unit that measures the amount of magnetization remaining on a tape after erasure.

Graphic equalizer An equalizer with sliding controls that gives a graphic representation of the response curve chosen.

Guard band The space between tracks on an audiotape recorder head to reduce crosstalk.

Haas effect The tendency to perceive the direct and immediate repetitions of a sound as coming from the same position or direction even if the immediate repetitions coming from another direction are louder. Also known as the precedence effect.

Hard wired Description of pieces of equipment wired to each other. *See also* **Patch panel.**

Harmonic distortion Nonlinear distortion caused when an audio system introduces harmonics to a signal at the output that were not present at the input.

Harmonics Frequencies that are multiples of the fundamental.

Headphones A pair of electro-acoustical transducers held to the ears by a plastic or metal headband. They may be mono or stereo, or switchable between the two formats.

Headroom The amount of increase in loudness level that a tape, amplifier, or other piece of equipment can take, above working level, before overload distortion.

Headset microphone A microphone attached to a pair of headphones; one headphone channel feeds the program and the other headphone channel feeds the director's cues.

Heads out Having the program information at the head or outside of the reel of tape or film ready for playback or projection.

Headstack A multitrack tape head.

Height One of the adjustments made when aligning the heads on an audiotape recorder. This adjustment aligns the height of the heads with the recording tape.

Helical videotape recording Videotape recording that uses one or more rotating video heads that engage the tape wrapped at least partially around the head drum. Video is recorded in slanted tracks across most of the tape's width. Also known as "slant track recording."

Helmholtz resonator A resonator designed to absorb specific frequencies depending on size, shape, and enclosed volume of air. The enclosed volume of air is connected to the air in the room by a narrow opening or neck. When resonant frequencies reach the neck of the enclosure, the air inside cancels those frequencies.

Hertz Unit of measurement of frequency; numerically equal to cycles per second.

High end The treble range of the frequency spectrum.

High-output tape High-sensitivity tape.

High-pass (low-cut) filter A filter that attenuates frequencies below a selected fre-

quency and allows those above that point to pass.

Humbuck coil A circuit built into a microphone to reduce hum pickup.

Hypercardioid microphone Unidirectional microphone that has a narrow angle of sound acceptance at the front, is off-axis at the sides, and is more sensitive at the rear than a supercardioid mic.

IEC standard The time code standard for R-DAT recording.

IFB (Interruptible foldback) A communications system that allows communication from the producer or director with the talent while on the air.

Impedance Resistance to the flow of alternating current (AC) in an electric system, measured in ohms. A low-impedance microphone has an impedance of roughly 50 to 300 ohms. A high-impedance microphone has an impedance of 10,000 ohms and up.

Indirect narration Describes something other than what is being seen or heard.

Indirect sound Sound waves that reflect from one or more surfaces before reaching the listener.

In-line console A console in which a channel's input, output, and monitor functions are placed in-line at the location that is associated with the input fader on first-generation multichannel consoles.

Inner ear The part of the ear that contains the auditory nerve, which transmits sound waves to the brain.

Input (1) The point to which signals feed into a component or sound system. (2) Feeding a signal to a component or sound system.

Input/output (I/O) module On a console, a module containing input, output, and monitor controls for a single channel.

Insert editing In electronic editing, inserting a segment between two previously dubbed

segments. Also, electronic editing segments out of sequential order.

Intermodulation distortion Nonlinear distortion that occurs when different frequencies pass through an amplifier at the same time and interact to create combinations of tones unrelated to the original sounds.

Internal dynamics The second stage in the sound envelope—the variations in loudness and sustains after the attack.

Interruptible foldback *See* **IFB**.

In the mud Sound level so quiet that it barely "kicks" the VU meter.

In the red Sound level so loud that the VU meter "rides" over 100 percent of modulation.

Inverse square law The acoustic situation in which the sound level changes in inverse proportion to the square of the distance from the sound source.

I/O console *See* **In-line console**.

Jack Receptacle or plug connector leading to the input or output circuit of a patch panel, tape recorder, or other electronic component.

Jam sync Locking a time code generator to the time code recorded on a tape to bring the two codes into alignment.

Jog mode In hard-disk, nonlinear editing, reproduces scrubbed samples in direct relation to the movement of the cursor over the defined region. *See also* **Shuttle mode**.

Laser drop *See* **Needle drop**.

Later reflections *See* **Reverberation**.

Lavalier microphone Microphone that used to be worn around the neck but is now attached to the clothing.

Layback Dubbing the composite audio track from the multitrack tape to the edited master videotape or the dialogue, sound effects, and music tracks to separate reels of magnetic film. *See also* **Layover, Prelay**.

Laydown *See* **Layover**.

Layover Dubbing the audio from the edited master videotape or audiotape, or both, to a multitrack ATR for premixing. Also called **Laydown**. *See also* **Layback, Prelay**.

Leader tape Nonmagnetic tape spliced to the beginning and end of a tape and between segments to indicate visually when recorded material begins and ends.

Lead-in Sound that introduces a scene before the scene begins.

Leakage Unwanted sound from one sound source being picked up through the microphone of another sound source.

Limiter A compressor with an output level that does not exceed a preset ceiling regardless of the input level.

Linear editing Nonrandom editing. *See also* **Nonlinear editing**.

Linearity Having an output that varies in direct proportion to the input.

Listening fatigue A pronounced dulling of the auditory senses inhibiting perceptual judgment.

Live mix Mixing during the recording session.

Localization (1) Positioning a sound source in a stereo field. (2) The direction from which a sound source seems to emanate in a stereo field. (3) The ability to tell the direction from which a sound is coming.

Longitudinal time code (LTC) A high-frequency signal consisting of a stream of pulses produced by a time code generator used to code tape to facilitate editing and synchronization. Also known as **SMPTE time code**.

Looping Postproduction recording of dialogue in synchronization with a picture. *See also* **Dialogue rerecording (looping) studio**.

Loudness Subjective perception of amplitude.

Loudness (or overload) distortion Distortion that occurs when the loudness of a signal is greater than the sound system can handle.

Loudspeaker A transducer that converts electric energy into acoustic energy.

Low bass Frequency range between roughly 20 and 80 Hz, the lowest two octaves in the audible frequency spectrum.

Low end The bass range of the frequency spectrum.

Low-output tape Low-sensitivity tape.

Low-pass (high-cut) filter A filter that attenuates frequencies above a selected frequency and allows those below that point to pass.

Low-print-through tape Low-sensitivity tape that is less susceptible to print-through.

Machine room A room equipped with magnetic film reproducers and recorders.

Magnetic film Sprocketed film containing sound only and no picture.

Magneto-optical (MO) recording Disc-based recording medium that uses tiny magnetic particles heated to extremely high temperatures.

Masking Phenomenon whereby one sound obscures another, usually one weaker and higher in frequency.

Master The original recording.

Master control The room to which audio and video outputs from other control rooms are fed for final adjustments before distribution to recording or broadcast.

Master fader The fader that controls the combined signal level of the individual channels on a console.

Master module A module with controls for mixing bus outputs, cue, send, and return lines. *See also* **In-line console.**

Message repeater *See* **Program repeater.**

Microphone A transducer that converts acoustic energy into electric energy.

Middle ear The part of the ear that transfers sound waves from the eardrum to the inner ear.

Middle-side miking A technique using a di-rectional microphone pointed toward the sound source and a bidirectional microphone with its dead sides perpendicular to the directional mic and facing the sides of the sound source.

MIDI *See* **Musical Instrument Digital Interface.**

MIDI time code (MTC) Translates SMPTE time code into MIDI messages that allow MIDI-based devices to operate on the SMPTE timing reference.

Midrange The part of the frequency spectrum to which humans are most sensitive; the frequencies between roughly 250 and 4,000 Hz.

Mil One-thousandth of an inch.

Milking the audience Boosting the level of an audience's sound during laughter or applause.

Mini Disc Magneto-optical disc 2.5 inches wide that can store more than an hour of digital-quality audio.

Mix The product of a rerecording session in which several separate sound tracks are combined through a mixing console into stereo, mono, or surround sound.

Mixdown The point, usually in postproduction, when all the separately recorded audio tracks are sweetened, positioned, and combined into stereo, mono, or surround sound.

Mixing Combining separately recorded audio tracks into stereo, mono, or surround sound.

Mobile unit A car, van, or tractor-trailer equipped to produce program material on location.

Monaural Literally means "one ear." Often used as a synonym for "monophonic."

Monitor Loudspeaker used in a sound facility.

Monitor system Internal sound system in a console that feeds signals to the monitor loudspeakers.

Monophonic Refers to a sound system with one master output channel.

Moving-coil loudspeaker A loudspeaker with a moving-coil element.

Moving-coil microphone A microphone with a moving-coil element. The coil is wrapped around a diaphragm suspended in a magnetic field.

M-S miking *See* **Middle-side miking.**

Multidirectional (or **polydirectional**) **microphone** Microphone with switchable pickup patterns.

Multiple-entry ports Several ports in a microphone, each of which is tuned to cancel a particular band of frequencies. Also known as a **Variable-D microphone.**

Multiple miking technique Using a separate microphone for each instrument or group of instruments and placing the mic close to the sound source to reduce ambience and leakage and gain greater sonic control of the voicings.

Multiples (1) On a patch panel, jacks interconnected to each other and to no other circuit. They can be used to feed signals to and from sound sources. (2) An amplifier with several mic level outputs to provide individual feeds, thereby eliminating the need for many.

Multistripe film Sprocketed film containing several magnetic stripes for sound and no picture.

Musical Instrument Digital Interface (MIDI) A protocol that allows synthesizers, drum machines, sequencers, and other signal-processing devices to communicate with and/or control one another, or both.

Mute To cut off a sound or reduce its level considerably, or a device that does this.

Mylar The DuPont Company name for polyester. *See also* **Polyester.**

Near-coincident miking A stereo microphone array in which the mics are separated horizontally but the angle or space between their capsules is not more than several inches.

Near-field monitoring Monitoring with loudspeakers placed close to the operator, usually on the console's meter bridge, to reduce interference from control room acoustics at the monitoring position.

Needle drop Using a cut or part of a cut from a recorded music library in a production. Fees for permission to use the music for any purpose are based on the number of needle drops used. Fees are paid to the holder of the copyright. The term derives from the time when recorded music libraries were available only on record. Now that they are available on compact disc, the term *laser drop* is also used.

Noise Any unwanted sound or signal.

Noise criteria (NC) Contours of the levels of background noise that can be tolerated within an audio studio.

Noise gate An expander with a threshold that can be set to reduce or eliminate unwanted low-level sounds, such as room ambience, rumble, and leakage, without affecting the wanted sounds.

Noise processor A signal processor that reduces analog tape noise.

Nondestructive editing Editing that does not alter the original sound or soundfile regardless of what editing or signal processing is effected. *See also* **Destructive editing.**

Nondirectional microphone An omnidirectional microphone.

Nondiversity receiver Single antenna receiving system used with wireless microphones. *See also* **Diversity receiver.**

Nonlinear The property of not being linear—not having an output that varies in direct proportion to the input.

Nonlinear editing Instant random access to and easy rearrangement of recorded material. *See also* **Linear editing.**

NOS microphone array In stereo miking, two cardioid mics about 12 inches apart at a 90-degree angle.

Notch filter A filter capable of attenuating an extremely narrow bandwidth of frequencies.

NT tape format Helical-scan nontracking digital tape format developed by Sony to replace the analog microcassette.

Octave The interval between two sounds that have a frequency ratio of 2 to 1.

Oersted A unit of magnetic force.

Off-mic Not being within the optimal pickup pattern of a microphone; off-axis.

Omnidirectional microphone Microphone that picks up sound from all directions. Also called a nondirectional microphone.

On-mic Being within the optimal pickup pattern of a microphone; on-axis.

Open-loop tape transport system Tape transport system with one capstan and a pinch roller usually located to the right of the head assembly.

Open-reel audiotape recorder A tape recorder with the feed reel and take-up reel not enclosed in a cartridge, requiring that they be mounted manually.

Organ of Corti The organ supported by the basilar membrane and containing the hair cells.

ORTF microphone array In stereo miking, two cardioid mics spaced 6.7 inches apart at a 110-degree angle.

Oscillator A device that generates pure tones or sine waves.

Outer ear The portion of the ear that picks up and directs sound waves through the auditory canal to the middle ear.

Output (1) The point from which signals feed out of a component or sound system. (2) Feeding a signal from a component or sound system.

Overdubbing Recording new material on a separate tape track(s) while listening to the replay of a previously recorded tape track(s) in order to synchronize the old and new material.

Overlapping sound A sound at the end of one scene continuing without pause into the next scene.

Overload Feeding a component or system more loudness than it can handle and thereby causing overload distortion.

Overload distortion *See* **Loudness distortion.**

Overtones Harmonics that may or may not be multiples of the fundamental. Subjective response of the ear to harmonics.

Pad An attenuator inserted into a component or system to reduce level.

Pan pot A potentiometer that changes the loudness level of a sound between two channels. Abbreviation for panoramic potentiometer.

Parabolic microphone system A system that uses a concave dish to focus reflected sound into a microphone pointed at the center of the dish.

Paragraphic equalizer An equalizer that combines the features of a parametric and a graphic equalizer.

Parametric equalizer An equalizer in which the bandwidth of a selected frequency is continuously variable.

Passive crossover network A crossover network in which the power amplifier precedes the crossover. *See also* **Active crossover network.**

Patch cord A short cord or cable with a plug at each end, used to route signals in a patch panel.

Patching Using patch cords to route or reroute signals by connecting the inputs and outputs of components wired to a patch panel.

Patch panel An assembly of jacks to which are wired the inputs and outputs of the audio components in a sound studio.

Some of these jacks are then wired to one another to create permanent or normaled signal paths.

PD format *See* **Pro Digi format.**

Peak program meter (ppm) A meter that responds to the loudness peaks in a signal.

Percentage of modulation The percentage of the applied signal with reference to the maximum signal that may be applied to a sound system.

Performance studio A studio in which talent performs.

Phantom power supply A circuit that sends DC power to a capacitor microphone, thereby eliminating the need to use batteries to generate the microphone's voltage.

Phase The time relationship between two or more sounds reaching a microphone or signals in a circuit. When this time relationship is coincident, the sounds or signals are in phase and their amplitudes are additive. When this time relationship is not coincident, the sounds or signals are out of phase and their amplitudes are subtractive. *See also* **Acoustical phase, Electrical phase.**

Phaser A signal processor that creates phase shifting, canceling various frequencies, thereby creating a swishing sound.

Phase reversal control The control on a console that inverts the phase (polarity) of an input signal 180 degrees.

Phase shift The displacement of a waveform.

Phasing An effect created by splitting a signal in two and time-delaying one of them.

Pickup pattern *See* **Polar response pattern.**

Pin When the needle of the VU meter hits against the peg at the right-hand corner of the red. Pin is to be avoided because it indicates too high a loudness level and it could damage the meter.

Pinch roller On a tape recorder the spring-loaded, free-spinning rubber wheel that holds the tape against the capstan. Also

called "capstan idler," and "pressure roller."

Pitch The subjective perception of frequency.

Pitch shifter A signal processor that varies the pitch of a signal.

Playback head Electromagnetic transducer on a tape recorder that converts magnetic energy into electric energy.

Plosive A speech sound that begins with a transient attack, such as "p" or "b."

Polarity reversal *See* **Phase reversal control.**

Polar response pattern The graph of a microphone's directional characteristics as seen from above. The graph indicates response over a 360-degree circumference in a series of concentric circles, each representing a 5-dB loss in level as the circles move inward toward the center.

Polydirectional microphone *See* **Multidirectional microphone.**

Polyester Durable, plastic-base material used in most recording tape made today. *See also* **Mylar.**

Pop filter Foam rubber windscreen placed inside the microphone head. Particularly effective in reducing sound from plosives and blowing.

Porous absorber A sound absorber made up of porous material whose tiny air spaces are most effective at absorbing high frequencies.

Ports One or more openings in a directional microphone that contribute to its pickup pattern by canceling sound from unwanted directions. *See also* **Dual-entry ports, Multiple-entry ports, Single-entry port.**

Post audio processing (PAP) The procedure whereby film images and sound are transferred to video and multitrack audiotape for editing and audio sweetening and then transferred back to film stock for final processing.

Postproduction The third stage in the production process when the recorded materials are edited, sometimes rerecorded, and mixed.

Postproduction studio A studio in which produced material is edited, sweetened, and sometimes put in its final form.

Potentiometer (or **Pot**) *See* **Fader.**

Preamplifier Device that boosts very low-level signals to usable proportions before they reach the amplifier. Abbreviated as *preamp.*

Precedence effect *See* **Haas effect.**

Prefader listen A control on a console that permits monitoring a signal in one channel, prefader, without having to turn off the other channels. *See also* **Solo mute.**

Prelay Recording audio elements, other than those from the edited video master, onto multitrack tape. *See also* **Layback, Layover.**

Premixing The stage in postproduction sweetening when dialogue, sound effects, and music are prepared for final mixing.

Preproduction The first stage in the production process during which the creative, technical, and business planning takes place.

Presence Perception of a sound as being close and realistic.

Presence range Those frequencies in the frequency spectrum that give sound the quality of closeness and realism; roughly from 4,000 to 5,000 Hz.

Presidential patch *See* **Multiples.**

Pressure Zone Microphone (PZM) A boundary microphone. Trade name of Crown International, Inc.

Printed-ribbon microphone A microphone with the compliance of a ribbon microphone and the durability of a moving coil mic. Its element is a spiral aluminum ribbon printed on a diaphragm made of polyester film. Also known as a regulated phase microphone.

Print-through Unwanted transfer of a magnetic signal from one tape layer to an adjacent tape layer.

Pro Digi format (PD) An alternative to the DASH format used by Mitsubishi and Otari.

Production (1) The middle stage in the production process during which recording takes place. (2) The material that is produced.

Production control room Studio used to produce and record audio materials.

Professional digital format *See* **Pro Digi format.**

Program (1) A broadcast presentation. (2) Planning and arranging various materials for on-air presentation. (3) The master channel(s) in a console.

Program repeater Used to record and reproduce repetitively occurring program material. Also known as a message repeater.

Proximity effect Increase in the level of bass frequencies relative to midrange and treble frequencies as the mic-to-source distance decreases.

Psychoacoustic processor Signal processor that adds clarity, definition, overall presence, and life or "sizzle" to recorded sound.

Psychoacoustics Study of the subjective perception of sound stimuli.

Pulse code modulation (PCM) The process in which an analog signal is digitally encoded as a series of pulses.

Punching in Inserting material into a recording by rolling the tape recorder in the playback mode and putting it in the record mode at the insert point.

Pure tone *See* **Sine wave.**

PZM *See* **Pressure Zone Microphone.**

Quantizing Converting a waveform that is infinitely variable into a finite series of discrete levels.

Radio microphone Wireless microphone.

Rarefaction Temporary drawing apart of vibrating molecules causing a partial vacuum to occur. *See also* **Compression**.

R-DAT *See* **Rotary head digital audiocassette recorder**.

Read head On a digital audiotape recorder, the equivalent of the playback head.

Read mode Mode of operation in an automated mixdown when the console controls are operated automatically by the data previously encoded in the computer. *See also* **Update mode, Write mode**.

Real-time analyzer A device that shows the total energy present at all audible frequencies on an instantaneous basis.

Record head Electromagnetic transducer on a tape recorder that converts electric energy into magnetic energy.

Reel-size switch *See* **Tension switch**.

Reference tone(s) A pure tone(s) recorded on a master tape used to ensure that the levels and metering during recording are duplicated during playback.

Reflected sound Reflections of the direct sound that bounce off of one or more surfaces before reaching the listener.

Release time The length of time it takes a limiter or compressor to return to its normal level after the signal has been attenuated or withdrawn. Also known as recovery time.

Relief stressor A de-esser that tracks sibilance, compressing it where it occurs.

Remote A broadcast or recording done away from the studio on location.

Remote survey The inspection of a remote location and the written plan for the setup and use of production equipment at the site.

Rerecording A general term used to refer to activities during postproduction such as automated dialogue replacement, Foley recording, or the rerecording mix.

Rerecording room (or **theater**) A good-sized room with a projector, screen, and mixing console where dialogue, sound effects, and music are combined in a final mix.

Resonance Transmitting a vibration from one body to another when the frequency of the first body is exactly, or almost exactly, the natural frequency of the second body.

Retentivity Measure of a tape's ability to retain magnetization after the force field has been removed. Retentivity is measured in gauss — a unit of magnetic energy.

Reverberation Multiple blended, random reflections of a sound wave after the sound source has ceased vibrating.

Reverberation time The length of time it takes a sound to die away. By definition: The time it takes a sound to decrease to one-millionth of its original intensity, or 60 dB-SPL.

Ribbon microphone A microphone with a ribbon diaphragm suspended in a magnetic field.

Riding the gain Adjusting the levels during recording or playback.

Ring off When a dialogue line ends with the ambient ring of a room and another line begins with that ring decaying under it.

Robinson-Dadson curves Equal loudness curves plotted by averaging the results obtained from a large number of listeners. They have replaced the original curves plotted by Fletcher-Munson. *See also* **Equal loudness curves**.

Room modes Unwanted increases in loudness at resonant frequencies that are a function of a room's dimensions.

Rotary head digital audiocassette recorder (**R-DAT**) Specifically, a cassette digital audiotape recorder with rotary heads.

Rotary head tape recorder A tape recorder that records and plays back with heads that spin at fast speeds.

Safe mode *See* **Read mode**.

Samplefile A sound sample that is stored on floppy or hard disk or compact disc.

Sampling (1) Examining an analog signal at regular intervals defined by the sampling frequency (or rate). (2) A process whereby a section of digital audio representing a sonic event, acoustic or electro-acoustic, is stored on disk or into a memory.

Sampling frequency (or **rate**) The frequency (or rate) at which an analog signal is sampled.

Scoring stage Large studio with a projector and screen where the music sound track for a motion picture is recorded and synchronized.

Scrape flutter filter A cylindrical, low-friction, metal surface, installed between the heads to reduce the amount of unsupported tape, thereby restricting the degree of tape movement as it passes across the heads. It reduces flutter.

Scrubbing In hard-disk editing, moving the playbar cursor through the defined region at any speed to listen to a sound being readied for editing. Scrubbing is similar to rocking a tape in cut-and-splice editing and the jog mode in electronic editing.

Seamless editing Smoothing the differences in ambience between scenes by cutting sound and picture at slightly different times.

Search-to-cue *See* **Auto-locator**.

Segue (1) Cutting from one effect to another with nothing in between. (2) Playing two recordings one after the other, with no live announcement in between.

Selective synchronization *See* **Sel Sync**.

Selector switch A control that selects what sound source is routed through a console.

Sel Sync Changing the record head into a playback head to synchronize the playback of previously recorded material with the recording of new material. Trademark of Ampex Corporation.

Sensitivity (1) Measurement of a tape's output level capability relative to a standard reference tape. (2) A level control at the microphone/line input on some multichannel consoles. *See also* **Pad, Trim**.

Sequencer A device that is like a "multitrack" recorder for MIDI data. As the brain of a MIDI studio, it receives, stores, and plays back MIDI information.

Sequential assembly *See* **A-mode assembly**.

Shelving Maximum boost or cut at a particular frequency that remains constant at all points beyond that frequency so the response curve resembles a shelf.

Shock mount A device that isolates a microphone from mechanical vibrations. It can be attached externally or built into a microphone.

Shotgun microphone A highly directional microphone with a tube that resembles the barrel of a rifle.

Shuffling Increases spaciousness so that coincident and near-coincident microphone arrays can sound as spacious as spaced microphone arrays. Shuffling is accomplished with a low-frequency shelving boost of the $L - R$ (difference) signals and a low-frequency shelving cut of the $L + R$ (sum) signals. Also known as Spatial equalization.

Shuttle mode In hard-disk, nonlinear editing, the initial direction and speed of the cursor is used as a reference and the rest of the scrubbed section is reproduced in the same direction and at the same rate without need of further cursor movement. *See also* **Jog mode**.

Sibilance The annoying hissing sounds produced by overaccenting "s," "z," "sh," "ch," and other, similar sounds.

Signal flow The path a signal follows from its sound source to its destination.

Signal processor A device that alters some characteristic of a sound, such as frequency, amplitude, phase, or quantity.

Signal-to-noise ratio The ratio between the signal level and the noise level of a component or sound system. The wider the signal-to-noise ratio, the better.

Silent film Film containing picture only.

Sine wave A pure tone or fundamental frequency with no harmonics or overtones.

Single-D microphone *See* **Single-entry port.**

Single-ended noise reduction One-step noise reduction that reduces noise from an existing signal rather than preventing it from entering a signal. It may be inserted into the signal flow at the recording or playback stage. *See also* **Double-Ended Noise Reduction.**

Single-entry port One port in a microphone to cancel all frequencies from unwanted directions. Also known as a **Single-D microphone.**

Single-system sound recording Recording picture and sound in a camera simultaneously.

Slap back echo The effect created when an original signal repeats as distinct echoes that decrease in level with each repetition.

Slate The part of a talkback system that feeds sound to tape. It is used to record verbal identification of the material being taped, the take number, and other information just before each recording.

Slave tape The tape to which the material on a master tape is transferred.

SMPTE time code *See* **Longitudinal time code.**

Solo mute A control on a multitrack console that automatically cuts off all signals feeding the monitor system except those signals feeding through the channel that the solo mute control activates.

Sound absorption coefficient A measure of the sound-absorbing ability of a surface. This coefficient is defined as the fraction of incident sound absorbed by a surface. Values range from 0.01 for marble to 1.0 for the materials used in an almost acoustically dead enclosure.

Sound chain The audio components that carry a signal from its sound source to its destination.

Sound design The overall artistic styling of the sonic fabric in an audio production.

Sound designer A person specifically designated to create the overall sound design of a production.

Sound envelope Changes in the loudness of a sound over time, described as occurring in three stages: attack, internal dynamics, decay; or in four stages: attack, initial decay, sustain, and release (ADSR).

Soundfield microphone system Four capacitor microphone capsules shaped like a tetrahedron, enclosed in a single casing, that can be combined in various formats to reproduce sonic depth, breadth, and height.

Soundfile A sound stored in the memory of a hard-disk editor.

Sound film Film containing an optical or magnetic-stripe sound track and picture.

Sound frequency spectrum The range of frequencies audible to human hearing: about 20 to 16,000 Hz.

Sound pressure level (SPL) A measure of the pressure of a sound wave, expressed in decibels.

Sound reader A playback head attached to a viewer or synchronizer and wired to an amplifier, thereby enabling a film editor to hear a magnetic or optical sound track.

Sound stage A film studio used to record picture and sound.

Sound transmission class (STC) A rating that evaluates the effectiveness of barriers in isolating sound.

Sound wave A series of compressions and rarefactions of molecules set in motion by a vibrating sound source and radiating from it.

Spaced miking Two, sometimes three, microphones spaced from several inches to several feet apart, depending on the width of the sound source and the acoustics, for stereo recording.

Spectrum processor A signal processor that affects a sound's spectral range.

Speed control On a tape recorder or film camera, the control that selects the speed at which these devices operate.

Splicing tape A specially made adhesive tape that does not ooze, is nonmagnetic and pressure sensitive, and is used to join cut ends of audiotape and magnetic film.

Split-track recording Recording two separate sound sources on two separate tracks of a stereo ATR or VCR with two audio tracks.

Standing wave A sound wave perceived as stationary, which is the result of a periodic sound wave having a fixed distribution in space. The result of interference of traveling sound waves of the same kind.

Stationary head digital audiotape recorder (S-DAT) A fixed-head digital audiotape recorder. *See also* **Rotary head digital audiotape recorder (R-DAT)**.

Stereo miking Using only two microphones, or microphone capsules, usually directional, to pick up sound from one voicing or ensemble. Sometimes, ambience or blending microphones may be added.

Stereo 180 microphone array A stereo microphone array that uses two hypercardioid mics spaced just under 2 inches apart at a 135-degree angle.

Stereophonic microphone Two directional microphone capsules, one above the other, with separate outputs, encased in one housing.

Stereophonic sound Two-channel, two-loudspeaker sound reproduction that gives the listener the illusion of sonic depth and width.

Stereosonic microphone technique *See* **Blumlein technique**.

Studio (1) A room in which the talent performs during a production or program. (2) Any room or group of rooms used for the performance, production, and processing of a program (or film) for recording or broadcast.

Submaster Generally, the fader that controls the level of an output bus. Specifically, the fader that controls the level of a signal at an output channel en route to the master fader.

Submix A group mix of instruments or sections of instruments within a larger mix, such as drums, the main and backup vocals, violins, and so on, and usually assigned to a submaster so that their group levels can be varied together.

Summing network A network that combines or mixes signals from two or more sources. The level of the combined signals is regulated by the master fader.

Supercardioid microphone Unidirectional microphone with a slightly narrower angle of sound acceptance than a cardioid microphone, little sensitivity at the rear sides, and some sensitivity at the rear.

Surround sound Sound that produces a soundfield in front of, to the sides of, and behind the listener by positioning loudspeakers either front and rear, or front, sides, and rear of the listener.

Sweetening Enhancing the sound of a recording through the procedures of layover, prelay, premixing, and layback.

Synchronizer (1) Device with sprocketed, ganged wheels that locks in the film reels of picture and sound so they can be wound in synchronization during editing. (2) Device that regulates the operating speeds of two or more tape recorders so they run in sync.

Sync pulse The pulse or tone that synchro-

nizes tape recorder speed and film camera speed in double-system recording.

Sync pulse head The head on an audiotape recorder used in double-system recording that records the sync pulse on the tape.

Synthesized stereo Monaural sound that is processed through a stereo synthesizer to create discrete stereo's sense of depth and spaciousness but that does not reproduce the localization or realism of true stereo.

Synthesizer An electronic musical instrument that can be used to imitate the sound of conventional instruments or generate its own sounds.

System message Addresses all channels in a MIDI system. It affects an entire device or every device in the system. It gives such information as timing and clocking functions. *See also* **Channel message.**

System microphone Interchangeable microphone capsules of various directional patterns that attach to a common base. The base contains a power supply and a preamplifier.

System noise The inherent noise an electronic device or system generates.

Tails out Having the end of the material on a tape or film at the head of the reel.

Take-up idler A spring-loaded control on a tape recorder that can activate or deactivate the transport without the machine being turned on and off.

Talkback System that permits communication from a control room microphone to a loudspeaker or headphones in the studio.

Tangency One of the adjustments made when aligning the heads of an audiotape recorder. This adjustment aligns the forwardness of the heads so the tape meets them at the correct pressure.

Tape guides Grooved pins on rollers mounted at each side of the head assembly to position the tape correctly on the head during recording and playback.

Tape loop A tape with the ends spliced together.

Tape noise Noise generated by tape in a recording/reproducing system.

Tape recorder A mechanical-electronic device that encodes and decodes audio and video information on a magnetic tape.

Tape splicer A device used to cut and splice magnetic tape or film.

Tape timer An indicator on an audiotape or videotape recorder that displays the amount of tape used in hours, minutes, and seconds. *See also* **Footage counter.**

Tape transport The mechanical portion of the tape recorder, mounted with motors, reel spindles, heads, and controls, that carries the tape at the constant speed from feed reel to take-up reel.

Temporal fusion When reflected sound reaches the ear within 10 to 20 milliseconds of the original sound, the direct and reflected sound are perceived as a single sound.

Tension switch A two-position switch that adjusts the torque to the feed and take-up reels to compensate for different sizes of reels and hubs.

3-D Sound Increasing the illusion of depth and width in aural space using frontally positioned stereo loudspeakers.

Three-to-one rule A guideline used to reduce the phasing caused when a sound reaches two microphones at slightly different times. It states that no two microphones should be closer to each other than three times the distance between one of them and its sound source.

Three-way system loudspeaker A loudspeaker that divides the high from the low frequencies and then divides the high frequencies again.

Tie line Facilitates the interconnecting of outboard devices and patch panels in a control room or between studios.

Timbre The unique tone quality or color of a sound.

Time code address The unique SMPTE time code number that identifies each 1/30 of a second of audiotape or each frame of videotape.

Time code editor A device that uses the time code recorded on a tape as the reference for editing.

Time compression Altering the time of material without changing its pitch.

Time processor A signal processor that affects the time interval between a signal and its repetition.

Track The path on magnetic tape along which a signal is recorded.

Transducer A device that converts one form of energy into another.

Transformer A device used to match the impedances of high- and low-impedance components or systems.

Transient A sound that begins with a sharp attack followed by a quick decay.

Transient distortion Distortion that occurs when a sound system cannot reproduce sounds that begin with sudden, explosive attacks.

Transmission loss (TL) The amount of sound reduction provided by a barrier such as a wall, floor, or ceiling.

Transmitter microphone Wireless microphone.

Treble Frequency range between roughly 5,000 and 20,000 Hz, the highest two octaves in the audible frequency spectrum.

Tremolo Variations in the amplitude of a sound, usually ½ to 20 times a second. *See also* **Vibrato.**

Trim (1) To attenuate the loudness level in a component or circuit. (2) The device, usually so called on a console, that attenuates the loudness level at the microphone/line input.

Tweeter The informal name of a loud-speaker that reproduces high frequencies. *See also* **Woofer.**

Two-way system loudspeaker A loudspeaker that divides the high from the low frequencies.

Type C format The standard 1-inch videotape format that carries three high-quality audio tracks, a nonsegmented video track, a control track, and a sync (address) track.

Ultracardioid microphone A directional microphone with a very narrow angle of acceptance, very little sensitivity at the sides, and some sensitivity at the rear.

Unbalanced line A line (or circuit) with two conductors of unequal voltage.

Underscoring Using music to provide informational or emotional enhancement to narration, dialogue, or action.

Unidirectional microphone A microphone that picks up sound from one direction. Also called "directional."

Update mode Mode of operation in an automated mixdown when an encoded control can be recorded without affecting the coding of the other controls. *See also* **Read mode, Write mode.**

Upper bass Frequency range between roughly 80 and 320 Hz.

Upper midrange Frequency range between roughly 2,560 and 5,120 Hz.

Variable-D microphone *See* **Multiple-entry ports.**

Variable-speed control Device on an audiotape recorder that alters the playing speed to various rates of the recorder's set speeds.

VCA *See* **Voltage-controlled amplifier.**

Velocity The speed of a sound wave: 1,130 feet per second at sea level and 70 degrees Fahrenheit.

Vertical Interval Time Code (VITC) Time code that is recorded vertically on videotape and within the video signal, but outside the picture area.

Vibrato Regular variations in the frequency of a sound, usually 2 to 15 times a second. *See also* **Tremolo.**

Videotape A plastic base coated with slanted magnetic particles used to record video and audio signals. (Magnetic particles on audiotape are horizontal.)

Voltage-controlled amplifier (VCA) An amplifier used to decrease level. The amount of amplification is controlled by external DC voltage.

Volume unit A measure that is related to a human's subjective perception of loudness.

Volume unit (VU) meter A meter calibrated in volume units and percentage of modulation.

Walla A nonsense word that used to be spoken by film extras to create ambient crowd sound without anything discernable actually being said.

Waveform A graphic representation of a sound's characteristic shape, displayed, for example, on hard disk editors.

Wavelength The length of one cycle of a sound wave. Wavelength is inversely proportional to the frequency of a sound; the higher the frequency, the shorter is the wavelength.

Wet sound A sound with reverberation or signal processing. *See also* **Dry sound.**

Wide-angle cardioid microphone A microphone with a wider directional pickup pattern than a cardioid microphone.

Windscreen Foam rubber covering specially designed to fit over the outside of a microphone head. Used to reduce plosive and blowing sounds. *See also* **Pop filter.**

Wireless microphone system System consisting of a transmitter that sends a microphone signal to a receiver connected to a console.

Woofer Informal name for a loudspeaker that produces the bass frequencies. *See also* **Tweeter.**

Workstation A multifunctional hard-disk production system, controlled from a central location, that integrates with other audio, video, and MIDI sources for recording, editing, and signal processing.

Worldizing Recording room sound to add the sound of that space to a dry recording or to use it to enhance or smooth ambient backgrounds that are already part of the dialogue track.

Wow (1) The instantaneous variations in speed at moderately slow rates caused by variations in the tape transport. (2) Starting the sound on a tape before it reaches full speed. *See also* **Flutter.**

Wrap One of the adjustments made when aligning the heads of an audiotape recorder. This adjustment aligns the head so it is in full physical contact with the tape.

Write head On a digital audiotape recorder, the equivalent of the record head.

Write mode The mode of operation in an automated mixdown during which controls are adjusted conventionally and the adjustments are encoded in the computer for retrieval in the safe mode. *See also* **Read mode, Update mode.**

Write-sync head On a digital audiotape recorder, the record head used for synchronous recording.

XLR connector Commonly used male and female microphone plugs with a three-pin connector.

X-Y miking Coincident or near-coincident miking that places the microphones' diaphragms over or horizontal to one another.

Zenith One of the adjustments made when aligning the heads of an audiotape recorder. This adjustment aligns the vertical angle of the heads so they are perpendicular to the tape.

Bibliography

Books

Aldred, John. *Manual of Sound Recording*, 3rd ed. Kent, England: Dickson Price, 1988. Theory and practice of audio recording. Covers basics and their application to recording, in general, and to music and motion picture sound, in particular. Introductory but substantive.

Aldridge, Henry and Lucy Liggett. *Audio/Video Production: Theory and Practice*. Englewood Cliffs, NJ: Prentice-Hall, 1990. Theoretical and aesthetic framework for creating audio/video messages and the technical procedures needed to produce them.

Alkin, Glyn. *Sound Techniques for Video and TV*, 2nd ed. Boston: Focal Press, 1989. In a manual format with general coverage of sound basics — acoustics, signal processing, microphones, tape recorders, and so on — applied specifically to video and TV — talk shows, drama, and music.

Altman, Rick, ed. *Sound Theory/Sound Practice*. New York: Routledge, 1992. New essays focusing on recent developments in film sound theory and historical perspectives. Essays cover such diverse topics as the motion picture indus-try's conversion to sound, documentary sound, voices of women in third-world cinema, and a glossary of new terms for sound analysis.

Amyes, Tim. *The Technique of Audio Post-Production in Video and Film*. London: Focal Press, 1990. From the British perspective, with many useful production tips. Detailed chapters on synchronization, studio and location recording, and editing.

Anderton, Craig. *The Digital Delay Handbook*, rev. ed. Woodstock, NY: Beekman Publishers, 1990. Specific applications and how-to directions for applying various long, short, and multiple digital delay effects to sound shaping.

———. *The Electronic Musician's Dictionary*. New York: Music Sales, 1989. Dictionary of more than 1,000 technical and operational terms related to synthesizers, computers, and MIDI.

Backus, John. *The Acoustical Foundations of Music*, 2nd ed. New York: W. W. Norton, 1977. The properties, production, behavior, and reproduction of musical sound.

Ballou, Glen, ed. *Handbook for Sound Engineers: The New Audio Cyclopedia*, 2nd ed. Indianapolis: H. W. Sams, 1991. Intended successor

to Howard Tremaine's classic *Audio Cyclopedia*. Mostly for the engineer but with some nontechnical material. Comprehensive coverage of acoustics for various types of studios, electrical components for sound engineering, microphones, loudspeakers, consoles, amplifiers, signal processors, tape recorders, sound systems design, and measurement.

Bartlett, Bruce and Jenny. *Practical Recording Techniques*. Carmel, IN: Sams Publishing, 1992. A general guide for the nonprofessional music recordist interested in studio or location recording of popular and classical music and the spoken word. For anyone involved in audio, however, there is useful material on the decibel, time code, guidelines for EQing, troubleshooting poor sound, recognizing quality sound, and evaluating the finished product.

———. *Stereo Microphone Techniques*. Boston: Focal Press, 1991. Practical, readable guide to stereo miking music, news, sports, film and video sound, samples, and sound effects.

Baskerville, David. *Music Business Handbook*, 5th ed. Denver: Sherwood, 1990. Comprehensive handbook about the music marketplace: songwriting, publishing, copyright, unions, agents, artist management, concert promotion, the record industry — including production, studios, and engineering — music in film and broadcasting, and career planning and development.

Bazelon, Irwin. *Knowing the Score: Notes on Film Music*. New York: Van Nostrand Reinhold, 1975. Includes chapters on the technique of film scoring and on what film music actually does, as well as interviews with composers.

Benson, Blair, ed. *Audio Engineering Handbook*. New York: McGraw-Hill, 1988. Cyclopedic reference to technical and practical audio includes principles of sound, hearing, acoustics, the audio signal spectrum, analog and digital recording, measurement techniques, production and postproduction techniques for film sound, industry standards, and recommended practices.

Berendt, Joachim-Ernst. *The Third Ear: On Listening to the World*. New York: Henry Holt, 1992. Socio-psychological treatise on the dominance of the ear as gatherer and processor of sensory information. Content includes comparing auditory and visual perception; thinking through the ear; sonic perceptions around the world; and what listening is.

Blake, Larry. *Film Sound Today*. Hollywood: Reveille, 1984. Short anthology of articles written for the now defunct magazine *Recording Engineer/Producer*. Among the subjects are: mixing Dolby Stereo film sound; sound design for the *Star Wars* trilogy; and 70 mm, six-track film sound.

Bordwell, David, and Kristin Thompson. *Film Art: An Introduction*, 4th ed. New York: McGraw-Hill, 1993. Useful chapter about sound.

Borwick, John. *Microphones: Technology and Technique*. London: Focal Press, 1990. Excellent guide to microphone usage. First half of the book deals with a brief history of microphones, basic theory of acoustics, electricity, and magnetism. The second half is devoted to creative techniques used in miking musical instruments, voices, and ensembles for classical and popular music, and miking for television programs.

———, ed. *Sound Recording Practice: A Handbook*, 3rd ed. New York: Oxford University Press, 1987. Practical and technical articles about audio recording, on the intermediate to advanced levels, covering principles, equipment, maintenance, analog and digital sound, studio and field production, radio, television, and film, and tape and disc manufacturing. From the British perspective.

Burch, Noel. *Theory of Film Practice*. New York: Praeger, 1973. Useful chapters on music and sound effects.

Burroughs, Lou. *Microphones: Design and Application*. Plainview NY: Sagamore, 1974. Basic principles of microphone design and application. A classic, and still useful, reference book.

Campbell, Murray, and Clive Greated. *The Musician's Guide to Acoustics*. New York: Schirmer, 1987. Extensive analysis of how sound is produced in musical instruments.

Camras, Marvin. *Magnetic Recording Handbook*. New York: Van Nostrand Reinhold, 1988. Comprehensive technical reference covering every branch of magnetic recording in audio, video, and computers up to the mid-1980s.

Carlin, Dan, Sr. *Music in Film and Video Productions*. Boston: Focal Press, 1991. Basic, but comprehensive, look at the process of composing, preparing, and producing a music score for film and TV. Content includes the roles of the various personnel involved, prescoring, recording, dubbing, editing, rerecording, tracking, and licensing.

Clifford, Martin. *Microphones*, 3rd ed. Blue Ridge Summit, PA: Tab, 1986. Basic guide combines operational theory and applications: acoustics, noise, anatomy of the mic, general techniques (ensembles and stereo), and specific techniques (musical instruments, voices, conference, and lecture).

Cooper, Jeff. *Building a Recording Studio*, 4th ed. Los Angeles: Synergy Group, 1984. A basic guide to constructing a recording studio by a master builder. Includes material on the effects of acoustics on sound and recording, the relationship of sonic material to room acoustics, the studio, and the control room. Extensive glossary.

Dancyger, Ken. *The Technique of Film and Video Editing*. Boston: Focal Press, 1993. Although devoted primarily to film and video, as the title suggests, sound is considered throughout the book, including chapters titled "The Early Sound Film," "Ideas and Sound," "The Sound Edit and Clarity," and "The Sound Edit and Creative Sound."

Davis, Don and Carolyn. *Sound System Engineering*, 2nd ed. Indianapolis: H. W. Sams, 1987. Authoritative technical reference that describes the design, installation, equalization, operation, and maintenance of a sound system.

Davis, Gary, and Ralph Jones. *The Sound Reinforcement Handbook*, rev. ed. Milwaukee: Hal Leonard, 1989. A guide to sound reinforcement in three sections: "Theory"—the decibel, dynamic range, sound outdoors, how to read and interpret specification sheets; "Sound Equipment and Systems"—microphones, consoles, amps, sound system test equipment; and "Putting It All Together"—the electronics and loudspeakers.

DeFuria, Steve, and Joe Scacciaferro. *The Sampling Book*. Milwaukee: Hal Leonard, 1988. The technology of sampling and its creative uses including looping, splicing, multisampling, crossfading, resynthesis, sampling rates, and hands-on experiments.

Deutsch, Diana, ed. *The Psychology of Music*. Orlando, FL: Academic Press, 1982. Advanced theoretical work dealing with ways music is processed by the listener and performer. Subject areas include acoustics, psychoacoustics, perception, and electronics.

DeVito, Albert. *Computer MIDI Desktop Publishing Dictionary*. Westbury, NY: Kenyon, 1991. Twenty-five-hundred definitions related to MIDI, computer music, and desktop publishing.

Dickreiter, Michael. *Tonmeister Technology: Recording Environments, Sound Sources, and Microphone Techniques*. Translated by Stephen Temmer. New York: Temmer Enterprises, 1989. A nontechnical primer from the Tonmeister perspective that integrates music and technology.

Dmytryk, Edward. *On Film Editing*. Boston: Focal Press, 1984. Mostly about editing picture but includes a valuable chapter on handling dialogue.

Dowling, W. J., and D. L. Harwood. *Music Cognition*. Orlando, FL: Academic Press, 1986. About the perception and cognition of music in relation to information processing. Includes chapters on the sense and perception of sound, emotion and meaning, and cultural contexts of musical experience. With audiocassette.

Eargle, John. *Handbook of Recording Engineering*, 2nd ed. New York: Van Nostrand Reinhold, 1991. Mostly technical approach to the recording process covering acoustical fundamentals, audio transmission systems, loudspeakers and monitoring, signal processing, and analog and digital recording, with easy-to-understand techniques applied to classical and popular music recording, and music in film and video production and postproduction.

————. *The Microphone Handbook*. Plainview, NY: ELAR, 1981. Handy reference work on the basics of microphone theory and techniques for speech and classical and popular music recording in studio and on location.

————. *Music, Sound, and Technology*. New York: Van Nostrand Reinhold, 1990. The relationship to and the influence of technology on music and sound production and perception.

Ebersole, Samuel. *Broadcast Technology Worktext*. Boston: Focal Press, 1992. Hands-on approach to technical concepts and procedures without using highly technical jargon. Deals mostly with video, but there are substantial portions devoted to audio. With self-study and project sections.

Edmonds, Robert. *The Sights and Sounds of Cinema and Television*. New York: Teachers College Press, 1982. How aesthetic experience influences our feelings; with roughly one-quarter of the book devoted to sound and one-quarter devoted to picture and sound together.

Eisenberg, Evan. *The Recording Angel: Explorations in Phonography*. New York: McGraw-Hill, 1987. The effects of technology on perception: How recording has changed the very nature of music and its role in our culture.

Eisler, Hanns. *Composing for Films*. New York: Oxford University Press, 1947. One of the first serious attempts to deal with the role of music in film, in general, and its relationship to picture, in particular. The aesthetics are still instructive. Also for historical interest, see *Music for Films*, by Leonid Sabaneev, translated by S. W. Pring, London: Sir Isaac Pitman & Sons, 1935.

Evans, Mark. *Soundtrack: The Music of the Movies*. New York: Hopkinson & Blake, 1975. The history of film music, with chapters on the functions of the film score and the ethics and aesthetics of film music.

Everest, F. Alton. *Acoustic Techniques for Home and Studio*, 2nd ed. Blue Ridge Summit, PA: Tab, 1986. Practical environmental acoustic design with emphasis on the small sound studio. Discusses principles of acoustics, human hearing, room resonance, diffusion of sound, and absorption properties of acoustic materials.

————. *Master Handbook of Acoustics*, 2nd ed. Blue Ridge Summit, PA: Tab, 1988. Basics of sound and acoustics applied to the professional recording studio. In addition to the customary material about the principles of sound and acoustics, coverage includes the human voice system, the control room, multitrack recording, and instruments for acoustical measurement.

Everest, F. Alton, and Mike Shea. *How to Build a Small Budget Recording Studio*, 2nd ed. Blue Ridge Summit, PA: Tab, 1988. Instruction in the budgeting, mathematics, acoustical design, and construction necessary in building a small sound studio.

Everest, F. Alton, and Ron Streicher. *The New Stereo Soundbook*. Blue Ridge Summit, PA: Tab, 1992. Stereo miking and multiple miking techniques including binaural setups.

Ford, Ty. *Advanced Audio Production Techniques*. Boston: Focal Press, 1993. Actually a basic book about sound production, including a chapter of insights from two audio pros.

Fraser, Douglas. *Digital Delays (and How to Use Them)*. Sherman Oaks, CA: Alfred, 1989. Guide to the common features of digital delay, including programming and beat-conversion charts.

Giannetti, Louis. *Understanding Movies*, 6th ed. Englewood Cliffs: Prentice-Hall, 1993. Useful chapter about sound and an analysis of *Citizen Kane* which, in part, deals with the soundtrack.

Gifford, F. *Tape: A Radio News Handbook*, 3rd ed. Englewood, CO: Morton, 1987. A basic, practical approach to the equipment and techniques used to prepare and produce audio for radio news.

Gorbman, Claudia. *Unheard Melodies: Narrative Film Music*. Bloomington: Indiana University Press, 1987. Theory and analysis of the functions of music in narrative film.

Gross, Lynne, and David Reese. *Radio Production Worktext: Studio and Equipment*. Boston: Focal Press, 1990. Basic audio production in a workbook approach, with self-study questions and projects.

Hagen, Earle. *Scoring for Films.* **Sherman Oaks, CA: Alfred, 1989.** Reissue and update of one of the few books of its kind. The focus is on composing for motion pictures and video, the mechanics and vocabulary of scoring, the psychology and aesthetics of creating music for picture, and the responsibilities of the composer and the editor. Useful to anyone interested in the dynamics of the sound–picture relationship. With compact disc.

Halper, Donna. *Radio Music Directing.* **Boston: Focal Press, 1991.** Duties and responsibilities of the person responsible for researching and creating playlists, maintaining the music library, and implementing formats. Includes historical perspective.

Horn, Delton. *DAT: The Complete Guide to Digital Audio Tape.* **Blue Ridge Summit, PA: Tab, 1991.** About half the book is devoted to DAT, the rest covers the history of recording and the basics of digital audio and compact discs.

Howell, Peter, et al. *Musical Structure and Cognition.* **Orlando, FL: Academic Press, 1985.** Advanced essays on human perception and on musical structure, recall, and recognition.

Hubatka, M. C., et al. *Audio Sweetening for Film and TV.* **Blue Ridge Summit, PA: Tab, 1985.** The equipment and techniques used in postproduction audio sweetening for film and video. Includes material on the sweetening process, sweetening techniques, audio in the video edit, system configurations and operations, and working with music.

Huber, David Miles. *Audio Production Techniques for Video.* **Indianapolis: H. W. Sams, 1987.** The technology and techniques of audio for video production and postproduction. Includes time code, electronic editing, digital audio, multitrack audio, and live broadcast stereo.

———. *Microphone Manual: Design and Application.* **Indianapolis: H. W. Sams, 1988.** Basics of microphone theory and usage applied to single and stereo microphone techniques for music recording, in studio and on location, for speech, and for video and film production.

———. *The MIDI Manual.* **Carmel, IN: Sams Publishing, 1991.** Technical, but readable, basics of MIDI and the functions and features of selected equipment and software.

———. *Random Access Audio.* **Carmel, IN: Sams Publishing, 1992.** Excellent introduction to digital audio, sampling, and hard disk recording and editing.

Hurtig, Brent. *Multitrack Recording for Musicians.* **Sherman Oaks, CA: Alfred, 1989.** Fundamentals of multitrack music recording, including MIDI and the workstation, with a step-by-step "hands-on" recording session.

Hutchins, Carleen, et al. *The Physics of Music.* **San Francisco: W. H. Freeman, 1978.** Essays from *Scientific American* about the physics of music and musical instruments and the acoustics of the singing voice.

Johnson, Lincoln. *Film: Space, Time, Light, and Sound.* **New York: Holt, Rinehart & Winston, 1974.** Worthwhile chapter on sound.

Jones, Steve. *Rock Formation: Music, Technology, and Mass Communication.* **Newbury Park, CA: Sage, 1992.** Influence of technology on popular music with chapters on the history of sound recording, marketing music technology, the process of sound recording, and technology and the musician.

Jorgensen, Finn. *Complete Handbook of Magnetic Recording,* **3rd ed. Blue Ridge Summit, PA: Tab, 1988.** Cyclopedic reference to virtually all technical aspects of magnetic recording. Relevant to the mid-1980s.

Karlin, Fred, and Rayburn Wright. *On the Track: A Guide to Contemporary Film Scoring.* **New York: Schirmer Books, 1990.** Mainly for the film music composer, but many useful insights into the aesthetics of composing for films. If you read music, the examples make the book all the more worthwhile. Includes a complete Click Book by Alexander Brinkman.

Keene, Sherman. *Practical Techniques for the Recording Engineer,* **3rd ed. Torrance, CA: S & S Engineering, 1989.** Instructional guide to engineering and producing divided into three parts: beginning, intermediate, and advanced; with supplementary workbook and cassette tapes (see Tapes).

———. *Quality Sound Engineering.* **Torrance, CA: S & S Engineering, 1991.** Emphasis is on

the number of factors in the recording and mixing process that often mean the difference between a quality sound recording and a mediocre one.

Keith, Michael. *Radio Production: Art and Science.* Boston: Focal Press, 1990. Solid, comprehensive introduction to radio operations, programming, and production.

Kerner, Marvin. *The Art of the Sound Effects Editor.* Boston: Focal Press, 1989. Applicable to film and television, this basic, easy-to-read book describes the responsibilities of the sound editor and the assistant sound editor, the purpose of sound effects, spotting, automated dialogue replacement, selecting sound effects, the Foley stage, dubbing, and handling foreign language films.

Kracauer, Siegfried. *Theory of Film: The Redemption of Physical Reality.* New York: Oxford University Press, 1960. With theoretical chapters devoted to the role and effects of sound in relation to picture.

Kryter, Karl. *The Effects of Noise on Man.* New York: Academic Press, 1970. Highly technical scientific study, but enough is understandable to the general reader to make the point about the variety of ways in which noise adversely affects hearing and mental and motor performance.

Lockhart, Ron, and Dick Weissman. *Audio in Advertising: A Practical Guide to Producing and Recording Music, Voiceovers, and Sound Effects.* New York: Frederick Ungar, 1982. The basics.

Lustig, Milton. *Music Editing for Motion Pictures.* New York: Hastings House, 1980. Dated but still useful, unique, book provides a "how-to" approach about this important, but generally not well known or understood, skill. Includes material on spotting, source music and scoring, the click track, click loops, sweetening, coding, the scoring session, and editing the music track.

MacDonald, James. *The Broadcaster's Dictionary.* Broomfield, CO: Wind River, 1987. More than 1,100 entries covering television, radio, recording, and production, with an appendix explaining relatively new broadcast technology and concepts and station diagrams.

McLeish, Robert. *The Technique of Radio Production,* 2nd ed. Boston: Focal Press, 1988. Radio broadcasting from the British perspective with some useful audio production techniques.

Madsen, Roy Paul. *Working Cinema: Learning from the Masters.* Belmont, CA: Wadsworth, 1990. A fresh approach to the crafts involved in producing Hollywood feature films. The chapter on "The Sound Designer" offers valuable insights by Walter Murch.

Mancini, Henry. *Sound and Scores.* Port Chester, NY: Cherry Lane, 1973. How different types or combinations of ensembles, instruments, musical styles, and arrangements convey mood and meaning. With illustrations and accompanying cassette.

Manvell, Roger, and John Huntley, revised by Richard Arnell and Peter Day. *The Technique of Film Music.* London: Focal Press, 1975. History of film music with still worthwhile chapters on the function of music in film and the role of the music director, as well as interviews with film composers and short analyses of four film soundtracks.

Martin, George. *All You Need Is Ears.* New York: St. Martin's, Press, 1979. Autobiography by the producer who "made" the Beatles, with unique and useful insights into music production, creativity, and what it means to have "ears."

Miller, Fred. *Music in Advertising.* New York: Music Sales, 1989. How jingles are written, sold, and recorded with attention to creative planning, the recording session, the film mix, and voiceover techniques.

Millerson, Gerald. *The Technique of Television Production,* 12th ed. London: Focal Press, 1989. About TV production, of course, but with worthwhile analytical and aesthetic material on sound.

Molenda, Michael, ed. *Making the Ultimate Demo.* Emeryville, CA: Electronic Musician Books, 1993. Insights from various perspectives.

Monaco, James. *How to Read a Film,* rev. ed. New York: Oxford University Press, 1981. Introduction to film criticism and aesthetics including useful material on sound.

Mott, Robert. *Sound Effects: Radio, TV, and Film.* Boston: Focal Press, 1990. Anecdotal look at the creative uses and production of sound effects past and present.

Nardantonio, Dennis. *Sound Studio: Production Techniques.* Blue Ridge Summit, PA: Tab, 1990. Entry-level text focusing on basic electronics, the console, signal processing, mics, monitors, MIDI, and recording procedures.

Nelson, Mico. *The Cutting Edge of Audio Production and Audio Post-Production.* White Plains, NY: Knowledge Industry, 1994. Beginning to intermediate level two-part book dealing with audio technology and its applications to production and postproduction in film and video.

Nisbett, Alec. *The Sound Studio,* 5th ed. London: Focal Press, 1993. Latest update of the British classic, formerly titled *The Technique of the Sound Studio.*

————. *The Use of Microphones,* 3rd ed. London: Focal Press, 1989. A manual, with sections titled "Sound," "Microphones," "Balance," "Sound and Picture," "Music Balance," and "Control." In each section each page of text is supported by a page of illustrations.

O'Donnell, Lewis, Philip Benoit, and Carl Hausman, 3rd ed. *Modern Radio Production.* Belmont, CA: Wadsworth, 1993. The role of production in radio programming. Includes material on equipment, operating procedures, practical techniques of on-air production, editing, dubbing, using sound effects and music, and achieving dramatic effects.

Olson, Harry. *Music, Physics, and Engineering.* New York: Dover, 1967. A classic. Chapters on sound waves, musical terminology and scales, resonators and radiators, musical instruments, properties of music, and acoustics are still instructive today.

Oringel, Robert. *Audio Control Handbook,* 6th ed. Boston: Focal Press, 1989. Introduction to audio equipment and procedures applied to radio production.

Peterson, George, and Steve Oppenheimer. *Electronic Musician's Tech Terms.* Emeryville, CA: Electronic Musician Books, 1993. Dictionary of terms for audio and music production including disk-based technology.

Pierce, John. *The Science of Musical Sound.* New York: Scientific American, 1983. Basic principles of sound in relation to music: periodicity, pitch, sound waves, resonance, the ear, hearing, power and loudness, masking, acoustics, sound reproduction, perception, illusion, and effect.

Pohlmann, Kenneth. *Advanced Digital Audio.* Carmel, IN: Sams Publishing, 1991. Digital audio concepts, practices, and related technologies on an advanced technical level. Includes: pulse modulation, multibit conversion techniques, and laser, fiberoptic and optical-disc technologies. Also examines digital audio in film, video, and satellite broadcasting.

————. *The Compact Disc Handbook,* 2nd ed. Madison, WI: A-R Editions, 1992. Technical discussion of CD technology includes CD-I, CD-ROM, and MiniDisc.

————. *Principles of Digital Audio,* 2nd ed. Indianapolis: H. W. Sams, 1989. Technical reference work on the fundamentals of digital sound, recording, audio interfaces, storage, reproduction, and workstations.

Prendergast, Roy. *A Neglected Art: A Critical Study of Music in Films,* 2nd ed. New York: W. W. Norton, 1992. In addition to the history of film music, this study includes the aesthetics of film music and the techniques of synchronizing music to picture and dubbing, with analyses of selections from film scores and updated chapters on video postproduction, digital audio, and the synthesizer.

Ratcliff, John, and Neil Papworth. *Single Camera Stereo Sound.* London: Focal Press, 1992. Stereo theory, location recording in stereo, and postproduction using the single-camera approach.

Recording Industry Sourcebook. Los Angeles: Recording Industry Sourcebook, Annual. Just about everything you need to know about the recording business from record labels to limousine services. Includes, among many things: artist management, music attorneys, performing rights societies, promotion, producers, re-

cording and mastering studios, music programmers, and rental and supply firms.

Robeson, E. M. *The Orchestra of the Language.* New York: T. Yoseloff, 1959. The meaning and effect of language as sound.

Rossing, Thomas. *The Science of Sound*, 2nd ed. Reading, MA: Addison-Wesley, 1990. Introduction to the various branches of acoustics written in nontechnical language for the student in college physics and mathematics. It includes physical principles, perception and measurement, musical instruments, the human voice, electrical production of sound, electronic music, room acoustics, and environmental noise.

Rothstein, Joseph. *MIDI: A Comprehensive Introduction.* Madison, WI: A-R Editions, 1992. Covers MIDI hardware and software as a single integrated system instead of particular brands of equipment and software programs. It describes categories of MIDI instruments, accessories, and personal computer software. Discusses basic MIDI principles but most of the book is intermediate level.

Rumsey, Francis. *Stereo Sound for Television.* London: Focal Press, 1989. Perception, psychoacoustics, microphone techniques, equipment, distribution, and transmission systems, as they relate to stereo for TV. Much of the book is useful, although from the British perspective, and some of it is quite technical.

———. *Tapeless Sound Recording.* London: Focal Press, 1990. Principles and mechanics of hard disk recording and editing.

Rumsey, Francis, and Tim McCormick. *Sound and Recording: An Introduction.* London: Focal Press, 1992. Survey of audio technology—analog and digital—and techniques, including MIDI and synchronization. Emphasis is on "how it works," rather than "how to work it." British.

Runstein, Robert, and David Huber. *Modern Recording Techniques*, 3rd ed. Indianapolis: H. W. Sams, 1989. Basics of multitrack sound recording for music production. In addition to the customary material on sound, microphones and miking technique, consoles, tape recording, signal processing, and so on, includes discussion of synchronization, digital audio, record and disc mastering, and MIDI.

Schafer, Murray. *The Tuning of the World.* New York: Alfred A. Knopf, 1977. Landmark book about the acoustic environment, or "soundscape," pre- and postindustrial; "the relationship between people and the sounds of their environment and what happens when these sounds change."

Schwartz, Tony. *The Responsive Chord.* Garden City, NY: Anchor, 1974. Using his "resonance principle" as the model and advertising as the focus, the influential author, an original thinker and practitioner in sound, explores how auditory communication interacts with the total communication structure in reaching and affecting specific audiences.

Seigel, Bruce. *Creative Radio Production.* Boston: Focal Press, 1992. Introduction to the hardware, but with the emphasis on the practical, operational, and creative "how to." With cassette.

Skinner, Frank. *Underscore.* New York: Criterion Music, 1960. Still-useful practical and aesthetic information about scoring for motion pictures and the role of music in relation to picture.

Soifer, Rosanne. *Music in Video Production.* White Plains, NY: Knowledge Industry, 1991. For the video producer. About the uses and accessibility of music: aesthetics, instrumentation, a brief history of Western music and style, permissions, copyright, licensing, agencies, reuse, misappropriations, the ins and outs of commissioning original music, music libraries, and using public domain.

Sound for Picture: An Insider's Look at Audio Production in Film and Television. Editors of *Mix* Magazine. Emeryville, CA: Mix Magazine, 1993. Compilation of articles from issues of *Mix* about how dialogue, sound effects, and music are recorded, edited, and assembled into soundtracks.

Spence, Keith, and Giles Swayne, eds. *How Music Works.* New York: Macmillan, 1981. A symposium of articles about the meaning and materials of music including chapters titled:

"Recording," "Music and Broadcasting," and "Sound and Vision."

Strong, William. *The Copyright Book: A Practical Guide*, 4th ed. Cambridge, MA: MIT Press, 1993. Covers musical and literary works, CD-ROMs, holograms, data bases, compilations, and shareware, among other categories. Not in legalese.

Taub, Eric. *Gaffers, Grips, and Best Boys*. New York: St. Martin's Press, 1987. Behind-the-scenes personnel in motion pictures, including some of the sound people.

Thomas, Tony. *Film Score: A View from the Podium*. Cranbury, NJ: A. S. Barnes, 1979. Articles about 20 of Hollywood's foremost composers with valuable insights into the techniques and aesthetics of composing for film. With film music discography and bibliography.

———. *Music for the Movies*. Cranbury, NJ: A. S. Barnes, 1972. Useful material about film music and its informational relationship to picture.

Time Code Handbook, 3rd ed. Frederick, MD: Cipher Digital, Inc. Background, basics, and applications of SMPTE, VITC, and MIDI time code.

Traister, Robert, and Anna Lisk. *The Beginner's Guide to Reading Schematics*, 2nd ed. Blue Ridge Summit, PA: Tab, 1991. Guide to understanding symbol conventions and reading schematic diagrams.

Truax, Barry. *Acoustic Communication*. Norwood, NJ: Ablex, 1984. Introduction to sound in an interdisciplinary framework with the aim of establishing a model for understanding acoustic and aural experience both in traditional terms and as it has been altered by technology. Major sections are "Sound, Listening, and Soundscape" and "Electroacoustics — The Impact of Technology on Acoustic Communication." With discography and extensive bibliography.

Utz, Peter. *Making Great Audio*. Mendocino, CA: Quantum, 1989. Basic audio for the non- and semiprofessional. Includes practical approaches to miking, setting up public address systems, using the compact disc player, editing, and maintenance.

Wadhams, Wayne. *Dictionary of Music Production and Engineering Technology*. New York: Schirmer, 1988. Dictionary of terminology and basic concepts in the fields of television, radio, music, and film audio production and engineering.

———. *Sound Advice: The Musician's Guide to the Record Industry*. New York: Schirmer, 1990. Covers the process from making a demo to negotiating a contract with a major label, including the important subject of artists' rights and how to protect them. Also explained are: unions, music publishing, and the workings of industry organizations and associations. Many examples of different kinds of contracts.

———. *Sound Advice: The Musician's Guide to the Recording Studio*. New York: Schirmer, 1990. Basic functions and operations of a recording studio including detailed nontechnical discussion of recording procedures and miking techniques. With excellent companion 2-disc CD set and accompanying explanatory booklets.

Watkinson, John. *The Art of Digital Audio*, 2nd ed. London: Focal Press, 1993. Updated technical book covering digital audio theory and the various uses of digital audio in rotary and stationary head tape recorders, disk drives, compact disc, compact cassette (DCC), and broadcasting.

———. *R-DAT*. London: Focal Press, 1991. Technical discussion of the operating theory and applications of digital audio tape.

Weis, Elisabeth. *The Silent Scream*. Rutherford, NJ: Farleigh Dickinson, 1982. Explores Alfred Hitchcock's use of the sound track in films. Included in the analyses are *Vertigo* and *Psycho*.

Weis, Elisabeth, and John Belton, eds. *Film Sound: Theory and Practice*. New York: Columbia University Press, 1985. Essays, from the highly theoretical to the practical, about the design and aesthetics of sound in relation to picture in film and television. Extensive bibliography.

White, Glenn. *The Audio Dictionary*, 2nd ed. Seattle: University of Washington Press, 1991. Dictionary of terminology and basic concepts in the fields of audio production, musical acoustics, and sound reinforcement.

Whitney, John. *Digital Harmony: On the Complementarity of Music and Art*. New York: McGraw-Hill, 1982. A unique perspective on the sound–picture relationship from the experimental filmmaker discussing his hypothesis: "how the application of graphic harmony — ratio, interference, and resonance — produces the same effect that these physical facts of harmonic force have upon musical structures."

Winckel, Fritz. *Music, Sound, and Sensation*. New York: Dover, 1967. A study of the relationships in the laws of nature that are responsible for musical perception.

Woodward, Walt. *An Insider's Guide to Advertising Music*. New York: Art Direction, 1982. How and why music in advertising works and when and how to use it.

Woram, John. *Sound Recording Handbook*. Indianapolis: H. W. Sams, 1989. Comprehensive coverage of recording technology includes basic theory about the decibel, sound, psychoacoustics, microphone design, loudspeakers, signal processors, dynamic range, tape, the tape recorder, recording consoles, noise reduction, and time code.

Zaza, Tony. *Audio Design: Sound Recording Techniques for Film and Video*. Englewood Cliffs, NJ: Prentice-Hall, 1991. Unique book focuses on the aesthetic and creative uses of sound in relation to picture. Provocative, sometimes highly theoretical, insights into how sound and image work together on the screen and in the mind. History of sound recording, selected films for study, many examples, and illustrations.

———. *Mechanics of Sound Recording*. Englewood Cliffs, NJ: Prentice-Hall, 1991. Companion volume to the author's *Audio Design* that covers the technology and techniques of audio production. Many examples and illustrations.

Zettl, Herbert. *Sight, Sound, and Motion: Applied Media Aesthetics*, 2nd ed. Belmont, CA: Wadsworth, 1990. Imaginative analysis of light, space, time, motion, and sound (two chapters) and their relationships to expression and meaning in television and film.

Tapes

Everest, F. Alton. *Auditory Perception Course*. Thousand Oaks, CA: SIE, 1987. Manual and four audiocassettes covering aspects of psychoacoustics including the hearing process, complexity of delayed sounds, auditory filters, masking, and perception of pitch and timbre.

———. *Critical Listening Course*. Thousand Oaks, CA: SIE, 1982. Training manual and 10 audiocassettes dealing with listening techniques including estimating frequency, frequency band limitations, sound-level changes, components of sound quality, distortion, reverberation effects on speech and music, and voice colorations.

Gibson, Bill. *Killer Demos: Hot Tips & Cool Secrets*. Federal Way, WA: Bill and Bob's Excellent Productions, 1991. VHS with tips on making a multitrack home recording not sound like a home recording.

Gibson, Bill, and Peter Alexander. *Hit Sound Recording Course*. Newbury Park, CA: Katamar Entertainment Corporation, 1992. Audiocassettes and manuals for 12 units including: console operation; signal processing; recording guitars and strings, acoustic drums, drum machines, bass, vocals, keyboards, synthesizers; panning and stereo imaging; the recording session; and the mixdown.

Hernandez, John. *Miking the Drum Set*. Claremont, CA: Terence Dwyer Productions, 1992. VHS tape and manual demonstrating many approaches to selecting and positioning drum microphones.

Keene, Sherman. *Sound Engineer Self-Study Course*. Sedona, AZ: SKE, 1986. Basic, intermediate, and advanced lessons on 12 audiocassettes per series. Basic lessons include operating procedures, microphones, console functions, basic theory, and tape recorders. Intermediate lessons include console operations, musical terminology, intermediate theory, and acoustics.

Advanced lessons include acoustics, tape machines, advanced theory, special effects, audio systems, and audio psychology.

Lubin, Tom. *Shaping Your Sound*. Los Angeles: Acrobat, 1988–1991. Six videocassettes, with manuals, covering microphones; equalizers, compressors, and noise gates; reverberation and delay; mixers and mixing; multitrack recording; and studio seconds: the assistant sound engineer.

Miller, Peter, ed. *Master Course for the Recording Engineer*. San Francisco: Audio Institute of America, 1988. Six 60-minute audio cassettes and a 500-page manual deliver 25 lessons on the fundamentals of recording technology and studio practice.

Sound Application for Video. Beverly Hills: Video International, 1987. Part of a series on video production, this videocassette, devoted to audio, demonstrates various pieces of audio equipment, use of sound effects and music, and soundtrack design.

Periodicals

American Cinematographer Journal of film and video production techniques with coverage of sound from time to time. Monthly.

Audio Engineering Society (AES) Journal The journal of the Audio Engineering Society devoted mainly to research and development in audio technology. Monthly.

AV Video Production techniques for the hands-on professional targeted to industrial and educational media. Monthly.

Billboard's International Directory of Manufacturing and Packaging Professional services and supplies for record and audio manufacturers, video and music producers, and production facilities. Annual.

Billboard's International Recording Equipment and Studio Directory Directory of statistics on professional recording and studios. Annual.

Broadcast Engineering Information for engineers and equipment operators in television and radio. Monthly.

Broadcaster News about Canada's broadcasting industry, including sound production in TV and radio. Monthly.

Cue Sheet News and studies of the art of composing for films. Features interviews with film composers. Quarterly.

dB, The Sound Engineering Magazine Technology and techniques for the professional in music recording, broadcasting, film, and sound contracting. Bimonthly.

Electronic Musician Devoted to the technology and practices that link electronics and computers with the world of music. Monthly.

EQ Covers projects in recording and sound studio techniques for the professional audio market. Quarterly.

Film and Video Covers all areas of the production and postproduction process including sound. Monthly.

Home and Studio Recording Practical production tips, sound and music theory, and equipment for the recording musician. Monthly.

HyperMedia Devoted to articles on interactive media production involving computers, audio, music, film, video, computer graphics, workstations, and networks. Quarterly.

The Illustrated Audio Equipment Reference Catalog Two volumes covering the product lines of manufacturers who serve the professional audio and the commercial and industrial sound industries. Bill Daniels Co. Annual.

International Musician and Recording World Practical advice and technical information for the recording musician. Monthly.

Millimeter Information on the technology, craft, and use of television and film media for communication, with occasional articles about audio. Monthly.

Mix Reports and interviews on production practices, equipment, facilities, education, and trends in the major areas of professional audio — music recording, video, and film. Monthly.

Mix Annual Directory of Recording Industry Facilities and Services Comprehensive directory of recording industry facilities and services. Annual.

Mix Bookshelf Comprehensive annotated bibliography and resource guide for the audio and video recording industry. Covers books, tapes, computer software, and sound libraries, available through the Mix Bookshelf service in the areas of studio and home recording, digital audio, audio and video production and technology, MIDI, electronic music, synthesizers, music composition, the music business, and music instruction and history. (Most titles and tapes are also available from the publishers.) Semiannual.

One to One International news magazine for mastering, pressing, and duplicating. Bimonthly.

On Location Film and videotape production magazine focusing on field recording, including attention to audio. Monthly.

On Location Directory Directory of national film and videotape production facilities. Annual.

On Production and Post-Production For producers, technicians, and film enthusiasts, it covers current trends, including those in audio. Bimonthly.

Post Magazine whose focus is postproduction, intended for professionals in audio, video, film, and animation. Monthly.

Producers Quarterly Audio and video production experiences and tips from and for professionals. Quarterly.

Professional Sound About the audio production scene in Canada. Quarterly.

Pro Sound News News magazine of developments in audio for professional recording and sound production. Monthly.

S & VC (Sound & Video Contractor) Management and engineering journal for sound and video contractors. Monthly.

SMPTE Journal The journal of the Society of Motion Picture and Television Engineers, devoted mainly to research and development in motion picture and television technology. Monthly.

Sound and Communications Covers professional audio for sound contractors and managers with information that is often useful to the working producer. Monthly.

Sound Engineer/Producer British publication for the professional producer/recordist covering techniques, equipment, news, and interviews related to music recording. Monthly.

Studio Sound British publication devoted to the practical and technical aspects of audio production in broadcasting, film, and music. Monthly.

Studio Sound and Broadcast Engineering News and feature articles on the technological state of sound engineering with product reviews and business analysis. British. Monthly.

Television Broadcast News magazine covering television equipment, applications, and technology, with articles about audio. Monthly.

Videography For the video production professional with articles on sound from time to time. Monthly.

Credits

ADC Telecommunications, Inc.: 6-17

Akai: 8-21

AKG Acoustics: 5-24, 5-39c,d, 5-49; Microphone section: p. 103, The Tube, C-414 EB ULS; p. 104, c535; p. 111, CK68/ULS; p. 113, 222, 224E; p. 114, D112; p. 117, 900E

Alpha Audio: 3-13a

Ampex Corporation: 16-10b

AMS Industries Plc: 5-29, 5-30, 5-31

Anchor Audio: 15-12

Aphex: 9-10a, 9-27

Atlas Sound: 5-56, 5-58

Audio Services Corporation: 15-43, 15-44

Audio Technica: 5-66

Audiotronics: 6-6

Benchmark Associates with Downtown Design: 4-5

Beyerdynamic: 5-4, 5-25; Microphone section: p. 110, MCE 10; p. 114, M 380; p. 114, M 600; p. 118, M 160, M 500

Broadcast Electronics, Inc.: 6-5, 7-22

Broadcast Engineering: 10-15 © 1989 Intertec Publishing Corporation. All rights reserved

Bruel and Kjaer: Microphone section: p. 104, 4003, 4004; p. 105, 4011

CellCast: 15-3

Coles: Microphone section: p. 118, Coles 4038

Comrex Corporation: 12-10, 15-11

Countryman Associates: 5-41, 5-43, 12-16, 14-37

Crown International, Inc.: 5-51, 5-53, 5-59; Microphone section: p. 105, GLM 100; p. 105, SASS; 15-19

Peter D'Antonio and RPG Diffusor Systems, Inc.: 3-16

dbx, A Division of AKG Acoustics: 9-3, 9-24, 9-32

Denecke: 7-30

Desper Products, Inc.: 17-13, 17-14

Digal: 10-17

digidesign: 6-21, 16-56, 16-57

Digital Audio Labs: 16-47, 16-50, 16-52, 16-53, 16-55

Dolby Laboratories, Inc.: 9-10b, 9-31, 15-45

Dan Dugan Sound Design: 15-21a

Editall Products, Xedit Corporation: 16-1, 16-2

Electro-Voice, Inc.: 5-11, 5-13, 5-36, 5-40b,c; Microphone section: p.105, CS15P; pp. 114–115, RE 15, RE 16, RE 18; p. 115, 27 N/D; p. 116, 635A and RE 50; p. 117, RE 45 N/D; p. 116, RE 55

ENSONIQ Corporation: 13-10

Ron Estes: 14-81

Esto Photographic: 4-2

Eventide: 9-21 (Harmonizer is a registered trademark of Eventide, Inc.)

Fairlight: 13-8

Fidelipac Corporation: 7-18, 7-19, 8-19

Fieldwood Systems: 17-18

J. L. Fisher: 5-63

Florida Department of Citrus: pp. 264, 265, 266

Fostex: 7-11, 8-13

Garner Industries: 7-8b

Gefen Systems: 13-6, 14-4

GHL: 4-15

Gotham Audio Corporation: 9-13, 9-14

G Prime, Ltd.: Microphone section: p. 106, Gelfell UM 70s

Groove Tubes . . . aú di-ō: Microphone section: p. 106, Groove Tubes MD-2

Harrison-(W, Inc.: 4-10

HEAD Acoustics: 14-17
International Tapetronics Corporation: 12-20
JBL Professional: 10-9, 10-16c
Killer Tracks: 14-5
Lexicon: 9-15, 9-22
McClear Pathé: 4-11
MacKenzie Laboratories: 12-19
Magnasync/Moviola: 7-31a, 16-38
Magnatech Electronic Company: 7-31b
Marshall Electronic: 9-18
Marti Electronics, Inc.: 15-4
Milab: Microphone section: p. 106–107, VIP-50, DC 96B; 5-23
Nagra Magnetic Recorders, Inc.: 15-37, 15-41
Neumann/USA: 5-26, 5-39e, 5-40a,d, 5-52, 5-62c; Microphone section: p. 107, KM 100; p. 107, TLM 50, TLM 170i; p. 108, U 87Ai, U 89i; p. 111, KMR 82i; p. 112, USM 69, 14-16
Opamp Labs: 15-20
Opcode Systems, Inc.: 14-71
Orban, A Division of AGK Acoustics: 9-4, 9-7, 12-30
Otari Corporation: 4-13, 16-54; pp. 50, 51, 52, 71, 120, 153, 187, 216, 245
Posthorn Recordings: Microphone section: p. 108, Schoeps Colette System; p. 112, KFM 6U Sphere
PROMUSIC, Inc.: 14-6
RCA: 5-3, Microphone section: p. 118, 77DX
R.D. Systems of Canada, Ltd.: 5-45
Record Plant (Chris Stone): 4-3
Roland Corporation US: 9-6, 9-33, 13-11
Rupert Nerve, Inc.: 4-7
Ryder Sound Services: 4-9
Samson: 5-47
Steve Sartori: 3-18, 5-35, 7-12, 14-18, 14-26–14-36, 15-7, 16-29, 16-31
Selco Products Company: 6-3, 6-4

Sennheiser Electronic Corporation: Microphone section: p. 109, MKH 40P48; p. 111, 416, 816, p. 116, 421, 441
Shure Brothers, Inc.: 5-12, 5-48, 5-57, 5-62a,b; Microphone section: p. 109, SM81; p. 110, SM 83; p. 113, VP88; pp. 116–117, Beta 57, Beta 58; p. 117, SM5; 14-43, 15-2, 15-5
Bruce Siegel: 14-1
Solid State Logic, Ltd.: 4-14
Sony Corporation of America: 4-12; Microphone section: p. 109, C-37P; p. 109, C-48; p. 110, C-800G; p. 110, ECM 66; 6-8, 6-9, 6-16, 6-19, 7-6, 7-14, 7-23, 8-23, 15-6, 16-32, 16-33; pp. 502, 503, 504, 558
SOUNDFORMS International: 3-13b
Spectral Music Corporation and The Sandbox: 4-6
Steenbeck: 16-39
William Storm: 5-7, 5-8, 5-39a,b, 5-54, 5-60, 5-61, 6-15, 7-3, 7-16, 7-17, 14-38, 14-41, 14-44, 14-49, 16-4, 16-5, 16-6, 16-10a, 16-11–16-21, 16-37, 16-40–16-46
Studer: 8-10, 8-18
Switchcraft: 6-11
Taber Manufacturing and Engineering Company: 7-8a
TASCAM, TEAC Professional Division: 8-14
Universal City Studios, Inc.: 4-4
UREJ—United Recording Electronics Industries: 10-10
Vega: 5-46
Westlake Audio: 10-1, 10-2, 10-3
Wheatstone Corporation: 4-1, 4-8, 12-11
Whirlwind: 15-18, 15-35
Yamaha Corporation of America: 6-20, 8-12, 8-20
Herbert Zettl: 5-64, 5-65, 15-14; pp. 288, 289, 290, 337, 359, 441

Index

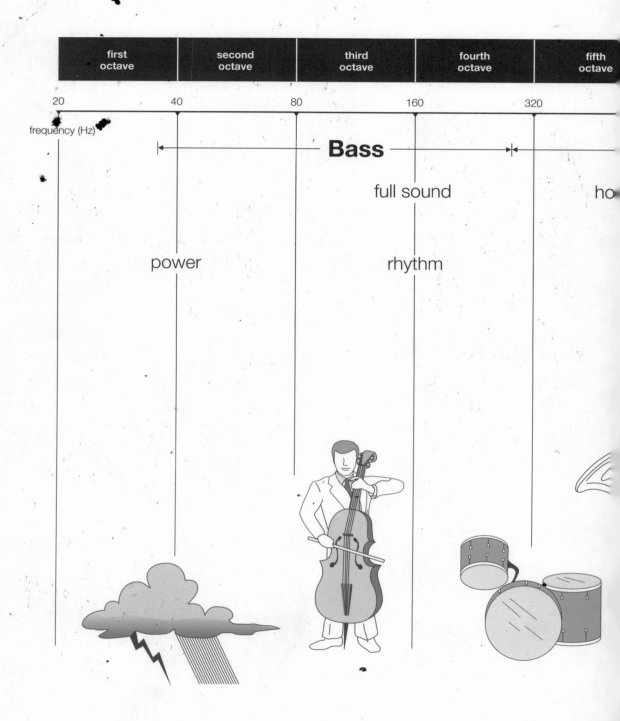

| first octave | second octave | third octave | fourth octave | fifth octave |

20 40 80 160 320

frequency (Hz)

Bass

full sound ho

power rhythm

fre